AZTECS

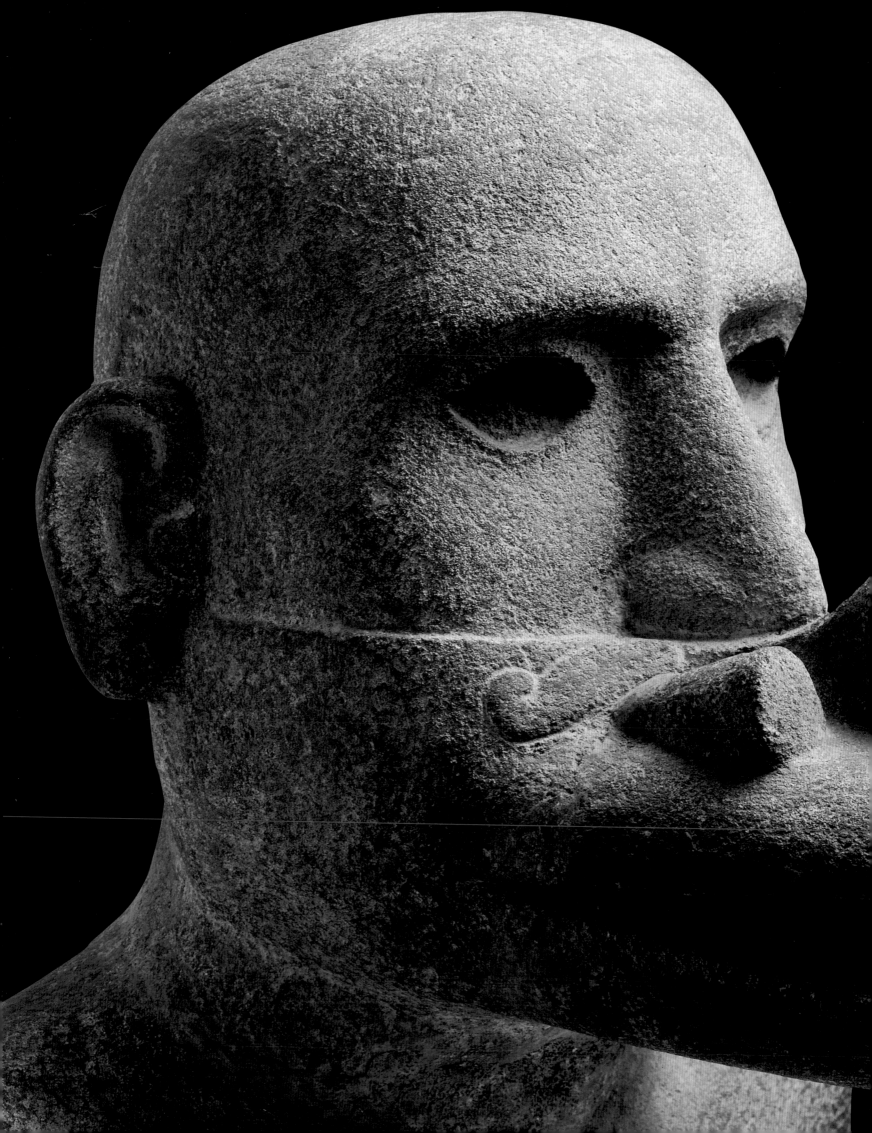

AZTECS

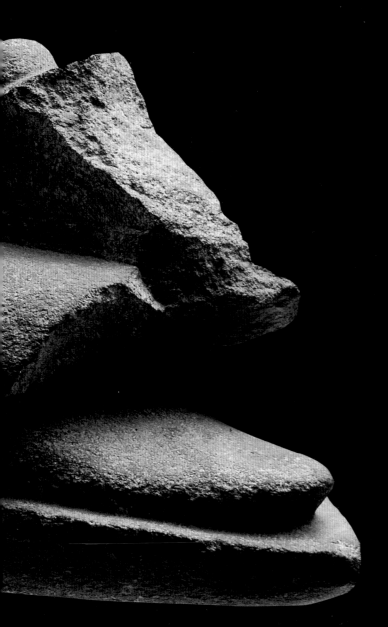

First published on the occasion
of the exhibition 'Aztecs'
Royal Academy of Arts, London
16 November 2002 – 11 April 2003

The Royal Academy of Arts is grateful to
Her Majesty's Government for agreeing to indemnify
this exhibition under the National Heritage Act 1980,
and to Resource, The Council for Museums, Archives
and Libraries, for its help in arranging the indemnity.

Supported by

Tourism Board

Generous support has also been received
from Virginia and Simon Robertson.

EXHIBITION CURATORS, MEXICO CITY
Eduardo Matos Moctezuma
Felipe Solís Olguín

ROYAL ACADEMY OF ARTS, LONDON
Tom Phillips RA, *Chairman of Exhibitions Committee*
Norman Rosenthal, *Exhibitions Secretary*
Adrian Locke, *Aztec Exhibition Curator*
Isabel Carlisle, *Curator*

EXHIBITION ORGANISATION
Emeline Max, *Head of Exhibitions Organisation*
Lucy Hunt, *Exhibition Organiser*
Hillary Taylor, *Assistant Exhibition Organiser*

PHOTOGRAPHIC AND COPYRIGHT COORDINATION
Andreja Brulc
Roberta Stansfield

CATALOGUE
Royal Academy Publications
David Breuer
Harry Burden
Carola Krueger
Fiona McHardy
Peter Sawbridge
Nick Tite

CONSULTING EDITOR
Warwick Bray

COPY-EDITING AND PROOFREADING
Michael Foster

TRANSLATION
Translate-A-Book, Oxford

BOOK AND MAP DESIGN
Isambard Thomas

PICTURE RESEARCH
Julia Harris-Voss with Celia Dearing

SPECIAL PHOTOGRAPHY
Michel Zabé

ILLUSTRATIONS
Russell Bell
Roger Taylor

COLOUR ORIGINATION
Robert Marcuson Publishing Services

Printed in Madrid by Turner at Artes Gráficas
Palermo, S.L., and bound at Hermanos Ramos

British Library Cataloguing-in-Publication Data

A catalogue record for this book is available
from the British Library

ISBN 1–903973–22–8 (paperback)
ISBN 1–903973–13–9 (hardback)
D. L.: M-46.614-2002

Distributed outside the United States and Canada
by Thames & Hudson Ltd, London
Distributed in the United States and Canada
by Harry N. Abrams, Inc., New York

EDITORIAL NOTE
All measurements are given in centimetres,
height before width before depth

The Royal Academy of Arts acknowledges with
gratitude the assistance of CONACULTA-INAH
in organising the loans from Mexico.

p. 6 Detail of cat. 340, page 7
pp. 10–11 Detail of cat. 130
pp. 12–13 Map of the extent of the Aztec
 empire, along modern political
 boundaries

CONTENTS

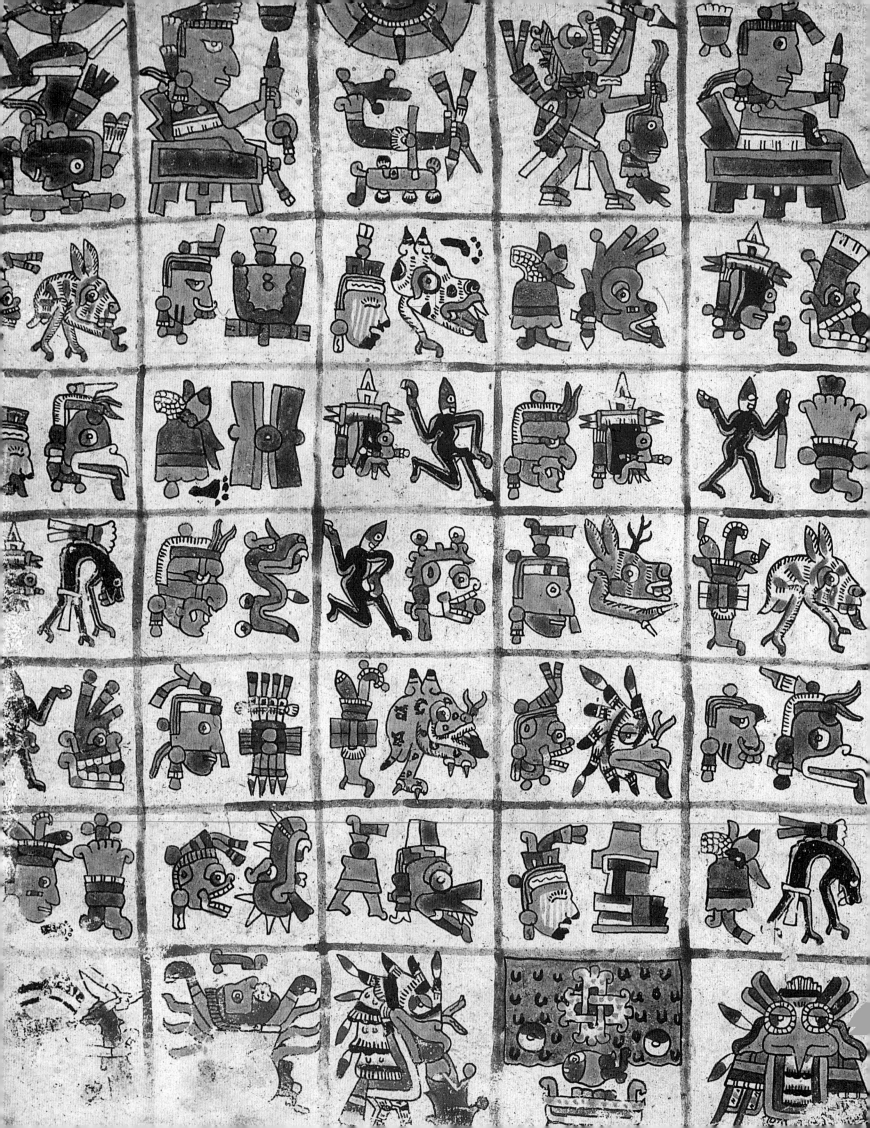

FOREWORDS

I am very glad to have the opportunity and honour to welcome this exhibition of Mexican artefacts to the United Kingdom. I am delighted that it is being officially opened by my friend and colleague President Vicente Fox of Mexico, at the Royal Academy of Arts.

I believe this exhibition will be a milestone in cultural relations between Mexico and the United Kingdom. I would like to acknowledge Mexico's great generosity in allowing so many wonderful works of art and treasured objects to come from its museums to London.

The era of the Aztecs represents one of the great historic milestones in human history, contributing richly to the modern world we know today. The first European encounter with this civilisation can only have been one of awe.

I was able to visit Mexico myself in August 2001. It became clear to me then that Mexico today is an exciting cosmopolitan country with a rich cultural heritage – a fine example of peoples from many races coming together to make one of the most vibrant countries in the world.

From all I saw during my time in Mexico, I do not doubt that the exhibition will be a great success.

Tony Blair
Prime Minister of Great Britain

The cultural legacy of Mexico is extraordinarily rich and varied: the imprint of Europe is everywhere apparent; echoes of Asia and Africa are easily discernible; and the Arab and Jewish worlds – through the medium of Spain – have also left their mark.

But the civilisations that flourished in Pre-Hispanic Mexico, before the arrival of the Europeans, occupy an especially prominent place within this vast heritage. The Mexica – or Aztecs – were one of the most highly developed among these civilisations. From inauspicious beginnings they built an empire that spanned central and southern Mexico, from the Atlantic to the Pacific. Their complex society displayed remarkable artistic and technical accomplishments, as well as customs that can seem, to contemporary eyes, harsh or violent.

The first Europeans to see the Aztec capital were amazed by its splendour. And although the civilisation that inspired this wonderment was ultimately to fall to Hernán Cortés, and, in the process, give rise to a new country, it has lost none of its fascination. The achievements of the Aztecs continue to excite the curiosity of scholars in Mexico and abroad. Recent decades have seen great advances in our understanding of the Aztec world, thanks to the discovery of the monumental disc of the goddess Coyolxauhqui in 1978 and the excavations of the ambitious Templo Mayor project in Mexico City.

The people and government of Mexico are thus proud to present this major exhibition at the Royal Academy of Arts. Although Britain has made an outstanding contribution to the study and conservation of the world's cultural heritage, it remains relatively unfamiliar with the rich legacy of the indigenous cultures of the Americas. We hope that this exhibition, together with the opening of the Mexican Gallery at the British Museum, will enhance interest in and awareness of the achievements of the civilisations that flourished in the Americas before the advent of the Europeans.

'Aztecs' at the Royal Academy will stand as a milestone in the dissemination of the achievements of the Pre-Hispanic world. Never before have so many major pieces been brought together. Many, indeed, are being exhibited for the first time. Our deepest gratitude and appreciation goes to the Royal Academy of Arts for providing such a splendid setting for this exhibition, with the support of the following Mexican institutions: the Consejo Nacional para la Cultura y las Artes (CONACULTA), the Instituto Nacional de Antropología e Historia (INAH), the Mexican Tourism Board, the Secretaría de Relaciones Exteriores and Petróleos Mexicanos (Pemex).

The display of Mexico's cultural legacy is a powerful means for us to let others see us as we truly are, fostering mutual understanding and strengthening ties of friendship. This is our ultimate purpose in bringing the unique heritage of the Aztecs to London.

Vicente Fox
President of Mexico

It is always an honour as well as a joyous responsibility to share the glories of Mexican culture and history with other nations. We are convinced that there is no better dialogue than that generated by the interchange of artistic expressions between peoples. For this we celebrate the presence of the Aztecs in the United Kingdom.

This exhibition, presented by the Royal Academy of Arts, shows the world of the Aztecs as a splendid crucible in which all aspects of their society, arts and culture are brought together. From the time of their arrival in the basin of Mexico and the foundation of their magnificent city of Tenochtitlan in 1325, the Aztecs built a civilisation whose influence spread across most of Mesoamerica.

Through the artistic and plastic properties of the works included in this exhibition, it is possible to glimpse the aesthetic values inherent in all aspects of Aztec life. Each one of these objects is an example of the conception they had of the world, the gods, and of themselves.

The knowledge we have of the Aztecs has been considerably enriched by research undertaken over the past 25 years, particularly by the excavations made at the Templo Mayor in Mexico City. Many of the subsequent finds are included in this exhibition.

We live in a world where there is increasing interest in the identity and culture particular to each nation. A growing fascination with pre-Hispanic Mexico, and in particular the world of the Aztecs, is a case in point. For this reason it is an honour for the Mexican people and the Consejo Nacional para la Cultura y las Artes (CONACULTA) to celebrate this exhibition which allows us to share our historical patrimony in such a rewarding way.

As a Nahua song collected in the seventeenth century reads, 'while the world lasts, the fame and glory of Tenochtitlan will never be lost'.

Sari Bermúdez
President, Consejo Nacional para la Cultura y las Artes (CONACULTA)

The ancient Nahuas wrote 'Oh my friends! I wish that we were immortal. Oh friends! Where is the land where one cannot die?' Today more than two million descendants of the Aztec people, dispersed across Mexico, use this language of jade and turquoise to convey their experiences, desires and hopes. The poetic talent of these people is reflected in their culture, a product of an evolutionary and well-maintained social, military, religious, artistic and economic society.

The Aztecs, one of the seven tribes that left the mythic land of Aztlan, followed the signs of their tutelary god, Huitzilopochtli, and based the foundation and development of a vast empire, the greatest of pre-Hispanic North America, on his prophecy. Their authority allowed them to dominate and impose a way of life over a large part of Mesoamerica. In the same way, the grandeur of their civilisation was built on elements they integrated from their predecessors' cultures.

The Consejo Nacional para la Cultura y las Artes (CONACULTA) and the Instituto Nacional de Antropología e Historia (INAH) joined forces with various cultural and educational organizations in Mexico to give rise to, and lay the foundations for, this exhibition. This show, comprised in large part of objects from Mexican museums, constitutes a recognition of the universality of Aztec civilisation as world heritage. The curatorial work undertaken by two important Mexican archaeologists stands out: Eduardo Matos Moctezuma, Co-ordinator of the Proyecto Templo Mayor, and Felipe Solís Olguín, Director of the Museo Nacional de Antropología.

Certainly, on looking at these pieces it is possible to hear the Nahua voice of 'he who speaks with understanding'. In communicating their immortal message regarding the customs and cosmovision of the Aztec people to an appreciative British public, these works reinforce the fraternal links between two countries already joined together through culture and art.

Sergio Raúl Arroyo García
General Director, Instituto Nacional de Antropología e Historia (INAH)

The encounter between Mexico and Spain in the early sixteenth century was an event which changed world history for ever. It brought together two sophisticated cultures previously unknown to each other: the Aztecs, the latest in a long line of extraordinary Mexican civilisations, and Europe, as represented by the Spanish conquistadors. Although it is widely thought that after the fall of their magnificent capital Tenochtitlan, in 1521, the Aztecs were a vanquished society, they remained a potent force in the subsequent development of the art and architecture of Mexico, then called New Spain. A new culture emerged, reflecting aspects of both America and Europe in much the same manner that the Aztecs had absorbed previous cultures like Teotihuacan and Tula.

The last time an exhibition dedicated to the art and culture of the Aztecs was shown in London, the Royal Academy was fifty-six years old and the distinguished painter Sir Thomas Lawrence (1769–1830) its fifth President. It is somehow fitting that the Aztecs should return to Piccadilly since it was in the Egyptian Hall, almost directly opposite Burlington House, in 1824, that William Bullock showed off the collection of Mexican objects that he had collected on his travels the previous year. The Egyptian Hall is sadly no more and almost two centuries have passed since that show, the first exhibition of Mexican pre-Columbian art in the world. Mexican culture is now familiar to many, and times have changed from those early days when a real 'live' Mexican formed part of Bullock's display. Recent great exhibitions on the cultures of the Olmec and Maya have paved the way for this ambitious presentation of the art and culture of the Aztecs. Many collections in Mexico, the USA, and Europe have generously agreed to lend their treasures to this exhibition which will provide an extraordinary glimpse into the world of the Aztecs.

The Royal Academy of Arts has worked very closely with the Mexican government on the preparation of this exhibition and owes a huge debt of gratitude to Sari Bermúdez, President of the Consejo Nacional para la Cultura y las Artes (CONACULTA), Sergio Raúl Arroyo García, General Director of the Instituto Nacional de Antropología e Historia (INAH), Jaime Nualart, Director General for International Affairs (CONACULTA) and José Enrique Ortiz Lanz, Co-ordinator for Museums and Exhibitions (INAH), for facilitating the loan of these treasures of Mexico's national heritage. Three Ambassadors of the Republic of Mexico have worked tirelessly to make this exhibition possible: Ambassador Jorge Alberto Lozoya, Ambassador Andrés Rozental, and Ambassador Alma Rosa Moreno. It is a measure of the importance of this exhibition that the President of Mexico, Vicente Fox, will do us the enormous honour of officially opening 'Aztecs'. Our thanks also extend to the distinguished Mexican Aztec scholars Eduardo Matos Moctezuma, Co-ordinator of the Proyecto Templo Mayor and Felipe Solís Olguín, Director of the Museo Nacional de Antropología who have curated this exhibition with the greatest skill and understanding. The Academy also acknowledges the help afforded by Her Majesty's Ambassadors to the Republic of Mexico, namely Ambassador Adrian Thorpe, and Ambassador Denise Holt. Tom Phillips, Chairman of the Exhibitions Committee, and many members of staff at the Royal Academy, including Norman Rosenthal, Isabel Carlisle, Adrian Locke and Emeline Max, have worked over several years to make it possible to realise this show. The exhibition has been designed with imagination and skill by Ivor Heal. Lastly I should like to extend the thanks of the Royal Academy to David Gordon, now Director of the Milwaukee Museum of Art, who worked tirelessly on this exhibition during his tenure as Secretary of the Royal Academy of Arts and to Peter Sawbridge who has edited the catalogue with great dedication and skill.

Ambitious loan exhibitions are increasingly impossible without generous subvention and therefore I would like to acknowledge the supporters for this exhibition, particularly the Mexico Tourism Board and Pemex. In addition I would like to thank Virginia and Simon Robertson for their generous donation, and also BAT for their support.

Phillip King
President of the Royal Academy of Arts

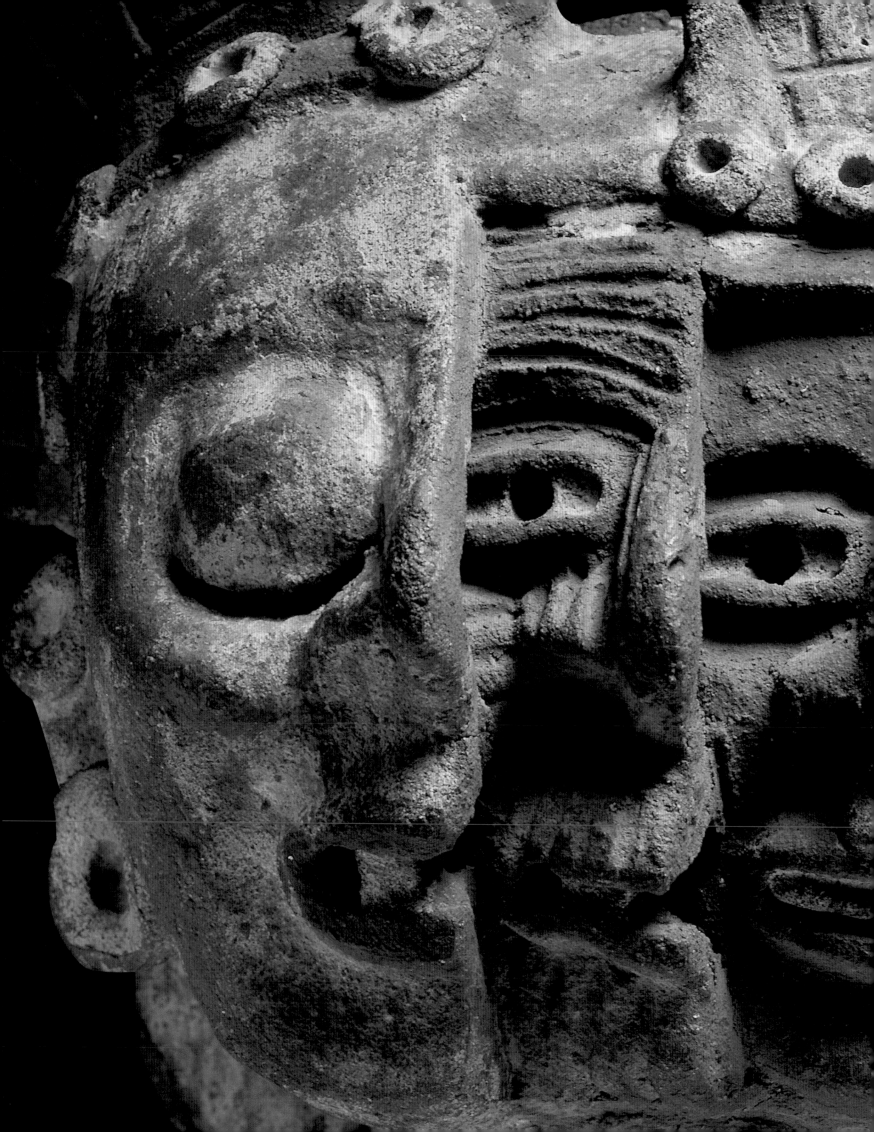

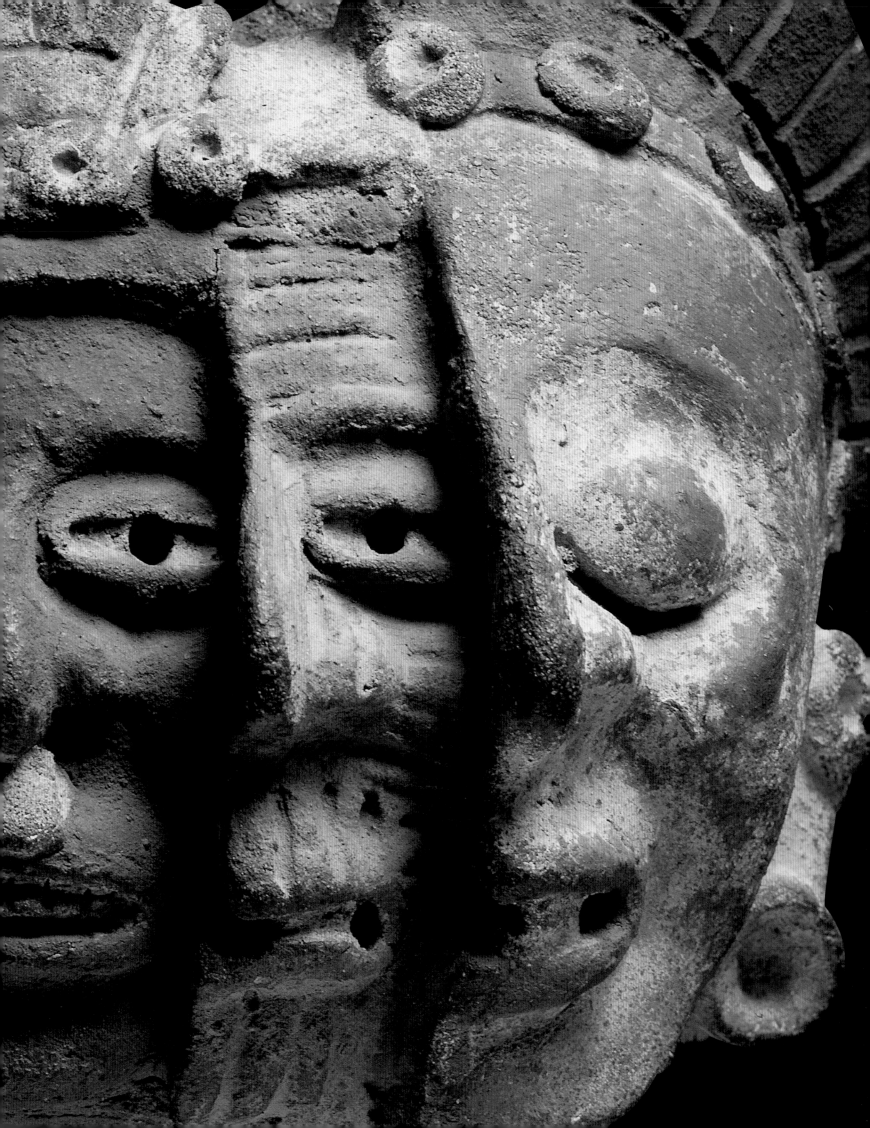

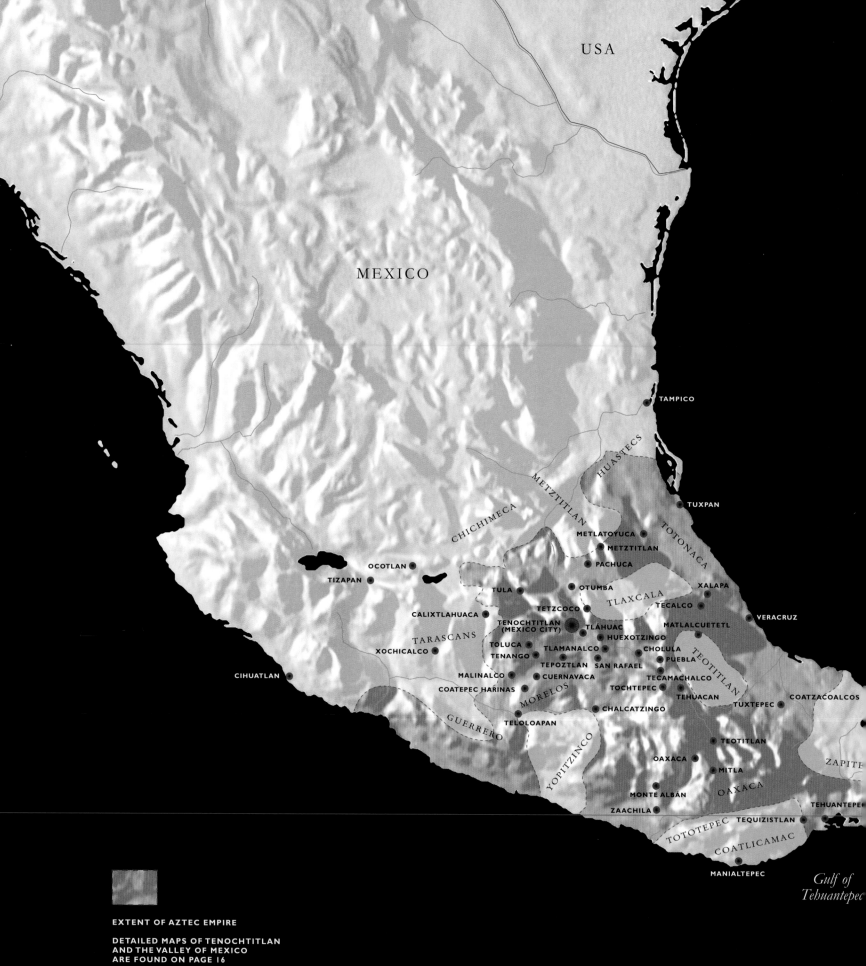

USA

MEXICO

TAMPICO

HUASTECS

METZTITLAN

CHICHIMECA

TUXPAN

METLATOYUCA

TOTONACA

METZTITLAN

PACHUCA

OCOTLAN

TIZAPAN

TULA

OTUMBA

XALAPA

TLAXCALA

TECALCO

CALIXTLAHUACA

TECZCOCO

TENOCHTITLAN
(MEXICO CITY)

TLÁHUAC

MATLALCUETETL

VERACRUZ

XOCHICALCO

TARASCANS

TOLUCA

HUEXOTZINGO

TENANGO

TLAMANALCO

CHOLULA

TEOTITLAN

TEPOZTLAN

SAN RAFAEL

PUEBLA

CIHUATLAN

MALINALCO

CUERNAVACA

TECAMACHALCO

COATEPEC HARINAS

TOCHTEPEC

TEHUACAN

TUXTEPEC

COATZACOALCOS

MORELOS

CHALCATZINGO

GUERRERO

TELOLOAPAN

TEOTITLAN

ZAPITE

YOPITZINCO

OAXACA

MITLA

TEHUANTEPEC

MONTE ALBÁN

OAXACA

ZAACHILA

TEQUIZISTLAN

TOTOTEPEC

COATLICAMAC

MANIALTEPEC

Gulf of
Tehuantepec

EXTENT OF AZTEC EMPIRE

DETAILED MAPS OF TENOCHTITLAN
AND THE VALLEY OF MEXICO
ARE FOUND ON PAGE 16

100 200 300 miles

0

100 200 300 400 500 kilometres

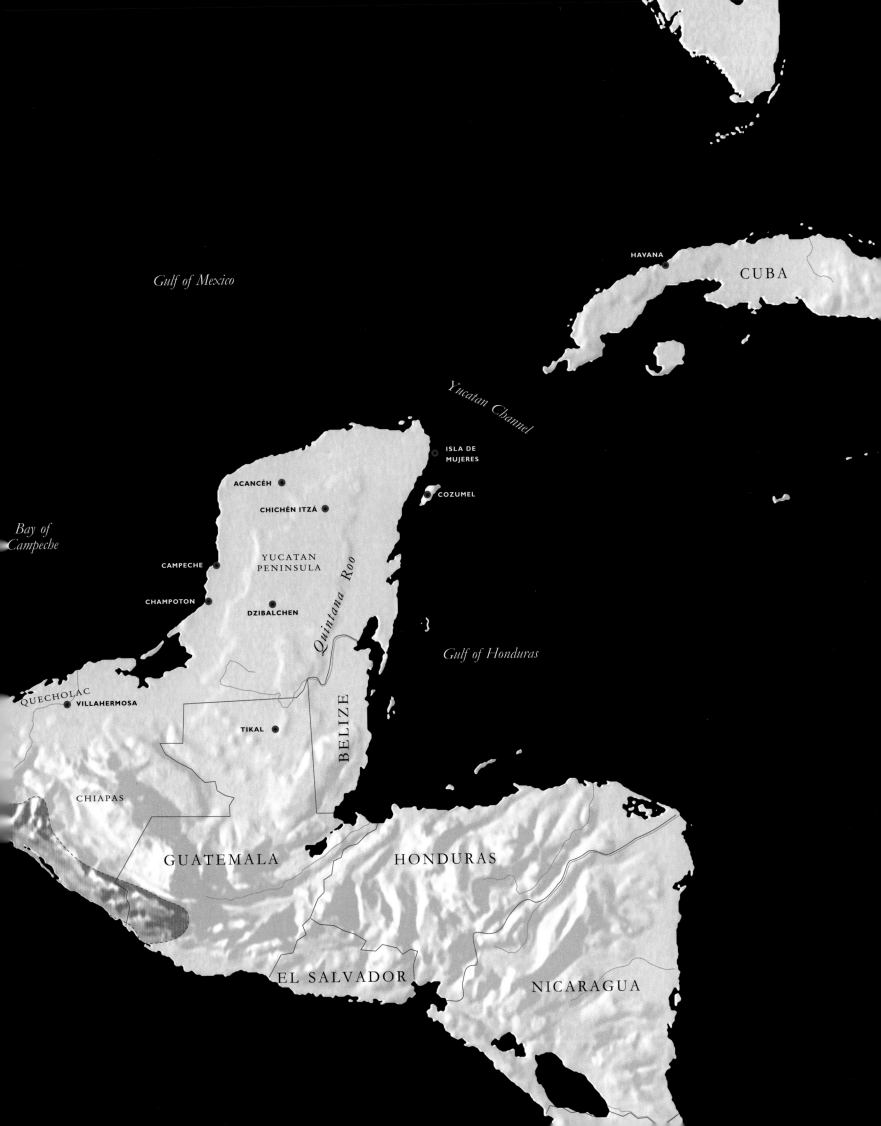

Gulf of Mexico

HAVANA

CUBA

Yucatan Channel

ISLA DE
MUJERES

ACANCÉH

CHICHÉN ITZÁ

COZUMEL

Bay of
Campeche

CAMPECHE

YUCATAN
PENINSULA

Quintana Roo

Gulf of Honduras

CHAMPOTON

DZIBALCHEN

QUECHOLAC

VILLAHERMOSA

BELIZE

CHIAPAS

TIKAL

GUATEMALA

HONDURAS

EL SALVADOR

NICARAGUA

INTRODUCTION

Eduardo Matos Moctezuma and Felipe Solís Olguín

... and you, Tenoch, will see that a cactus has grown over there that is the heart of Copil; on it is perched an eagle holding a serpent in its claws which it rips apart and devours. You are that cactus, Tenoch, and I am the eagle, and that will be our glory, as while the world lasts, the fame and glory of Tenochtitlan will never be lost.
Codex Chimalpahin[1]

SYMBOL OF A NATION

At the beginning of the fourteenth century, after two hundred years of migration, a group of Mexica watched an eagle devour a serpent on a prickly-pear cactus and knew that their journey was at an end (fig. 1). According to legend, the cactus had grown where the heart of their enemy Copil, torn out after a battle at Chapultepec and thrown across the waters of the lake, had landed. This was the long-awaited sign from their patron god, Huitzilopochtli, that they had reached the site of their city, Tenochtitlan. Over the next two centuries, their simple settlement on a swampy island in Lake Tetzcoco was to grow into a great metropolis, the most important in Mesoamerica,[2] and a seat of power from which they set out to conquer the world.

Even though the Spanish conquistadors captured and destroyed Tenochtitlan in 1521, the sixteenth-century coat of arms of colonial New Spain boasted a crenellated tower with two broken

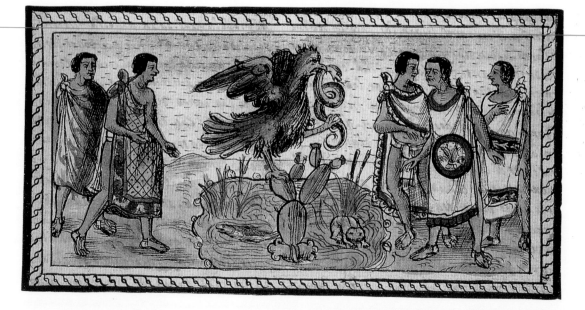

Fig. 1
An eagle devours a serpent on a prickly-pear cactus, Huitzilopochtli's sign to the Mexica that their migration was at an end. Folio 6 of the Codex Durán, 1579–81 (cat. 343).
Biblioteca Nacional, Madrid

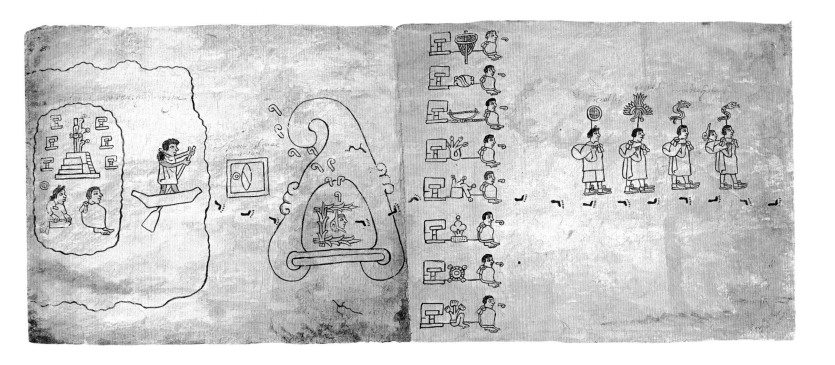

Fig. 2
The first two pages of the
Codex Boturini, the Tira de la
Peregrinación, depicting the
Mexica migration from Aztlan,
sixteenth century.

Biblioteca Nacional de Antropología
e Historia, Mexico City

bridges, symbols of the causeways that joined
Tenochtitlan to the mainland. A cactus was used
as a decorative element in the band that framed
the coat of arms of the colonial capital. By the
eighteenth century, the emblem of the metropolis
was still an eagle perching on a cactus, although
it wore an imperial crown. From the early
nineteenth-century struggle for Mexican
independence to the present day, the same
emblem has dominated the national coat of
arms as the symbol of Mexican identity.

AZTECS, MEXICA AND TENOCHCAS
The people to whom we owe the foundation of
Huitzilopochtli's city are historically known by
three names in Nahuatl, their original language:
Aztecs, Mexicas and Tenochcas.

The first links them to the place they left at the
beginning of the twelfth century. The chronicler
Hernando Alvarado de Tezozómoc, in his *Crónica
mexicáyotl*, records that 'their home is called Aztlan
and that is why they are called Aztecs'.[3] Although
we cannot be sure that Aztlan ever existed, it is
described as an island and shown as such in the
Codex Boturini (fig. 2). Alvarado de Tezozómoc
tells that Huitzilopochtli gave them a new name,
saying: 'You will no longer be called Aztecs: you
are now Mexica.' The origin of this second name
is obscure, although it is thought to have been
derived from Mexi, a secret name for the patron
deity. 'Tenochcas' is derived from the name
Tenoch, the leader who successfully guided them
through the last stages of their migration from
Aztlan.

Although Huitzilopochtli's predictions had
foretold greatness and power for them, the Aztecs
had many sufferings and trials to bear before they
could enjoy the power and riches brought by an
empire on the scale of that discovered by the
Spanish. Aztec history falls into two great
episodes: the foundation of Tenochtitlan at a time
when the Tepanec city of Atzcapotzalco ruled the
lake area; and the military conquests of the Aztecs,
which brought them inexhaustible riches from
subjugated provinces. This second period saw their
capital, Tenochtitlan, flourish under the successive
governments of *tlatoque*, the Aztec rulers.

A HOME FOR THE EAGLE
After Tenoch had carried out the foundation ritual
in the year 2-house, or 1325, he distributed the
population around the island in a pattern designed
to imitate that of the Aztec universe, dividing the
reedbeds into four sectors with canals or ditches
that marked the four quarters of the city.

Tenoch died in 1363. Some years later, the
council of elders elected Acamapichtli, a young
prince of Toltec lineage from nearby Culhuacan,
as the first *tlatoani*; he governed from 1375 to 1395.
Acamapichtli married Ilancueitl, who descended
from an old Aztec family, in a union which
mystically personified them as the deities
Xiuhtecuhtli and Coatlicue. To institute a new
nobility and create a royal family for Tenochtitlan,
Acamapichtli was given twenty young women
of the leading families from whom future rulers
would descend. Acamapichtli was succeeded as
tlatoani by his son Huitzilihuitl (1396–1417), who

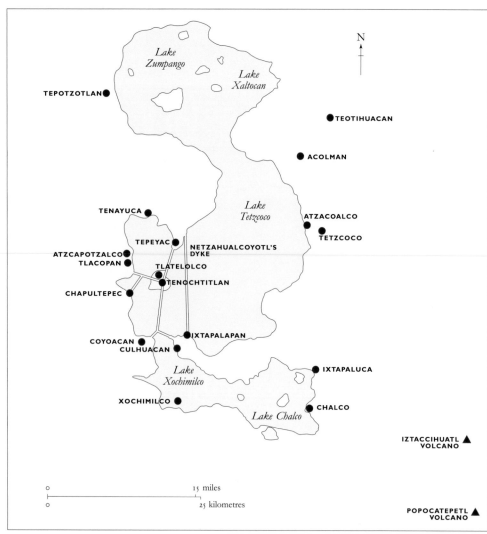

Fig. 3
The Basin of Mexico.

Lake
Zumpango

Lake
Xaltocan

TEPOTZOTLAN●

N

●TEOTIHUACAN

●ACOLMAN

Lake
Tetzcoco

TENAYUCA●

ATZACOALCO●

TEPEYAC●

TETZCOCO●

ATZCAPOTZALCO●
TLACOPAN●

NETZAHUALCOYOTL'S
DYKE

TLATELOLCO●

●TENOCHTITLAN

CHAPULTEPEC●

COYOACAN●
CULHUACAN●

●IXTAPALAPAN

Lake
Xochimilco

●IXTAPALUCA

XOCHIMILCO●

CHALCO●

Lake Chalco

IZTACCIHUATL ▲
VOLCANO

0 15 miles
0 25 kilometres

POPOCATEPETL ▲
VOLCANO

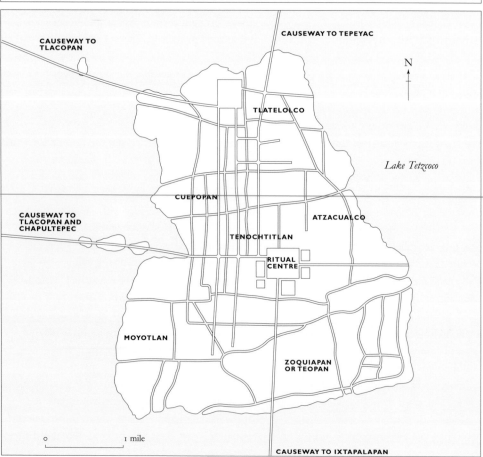

Fig. 4
Tenochtitlan and Tlatelolco.

CAUSEWAY TO
TLACOPAN

CAUSEWAY TO TEPEYAC

N

TLATELOLCO

Lake Tetzcoco

CUEPOPAN

CAUSEWAY TO
TLACOPAN AND
CHAPULTEPEC

ATZACUALCO

TENOCHTITLAN

RITUAL
CENTRE

MOYOTLAN

ZOQUIAPAN
OR TEOPAN

0 1 mile

CAUSEWAY TO IXTAPALAPAN

in turn was followed by Chimalpopoca (1417–27). Because the lake territories remained subject to the military authority of Atzcapotzalco, these first three rulers of Tenochtitlan worked as mercenaries for the Tepanecs, conquering lakeside communities and extending their victories as far as the tropical valleys of Cuernavaca and Oaxtepec.

The principal duty of each *tlatoani* was to enlarge the temple to the supreme deities first constructed by Tenoch, following the example of the double pyramid at Tenayuca. Huitzilopochtli's first pyramid was built of earth and wood at a time when houses in Tenochtitlan were made of mud and thatch. This was the construction that would one day grow into the magnificent Templo Mayor, the building at the heart of the ritual precinct in Tenochtitlan. Chimalpopoca (grandson of Tezozomoc, one of the greatest kings of Atzcapotzalco) began a programme of improvement works in his capital, particularly the renovation of the drinking-water aqueduct that came from Chapultepec. But the death of Tezozomoc brought these plans to an abrupt halt: the young Aztec king was assassinated by Maxtla, his uncle and the usurper of the Tepanec throne.

The threat of war brought about the election of Itzcoatl as the fourth *tlatoani* (1427–40). A charismatic warrior, he negotiated the so-called Triple Alliance with Netzahualcoyotl, leader of the Acolhuas of Tetzcoco, and a dissident group of Tepanecs from Tlacopan. That coalition triumphed in 1428 with the crushing defeat of the city of Atzcapotzalco and was consolidated three years later with the death of Maxtla, his heart torn out by Netzahualcoyotl in a ritual killing, and the reconquest of Tetzcoco.

Now free to act, the Aztecs and their allies began the conquest of settlements in the Basin of Mexico (fig. 3). Tenochtitlan was strengthened as a political capital, while Tetzcoco became a centre for the arts and culture. It was there, indeed, that the most important sculpture workshops flourished. After the conquest of the Xochimilcas, the southern causeway leading to the mainland was built to allow armies to advance towards the valleys of Morelos and the south (fig. 4). The alliance between gods and kings had been reinforced: Itzcoatl enlarged the temple in gratitude to Huitzilopochtli for his guidance and protection in battle.

THE FLIGHT OF THE LEFT-SIDED HUMMINGBIRD

By now the Aztecs' power was widely respected throughout Mesoamerica. Their patron god Huitzilopochtli, the 'left-sided hummingbird', guided their armies wherever they went. Motecuhzoma Ilhuicamina ruled as fifth *tlatoani* from 1440 to 1469. Tlacaelel, a peerless strategist who had done much during the struggle against Maxtla and the Tepanecs, assisted him greatly in the expansion of the empire, which by this time extended to Oaxaca, the centre of Veracruz and the Huasteca. The 'flowery wars' against Tlaxcala and Huexotzingo, ritual encounters whose purpose was the capture of sacrificial victims, were staged during this period. Tlacaelel helped Motecuhzoma to beautify Tenochtitlan, and, with the support of Netzahualcoyotl, they rebuilt the great double aqueduct from Chapultepec and a flood barrier to protect the city.

Fig. 5
The Sun Stone, Late Postclassic. Basalt, diameter 360 cm.
Museo Nacional de Antropología, Mexico City

Fig. 6
The Tizoc Stone, Late Postclassic. Stone, height 94 cm, diameter 265 cm.
Museo Nacional de Antropología, Mexico City

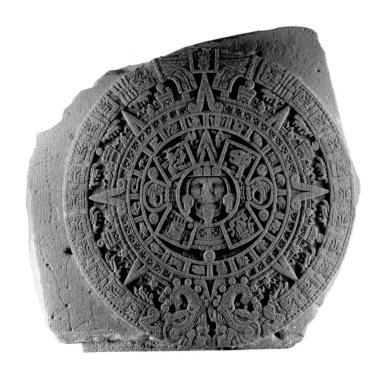

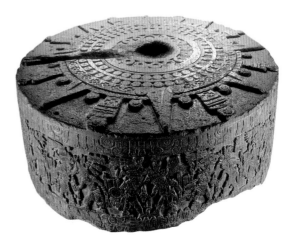

Motecuhzoma Ilhuicamina was succeeded by three of his grandsons: Axayacatl (1469–81), Tizoc (1481–86) and Ahuizotl (1486–1502). Axayacatl defeated Tlatelolco, neighbour and twin city of Tenochtitlan and a threat because of its commercial power and famous market. He conquered 37 towns, many in the Toluca valley, but the bellicose Purepecha (Tarascan) people of Michoacán halted his advance. It is believed that the Sun Stone (fig. 5), a carved representation of the five Aztec world-eras, was carved during his reign. Although Tizoc is said to have captured fourteen towns, his short reign suggests that he was eliminated for not complying with the expansionist policies of the empire. The stone that bears his name (fig. 6) is one of the most important artefacts of Pre-Hispanic Mexico. Ahuizotl brought 45 towns, from Guerrero to Guatemala, under the sway of Tenochtitlan. His armies subjugated Soconusco, bringing the Aztecs control of the valuable cacao grown in that province. In Oaxaca he unleashed his fury on the Mixtecs and the Zapotecs from Mitla and Tehuantepec.

The ninth *tlatoani*, Motecuhzoma Xocoyotzin, ruled from 1502 to 1520. In 1507 he organised the last New Fire ceremony, whose rites marked the turn of a 52-year cycle in the Aztec calendar, with a lavish splendour that reflected the greatness and size of the empire, which by now extended from Michoacán, Bajío and the Huasteca in the north to the frontier of the Maya territories in the south. Tenochtitlan prided itself upon the splendour of its ceremonial precinct, whose latest phases of construction had raised the main pyramids so far above the horizon that they could be seen from the far shores of the lake (fig. 7).

The sumptuousness of the Aztec capital and its imperial riches gave rise to innumerable descriptions,[4] mainly the accounts of Spanish soldiers. Some likened it to Venice with its characteristic walks and canals. Bernal Díaz del Castillo saw it as an enchanted city, something from a fairytale.

In 1521 the Spanish destroyed the great city without mercy. Figures of the gods were vandalised or at best buried by natives to hide them from the inquisitorial gaze of the Catholic Church. Treasures were melted down and turned into ingots to be taken to Europe to finance wars. Pyramids and palaces were demolished and used as rubble in the foundations of the buildings of the emerging New Spain.

In the early days of colonialism some fragments of the glory of Tenochtitlan must still have been visible, but by the end of the sixteenth century the city's appearance had been all but forgotten. The maps and plans that attempted to represent it were merely fantastic, stylised drawings (fig. 8). In the wider Aztec territories, abandoned towns disappeared or, as at Tenochtitlan, were replaced with new settlements built on the ruins of the past.

All that remained of the splendour of Aztec court life and their complex religious rituals were indigenous accounts recorded by chroniclers, mostly missionaries trying to eradicate Aztec systems of belief. Young Indians educated at Spanish schools learnt to write in Nahuatl as well as Spanish and Latin, and wrote down the oral histories of their families and people in codices (manuscript texts which were frequently illustrated). During three centuries of Spanish rule the efforts of the viceroys and the Church were directed towards the elimination of every vestige of the Aztec world. In the Mexican countryside nature reclaimed her territory, covering magnificent monuments in vegetation.

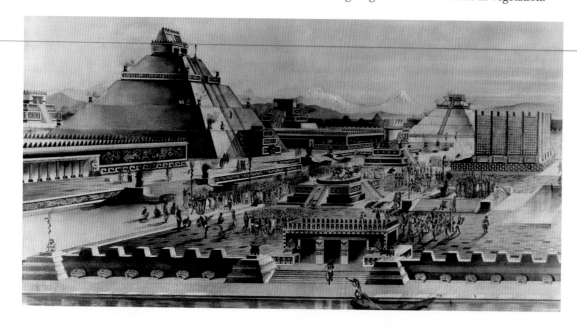

Fig. 7
Ignacio Marquina,
Reconstruction of the Templo
Mayor, Tenochtitlan, 1951.

American Museum of Natural History,
New York

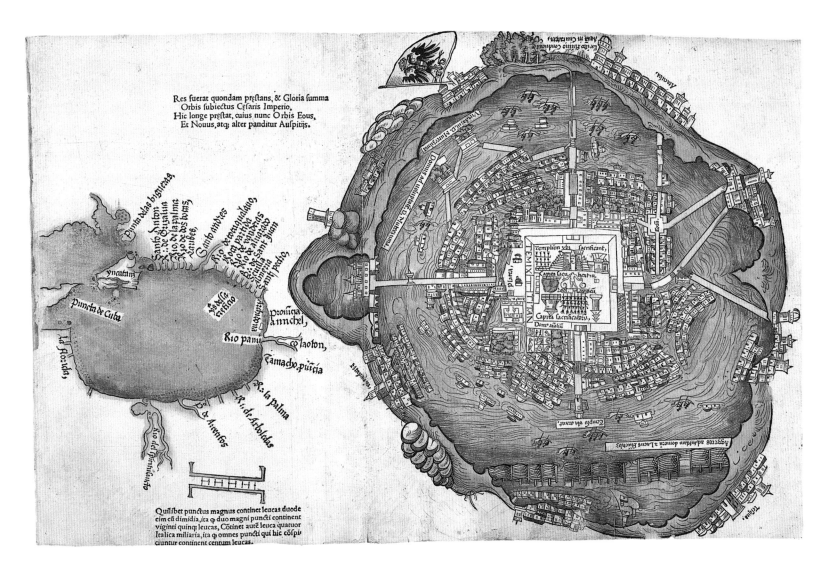

Res fuerat quondam prestans, & Gloria summa
Orbis subiectus Cesaris Imperio.
Hic longe prestat, cuius nunc Orbis Eous,
Et Nouus, atq; alter panditur Auspitijs.

Quilibet punctus magnus continet leucas duode
cim cu dimidia, ita q duo magni puncti continent
viginti quinq; leucas, Cotinet autè leuca quatuor
Italica miliaria, ita q omnes puncti qui hic cospi
ciuntur continent centum leucas.

Fig. 8

Map of Tenochtitlan and the Gulf
of Mexico, from Hernán Cortés's
*Praeclara de Nova Maris Oceani
Hyspania Narratio…*, Nuremberg,
1524. Handcoloured woodcut,
31 × 46.5 cm.

Newberry Library, Chicago

THE GODS WHO REFUSED TO DIE

A discovery of great importance took place in
1790, when a sculpture of the deity Coatlicue
(fig. 9) and the Sun Stone were discovered while
flagstones were being laid in the main square
in Mexico City, formerly Tenochtitlan and in
colonial times the capital of New Spain. The great
Coatlicue was sent for safekeeping to the Royal
and Pontifical University of Mexico, and the Sun
Stone was placed on one of the towers of the
Metropolitan Cathedral to be viewed by the
public.[5] Various archaeological objects were
displayed from 1790 onwards in a corner of the
main entrance to the university. Despite its
simplicity, the site became the first exhibition
area for Pre-Hispanic art. Images drawn by Pedro
Gualdi show the huge figure of Coatlicue and the
Tizoc Stone placed behind a simple wooden
trellis.[6] Many years were to pass before they were
celebrated as the artistic expression of Amerindian
societies and not as primitive carvings.[7]

In 1825, shortly after the first federal republic
of Mexico was founded, the National Museum
at the university was established. W. Franck
illustrated much of the museum's collection and

his unpublished drawings are kept in the library of
the British Museum, London.[8] These early visual
records include objects discovered on the
Island of Sacrifices in the Gulf of Mexico, some
remaining items from the holdings of the notable
Italian collector Lorenzo Boturini, and, most
particularly, finds from central Mexico, largely
from the capital. In addition to the large
sculptures, there were objects found by Captain
Guillermo Dupaix,[9] who travelled across much of
New Spain to gather archaeological information,
and private donations, the most interesting of
which came from ruined houses and discoveries
made during public works carried out in Mexico
City. From the outset, the museum displayed
Aztec art to the public through archaeology.

We know the condition of these objects and
how they were exhibited from descriptions
provided by European travellers,[10] who recounted
seeing the large figures in the patio of the museum.
Minor works, particularly smaller sculptures,
pottery, greenstone ornaments, weapons and
projectile points, were kept in poorly lit and even
more poorly ventilated rooms on the top floor of
the university, placed together haphazardly with

ethnographic objects and historical testimonies of the colonial era. This was the birthplace of Mexican museology.[11]

During the first half of the nineteenth century, travellers and artists disseminated these early images of Pre-Hispanic art in various ways. In 1824 London hosted the first exhibition of Mexican art, which consisted mainly of objects from the Aztec era.[12] Engravings were used to illustrate albums and books. Carl Nebel published an album in Paris in 1836 showing the Coatlicue, the Sun Stone and the Tizoc Stone. These gigantic sculptures were accompanied by diminutive clay figurines – images of the Aztec deities – and by models of pyramids and temples which expressed the popular traditions of the people of Tenochtitlan.[13]

In 1854 José Fernando Ramírez further developed our knowledge of ancient Mexican art by describing the most important pieces in the National Museum's collection, illustrating his historical and aesthetic text with a beautiful engraving showing the monoliths, the commemorative tombstone from the Templo Mayor, the ball-game ring with the relief of the decapitating warrior, a 'year bundle' (a stone carving of a bundle of 52 reeds, each representing a year in the Aztec cycle), and sculptures of gods and sacred animals, principally the plumed serpent.[14] The engraving also shows smaller objects, such as wooden musical instruments, feathered objects, pipes and the usual figurines and models of temples.

During the reign of the Habsburg Emperor Maximilian (1864–67), the archaeological collection was transferred from the university to a building that had previously served as a mint. The completion of this monumental task coincided with the triumph of the republican government. In what was now a burgeoning new institution, large works of sculpture were again exposed to the elements in the middle of the patio, surrounded by the vegetation that decorated the building.[15]

A solemn bond between the Aztecs and the public at large was established in 1888, with the opening of the museum's Hall of Monoliths. The hall triumphantly exhibited the Sun Stone, which had been at the mercy of the elements at the Metropolitan Cathedral for nearly a hundred years.[16] Works could finally be appreciated by those interested in the artistic creations of the Pre-Hispanic world, particularly the legacy of Tenochtitlan. During the second half of the nineteenth century, many research projects were carried out at the museum. The most notable were the studies of Aztec monumental sculpture published in the institution's first series of *Annals*.

At the same time, the first catalogues of the various collections were published.[17]

With the new century came the extraordinary discoveries made in the Calle de las Escalerillas in 1900 while a deep-drainage trench was being cut across the Mexican capital from east to west. At last, archaeological finds could be related to their original contexts. The discovery of this complex, excavated by Leopoldo Batres, permitted the exact positioning of finds in the plan, thereby allowing their cultural and historical associations to be established.[18]

The first Mexica Hall in the museum was installed in the late 1940s and displayed objects from the Aztec capital and its empire. Unlike the Hall of Monoliths, in which sculptures had been arranged according to size, the Mexica Hall showed the art and culture of the Aztec civilisation in an ordered thematic sequence.[19] In 1964 a new building was inaugurated to house the museum's collections.

At around midnight on 21 February 1978, a team of archaeologists finished clearing away the debris which for hundreds of years had covered the monumental disc of the goddess Coyolxauhqui (fig. 10), sister and adversary of Huitzilopochtli. The monument had remained hidden from the Spanish and its discovery launched a new era in Aztec studies, providing

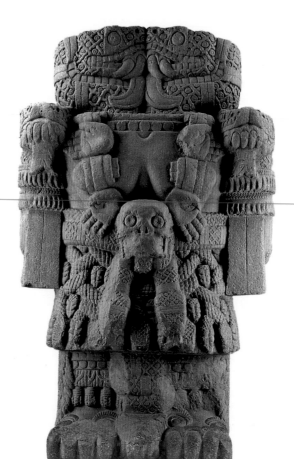

Fig. 9
The great Coatlicue, earth mother and goddess of life and death, Late Postclassic. Stone, height 257 cm.

Museo Nacional de Antropología, Mexico City

Fig. 10
The dismemberment of
Coyolxauhqui, goddess of the
moon, Late Postclassic. Stone,
diameter 300 cm.

Museo del Templo Mayor, Mexico City

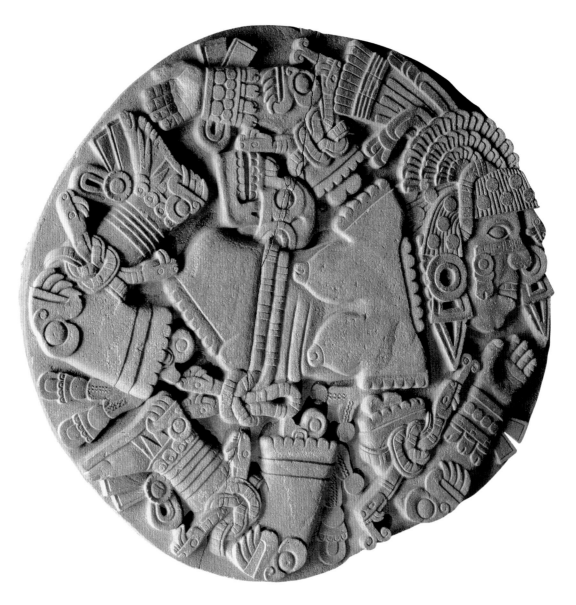

scope for a new generation of researchers to
work with established academics to test earlier
theories and put forward new interpretations that
would shape the modern understanding of Aztec
culture. Throughout the twentieth century, major
excavations took place to discover the origins of
Mexico City and to find evidence of the ancient
Aztec empire, a process which led to the research
and discoveries being made today in the context
of the Proyecto Templo Mayor.

The study of Pre-Hispanic art continues
to develop as research provides a modern
understanding of indigenous aesthetics.

The most select objects from museums in Mexico
and around the world are shown together once
more in this exhibition, in acknowledgement of the
boundless creativity of the Aztec civilisation. Thus
Huitzilopochtli's plan to conquer the hearts of
people in every corner of the globe will be fulfilled.
The Aztec gods re-emerge, but without ceremony;
this time they open the door to the study of the
society, the culture and the art of their time.[20]

THE AZTECS' SEARCH FOR THE PAST

Leonardo López Luján

*Everything made now is either a replica or a variant of
something made a little time ago and so on back without
break to the first morning of human time.*
George Kubler[1]

THE AZTECS' PRAGMATIC VIEW OF THE PAST

The Aztec kings exploited history for
propaganda purposes. They used it as a
powerful tool to justify, in the eyes both of their
own people and of foreigners, the hegemonic role
they had acquired after gaining independence from
the lords of Atzcapotzalco in 1430. By re-creating
history – reinterpreting the past from the
perspective of the present – they convinced
their people that the role of the Aztec nation was
to dominate all others and that their destiny was
to engage in ambitious expansionist campaigns.

At a time when great changes were taking
place in Tenochtitlan, the legitimacy of power
was derived from the relationship between the
Aztec people and their patron god Huitzilopochtli,
via a sacred link: the ruler. The sovereign was
considered a semi-divine being who belonged
to the lineage closest to the protective numen.
This explains why Aztec historical records,
commissioned by the rulers themselves to leave
traces of their passage across the earth, detail
long dynastic lists in chronological order (the main
genealogies always begin in mythic times), as well
as coronation ceremonies and endless accounts of
military triumphs. The official Aztec history also
sets down exceptional events of huge importance

for the state: major architectural programmes
embarked on by the government (temples, ditches,
aqueducts and other public works), migrations
(movements of people, foundations, arrivals of
foreigners) and extraordinary natural phenomena
(astronomical, climatological and geological).[2]

As well as being limited to these themes, Aztec
historical records suffer from great conciseness,
given the lack of a proper phonetic script.
Knowledge of the most important events in the
lives of the Aztecs tended to be transmitted orally
from generation to generation, a practice which in
the long term distorted reality. Only some events
were worthy of being set down using a mixed
form of writing, which combined pictograms
and ideograms with phonetic symbols. This system
also included numerical and calendar symbols that,
among other things, allowed events to be fixed in
time. These messages passed into posterity either
in the form of manuscript books made of animal
skins or tree bark, or as reliefs etched into hard
rock. Unfortunately, as the centuries passed,
almost all these historical records were damaged
or destroyed through the interaction of nature –
in the form of catastrophes and weather – and
human beings. The book-burning ordered by
Itzcoatl (1427–40) to eliminate these magic tools
that the old *calpulli* leaders had used to wield power
is one example of the latter.[3]

As a direct result of the above, Aztec
knowledge of the past was always limited in
terms of time. As has been demonstrated by
H.B. Nicholson, the annals of central Mexico

can provide no certainty of events earlier than three or four centuries before the arrival of Hernán Cortés.[4] Furthermore, this scholar warns, any records of events prior to 1370 should be viewed with scepticism. Under these conditions, at the close of the Late Postclassic period (1250–1521), the remote past had become as malleable as the future, a game of mirrors which reflected both historical accounts and mythical tales.

This is clear in the Aztec image of Tula (fig. 11), in which vague recollections of a militaristic capital city, which achieved its greatest splendour between 950 and 1150, are combined with the well-established myth of Tollan, the wonderful 'place of the Tules [reeds]', where fruit grew to gigantic proportions, the inhabitants were great craftsmen

and the government had been in the hands of Quetzalcoatl, a wise and virtuous priest who instituted self-sacrifice.[5]

Teotihuacan (fig. 12), however, because of its greater age, was devoid of historical context in the eyes of the Aztecs. The various versions given of its inhabitants undoubtedly resulted from Aztec amazement at the majesty of the Pyramids of the Sun and the Moon. Depending on the version, these Cyclopean buildings were considered to be the work of powerful Toltecs, deformed giants with long thin arms, or of the gods themselves. When the Spanish arrived, this archaeological metropolis, enveloped in a divine aura, was considered to be the revered place of origin, the birthplace of the Fifth Sun and the place whence the primordial peoples set forth on their journey.[6]

Fig. 11
The carved stone atlantes of Pyramid B at Tula.

Fig. 12
The Processional Way and Pyramids of the Sun and Moon at Teotihuacan.

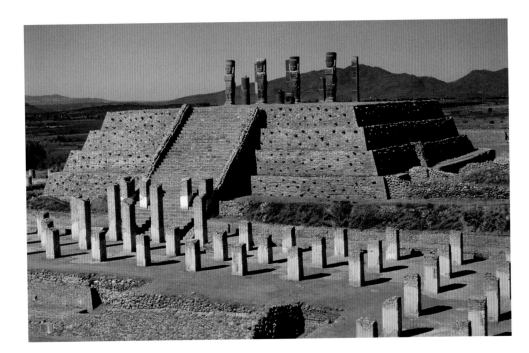

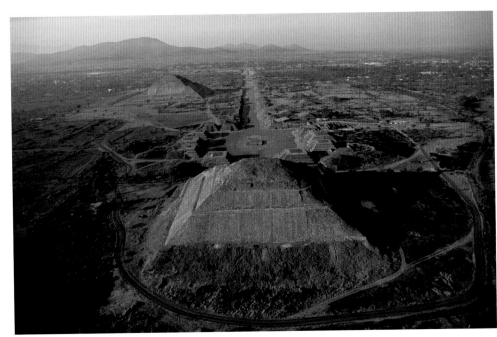

AZTEC ADDITIONS TO ARCHAEOLOGICAL SITES
We know that Mesoamericans frequently visited ruined ceremonial sites, avidly exploring buildings and monuments whose shapes they could just make out under the cover of vegetation. There is no doubt that this activity was common among the Aztecs, particularly considering that Tenochtitlan was surrounded by perfect material testimonies of great civilisations. Within a radius of 70 km lay vestiges of real cities that had been populated by tens or even hundreds of thousands of people. The most important were Teotihuacan, to the north-east, the famous metropolis of the Classic period (AD 200–650); Xochicalco, to the south, one of the most cosmopolitan centres of the Epiclassic period (650–900); and Tula, to the north-west, a city which unquestionably dominated a major part of the Early Postclassic period (900–1250).

At these archaeological sites, dominated by silence and desolation, the Aztecs performed a huge range of activities. Unfortunately, many of these have left no perceptible traces for modern archaeologists. We know that they took place because a few sixteenth-century historical records exist, particularly a report on the town of Tequizistlan ('Relación de Tequizistlan y su partido').[7] This document shows that societies living eight centuries after the turbulent collapse of Teotihuacan, including the Aztecs, used the ancient Pyramids of the Sun and the Moon for worship, to consult oracles, to perform sacrifices and as a place to execute criminals.

There were other lesser idols [worshipped by the Aztecs] in the town of San Juan [Teotihuacan], which was the [location of the] temple and oracle attended by nearby towns. In this town they had a very tall temple [...]: at the summit of it was a stone idol called by the name Tonacateuctli. [...]

It faced the west and on a plain that stretched in front of this temple, there was another smaller temple [...] on which was another idol a little smaller than the first one, called Mictlanteuctli, which means 'Lord of Hell'. [...] A little further, toward the north, was another temple slightly smaller than the first, which was called 'the hill of the Moon', on top of which was another idol [...], which was called the Moon. All around it were many temples, in one of which (the largest of them) there were six other idols, who were called Brothers of the Moon, [and] the priests of Montezuma, lord of Mexico, came with this Montezuma, every twenty days to [offer] sacrifices to all of them.[8]

Other Pre-Hispanic activities, however, did leave an indelible mark on archaeological sites. The first group of these we might define as additive, because they resulted in new elements being added to the ruins. Such interventions were carried out by many different people at different times and practically everywhere in Mesoamerica. A clear example of this can be found in the Preclassic settlement of Cerro Chalcatzingo, Morelos.[9] On the sides of this sacred mountain sufficient evidence exists for us to state that the Olmec-like reliefs sculpted there between 700 and 500 BC were venerated two thousand years later. In fact, around the thirteenth century AD, the Tlahuicas who lived in the immediate surroundings built a series of wide stairways and platforms which led to a place of worship. These structures allowed people to ascend 30 metres with ease and perform ceremonies in front of the relief known as Monument 2.

Other additions include offerings and corpses buried inside destroyed buildings, indicating the way in which ruins were regarded as sacred. Both practices were widespread during the Postclassic period. Examples are the Mayan effigy censers that were buried as propitiatory gifts or as symbols of gratitude in the collapsed temples of the Late Classic period in Dzibanché, Quintana Roo;[10] the sumptuous Mixtec funerary offerings deposited in Tomb 7 at Monte Albán, Oaxaca;[11] and the mortal remains of two individuals with Aztec and Tetzcocan pottery placed in Structure 1-R of the Ciudadela in Teotihuacan.[12]

However, it is the ruins of Tula which provide the most evidence. As a consequence of two decades of excavations in the main square, the archaeologist Jorge R. Acosta recovered huge quantities of so-called Aztec pottery, unquestionable proof of three hundred years of human activity taking place directly over the ruins of the city.[13] Unfortunately it has been impossible to determine exactly who brought this pottery here because we know it was made in at least four

different zones of the Basin of Mexico: Tenochtitlan, Tetzcoco, Chalco and the far western end of the Ixtapalapan peninsula. We can establish with accuracy, however, the type of additive activities which these groups engaged in. Large quantities of offerings are buried inside the ruins of the main buildings of the Toltec golden age, including the Central Shrine, Buildings B and C, and the Burnt Palace. Fewer in number are the tombs of individuals of all ages, almost always buried with very humble funerary offerings, discovered in Building B, Building 4 and the Burnt Palace. It is also worth mentioning the construction of religious buildings and sumptuous residences over the ruins of the ancient ceremonial centre. Examples of this include the residential complex erected over Building K, the shrine attached to the north-west corner of Building C and the pyramidal plinth placed over the Burnt Palace.

Another additive activity engaged in by carriers of Aztec pottery, albeit of a different nature, relates to the creation of sculptures in the immediate surroundings of the main plaza, specifically the reliefs of Cerro de la Malinche, created at the end of the fifteenth century in the purest Aztec style.[14] This unique group, which consists of the effigies of Ce Acatl Topiltzin Quetzalcoatl and Chalchiuhtlicue, has been interpreted both as an Aztec homage to the deities inherited from their Toltec forefathers[15] and as a 'retrospective historical image' of Ce Acatl – the most famous ruler of Tula – validating the Aztec tradition of sculpting portraits of their rulers on the rocks of Chapultepec hill.[16]

The Dominican friar Diego Durán recounts one of the last recorded additive activities.[17] He states that in 1519, while still at the coast of the Gulf of Mexico, Hernán Cortés sent Motecuhzoma Xocoyotzin a gift of wine and biscuits. On receiving the gifts in Tenochtitlan, the Aztec *tlatoani* (ruler) refused to consume them – whether because he found them strange or because of the way they looked after having travelled across the ocean we shall never know – and stated that they 'belonged to the gods'. He gave orders for his priests to take them all to the ruins of Tula 'with great solemnity and to bury them in the temple of Quetzalcoatl, whose sons had arrived'.

AZTEC REMOVALS FROM ARCHAEOLOGICAL SITES
Archaeology and history also provide much evidence of activities we could define as subtractive. Naturally they include the excavation of buildings to extract architectural elements, sculptures, offerings and bones, all actions that

many modern authors have defined pejoratively as sacking and pillage. Most of these operations, however, were clearly not carried out for profit but only to recover useful construction materials or objects that were appreciated for their aesthetic beauty, particularly because they were considered to be the work of gods, giants or almost mythical people.

In the case of Teotihuacan, a simple bowl – a fragment of an Aztec container found at the entrance to a large man-made cave over which the Pyramid of the Sun was built – could be a clue to planned excavations having taken place just before the arrival of the Spanish. When archaeologists entered this sacred space in the early 1970s, they found that the walls that sealed access along the tunnel had been knocked down, and that in the four-lobed chamber at the end there were no traces of offerings or burials. According to some researchers, unless it was accidentally left there in recent times, the fragment of pottery would suggest that the people who broke in were the Aztecs themselves.[18]

Historical sources from the sixteenth century provide firmer evidence. For example, the indigenous informants of Friar Bernardino de Sahagún describe the procedures individuals had to perform to acquire precious stones:

And those of experience, the advised, these look for it [the precious stone]. In this manner [they see,] they know where it is: they can see that it is breathing [smoking], giving off vapour. Early, at early dawn, when [the sun] comes up. They find where to place themselves, where to stand; they face the sun [...] Wherever they can see that something like a little smoke [column] stands, that one of them is giving off vapour, this one is the precious stone [...] They take it up; they carry it away. And if they are not successful, if it is only barren where the little [column of] smoke stands, thus they know that the precious stone is there in the earth.

Then they dig. There they see, there they find the precious stone, perhaps already well formed, perhaps already burnished. Perhaps they see something buried there either in stone, or in a stone bowl, or in a stone chest; perhaps it is filled with precious stones. This they claim there.[19]

The same work contains a more explicit mention, and talks not only about the profound knowledge Aztecs had of the vestiges of Tula but also of the way they went exploring underground in search of antiquities:

Because verily they [the Toltecs] there [in Tula-Xicocotitlan] resided together, they there dwelt, so also many are their traces which they produced. And they left behind that which today is there, which is to be seen, which they did not finish – the so-called serpent column. [...] And the Tolteca

mountain is to be seen; and the Tolteca pyramids, the mounds, and the surfacing of Tolteca [temples]. And Tolteca potsherds are there to be seen. And Tolteca bowls, Tolteca ollas are taken from the earth. And many times Tolteca jewels – armbands, esteemed greenstones, fine turquoise, emerald-green jade – are taken from the earth.[20]

Various people who lived at the same time as the Aztecs were also involved in taking Toltec antiquities. There is credible testimony that, after they had been exhumed, old sculptures were taken to various destinations, one of which was the city of Tlaxcala, capital of the Aztec empire's greatest enemies. According to Friar Toribio de Benavente (Motolinía),[21] a mask and a small image brought from Tula were venerated in the main pyramid of this city, together with the sculpture of the fire god Camaxtli. Another destination was Tlatelolco, as described in a short passage of *Historia de los mexicanos por sus pinturas* (*A History of the Mexicans Through Their Paintings*):

In the year 99 [AD 1422] the people of Tlatilulco went to Tula and since [the Toltecs] had died and left their god there, whose name was Tlacahuepan, they took him and brought him back to Tlatilulco.[22]

These activities, which had been carried out intensively since at least the thirteenth century, had a devastating effect from an archaeological point of view. In fact no records exist whatsoever of the massive, if not total, loss of sculptures and covering stones.

RECOVERY OF A GLORIOUS PAST: REUSE

These additive and subtractive activities not only had a serious impact on archaeological sites but also affected the populations responsible for them. Relics recovered during planned excavations, as well as those discovered accidentally and handed down from generation to generation,[23] were reused as worthy relics of vanished worlds.[24] The high quality of the raw materials and manufacture of these objects certainly had an influence on their value, but the allegedly supernatural origin of these items, which were thought to have been created by powerful beings, convinced their owners to wear them as amulets or to re-bury them inside temples and palaces as part of dedicatory and funerary offerings. Furthermore, as is often the case with all kinds of relic, fragments were also venerated. This would explain why these offerings include so many broken bits and pieces (fig. 13).[25]

The Aztecs were not the first Mesoamerican people to reuse antiquities to establish a direct connection with their ancestors and gods.

Evidence of this practice has been found in many other Mesoamerican regions. Examples include numerous anthropomorphic and zoomorphic figurines, masks, pendants, ritual spoons, miniature canoes, celts and self-sacrifice instruments all made of greenstone and produced by both the Olmecs and their contemporaries of the Middle Preclassic period (1200–400 BC) which have been found by modern archaeologists in Protoclassic (100 BC–AD 200) and Classic (AD 200–900) sites. The most notable finds were made at Cerro de las Mesas, Veracruz;[26] Dzibilchaltún and Chacsinkín, Yucatan;[27] Cozumel, Quintana Roo;[28] Laguna Francesa, Chiapas;[29] and Uaxactún and Tikal, Guatemala.[30] Similar objects have also been found at Postclassic (900–1521) sites, including Mayapán, Yucatan,[31] and San Cristóbal Verapaz, Guatemala.[32] To this list we could add the Olmec pieces found in the sacred well at Chichén Itzá, which may have been thrown into the water by the Maya during the Classic and Postclassic periods.[33]

Although we lack any contextual archaeological information, other Olmec works of art were clearly reused as amulets by dignitaries of the Protoclassic and Classic periods, as is demonstrated by the presence of Mayan inscriptions on their surfaces.

Examples include the ritual spoon in the Museum of San José, Costa Rica,[34] and the greenstone pendants in the shape of a human face in the Brooklyn Museum of Art,[35] the British Museum[36] and at Dumbarton Oaks.[37] Around 50 BC, an effigy and an inscription in the early Mayan style were engraved on the back of this Dumbarton Oaks piece which appeared to allude to the enthronement of a ruler called 'sky-moan bird'.

Although these activities were commonplace throughout the vast Mesoamerican territory, Tenochtitlan was the centre when it came to reusing antiquities. A century of archaeological excavation in the Aztec capital has unearthed hundreds of relics in the main religious buildings (fig. 14). Items made of greenstone predominate, although there are also beautiful ceramic and basalt objects. Most notable are a mask, a pendant and various fragments of figurines made by the Olmecs and other Middle Preclassic societies;[38] hundreds of masks, and anthropomorphic and zoomorphic figurines, in addition to a model of a temple, Mezcala-style objects, all of them ranging from the Middle Preclassic to the Epiclassic periods;[39] various pendants that may date back to the Classic Mayan period; tens of masks, anthropomorphic

Fig. 15
An Early Postclassic Toltec *chacmool*. Stone, 49 × 106 × 46 cm. Found in the colonial building known as the Casa del Marqués del Apartado, located in front of the ruins of the Templo Mayor.

Museo del Templo Mayor, Mexico City

Fig. 16
Front and rear views of a mask made in the Mezcala region, AD 150–650. Greenstone, 11 × 9.5 × 3.9 cm. From Chamber III of the Templo Mayor. The Aztecs added the image of a person playing a horizontal drum.

Museo del Templo Mayor, Mexico City

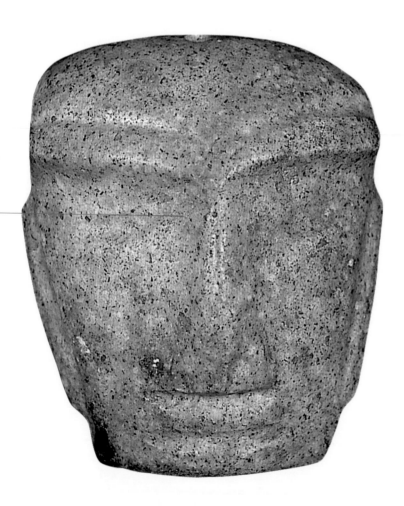

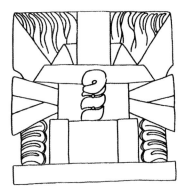

Fig. 17
Line drawing of a stone discovered in front of the Pyramid of the Sun at Teotihuacan showing the symbol of the *xiuhmolpilli*, or cycle of 52 years.

Fig. 18
La Chinola, *c.* 1500. Volcanic stone, 107 × 40 × 10 cm. Discovered at Cerro de la Chinola in the late nineteenth century. This Aztec-style slab seems to represent Chalchiuhtlicue, the water goddess, wearing an archaic headdress in the shape of the Teotihuacan symbol of the *xiuhmolpilli*, or cycle of 52 years.

Museo Nacional de Antropología, Mexico City

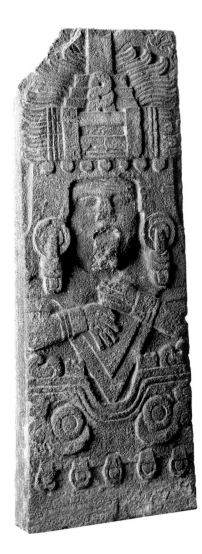

figurines, nose-plugs in the shape of snake rattles and containers dating back to the Teotihuacan Classic period;[40] and a *plumbate* vessel made in the eastern part of Soconusco during the Early Postclassic period.[41] Strangely, only one antiquity which is undeniably Toltec has been unearthed to date: a decapitated *chacmool* which was discovered in the foundations of the colonial Casa del Marqués del Apartado, opposite the ruins of the Templo Mayor in Mexico City (fig. 15).[42] The piece's typically Toltec features, in terms of raw material, size, proportions, style and iconography, make its origin unquestionable.

Interestingly, the Aztecs did not bury all relics just as they found them.[43] They altered quite a number, adding paint or tar to accentuate their original religious significance or to confer new meaning upon them. Thus, for example, Tlaloc jars from Teotihuacan retained their pluvial symbolism by being painted blue or with tar. Many Mezcala human masks and figurines, however, were transformed into divinities by having the faces of Xiuhtecuhtli or Tlaloc painted on them. As if that were not enough, the inside of tens of Mezcala masks were decorated with aquatic glyphs and human figures (fig. 16).

RECOVERY OF A GLORIOUS PAST: IMITATION
Tenochtitlan was the main centre of imitation in Mesoamerica. Aztec exploration was sufficiently intensive for the island's artists to have the opportunity of copying ancient styles of sculpture, painting and architecture, as well as completing iconographic scenes. It is well known that Aztecs used alien artistic types in their capital, often without being particularly faithful to their original form and meaning.[44] We might say that their imitations reinterpreted the past, eclectically combining the ancient with the modern. Their archaisms were therefore fragmentary evocations of times gone by, rather than identical and integral copies of specific artistic creations.

As examples of these, the Aztec sculptures based on the effigies from Teotihuacan could be mentioned. One of them is the image of the old fire god, found near the North Red Temple at Tenochtitlan (cf. cat. 5).[45] The Aztec sculptor was faithful to the Teotihuacan models in copying the round-shouldered posture of the deity as well as the position of his hands and feet, but he added new iconographic attributes – connected with water and the underworld – such as the fangs, the rectangular plates over the eyes and mouth, a huge brazier and terrestrial figureheads. A different example is the famous stone of La Chinola, an Aztec-style slab discovered near the site of Castillo de Teayo, Veracruz (fig. 18). Everything seems to indicate that the front side of the monument represents Chalchiuhtlicue – the water goddess – emerging from or descending into the jaws of a terrestrial monster. On the back, however, are four flying *tlaloque* (assistants of the rain god Tlaloc) making rain fall with their jugs of water. Intriguingly, the main divinity wears an archaic headdress[46] in the shape of the Teotihuacan symbol of the *xiuhmolpilli*, a composite bundle representing the cycle of 52 years (fig. 17).[47] It is extremely likely that the Postclassic artist knew the meaning of this ancient symbol and sculpted it to allude to one of the first four eras of humanity, which was ruled by Chalchiuhtlicue and ended with a flood.

As regards Epiclassic art, we know of only one Aztec greenstone plaque inspired by the Temple of the Plumed Serpents at Xochicalco, and a sculptural complex at Tenochtitlan, consisting of three fire-serpent heads with calendar dates in the Xochicalcan style.[48] It is also worth mentioning the many evocations of Tula sculpture. Contrary to what happened with the religious images of Teotihuacan and Xochicalco, the Aztecs copied practically every Toltec vestige that met their eyes, particularly braziers with the face of Tlaloc, telamons, standard-bearers, colossal

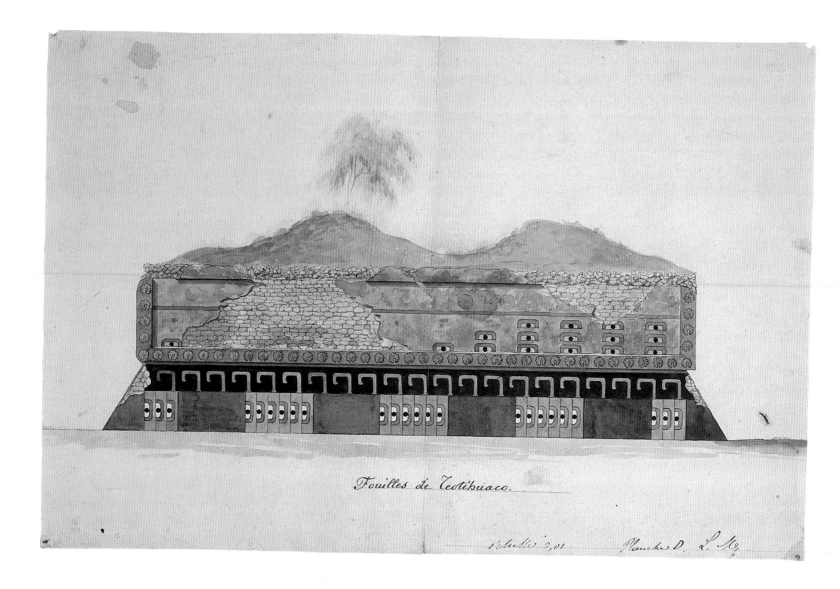

Fouilles de Teotihuaco.

plumed serpents, as well as reliefs showing people bearing arms, undulating serpents, birds of prey, felines and the so-called man-bird serpents.[49]

Imitation extended, even more effectively, to religious architecture. At the end of the fifteenth century, the sacred precincts of Tenochtitlan and Tlatelolco included several buildings which revived the forgotten shapes of Teotihuacan. Known as the Red Temples, five small shrines harmoniously combine the typical Teotihuacan *talud-tablero* (a rectangular panel [*tablero*] sitting on a sloping panel [*talud*]), a structure that had not been built for several centuries, with decorative Aztec elements fashionable at the time of construction.[50] Even though the builders of the Red Temples undoubtedly used local materials and applied their own architectural techniques, they took special care to reproduce the ancient proportions and, in particular, to re-create the mural paintings of the Classic period (fig. 19).[51] In so doing, they copied various Teotihuacan symbols on red backgrounds following repetitive patterns: storm god masks, trilobes (water droplets), elongated eyes (flowing water) and cut shells

(wind?; fig. 21). To these motifs they added the red and white stripes and knots that distinguish Xochipilli, the Aztec god of music and dance (fig. 20). These elements, and boxes found inside the shrines, filled with musical instruments, demonstrate that the Red Temples were used to worship Xochipilli.[52]

Finally, mention should be made of the House of Eagles, a fifteenth-century religious building located to the north of the Templo Mayor in Tenochtitlan. The design of this building is vaguely reminiscent of the Toltec hypostyle halls, but its iconographic and decorative programme revives Tula in all its splendour. Braziers with the face of Tlaloc, benches with undulating serpents and processions of armed men, and mural paintings with multi-coloured friezes decorate interiors to convey the living image of a glorious past. Petrographic, chemical, technological, iconographic and stylistic studies[53] have shown that these decorative elements are local copies that illustrate a kind of Neo-Toltequism in the art of the Aztec capital.[54] There is, therefore, much evidence to support the observation made by the

Fig. 19

E. L. Méhédin, Detail of a temple in Teotihuacan excavated by Longpérier in 1865. Watercolour, 20 × 36 cm. The proportions and mural paintings of this temple may have inspired the Aztecs when they built the North Red Temple at Tenochtitlan.

Collection Agence Régionale de l'Environnement de Haute-Normandie, Rouen

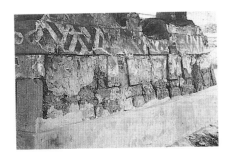

Fig. 20
Building L of Tlatelolco was
excavated in 1963–64. Its mural
paintings, with Xochipilli's stripes
and knots, are very similar to those
of the South Red Temple at
Tenochtitlan.

Fig. 21
Certain decorative elements of the
North Red Temple, among them
cut shells and aquatic currents in
the shape of an eye, are identical
to those of the Teotihuacan temple
excavated by Longpérier.

Mexican poet Octavio Paz, who commented
that 'if Tula was a rustic version of Teotihuacan,
México-Tenochtitlan was an imperial version
of Tula'.[55]

THE FUNCTIONS OF THE PAST
The reuse of relics, the imitation of ancient
sculptures and the construction of archaic
buildings in Tenochtitlan and Tlatelolco coincided
with the period of maximum integration,
consolidation and expansion of the Aztec empire.
The recovery and ennoblement of extinct
civilisations in this particular historical context
should perhaps be seen as one of the many
strategies adopted by Aztec rulers to sustain a new,
dominant position in the eyes of both kindred and
strangers. As the centuries passed, these
antiquities, making direct allusion to a grandiose
past and genealogically legitimising the actions
of their belligerent users,[56] no doubt became the
ultimate sacred symbols.

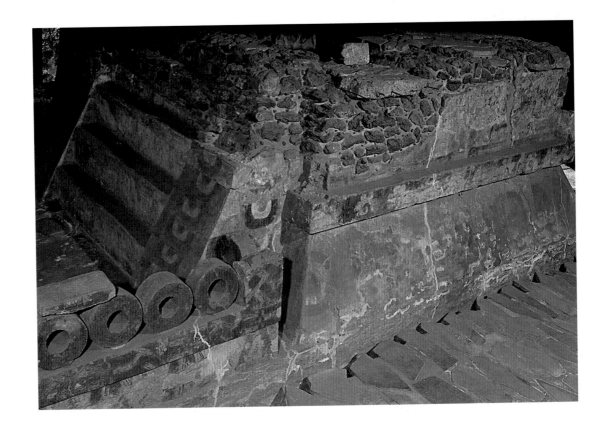

COSMOVISION, RELIGION AND THE CALENDAR OF THE AZTECS

Alfredo López Austin

EXODUS AND SETTLEMENT

Through 'official' histories, we have become familiar with the subject of native peoples and their origins. Although our interest in these origins is at times overshadowed by a metaphysical search for 'true ethnic identity', many of the issues it raises are fundamental to our understanding of the historical development of human societies.

The Aztecs referred to their origins obsessively in abundant, detailed, sometimes contradictory tales. Some were more concerned with human events; others focused on the presence of gods in the life of men. A concise summary of the numerous versions highlights a number of important aspects in these tales.

The Aztecs identified themselves as *chichimecas*[1] from a city called Aztlan,[2] situated to the northeast of the Basin of Mexico. Aztlan was a lacustrine city inhabited by a powerful civilisation that the Aztecs served as fishermen and bird-hunters, work assigned to them by their patron god, Huitzilopochtli. In the early years of the twelfth century, by express and miraculous order of Huitzilopochtli, the Aztecs left Aztlan in search of their promised land. Guided by their god, whose image was carried on the shoulders of a priest, the Aztecs began a punishing two-hundred-year migration (fig. 22) that was to be interrupted only by brief periods of settlement in favourable sites. In Coatepec, north of the Basin of Mexico, the Aztecs believed that they had found their goal and settled, building the artificial lake they needed to carry out their work. Soon

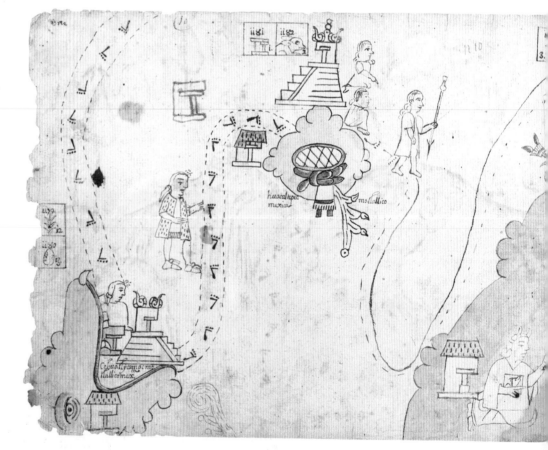

afterwards, however, convinced now that they were mistaken, they left and travelled onwards to the Basin of Mexico, a densely populated area at that time. On arrival, they encountered hostility from the inhabitants. Finally, the gods spoke to them on an islet in Lake Tetzcoco. A majestic eagle alighted on a prickly-pear cactus to show them that they had found the place chosen by Huitzilopochtli. They settled, founding Tenochtitlan (c. 1325) and Tlatelolco (c. 1338), twin towns, and political adversaries, on islands protected by the waters of the lake. Settlement and development were made possible by the use of complex techniques to drain marshes to create farming plots called *chinampas* (fig. 71).

Even in this brief summary a significant contradiction exists: how could nomads (by definition *chichimecas*) have once lived in a city? How had they acquired the skills to drain and cultivate marshland? The question has divided historians. Some argue that the Aztecs began a process of adaptation, learning and cultural appropriation that very quickly led them to the pinnacle of political power. Others prefer the idea of a gradual march by a poor Mesoamerican people to a position of hegemony.[3] This second theory takes into account the dual meaning of the term *chichimeca*: hunter-gatherer and rustic man of the north. The Aztecs saw themselves as rough men of the north, but never as real nomads. Whatever the case, the Aztecs were a marginalised group from the frontier of civilised Mesoamerica, although they had always participated in the maize-growing traditions of the settled farmers.

The second theory supports the idea of a common history of people striving to better themselves but provides no explanation for the prodigious historical and cultural development achieved by the Aztecs. Not only does this second theory allow us to understand the position of the Aztecs in Mesoamerican culture, but it also permits the migration to be interpreted from a different point of view. The short historical time-depth of the story, the *chichimeca* origin, the fact that the place of departure is close to Chicomoztoc ('the place of the seven caves')[4] or is identified with such a place, the guidance given by a patron god leading them to a promised land, the existence of a founding miracle and many other fascinating episodes which took place during the journey are not specific to the Aztec migration but typical of similar tales told by other Mesoamerican peoples, from the Basin of Mexico to the remote highlands of Guatemala. We should assume, therefore, that the Aztecs were already part of the great Mesoamerican tradition before their migration.

THE AZTEC VIEW OF THE COSMOS

The Mesoamerican view of the cosmos belongs to an ancient tradition shared by farmers from very different ethnic groups and linguistic families who lived in environments ranging from semi-desert to rainforest, from sea level to snow-covered mountains, all with different levels of social and political complexity, and with many different local and regional histories. Obviously, such diversity gave rise to local peculiarities and slight differences over time and in each cultural area. But the thinking they jointly developed over 41 centuries (25 before Christ's birth and 16 afterwards) in the vast territory of Mesoamerica was based on a set of core ideas that allowed them to perceive situations, conceive ideas and explain their surroundings in a similar way. These ideas covered various fields of thought and action: perception of time and space, man's relationship with nature, the treatment and care of the human body, basic principles of social organisation, religion, mythology, ritual, magic, medicine and the calendar.

Fig. 22

The Mexica migration from Aztlan. Folios *5v* and *6r* of the Codex Azcatitlan, late sixteenth century (cat. 355).

Bibliothèque Nationale de France, Paris

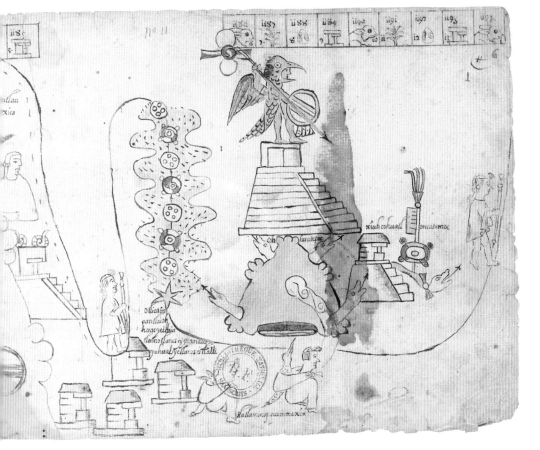

The Mexica shared with their contemporaries their deepest and most organisational thinking, based on a dualism that saw the whole of existence as consisting of substances in balanced opposition. This manifested itself in many different, binary oppositions. The first group contained life, heat, light, dryness, height, masculinity, strength, daytime, while the other contained death, darkness, dampness, smallness, femininity, weakness, night-time and other correspondences. When two opposites were combined, the proportion or dominance of one over the other determined the nature of each being and its inherent properties. The same law also applied to gods, who belonged to one or other opposing camp of the cosmos to a greater or lesser extent, but who had a dual nature which could be expressed as a divine couple.

Within the geometry of the cosmos, various natural and supernatural components circulated. There were three vertical levels, comprising a set of nine celestial planes (Topan), the surface of the earth with the four closest celestial planes (Tlalticpac), and the nine planes of the underworld, or place of death (Mictlan). The middle section, surrounded by the sea, was inhabited by men, animals and plants, but also by meteorological phenomena and the astral bodies which travelled through the sky. The earth's plane was divided into quadrants and represented as a surface on which there were five points, often depicted as five trees (fig. 23), corresponding to the *axis mundi* and four pillars which separated Topan and Mictlan. The central tree, the *axis mundi*, was rooted in the world of the dead but as tall as the highest skies. The pillars were extensions of the central tree in the four extremities of the world. At the foot of each of the five trees stood a hollow hill. Inside the trees, which were also hollow, flowed the forces of the Topan and Mictlan, which permitted the cyclical movement of time, life and death, meteorological phenomena, astral bodies and sustenance. If the trees were broken or the wall around their petrified bases knocked down, the forces poured out over Tlalticpac to return in the following cycle. The beings that inhabited Tlalticpac (including objects created by men) were part of the divinity of nature and constituted an animated environment in which men could communicate and establish relationships.

THE MYTH OF THE FIVE SUNS

Although rituals and iconography are vital to our understanding of the Aztec view of the cosmos, our best source is undoubtedly mythology. Interpretation of Aztec mythology can be

considerably enriched by making comparisons with that of other Mesoamerican peoples and even that of the indigenous people of today, their descendants, who have preserved copious amounts of tales in the southern half of Mexico and western Central America.

The principal myths allow us to reconstruct the process of the creation of the world. The father and mother of the gods[5] faced a revolt by their children, whom they punished for wanting to be worshipped or for violating the celestial prohibition of picking flowers from the cosmic trees or breaking their branches. Those who refused to comply were condemned to populate the earth and the underworld. One of them, the proto-Sun,[6] rose to supremacy with his self-sacrifice, thus establishing the fate of his fellow-gods by his example. After his death, he rose in the east as a creature: the star that would rule the world. However, before he would consent to begin his journey, the Sun imposed the condition that all the expelled gods should offer themselves for sacrifice. By dying, the victims gave birth to the various creatures of the world. For example, when he was beheaded, the god Yappan became the first dark scorpion, while the god Xolotl became the amphibian called *ajolote*. It was thought that every terrestrial being consisted of a divine part, which was imperceptible but gave it its 'soul' and essential characteristics, and a worldly part, similar to a hard shell which grew, deteriorated and destroyed itself with the passage of time. The archetypal death of the Sun and his siblings not only gave birth to creatures but also started the cyclical journey which was the fate of the gods. Their existence was divided between their transitory appearance on earth in the form of creatures, and their period of rest in the world of the dead.

Not all of the myths refer to the origin of worldly beings. Others describe the structure of the cosmos. One of the most important is the myth of the cosmogonic eras, or suns, which tells how various gods succeeded one another in ruling the world until it reached its definitive form. Major versions of the myth speak of five successive eras,[7]

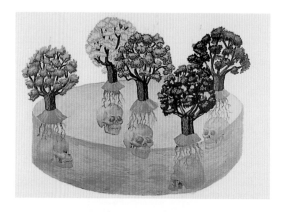

Fig. 23
The cosmic trees.

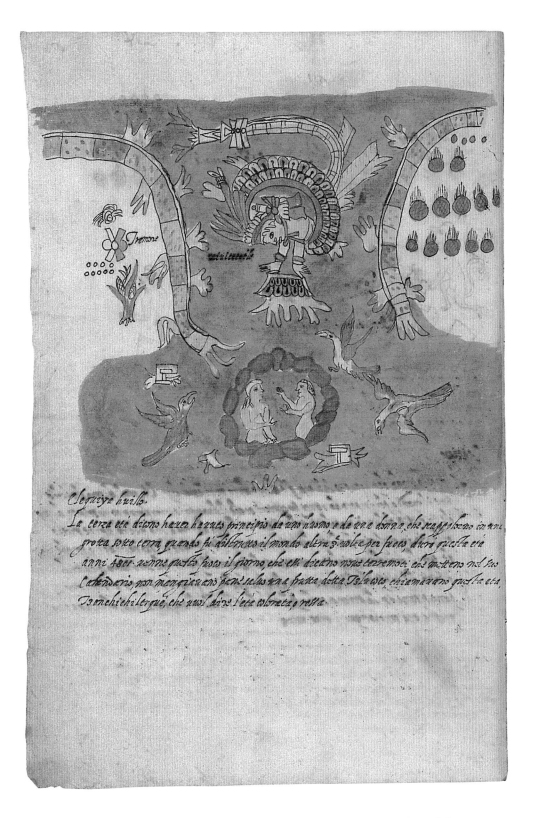

Fig. 24
The third world-era, presided over by Chiconahui Ollin. Folio 6*v* of the Codex Ríos, *c.* 1570–95 (cat. 346).

Biblioteca Apostolica Vaticana, Vatican City

each ruled by a god who performed the functions of the Sun (fig. 24). The stability of the eras was interrupted by an attack from an opposing god, the weakening of the ruling god and a chaotic cataclysm. The fifth and final era is presided over by Nahui Ollin ('4-movement'). This era, during which human beings and maize took shape, is destined to end at the termination of one of the 52-year cycles at which time Nahui Ollin will be attacked by the dark god of destiny, Tezcatlipoca. Terrible earthquakes will destroy

the world and its creatures will perish in an ensuing famine.

The various versions of the myth associate each era with a colour; these colours reflect the horizontal divisions of the earth's surface. One of the symbols of the earth's surface was a four-petalled flower in which the centre, quadrants and trees were all of different colours. In the versions which refer to four eras, the myth can be interpreted as the successive establishment of the four quadrants of the world and of the function of its pillars. Where five eras are mentioned – as in a number of Aztec versions – in addition to the above quadrants there is the establishment of the central tree and the beginning of the cosmic processes of the *axis mundi*. The erection of the cosmic trees marks the beginning of the ordered passage of time, in other words the order of the calendar.

THE AZTEC CALENDAR

The Mesoamerican calendar is a system which includes cycles of different sizes and their respective combinations. Some cycles were based on the movement of the astral bodies; others were merely based on numeric values. Regardless of its structure in the general calendar system, each cycle had its own specific mechanism and functions. Thus, for example, the cycle of 365 days – sometimes called *xihuitl* – consisted of 18 'months' of 20 days each, plus five fateful days, giving a total that corresponds to the days of the common solar year. This cycle was essentially religious, because it established the order of the most important feasts dedicated to the gods, and work-related, since it linked human activities to the seasons.[8]

Alongside this cycle ran the *tonalpohualli*, which consisted of a combination of 13 numerical symbols (1 to 13) with 20 non-numerical symbols (fig. 25), corresponding to animals, elements, gods and artificial objects (crocodile, wind, house, lizard, snake and death etc.). The 260 possible combinations result in a cycle of 260 days. The *tonalpohualli* is out of step with the solar calendar and was essentially divinatory, although some of its days indicated the celebration of important religious feasts. Thus the fortune of the day *chicome ácatl* ('7-reed') was told by referring to the specific positive or negative influences of the number 7, of the *ácatl* symbol and of the day which preceded the *trecena* (a period of thirteen days which started whenever the number one recurred). The combination of these influences was thought to affect significantly the lives of wordly beings.

Other cycles included those of the Moon, Venus and the Nine Lords of the Night. These

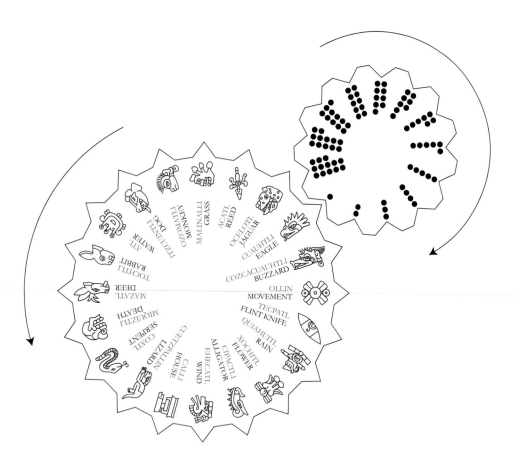

combinations formed higher cycles, which were also charged with divine influences. For example, the *xihuitl* and the *tonalpohualli* formed 18,980 unrepeatable compounds, which gave rise to the 'century' or *xiuhmolpilli*, a period which consisted of 52 *xihuitl* years, equivalent to 73 turns of the *tonalpohualli* wheel.

Time was considered a sacred substance. Days, months, years and centuries were not only protected by specific gods, but were part of the gods themselves, who influenced creatures. Men received these influences daily and did their best to benefit from the positive ones and lessen the blow of the negative. Time, dictated by the gods, was ordered mathematically to flow inside the four pillars at the extremities of the cosmos and over the world through the eastern, northern, western and southern trees, circulating anticlockwise.

THE GODS

The Aztecs believed that time was the gods themselves, but what were the gods? Essentially, the Aztecs – like all Mesoamerican peoples – believed them to be entities, made of a substance imperceptible to humans,[9] who acted on the world that humans could perceive and whose origin predated the creation of that world. These beings could be likened to the supernatural in European thinking. For the Aztecs, the gods were supernatural beings who had power, will and personality in a similar way to men. Because the gods were transformed into worldly beings, the

Aztec cosmos was full of divinity. At one end there was the One God, union and source of all the gods,[10] and at the other an extraordinary multiplicity of the divine existed, which filtered into even the humblest of insects, blades of grass and particles of rock.

Between these two extremes was a crowded pantheon of gods, all of whom had well-defined strengths and powers, despite the fact that they could easily merge with one another or divide into others. The most important Mexican gods included Tezcatlipoca (night and destiny), Huitzilopochtli (a solar deity), Xiuhtecuhtli (fire; fig. 26), Tlaloc (rain), Quetzalcoatl (deliverer of the goods of the gods), Chicomecoatl (maize), Tlaltecuhtli (earth), Cihuacoatl (mother goddess and also goddess of the earth), Chalchiuhtlicue (water), Toci (childbirth), Mictlantecuhtli (death), Tlazolteotl (love), Xolotl (transformations), Xochipilli (flowers, music and song) and Xipe Totec (oppositions and transitions). One example of division is that of Tlaloc, who divided into four *tlaloque*,[11] each a different colour, who created various kinds of rain and each of whom was situated in one of the cosmic trees. Another is that of Quetzalcoatl, who manifested himself as Ehecatl (wind) or Tlahuizcalpantecuhtli (dawn; fig. 26).

The plurality of the gods reflected the diversity of the cosmos, and the interaction between complementary forces or the conflict that men believed they could perceive in nature. Throughout the eighteen twenty-day periods of

Fig. 26
Xiuhtecuhtli, god of fire, and
Tlahuizcalpantecuhtli, god of dawn,
on page 8 of the Codex
Borbonicus, sixteenth century.

Bibliothèque de l'Assemblée Nationale
Française, Paris

the year a succession of feasts honoured the gods, who successively exercised their influence on the world.

The various peoples of Mesoamerica chose to descend from and be protected by a particular god, creating a cult around him and often assigning him a unique, familiar name. Each of these peoples considered their patron god the being who had created their remote ancestors and given them their language, customs, profession and characteristics. The Aztecs believed that their patron, Huitzilopochtli, was a sun-god who had

assigned them the tasks of fishing and other waterborne activities, which were represented by a spear-thrower (*átlatl*), a harpoon or a trident (*minacachalli*) and a net in which to load the catch. As the Aztecs became a powerful and militarised civilisation they came to see their god as an increasingly aggressive being, interpreting the *átlatl* and the *minacachalli* as offensive weapons. The initial promise which Huitzilopochtli had made to them – a lacustrine settlement where they would develop by dint of labour – also became a prediction of the glory they would

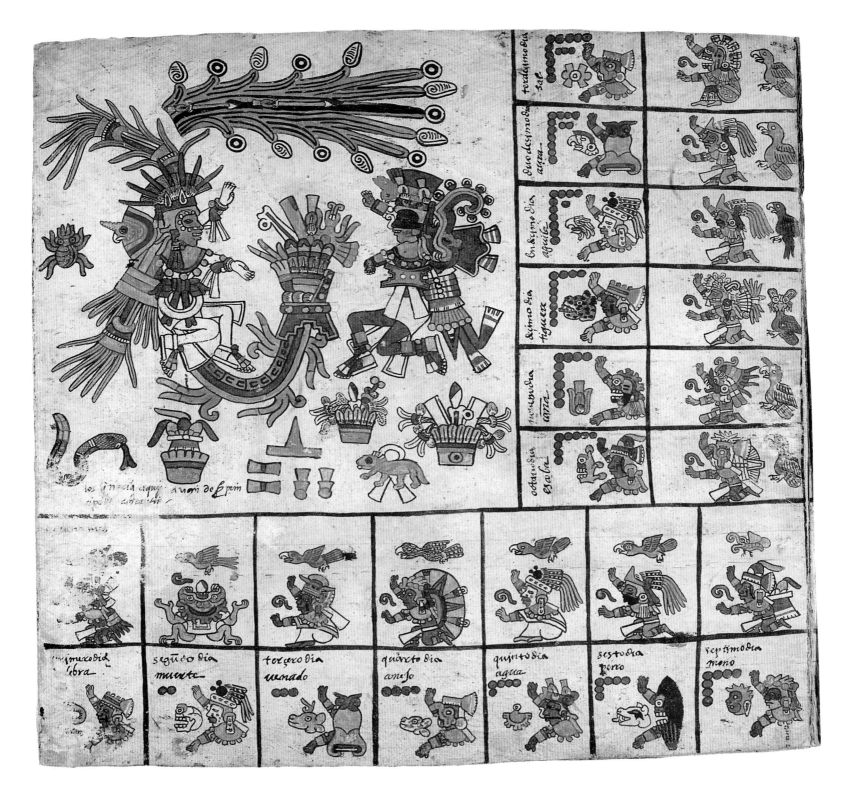

achieve as conquerors, forcing their enemies to acknowledge the supremacy of their god and to pay high taxes to the Aztec state.

A PIOUS SOCIETY AND STATE

From the first quarter of the fifteenth century to the time of the Spanish conquest, the Aztecs lived in a permanent state of religious and military fervour. Children and young people – both male and female – were taught to connect their devotion to the gods with a passion for war. All members of society were priests at least in the first stages of their lives, since children were offered to the temple soon after birth and their parents committed them to serve its gods once they had reached the age of reason (fig. 27). Therefore, education associated priesthood with a career in the army. Child priests (*tlamacaztoton*) rose through the ranks until they became military men forged on the field of battle. Even when they left school to marry, young people would leave behind an amulet as security, which contained part of their soul and ensured that the link between themselves as adults and the institution would never be broken.

The fusion between the divine order and the political order meant that each official was responsible for executing the plans of the gods, particularly those of the patron god. The ruler (*tlatoani*) was the image of divine power in the eyes of his people, although his representation favoured the celestial and masculine part of the cosmos. At his side, an assistant (*cihuacoatl*) dealt with matters that related to the underworld, including fiscal ones.[12] Both these leaders were the highest authorities in politics, religion, the army, worship, administration and trade. Such public positions reproduced the duality of the cosmos.[13]

The whole apparatus of state was directed, by divine design, towards hegemonic expansion and the subjugation and plundering of conquered peoples.

Priests, of whom there were many, were responsible for worshipping the gods, educating children and young people (a task in which they were assisted by the army), advising rulers, administering the property of the temple, caring for the faithful, and predicting the future. The clergy consisted of both men and women, although the main functions were performed by men. They were assisted in their activities, which were highly specialised and organised by hierarchy, by numerous devotees who had promised to serve the gods for a certain number of years.

MILITARISM, RELIGION AND HUMAN SACRIFICE

As can be imagined, the militaristic ideology of the Aztecs considerably influenced their beliefs, mythology and ritual. Personal, family, community and religious matters were conditioned by the interests of the ruling élite and all benefited from war.

One of the most important feasts of the Aztec cult was the binding of the years into a *xiuhmolpilli*, a bundle of 52 reeds (fig. 28). Every 52 years saw the end of the 18,980-day cycle produced by the combination of the *xihuitl* and the *tonalpohualli*. All fires were extinguished and the world was temporarily at risk of being ruled by the terrifying beings of the night. Domestic objects, including representations of deities, millstones and grinding stones, were destroyed for fear of their sacred essence rebelling at a critical time of darkness and exacting revenge for daily abuse and mistreatment. The main worry, however, was that the Fifth Sun – Nahui Ollin – would be extinguished forever. During the night, on Mount Huixachtepetl, south-

Fig. 27
A father takes his son to school. Vol. 1, folio 232*v*, of the Florentine Codex, 1575–77 (cat. 344).
Biblioteca Medicea Laurenziana, Florence

Fig. 28
The Aztecs celebrate the binding of the years during their sojourn in Apazco. Page 10 of the Codex Boturini, the Tira de la Peregrinación, sixteenth century.
Biblioteca Nacional de Antropología e Historia, Mexico City

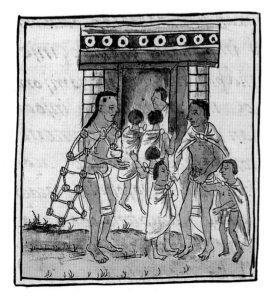

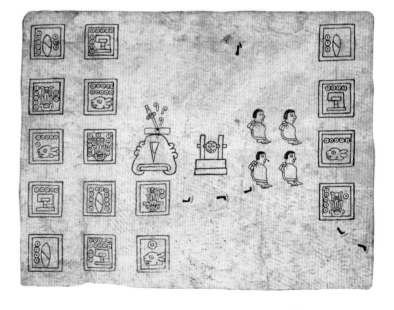

Fig. 29
A human sacrifice. Folio 70r
of the Codex Magliabechiano,
sixteenth century (cat. 342).

Biblioteca Nazionale Centrale di Firenze,
Florence

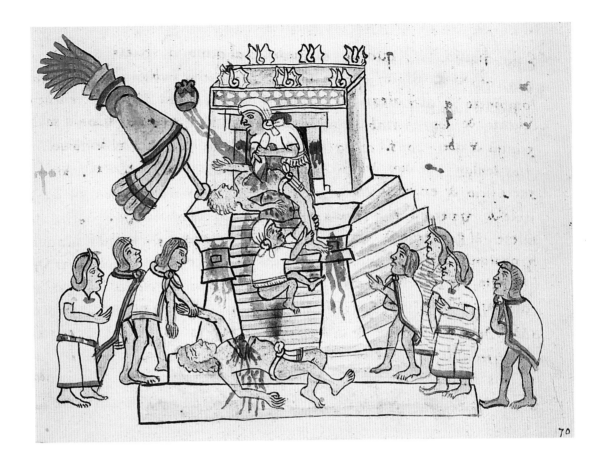

east of Tenochtitlan, a priest placed the fire-drill[14] on the chest of a sacrificed enemy and lit a new flame there. The new fire began to glow, to great public jubilation, and every home was filled with light and heat. From that moment, to prevent the weakened Sun from extinguishing itself forever at the end of the next 52 years, humankind was obliged to strengthen the god by providing him with suitable nutrition: human blood and hearts.

The practice of human sacrifice had been common among sedentary farmers for a thousand years and remained one of the main rituals of Mesoamerican religion (fig. 29). However, the number of ritual murders increased to untold proportions when militarism developed in civilisations such as those of the Aztecs and the Tarascans in the years leading up to the Spanish conquest, and at certain times among the northern Maya.

The type of victim varied according to the specific deity and ceremony. One important feast required the sacrifice of a mature woman from a noble family of Aztec descent. The Aztecs believed that the rain gods, the *tlaloque*, required children who had two cowlicks in their hair for sacrifice. Furthermore, to prevent damage to the Sun during eclipses, the god was strengthened by the sacrifice of albinos, people full of light. With military expansion, the majority of victims came to be enemies captured in battle who were so numerous

that they had to be divided among the various districts of the city for their keepers to feed them until the time came for them to be delivered to the gods.

These ritual murders had different meanings. Some victims were considered to be sources of energy for the gods who drank their blood and devoured their hearts; but there were also the so-called *in teteo imixiptlahuan*, human beings chosen to receive the fire of the gods in their bodies, as if they were vessels of divinity. They were killed on the feast day of the god they impersonated in the belief that the god would be freed of its host and, thus rejuvenated, could enter the body of another man who could contain its strength until the next feast day.

The Aztecs, heirs of an ancient cultural tradition, lived in and developed a shared view of the cosmos, stamping upon it their own conceptions of their history. Their primary view of themselves as farmers, hunters, fishermen and lacustrine gatherers changed considerably when it had to fulfil the requirements of hegemonic expansion.

4 | AZTEC SOCIETY: ECONOMY, TRIBUTE AND WARFARE

Frances Berdan

In the year 1325, '2-house' in the Aztec calendar, a group of nomadic travellers who called themselves Mexica settled on a small island in the middle of Lake Tetzcoco in the Basin of Mexico. It was the end of a long and arduous journey, and the beginning of a new era in Mesoamerican history. This era took place during the period labelled today as Late Postclassic (1250–1521).

Lake Tetzcoco was largely drained in colonial times, and today the metropolis of Mexico City sprawls over most of this interior-drainage basin. In the fourteenth century, the Basin, dominated by a series of freshwater and saline lakes, must have seemed an attractive region for human settlement. Many peoples had settled there prior to the Mexica, as had numerous Chichimec migrants from northern regions. The Mexica were the last of these migrants to arrive.

Mexica history can be divided conveniently into two phases of roughly equal duration. From 1325 until 1430 the Mexica established their city; married their élite into prestigious, well-established dynasties in the Basin; and served as mercenaries in the wars of larger, more powerful neighbouring polities. Their fierceness on the field of battle was legendary, but although their military successes gained them tributes and lands, they remained mercenaries. In 1428–30 the tide turned: Atzcapotzalco, the dominant city-state in the Basin, was wracked with internal conflict, and the Mexica joined forces with the Acolhua of Tetzcoco to gain control of the Basin. The Mexica and the Acolhua then formed a Triple Alliance with the Tepanecs of Tlacopan, which was designed to dominate the Basin and conquer more distant regions. From this time, the Mexica population grew rapidly, their wars were incessant, their arts flourished, and mercantile activity thrived.

Tenochtitlan, as the Mexica called their settlement, had become one of the world's largest cities by 1519, the year when Hernán Cortés and his Spanish conquistadors arrived. With an estimated 250,000 inhabitants, the island city had risen from its humble origins to become the hub of a large and powerful military empire. Many other cities rimmed Lake Tetzcoco and dotted the surrounding valleys, and, as enemies or allies of the Mexica, each played an important role in the development of this extensive empire.

Although modern scholars frequently subsume most of these groups under the label 'Aztec' because they shared a common language (Nahuatl) and similar cultural features, these peoples maintained strong local identities, distinguishing themselves as the Mexica of Tenochtitlan, the Acolhua of Tetzcoco, the Chalca of Chalco, and so on.

The Mexica and their neighbours arranged their lives around an array of complex social, political and economic rules and institutions during the brief 91-year span of their imperial domination (1430–1521). This essay focuses on these, and examines the strategies the Mexica used in developing their militaristic empire.

SOCIAL AND POLITICAL ARRANGEMENTS

While settling in the Basin, the Mexica followed several well-established patterns: they claimed a territory as a city-state, developed an urban centre with a ceremonial district at its heart, and established and legitimised a ruling dynasty. Like other groups in the Basin, they distinguished themselves through language, overt cultural features such as clothing and art forms, and worship of a specific patron deity. To all of this, the Mexica added a particularly militaristic flavour.

The basic political unit of organisation in Late Postclassic Mesoamerica was the city-state, known in central Mexico as an *altepetl* (literally 'water-hill'). An *altepetl* was 'an organisation of people holding sway over a given territory',[1] although the term was also used to indicate the place itself. An *altepetl* would have a predominant ethnic identity, a dynastic ruler (*tlatoani*), a founding legend, a patron deity with a temple, and would often be known for some specialised occupation or notable market, or as a pilgrimage destination. Most city-states were subdivided into smaller units: Tenochtitlan, for example, consisted of four large quarters, and an estimated 80 smaller units (called variously *calpulli* or *tlaxilacalli*). These also had land rights, a patron deity and temple, and a school, and each was the focus of a particular occupation, and a centre for tribute collection and military conscription.[2]

Rulership could likewise be quite complex. There was generally one ruler per *altepetl*. However, the government of certain *altepetl* might be shared by as many as four rulers, each with their own 'sub-domain', and each in a hierarchy in relation to the others.[3] This situation prevailed in Tlaxcala (which later allied itself with the Spanish) and Chalco (in the south-eastern Basin of Mexico).

Aztec social organisation was highly stratified, more closely resembling a caste than a class system. Roughly speaking, people were nobles or commoners, and this distinction was based on birth. In addition, an individual's destiny was intimately linked to his or her birth date in the ritual calendar, and futures differed for nobles and commoners. A noble born on the day '1-alligator' would become a prosperous ruler, while a commoner born on the same day was destined to be a brave warrior.

Nobles begat nobles, exalted individuals who occupied positions of power, prestige and wealth. They enjoyed special perquisites: the men practised polygamy and sired numerous children; they built houses of two storeys and administered large households; they controlled access to land and other capital resources; they and their children were educated in priestly schools; they enjoyed access to the most influential jobs; and both noble men and women were permitted to wear elegant clothing and accoutrements.

City-state rulers were descended from noble lineages, although rules of succession varied. In Tenochtitlan, for instance, brothers succeeded brothers, while in Tetzcoco sons succeeded fathers. In either case, an election (perhaps token) was conducted among other high-ranking nobles to validate the succession, and the position was confirmed and formally bestowed by a high priest. Other nobles served as royal advisers, judges, provincial governors, ambassadors, tax-collectors, military officers and priests. Others of somewhat lower rank became teachers, scribes or lesser bureaucratic officials. Such positions required noble descent and an appropriate education: in the *calmecac*, or priestly schools, noble boys learned reading, writing, history, calendrics, mythology and military strategy, along with the martial arts that were universally taught to males.

Commoners comprised the majority of the population. These were the farmers, the fishermen and the artisans. Many worked on communally managed *calpulli* lands, and were also subject to labour conscription and payments of taxes in goods to their city-state ruler. Other commoners, called *mayeque*, were directly attached to the lands of a specific noble to whom they owed extra labour and production. Others became slaves. Entering into slavery was often a voluntary act whereby an individual in dire straits might exchange his labour for a year's subsistence, or offer it as payment for gambling debts. In either event, slavery was more of a social-security system than it is usually considered in the Western world. Children of slaves did not inherit their parents' status, and an individual could move in and out of slavery depending on his or her circumstances. Other individuals often described as slaves were warriors captured on the battlefield; destined for ritual human sacrifice, however, these valiant men had no long-term position within the social system.

Nestled between nobles and commoners was the ambiguous category of professional merchants and artisans of luxury goods. These ambitious members of Mexica society were organised in guild-like arrangements, and although not noble by descent, were nonetheless able to accumulate abundant wealth. *Pochteca*, professional merchants, were held in high esteem by city-state rulers; they travelled widely, trading their own personal goods as well as those of their ruler, and their occasional assassination in foreign lands was cause for immediate military reprisals. In the cities of the Basin of Mexico, *pochteca* occupied specific *calpulli* and exercised considerable control over their own

affairs. Similarly, artisans making precious stone ornaments, gold and silver jewellery, and featherwork accoutrements lived in exclusive *calpulli*. Some were in the employ of specific rulers or nobles, but others produced more generally for the market. In either case, the consumers of their exquisite products were nobles and demand was high, with the result that these artisans became quite wealthy. They enjoyed political and social rights denied to other commoners, but were at pains to hide their considerable wealth from the possibly jealous eyes of the nobles. They were a vigorous force in an increasingly commercialised economy.

In theory, some avenues of mobility existed in this apparently rigid society. The most important of these was personal achievement on the battlefield. A primary goal of warfare was the capture of enemy warriors for ritual sacrifice; each capture enhanced the captor's status and rewards.

However, as the empire expanded, rifts developed between nobles and commoners, perhaps predictably, in view of the increasing number of noble children being born and the relatively slower expansion in the number of noble-level occupations available.

ECONOMIC PRODUCTION

The large populations and complex specialisations of Aztec Mexico were supported by extensive agricultural surpluses (fig. 30). Intensive cultivation of maize, beans, chillis, squashes, tomatoes and other vegetables provided sustenance for noble and commoner alike. In the Basin of Mexico and other lacustrine areas, abundant aquatic resources and migratory birds supplemented this diet. In drier environments, prickly-pear cactuses supplied reliable foods, and maguey plants provided *octli* (*pulque* in Spanish), a fermented beverage made

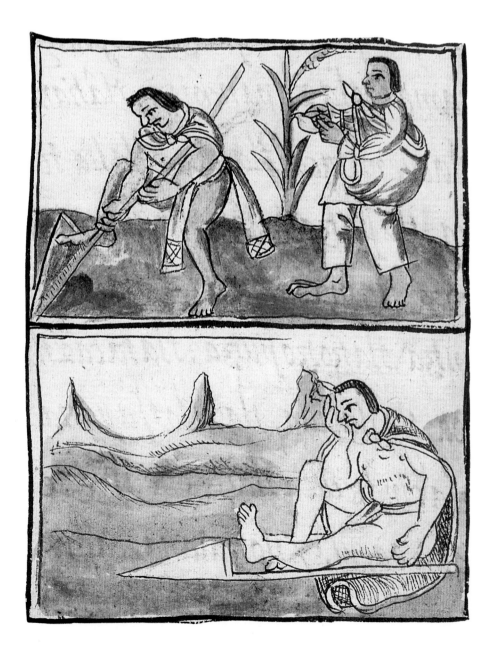

Fig. 30
Farmers at work in the fields. Vol. 3, folio 30*v*, of the Florentine Codex, 1575–77 (cat. 344).

Biblioteca Medicea Laurenziana, Florence

from the heart of the plant.[4] Salt, a dietary essential, was extracted along the shores of lakes and ocean coastlines. Cacao (chocolate) was grown in humid, tropical regions, and animals such as deer and rabbits were hunted in wild habitats. Prominent among the few domesticated animals were the dog and the turkey, both of which were eaten. Horses, cattle, sheep, pigs and goats were all introduced by the Spanish.

The Mexica and their neighbours were accomplished horticulturists, and devised many ingenious means of increasing food production. They terraced highland slopes, and controlled water courses through the construction of irrigation canals and check dams.[5] Perhaps most important for the urban development of the Basin of Mexico were the *chinampas*, more commonly known today as 'floating gardens' (fig. 71). These high-yield plots increased the land area available for cultivation, and served as settlement extensions

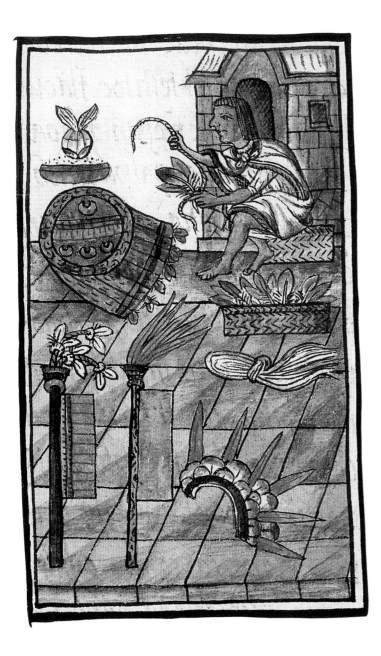

Fig. 31
Featherworkers.
Vol. 2, folio 371r, of the Florentine Codex, 1575–77 (cat. 344).

Biblioteca Medicea Laurenziana, Florence

of lakeside cities. Tenochtitlan would never have attained its estimated population of 250,000 on its original small island, and numerous other cities expanded in the same fashion.[6]

Chinampas, remarkably productive tracts of land built up in the shallow beds of freshwater lakes, were constructed from alternate layers of mud and vegetation which were secured by posts and the roots of willow trees. Plots were systematically planned and arranged in the lake, and each was typically bordered on one side by a canal and on the other by a footpath adjacent to another field (see fig. 71). Fertility was enhanced by intensive cultivation techniques: water for irrigation was supplied by dipping into adjacent canals, a process which also dredged the canals and kept them clear for canoe transport. Cultivation was accomplished by the effective use of seedbeds, thus allowing for continuous planting and harvesting of crops. Although the fecundity of these fields was remarkable, Edward Calnek has suggested that about 500 square metres of this type of land would be required to support one person.[7] In that Tenochtitlan *chinampas* ranged in size from 100 to 850 square metres and were cultivated by an average of 10 to 15 persons each, Calnek maintains that these fields were not self-sufficient and were not capable of producing a substantial surplus for sale to the urban population. Perhaps their value lay more in their ability to produce high yields of the garden vegetables and aromatic flowers essential for the endless round of flamboyant rituals and political displays.

Many farmers maintained fields comparable to kitchen gardens, planted with foods, herbs and medicines. But some cultivators and other food producers grew more specialised crops in suitable environments. As we have seen, *chinampa* horticulturists may have concentrated upon vegetable and flower cultivation. Chalco (in the south-eastern Basin of Mexico) and Tlaxcala (east of the Basin of Mexico) were known as maize 'breadbaskets'; Tochtepec near the coast of the Gulf of Mexico was famous for its cacao; northern Yucatan was the source of the finest salt; and other city-states gained reputations for producing high-quality chillis, cacao and chia.[8]

Non-food crops were also grown in abundance throughout the Aztec world. In drier environments, as well as providing a desirable (but normally prohibited) beverage, maguey, an agave plant, yielded cloth and net fibres, its sharp spines providing sewing needles and its sap offering medicines. Similarly, the prickly-pear cactus (a source of food from its pads, fruit and flowers) provided a habitat for the small insects which gave prized red cochineal dyes. The cultivation of

cotton, a particularly significant product, was restricted to lowland areas, although cotton clothing was woven by both highland and lowland women. Other raw materials included obsidian from volcanic zones, gold from certain rivers, reeds from lake shores, wood from forests, shells from marine environments, paper from forests with the appropriate trees, and exotic feathers and jaguar pelts from tropical zones. Clays, mineral dyes, jade, turquoise, glues and assorted other materials were found in dispersed areas.

Aztec consumers had access to an impressive array of products. Raw materials were transformed into usable and exotic goods by a myriad of artisans who specialised in their manufacture. Specialised artisans were concentrated in the large Basin of Mexico cities, but were also dispersed throughout the Aztec domain and beyond. Although there appears to have been minimal state control over artisans making utilitarian objects,[9] a more formalised organisation was instituted for the luxury crafts. The fine art of featherworking, for instance, was carried out by accomplished, meticulous craftsmen in a particular *calpulli* of Tlatelolco. These featherworkers (fig. 31) crafted elaborate mosaic shields, flowing headdresses and decorative banners, overseeing their own affairs with their own officials and worshipping a specific patron deity. Artisans working with precious metals and stones established a similar guild-like system; they were localised in their own *calpulli* and exercised control over training, manufacture and production quality. Similar types of item were made all over the Aztec empire and beyond, and warriors from all regions charged onto the battlefield flaunting their splendid paraphernalia. It is not known if such artisans enjoyed special attention and privileges in more remote cities, but given their importance to the nobility it appears likely.

Not all specialist workers produced material goods. The complexity of an urban society demanded the full attention of administrative and bureaucratic officials (from rulers to tax-collectors and scribes), and the Aztecs' elaborate polytheistic religion required an extensive retinue of priests, priestesses and temple-workers. Commerce, too, was highly developed in Aztec Mexico, and, as we shall see, professional merchants gained a lucrative livelihood.

TRADE AND MARKETS

Specialisation requires some type of exchange system to allow distribution of utilitarian products, exotic goods and necessary or desired services. Among the Aztecs and their neighbours,

distribution took several forms: market exchange, long-distance commerce by professional merchants, tribute, and reciprocity among élites. Tribute and élite reciprocity were essentially political institutions, and will be discussed in the final section of this essay.

The most common mode of economic distribution in the Aztec domain was market exchange (fig. 33). Virtually every community of any size held a market either daily or in rotation with neighbouring communities. The outdoor marketplace, or *tianquiztli*, was undoubtedly the liveliest spot in a town. Not only the setting for trade in a wide range of goods, it also served as the venue for circulation of the latest news among kin and acquaintances.

Marketplaces varied considerably in scale, depending on city size, location, reputation and specialisation. The grandest marketplace in Aztec Mexico, at Tlatelolco, reportedly offered virtually everything produced in the known world, from a wide selection of foodstuffs, to medicines, cooking vessels, lumber, clothing and fancy adornments. Vendors ranged from commoner-producers of small garden surpluses (a few chillis or tomatoes), to regional merchants carrying products such as cotton or cacao from market to market (fig. 32), to professional luxury merchants trafficking in expensive exotic goods such as tropical feathers and jadeite ornaments.

Other marketplaces were smaller and their produce often reflected their environment. Coyoacan's market, for instance, was known for wood products from its nearby forested hinterland, and Cholula's was famed for its locally produced

Fig. 32
Travelling merchants.
Vol. 2, folio 316*r*, of the Florentine Codex, 1575–77 (cat. 344).

Biblioteca Medicea Laurenziana, Florence

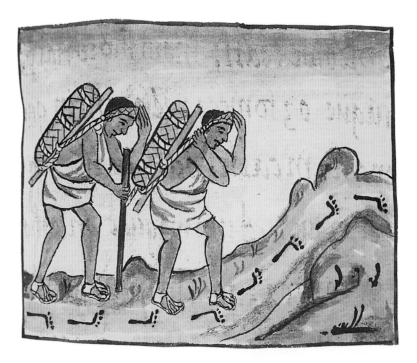

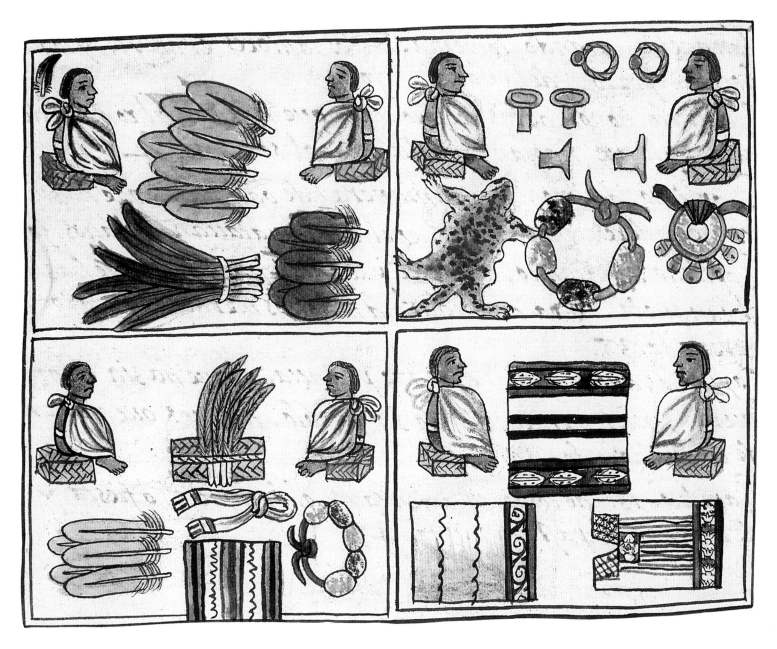

Fig. 33
Merchants selling their wares.
Vol. 2, folio 308*v*, of the Florentine
Codex, 1575–77 (cat. 344).

Biblioteca Medicea Laurenziana, Florence

and well-reputed chillis and maguey honey.[10] Aztec consumers knew that it was best to go to the Acolman market for a wide selection of dogs, to the Tetzcoco market for ceramics, cloth and fine gourds, or to the markets at Atzcapotzalco or Itzocan for slaves.

Barter was the usual means of exchange in Aztec marketplaces. But exchanges were facilitated by the use of commonly accepted currency, especially cacao beans and large cotton cloaks. Cacao beans served as 'small change' and were valuable enough to engage the energies of counterfeiters, who would remove the chocolate from the outer husk and replace it with sand or ground avocado stones. Individual cacao beans carried little value: in early Colonial times one cacao bean was equivalent to a large tomato or a tamale, three cacao beans could purchase a turkey egg or a newly picked avocado, 30 cacao beans would buy a small rabbit, while 200 were required

to purchase a turkey cock.[11] Large, white cotton cloaks served as higher-value media of exchange; depending on the respective qualities of bean and garment, values ranged from 65 to 300 cacao beans for one cloak.[12] As a measure of standard of living, twenty cloaks (of unstated quality) could support a person, probably a commoner, for a year.[13]

Marketplaces attracted *pochteca*, who traded their expensive merchandise both inside and outside the Aztec imperial domain, often becoming quite wealthy in the process. As will be recalled, well-established *pochteca* also served as city-state and imperial emissaries, formally trading their ruler's goods for the goods of a foreign ruler. Some specialised *pochteca* (known as *oztomeca*) served as spies by disguising themselves and gathering current news in outlying marketplaces. Known as political as well as economic agents, *pochteca* risked assault and assassination on the road (fig. 34).

Marketplace exchange and long-distance trading enterprises moved a vast array of goods from region to region and from hand to hand. These activities evened out regional availabilities, seasonal fluctuations and specialised manufacture. Exchanges were not strictly economic events, but were intimately tied to social and political networks: friendships were established, news was exchanged, spying was carried out and alliances were forged.

DAILY LIFE

Standards of living varied considerably across the Aztec social scheme. Everyone lived in houses, but their size and quality were a measure of status. At one end of the scale were the royal palaces. Motecuhzoma's palace in Tenochtitlan was not just a residence but also a government building; it contained courthouses, warriors' council chambers, tribute storage rooms (including two armouries), rooms for bureaucratic officials and visiting dignitaries, a library, an aviary, a zoo, and various courtyards, gardens and ponds.[14] The palace of Netzahualcoyotl[15] (fig. 35) in neighbouring Tetzcoco reportedly covered over 200 acres.[16] Wealthy merchants and luxury artisans enjoyed quality housing, but on a much smaller scale. Commoners' houses were more modest still, although they varied with the economic circumstances of each household. Some were made of adobe and consisted of a number of rooms surrounding a central patio. Rooms tended to be small and windowless, and most daily living seems to have taken place outside on the patio. Others were constructed of wattle and daub, wooden planks or stone. The houses of Mexica from all backgrounds contained few furnishings and household possessions.

Diet was another dimension of life separating noble from commoner. The Mexica ruler was reportedly presented with two thousand kinds of food each day: 'hot tortillas, white tamales with beans forming a sea shell on top; red tamales; the main meal of roll-shaped tortillas and many [foods]: sauces with turkeys, quail, venison, rabbit, hare, rat, lobster, small fish, large fish; then all [manner of] sweet fruits'.[17] Contrast this with a commoner's mid-day meal of *atolli* (maize gruel) and a later meal of tortillas with a chilli sauce, beans and other vegetables, with meat only on special occasions. In between these extremes, professional merchants and luxury artisans apparently ate quite well and were able to afford to host lavish feasts.

Clothing tended to advertise social and economic status. Cotton was more prestigious than the coarser maguey fibre, and elaborate designs carried special meanings. Successful warriors, for instance, were awarded cloaks of specific designs to signal their achievements. Nonetheless, clothing was relatively simple, with men wearing loincloths and capes, and women wearing tunics and skirts.

Daily work in Aztec Mexico was labour-intensive. Women-commoners' work was physically demanding and time-consuming. All clothing was woven on backstrap looms by women who also spun thread for weaving by hand. Women spent hours at the *metate*, grinding maize for the day's tortillas. They prepared special tamales and other foods for ceremonial occasions, and devoted considerable time to childcare. They were periodically called upon to labour in a noble's palace. Their men worked long hours in the fields cultivating crops with hoes and digging sticks, on lakes catching fish with nets, or at home making pottery or obsidian blades by hand. Men were also subject to military or labour conscription. Noble occupations generally required less physical effort, but often carried heavy responsibilities. Professional merchants trekked difficult and treacherous trails, and luxury artisans spent long hours in their meticulous arts.

Despite their differences, noble, merchant and commoner alike were subject to the same cultural mores and legal codes. The virtues of 'the exemplary life', representing 'obedience, honesty, discretion, respect, moderation, modesty and energy',[18] were extolled. Individuals were expected to work hard (and not to sleep long hours),

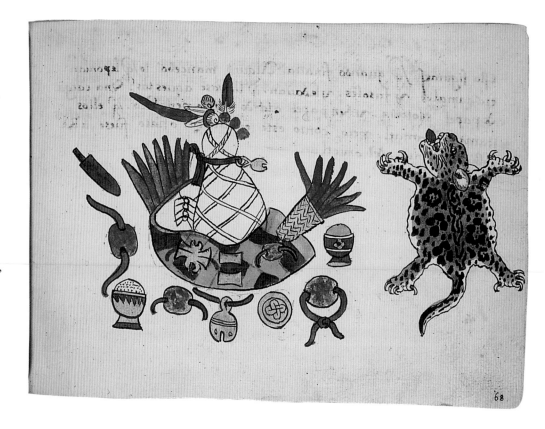

Fig. 34
The funeral of a wealthy merchant. Folio 68r of the Codex Magliabechiano, sixteenth century (cat. 342).

Biblioteca Nazionale Centrale di Firenze, Florence

Fig. 35
Netzahualcoyotl, King of Tetzcoco. Folio 106r of the Codex Ixtlilxochitl, sixteenth century.

Bibliothèque Nationale de France, Paris

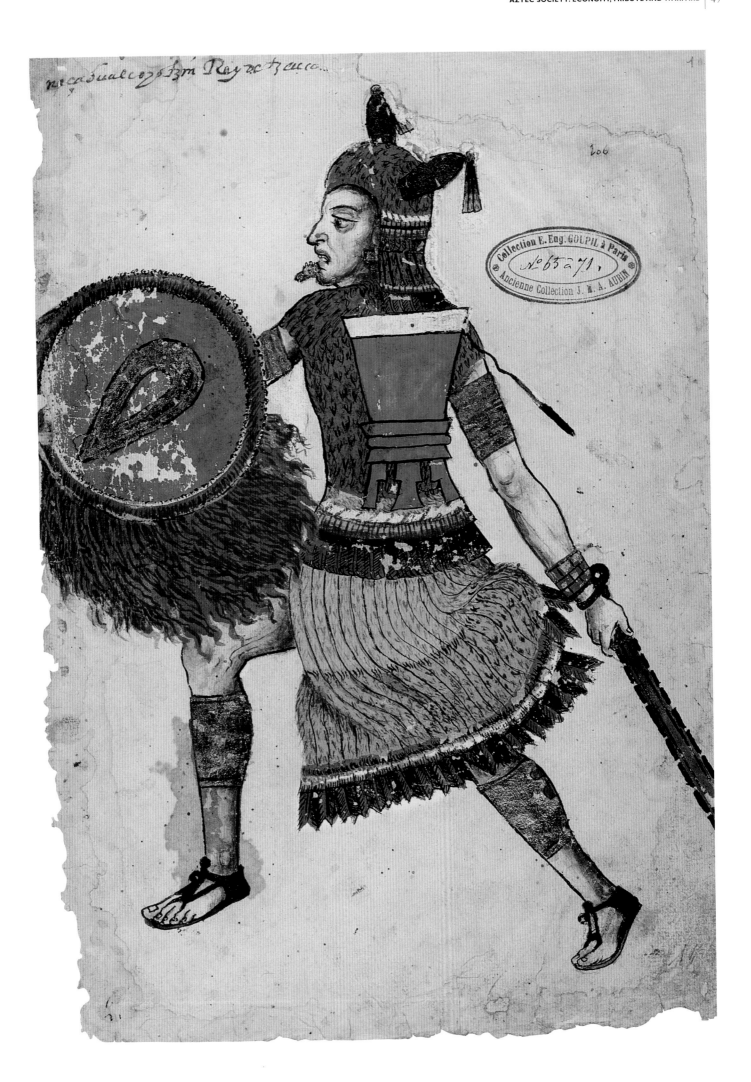

Fig. 37

A register of tribute paid by the province of Xoconochco on the Pacific coast. Folio 13*r* of the Matrícula de Tributos, early sixteenth century.

Biblioteca Nacional de Antropología e Historia, Mexico City

Fig. 36

The instruction of Aztec children aged between three and six. Folio 58*r* of the Codex Mendoza, *c.* 1541 (cat. 349).

Bodleian Library, University of Oxford

to dress modestly, to eat quietly and speak thoughtfully. Children were explicitly taught these rules along with practical skills (fig. 36), and discipline was severe for those who did not comply.[19] Legal codes were in place to direct and punish those who infringed these rules. Punishments tended to be more severe for nobles than for commoners; because they carried more responsibility, it was thought that nobles should be held more accountable for the consequences of their actions. Ceremonial events called for participation by both noble and commoner, with each performing complementary roles. Participation in such events welded noble and peasant into a common cultural milieu.

WARFARE AND THE AZTEC EMPIRE

In 1430 the Aztec empire took form, based on the Triple Alliance between the city-states of Tenochtitlan, Tetzcoco and Tlacopan. This militarily aggressive coalition had conquest as its primary goal. Over the 91 years in which it held sway, the Triple Alliance conquered numerous city-states in central and southern Mexico, ranging from areas to the north of the Basin of Mexico to present-day Guatemala, and from the Pacific coast to the coast of the Gulf of Mexico.

Conquest and empire-building relied on successful military engagements. The goals of warfare were essentially twofold: to capture enemy warriors for sacrifice, and to conquer other polities for the extraction of tribute. As we have seen, enemy captures on the battlefield were a measure of a warrior's personal achievements. Significant rewards and renown awaited the courageous warrior, important incentives in motivating a fighting force that engaged essentially in hand-to-hand combat. To this end, the Mexica arranged military engagements called 'flowery wars', scheduled battles with long-term enemies such as the Tlaxcalans. Each city-state used these encounters as training grounds for neophyte warriors as well as a convenient source of sacrificial victims. These goals aside, however, it seems that the battles were fought in earnest and that conquests were indeed sought.

Although the warriors of the Triple Alliance did not always emerge victorious,[20] on balance they were the dominant military force in Mesoamerica during their 91-year heyday. In the course of imperial growth, they dealt with subjugated city-states by establishing 'strategic provinces' and 'tributary provinces'.[21] Strategic provinces were formed more through alliance than conquest, and involved gift-exchanges among élites rather than outright tribute payments. These provinces were

located in hostile borderlands, at important resource sites, or along major transport routes. Tributary provinces experienced military conquest and were required to pay an established tribute on a predetermined schedule. The style of imperial management of these conquered polities was hegemonic; following conquest, a city-state was permitted to retain rulership as long as tributes were paid on time.

Typically, tribute payments were required in goods readily available to the conquered subjects: wood products from forested regions; maguey cloth from drier northern areas; and shimmering feathers, jaguar pelts and cacao beans from tropical lowland environments (fig. 37). Cotton clothing was paid by all but two tributary provinces, demonstrating its widespread use and generalised demand. Staple foodstuffs such as maize and beans, being heavy and bulky, were given in large quantities by provinces close to the imperial capitals.

Tribute demands were carefully planned by the imperial powers. They ranged from subsistence staples to store against famine, to decorated clothing and costumes for awards to valiant warriors, to precious gold and jadeite ornaments for élite display. As the empire expanded in the later years of its growth, more and more tributes took the form of fancy, élite goods. This in part indicates the availability of these precious materials in distant regions, but undoubtedly also represents the expansion of the nobility and a growth in its taste for extravagance.

Although the loose, hegemonic style of imperial administration was an inexpensive strategy for the Mexica, it was ultimately to be their undoing. As Hernán Cortés sought to defeat Motecuhzoma Xocoyotzin of Tenochtitlan, he engaged as allies the many disenchanted conquered and unconquered city-states whose dynasties, resources and fighting forces remained intact despite continued demands and pressures from the powerful Triple Alliance. With the arrival of the Spanish, the tide of conquest turned on the powerful Mexica.

THE TEMPLO MAYOR, THE GREAT TEMPLE OF THE AZTECS
Eduardo Matos Moctezuma

The night after the Mexicans had finished repairing the chapel of their god, having blocked off most of the lagoon and created the base on which the houses would be built, Huitzilopochtli spoke to the priest and said: 'Tell the Mexican congregation that they must split up, with each nobleman taking his relatives, friends and those closest to him, into four main districts around the house you have built for me to rest in…'[1]

Thus Friar Diego Durán described how the god Huitzilopochtli ordered the construction of the city of Tenochtitlan in 1325, leading to the establishment of the two areas of the city: the sacred and the profane. The first is where the Templo Mayor and its surrounding buildings were constructed within the ceremonial precinct (fig. 38), the ultimate sacred site inhabited by the gods. This was to become the absolute centre of the city and within it the Templo Mayor occupied the most sacred space: the centre of centres, the place from which you could ascend to the sky or descend to the underworld, the point from which the four directions of the universe began. For all these reasons, the Templo Mayor was hugely important; it lay at the heart of the Aztec universe, where the various forces of their cosmos met. The profane space, as the god explained, was destined to house the Aztec community, divided into four districts or *calpullis*. The rapid enlargement of the city led these *calpullis* to proliferate; at the time of its greatest splendour, Tenochtitlan numbered some 250,000 inhabitants.

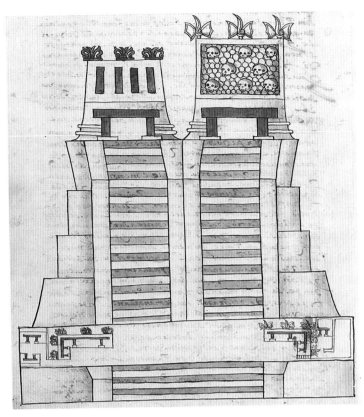

Fig. 38
The site of the ceremonial
precinct of Tenochtitlan in present-
day Mexico City, showing the
Cathedral and the excavations
of the Templo Mayor.

Fig. 39
The two shrines at the top of the
steps of the Templo Mayor where
the figures of the gods stood. Folio
112*v* of the Codex Ixtlilxochitl,
sixteenth century.

Bibliothèque Nationale de France, Paris

A review, based both on archaeological evidence and on historical sources, of the various stages of the Templo Mayor's construction follows, as well as a discussion of the elements associated with each stage. Archaeology has provided much new information after five years of digging in the heart of Mexico City. It is well known that what is now Mexico City covers various Pre-Hispanic cities and towns which existed at the time of the Spanish conquest in the area of Lake Tetzcoco. Both Tenochtitlan and Tlatelolco, its twin city, were situated in the middle of the lake. The first was linked to the mainland by the Tacuba causeway to the west, the Ixtapalapan causeway to the south, and the Tepeyac causeway to the north. Reports also exist of a fourth causeway leading eastwards. These wide causeways led from the ceremonial precinct out along the four directions of the universe, according to the Aztec view of the cosmos.

Historical sources provide a great deal of information on the Templo Mayor. Various chroniclers of the sixteenth and seventeenth centuries left records stating that the temple was dedicated to two gods: Tlaloc, god of water, rain and fertility, and Huitzilopochtli, god of the sun and war. Various pictures of the temple survive (fig. 39), showing its stairways leading to the upper part and the two dedicated shrines at the top of the building where the figures of the gods stood.

All this information led to the setting up of the Proyecto Templo Mayor under the auspices of the Mexican Instituto Nacional de Antropología

e Historia (INAH), which, following the chance discovery of a sculpture of the goddess Coyolxauhqui (fig. 10) in 1978, carried out archaeological work with an interdisciplinary team consisting of archaeologists, biologists, chemists, historians and physical anthropologists who worked hard over the next five years to understand the Templo Mayor and the Aztecs themselves.

STAGE 1:

CONSTRUCTION OF THE FIRST TEMPLE (1325)
Archaeologists have not reached the site of the first shrine built in Huitzilopochtli's honour. The only information we have lies in historical sources, which say that the god ordered the first temple to be built of wood, reeds and mud. Friar Diego Durán describes how this temple was erected. As his account shows, it must have been very small:

…let us all go, and, in that place where the prickly-pear cactus grows, build a small chapel where our god may now rest; though it cannot be made of stone let it be made of wattle and daub, since that is all we can do for the time being. Then everyone went very willingly to the place where the prickly-pear cactus grew and cutting down thick grasses from the reeds that grew next to the cactus, they built a square base, which was to serve as the foundation of the chapel for the god to rest in; and so they built a poor but pretty little house…covered with the reeds they gathered from the water itself…they were so poor, destitute and fearful that they built even that small mud hut in which to place their god in fear and trepidation.[2]

Recent studies have shown that a solar eclipse, a very significant symbolic event in ancient Mexico, took place in the year 1325 when Tenochtitlan was founded and the first temple was built. Eclipses were thought to be a fight between the sun and the moon from which the sun emerged triumphant. This led to myths which tell of the fight between the powers of day and those of night: one, which we will discuss later because it is closely connected with the Templo Mayor, tells of the fight between Huitzilopochtli (the sun god) and his sister Coyolxauhqui (the moon goddess).

STAGE II (c. 1390)

This stage of construction is associated with the building that has been excavated, whose top portion was found with the shrines to Tlaloc and Huitzilopochtli. The lower part of the temple could not be excavated because it lies below the groundwater level. A calculation of the height of the building reveals that it was around 15 metres high. The two shrines at the top, as well as the two stairways that lead to them, are fairly well preserved. The side dedicated to Huitzilopochtli, god of the sun and war, had its sacrificial stone *in situ* in front of the entrance to the shrine. Beneath it, an offering of sacrificial knives and green beads was discovered. At the far end of the shrine is a bench on which the statue of the god must have stood. At its feet, under the stucco floor, were two funerary urns. One, made of obsidian (offering 34), was found to contain a golden bell and a small silver mask. The few bones that were discovered showed signs of having been burnt. Very close to this urn was another, made of alabaster with an obsidian lid (offering 39). Inside it were burnt bones, a golden bell and two small greenstone discs, in addition to ear ornaments and obsidian discs. Recent studies have shown that the two urns and the cremated bones are related and that, given their placement at the feet of the god, they must have belonged to a high-ranking Aztec. Because of the year to which this stage of construction has been dated, we must assume that the Aztecs were still under the rule of the Tepanecs of Atzcapotzalco and that, therefore, these remains must belong to one of the first three rulers: Acamapichtli, Huitzilihuitl or Chimalpopoca. Everything points to the remains belonging to the last of these, who ruled Tenochtitlan from 1417 to 1427.[3]

Six offerings were found in all on the Huitzilopochtli side, four of them funerary urns. One, a *plumbate* pot (whose clay has a metallic sheen) in the shape of a dog, was produced in the south-eastern regions of Mesoamerica.[4]

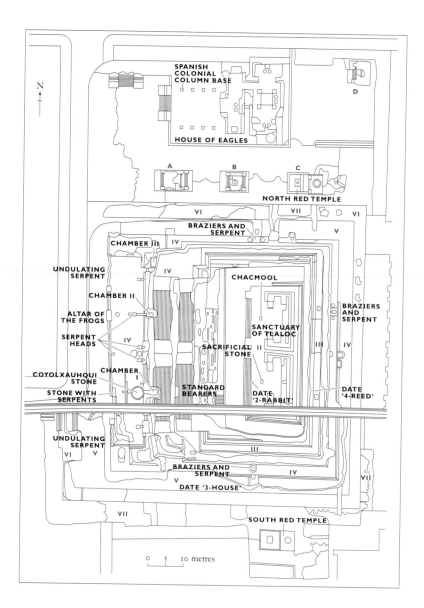

Fig. 40
Plan of the excavations of the Templo Mayor.

Fig. 41
Drawing of the excavated foundations of the Templo Mayor.

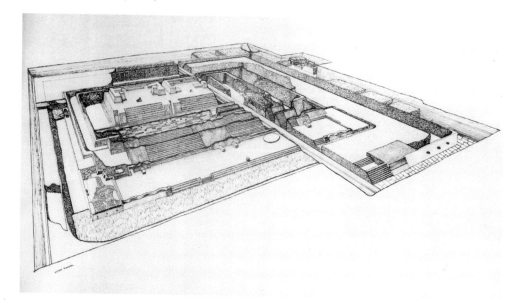

The date of this stage was taken from a glyph found on the highest step, on axis with the sacrificial stone and the place where the statue of the god would have stood. The glyph gives the year '2-rabbit', or 1390.

The Tlaloc side was also found to be in good condition. In front of the entrance to the shrine stands a statue of a *chacmool*, a recumbent figure with a container on its stomach. This has been identified as Tlaloc.[5] The pillars which form the entrance to the shrine still had the remains of painted decoration consisting of black circles resembling eyes with a blue stripe beneath them. Under this stripe were two horizontal red stripes attached to vertical, alternating black-and-white stripes. At the back of each pillar are remnants of painted decorations showing a yellow figure with ornaments on its forearms, walking on a blue line that may represent water. The figure is associated with the gods of maize. There is also a bench at the far end of the chamber, on which the figure of Tlaloc must have stood.

On this side, four offerings were found, three of them inside the shrine. Under the sculpture of the *chacmool*, an offering of 52 green obsidian knives and 41 stone beads of the same colour was discovered. The importance of the number 52 in relation to the Nahua century (see pp. 33–34) is clearly demonstrated.

No marine remains were found in any of the offerings. If our chronology is correct, this need not surprise us, as the Aztecs were under the control of the Tepanecs of Atzcapotzalco during these years, and had not yet begun the expansion that would lead them to dominate part of both coasts.

STAGE III (*c.* 1431)

This stage of construction completely covered Stage II and the various, seemingly unsuccessful, attempts that had been made to build the temple. The date assigned to this stage comes from a '4-reed' carved on a stone set into the rear wall at the base of the temple platform on the side assigned to Huitzilopochtli. If this is a calendrical date it would be equivalent to 1431. The building grew considerably in size, indicating that a large number of workers were already available. Perhaps this reveals that by now Tenochtitlan had taxpayers who were obliged to pay both in kind and in labour. In 1428, under the rule of Itzcoatl (1427–40), the Aztecs freed themselves from the yoke of Atzcapotzalco, creating the Triple Alliance with Tetzcoco and Tlacopan.

Among the most significant finds here were eight sculptures – some life-size – recumbent on

the stairway on the Huitzilopochtli side. I believe these stone figures represent the Huitznahuas, warriors from the south against whom the god of war had to do battle. This opinion is based on the fact that each figure has a cavity in its chest which contains a greenstone, like a heart. Others have their arms crossed over their chests, as if to protect their hearts. Remember that, according to our sources, Huitzilopochtli ate the hearts of the Huitznahuas after the battle. Furthermore, several of the figures have a *yacameztli* or lunar nose-ring in their nostrils, which was associated with the gods of *pulque* (a drink made from fermented cactus sap) and the moon. Recumbent figures were also found on the stairway on the Tlaloc side. One represents a figure with half its body painted black and the other painted red. Another piece found was the body of a stone serpent with a face emerging from the jaws of an animal.

A total of thirteen offerings associated with this stage of construction were found. The remains of marine animals were found in some of them, such as fish bones (offering 8), and the saw of a sawfish and shells (offering 21). This offering, found at the rear of Stage III, on the Tlaloc side, contained a magnificent blue-painted pot with the raised face of the god Tlaloc.

STAGES IV AND IV(A) (*c.* 1454)

These stages are attributed to Motecuhzoma Ilhuicamina, who ruled from 1440 to 1469. The Aztec empire was expanding continuously and this is confirmed by the materials found. The richness of the building is made clear by its symbolic and decorative elements, such as the great braziers and the serpent's heads found towards the centre of the north and south faces and at the back of the temple platform. The braziers on the Huitzilopochtli side, characterised by a bow tied to the front, stood on either side of a serpent's head. Those on the Tlaloc side, in the shape of large pots with the face of the god on the front, still have some of their original painted decoration. The expansion of this stage, referred to as IV(a), did not involve all four sides of the building, but only the main façade. It is characterised by a very large number of offerings and a strong presence of remains of fish, corals, various shells, and a significant quantity of items from the region of Mezcala, in what is now the state of Guerrero, south of Tenochtitlan. Mixtec stone figures known as *penates* occur too, indicating that part of the region of Oaxaca was also ruled by Tenochtitlan. Important among these offerings is that known as Chamber II, situated at the centre of the stairways leading to the Tlaloc shrine, which

contained a large quantity of Mezcala-style masks. In Chamber I, on the Huitzilopochtli side, was found a figure identified as Mayahuel, god of *pulque*, made from a large piece of greenstone that undoubtedly came from the south of Mesoamerica. Another important offering was Chamber III, on the Tlaloc side, which contained two multi-coloured pots with images of Chicomecoatl, the goddess of foodstuffs and sustenance (cat. 284). The remains of feline bones were found between the two pots, in addition to a large quantity of objects and animals from both the coast and the highlands.

STAGE IV(B) (*c.* 1469)

This stage represents a partial extension to the western side of the Templo Mayor which is attributed to Axayacatl, who came to the throne of Tenochtitlan during 1469 and remained in power until 1481. The empire conquered several regions and was defeated only when it tried to overcome the Tarascans of Michoacán. One of the most significant of its conquests was that of the twin city of Tlatelolco in 1473; their neighbours' remarkable commercial success must have made Tlatelolco a tempting prospect for the people of Tenochtitlan.

During this period, the main façade of the Templo Mayor was extended. The architectural remains consist of the main platform on which the temple base sat. This platform has five steps leading up from the ceremonial square, which consists of a paved surface. The stairway has no central division, as can be seen on those leading to the upper part of the temple. It is interrupted only by a small altar, in line with the centre of the Tlaloc side, which is known as the Altar of the Frogs because it is decorated with two of these animals linked to the god of water. On the Huitzilopochtli side, towards the middle of the steps, an enormous sculpture of Coyolxauhqui (fig. 10) was found. Various offerings with rich contents are associated with this goddess, among them two funerary urns, made of orange clay and covered with lids (offerings 10 and 14), which contained the cremated bones of two adult males (cat. 279). Tests carried out on the bones showed that they may have belonged to people involved in military activities, given the clear evidence of musculature on the bones. From the moment of the discovery of these urns it was suggested that they might be those of high-ranking soldiers injured in the war against the people of Michoacán and brought to Tenochtitlan to die, because of

Fig. 42
Shrine B, from Stage VI, is decorated with 240 stucco-covered stone skulls.

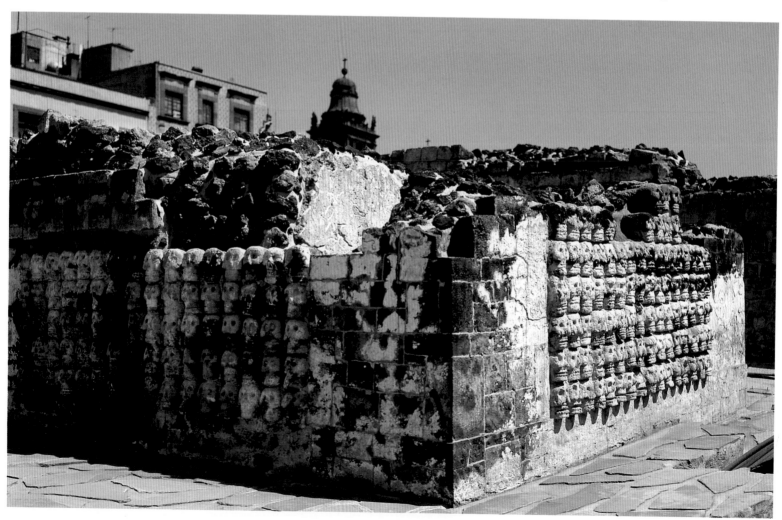

their placement beneath the platform on the side of the temple dedicated to Huitzilopochtli and very close to the sculpture of Coyolxauhqui, a goddess who died in combat. Furthermore, the urns were decorated with two figures of gods armed with spear-throwers and spears. Their location suggests that the urns date from the time when Axayacatl was ruler, as shown by the '3-house' glyph placed south of the Huitzilopochtli side, which gives 1469, the year of this ruler's accession. Under Axayacatl's rule the Aztecs suffered defeat at the hands of the people of Michoacán.

To continue with our description of the main platform, on both sides of the two stairways leading to the shrines of Tlaloc and Huitzilopochtli, the heads of four serpents rest on the platform. The two on the side devoted to the water god differ from those on the side of the war god. In between the two central heads are offerings, two of which stand out from the others because they were placed in stone boxes with lids. Inside each of the offerings were thirteen Mezcala-style figures arranged in a row facing south, in addition to greenstone beads. This is significant because the southward direction of the universe was ruled by the god Huitzilopochtli, who was closely connected to this quadrant because of the movement of the sun.[6]

The north and south ends of the platform have chambers with floors paved with marble. Two enormous serpent bodies meet on the platform, one looking northwards and the other southwards. Between them is a serpent's head. The three snakes still bear some of their original painted decoration.

Interestingly, Stage IV(b) is the stage in which most offerings were found, showing that Tenochtitlan was at the zenith of its success and in full military expansion at this time. The number of tributary towns had increased and the contents of the offerings demonstrated this expansion, both in the types of animal sacrificed and in the objects deposited. The Templo Mayor had increased in size and splendour, reflecting the military might of Tenochtitlan in other regions.

STAGE V (c. 1482)

All that remains of this stage is the part of the main platform upon which the Templo Mayor sat. It retains some of the stucco that covered it. Four offerings were found. This stage may correspond to the government of Tizoc, who ruled Tenochtitlan from 1481 to 1486. This may also be the period during which the building known as the House of Eagles was constructed, north of the Templo Mayor, in which superb clay sculptures

of eagle men (cat. 228) were found as well as sculptures of skeletons and two life-size representations of the god Mictlantecuhtli, lord of the underworld (cat. 233).[7] The building consists of a vestibule area, with pillars supporting the roof, which leads into a rectangular chamber. A short corridor leads to an internal patio with rooms at the north and south ends. The whole complex has stone benches decorated with processions of warriors, still in their original colours (fig. 44). Various studies have been carried out to determine where rituals were carried out. The clay sculptures of eagle men, the skeletons and the gods of the underworld are all associated with war.[8]

STAGE VI (c. 1486)

This stage may be attributable to Ahuizotl, who ruled from 1486 to 1502. The building was extended on all four sides; among the excavated remains is the main platform supporting the temple. This is characterised by decoration on the balustrades of the east-facing stairway, consisting of a moulding made up of three elements. This stage is important because it brought to light various shrines surrounding the Templo Mayor. Each of these will be described in turn.

The Red Temples, the two shrines found on the north and south side of the Templo Mayor respectively, are east-facing and have a vestibule with a circular altar at the centre. The vestibule is made up of two walls that are bordered by two stone hoops painted red. Their stairways face east and the walls are decorated with paint. An offering, containing a considerable number of musical instruments, both real and in the form of small representative sculptures, was found on the upper part of the south side. Among other items discovered were large, painted ceremonial knives. A study carried out on these shrines showed that they were related to the god Macuilxochitl. The Red Temple on the north side was aligned with Shrines A and B, and is also known as Shrine C.

Shrines A and B lie to the north of the Templo Mayor and are aligned with the wall of the main platform, standing on a paved stone floor which forms the floor of the ceremonial square. Shrine A has two stairways, one facing west and the other east. There is no particular decoration on its walls. Shrine B (fig. 42), however, has a west-facing stairway and is decorated on its three remaining walls with 240 stucco-covered stone skulls arranged close together like a *tzompantli* (a wooden rack on which the skulls of sacrificial victims were displayed). This shrine may have indicated the northern sector of the universe, given that this region was related to death, being the territory of

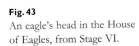

Fig. 43
An eagle's head in the House of Eagles, from Stage VI.

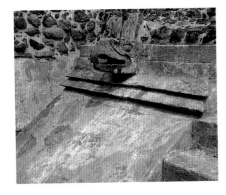

Mictlampa. On the upper part there are offerings, one of which contains felines and objects connected with Tlaloc (fig. 45).

Shrine D is a west-facing building which also lies to the north of the Templo Mayor. It is well preserved and has a recess in the floor of its upper storey, indicating that it once housed a circular sculpture, which was not found during the excavation.

The House of Eagles, with its magnificent clay sculptures of warriors, skeletons and the gods of the underworld, has been mentioned in connection with the previous stage. During Stage VI it was covered by another, similar building. Only the platform was found, on top of which was a colonial-style patio which must have belonged to one of Cortés's captains, an example of a Pre-Hispanic structure being used as the foundations for a house for conquistadors. The platform has a west-facing stairway and is decorated at the ends with bird heads which still have yellow paint on their beaks as well as black-and-white feathers on their heads (fig. 43). To the north it turns a corner and the House of Eagles runs westwards to another stairway.

Recent excavations have uncovered part of the stairway that led to the main platform. It was found to be in good condition and various offerings were discovered on it. These correspond to the next stage of construction.

STAGE VII (c. 1502)

All that remains of this stage is the main platform on which the Templo Mayor stood. Attributed to Motecuhzoma Xocoyotzin (1502–20), this was the stage which the Spaniards saw and razed to the ground in the sixteenth century. By that time, the building was around 82 metres square and is estimated to have been 45 metres high. Destroying this architectural mass, of which only the platform exists, must have presented a formidable challenge to the Spaniards. We have already mentioned the various offerings found in the filling that covered Stage VI and lay beneath Stage VII. Offering 102 was particularly important because it contained pieces of paper made from *amate*-tree bark and well-preserved fabrics which seemed to form part of the garb of a priest who worshipped Tlaloc.

Almost two centuries passed between 1325, the date of Tenochtitlan's supposed foundation, and 1521, the date of the destruction of the Templo Mayor by the Spaniards and their indigenous allies. Having followed the course of the building's development from its beginnings to the grandeur it had attained just before the Spanish

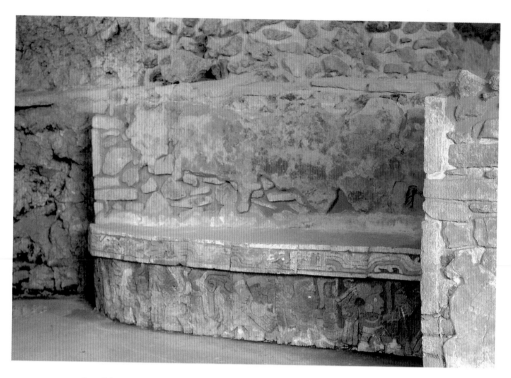

conquest, we should now turn our attention to the symbolism of the Templo Mayor, and to the reasons why it was the most important building in the ceremonial complex.

Fig. 44
The painted benches in the House of Eagles.

THE SYMBOLISM OF THE TEMPLO MAYOR

To begin with, it should be remembered that the Templo Mayor was the very centre of the Aztec universe. According to the cosmovision of the Aztecs and other Mesoamerican peoples, the universe was divided into three levels, of which the central level, the terrestrial zone, was inhabited by man. Above it were 13 planes, or skies, the last being Omeyocan, the place of duality. Below it was the underworld, consisting of nine planes, the deepest of which was Mictlan, inhabited by the couple formed by Mictlantecuhtli and Mictlancihuatl, the discarnate deities who ruled the world of the dead.

Four universal directions coincided with the cardinal points. Each direction was identified by a god, a plant, a bird, a colour and a glyph. The north was the direction of death and cold. It was known as Mictlampa, or the region of death. Its glyph was a sacrificial knife and it was associated with the colours black and yellow. The tree which symbolised it was a xerophyte, a plant native to these regions. It was ruled by the god Tezcatlipoca. The south was the region of dampness; it was identified by the colour blue and ruled by the god Huitzilopochtli. Its glyph was a rabbit, the symbol of fertility and abundance. The east, where the sun rose, was the masculine quadrant of the universe and was the path along which warriors, killed in combat or by sacrifice, travelled to accompany the

sun from dawn until midday. It corresponded to the red Tezcatlipoca or Xipe Totec and was identified by this colour. Its glyph was a reed. The west was the female sector of the universe. Women who had died in childbirth – considered a battle by the Aztecs – accompanied the sun from midday to dusk, when the sun was devoured by the earth (Tlaltecuhtli) and passed through the world of the dead until the earth goddess (Coatlicue) gave birth to it again the next morning in the east. Its colour was white, its glyph was a house and it corresponded to the god Quetzalcoatl.

The centre of this vision of the cosmos was the Templo Mayor, the centre of centres, the most sacred place, the universal *axis mundi*. It was crossed by both the ascendant and descendant forces and from it departed the four directions of the universe, with the result that it contained the forces of each.

As we have seen, the Templo Mayor was split into two parts: one dedicated to the god of war and the other dedicated to the god of water. The Aztecs were extremely concerned to portray these deities, both in the architecture of the building and in the elements that surround it: from the sculptures with serpent's heads to the braziers that adorned the great platform on which stood the four structures that formed the pyramidal platform, to the upper shrines dedicated to Huitzilopochtli and Tlaloc, each painted specific colours (red and black for Huitzilopochtli, blue for Tlaloc) to show that they were two separate entities. Each part corresponded to a hill. The Huitzilopochtli side was Coatepec, the place where Coatlicue, the earth goddess, had given birth to the Aztecs' patron god to fight her enemies. The Tlaloc side was Tonacatepetl, the hill where the grains of maize that the gods give to men were stored. These two entities formed a single unit, the *axis mundi* of the Aztecs' universal conception. Furthermore, ceremonies were performed in them that were dedicated to these gods and recalled the myths associated with each part of the building. The Templo Mayor expressed the ultimate duality, the duality of life and death.

By analysing the temple we can see how the main platform on which it stands corresponds to the terrestrial level. Throughout excavations, this is where most offerings have been found. The presence, on the platform at the foot of the temple-hill, of the sculpture of the goddess Coyolxauhqui, goddess of the moon, against whom the sun god Huitzilopochtli battled, is very significant. In the myth that recounts the story of this battle, the gods fight at the top of Coatepec. Coyolxauhqui is captured by Huitzilopochtli, who beheads her and throws her body over the side of the hill. As it falls, the body is dismembered and ends up at the foot of the hill. This is what the Aztecs intended to reproduce in the Templo Mayor on the Huitzilopochtli side: the victor at the top of the temple-hill and the vanquished goddess, beheaded and dismembered, lying on the ground (the main platform).

The four tiers of the Templo Mayor's pyramidal platform may represent celestial levels. At the top, the two shrines dedicated to each of the gods are the clearest representation of the life and death duality: on one side is the god of the sun and war; on the other is the god of water, fertility and life. This reflects the essential needs of the Aztecs: war as an economic necessity which provided Tenochtitlan with tax from the conquered regions, and the overriding requirement for agricultural produce. Furthermore, each side of the building was identified with the places where people went after death. Warriors who died in battle or sacrifice accompanied the sun along part of its path, and are therefore associated with Huitzilopochtli. People who died in water (as a result of a waterborne disease, drowning or being struck by lightning) had to go to Tlalocan, the place of eternal summer ruled by the god of water. The two sacred hills or mountains represented by the Templo Mayor were one of the first steps one had to take to reach Mictlan, the place to which those who died of all other causes were destined. An old poem speaks of the places where people would go after death:

Oh, where will I go?
Where will I go?
Where is the duality?…Difficult, oh so difficult!
Perhaps everyone's home is there,
where those who no longer have a body live,
inside the sky,
or perhaps the place for those who
no longer have a body is here on earth!
We will all go, all go completely.
No one will remain on the earth!
Who would say: 'Where are our friends?'
Rejoice!

Thus the Templo Mayor was the focal point of the Aztec view of the cosmos: the survival of the Aztec people, the order of the universe and the unimpeded daily progress of heavenly bodies, including the sun, relied on what it represented.

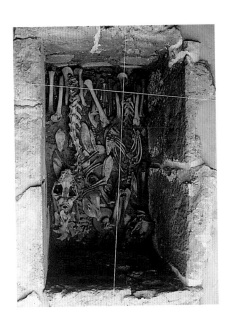

Fig. 45
Offering H, found in the upper part of Shrine B, contained remains of felines and objects associated with Tlaloc.

ART AT THE TIME OF THE AZTECS

Felipe Solís Olguín

*Aztec monumental art reached a pinnacle of splendour
and brought the period of indigenous Pre-Hispanic art to
a dazzling conclusion, not only because of its proportions
and masterly technique, but also, and predominantly,
because of its overwhelming sculptural power, its sense
of melodrama and its masculine and distinctive style.*
Miguel Covarrubias[1]

TOLTECAYOTL

The Toltecs, inhabitants of Tollan (Tula),
were the inspiration behind the Aztecs'
creation of 'prime, polished and striking' works
of art. The name Toltec is the origin of the
Nahuatl descriptive term *tolteca*, or 'prime official
artist', and the root of the word *toltecayotl*, whose
meaning is close to our concept of artistic
sensitivity.[2]

The link between Tula and Tenochtitlan was
established in the initial migration from Aztlan.
The Aztecs describe a period spent among the
abandoned ruins of Tula, the ancestral city
founded by Quetzalcoatl, the man-god or
'plumed serpent'. They gazed in wonder at
pillars shaped like serpents and other material
testimonies of bygone glory, attributing the origin
of *toltecayotl* to Quetzalcoatl.

Following in the footsteps of his teacher
Ángel María Garibay Kintana, Miguel León-
Portilla, a well-known expert on Nahuatl literature
and philosophy, has delved more deeply into
the meaning of *toltecayotl* by studying texts
collected by Friar Bernardino de Sahagún.[3]

His analysis demonstrates the esteem in which
the creators of valuable objects were held in the
Aztec world. Various expressions existed for
artists, such as *yolteotl*, 'god in his heart', to
describe the inspiration which the god gives the
artist; *tlayolteuhuiani*, 'he who puts the deified heart
into objects', to describe the action of introducing
divine breath into the material the artist will work
in; and *moyolnonotzani*, 'he who confers with his
heart', to describe those who feel the divine touch
and shape it into a work of art.[4]

The Franciscan friar's Indian informants
attributed the origin of the manual trades to
the Toltecs, classifying artists according to the
importance of their works: *amantecas*, who
invented the art of feathers; *tlacuiloque*, painter-
scribes specifically dedicated to creating codices;
and the artisans who worked so masterfully with
jade, turquoise and other semi-precious stones
(fig. 46). These were followed by craftsmen:
carpenters, bricklayers, whitewashers, potters,
spinners and weavers. Also defined as *tolteca* were
goldsmiths and silversmiths, whose ingenuity
allowed them to discover the secrets of
metallurgy, and herbalist doctors, who knew the
secrets of plants. The Toltecs were also credited
with the development of the first calendars, the
result of their accurate observations of the stars.[5]

THE CHARACTERISTIC FEATURES OF AZTEC ART

Although the modern Western world accepts the
existence of art for its own sake, it must be

remembered that in Aztec Mesoamerica sculpture could not be disassociated from the ideological concepts, whether religious, economic, political or social, that had characterised the cultural development of the area before the arrival of the Spaniards. For the citizens of Tenochtitlan, and indeed for all the peoples of ancient Mexico, art was a material manifestation of their vision of the universe. Its symbols, its association with real and imaginary nature, and its visual language allowed them to create parallel realities in which the human and the divine expressed the sacred messages associated with the cosmogonic concepts that determined their perception of the world around them. The act of creating images of men, animals, plants and supernatural beings reinforced the magic of the genesis of the universe, in which the destiny of each was established in a primordial pact with the gods. Flora and fauna symbolise the power and strength of the deities, personifying their actions in the cosmos. Supernatural beings display the true function of indigenous sculpture, giving physical form to fears and anxieties and invoking the forces of the unknown by means of symbols that are repeated like prayers and chants.

No surviving original texts attest to the value placed by Aztec society on artistic creations. The only remaining examples that mention the arts, mainly those collected by Sahagún, do so indirectly. Sahagún contrasts a good artist with one who does not do his work properly. One is dedicated, careful and able to achieve perfection; the other is careless and does not apply his skills properly.[6] The end of the reign of the fifth *tlatoani* of Tenochtitlan most clearly demonstrates the Aztec civilisation's appreciation of sculptural work. A native account of this time was recorded by Diego Durán. In his twilight years, Motecuhzoma discussed with his brother Tlacaelel the need to perpetuate his memory in scenes to be carved in the rock of Chapultepec hill. Stone-cutters and quarrymen were ordered to select the most suitable rock surfaces.[7] Motecuhzoma was so pleased with the carving that he rewarded the sculptors with clothes described as 'embroidered cloths' and 'honourable garments'.[8]

Scarce information exists about the worth of artistic works in Pre-Hispanic times. Durán's text states that the means of payment varied according to the recipient. Valuable objects were usually used for this purpose, such as the cotton textiles with painted designs shown in the Codex Magliabechiano (cat. 342), the Matrícula de Tributos (fig. 37) and the Codex Mendoza (cat. 349); jewellery set with semi-precious stones, jade, rock crystal and obsidian; feathered ornaments (figs 47, 51); and cacao beans and powdered gold.

AZTEC ARCHITECTURE AND TOWN-PLANNING

The style of Aztec ritual architecture evolved principally in Tenayuca, where archaeologists discovered substructures from earlier periods beneath a mound of rubble. The site illustrates the genesis of the double pyramid typical of Tenochtitlan, and was the earliest example found in Mesoamerica of this innovative structure, which unites two pyramidal bases supporting a pair of twin temples.[9] This successful architectural formula was adopted by the Aztecs and their neighbours in buildings designed for the worship of their own supreme deities.

The origins of the pyramid of circular plan, such as that used at the Aztec temple of the wind god Ehecatl, can be recognised at Calixtlahuaca in

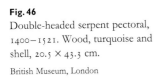

Fig. 46
Double-headed serpent pectoral, 1400–1521. Wood, turquoise and shell, 20.5 × 43.3 cm.

British Museum, London

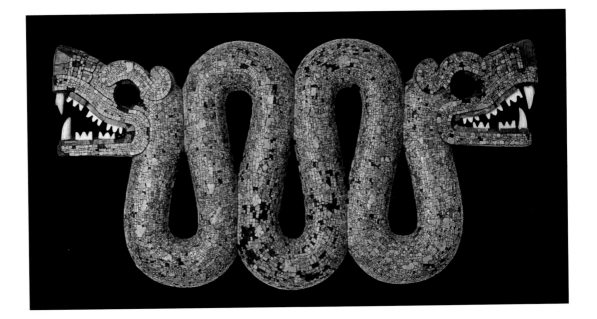

Fig. 47
Feather fan, early sixteenth century.
Quetzal feathers and gold appliqué,
height 119 cm, diameter 68 cm.
Museum für Völkerkunde, Vienna

the Valley of Toluca,[10] although the beginnings
of the form are much older and lie in the distant
Mayan territories, particularly in the Yucatan
Peninsula. Various stages of construction have
been detected at Calixtlahuaca. These recur, with
stylistic variations, in the sacred dwelling of the
god of the wind in the Aztec world, a circular-
based building that combines a rectangular façade
for the access stairway with the curved temple wall
and conical roof. The characteristic Aztec ball-
game courts (fig. 48) must have originated in Tula,
Xochicalco or Teotenango.[11] The architectural
benches in various buildings in Tenochtitlan that
portray processions of richly attired warriors
originated in Chichén Itzá, via Tula.[12]

The steep platform façades and the enormous
temples that dominated Huitzilopochtli's capital
and other cities of the Aztec world, with rooms

built one on top of another serving as storerooms
for vestments, offerings and treasures of the gods,
were all characterised by verticality. Studies of Pre-
Hispanic architecture identify the Late Postclassic
construction period with the so-called
architectural dado, an element which finishes off
the upper part of the balustrades and is used as
the base for ceremonial braziers, and with the
moulding that decorates the uppermost tier of the
platform, whose purpose was to accentuate the
verticality of the structures.[13]

The layout of Tenochtitlan, the island city
whose beauty so impressed the Spanish
conquistadors, is a model of the indigenous view
of the universe, a vision of the cosmos that dates
from the time of the Olmecs. Essentially, it is
a four-sided shape whose diagonals meet at the
very centre of the creation of the gods. The design

appears in pictographical manuscripts such as the Codex Tro-Cortesianus from the Postclassic Mayan period, and the Codex Fejérváry-Mayer (cat. 341), produced by artists in Puebla and Oaxaca states. In both, an illustration shows the four-sided shape, locating the patron gods of the four directions and the one who governs the centre of the universe (fig. 54).[14] An early image of the Aztec capital on the first folio of the Codex Mendoza (cat. 349; of indigenous authorship) tells how the city of Huitzilopochtli was founded. Again this shows the four cardinal divisions corresponding to the main districts. In the central area, where the magnificent Templo Mayor was later to be built, appears the sign awaited by the Aztecs on their sacred migration from Aztlan, an eagle on a prickly-pear cactus (see p. 14).

Tenochtitlan was based on the Aztecs' memories of the city they had left behind. Aztlan, an island city situated in an aquatic environment, probably a lake, was shown on the first pages of the Codex Boturini, known as the Tira de la Peregrinación (fig. 2), a text that chronicles the wanderings of the Aztecs before the foundation of their island capital. The island of Aztlan is pictured as having six houses, which were probably intended to represent the six original divisions of the town. The people of four of these divisions migrated, and two probably decided to stay where they were. Tenochtitlan was divided into four main districts in which the indigenous families lived: Teopan, Moyotlan, Atzacualco and Cuepopan (fig. 4). The central area of the island was occupied by the four-sided Templo Mayor complex, a sacred precinct which contained

numerous buildings associated with religious rites, the largest of which was the great double pyramid. Tenochtitlan was connected to the mainland by three causeways which were centred on the ceremonial precinct. A detailed description of the Aztec capital was made by Hernán Cortés in his second report to the Spanish king Charles I.

Records describe the difficulties encountered by the Aztecs as they struggled to expand their new capital. We have a description of the indigenous city from the later period, when Tenochtitlan was at the height of its splendour. By then the island city covered a wide area which had grown through the creation of *chinampas*, artificial islands that served both as dwellings and as fields for farmers to grow their crops, as depicted in the so-called maguey-paper plan (fig. 71).[15]

THE MONUMENTAL SCULPTURES

The artistic creations that best define the Aztec world are its sculptures, whose style extended throughout the Central Highlands. The gigantic monoliths carved throughout the Late Postclassic period took their inspiration from Teotihuacan and Tula, where huge figures survived, such as the image of the water-goddess or the so-called atlantes (stone columns in human form that supported the roofs of temples; fig. 11).[16]

The colossal scale of the sculptures in Tenochtitlan reinforced the power of the Aztec gods and the strength of the natural elements that were thought to be governed by the creators of the universe. The devotion and the Messianic character of the Aztec people led them to sculpt

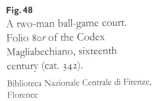

Fig. 48

A two-man ball-game court. Folio 8*or* of the Codex Magliabechiano, sixteenth century (cat. 342).

Biblioteca Nazionale Centrale di Firenze, Florence

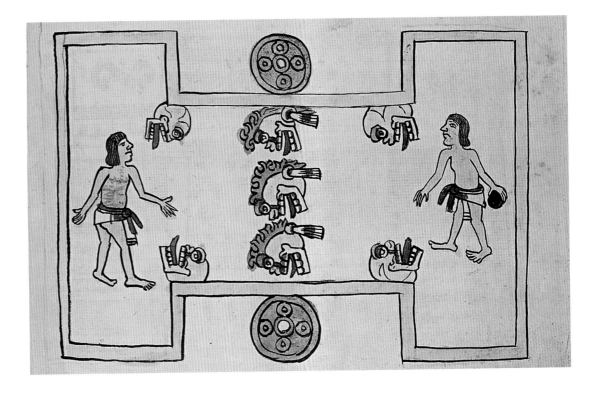

monuments that represented the cosmos and to place themselves at the centre of creation.[17] Conspicuous among these monuments are the great Coatlicue (fig. 9) and Yolotlicue, which represent the earth goddess, sustainer of humanity and source of all life but also ruler of the ultimate destination of the dead. Both carvings show the symbols of life and death united. For its part, the Sun Stone (fig. 5) recounts the sequence of the cosmogonic suns, an eternal cycle of creation and destruction. The sequence speaks eloquently of the Aztecs' concept of time and was indeed the basis of their calendar.[18] The sculptural art of the Late Postclassic period is characterised by date-glyphs which are carved into the reliefs to mark historical and mythological events (fig. 50).[19]

Monuments dedicated to the solar cult that show Aztec military conquests alongside the sun's image were the greatest contribution made by the inhabitants of Tenochtitlan to Mesoamerican art. These monoliths give physical form to the religious ideology of the Aztecs, who followed the instructions of Huitzilopochtli and imposed their military might on the known universe. Indigenous chroniclers tell of the sacred obligation of each *tlatoani* (ruler), from Motecuhzoma Ilhuicamina onwards, to order the carving of these *temalácatl-cuauhxicalli*, which celebrated their military victories and those of their ancestors. The surviving sculptures include one ordered by Motecuhzoma Ilhuicamina (fig. 49), and that of his grandson Tizoc (fig. 6), which was known as the Sacrificial Stone for a long time because it was used in the Tlacaxipehualiztli ceremony, a springtime rite signifying renewal. The Sun Stone mentioned above is another example of this type of monument, but it is incomplete and is thought to have been made around the time of Axayacatl.

Monumental sculptures and those on a smaller scale were displayed during public celebrations in open spaces or on the altars of temples and palaces. Those with a human appearance – deities, priests or the people themselves – represent the inhabitants of the sacred universe created by the gods. Figures of plants and animals, both naturalistic and anthropomorphic, link the world of nature to the cosmic order of creation.

Clay sculptures, covered with plaster and garishly coloured, probably came from the coast of the Gulf of Mexico, where they were popular during Classic times.[20] Discoveries made at the site of the Templo Mayor have brought to light important pieces made of this fragile material, including works with great visual impact, such as the eagle men (cat. 228) and the two statues of Mictlantecuhtli (cat. 233), lord of the dead, that marked the entrances to the House of Eagles.[21]

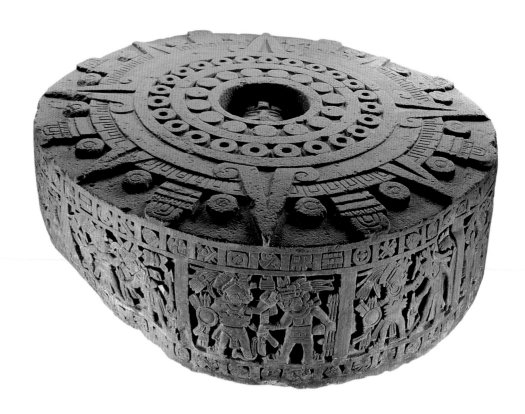

THE MINOR ARTS

Tenochtitlan and its twin city and enemy Tlatelolco have yielded many archaeological objects which demonstrate that many differences in lifestyle existed between the commoners, or *macehualtin*, and the *pipiltin*, the nobility.

Humble peasants lived in individual family huts and had only the essentials: woven mats made from plant fibres, on which they worked, sat and slept, and diminutive images of deities and of temples where they were worshipped, made of clay and intended for family altars. The most abundant objects in their homes were ceramic vessels, mostly large, monochrome pots used to store liquids and grains, and containers used for daily cooking. Distinctive pieces from the Late Postclassic period include jugs, plates and grinding stones called *molcajetes*, which were used to prepare sauces and tend to be decorated with black geometric or naturalistic representations of plants and animals.

Life was very different for members of the Aztec nobility. The Spanish conquerors, who were accommodated with great courtesy by indigenous rulers, described the splendour of their reception with astonishment. Palaces contained vast, porticoed rooms arranged around the four sides of patios, representing the four-sided vision of the Aztec universe. Only one palace precinct of a ceremonial character remains from Tenochtitlan, within the complex of the Templo Mayor. Known as the House of Eagles, it is profusely decorated with wall paintings and sculptures.[22]

Fig. 49
Cuauhxicalli of Motecuhzoma Ilhuicamina, showing scenes of conquest. Late Postclassic. Basalt, height 76 cm, diameter 224 cm.

Museo Nacional de Antropología, Mexico City

Fig. 50

Teocalli of the Sacred War, commemorating the New Fire ceremony of 1507. Late Postclassic. Basalt, 123 × 92 × 99 cm. Date-glyphs appear on either side of the 'stairway' at the lower front.

Museo Nacional de Antropología, Mexico City

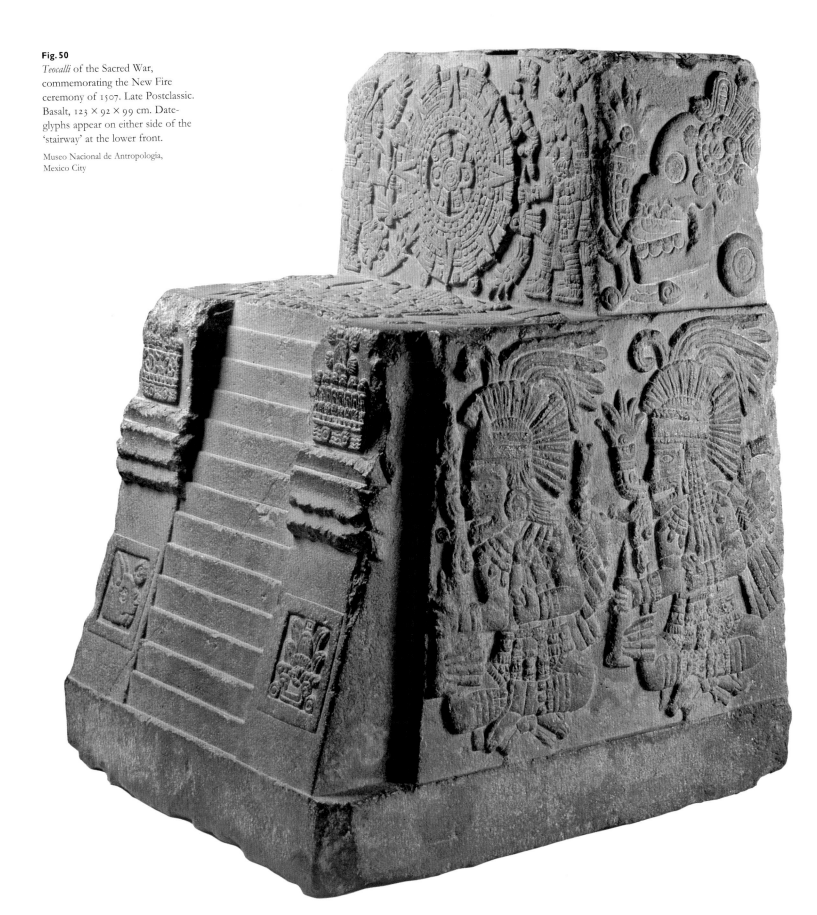

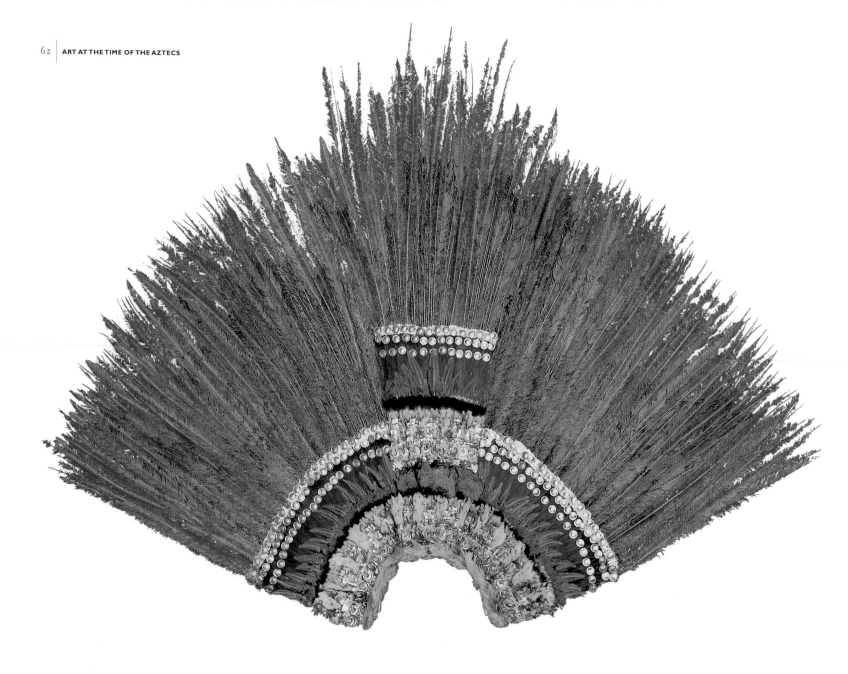

Fig. 51

A large feather headdress of the type worn by Aztec priests representing deities in the early sixteenth century. 450 quetzal feathers, gold appliqué and fibre net, 116 × 175 cm.

Museum für Völkerkunde, Vienna

In order to gauge the dimensions of Aztec palaces, we can compare them with the housing complexes unearthed in Teotihuacan, which must have been similar in many ways, or analyse the details of the palace of Netzahualcoyotl at Tetzcoco, reproduced in the Codex Quinatzin (Bibliothèque Nationale de France, Paris).

For decoration, the austerity of dwellings characterised by plain plastering was softened by murals or stone reliefs of sacred images or geometric motifs, particularly the rhythmic repetition of stepped fretwork known as *xicalcoliuhqui*. There was little furniture, apart from the seats or thrones used exclusively by the ruler. These were made of sculpted wood or woven reeds and covered with jaguar skins. In some areas, benches were placed against the walls. These were variously decorated and used for solemn meetings, such as the performance of specific rites for rulers and deities.

The pottery vessels used for rulers' banquets, which were also used to make sacred offerings and during the burial of high-ranking individuals, came mainly from the workshops of the Tetzcoco region. Highly polished red containers were the most popular during this period. For the purposes of trade, the nobility also ordered garish multicoloured ceramics from Cholula and the Mixtec region of Oaxaca.[23]

Various musical instruments were used on feast days, particularly vertical drums called *huehuetl*, made from tree-trunks and covered with jaguar skin (see cat. 156). Horizontal *teponaxtli* (cats 126, 157–58, 338), xylophones with a double tongue, were decorated with images related to the rites and ceremonies for which they were used. As an accompaniment to the drums and xylophones, the musicians played flutes, whistles and trumpets made from clay or sea shells. Rattles made of clay contained little stones to produce harmonious sounds. A characteristic feature of Aztec feasts was the *omexicahuaztli*, a special notched rasp made of a human femur or animal horn which produced unique musical sounds when scraped with a shell.[24]

Clothing was another expression of differences in lifestyle: commoners were limited to textiles made of cactus fibres, whereas

members of the nobility wore cotton fabrics, dyed in bright colours and decorated with a multitude of naturalistic and geometrical designs, occasionally with feathers, gold or shell plaques and jade beads sewn or woven into them.[25] As well as social rank, clothing distinguished gender in Aztec society. Men covered their genitals with a *máxtlatl*, a long strip of cloth which passed between the legs and around the waist and was then knotted at the front and held by straps. The back and torso were covered by a *tílmatl*, a long cape generally knotted over one shoulder. Women wore a skirt called a *cúeitl*, simply a long piece of cloth wrapped around the body and held in place by a sash. The women of Tenochtitlan traditionally wore the *huipil*, a type of long shirt, while women in other regions of the Central Highlands and on the coast of the Gulf of Mexico wore the *quechquémitl*, a rhomboid cape-type garment that covered the torso, or simply wore nothing on the upper part of their bodies.

The nobility wore *cacli* (sandals) made of animal skins or woven plant fibres, while commoners went barefoot. Only rulers wore the *xicolli*, a type of highly decorated waistcoat, while warriors were identified by a triangular cloth worn like an apron. Like many Mesoamerican civilisations, the Aztecs liked to wear animal skins, particularly those of jaguars, and elaborate ornaments made from vividly coloured feathers. A rare survival is the so-called headdress of Motecuhzoma (fig. 51).[26]

The fabulous riches of the Aztec rulers – masks covered with turquoise mosaics (fig. 52), gold and silver jewellery, and jade and rock-crystal ornaments – complete this vision of art and culture in Tenochtitlan at the time of the European conquest. Objects scattered around collections in Mexico, Europe and the United States stand as silent witnesses to the greatness of the empire that succumbed to the conquest of Hernán Cortés and his army at the beginning of the sixteenth century.

Fig. 52

Mask of Quetzalcoatl, Late Postclassic. Turquoise, mother-of-pearl, jade, shell, 25 × 15 cm.

Museo Nazionale Preistorico-Etnografico 'L. Pigorini', Rome

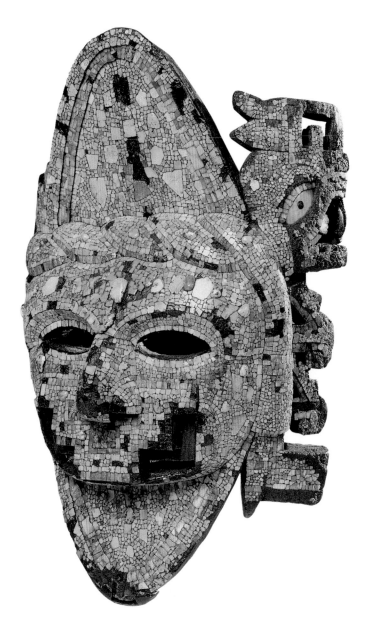

AZTEC CODICES, LITERATURE AND PHILOSOPHY

Miguel León-Portilla

Fig. 53

A representation of the Aztec underworld. Folio *2r* of the Codex Ríos, *c.* 1570–95 (cat. 346).

Biblioteca Apostolica Vaticana, Vatican City

Monuments in stone, mural paintings, codices (books of paintings and glyphs), and the oral tradition of the ancient Mexicans are the conduits through which we can gain an understanding of their religious beliefs, ritual practices, world-view, history, and social, economic and political organisation. Although the Spanish conquest brought about the destruction of much material, some small consolation can be derived from the fact that, as a direct result of it, many new records came into being. Some of these were the fruit of enquiries carried out by missionary friars anxious to find out more about indigenous culture and thus identify the idolatries that they sought to suppress. Others were the product of the diligent efforts of surviving natives who were determined to preserve the memory of their past and the core of their culture. By studying both the surviving material remains, and, with their inevitable shortcomings, the Post-Conquest sources, an appreciation of Aztec codices, literature and philosophy can be pieced together.

Codices are one of the prime sources for the study of Aztec literature and philosophy. Some texts in Nahuatl from the native oral tradition are literary productions; others convey the doubts, reflections and wisdom of philosophers, or *tlamatinime*, 'those who know something'. By correlating these texts with the codices and the results of archaeological findings we can begin to glimpse some of the more refined aspects of the spiritual culture that flourished in ancient Mexico.

CODICES

Much discussion has centred upon the debate about whether at least one Pre-Hispanic Aztec codex survives. Three possible candidates – the Codex Borbonicus (fig. 57), the Matrícula de Tributos (fig. 37) and the Codex Boturini (fig. 2) – exist. Most interesting in the context of this essay is the Codex Borbonicus, which deals with many aspects of Aztec spiritual culture. Even if it is not Pre-Hispanic, it conveys indigenous concepts in accordance with ancient tradition.

Similar Aztec codices with parallel contents were produced after the Conquest. Among these the Ríos (cat. 346) and the Telleriano-Remensis (cat. 348) stand out. They include a *tonalamatl*, a book of the destinies of each day, a presentation of the feasts throughout the solar year, and a historical section which embraces a lengthy time-span. In addition, the Ríos contains a sort of cosmological treatise. Five other codices, which, if not properly Aztec, are certainly closely related to that culture and are Pre-Hispanic in origin, have survived: the Borgia and the Vaticanus B (Biblioteca Apostolica Vaticana, Vatican City), the Cospi (cat. 340), the Laud (Bodleian Library, Oxford) and the Fejérváry-Mayer (cat. 341).

The cosmological ideas of Aztec *tlamatinime* can be studied in depictions such as those on the Aztec Sun Stone (fig. 5) and in the Ríos. The cosmic eras which preceded the present – that of the sun which was brought into being on the day known as Nahui Ollin ('4-movement') – are represented in these.[1] Besides these representations

of cosmic time, images of both horizontal and vertical cosmic space appear in the codices Fejérváry-Mayer and Ríos.

The Ríos depicts the thirteen planes of the heavens, the surface of the earth and the nine planes of the underworld (fig. 53).[2] In the uppermost plane, Ometeotl, the supreme god of duality, presides over the world. In a parallel role, Xiuhtecuhtli, god of fire and time, is represented at the centre of the horizontal image of the universe. A text in Nahuatl, which belongs to a *huehuehtlahtolli*, or 'ancient word', obtained by Friar Bernardino de Sahagún from Aztec elders, tells us that Xiuhtecuhtli is none other than the father and mother of the gods, the ultimate He-She, the dual-god Ometeotl, who resides in the navel of the earth.[3] Aztec beliefs concerning the afterlife are depicted in the nine planes of the underworld. Texts in Nahuatl, testimonies of the ancient oral tradition, explain in detail the fate that awaits those going to Mictlan, the region of the dead.[4]

On the first page of the Codex Fejérváry-Mayer (fig. 54) we see a horizontal image of the world, with the five great cosmic sections: east, north, west, south and centre. Each has its own colour, gods, cosmic bird and tree.[5] As if to confirm the idea that Mesoamericans were deeply concerned with knowing their destinies, both collective and individual, two counts of the destinies of each day (*tonalpohualli*) appear in the same image of horizontal cosmic space, permeating everything that exists. Time is a recurrent theme in both literary and philosophical texts.

Several Aztec codices of the type known as *xiuhamatl*, or 'papers of the years' (among them the Codex Azcatitlan [cat. 355], the Codex Mexicanus [Bibliothèque Nationale de France, Paris] and the Codex Aubin [cat. 354]), record happenings, many of which were considered manifestations of the *tonalli*, or destinies, of individuals and peoples in general. Some expressions of the oral tradition in Nahuatl are commentaries on the scenes depicted in the paintings. A dramatic example of this occurs in the Florentine Codex (cat. 344), in which anguished words concerning the omens which anticipated the arrival of the Spaniards were recorded by the assistants of Friar Bernardino de Sahagún.

LITERATURE

The survival of ancient indigenous Aztec literature is due to the process of collaboration that took place between Spanish friars and native Americans. Sometimes working together and sometimes independently, they drew on the oral tradition and

Fig. 54

The Aztec world-view. Page 1
of the Codex Fejérváry-Mayer,
before 1521 (cat. 341).

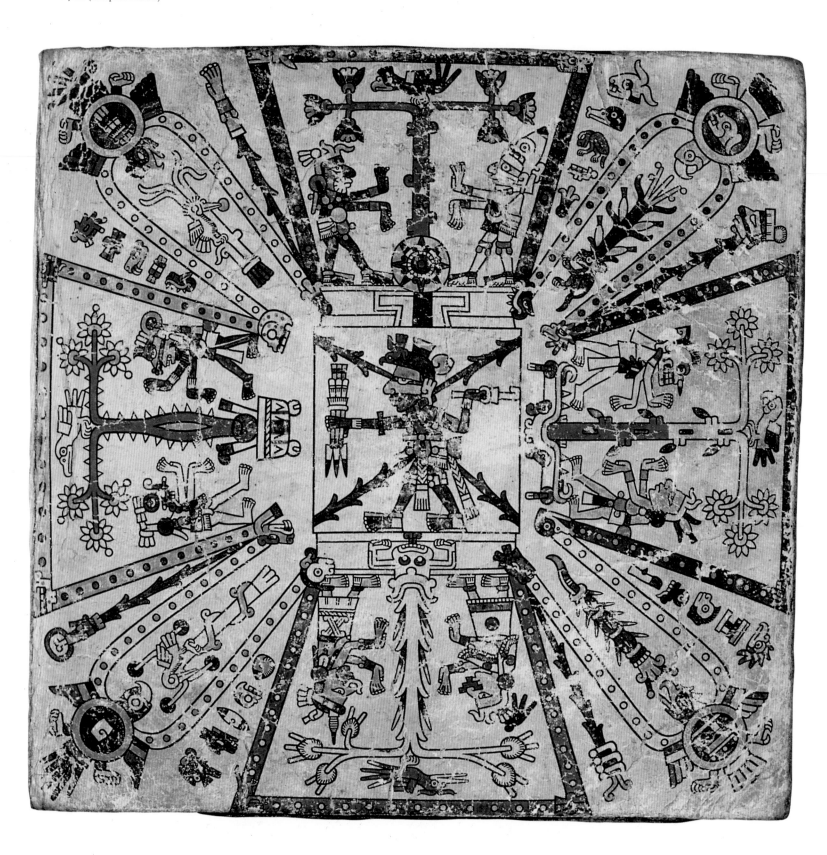

the contents of books of paintings and characters as their ultimate sources. The native elders agreed, after lengthy deliberations, to communicate to the friars what they knew of their past and culture, and showed them codices made of *amate*-tree bark, deerskin or cotton, with the proviso that these were to remain in their possession. Following the contents of the codices, as they did in their *calmecac* (priestly schools), the elders recited commentaries on the meanings of paintings and glyphs. Young Aztecs who had mastered the European alphabet transcribed the elders' commentaries or readings. As early as 1531, Friar Andrés de Olmos was assisted by native elders knowledgeable about their antiquities and young scribes who had been their disciples; Friar Bernardino de Sahagún received the same assistance from 1545 to 1565.

Similar procedures were also followed, but independently, by surviving elders and sages interested in the preservation of their culture. An example of this is the alphabetic transcript of the Nahuatl text known as the 'Legend of the Suns', an account of the cosmogonies and other portentous happenings related to the Aztec past. In the 'Legend', written in 1558, the presence of phrases such as 'here is', 'here we see' and 'this follows' indicates that the scribe had a codex before him from which text was being extracted.[6]

Although the Aztecs had not developed an alphabetic form of writing, some of their compositions, drawing on both oral traditions and manuscript codices, are true works of literature. In these compositions, as in other cultural productions, the inspiration of the *toltecayotl* – summing up the great achievement of the Toltecs under the wise guidance of the culture-hero Quetzalcoatl – is manifest, and these works show great dexterity. Such is the case with Aztec temples and palaces, paintings, sculptures and all sorts of jewels. Archaeology gives ample testimony to this. The uncovered remains of mural paintings and fine sculptures in stone and clay from the Aztec Templo Mayor in Tenochtitlan reveal something of its former splendour. For their part, the pages of the Codex Borbonicus and other indigenous manuscripts speak eloquently of the adroitness of the *tlacuiloque* (painter-scribes) who produced them. The same can be said about their literature. Extant compositions in the Nahuatl language compare very favourably with those preserved from Classic cultures of antiquity, as a few examples with a commentary will demonstrate.

Sacred hymns, epic and lyric poetry, chronicles, history and other forms of prose are the main genres. Hymns are known to have been intoned in honour of the gods at great religious ceremonies. Some were in the form of entreaty to Tlaloc, the god of rain; Centeotl and Chicomecoatl, gods of maize; Huitzilopochtli, a solar deity and god of war; and to several goddesses. This is the hymn to Huitzilopochtli, the patron god of the Aztecs:

Huitzilopochtli, the young warrior,
he who acts above, moving along his way.

'Not in vain did I take the raiment of yellow plumage,
for it is I who makes the sun appear.'

Portentous one, who inhabits the region of clouds,
you have but one foot!
Inhabiter of the cold region of wings,
you have opened your hand!

Near the wall of the region that burns,
feathers come forth.
The Sun spreads out,
there is a war cry.
My god is called Protector of Men.
Oh, now he advances, comes well adorned with paper,
he who inhabits the region that burns,
in the dust, in the dust, he gyrates.

Our enemies are those of Amantla;
come adhere to us!
War is made with combat,
come adhere to us!

Our enemies are those of Pipiltlan:
come adhere to us!
War is made with combat,
come adhere to us![7]

The hymn to the young warrior was probably intoned in the form of a dialogue. A singer begins by referring to Huitzilopochtli, the sun which follows its path in the heavens. The god answers in the voice of a chorus saying that he is the one who has made the sun appear. Again, the singer exalts the magnificence of the one who inhabits the clouds. The last part, again chanted by the chorus, praises the god and ends with warlike exclamations. Stylistically, repeated phrases and numerous metaphors enhance the hymn's effect.

Examples of epic poetry can be identified in compositions that recall the beginnings and violent destructions of the cosmic eras; the cycle of the culture-hero Quetzalcoatl; and the birth of Huitzilopochtli. Poems of great force, they bring forth key concepts of the Aztec world-view. In the one which deals with Huitzilopochtli's birth, the key was found to the meaning of the great bas-relief unearthed in the Templo Mayor (fig. 10). The goddess Coyolxauhqui, Huitzilopochtli's sister, was beheaded by him; her body, as the poem tells, fell to the bottom of the Snake Mountain which much later was transformed into the Templo Mayor.

Lyric poetry, intoned at feasts with music and dance, is the best-preserved literary genre. Among its most common stylistic characteristics, the repetition of ideas and expression of sentiments stand out. A frequently appearing device consists of uniting two words which complement each other, either because they are synonyms or because they metaphorically evoke a third idea: 'flower and song' mean poetry, art and symbolism; 'arrow and shield' stand for war; 'seat and mat' suggest authority and power; and 'skirt and blouse' evoke woman in her sexual aspect.

Lyric compositions embraced a number of subgenres known as *xochicuicatl*, flowery chants; *xopancuicatl*, songs of springtime; *yaocuicatl*, songs of war; and *icnocuicatl*, songs of orphanhood and vehicles for philosophical reflection. The following is an example of a *xochicuicatl*:

At last my heart knows it,
I hear a song.
I contemplate a flower,
would they will not wither! [8]

A *xopancuicatl*, a song of the springtime composed by Tecayehuatzin, ruler of Huexotzingo by the end of the fifteenth century, exalts above all the value of friendship on earth:

Now, oh, friends,
listen to the words of a dream,
each spring brings us life,
the golden corn refreshes us,
the pink corn becomes a necklace.
At last we know,
the hearts of our friends are true! [9]

Songs of war, *yaocuicatl*, abound, confirming the belligerent inclinations of the Aztec nation:

Do not fear, my heart!
In the midst of the plain
my heart craves death
by the obsidian edge.
Only this my heart craves:
death in war. [10]

Examples of *icnocuicatl*, songs of orphanhood, appear below in a discussion of Aztec philosophy.

Chronicles, historical accounts and legends also make up a part of ancient Mexican literature. Most of these compositions have a parallel in the *xiuhamatl*, 'books of years' or pictoglyphic annals. Numerous examples exist of this genre. Among them the Historia Tolteca-Chichimeca (cat. 345), accompanied by some paintings and glyphs, stands out. Covering a long period, this book describes

Fig. 55

An *icnocuicatl*, or poem of orphanhood. Folio 35r of the Cantares Mexicanos, transcribed in the sixteenth century.

From a facsimile edition, 1994, published by the Universidad Nacional Autónoma de México, Mexico City

the events that followed the collapse of the Toltec metropolis until several decades after the arrival of the Spaniards. [11]

Other manuscripts of historical interest include the Annals of Cuauhtitlan and those of the cities of Tlatelolco, Tecamachalco, Puebla-Tlaxcala and Quecholac. The Codex Aubin, for its part, was produced by a painter-scribe who placed images next to one another, accompanied by the glyphs of the corresponding years and an explanatory text in Nahuatl. In most of these manuscripts, accounts exist of how the Aztecs viewed the Spanish invasion of their land, and the drama of the conquest. Particular mention should be made of the Nahuatl texts of the Florentine Codex and of the Codex Tlatelolco (Museo Nacional de Antropología, Mexico City), which give extensive accounts from the viewpoint of the vanquished.

The existence of *xiuhamatl*, such as the Codex Azcatitlan (cat. 355), the Codex Tlatelolco, the Codex Mexicanus and others, permits an approach to the way in which books of years were conceived and produced. All in all, notwithstanding the losses that followed the conquest, surviving Aztec historical manuscripts represent a rich corpus.

Other texts in prose, such as *huehuehtlahtolli*, testimonies of the ancient word, exist. Expressed in the form of discourses and long prayers, these cover a variety of subjects. Friar Bernardino de Sahagún transcribed forty, describing their contents as compositions in which the Aztecs 'displayed their rhetoric and moral philosophy'. [12] We will turn our attention to these next.

PHILOSOPHY

Some scholars maintain that to speak of an Aztec philosophy is to exaggerate greatly. Nevertheless, texts related to the problems of human life do exist, and they reveal a restlessness of spirit. It is true that such texts were transcribed after the Conquest, but independent native sources exist which concur with them.

Some collections of poems, songs and discourses in Nahuatl have been preserved. Strange as it may appear to modern people used to encountering philosophy as a solitary exposition in written form, the questions, doubts and assertions of *tlamatinime* regarding humanity, the world and the gods were often expressed in public ceremonies in a sort of open-air philosophical discourse. Examples of this are provided by several *icnocuicatl* and the *huehuehtlahtolli* (fig. 56). A relation can be perceived in them with the contents of some *tonalamatl*, which display a concern for human destiny (fig. 57).

Netzahualcoyotl (1402–72; fig. 35), a famous poet and sage, expressed a keen awareness of the change and destruction wrought by time. The Nahuatl word for time is *cahuitl*, 'that which leaves us'. Everything on earth appears and in a brief while disappears:

I, Netzahualcoyotl, ask this:
is it true that one lives on the earth?
What is it that has roots here?
Not forever on earth,
only a brief while here.
Although it were jade,
it will be broken;
although it were turquoise,
it will be shattered
as if it were just quetzal feathers.
Not forever on earth,
only a brief while here.[13]

The assertion about the evanescence of all things terrestrial is repeated many times in the texts. As we have seen, expressions of this concern were often heard at feasts. There, *icnocuicatl* (fig. 55), songs of orphanhood, were intoned in the open air, accompanied by the music of flutes and drums:

One day we must go,
one night we will descend
into the region of mystery.
Here we only come to know ourselves;
only in passing are we on earth.[14]

As if to compensate for the sadness that the idea of our inescapable end provokes, the song continues with an invitation that would touch the hearts of participants in the feast:

Let us spend our lives
in peace and pleasure.
Come, let us enjoy ourselves!
This is not for us, wrath,
the earth is vast indeed!
Would that one could live forever,
that we were not to die![15]

Again, mention should be made of the *tonalpohualli*, the count of the destinies of each day.

Fig. 56
A *huehuehtlahtolli* in which an Aztec father admonishes his sons and daughters. Vol. 2, folio 73*r*, of the Florentine Codex, 1575–77 (cat. 344).

Biblioteca Medicea Laurenziana, Florence

Sages believed that it was a means, if not to escape transience and death, at least to foresee and interpret the destinies built into all the segments of time. Although the *tonalpohualli* could not allay fears and anxieties about the human condition, it afforded the possibility of divining the most suitable response to the complex omens, good or bad, converging at given moments and places in the world. We should recall at this point the horizontal image of the world in the Codex Fejérváry-Mayer (fig. 54) where the development of two counts of the destinies of each day permeates whatever exists in the four quadrants and the centre of the earth.

The author of a *huehuehtlahtolli* puts these words into the mouth of an Aztec father addressing his daughter about her destiny on earth:

Here you are, my little girl, my necklace of precious stones, my plumage. You are my blood, my colour, my image [...] Here on earth is the place of much wailing, the place where our strength is worn out, where we are well-acquainted with bitterness and discouragement. A wind blows, sharp as obsidian it slides over us. They say that we are burned by the force of the sun and wind. This in the place where one almost perishes of thirst and hunger. This is the way here on earth [...]

But the elders have also said: 'So that we should not go always moaning, that we should not be filled with sadness, the one who is near and close has given us laughter, sleep, food, our strength and fortitude and also the act by which we propagate.'

All this sweetens life on earth so that we are not always moaning. But even though it be like this, though it be true that there is only suffering, and this were the way things are on earth, even so, should we always be afraid? Should we always be fearful? Must we live weeping?[16]

These courageous words recognise that not only the awareness of transience and death afflicts human beings but also that life itself, with its 'bitterness' and 'much wailing', is a challenge. Besides expressions like these, some texts reflect the doubts of the sages on other crucial subjects. One text questions the truth of anything seen or spoken on earth. Addressing himself to the supreme dual god Ometeotl, also known as Ipalnemohuani, the 'giver of life', and Tloque Nahuaque, 'the one who is near and close', a sage asks:

Do we speak true words here, giver of life? We merely dream, we only rise from a dream. All is like a dream. No one speaks here of truth.[17]

Singing at a feast, a dancer intones the deep reflection of a sage:

Does man possess any truth? If not, our song is no longer true. Is anything stable and lasting? What reaches its aim?[18]

In a social and political context in which religious beliefs were firmly established, we might not expect utterances of doubt about the ultimate realities. Nevertheless there were questions along these lines: if Ometeotl really exists, how is it possible to speak the truth about him? Is it possible to discover a path to approach him?

Where shall I go? Oh, where shall I go? The path of the god of duality Is your home in the place of the dead? In the interior of the heavens? Or only here on earth is the abode of the dead?[19]

Questions like these, which imply some distrust of established beliefs, resemble those put forward at different times and places by persons known as philosophers. In ancient Mexico those who posed them were called *tlamatinime*, 'those who know something'.

Fig. 57
Page 4 of the Codex Borbonicus, a page from the *tonalamatl*, depicting the water-goddess Chalchiuhtlicue, sixteenth century.

Bibliothèque de l'Assemblée Nationale Française, Paris

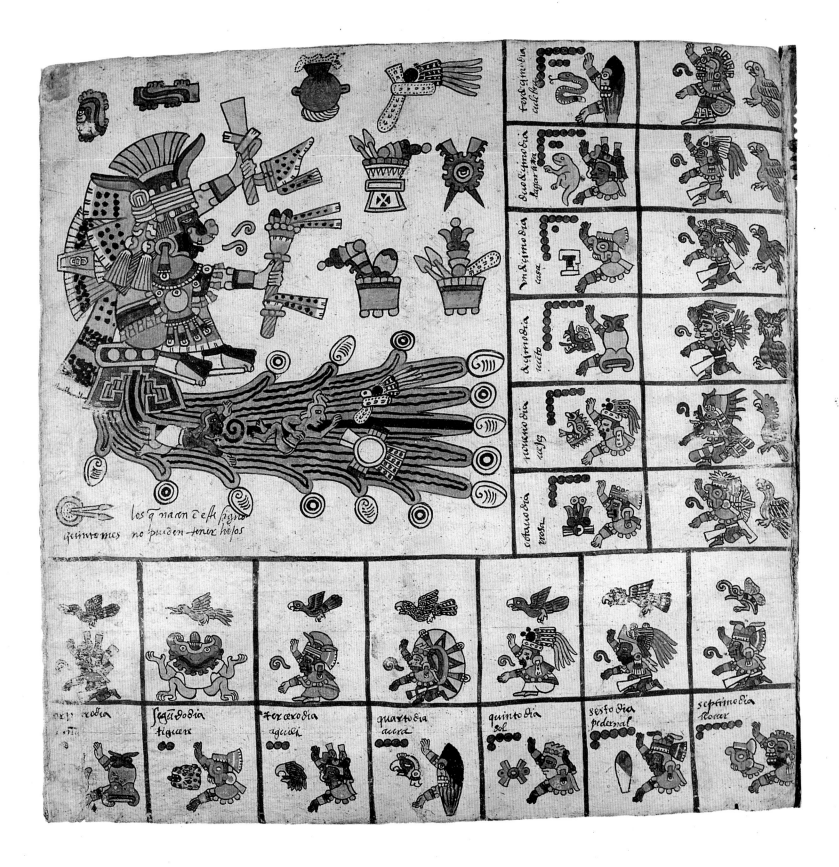

los q̃ nacen deste sigño
quintoneus no pueden tener hijos

texcçimo dia cuelebra

duodecimo dia lagartija

un decimo dia casa

decimo dia uento

nueveno dia casa

octavo dia llouia

orto dia
unia

segundo dia tiguere

tercero dia aguila

quarto dia aura

quinto dia sol

sesto dia pedernal

septimo dia llouia

THE CONQUEST

Hugh Thomas

In 1500 the empire of the Aztecs, or, as we are learning to call them, the Mexica, constituted the paramount power in what is now known as Mesoamerica.[1] Their beautiful capital, Tenochtitlan, dominated the Basin of Mexico. True, to the west, the monarchs of Michoacán had, because of their use of copper weapons, been able to put a rude end to the Mexica's expansion. In the temperate land to the east of the volcano Popocatepetl, the city-state of Tlaxcala was an enclave whose inhabitants the rulers of Tenochtitlan alternately teased and fought. In the east and the south, the declining Maya principalities, like several polities in central America, remained independent but traded with the Mexica. The Mexica held sway over a large number of tributaries, whose contributions were skilfully and interestingly recorded for the Spanish in the Codex Mendoza (cat. 349).

The Mexica believed, as their ruler Motecuhzoma Xocoyotzin (in the past often Europeanised as 'Montezuma') is reported to have said, that they were the 'masters of the world'.[2] But they did not concern themselves much with what lay beyond the wild tribes whom they called the Chichimeca in the north, and the Maya in the south, although their merchants certainly knew that beyond the Chichimeca turquoise could be obtained for use in mosaic such as that so wonderfully represented in the Mexican room at the British Museum, London. South of the Maya lived peoples who traded in jade and, further on,

in emeralds and gold, which some of the Mexica's tributaries learned to work with incomparable skill. From both north and south, too, slaves were obtained by the rulers of Tenochtitlan.

Equally, the Mexica had no interest in what happened beyond the Eastern Sea, which we now think of as the Gulf of Mexico, though legend told that the intellectual and reforming god Quetzalcoatl (fig. 58) had vanished there. Cuba is only 125 miles from Yucatan, but the currents between the two are strong. Some believe that the long, Mexican-style drums found in Cuba derive from some kind of commerce with Mexico, but it is more likely that their presence can be explained by a canoe shipwreck. Later there were rumours in Cuba of trading connections with the 'north-west', but these did not amount to much. On the other hand, the Western Sea, or the Southern Sea (as the Spaniards at first called the Pacific), seemed to the Mexica to mark the end of the world.

From about 1500 onwards, strange rumours came to Tenochtitlan from the east. In 1502, for example, some indigenous merchants, perhaps Jicaques or Payas, met Columbus, then on his fourth voyage, somewhere off the islands now called the Bay Islands in the Gulf of Honduras; and presumably descriptions of bearded Europeans were carried back to the Maya authorities as they were to the ruler of the Mexica in Tenochtitlan. Columbus is said to have thought that he had discovered a 'land called Maya'.[3] Then, in 1508, two master sailors from Seville, Vicente

Fig. 58

The god Quetzalcoatl in human–animal form, probably fifteenth century. Red porphyry, 44 × 25 × 23 cm.

Musée du Louvre, Paris

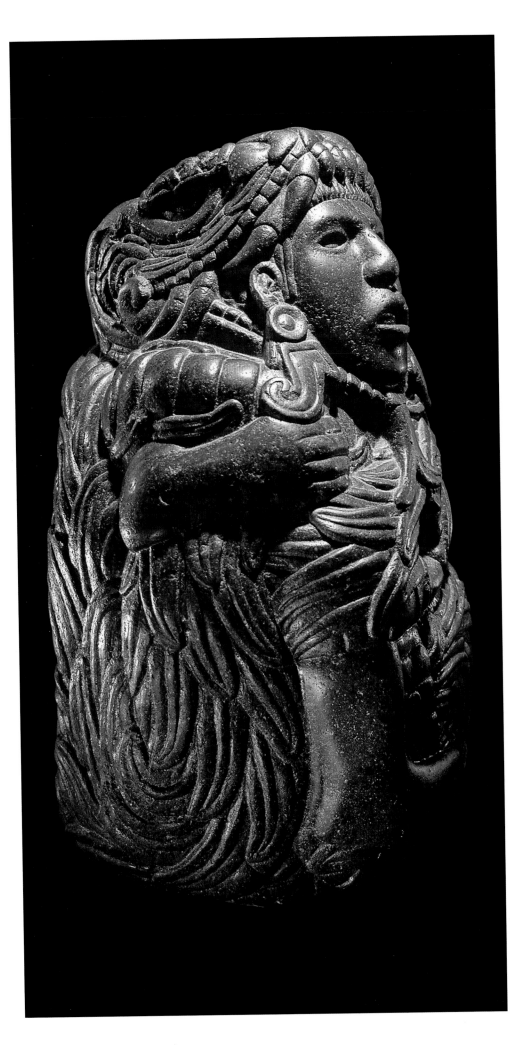

Yáñez Pinzón, who had been captain of the carabel *Pinta* on Columbus's first voyage, and Juan Díaz de Solís, who was later to discover the River Plate, seem to have made landfall in Yucatan. They found nothing interesting, but possibly their journey led to the depiction by a Mexican merchant about that time of what looked like three temples floating in the sea on large canoes. The sketch was sent up to Tenochtitlan, where Motecuhzoma consulted both advisers and priests.[4] A little later a trunk was washed up on the Gulf of Mexico near Xicallanco, a Mexica trading outpost near what is now Campeche. Inside were several suits of European clothes, some jewels and a sword. No one there had ever seen such things before. Whose possessions were these? Motecuhzoma is said to have divided the trunk's contents with his cousins the kings of Tetzcoco and Tacuba.

A Spanish settlement was established in 1510 at Darién in Panama, at first directed by Vasco Núñez de Balboa, the first European to see the Pacific, and afterwards by Pedrarias Dávila. Darién was the first Spanish colony in the mainland of the New World. The conquistadors' brutalities under the leadership of Pedrarias would have made it likely that some rumour of what was happening reached the Mexica. Indeed, a magician in Tenochtitlan, later known to the Spaniards as Martín Ocelotl, predicted the arrival of 'men with beards coming to this land'.[5]

In 1511 Diego de Nicuesa, a merchant-explorer sailing from Darién to Santo Domingo, was wrecked off Yucatan. Several Spanish sailors survived, and two of these, Gonzalo Guerrero and Jerónimo de Aguilar, were for some years Maya prisoners, the former openly siding with his captors (the latter would later be a useful interpreter to Hernán Cortés).

Another Spanish landing probably took place in 1513, when Juan Ponce de León stopped in Yucatan on his return from an unsuccessful journey to Florida on a quest to find the Fountain of Eternal Youth. Several Maya texts seem to speak of that landing.[6] In 1515 another curious contact between Spain and the Mesoamerican world occurred: a judge named Corrales in the Spanish colony in Darién reported that he had met a 'refugee from the interior provinces of the West'. This man had observed the judge reading a document and asked, 'You too have books? You also understand the signs by which you talk to the absent?'.[7] Although Mexican painted books were very different to their European counterparts they had the same purpose.

The last years of old Mexico were full of legends and stories of comets, predictions and

strange visions. But more tangible signs of the ever-closer Spanish presence were evident. In 1518 a labourer apparently came to the court of Motecuhzoma with no thumbs, no ears and no toes: all had been cut off as punishment for some unrecorded crime.[8] He said that he had seen a 'range of mountains, or some big hills, floating in the sea'. Motecuhzoma imprisoned the man but sent some trusted advisers to the coast to find out what was happening (fig. 59). The advisers reported:

It is true that there have come to the shore I do not know what kind of people; there were mountains on the waves and a number of men came from them towards the coast. Some of them were fishing with rods, others with a net. They were fishing in a small boat. Then they got back into a canoe and went back to the thing on the sea with two towers and went into it. There must have been about fifteen of them, some with red bags, some blue, others grey and green [...] And some of them had green handkerchiefs on their heads and others scarlet hats, some of which were very big and round, in the style of little frying pans, against the sun. The skins of these people are very white, much more so than our skins are. All of them have long beards and hair down to their ears.[9]

These new people were not from the expedition of Cortés. They had come in 1518 from the Spanish island of Cuba in a flotilla of four ships under the leadership of the Governor's nephew, Juan de Grijalva. The long calvary of the Mexica at the hands of the Spaniards was about to begin (fig. 60).

THE SPANISH EXPEDITIONS

Grijalva's was actually the second Spanish expedition to the territory now known as Mexico. The first had taken place a year before, in 1517, and its three ships had been led by Francisco Hernández de Córdoba, who, with a little more than a hundred men, had been looking for Indians to kidnap and take back to Cuba as slaves. Hernández de Córdoba sailed first to the Isla de Mujeres, off what is now Cancún, and afterwards up the coast. Many friendly contacts were made between Spaniards and Indians, but, in the end, Hernández de Córdoba had to abandon his endeavours, after a battle with the Maya near what is now Champotón. He left for home mortally wounded, although his small force of arquebusiers made some impression on the indigenous people, who now smelled gunpowder for the first time. Hernández de Córdoba took some of their well-worked little gold objects, small discs of silver and clay figurines home with him. The Spaniards noted the Indians' cotton clothing and sandals of dried deerskin, their stone pyramids and temples, their drums and reed flutes, and signs of an agriculture which, in most ways, was superior to anything that they had encountered in the Caribbean. They found the birds of the forests of Yucatan amazing. They also encountered signs of human

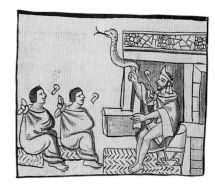

Fig. 59
Motecuhzoma Xocoyotzin listens to a description of the Spaniards. Vol. 3, folio 418*v*, of the Florentine Codex, 1575–77 (cat. 344).

Biblioteca Medicea Laurenziana, Florence

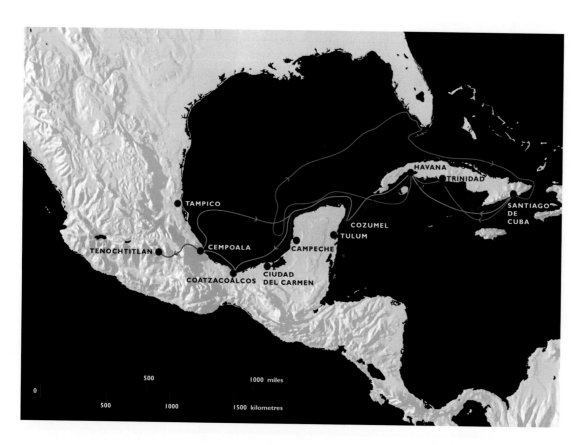

Fig. 60
Map of the routes followed by the expeditions of Francisco Hernández de Córdoba (1517, shown in green), Juan de Grijalva (1518, shown in blue) and Hernán Cortés (1518–19, shown in red).

NOTE: Until *c*.1525 Havana was on the southern coast of Cuba

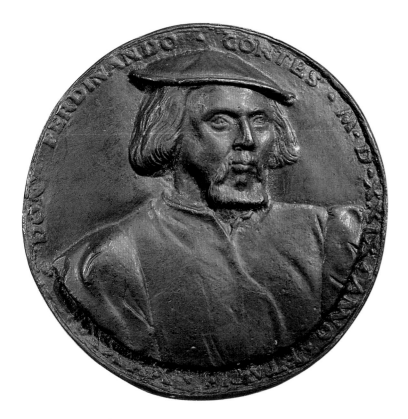

Fig. 61

The obverse and reverse of Christoph Weiditz's medal of Hernán Cortés, 1529. Lead, diameter 4.5 cm.

British Museum, London

sacrifice on a small scale. 'Better lands have never been discovered,' wrote one of the expedition, Bernal Díaz del Castillo.[10]

In 1518 Grijalva had a larger force with him, in four ships, and also took some artillery, probably culverins, capable of firing twenty-pound cannon balls about four hundred yards. He had arquebusiers, crossbowmen and a few fighting dogs, probably mastiffs, but no horses. He landed at Cozumel, an island a little to the south of the Isla de Mujeres but in the same region, before turning west and reaching the site of what would become Veracruz and eventually that of Tuxpan. Then he went back and sailed down the coast as far as Yucatan, returning to Cuba via the Yucatan channel. One of his captains, Pedro de Alvarado, had gone back to Cuba ahead of his leader, taking with him some gold that Grijalva had been given, including a golden breastplate and mask.

The noise of Grijalva's artillery had a great effect on the Indians, and so did its effectiveness in destroying objects at a distance; its inaccuracy seemed less important. The Spaniards were this time much impressed by the level of craftsmanship that they encountered, and discovered that the Indians of these territories had fermented alcohol (unlike those of the Caribbean). They probably took back a sense that the tributary Indians, such as the Totonacs, who lived near what was to become Veracruz, were so hostile to the imperial power of the Mexica that they might even become allies of Spain. But the detailed evidence of human

sacrifice that they encountered at the island of Ulúa, off what is now Veracruz, distressed everyone on the expedition.

The third Spanish expedition to what is now Mexico was that of Cortés (fig. 61). Then in his late thirties, having been born about 1481 in the city of Medellín in Extremadura, he had first gone to the Indies in 1506. His was a more formidable undertaking than those of his predecessors, for he took with him twenty ships and nearly six hundred men, including sailors. Like Hernández de Córdoba, he had arquebusiers; like Grijalva, he had artillery; but, unlike both of them, he also had horses,[11] animals never before seen by the Indians (fig. 62). Accompanying him were a priest, Juan Díaz, and a Mercedarian friar, Bartolomé Olmedo. About twenty women seem to have been with Cortés, more as nurses and even fighters than as mistresses. Cortés's instructions included the command to settle (*poblar*) the lands discovered by Grijalva, to preach Christianity, to map the coastline from Yucatan to the north (and by implication to discover whether there was a strait to the Pacific) and wherever he landed to take possession of territory in the name of the Spanish monarchs Charles I (the Holy Roman Emperor Charles V) and his mother Queen Juana. Cortés's men came from all over Spain, but the majority were from Andalusia, Extremadura and Old Castile. Their leaders, among them men whom Cortés had known all his life, were mostly from Extremadura.

ACALFI. YQVII FLATLAII. CAPITA.

La llegada de Cortes al puerto de Cempuala de la nueva España) con su armada y gente, y quando Sido barrenar los navios y hechar los a fondo

The Spaniards established a base near Veracruz, in defiance of the wishes of Diego Velázquez, Governor of Cuba. There Cortés left about a hundred of his men, while he led the rest up to Tenochtitlan. The Mexica seem to have confused him with the lost god Quetzalcoatl; or perhaps it suited some in Motecuhzoma's court to argue that this was the case. Quetzalcoatl, god of learning and the wind, was supposed to have been opposed to human sacrifice. It appears that Motecuhzoma accorded him special devotion. The god was said to have vanished several hundred years before in the Eastern Sea, the Gulf of Mexico, but was expected to return. As if to confirm this Mexica belief, Cortés's landfall was made at exactly the location of Quetzalcoatl's departure and in a year '1-reed', the prophesied year of the god's return. Cortés and his army were received as guests by Motecuhzoma, who was soon seized and held captive in the lodgings that had been allocated to the Spaniards. For a time, Motecuhzoma continued to rule Mexico, while Cortés ruled Motecuhzoma; a style of rule which, ironically, echoed in some ways that of the Mexica towards their tributaries.

This period came to an end in April 1520 when about a thousand Spaniards, led by a veteran conquistador, Pánfilo de Narváez, landed at Veracruz determined to capture or kill Cortés and restore the authority of the Governor of Cuba. Cortés left his deputy Pedro de Alvarado, who had been with Grijalva in 1518, in Tenochtitlan and set off for the coast, where he surprised his fellow Spaniards in a night attack. Then he returned to Tenochtitlan, his forces enlarged by some newcomers who had switched their allegiance. In the meantime the rash Alvarado, fearing an attack, had, in what modern strategists would term a pre-emptive strike, massacred much of the Mexican

nobility and was being besieged. Cortés sought to raise the siege but could not do so and decided, with Alvarado, to leave the city by night. They were surprised and in a fierce battle on the city's causeways on the night of 30 July 1520, the so-called 'Noche Triste', lost a great many men. The Spaniards regrouped in the town of Tacuba and were then able to recover in the city-state of Tlaxcala where the indigenous enemies of the Mexica welcomed and succoured them, in return for a treaty which gave them authority in the Basin of Mexico. Tlaxcala was the leading city-state to have successfully resisted incorporation into the Mexican empire. Other peoples had been conquered and forced into resentful submission, and some of these saw the Spaniards' arrival as a heaven-sent opportunity to recover their independence, but the Tlaxcalans viewed the Spaniards as mercenaries from whose help they might benefit, and drove a hard bargain with Cortés in return for their support.

Cortés regrouped, and devoted several months to the brutal conquest of minor cities of the Mexican empire to the east of the capital. Next, his army, much enhanced both by the help of indigenous allies and by new Spanish volunteers from Santo Domingo, set about besieging Tenochtitlan. Cortés was able to attack Tenochtitlan from its lake (fig. 63) by commissioning twelve brigantines from Martín López which were built at Tlaxcala and then carried over the hills in separate pieces to be assembled on Lake Tetzcoco, an astonishing feat.

The siege, a long and bloody battle, brought many setbacks for both sides. It led to the destruction of the city and the death from starvation of many Mexica. Motecuhzoma had been killed, probably by a stone thrown by one of his own people, in June 1520 (the story that

he was murdered by Spaniards lives on but there is no solid basis for it). His nephew and eventual successor, the youthful *tlatoani* Cuauhtemoc, surrendered the city to Cortés on 13 August 1521.

Cortés's victory has several explanations. The better-disciplined Spaniards were organised in companies and command groups for which there was no real Mexican equivalent. Cortés showed himself to be a brilliant commander: always calm, particularly at difficult moments; always at the forefront of the battle; and always able to improvise when things went wrong. He was as good a leader in retreat as in advance, and spoke to his men often, in a measured and inspiring tone.

His capacity to communicate effectively with both his indigenous allies and with Motecuhzoma derived from a skilful use of interpreters. Early on in his expedition he rediscovered Jerónimo de Aguilar, who had been wrecked on the 1511 voyage of Diego de Nicuesa and who had lived for several years with the Maya. By 1518 this lay brother could speak a version of Maya and had not forgotten his Spanish. Along the coast, near what is now Coatzacoalcos, the Spaniards were offered a female slave, Malinalli, who was Mexica in origin but had been sold by her mother and stepfather to Maya merchants. She spoke both Nahuatl, the language of the Mexica, and Maya. Cortés used her and Aguilar to translate first into Maya, then into Nahuatl. The process was a little drawn out and was further complicated when Cortés wanted to talk to the Totanacs, for a third interpreter was necessary. But communication with the tributaries of the Mexica was one of the great successes of the campaign, and Marina, as the Spaniards named Malinalli after she became a Christian, was one of the heroines of the era.[12] She also became for a time the mistress of Cortés, to whom she bore a son.

Communication of other sorts counted too. Bernal Díaz del Castillo recounts how, during the siege, Cortés was able to communicate effectively in writing with Alvarado: 'He was always writing to us to tell us what we were to do and how we were to fight.'[13]

Weapons, however, were the determining factor. In order to prevent the Mexica from hiding on the rooftops, artillery fire, however inaccurate, came into its own. Horses were less effective in hand-to-hand fighting in the city, but they had already been shown to be decisive in combat in open country in the Battle of Otumba, during the Spanish retreat from the capital in the summer of 1520. All the same, to begin with, horses – strange, alien beasts to the Mexica – must have seemed a terrifying innovation on the battlefield. Handguns,

such as arquebuses, and crossbows do not seem to have made much difference, but the long, sharp Castilian sword (fig. 64) was a determining element of Spanish success. In comparison, Mexica swords, set with sharp blades principally of obsidian (a volcanic glass) slotted into wooden shafts, were intended primarily to wound, not to kill: the Mexica hoped for wounded captives to be sacrificed at festivals, not corpses.

The successful execution of warfare requires efficient transport. Here the Spaniards were able to count on the help of their Indian allies to a great extent. Indeed it is unlikely that they could ever have left Veracruz for Tenochtitlan if they had not had such a supply of 'sepoys'. Even foot soldiers had servants and they too, like their commanders, often had Indian girls with whom to sleep. The effect of these affairs, which incidentally founded the Mestizo race in Mexico, was most beneficial for the morale of the Spaniards. The Spanish camp must have seemed a Babylon for much of the time, for numerous tributaries looked on the Spanish as a great force for their liberation, hence their close association with the conquerors. A final element was contributed by the outbreak in old Mexico of a smallpox epidemic in the autumn of 1520 which seriously weakened indigenous resistance.

INTEGRATION

After the conquest, Cortés set about rebuilding Tenochtitlan. He employed the surviving Mexica and also the services of several of his allies, such as the people of Chalco who had been known as builders from the days when they had first built the Mexica city in the fifteenth century. The reconstruction was one of the great triumphs of Renaissance urban planning: before its destruction, Tenochtitlan had been bigger than any western European city, and it was rebuilt within three years on a plan devised by one of Cortés's friends from Badajoz, Alonso García Bravo.

The Indians worked, so the Franciscan monk Toribio de Benavente (Motolinía) recalls, with enthusiasm and a will barely believable. They were much impressed by two devices introduced by the Spaniards: the wheeled cart and the pulley. It is possible that wheeled carts had been used by the Spaniards to transport artillery during the war. Although the Mexica had potter's wheels, they did not use the wheel for the purposes of transport, perhaps because they lacked the appropriate domesticated animals. Both the cart and the pulley, therefore – which transformed work on the building site of Tenochtitlan (it soon became known as just Mexico) – were revelations.

Fig. 64
The sword said to have belonged to Gonzalo Fernández de Córdoba ('El Gran Capitán'), c.1504–15. Steel, bronze, gold and cloth, length 96.9 cm.
Real Armería, Madrid

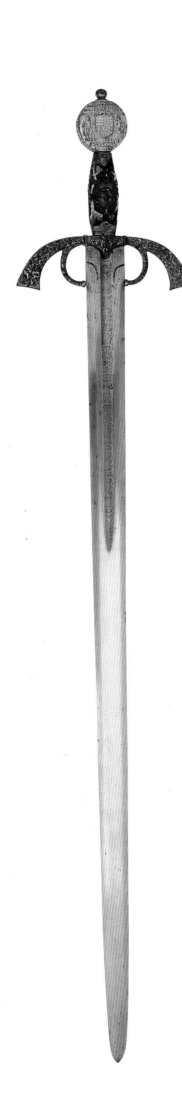

In the next generation, countless Indians worked under the direction of monastic amateur architects to construct some of the grandest of Christian monuments in Mexico. Vast *conventos*, or monasteries, as well as churches and many palaces, were erected, often using, especially in Mexico-Tenochtitlan, *tezontl*, the hard, red stone that had been such a characteristic feature of Indian architecture. These new buildings often employed magnificently flamboyant variations on indigenous styles of ornament in their stone carvings. The careful building of the cathedral of Pátzcuaro by Bishop Quiroga on the site of an ancient Tarascan temple in the style of the recently completed cathedral at Granada is an example of the architectural assimilation of Indian monuments common at the time. By the 1540s, the sons of Mexica noblemen killed in the siege or other fighting were showing themselves adept at learning Christian texts, and, at the college of San Francisco at Tlatelolco (in the north of Tenochtitlan), some were also composing Latin hymns to be set to Spanish music. Had it not been for the terrible outbreaks of European diseases that destroyed so much of the indigenous population in the second half of the sixteenth century, the meeting of the Spanish and the ancient Mexican cultures might have been one of the triumphs of the Renaissance. As it was, the Spanish onslaught on the indigenous religions – 'onslaught' is the right word if we recall the scale of the mass conversions undertaken by the Franciscans and Dominicans, as well as the innumerable burnings of indigenous books and idols – was assisted by the disposition of the conquered peoples to accept, at least on the surface, the religious beliefs of the victors: this had always been the custom in old Mexico.

After the military conquest came the spiritual one, to cite the French historian Robert Ricard. Although Bartolomé Olmedo, an important Mercedarian, had accompanied Cortés on his expedition, the Franciscans were the first of the itinerant orders to go to Mexico. A moving description exists of how amazed the indigenous survivors were to see Cortés, the victorious captain-general, kneeling to greet the twelve Franciscans who walked up to Tenochtitlan barefoot from the sea in 1524. The Augustinians and Dominicans followed and much later, in the 1570s, the Jesuits came too. Their pastoral work established firm foundations for Mexican Christianity. It must have been difficult for the surviving Mexica to defend, much less to continue to worship, their old gods, who had apparently so completely let them down. But minor worship of spirits of the dew or the hillside continued (as indeed it did in many European countries until industrialisation). Small earthenware figurines of Mexica deities were tolerated by the Spanish, but more serious acts of religious resistance were quickly discovered – if their perpetrators were not betrayed by Indians – and harshly suppressed.

Mexican contributions to Spain are less easy to identify. One or two reminders in northern Europe (such as the frieze in the courtyard of the Palace of the Prince-Bishop of Liège) are rather far-removed and, besides, scarce. The great achievements of old Mexico were either monumental – the architecture of Teotihuacan and Tula – and immoveable, or appeared monstrous to European eyes, like the heads of monarchs. Mexican sculpture was of high quality but little was sent back to Spain. And although the Spaniards liked Mexican gold, they melted it down when it reached Seville, much to Cortés's surprise and sadness. The same fate awaited Mexican silver obtained from the Tarascans at Michoacán. The craft of turquoise mosaic had no following in Renaissance Europe or a Spain increasingly dominated by the Inquisition, and nor did Mexican musical instruments. As Miguel León-Portilla has so eloquently shown in his essay in this volume (pp. 64–71), Mexica poetry was elegant and of high quality. But it seemed too alien to European readers. Pottery from Mexico was fashionable in Spain for a time. Some would say that feather mosaics were the supreme achievement of old Mexico. Cortés sent many of the best examples to Spain in 1522 only for them to be captured by French pirates. Later, the craft continued, using Christian iconography (cats 323, 326), but demand in Spain was modest.[14]

The real intercultural consequence of the conquest of Mexico was the creation of the gifted Mexican people of today: men and women whose Spanish surnames and Christian culture have fused with their Indian blood and Indian features. They may descend from the Mexica, but their ancestry is equally likely to stem from one of their tributaries or from one of the five hundred or so other peoples who inhabited Mexico 'at contact' with the Europeans.

EXHIBITIONS AND COLLECTORS OF PRE-HISPANIC MEXICAN ARTEFACTS IN BRITAIN

Adrian Locke

British involvement with, and interest in, the archaeology of Pre-Hispanic Mexico spans more than four hundred years. In Europe the collecting of artefacts other than books began in earnest during the sixteenth century with the so-called 'cabinets of curiosities' assembled by individuals who sought to understand better the world in which they lived. Hernán Cortés sent several objects back to Spain in the first shipment from Mexico in 1519 but these were subject to the aesthetics of the time; as Anthony A. Shelton explains, 'the New World's material products that most attracted the Spaniards were items that closely corresponded with the canons of taste they had inherited from medieval thought'.[1] Although much was lost through ignorance or greed in those early days of collecting, significant numbers of objects exist in museum collections outside Mexico, especially in Europe and the United States of America. Early collections, however, such as that formed by Archduke Ferdinand II of Tyrol (1529–1595) and now housed at the Museum für Völkerkunde in Vienna, are exceptional: most collections of Mexican artefacts date from the nineteenth century.

In general terms the English have been interested in Mexico since its discovery in the early part of the sixteenth century and its subsequent annexation by the Spanish crown. The apparent wealth of the Spanish colonies in the Americas generated great curiosity and fuelled economic rivalries as European nation states competed in the race for betterment. Spain jealously guarded her richest colonies of Mexico, then known as Nueva España (New Spain), and Peru, refusing to permit any country to trade with her American colonies or to allow non-Spaniards to enter or travel within them. There was an enormous desire to understand, and exploit, economic opportunities in Mexico, in the light of the large shipments of gold and silver that were regularly sent back across the Atlantic (and intercepted by pirates from, among other countries, England, France and the Netherlands) and the arrival of such previously unknown natural products as tobacco, potatoes, tomatoes, maize and chocolate. The mineral and natural wealth of the Americas was all too evident.

The Americas in general continued to pose a serious intellectual question to the Europeans' world-view, since the continent was not mentioned in the Bible and was absent from all medieval maps.[2] Despite the immediate wealth provided by objects made of precious metals, the codices, often referred to as 'painted books', attracted great interest in England because, remarkably, they were recognised early on as literary texts by three seventeenth-century collectors: William Laud (1573–1645, Archbishop of Canterbury under Charles I), Sir Thomas Bodley (1545–1613, a scholar and diplomat), and John Selden (1584–1654, a jurist and scholar).[3] Indeed the earliest-known English connection with these books was in 1588 when the geographer Richard Hakluyt (c. 1552–1616) acquired the Codex Mendoza (cat. 349) from André Thevet

Fig. 65
The title page of the Codex Mendoza (see p. 358), reproduced as a woodcut in Hakluyt's *Haklvytvs Posthvmvs; or Pvrchas his Pilgrimes*, London, 1624.

British Library, London

This Picture presents the number of 51. yeares: that is, the time of Tenuchs reigne: in this wheele or square (which, as all the like representing yeares, are in the originall picture coloured blew) The pictures of men signifie the ten Lords or Gouernours before mentioned; their names are inscribed in the originall pictures, which here we haue by the letters annexed directly to a following glosse. A. Acacitli. B Quapan. C Ocelopan. D Aguexotl. E Tecineuh. F Tenuch. G Xomimitl. H Xocoyol. I Xiuhcaqui.

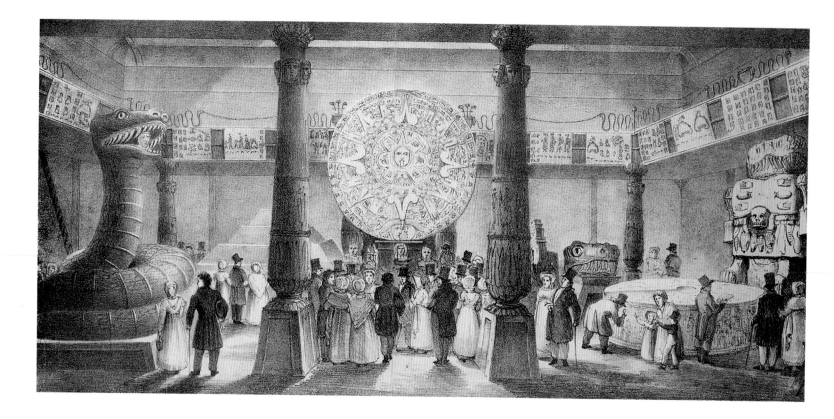

Fig. 66

Agostino Aglio, *View of the 'Ancient and Modern Mexico' exhibition at the Egyptian Hall, Piccadilly*, 1824. Lithograph on paper.

Guildhall Library, Corporation of London

(1502–1590), cosmographer to Henry II of France. The clergyman Samuel Purchas (*c.* 1577–1626), who inherited the manuscript from Hakluyt, reproduced a number of pages of the codex as woodcuts in his London publication *Haklvytvs Posthvmvs; or Pvrchas his Pilgrimes* (1624; fig. 65).[4] From Purchas the Codex Mendoza passed to Selden and entered the collection of the Bodleian Library, Oxford, in 1659. Altogether some twenty Mexican manuscripts reside in UK collections, including the Codex Laud (Bodleian Library, Oxford), the Codex Fejérváry-Mayer (cat. 341), the Codex Zouche-Nuttall (British Museum, London) and the Codex Aubin (cat. 354).[5]

Undoubtedly the pre-eminent holding of Mexican archaeological material in Great Britain belongs to the British Museum. The core of the collection was formed during the mid-nineteenth and early twentieth centuries, although little is known about some of the collectors who contributed to it. Between 1835 and 1841, Captain Evan Nepean, an English seaman, collected a large number of objects from the Isla de Sacrificios off the coast of the Gulf of Mexico; these were accessioned in 1844.[6] John Wetherell published a catalogue of Mexican objects in his possession in Seville in 1842, which includes an engraving of the sandstone Mictlantecuhtli now on display in the British Museum's Mexican Gallery. The Wetherell Collection was accessioned in 1849. Three further collectors of note, about whom more is known, also donated their collections to the British Museum: William Bullock (*c.* 1770–1849), whose

collection was accessioned in 1825; Henry Christy (1810–1865), a wealthy businessman who developed a keen interest in ethnography, whose holdings were accessioned in 1883 although donated in 1866; and Arthur Percival Maudslay (1850–1931). Other significant nineteenth-century collectors include Augustus Henry Lane Fox Pitt Rivers (1827–1900), Sir Henry Wellcome (1853–1936), and Weetman Dickinson Pearson, 1st Viscount Cowdray (1856–1927).[7]

The first exhibition of Mexican archaeological artefacts in Britain, which Ian Graham argues 'deserves to be recognised as the first exhibition of Pre-Columbian antiquities anywhere in the world',[8] took place in 1824. William Bullock's 'Ancient and Modern Mexico' was held at the Egyptian Hall in Piccadilly, London (fig. 66). The exhibition was built upon renewed interest in Mexico after the country gained independence from Spain in 1821.[9] Free at last from colonial restrictions, Mexico, keen to develop international trade, opened its borders to foreign visitors. Europeans and Americans began to explore the country in part to satisfy their scientific curiosity but also to develop business opportunities. One of the first such visitors was Bullock who, accompanied by his son, travelled for several months in Mexico in 1823. An account of their trip, illustrated by William Bullock Jr, was published the following year.[10] Although driven in part by business interest, Bullock's trip was intended as a collecting venture; he was the proprietor of the London Museum, a highly successful exhibition space. Indeed Bullock

is credited with developing 'the museum as an instrument of pleasurable and popular entertainment'.[11]

Bullock had begun collecting in Liverpool where he would buy objects of interest from the crews of ships as they docked; he displayed his purchases in a purpose-built museum in Church Street.[12] In 1809 he moved to London and rented a hall to display his collection near Piccadilly Circus. The success of this project allowed Bullock to spend £16,000 building his own galleries, which opened in April 1812, complete with a fine Egyptian-style façade.[13] Called the London Museum of Natural History and Pantherion, it became more commonly known as the Egyptian Hall. After a series of highly successful exhibitions, Bullock sold his collection of natural history specimens, Roman antiquities and curiosities and undertook a series of temporary exhibitions. The success of these exhibitions led him to Mexico in search of ever more interesting material. On his journey Bullock acquired a number of Pre-Hispanic artefacts, such as the greenstone

Quetzalcoatl and the celebrated Xiuhcoatl, both now in the British Museum.[14] In Mexico City the remarkable Aztec statue of Coatlicue (fig. 9) was disinterred at his request to allow him to make a cast before it was reburied. He also made a cast of the Sun Stone (fig. 5), then affixed to one of the walls of the cathedral.[15] Bullock's exhibition attracted much interest and comment.[16] After the exhibition all the objects were sold and some subsequently entered the collection of the British Museum.[17]

Bullock was the first of many Britons to undertake explorations in Mexico during the nineteenth century, culminating with the great expeditions of the topographical artist Frederick Catherwood (1799–1854), who accompanied the American John Lloyd Stephens (1805–1852),[18] and Arthur Percival Maudslay who travelled throughout Mexico and Central America and was fascinated by the Maya. Perhaps the most celebrated English painter to have worked in Mexico was Daniel Thomas Egerton (1797–1842), but many others, such as George Henry White (1817–1889), also produced fine landscapes of central Mexico.[19]

George W. Stocking Jr proposes that the Great Exhibition held at Crystal Palace in 1851 stimulated the two great ethnological collections of the evolutionary period, those of Christy and Pitt Rivers, encouraging individuals to think about human origins and the progress of civilisation.[20] Yet, as a short article from the *Illustrated London News* reveals, there was already interest in the archaeological remains of Mexico and Peru (fig. 67).[21] The excitement generated by all things Mexican can be seen in the announcement for an exhibition of two 'Aztecs' from Ixamaya at the Egyptian Hall as part of an eighteen-year European tour and following an audience on 4 July 1853 at Buckingham Palace with Queen Victoria and members of the royal family (fig. 68).

After Bullock's, a number of smaller exhibitions of Mexican archaeology were held in London, although these tended to feature objects from private collections. For example, Christy's collection was shown at 57 Pall Mall in 1855, and again at 103 Victoria Street, Westminster, in 1868, three years after his death, once it had been bequeathed to the Trustees of the British Museum. Many of these objects, which include three turquoise pieces (cats 296, 303–04), are now on permanent display in the Mexican Gallery of the British Museum.[22]

There was little activity between the display of the Christy collection and 1920 when the Burlington Arts Club held an 'Exhibition of Objects of Indigenous American Art' curated by

Fig. 67

Engraving by J. W. Archer highlighting the recent acquisitions of Mexican archaeological objects by the British Museum, *Illustrated London News*, 3 April 1847.

Guildhall Library, Corporation of London

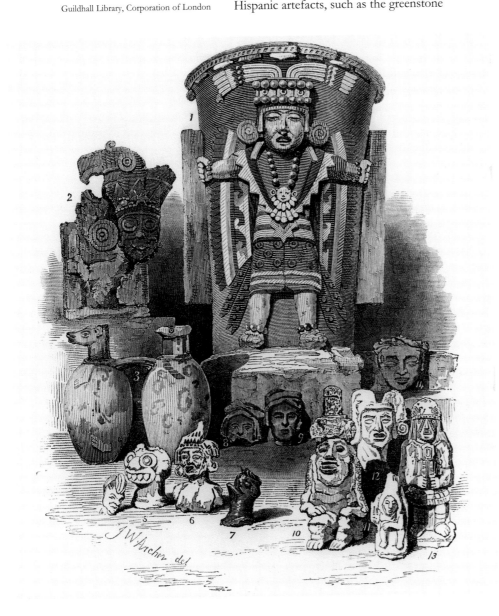

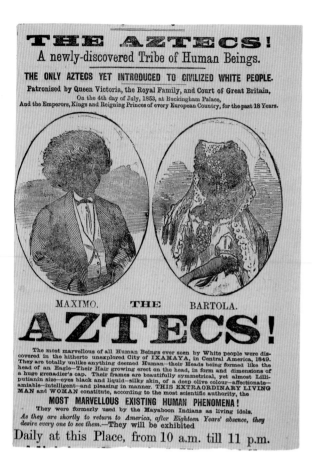

Thomas Athol Joyce, the British Museum's Keeper of Ethnography. This was followed in 1947 by 'Art of Ancient America' organised at the Berkeley Galleries by Irwin Bullock and G. H. S. Bushnell (Curator of the Museum of Archaeology and Ethnography at the University of Cambridge). Catalogues were produced for both exhibitions. In the meantime, attention was drawn to the celebrated collection of originals and casts made by Maudslay on his numerous expeditions to Mexico and Central America. Maudslay's collection, which included the Yaxchilan lintels now at the British Museum, reflects his particular interest in the Maya. His work was included in the *Biologia Centrali-Americana*.[23]

From 4 March to 3 May 1953 the Tate Gallery in London hosted the monumental 'Exhibition of Mexican Art from Pre-Columbian Times to the Present Day'. With some thirteen hundred objects divided into three principal sections (ancient, colonial and republican), this was the largest exhibition of its kind mounted to date in Great Britain (fig. 69).[24] The exhibition, previously displayed in Paris and at the Statens Etnografiska Museum, Stockholm, was nearly not held in London as had been arranged. On 3 January 1953 the London press, following an official announcement made the previous day, reported that the exhibition had been cancelled without reason by the Mexican government despite the

success it had already generated. The American leg of the tour, scheduled for the Metropolitan Museum of Art in New York, was also withdrawn. Then, in what was reported as a gesture of friendship to Great Britain, President Adolfo Ruiz Cortines of Mexico revoked the decision and agreed to hold the exhibition as arranged.[25]

In a letter to Sir John Rothenstein, Director and Keeper of the Tate Gallery, Susana Gamboa, General Secretary of the Mexican Exhibition, testified to the huge popularity of the show in Stockholm, where it had attracted 182,000 paying visitors who bought 32,000 copies of the catalogue.[26] Despite the complex logistics of bringing all the works to London, and a River Thames flood warning which delayed the opening, the exhibition was a huge success. It was widely reported in the press throughout the country where it attracted much attention and received numerous reviews. There was a marked tendency among the reporters to emphasise the concept of sacrifice and the headlines were often shocking. Nevertheless reports reveal the degree of fascination exerted on the postwar British public by the Mexican culture on display. The press described 'Mexican Art' as 'the most ghastly, horrifying and exciting exhibition London has ever seen',[27] 'one of the most extraordinary exhibitions ever seen in London',[28] and 'the most gripping, emotional experience ever offered the inhabitants of the Old World by the New'.[29] On 4 March 1953 the *Evening Standard* captured the excitement generated by the exhibition in reporting the huge turn-out of nearly a thousand visitors for a private view organised by the Contemporary Arts Society, despite thick fog.

'Mexican Art', at the time the largest exhibition ever mounted by the Arts Council of Great Britain, was a great success. The Tate Gallery was open seven days a week with late openings every weekday until 9 pm, including a special reduced admission fee after 6 pm, to satisfy demand. The exhibition, originally intended to close on 26 April, was extended for a week. On 4 May the *Manchester Guardian* reported that 'Mexican Art' had received a total of 121,520 visitors.[30] The catalogue reveals that there were several non-Mexican lenders to the exhibition, such as the British Museum, Mr Robert Woods Bliss (whose collection is now at Dumbarton Oaks, Washington DC), the Philadelphia Museum of Art and the Art Institute of Chicago. 'An Exhibition of Pre-Columbian Art' (1958) at Gimpel Fils reveals a continuing interest in the subject in London.

Since 'Mexican Art', a number of smaller exhibitions in Britain have included Mexican

Fig. 68
A newspaper advertisement announces the exhibition of two 'Aztecs' from Ixamaya at the Egyptian Hall, Piccadilly, in 1853.
Guildhall Library, Corporation of London

Fig. 69
The poster for the Tate Gallery's 'Exhibition of Mexican Art from Pre-Columbian Times to the Present Day', 1953.
Tate Archive, London

archaeological objects, although not always exclusively. At the centre of these exhibitions was the Museum of Mankind in Burlington Gardens, which until recently housed the ethnographic collections of the British Museum. The inauguration of the Mexican Gallery at the British Museum in 1994 signalled a decision to unite all of the museum's ethnography collections at its Bloomsbury site.[31] The project was a collaboration between the Consejo Nacional para la Cultura y las Artes (CNCA), the Instituto Nacional de Antropología e Historia (INAH) and the British Museum. The gallery, designed by the Mexican architect Teodoro González de León, provides a permanent exhibition space for the museum's Mexican artefacts, demonstrating their importance within the whole collection. Exhibitions at the Museum of Mankind included 'Maya Sculpture and Pottery from Mexico: The Manuel Barbachano Ponce Collection' (1971),[32] 'The British and the Maya' (1973), 'The Other America: Native Artefacts from the New World' (1982), 'Lost Magic Kingdoms and Six Paper Moons from Nahuatl' (1985), and 'The Skeleton at the Feast: The Day of the Dead in Mexico' (1991).

'Lost Magic Kingdoms and Six Paper Moons from Nahuatl' was particularly innovative since it was the first time that the Museum of Mankind had directly involved a major contemporary artist in the creation of an exhibition. In a sense, the exhibition, curated by the distinguished British sculptor Eduardo Paolozzi (b. 1924), followed the publication of *Henry Moore at the British Museum* (1981), in which Paolozzi's fellow British sculptor Henry Moore (1898–1986) appraised the qualities of the museum's collection of statuary. Moore believed that people needed to be able to examine the back of sculpture, especially that of the Aztecs, which he found extremely relaxed and expressive.[33] Paolozzi chose to display a variety of objects from the ethnographic collections which he juxtaposed with his own work. The title of the exhibition and, for example, the papier-mâché copy of the celebrated Tlazoteotl from the Dumbarton Oaks collection (cat. 320) that he made for the exhibition reflect Paolozzi's interest in Mexico: '"Six Paper Moons" is a metaphor for the way the Aztec looked at the moon: according to them, the moon was a mother, the sun a father, and the stars were their children' (fig. 70).[34]

Several exhibitions outside London have incorporated Mexican archaeological objects, such as 'Ancient American Art' at the Royal Scottish Museum, Edinburgh (1971), which included some items owned by Cowdray, and 'Men and Gods of Ancient America: An Exhibition of Treasures from Mexico and Peru' at the Liverpool Museum (1973). 'The Art of Ruins: Adela Breton and the Temples of Mexico' at the Bristol Museums and Art Gallery (1989) highlighted the museum's extensive collection of watercolours of Mexico and Central America by Adela Breton (1849–1923) and included part of her collection of artefacts. Born in Bath, Breton made numerous trips to Mexico between 1894 and 1923 and developed a passionate interest in the Pre-Hispanic architecture of the region. She is best known for her paintings and sketches of the Mayan sites of Chichén Itzá and Acancéh in the Yucatan. Indeed her representations of Acancéh have become an important archaeological record of the now-deteriorated reliefs at the site.[35] In 1908 she produced a copy of the 'Plano en papel de maguey' (fig. 71) (now part of the collection of codices at the Museo Nacional de Antropología, Mexico City) for Maudslay's English translation of the classic *Historia verdadera de la conquista de la Nueva España* by Bernal Díaz del Castillo, one of Cortés's footsoldiers. The original map, first published in Bullock's *Six Months' Residence and Travel in Mexico*, was exhibited at the Egyptian Hall in 1824.

Fig. 70
An array of objects featured in 'Lost Magic Kingdoms and Six Paper Moons from Nahuatl', an exhibition curated by Eduardo Paolozzi at the Museum of Mankind, London. Tlazolteotl, the Aztec goddess of filth, derived from cat. 320, was sculpted in papier mâché by Paolozzi himself.

Fig. 71

A *chinampa* district, probably located in the outskirts of north-western Tenochtitlan. Detail of Adela Breton's 1908 copy of the 'Plano en papel de maguey' (*c.* 1523–25; Museo Nacional de Antropología, Mexico City). Maguey paper, *c.* 215 × 150 cm.

Bristol Museums and Art Gallery

A number of exhibitions in Britain, such as 'Sañuq and Toltecatl: Pre-Columbian Arts of Middle and South America' at the Manchester Museum (1992), commemorated the quincentenary of Columbus's 'discovery' of the Americas in 1492. 'Painted Books of Mexico' at the British Museum (1992) reunited many of the codices in British collections. In addition, three manuscripts from the British Museum, the Metlatoyuca Map, the Itzcuintepec Codex and the Itzcuintepec Roll, were included in the exhibition 'Mapping the Americas' at the University Gallery of the University of Essex, Colchester (1992), which was part of the acclaimed Fourth World conference.

Numerous large-scale survey exhibitions have taken place around the world over the last hundred years. These have included 'Les Arts anciens de l'Amérique: exposition organisée au Musée des Arts Décoratifs' at the Palais du Louvre, Paris (1928); 'Twenty Centuries of Mexican Art' at the Museum of Modern Art, New York (1940); 'Master Works of Mexican Art from Pre-Columbian Times to the Present' at the Los Angeles County Museum of Art (1963); 'Before Cortés: Sculpture of Middle America' at the Metropolitan Museum of Art, New York (1970); 'México antiguo' at the Museo de América, Madrid (1986); 'Mexico: Splendors of Thirty Centuries' at the Metropolitan Museum of Art, New York (1990); 'L'America prima di Colombo: arte precolombino dal 2000 a.C. agli Aztechi' at the Castello di Lerici, Milan (1990); 'Circa 1492: Art in the Age of Exploration' at the National Gallery of Art, Washington DC (1991); and 'Arte precolombino en la colección Barbier-Mueller' at the Casa de América, Madrid (1994). More recent exhibitions include 'Soleils mexicains' at the Petit Palais, Paris (2000); 'The Journey to Aztlan: Art from a Mythic Homeland' at the Los Angeles County Museum of Art (2001); and 'Art Treasures from Ancient Mexico: Journey to the Land of the Gods' at the Nieuwe Kerk, Amsterdam (2002).[36]

A number of more specifically Aztec exhibitions are also worthy of mention: 'Aztec Stone Sculpture' at the Centre for Inter-American Relations, New York (1976); 'Mexique d'hier et d'aujourd'hui: découverte du Templo Mayor de Mexico; artistes contemporains' at the Ministère des Relations Extérieures, Paris (1981); 'Art of Aztec Mexico: Treasures of Tenochtitlan' at the National Gallery of Art, Washington DC (1983); 'Glanz und Untergang des alten Mexiko: Die Azteken und ihre Vorläufer' at the Roemer–und Pelizaeus-Museum, Hildesheim (1986); 'Die Azteken: Maisbauern und Krieger' at the Museum für Völkerkunde, Basle (1986); and

'Azteca-Mexica: las culturas del México antiguo' at the Sociedad Estatal Quinto Centenario, Madrid (1992).

'The Art of Ancient Mexico' at the Hayward Gallery, London (1992), was the most recent and largest exhibition specifically dedicated to Mexican archaeology to be held in Britain. The show, which toured extensively before arriving in London, was a major collaboration with the British Museum, which lent many of its holdings;[37] indeed Joanna Drew, Director of the Hayward Gallery, described the exhibition in the catalogue acknowledgements as 'in a small but important way a collaboration between the national museums in both countries'. A complete survey of Mexican archaeology from the Preclassic through to the Postclassic period, including the coast of the Gulf of Mexico, Oaxaca, Yuacatan and Chiapas, Teotihuacan, Tula, Tenochtitlan, as well as northern and western Mexico, the exhibition proved to be very popular.

Although library holdings were formed much earlier, the great collections of Mexican archaeology in Britain were formed during the nineteenth century. The Ethnography Department of the British Museum, which acquired many of these objects, has been at the heart of all the great twentieth-century exhibitions of Mexican archaeological objects in Britain, either as a lender or an organiser. This position has been consolidated through the inauguration of the permanent Mexican Gallery. However, the British Museum's important role does not diminish the achievements of numerous museums throughout Britain with significant holdings of ancient Mexican artefacts that have organised innovative exhibitions and have many objects on permanent display. Together these institutions demonstrate the international importance of British collections of Mexican art, and illustrate the long tradition of exhibitions of Mexican artefacts in Britain, of which 'Aztecs' at the Royal Academy is the latest chapter.

NOTES

I INTRODUCTION

01 Codex Chimalpahin 1997.

02 Mesoamerica is the term used throughout this book to denote the area comprising central Mexico and southern Mexico, Guatemala, and the adjacent parts of El Salvador, extending from the coast of the Gulf of Mexico up to Yucatan and down to present-day Honduras.

03 Alvarado de Tezozómoc 1998, p. 22.

04 Among the most colourful are those by Hernán Cortés (Cortés 1986) and Bernal Díaz del Castillo (Díaz del Castillo 1956; Díaz del Castillo 1984).

05 The Spanish Viceroy, Count de Revillavigedo, was keen to protect these objects from neglect and destruction (Bernal 1979, p. 76). A publication by Antonio de León y Gama, a contemporary expert on Aztec astronomy and history who studied both monuments, is crucial to our understanding of this discovery. Two editions of his book were published, one in 1792, the other in 1832. The second included other monuments in addition to the Coatlicue and the Sun Stone, conspicuous among them a head of Xiuhcoatl.

06 An engraving showing the 'Interior of the University of Mexico' in Gualdi's album (Gualdi 1841) and an oil painting at the Amparo Museum in Puebla (Solís Olguín 2001, p. 349) both show the trellis behind which the monoliths stood.

07 Kubler 1991 is dedicated to appraising artistic records of Pre-Hispanic cultures, from the time of the Spanish conquest to the twentieth century.

08 Franck 1829 contains 81 unbound sheets, 79 of which illustrate works from the museum's collection of pre-Hispanic art. One of the two remaining pages illustrates Egyptian artefacts; the other is a portrait of a Mexican woman.

09 The illustrations in Dupaix 1978 are by the draughtsman José Luciano Castañeda.

10 For descriptions that allow assessment of the contemporary appreciation of Aztec art and culture, see Bullock 1824; Calderón de la Barca 1843; Mayer 1844; and Mühlenpfordt 1844.

11 Calderón de la Barca 1843, pp. 102–03.

12 The catalogue of the exhibition held at the Egyptian Hall, Piccadilly, contains a detailed description of the objects as well as an engraving showing various original statues from Aztec times (now part of the collection of the British Museum, London), plaster reproductions of the main monoliths, such as the Sun Stone, the Coatlicue and the Tizoc Stone, a model of the Pyramid of the Sun in Teotihuacan and various original codices, one of the most important of which was the Tira de la Peleegrinación. See London 1824; London 1824B; London 1824C; Bullock 1991; and Adrian Locke's essay in this volume, pp. 80–87.

13 Nebel 1963 contains pictures of the Pre-Hispanic sites and monuments of various Pre-Hispanic Mexican cultures. From the Aztec world there are stone sculptures and figurines as well as views of Tusapan, a place on the coast of the Gulf of Mexico that was artistically influenced by the Aztecs.

14 Ramírez 1844–46, a study of a number of sculptures in the museum's collection, can be found in the Mexican edition of William H. Prescott's *History of the Conquest of Mexico*. See also Ramírez 1864.

15 An oil painting by Cleofas Almanza of the patio of the old museum is kept in the administrative offices of the Museo Nacional de Antropología. Fernández 1987, p. 16.

16 For a long time it was maintained that the Sun Stone was painted in a wide range of colours. During the restructuring of the new Mexican Room at the Museo Nacional de Antropología, samples were taken of each section of the relief and it was established that only red and ochre were used. Solís Olguín 2000, pp. 38–39.

17 Although Galindo y Villa's work on the Hall of Monoliths is excellent, it lacks detail. His catalogue (Galindo y Villa 1897) describes 364 sculptures divided into nine sections and contains images of 31 pieces as engravings produced by Jonas Engberg.

18 Batres 1902 shows the discoveries made between 4 September and 13 December 1900 in Calle de las Escalerillas, including drawings, engravings and photographs of the main objects found. It is accompanied by a plan of the excavations.

19 The Mexica Hall took over the space previously occupied by the Hall of Monoliths. Separate rooms containing codices and Pre-Hispanic musical instruments also displayed pieces from the Aztec world (INAH 1956, pp. 86–115).

20 Nicholson 1971 is one of the most extensive bibliographies on Pre-Hispanic art, particularly regarding the sculptural works of the Central Highlands, from Preclassic times to the Aztecs.

2 THE AZTECS' SEARCH FOR THE PAST

I should like to thank Fernando Carrizosa, Alfredo López Austin, Peter Sawbridge, Eric Taladoire and Germán Zúñiga for their assistance.

01 Kubler 1963, p. 2.

02 Nicholson 1955, p.596; Nicholson 1979, p.195.

03 López Austin 1985, pp.310, 325.

04 Nicholson 1979, p.192–93.

05 Nicholson 2001.

06 López Luján 1989, pp.43–49; Boone 2000. See also Alfredo López Austin's essay in this volume, pp.30–37.

07 Castañeda 1986.

08 Ibid., pp.235–36.

09 Arana 1987, p.395.

10 Nalda and López Camacho 1995, pp.22–23.

11 Caso 1932.

12 Romero 1982.

13 Acosta 1956–57, pp. 75–76, 92. A detailed study of Acosta's Postclassic finds is being prepared (López Luján forthcoming).

14 Navarrete and Crespo 1971, p.15; Nicholson 2001, p.234–36.

15 Fuente 1990, p.39.

16 Quiñones Keber 1993, p.153.

17 Durán 1967, vol. 2, p.511.

18 Heyden 1973, p.5.

19 Sahagún 1950–82, vol. 11, p.221.

20 Sahagún 1950–82, vol. 10, p.165.

21 Benavente 1971, p.78.

22 Historia de los mexicanos por sus pinturas 1965, p.60.

23 López Luján 1989, pp.61–65.

24 López Luján 1989, pp.17–19.

25 López Luján 1989, p.73.

26 Drucker 1955, pp.29–33, 47, 56–60, 66–67.

27 Proskouriakoff 1974, p.10; Andrews 1987.

28 Rathje 1973.

29 Gussinyer and Martínez 1976–77.

30 Kidder 1947, p.48, figs 37t, 74; Proskouriakoff 1974, p.10.

31 Smith and Ruppert 1953, fig. 9c; Proskouriakoff 1974, p.10.

32 Navarrete 1995.

33 Proskouriakoff 1974, pp.10–11, 36, plates 37a, 38a, 52c, 53a and colour plate III.

34 The inscription apparently refers to the 'lord of the nocturnal place'. Graham 1998, pp.46–48, 51–52, 105.

35 Piña Chan 1982, p.232.

36 McEwan 1994, p.22.

37 Coe 1966.

38 Matos Moctezuma 1979; López Luján 2001, pp.24–25.

39 González and Olmedo Vera 1990; Olmedo Vera 2001, p.304.

40 Batres 1902, pp.61–90; Gussinyer 1969, p.35; Gussinyer 1970, pp.8–10; López Luján 1989, pp.25–36; López Luján, Neff and Sugiyama 2000.

41 Matos Moctezuma 1983; López Luján 1994, pp.225, 340–41.

42 López Luján 2001, p.25. This *chacmool* measures 49 × 106 × 46 cm; cf. Acosta 1956.

43 López Luján 1989, p.74.

44 López Luján 1989, p.19.

45 López Luján 1989, pp.32–33.

46 Cf. Heyden 1979, pp.62–65.

47 Batres 1906, p.25, plates 30–31; Langley 1986, pp.152–53, 245, 254, 332. Cf. Caso 1967, pp.130–38.

48 Caso 1967, pp.14–16; Nicholson 1971, pp.120–22; Umberger 1987, pp.92–95.

49 Nicholson 1971, pp.118, 131; Umberger 1987, pp.74–82; Fuente 1990, pp.48–52; Solís Olguín 1997; López Luján forthcoming.

50 Four of these buildings have been unearthed in the ruins of Tenochtitlan and one more in Tlatelolco. See Matos Moctezuma 1965; Gussinyer 1970B; Matos Moctezuma 1984, p.19; López Luján 1989, p.37–42; Matos Moctezuma and López Luján 1993, pp.160–61.

51 See Gerber and Taladoire 1990, pp.6–8.

52 Olmedo Vera 2002.

53 López Luján, Torres Trejo and Montúfar 2002; López Luján forthcoming.

54 Fuente 1990; López Luján forthcoming.

55 Paz 1989, vol. III, 1, pp.77–78.

56 López Luján 1989, pp.77–89.

3 COSMOVISION, RELIGION AND THE CALENDAR OF THE AZTECS

01 A generic name given to northern hunter-gatherer nomads.

02 The name Aztecs is derived from Aztlan. During their migration, the Aztecs changed their name, by order of Huitzilopochtli, from Aztecs to Mexitin or Mexicas.

03 Part of this argument appears in the journal *Historia Mexicana* (Florescano 1990; López Austin 1990). I support the second theory. I should underline the fact that the Aztecs considered themselves more civilised and urban than the 'true' *chichimecas*, defining these as a 'barbaric people who support themselves by hunting and do not settle' (Sahagún 2000, vol. 10, p.978).

04 The 'place of the seven caves' is the mythical place of origin of various Mesoamerican peoples, but the stories describe it as a real place. Various creation myths state that seven different peoples emerged there, although their names vary according to who is telling the story.

05 The supreme god was also seen as a conjugal duality.

06 Another conjugal duality, split between proto-Sun and proto-Moon.

07 Many different versions of the myth exist. In some there are not five, but four suns (Moreno de los Arcos 1967).

08 This is according to authors who agree that the Aztecs made the corrections required to ensure that the common year was equal to the tropic year.

09 The gods could be seen by humans only in dreams, in hierophanies or in altered states of consciousness.

10 The One God was known by various names, including Moyocoyani, Icelteotl, Ipalnemohuani, Tloque Nahuaque, Tlacatl, Yohualli Ehecatl, Ometeotl and Moche.

11 Plural of Tlaloc and name of the four cardinal divisions, as well as of the huge army of minor rain-gods.

12 *Tlatoani* means 'the one who commands', and *cihuacoatl*, 'female serpent', is one of the names of the goddess of the earth. Both appointments were for life and obtained by election among the members of the most noble families.

13 The highest-ranking priests were the Quetzalcoatl Totec *tlamacazqui*, who was consecrated to Huitzilopochtli, and the Quetzalcoatl Tlaloc *tlamacazqui*, devoted to worshipping Tlaloc. The supreme generals were the *tlacatecatl*, who led the armies, and the *tlacochcalcatl*, who administered weapons and victuals. The managers of public finance were the *huei calpixqui*, chief collector, and the *petlacalcatl*, who were responsible for the collected goods.

14 The fire-drill, or *mamalhuaztli*, was an instrument consisting of two pieces of wood, one 'female' and softer, the other 'male' and in the shape of a lance. The 'male' piece rested in a groove on the 'female' part and was rotated with an up-and-down movement of the palms of the hands until a fire was lit by friction.

4 AZTEC SOCIETY: ECONOMY, TRIBUTE AND WARFARE

01 Lockhart 1992, p.14.

02 Berdan 1982, pp.56–59.

03 Lockhart 1992, pp.20–28.

04 When distilled, this same 'maguey honey' yields tequila. The process of distillation was introduced by the Spanish.

05 Smith 1996, p.73.

06 The size of Tenochtitlan was extraordinary. Other cities rimming Lake Tetzcoco ranged from fewer than 10,000 to approximately 30,000 residents.

07 Calnek 1972.

08 Chia, a plant of the *Salvia* family, yields small seeds that were typically ground and eaten in the same manner as maize. High in calcium, phosphorus and iron, chia was a nutritious part of the Aztec diet (see Smith 1996, p.69).

09 This seems to have been the case even with obsidian-workers, perhaps surprisingly, given that obsidian blades were such important components of Aztec weaponry.

10 Berdan 1982, p.42.

11 Anderson, Berdan and Lockhart 1976, p.211.

12 Información sobre los tributos 1957; Sahagún 1950–82, vol. 9, p.48.

13 Benavente 1971, p.367.

14 Díaz del Castillo 1956, pp.211–14; Calnek 1976.

15 Netzahualcoyotl was not only a ruler but also a poet and philosopher. He enjoyed a lengthy reign, from 1418 to 1472.

16 Alva Ixtlilxochitl 1975–77, vol. 2, pp. 92–100.

17 Sahagún 1950–82, vol. 8, p. 39.

18 Berdan 1982, p. 73.

19 Codex Mendoza 1992.

20 Their most disastrous defeat came at the hands of the powerful Tarascans to the west. Of the untold thousands of Triple Alliance warriors who fought, a mere 200 stumbled home to Tenochtitlan (see Durán 1964, p. 167).

21 Berdan et al. 1996.

5 THE TEMPLO MAYOR, THE GREAT TEMPLE OF THE AZTECS

01 Durán 1951, p. 42.

02 Durán 1951, pp. 40–41.

03 Chávez Balderas 2002.

04 Matos Moctezuma, Broda and Carrasco 1987.

05 López Austin and López Luján 2001.

06 Matos Moctezuma 1993.

07 López Luján forthcoming.

08 López Luján 1994.

6 ART AT THE TIME OF THE AZTECS

01 Covarrubias 1961, p. 348.

02 Codex Matritense 1907, fol. 144r.

03 León-Portilla 2002, pp. 49–53.

04 Manrique 1960.

05 Sahagún 1988, vol. 2, pp. 652–53.

06 Codex Matritense 1907, fols 117v and 172v–176r.

07 Durán 1995, vol. 1, p. 299.

08 Ibid., p. 300.

09 Marquina 1951, pp. 187–89.

10 García Payón 1979.

11 Taladoire 1981, pp. 283–92.

12 Architectural benches decorated with processions of warriors marching towards the *zacatapayolli*, the ball of straw set with bloody thorns, the supreme symbol of self-sacrifice, were found both on the north and the south sides of the Templo Mayor. Beyer 1955.

13 Pasztory 1983, plate 22, which represents the precinct of the 'First Memorials' at the Templo Mayor, shows the stylistic unity of the sacred buildings with the presence of the architectural dado and the moulding on the bases and the walls of the temples.

14 Codex Tro-Cortesianus 1967, plates 75–76. Codex Fejérváry-Mayer 1971, page 1.

15 This pictorial document represents a section of an indigenous city, probably Tenochtitlan, and shows the boundaries of the land owned by each family, the fields of crops and houses as well as the pyramidal base that corresponds to the local temple, also showing the irrigation ditches and the earth streets. Toussaint, Gómez de Orozco and Fernández 1938, pp. 49–84.

16 Kubler 1986, pp. 64 and 85–89.

17 Townsend 1979, pp. 40–43.

18 Caso 1967, pp. 1–41.

19 Umberger 1981.

20 Solís Olguín 1992, pp. 101–08.

21 López Luján 1995.

22 In the northern area of the Templo Mayor, a courtly precinct was excavated whose architectural plan repeated a Toltec pattern; in the internal and external part of the entrance to the vestibule were located the pair of eagle men (cat. 228) that

corresponded to a pair of figures, unfortunately very fragmented and incomplete, of the god Mictlantecuhtli (cat. 233). Matos Moctezuma 1989, pp. 64–71.

23 In the former Volador, Eduardo Noguera discovered a pyramid filled with more than a thousand ceramic vessels from various traditions. Containers made in Cholula and in the Mixtec area were mixed with Aztec pottery, which proves that they existed at the same time. Solís Olguín and Morales Gómez 1991.

24 Information provided by clay models of bone rasps, discovered during excavation work in Calle de las Escalerillas shows that musicians produced sound using cut-down snail shells joined together with string tied to the ends of the bone. Castillo Tejero and Solís Olguín 1975, p. 13, pl. XII.

25 In the Cave of the Carafe, in Chiapas, textiles were found with Mexican-style multicoloured decoration showing images of deities, particularly Tezcatlipoca. Landa et al. 1988, pp. 18–182.

26 The headdress, or *quetzalapanecayotl*, kept at the Museum für Völkerkunde in Vienna was part of the Ambras Treasure. A 1596 inventory described 15 feathered objects as part of the Austrian empire's treasure. Anders 1970, pp. 32–34.

7 AZTEC CODICES, LITERATURE, POETRY AND PHILOSOPHY

01 Codex Vaticanus 3738 1979, fols 3v–7r.

02 Codex Vaticanus 3738 1979, fols 1v–2r.

03 Sahagún 1979, vol. 2, book 6, fol. 34r.

04 Sahagún 1979, vol. 1, book 3, fols 25r–26r.

05 Codex Fejérváry-Mayer 1971, page 1. See also Alfredo López Austin (p. 33) and Eduardo Matos Moctezuma (pp. 54–55) in this volume.

06 'Legend of the Suns' 1992, pp. 142–62.

07 Sahagún 1979, vol. 1, book 2, fol. 137r.

08 Romances de los Señores 1964, fol. 39v.

09 Cantares Mexicanos 1994, fol. 11v.

10 Cantares Mexicanos 1994, fol. 9r.

11 Historia Tolteca-Chichimeca 1976.

12 Sahagún 1979, vol. 2, book 6, fol. 1r.

13 Cantares Mexicanos 1994, fol. 17r.

14 Cantares Mexicanos 1994, fol. 26r.

15 Ibid.

16 Sahagún 1979, vol. 2, book 6, fols 74v–75v.

17 Cantares Mexicanos 1994, fol. 5v.

18 Cantares Mexicanos 1994, fol. 10v.

19 Cantares Mexicanos 1994, fol. 35v.

8 THE CONQUEST

01 The people whom we know as the Aztecs were described as the 'Mexica' during the fifteenth and sixteenth centuries. The word 'Aztec' seems to come from Aztlan, the city in what is now north-west Mexico from which the Aztecs' patron god, Huitzilopochtli, urged them to depart in search of the site of a settlement of their own. The name 'Aztec' first began to be attached to them in the eighteenth century.

02 Durán 1967, vol. 2, p. 128.

03 Colección de documentos ineditos 1864, vol. 39, p. 415: 'A certain Benito González, a Valencian, said in 1515 "que el dicho

almirante el postrimero viaje que fizo descubrió una tierra dicha Maya…"'.

04 Toribio de Benavente (Motolinía) in García Icazbalceta 1980, vol. 1, p. 65; Sahagún 1950–82, vol. 1, p. 341.

05 Klor de Alva 1981.

06 Closs 1976.

07 Anglería 1989, p. 241, letter to Pope Leo X: 'Eh, tambien vosotros teneis libros? ¡Cómo! Tambien vosotros usáis de caracteres con los cuales os entendéis estando ausentes.' The judge must have been Rodrigo de Corrales from Valladolid.

08 Alvarado de Tezozómoc 1987, pp. 684ff.

09 Ibid.

10 'Otras tierras en el mundo no se habían descubierto mejores', in Díaz del Castillo 1984, vol. 2, p. 321.

11 See the introduction to my *Who's Who of the Conquistadors*, London, 2000.

12 The name Malinche signifies Cortés himself, for it means 'master of Malinalli', but it has often been falsely used to indicate Marina.

13 Díaz del Castillo 1984, vol. 2, p. 515.

14 I am indebted to Teresa Castelló Iturbide's brilliant *El arte plumaria en México*, Mexico City, 1993.

9 EXHIBITIONS AND COLLECTORS OF PRE-HISPANIC MEXICAN ARTEFACTS IN BRITAIN

01 Shelton 1994, p. 190.

02 Brotherston 1979, p. 13.

03 Brotherston 1995, p. 18.

04 Harwood 2002, pp. 25–29. These woodcuts were included in part III, book V, chapter VII, pp. 1066–117 of Purchas 1624.

05 See Brotherston 1995 and Berger 1998 for more details on codices in British collections. Recent facsimiles of codices include Codex Zouche-Nuttall 1992; Codice Fejérváry-Mayer 1994; and Códice Laud 1994. A new facsimile edition of the Codex Aubin, currently being prepared by the University of Oklahoma with a commentary by J. Richard Andrews and Ross Hassig, is expected to be published in 2003.

06 See the transcription of a letter from Captain Nepean to the Earl of Aberdeen, President of the Society of Antiquaries of London, dated 11 July 1842, in Society of Antiquaries of London 1844, pp. 138–43. I am grateful to Clara Bezanilla, Research Assistant at the British Museum, for sharing her research on Captain Nepean with me.

07 The Pitt Rivers collection was originally offered to the British Museum before becoming the Pitt Rivers Museum at the University of Oxford in 1884. The Wellcome Trust distributed their extensive American archaeological collection to numerous British museums, including large donations in 1951 and 1982 to Birmingham Museums and Art Gallery, the British Museum, the Hancock Museum (Newcastle-upon-Tyne), Ipswich Borough Council Museums and Galleries, National Museums of Scotland and the Pitt Rivers Museum. The British Museum purchased 22 objects from the Cowdray collection at auction in London (Sotheby's). These were accessioned in 1946.

08 Graham 1993, p. 62.

09 Agustín de Iturbide (1783–1824) declared himself Emperor of Mexico in 1821. The United States of Mexico was proclaimed a federal republic in 1824. Bullock, on landing in Veracruz in 1823, was granted free passage to Mexico City by Antonio López de Santa Anna, an anti-monarchist fighting for the establishment of a republic.

10 *Six Months' Residence and Travel in Mexico, Containing Remarks on the Present State of New Spain*, London, 1824.

11 Alexander 1985, p. 143.

12 Graham 1993, p. 55.

13 The galleries were situated on the south side of Piccadilly facing Old Bond Street and the Burlington Arcade. Their façade was reputedly inspired by the Temple of Hat-hor at Dendera (Graham 1993, p. 56). They remained a landmark of London entertainment until its demolition in 1905. Egyptian House, 170–173 Piccadilly, was built on its site (Honour 1954, p. 39).

14 Both of these objects are illustrated in Bullock 1824, as are some of the other objects in the British Museum collection, including stone sculptures of Chalchiuhtlicue and Xochipilli.

15 These casts were later donated to the Society of Antiquaries of Scotland by E. W. A. Drummond Hay (Graham 1993, p. 63).

16 Among the exhibits were a number of original codices that Bullock had borrowed from the Mexican government. An enlarged copy of the Codex Boturini (which recounts the migration of the Mexica from their mythical home of Aztlan to the foundation of Tenochtitlan) was produced for Bullock by Agostino Aglio (1777–1857), who also produced engravings of the exhibition for the catalogue. These were seen by Edward King, Lord Kingsborough (1795–1837), who later commissioned Aglio to reproduce a number of codices for his monumental nine-volume publication *The Antiquities of Mexico, Comprising Facsimiles of Ancient Mexican Painting and Hieroglyphs*, London, 1831–48.

17 Many items were purchased by the Reverend Professor William Buckland, Dean of Westminster and Professor of Geology at the University of Oxford, and donated to the British Museum.

18 See John Lloyd Stephens and Frederick Catherwood, *Views of Ancient Monuments in Central America, Chiapas and Yucatan*, London, 1844, and the same authors' *Incidents of Travel in Central America, Chiapas and Yucatan…Illustrated by Numerous Engravings…Twelfth Edition*, London, 1854.

19 See Mexico City 1996 and King 1996 for more details on these and other artists.

20 Stocking 1985, p. 5.

21 'Additions of the British Museum', *Illustrated London News*, no. 257, vol. 10, 3 April 1847.

22 As can be seen in Sotheby and Wilkinson 1859, these three objects were in the collection formed by the German Bram Hertz, a long-time resident of London, and sold by Joseph Mayer (1803–1886), who acquired the collection through Sotheby and Wilkinson of the Strand as part of a nine-day sale. Christy paid a total of £113 for lots 1,834 (inlaid mosaic mask: £32), 1,835 (mosaic sacrificial knife: £41), and 1,836 (decorated human skull: £40) on 16 February 1859.

23 Maudslay contributed the six-volume section 'Archaeology' to the comprehensive *Biologia Centrali-Americana*. With his wife, Anne Cary Maudslay, he published *A Glimpse at Guatemala…* as a more accessible account of their seven voyages between 1881 and 1894. The casts were originally displayed and stored at the Victoria & Albert Museum in London before being integrated into the British Museum's collections. Copies of the casts were made for the Trocadéro Museum, Paris, and the American Museum of Natural History, New York.

24 The catalogue (London 1953) lists 1,243 objects, excluding the popular art section, of which 101 were classified as Aztec. Thirteen objects in this section were on loan from the British Museum.

25 Ruiz Cortines, like his predecessor, Miguel Alemán, 'pledged to foster economic growth in general and large-scale industrialisation in particular' (Meyer and Sherman 1979, p. 639) and no doubt used the exhibition to increase Mexico's international profile in the postwar years.

26 Tate Gallery Archive: TG92/97/1, p. 5.

27 Bernard Denvir, *Daily Herald*, 4 March 1953.

28 *London Evening News*, 3 March 1953.

29 Pierre Jeannerat, *Daily Mail*, 4 March 1953.

30 As a consequence Fernando Gamboa, director of the exhibition, and Dr Andrés Iduarte, Director of the Instituto Nacional de Bellas Artes (INBA), were awarded the CBE, and Susana Gamboa, and Luis Aveleyra Arroyo de Anda, of the Instituto Nacional de Antropología e Historia (INAH), the OBE. The honours were conferred by the British ambassador on 14 August 1953 in Mexico City. Tate Gallery Archive: TG92/97/1, p. 100.

31 This ambitious programme has recently seen the opening of the North American and African galleries at Bloomsbury, and current renovation of the King's Library following the transfer of its contents to the British Library at St Pancras.

32 This loan exhibition, arranged in collaboration with the Mexican National Tourist Council, was also shown at the Museum für Völkerkunde, Frankfurt am Main (1972), and the Nationalmuseum, Stockholm (1973).

33 Moore 1981, p. 73.

34 London 1985, p. 9.

35 McVicker 1989, p. 16.

36 Antwerp 1992 and Brooklyn 1996 examined the art of the early colonial period more specifically.

37 Held from 17 September to 6 December 1992, 'The Art of Ancient Mexico' had visited venues in Venice, Paris, Madrid, Berlin and Tokyo over a period of two years before arriving in London. See Oriana Baddeley's supplement to the catalogue (London 1992) for details of the 56 objects from the British Museum included in the exhibition.

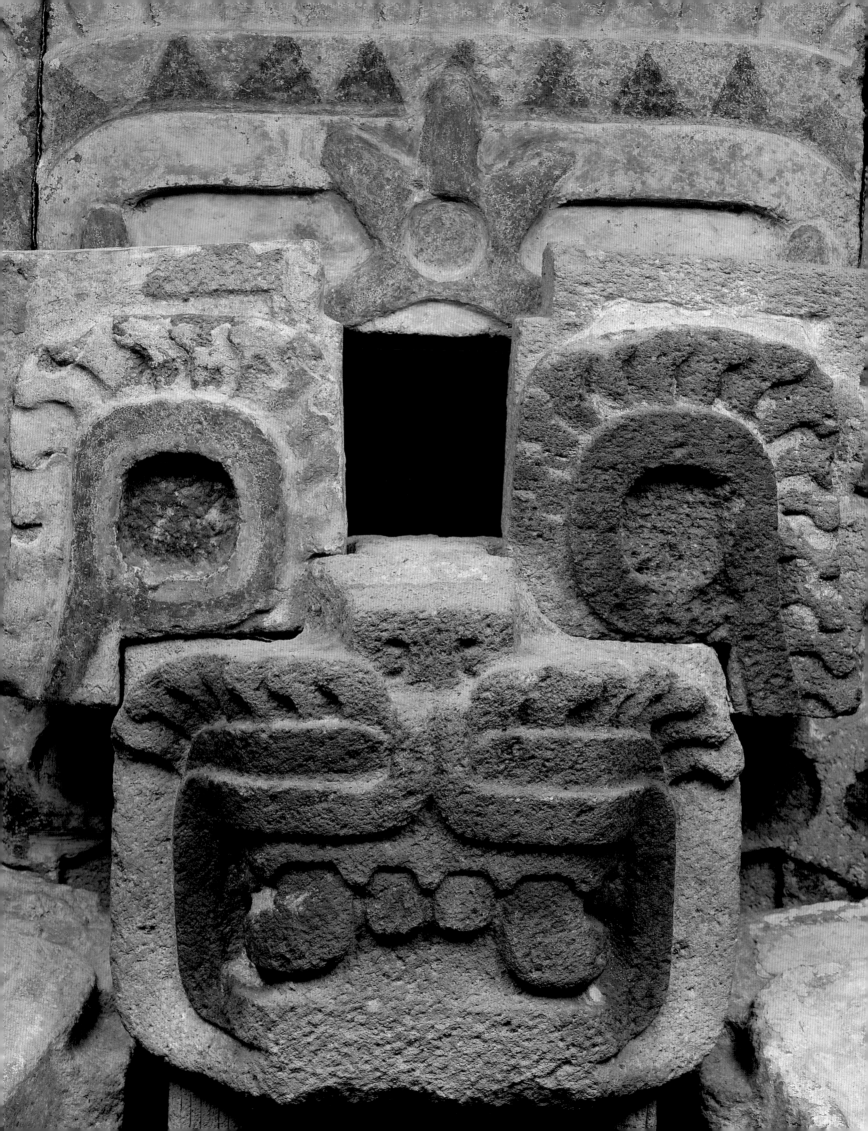

1 | ANTECEDENTS

The Aztecs' view of the past was determined by their relatively late arrival on the Mesoamerican scene. Although they described their ancestors as nomads who hunted with bows and arrows and lived in caves, their landscape was littered with magnificent ruins of cities with monumental architecture and sculpture. They had a strongly romantic view of their predecessors, who, they imagined, lived in a Golden Age. At Tula, so their lore related, cotton grew in many bright colours.

The Aztecs probably knew little of the antiquity and nature of Olmec culture, the first Mesoamerican civilisation to erect colossal monuments, from *c.* 1200 to 500 BC. The Olmec centres, notable for powerful, colossal stone heads, were located in the region of the Gulf of Mexico and the Isthmus of Tehuantepec, and were not discovered until modern times. Closer to home, the Aztecs were familiar with the Olmec-style rock carvings of Chalcatzingo in the state of Morelos; these they turned into a shrine of their own. Small Olmec objects in jade and greenstone, such as masks and figurines (cats 1, 2), were handed down as heirlooms. Scholars are hard put to interpret Olmec images: with strikingly peculiar features, such as angular mouths, some are thought to represent rulers, others supernaturals.

The Aztecs subsumed all ancient civilisations into one, which they called Tollan. According to sixteenth-century texts, Tollan was a great centre that flourished immediately before the rise of the Aztecs. It was identified, both by the Aztecs and by modern scholars, with the ruins of a number of cities, especially Teotihuacan and Tula. Hence, the Teotihuacan civilisation was long thought to have existed hundreds of years later than we now know to have been the case (*c.* 100 BC to AD 650, predating the Aztecs by 600 years).

Ever since the Olmecs, Mesoamerican rulers and élites had perpetuated a tradition of monumental art that represented rulers and/or their captives, as well as their patron deities. In all cases, political and

religious ideas were intermixed. Oddly, Teotihuacan did not follow this pattern. Images of one of the few deities found there, Huehueteotl ('old, old god'), a crouching figure of a man with a brazier on his head (cat. 5), were common, and were imitated and reinterpreted by Aztec sculptors. The recent find of a mythological feline (cat. 17) indicates the allegorical and metaphorical nature of much of this art. The most common stone carvings from Teotihuacan are masks (cats 10, 12). To the Aztecs these were ancient treasures, and some were reused with the addition of Aztec-style mosaic (cats 11, 13). Although the function of the Teotihuacan masks was funerary, they are not found in burials. It is now widely thought that they were attached to perishable figures that were dressed in textiles and feathers and used to represent nature spirits and/or ancestors. It seems that the sculptors of Teotihuacan preferred to glorify the many – perhaps lineage heads – rather than the ruling few, an anomaly in Mesoamerica.

The Aztecs had no reliable information about Teotihuacan. The immense scale of the architecture there made them feel that its builders must have been superhuman, hence their name for it, 'place of the gods'. They imagined that the most recent creation of the world had taken place there. They saw that parts of the ruins were on a more human scale and named the avenue the Avenue of the Dead, thinking that it was flanked by the tombs of ancient kings. They admired the grid plan of Teotihuacan and imitated it in their own capital. In the Aztec migration story, Teotihuacan is also associated with laws: the wandering tribe sojourned in the city and learned the laws of civilised life there before settling in the Basin of Mexico and founding Tenochtitlan.

The engraved plaque of an elegant woman with raised hands and a reptile eye-glyph from Ixtapaluca (cat. 14) is close in style to Xochicalco in Morelos and is probably of the same date. Although a small site, Xochicalco was famous for its Temple of the Feathered Serpent, a building that is related to Teotihuacan. Xochicalco flourished towards the end of Teotihuacan and the beginning of Tula. The ruins of Xochicalco were visited by the Aztecs, and several important events in Aztec legend take place there. The Xochicalco style was eclectic and combined Teotihuacan and Maya features. The reptile-eye glyph, perhaps a day-sign as well as a name, is found at Teotihuacan. In general, however, few glyphs occur in Teotihuacan and Tula images. The use of glyphs and inscriptions on monuments is a southern Mesoamerican trait, which was taken up extensively by the Aztecs.

Tula, perhaps 'Tollan', was the ancient site best known to the Aztecs, and its sculpture was the most admired by them despite the fact that it is often roughly carved, not highly polished and iconographically simple. In fact, Aztec copies of Toltec sculpture are much finer than the originals, which nevertheless possess an impressive austerity as a result of their basis in geometric forms with strong horizontals and verticals. Perhaps Tula, lasting only a few hundred years on the precarious northern frontier of Mesoamerica, had political or military reasons for expressing great power in its monuments.

Tula was the city of the legendary king Quetzalcoatl, for the Aztecs the epitome of wisdom and the most legitimate dynastic ruler of the Basin of Mexico. The Aztecs did not begin to be ruled by a single individual until later in their history when they married into Quetzalcoatl's line. According to legend, Quetzalcoatl was driven from Tula in a coup and promised to return to retake his empire. The fact that Hernán Cortés arrived from the east, the direction in which Quetzalcoatl had vanished, and met Motecuhzoma II on Quetzalcoatl's name day, has often been seen as a crucial factor in the downfall of the Aztec empire.

The Aztecs had a great deal to learn from the arts of their predecessors and chose at will from them in creating their new, synthetic style. They were undoubtedly more familiar with the arts of the past than with the cultures that had produced them. They knew nothing, for instance, of the Olmec personality cult of the ruler; of the Teotihuacan experiment in collective rule; of Tula's contacts with Chichén Itzá; and, probably, of the nature of the Maya city-states. Yet they did have a strong feeling that their culture was in some way less significant than those of their predecessors, and this sense of inferiority possibly fuelled their vacillation in the face of the Spanish who, they may have thought, were the people of Quetzalcoatl who had come to reclaim their rightful and glorious inheritance.

1 Anthropomorphic figure

c. 800 BC, Olmec
Jade and cinnabar, 52 × 29 cm

Museo Regional de Puebla, CONACULTA-INAH,
10-203321

2 Mask

c. 900–400 BC, Olmec
Jade, 15.5 × 13 × 7 cm

Museo de Antropología de Xalapa
de la Universidad Veracruzana,
Veracruz, Reg. Pj. 49-4013

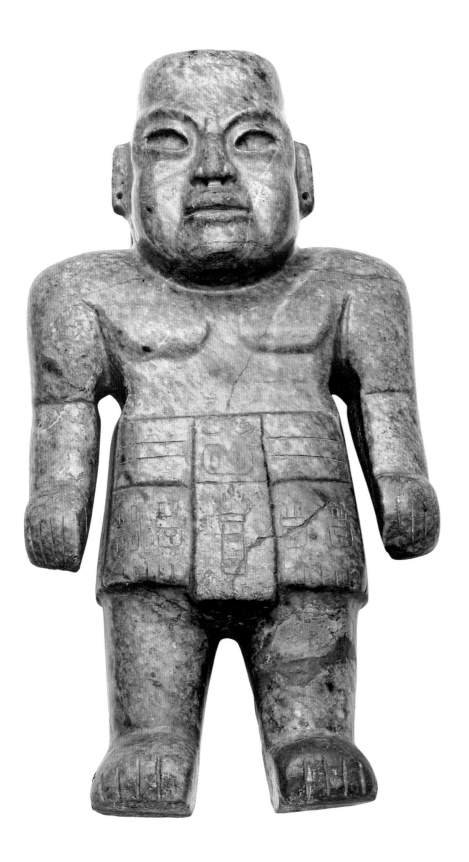

4 Goblet

c. 1100, Maya
Fired clay, height 31 cm,
diameter 12.5 cm

Museo Regional de Antropología
Carlos Pellicer, Villahermosa, 64

3 Plaque in the form
of a Maya warrior

c. 250–700, Maya
Shell, 9.5 × 5.8 × 0.8 cm

Collections of The Field Museum,
Chicago, 95075

5 Huehueteotl

c. 450, Teotihuacan
Stone, height 74.5 cm, diameter 80 cm

Museo Nacional de Antropología,
Mexico City, CONACULTA-INAH, 10-79920

7 Standing goddess

c. 250–650, Teotihuacan
Volcanic stone and traces of paint,
height 91.4 cm

Philadelphia Museum of Art, The Louise and Walter
Arensberg Collection, 1950, 1950-134-282

6 Urn

c. 400, Teotihuacan
Greenstone, 24.5 × 14 cm

Museo Nacional de Antropología, Mexico City,
CONACULTA-INAH, 10-9626

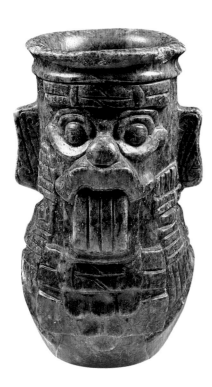

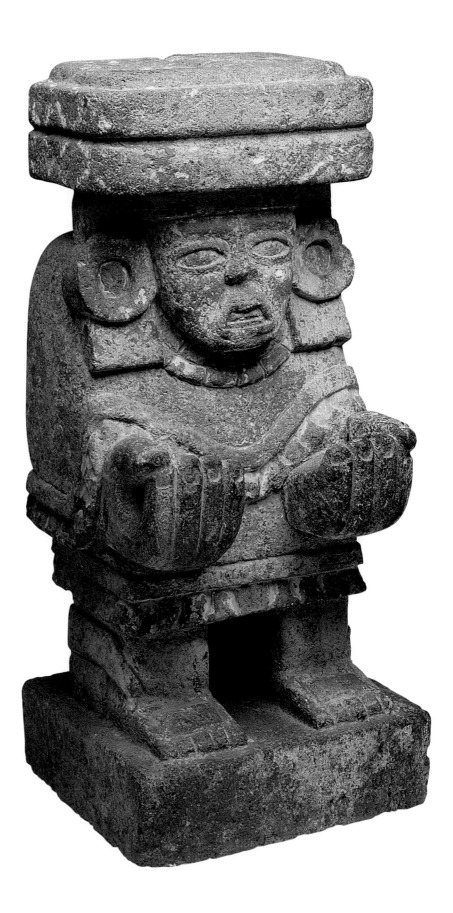

9 Tripod vessel

c. 500, Teotihuacan
Fired clay and stucco, height 25 cm,
diameter 28 cm

Museo de Sitio de Teotihuacan,
CONACULTA-INAH, 10-336713

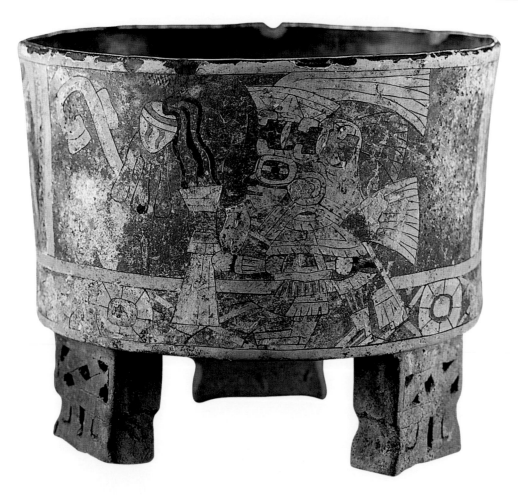

8 Tripod bowl

c. 450, Teotihuacan
Fired clay, stucco and paint,
height 15 cm, diameter 16.5 cm

Museo Nacional de Antropología, Mexico City,
CONACULTA-INAH, 10-79930

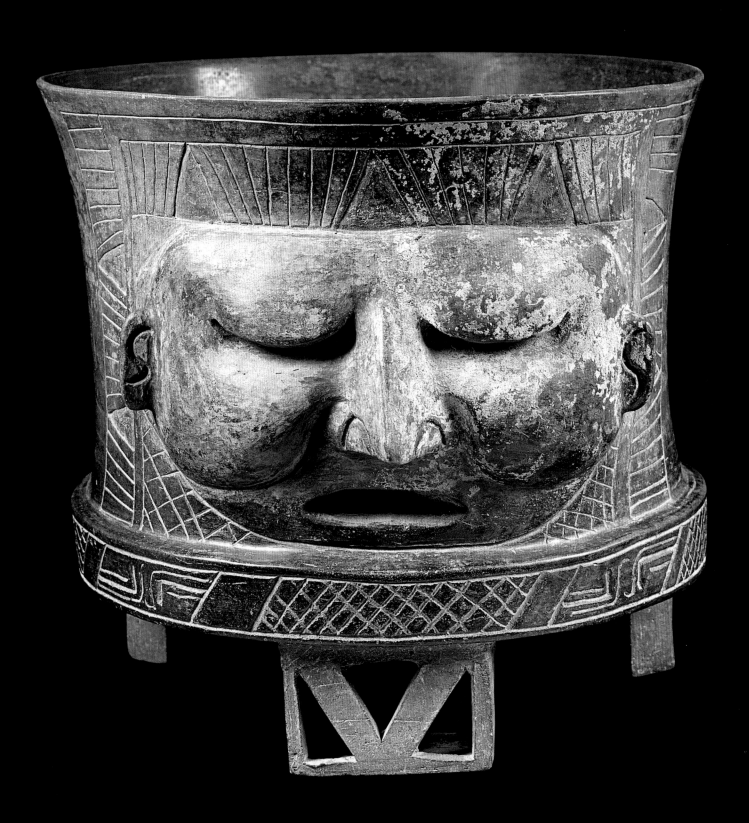

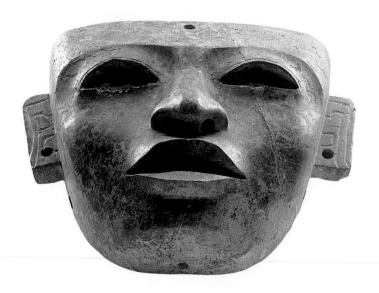

10 Mask

c. 450–650, Teotihuacan
Stone, 22.5 × 28 cm

Museo Nacional de Antropología,
Mexico City, CONACULTA-INAH,
10-9628

13 Mask

c. 450, Teotihuacan
Stone, turquoise, obsidian
and shell, 21.5 × 20 cm

Museo Nacional de Antropología,
Mexico City, CONACULTA-INAH, 10-9630

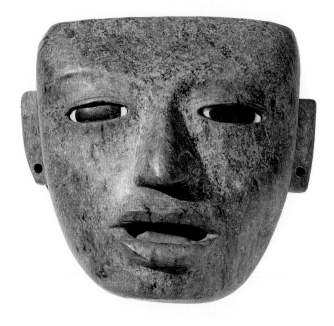

11 Mask

c. 250–600, Teotihuacan
Granitic stone, iron pyrite
and shell inlay,
21.6 × 24 × 10 cm

Philadelphia Museum of Art,
The Louise and Walter Arensberg
Collection, 1950, 1950-134-947

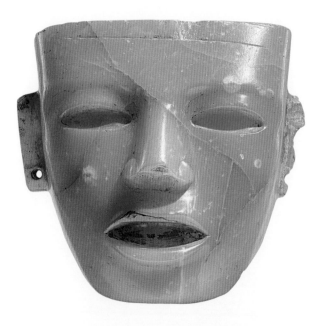

12 Mask

c. 250–600, Teotihuacan
Greenstone,
15.8 × 17.3 × 5 cm

Museo degli Argenti, Florence,
Gemme 824

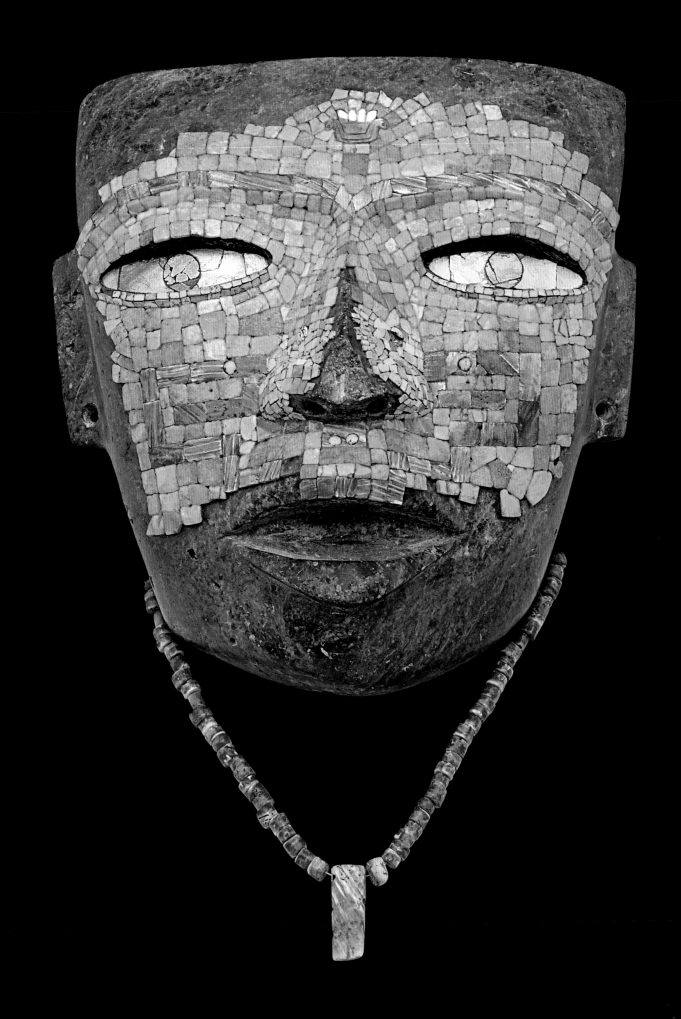

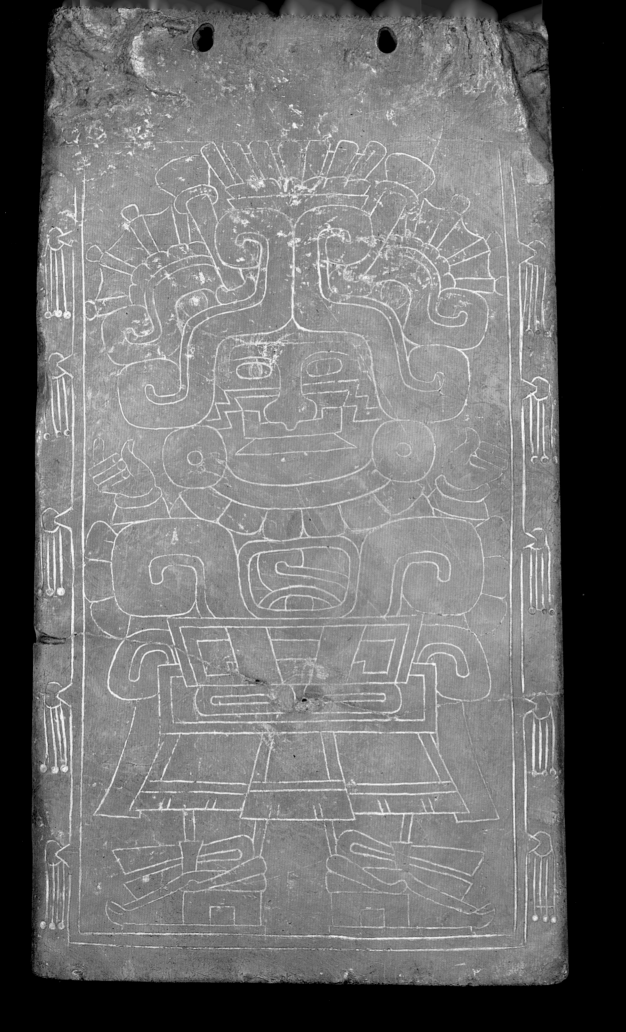

14 Plaque with an image of a
goddess with a reptile-eye glyph

c. 250–700, Teotihuacan
Pale green, translucent onyx,
29 × 16 × 3 cm

Collections of The Field Museum, Chicago,
23913

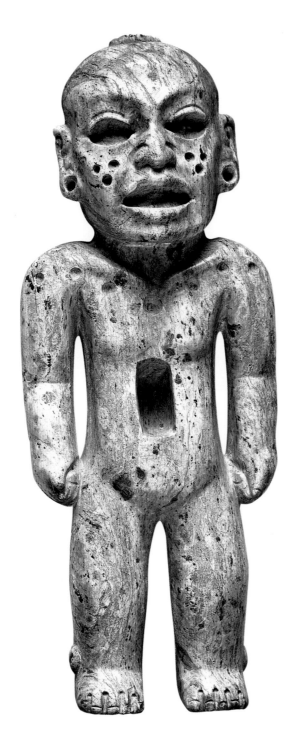

15 Anthropomorphic figure

c. 400, Teotihuacan
Greenstone, 25.5 × 10 cm

Museo Nacional de Antropología, Mexico City,
CONACULTA-INAH, 10-2562

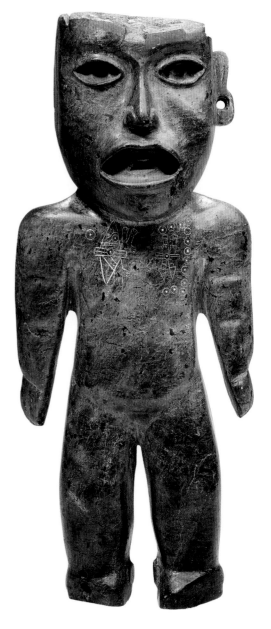

16 Anthropomorphic figure

c. 400–600, Teotihuacan
Serpentine, height 34 cm

Museum für Völkerkunde, Hamburg, B264

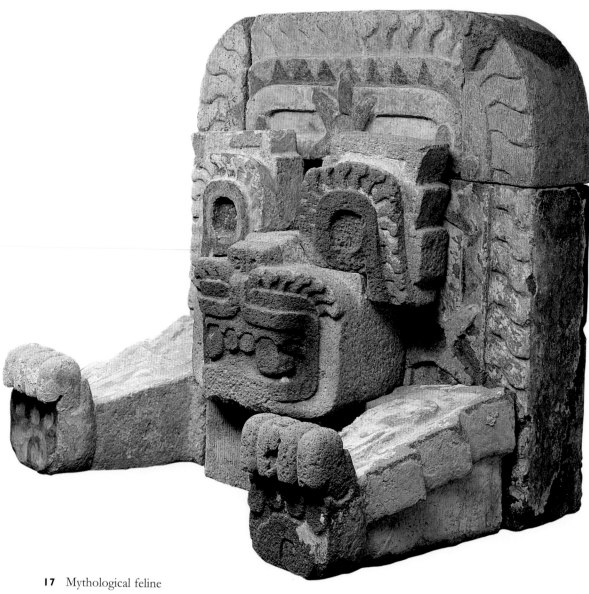

19 Model of a temple

c. 1500, Aztec
Fired clay and stucco,
31.5 × 35 × 23 cm

Museo de Sitio de Tula,
CONACULTA-INAH,
10-215143

17 Mythological feline

c. 400, Teotihuacan
Volcanic stone, stucco and paint,
96.5 × 97.5 × 74.5 cm

Museo Nacional de Antropología,
Mexico City, CONACULTA-INAH, 10-626269 0/10

18 Offering vessel in the form
of an ocelot

c. 400–600, Teotihuacan
Calcite onyx, 16 × 31 × 33.5 cm

Trustees of the British Museum, London,
Ethno. 1926-22

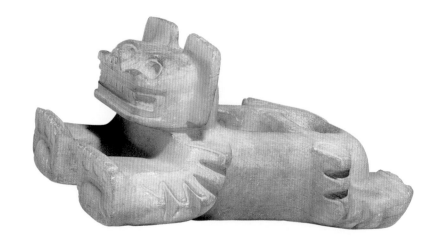

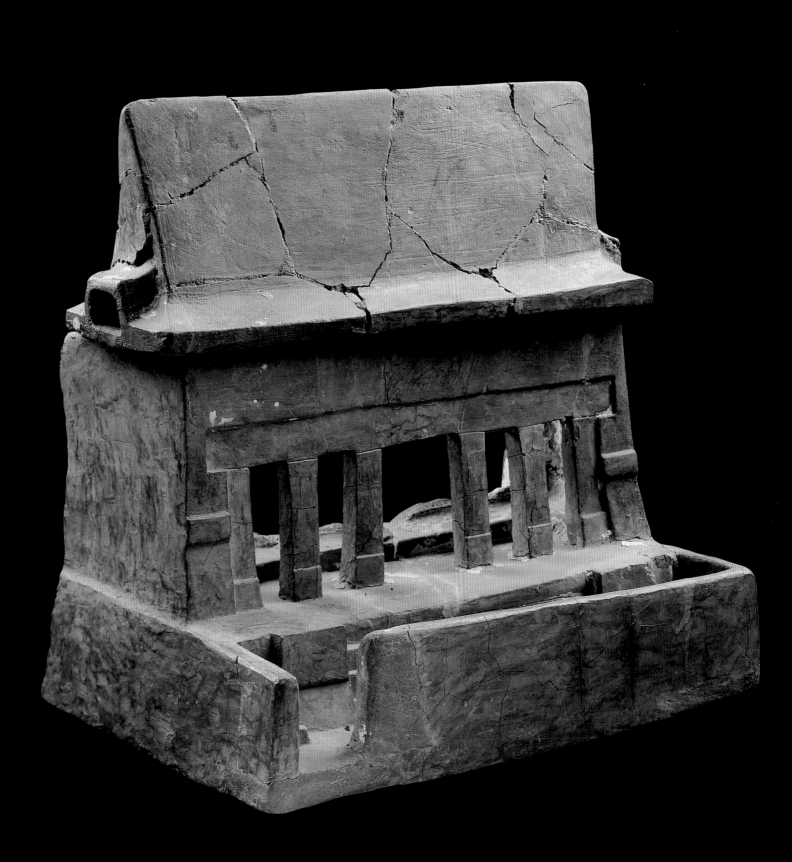

20 *Chacmool*

c. 1100, Toltec
Stone, 85 × 120 × 54 cm

Museo de Sitio de Tula,
CONACULTA-INAH, 10-215198

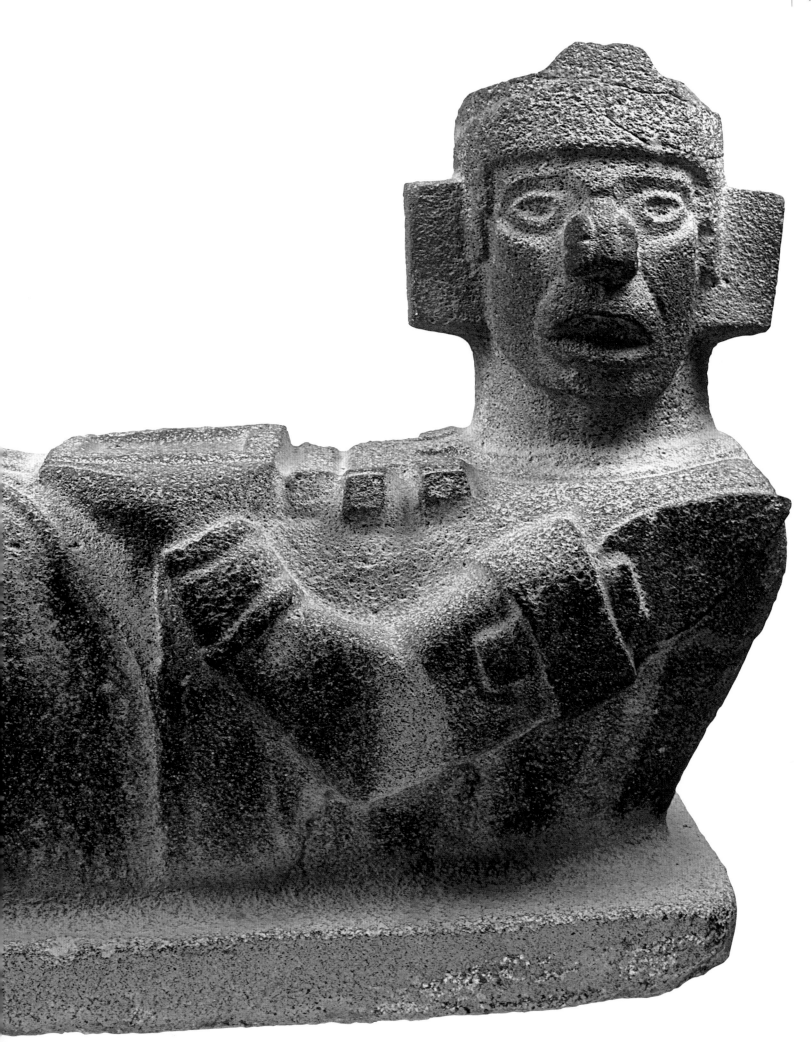

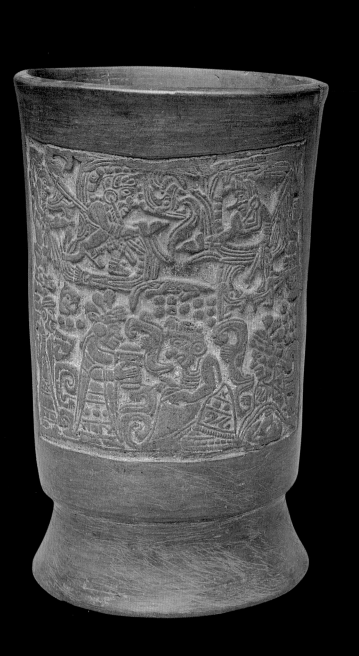
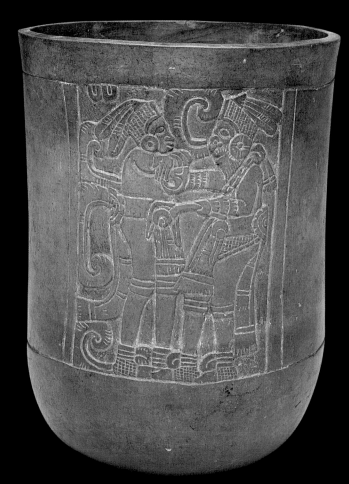

21 Vessel

c. 950–1150, Toltec
Fired clay, height 24.5 cm,
diameter 19 cm

Museum für Völkerkunde Wien
(Kunsthistorisches Museum mit MVK und
ÖTM), Vienna, 60.303, Becker Collection

22 Vessel

c. 1250–1521, Toltec–Mixtec
Fired clay, height 24.7 cm,
diameter 15.3 cm

Museum für Völkerkunde Wien
(Kunsthistorisches Museum mit MVK und
ÖTM), Vienna, 14.698, Bilimek Collection

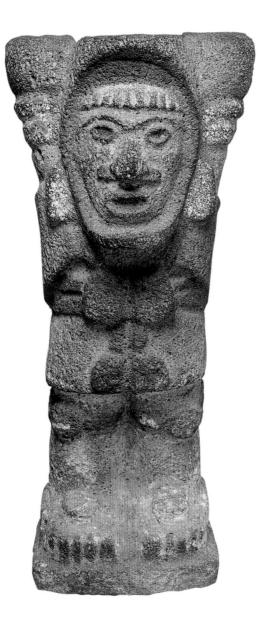

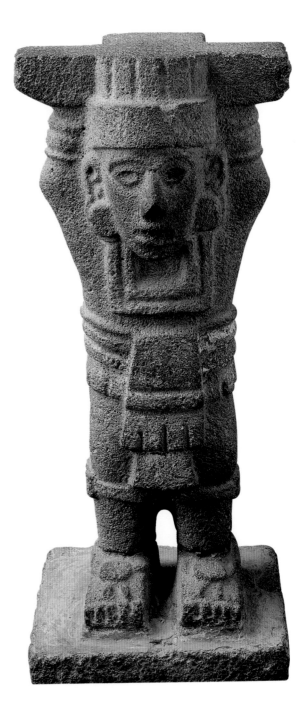

23 Atlantean figure

c. 950–1150, Toltec
Volcanic stone and paint,
81 × 36 × 31 cm

Museum für Völkerkunde Wien
(Kunsthistorisches Museum mit MVK und
ÖTM), Vienna, 59.143, Becker Collection

24 Atlantean figure

c. 1100, Toltec
Stone and paint, 94.5 × 38.5 × 34 cm

Museo de Sitio de Tula, CONACULTA-INAH,
10-215119

25 Eagle reliefs

c. 1000–1300, Toltec
Volcanic stone (andesite/dacite)
and remains of paint,
69.8 × 74.9 cm and 69.8 × 77.5 cm

Lent by The Metropolitan Museum of Art,
New York, Gift of Frederic E. Church, 1893,
93.27.1, 2

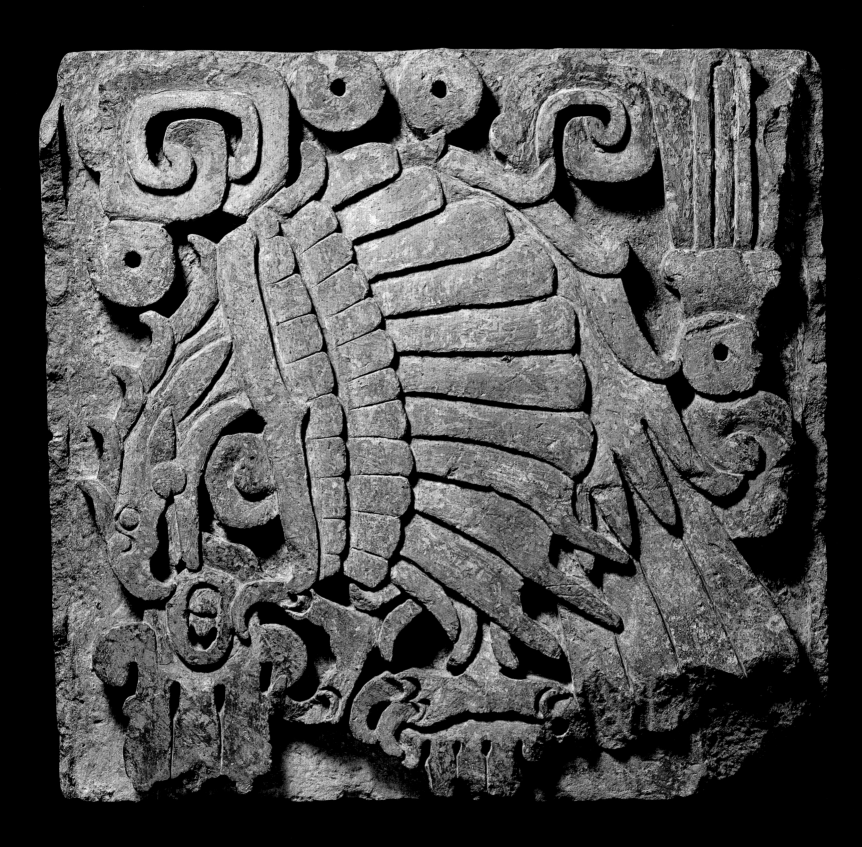

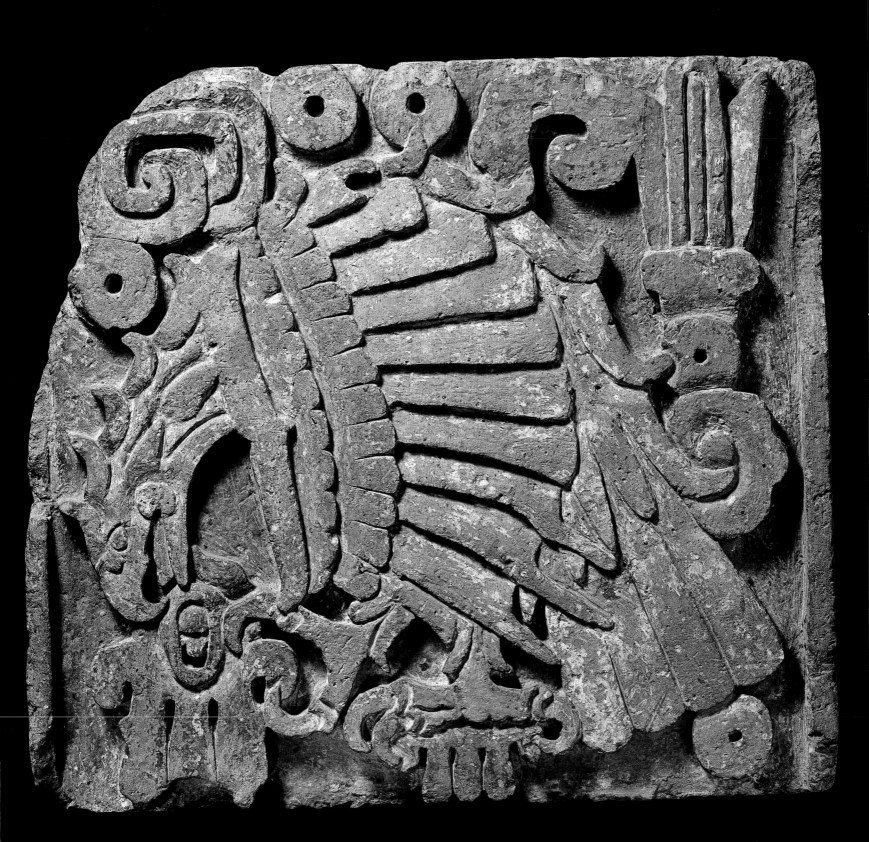

27 Deified warrior

c. 1500, Aztec
Stone, 119 × 48 × 34.5 cm

Museo Nacional de Antropología,
Mexico City, CONACULTA-INAH,
10-48555

26 Plaque with an image
of a bleeding heart

c. 1100, Toltec
Stone and stucco, 61.5 × 60 × 7 cm

Museo Nacional de Antropología, Mexico City,
CONACULTA-INAH, 10-81752

28–31 Deified warriors

c. 1500, Aztec
Stone, 120 × 42 × 37 cm,
120 × 41 × 39 cm,
119 × 38 × 34 cm and
122 × 42 × 39 cm

Museo Nacional de Antropología,
Mexico City, CONACULTA-INAH,
10-81768, 10-9774, 10-81769
and 10-81767

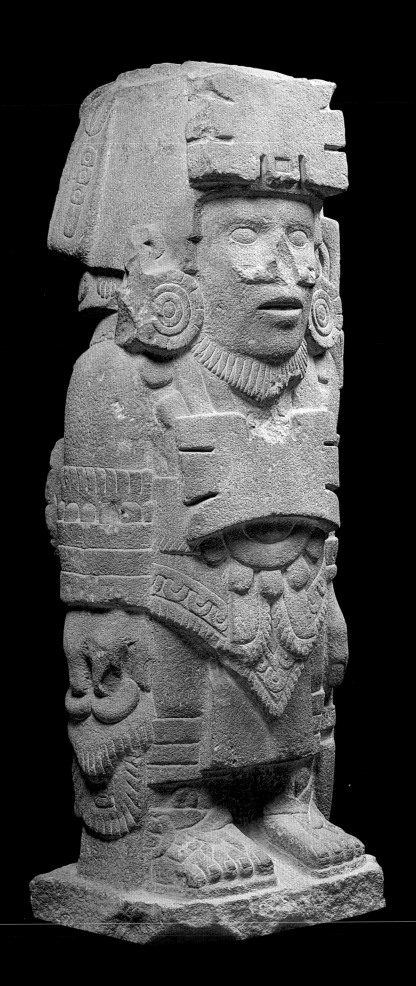

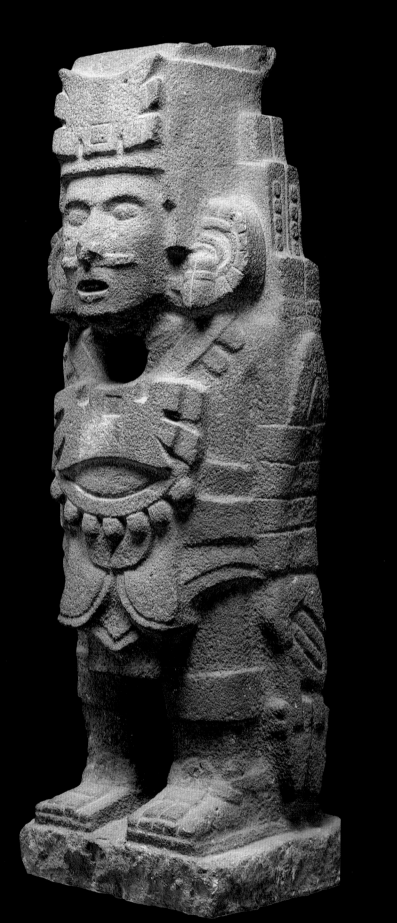
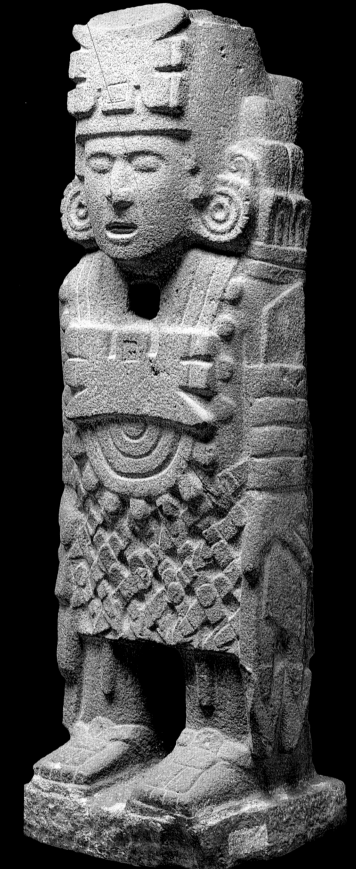

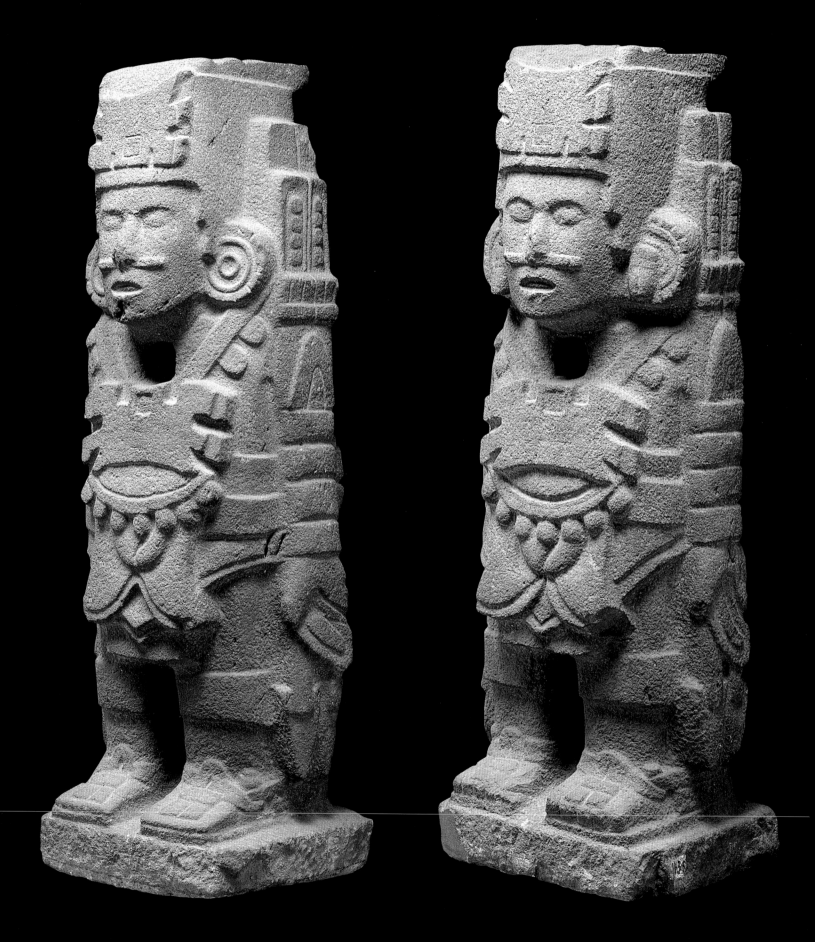

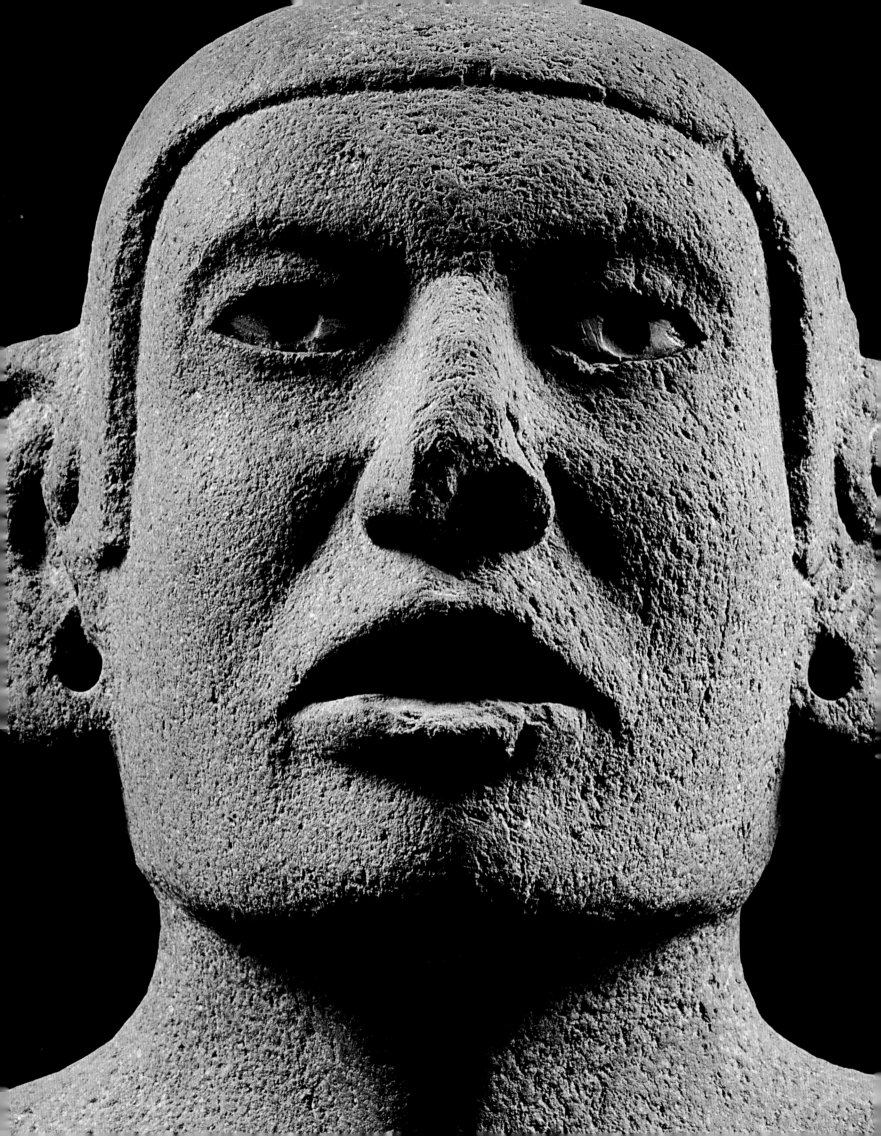

II | THE HUMAN FIGURE

Curiosity about civilisations different from our own must always include a desire to know about the people themselves. What did they look like? What place did they occupy in their own cosmology? By what emotions were they driven? Most human figures in Aztec art are male. Despite their static poses, be they seated or standing, a suggestion of imminent movement is apparent, and mouths are open as if in speech. Their hand gestures are also eloquent communicators, and the eyes, in most cases now void, were once inlaid with shell or stone to achieve greater realism and direct engagement with the viewer. The stone head (cat. 48), with its shell teeth and startling eyes flecked with red, is thought to represent a man intoxicated with the alcoholic beverage *pulque*.

Yet no faces in Aztec art can be regarded as portraits. In a society in which the individual was subordinate to the group and all events were controlled by the gods, only the *tlatoque*, the great rulers, might be immortalised in art. Even then, as in the codices, they are identified not by facial or bodily characteristics but by their name-glyphs. No statues of the Aztec rulers have survived, and the relief of Motecuhzoma Ihuilcamina that we see being carved in Chapultepec in the Codex Durán (cat. 343) was in all probability destroyed by the Spanish. Such figures should be understood instead as representations of an ideal.

Perhaps the seated or standing nude and semi-nude male figures (cats 33–35, 37) acted as guardians or standard-bearers in shrines, as was suggested by Esther Pasztory in her *Aztec Art* (1983). They may have been dressed in colourful clothing with painted and perfumed bodies hung with jewels. Many ear lobes are pierced in order to take ornaments. (In some cases, such as cat. 35, the hands of standing males grasp a vanished staff.) They may also have been carried in procession in the many festivals that regulated the daily and seasonal life of the Aztecs.

For the Aztecs, religious power could be exercised through bodily transformation. This central tenet of Aztec belief is shown most vividly in the codices, where priests elaborately dressed as gods assume the attributes of the deities they represent. The hand gestures, grave facial expressions and controlled bodily stance of small votive statues can in this context be read as an expression of their religious role as mediators between the people and their gods. They were almost certainly placed in domestic shrines, in public spaces and alongside principal routes, much as is seen in Catholic countries today.

Physical beauty was held to be a sign of favour from the gods. The Franciscan friar Bernardino de Sahagún recorded that it marked out individuals as candidates for human sacrifice to the gods. What was given had to be returned in the cycle of death and rebirth: 'For he who was chosen was of fair countenance, of good understanding and quick, of clean body – slender like a reed; long and thin like a stout cane; well built; not of overfed body, not corpulent, and neither very small nor exceedingly tall…like something smoothed, like a tomato, or like a pebble, as if hewn of wood. [He did] not [have] curly hair, [but] straight, long hair; no scabs, pustules or boils on the forehead, nor large-headed…' (Sahagún 1950–82, vol. 2, pp. 64, 66).

This, then, is the ideal type depicted in the masks and in the statues of youths and men, their faces emphasised by being made larger than the rest of their bodies. What seems to have been valued in art, more than ideal form, was an appearance of vitality, of the divine spark of life. The Aztecs' quest for realism in their art distinguishes their representation of the human form from that of their predecessors, the Olmecs, the Toltecs and the people of Teotihuacan. It was an impetus that challenged sculptors to depict the different ages of man from youth to old age.

The old men, with their furrowed brows and prominent ribcages, may be representations of the fire god Xiuhtecuhtli. One of his personifications was as Huehueteotl ('old, old god'), who is shown with a brazier on his head, as in the figure found at Teotihuacan (cat. 5). Indeed, an alternative reading of the more youthful figures is as gods rather than guardians, in this case goddesses of maize shown with anthropomorphic features. The exceptionally finely carved standing goddess with her tasselled headdress (cat. 38) has a folded paper fan at the back of her head. Unlike the other maize goddesses with their large paper headdresses resembling houses or granaries, her diamond-patterned skirt is fastened with a serpent belt.

Very little Aztec sculpture in wood has survived the alternating wet and dry seasons of Mesoamerica. Quite exceptional therefore is the standing fertility goddess (cat. 41) who still has remains of the shell inlays used for her eyes and teeth. Her hands, cupped under her breasts, have beautifully carved fingers and fingernails. The so-called Venus of Tetzcoco (cat. 40) is unique. Nearly 1.5 metres tall, she is the only known extant standing female nude in Aztec art. Her flexed knees and open mouth suggest tension, if not suffering. In common with some other statues (see cats 36, 43) there is a cavity in her chest that probably held a precious stone secured by paste. Again, it is likely that she was dressed in a costume.

Together with these statues, mainly carved of the volcanic rock native to the Basin of Mexico, are shown masks of precious greenstone, obsidian, alabaster and gilded wood (cats 49–53). As Esther Pasztory has pointed out: 'These masks represent the Aztec facial ideal: a long head, wide mouth, straight nose, and eyebrows set close to the eyes. In all cases the ears are carefully detailed with a spiral form and the lobes have holes for the insertion of ornaments' (Pasztory 1983, p. 257). The eye-sockets will originally have contained inlays. Doubtless based on human features although they almost certainly depict gods, these masks bring us close to an encounter with Aztec faces. Poignantly, they recall the Nahuatl poem about the afterlife:

Will I have to go like the flowers that perish?
Will nothing remain of my name?
Nothing of my fame here on earth?
At least my flowers, at least my songs!
Earth is the region of the fleeting moment.
Is it also thus in the place
where in some way one lives?
Is there joy there, is there friendship?
Or is it only here on earth
we come to know our faces?
(León-Portilla 1969, pp. 81–82)

32 Ehecatl-Quetzalcoatl

c. 1500, Aztec
Basalt, 176 × 56 × 50 cm

Instituto Mexiquense de Cultura:
Museo de Antropología e
Historia del Estado de México,
Toluca, A-36229 10-109262

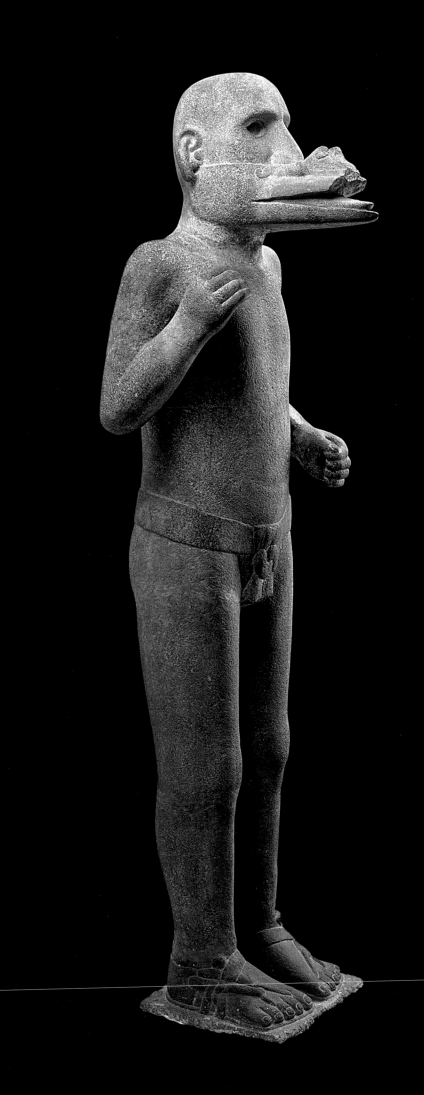

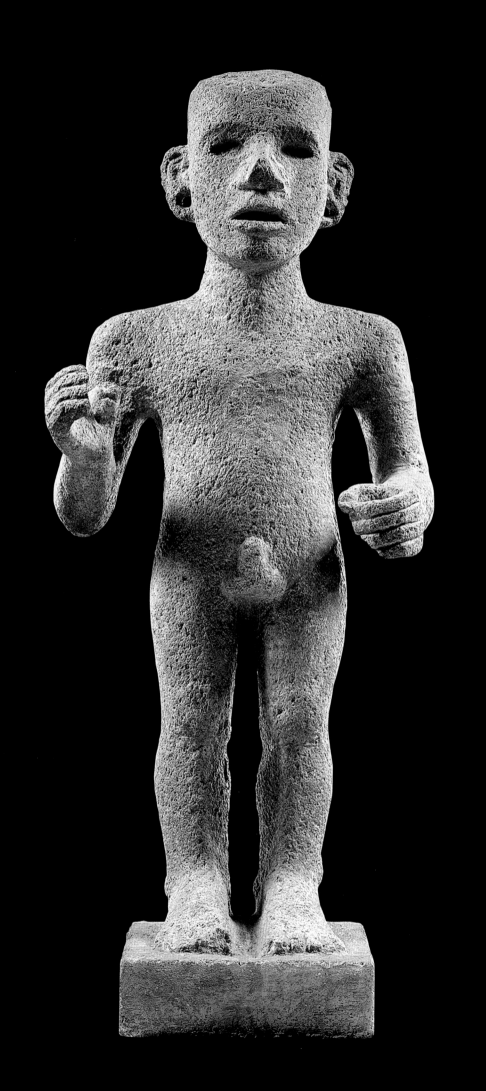

33 Young man

c. 1500, Aztec
Stone, 55 × 20 × 15 cm

Museo Nacional de Antropología,
Mexico City, CONACULTA-INAH, 10-1121

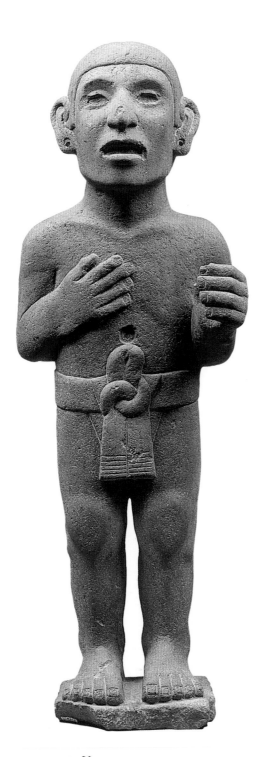

34 Young man

c. 1500, Aztec
Stone, 80 × 28 × 19 cm

Museo Nacional de Antropología, Mexico City,
CONACULTA-INAH, 10-220926

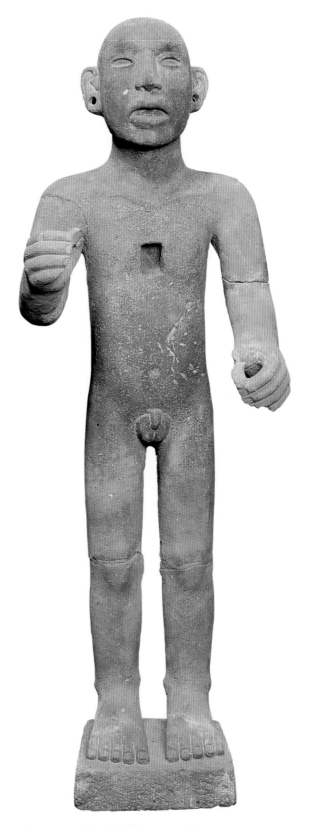

35 Standing male nude

c. 1400–1521, Aztec
Grey basalt, 107.5 × 37 × 25 cm

Peabody Museum of Natural History, Yale University,
New Haven, ANT.008525 (Avery Judd Skilton collection)

37 Huehueteotl

c. 1500, Aztec
Stone, 48 × 23 cm

Museo Nacional de Antropología,
Mexico City, CONACULTA-INAH,
10-220145

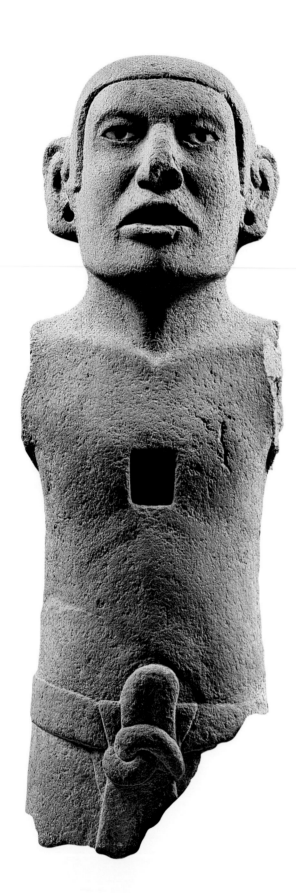

36 Male head and torso

c. 1500, Aztec
Stone and white shell, 63 × 20 cm

Museo Nacional de Antropología, Mexico City,
CONACULTA-INAH, 10-40607

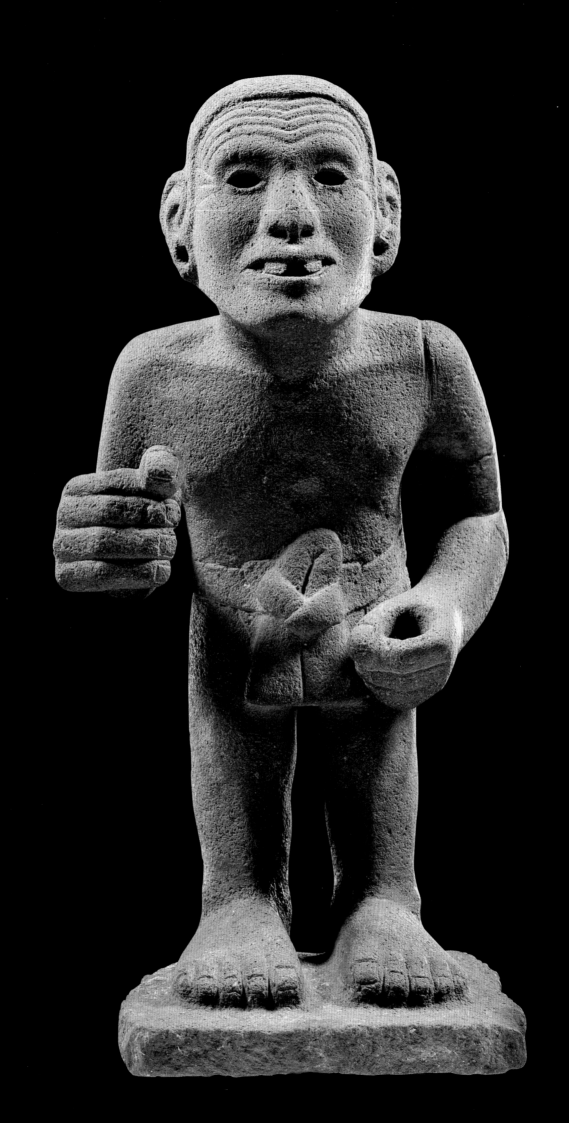

38 Chalchiuhtlicue

c. 1500, Aztec
Diorite, 85 × 37 × 25 cm

Museo Nacional de Antropología,
Mexico City, CONACULTA-INAH,
10-82215

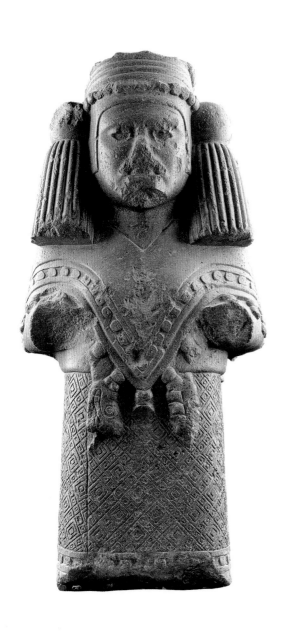

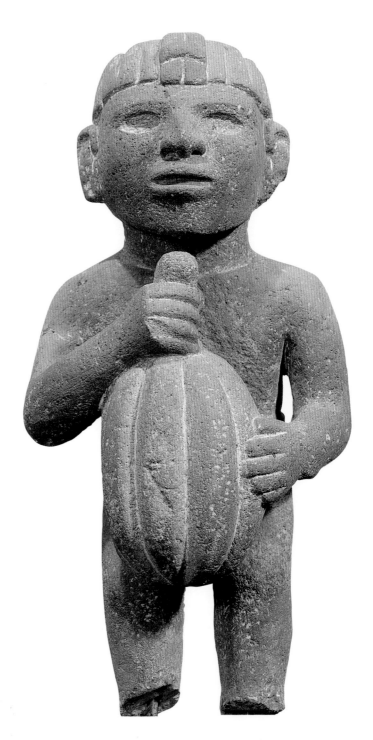

39 Man carrying a cacao pod

c. 1200–1521, Aztec
Volcanic stone and traces of paint,
36.2 × 17.8 × 19.1 cm

Brooklyn Museum of Art, Museum Collection Fund,
40.16

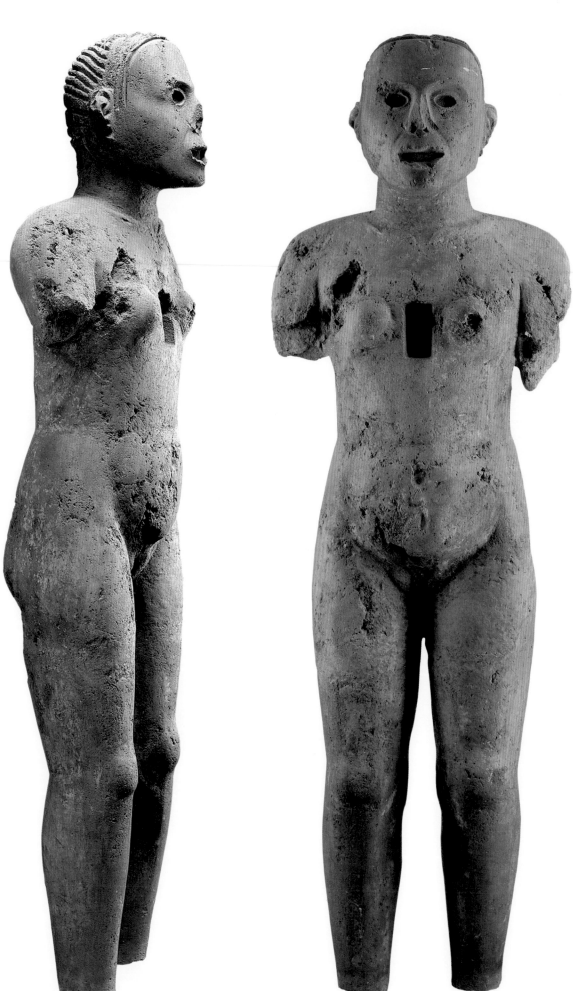

40 Female nude

c. 1500, Aztec
Stone, 146 × 40 × 25 cm

Museo Nacional de Antropología,
Mexico City, CONACULTA-INAH, 10-81543

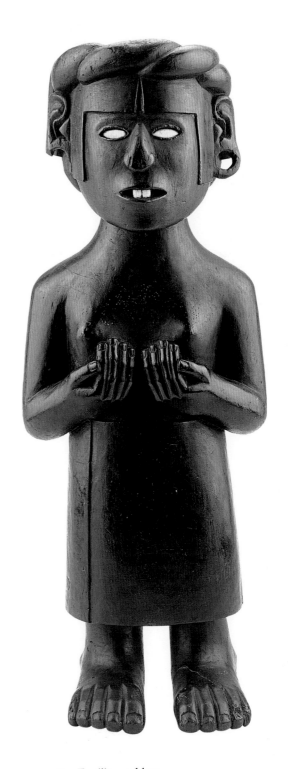

41 Fertility goddess

c. 1500, Aztec
Cedarwood and white shell, 40 × 15 × 10 cm

Museo Nacional de Antropología, Mexico City,
CONACULTA-INAH, 10-74751

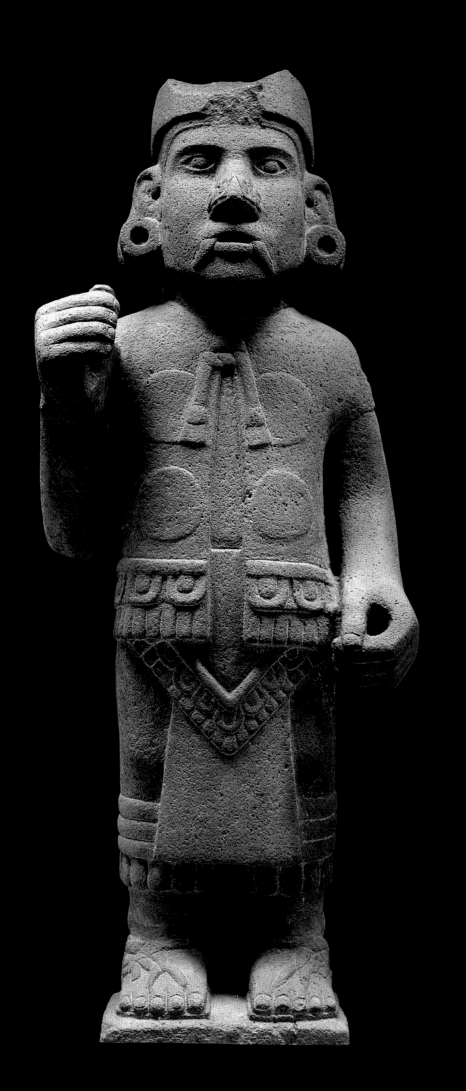
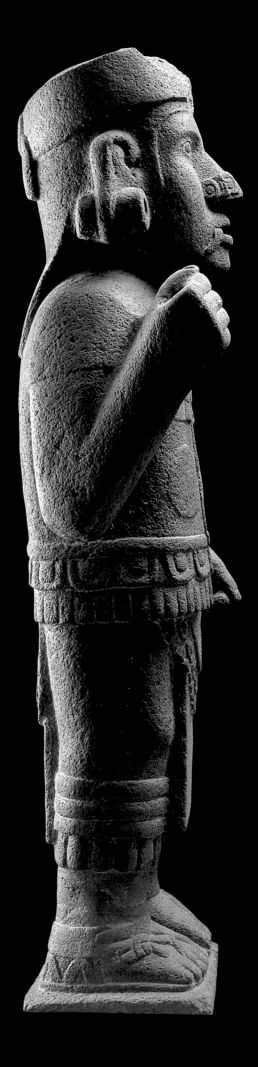

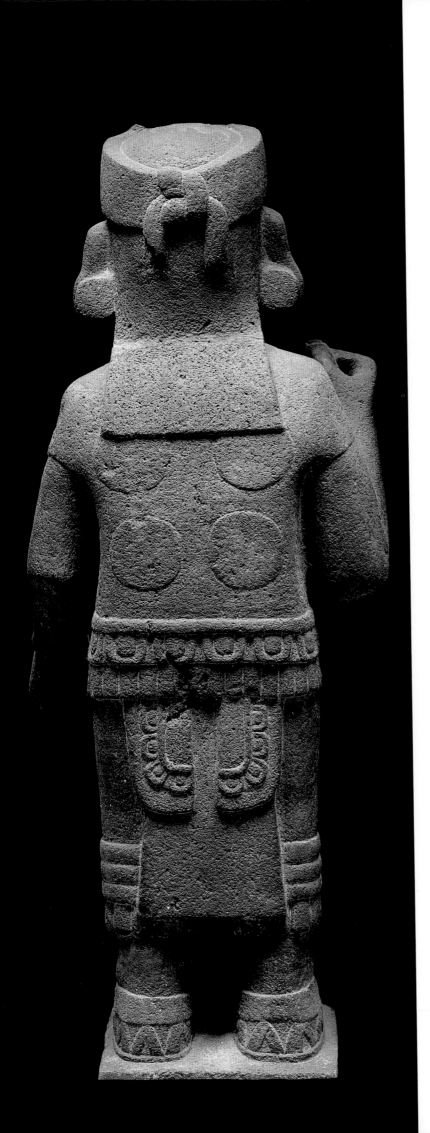

42 Xiuhtecuhtli

c. 1500, Aztec
Stone, 80 × 32 × 18 cm

Museo Nacional de Antropología,
Mexico City, CONACULTA-INAH,
10-81575

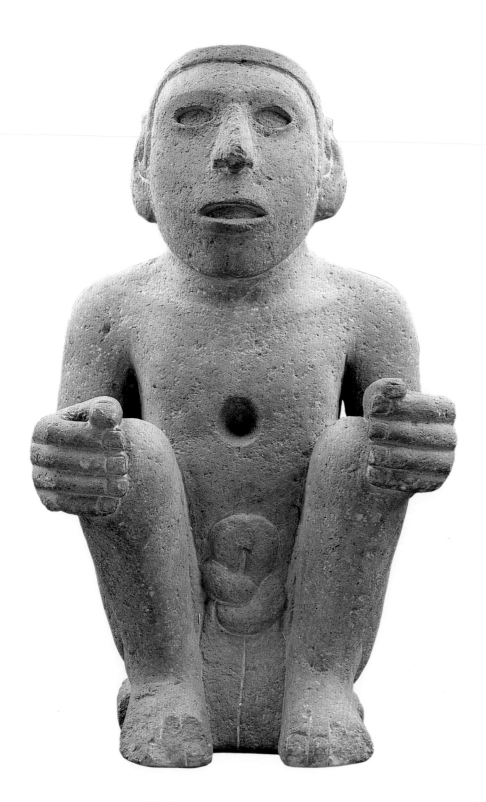

43 Young man

c. 1500, Aztec
Stone, 63 × 20 cm

Museo Nacional de Antropología, Mexico City,
CONACULTA-INAH, 10-620964

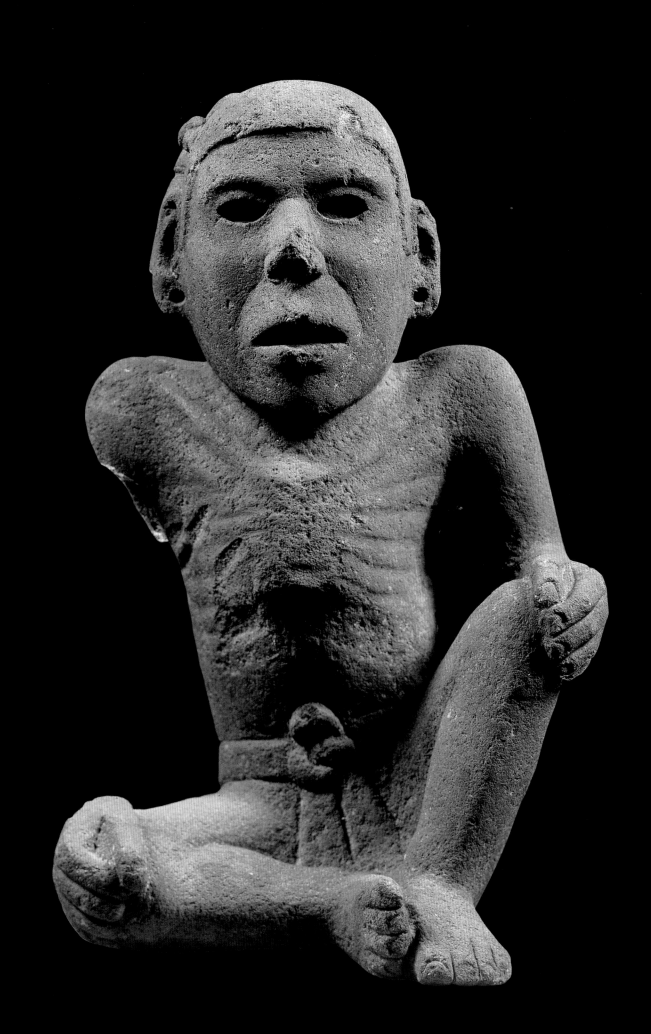

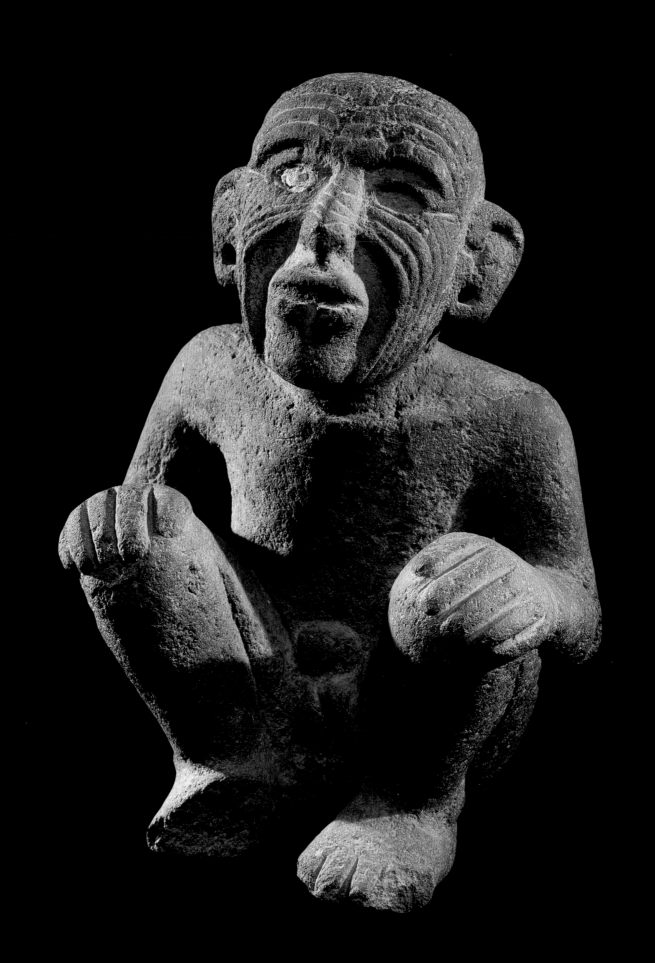

45 Seated male figure

c. 1350–1521, Aztec
Basalt, 31 × 21.5 × 18 cm

Museum der Kulturen Basel,
Basle, IVb 627

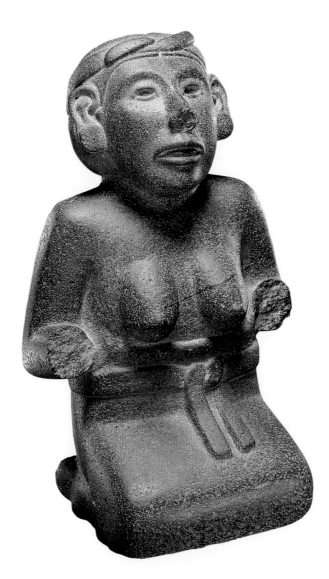

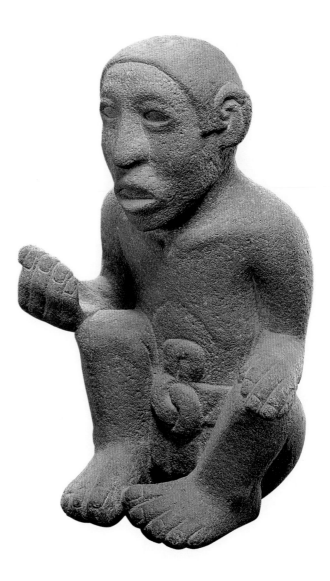

46 Kneeling woman

c. 1250–1521, Aztec
Stone and traces of paint, 54 × 34 × 22 cm

American Museum of Natural History, New York,
30.1/1201

47 Seated male figure

c. 1350–1521, Aztec
Stone, 30.5 × 19 × 15.5 cm

Staatliche Museen zu Berlin, Preußischer Kulturbesitz,
Ethnologisches Museum, IV Ca 4401

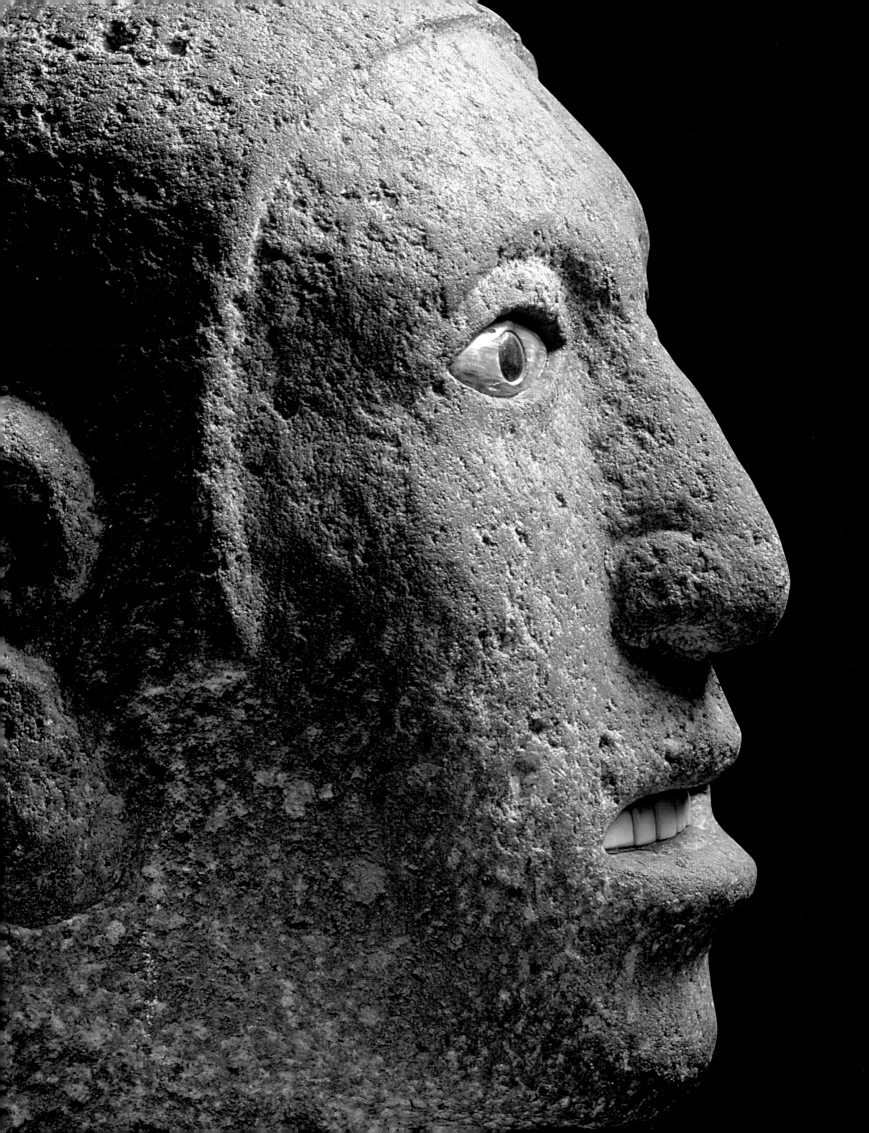

48 Head of a youth

c. 1500, Aztec
Stone, red shell and obsidian,
19.5 × 15.5 cm

Museo Nacional de Antropología,
Mexico City, CONACULTA-INAH, 10-92

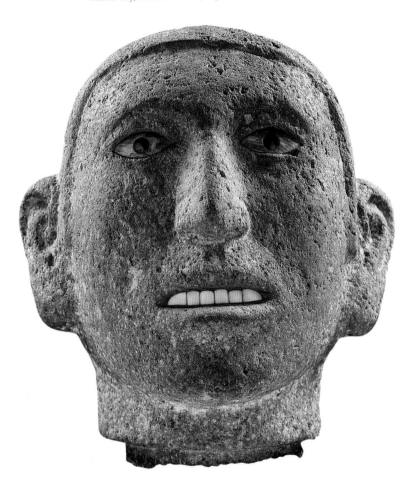

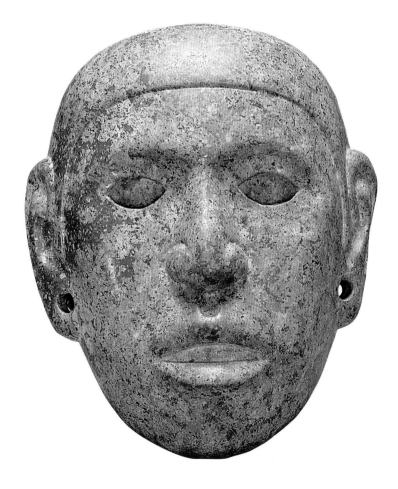

49 Mask

c. 1450–1521, Aztec
Stone, 20 × 17 × 8 cm

American Museum of Natural History,
New York, 30/11847

53 Mask

c. 1500, Aztec
Wood and traces of stucco
and gold leaf,
20 × 20.5 × 11.4 cm

Princeton University Art Museum,
Gift of Mrs Gerard B. Lambert,
Y 1970-111

50–52 Anthropomorphic masks

c. 1500, Aztec
Obsidian, 15 × 13.5 × 11 cm
and 20.5 × 17 × 9 cm
Alabaster, 22 × 23 × 11 cm

Museo Nacional de Antropología,
Mexico City, CONACULTA-INAH, 10-9681,
10-96 and 10-223664

III | THE NATURAL WORLD

Like the other indigenous peoples of Mesoamerica, the Aztecs were immersed in a nature that they believed was infused with spirit. Every species, animal or vegetable, every mineral, heavenly body or element was created by a deity out of his or her own essence, so that divinity and creation shared the same substance. Although in such creations the divine essence was thought to be partly concealed by a solid and dense material layer, beneath this lay a network of invisible links that demanded acknowledgement. For that reason the Aztecs needed to approach these creations not only with the traditional knowledge of the correct way to exploit resources, but also with the consideration of someone dealing with other animate individuals. Before taking the life of a vegetable or an animal, a man would apologise to it for his action, explaining that he was obliged to kill it for his own survival and that his attack on its species would be strictly limited to the satisfaction of his needs.

Documentary evidence of this conception of the world is not unusual: asking bees respectfully for honey; persuading fish to enter the net; courteous treatment of a tree felled by an axe; or saying to maize you are about to eat: 'Don't be insulted, I will draw sustenance from you, you will keep me alive.' Many sources illustrate this view of nature, among them carvings, pottery, murals, pictograms and books dating to earliest colonial times. Notable among these is Book XI of *Historia general de las cosas de Nueva España* (*'General History of the Things of New Spain'*) by Bernardino de Sahagún, which contains the text of the Franciscan's interviews with natives in Nahuatl along with a Spanish translation and beautiful drawings of animals, plants and minerals. Also particularly important are *Historia natural de la Nueva España* (*'The Natural History of New Spain'*) by Francisco Hernández, Philip II's principal physician, and the *Libellus de medicinalibus indorum herbis* (*'Book of Indian Medicinal Herbs'*), written by the native doctor Martín de la Cruz and translated

into Latin by Juan Badiano. This latter work contains pictures of medicinal plants in a style that achieves a harmonious mixture of the Aztec and European traditions.

Pottery provides many fine images of animals and plants, stamped or painted on its surfaces. They may be the main motif, including deer (cat. 84), dogs (cat. 85), birds (cat. 88), fish (cat. 76) and centipedes (cat. 91), or they may be incorporated into geometric patterns (cats 62 and 89). However, stone carving was more important to the Aztecs than pottery. As H. B. Nicholson has pointed out, no other central American culture surpassed them in the abundance and sculptural variety of their animal representations, which were intensely alive compared to the rigidity of their human figures. This artistic expression favoured animals charged with religious symbolism: serpents (cats 79–81), felines (cat. 71), eagles (cats 82–83), and, to a lesser extent, dogs (cat. 70), coyotes (cat. 69), monkeys, rabbits, snails, tortoises, toads (cat. 59) and fish, as well as tiny creatures depicted on a large scale (cats 73–75). In Aztec sculpture we also find plants, mainly flowers, pumpkins (cat. 67), cacti (cat. 68) and of course maize, often linked to their deities (cat. 56).

To modern eyes Aztec animal and plant images achieve a distinctive realism. Plants expose their roots to view (cat. 68) or serpents coil themselves into positions that are unusual in Mesoamerican art (cats 79 and 81) and have carefully carved underbellies which would never have been seen. The same is true of mammals that reveal the pads of their paws and of toads that have cosmic symbols on their bellies (cat. 59). By carving these hidden areas, realism could transcend its strictly human aesthetic function in order to please the gods. Yet the Aztecs' realism goes even further: for them it encompassed invisible reality. The stars, like gods, are loaded with symbols (cat. 54), the pillars that hold up the sky become flowering trees (cat. 60), gods appear in partly animal form (cat. 55) and one suspects that behind an animal's all-too-human stance or expression (cats 71–72) lies the artist's intention to show a *nahualli*, a being possessed by a god or a sorcerer.

As a vehicle for the expression of hidden reality, the serpent stands above the rest of nature. According to Esther Pasztory, the most impressive sculptural examples are the feathered serpent and the fire serpent, both incarnations of the opposing and complementary elements in the cosmos. The first, Quetzalcoatl (cat. 78), represents water and wind. In this form he is also the god of dawn, the creator of earthly creatures, and the god of the rainy season. The second, Xiuhcoatl, is the weapon of the sun and the embodiment of the dry season. The same duality of complementaries exists in some anthropomorphic images: one half of a face belongs to cold, serpentine, deadly powers, while the other half expresses life and warmth (cats 57–58).

In summary, Aztec images naturalistically reproduce the main visible features of the world's creations but also attempt to show another reality: their intangible hidden essence, which points to their divine origin and highlights the profound connection between animals, vegetables, minerals, heavenly bodies or elements that are constantly interacting within the complex and indivisible unity of the cosmos.

54 Solar disc

c. 1500, Aztec
Stone, height 11 cm,
diameter 46 cm

Museo Nacional de Antropología,
Mexico City, CONACULTA-INAH,
10-13570

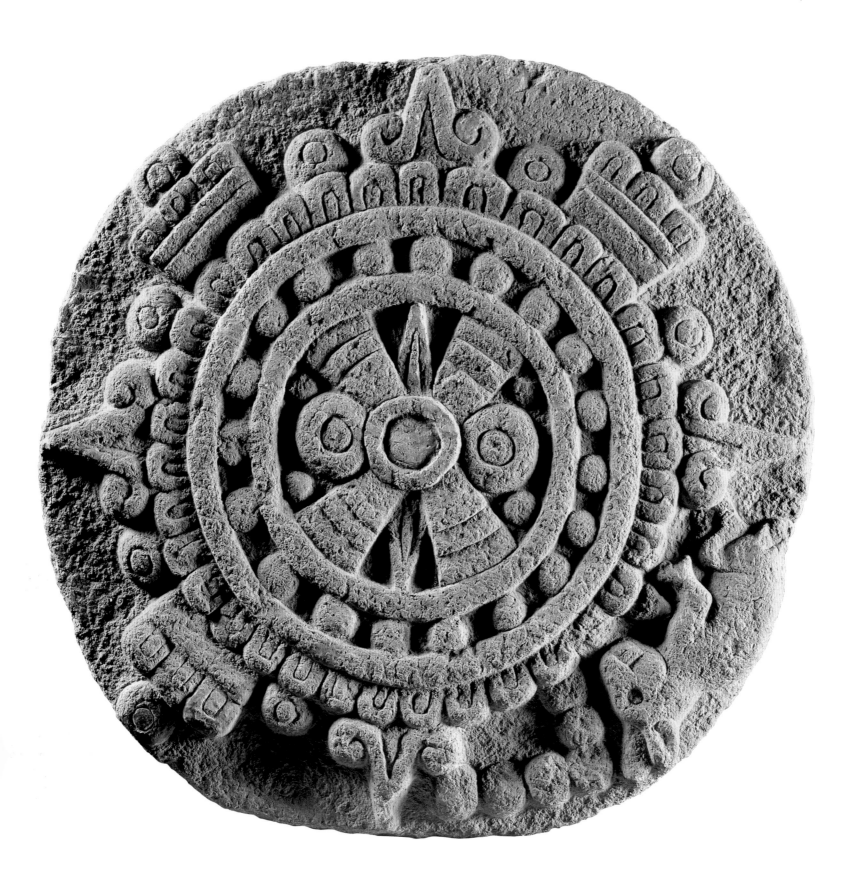

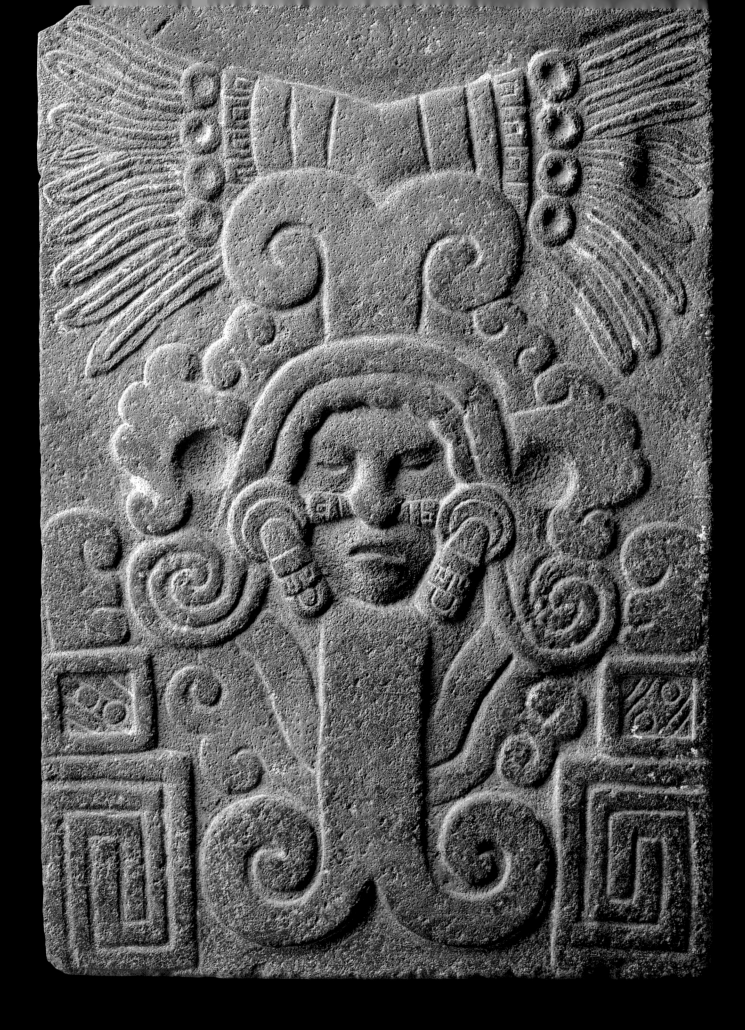

55 Cihuacoatl

c. 1500, Aztec
Stone, 61 × 44.5 × 15 cm

Museo Nacional de Antropología,
Mexico City, CONACULTA-INAH,
10-81787

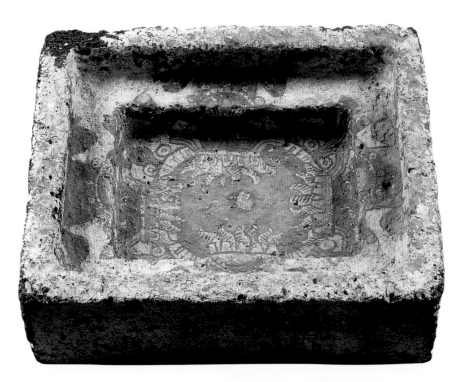

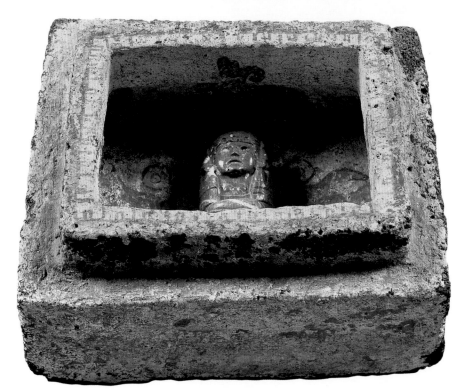

56 Casket

c. 1500, Aztec
Stone, jade, stucco and paint,
19.5 × 20 × 20 cm

Museo Nacional de Antropología, Mexico City,
CONACULTA-INAH, 10–280180/2

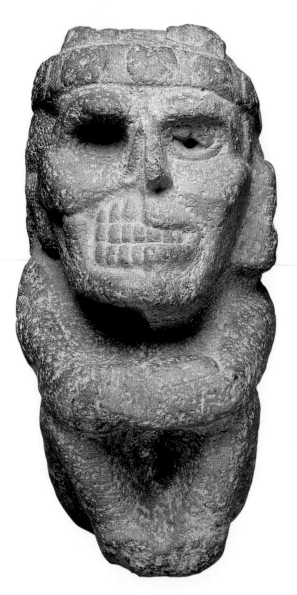

57 Life–death figure

c. 1200–1521, Aztec
Volcanic stone, 26.7 × 14 × 15.6 cm

Brooklyn Museum of Art, Purchased with
funds given by The Henfield Foundation,
64.50

59 Toad with an image
of Chalchihuitl

c. 1500, Aztec
Stone, 19 × 51 × 34 cm

Museo Nacional de Antropología,
Mexico City, CONACULTA-INAH, 10-1097

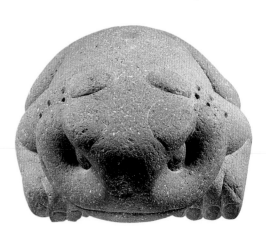

58 Figure representing the duality

c. 1500, Aztec
Greenstone, 9.5 × 8 × 9 cm

Museo Nacional de Antropología,
Mexico City, CONACULTA-INAH, 10-9683

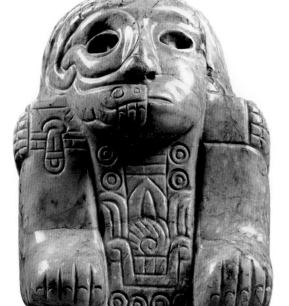

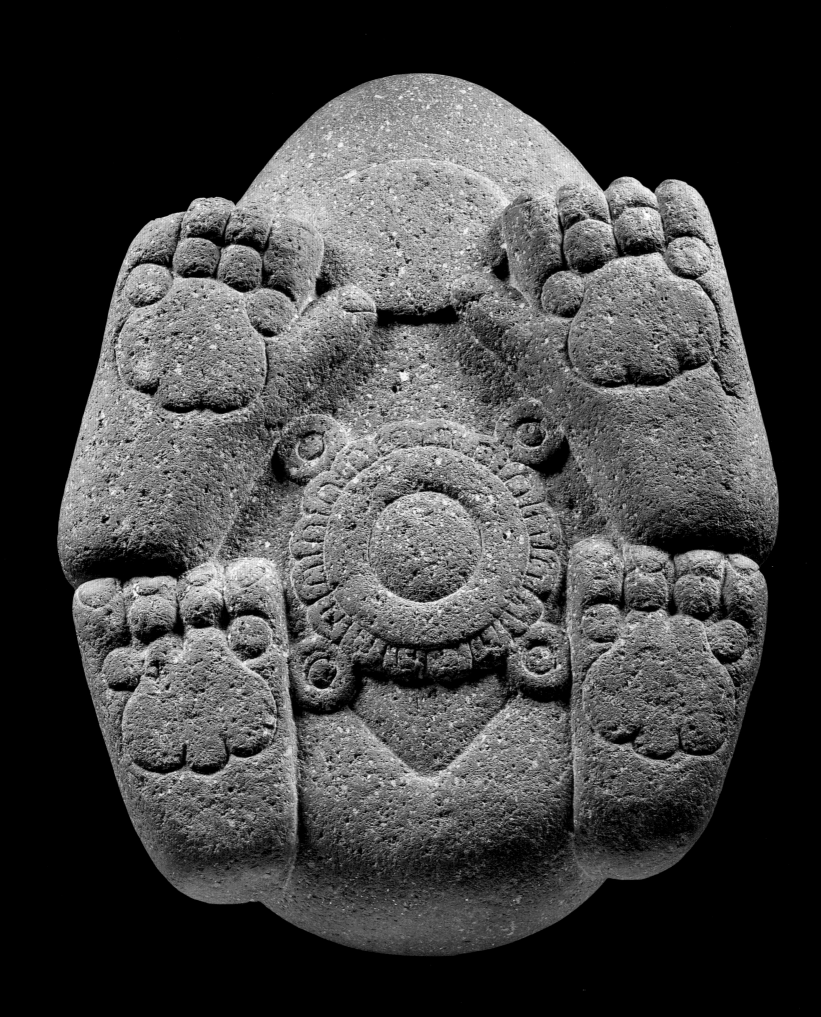

60 Altar of the sacred tree

c. 1300, Aztec
Stone, 58 × 72 × 67 cm

Museo Nacional de Antropología,
Mexico City, CONACULTA-INAH, 10-81641

61–65 Stamps

c. 1500, Aztec
Fired clay, 5.5 × 13.5 × 5 cm,
5 × 18.5 × 6.5 cm, 6 × 7.5 × 9.5 cm,
4.5 × 11 × 15.5 cm and 5 × 8 × 4 cm

Museo Nacional de Antropología, Mexico
City, CONACULTA-INAH, 10-5383, 10-78298,
10-79963, 10-116493 and 10-532896

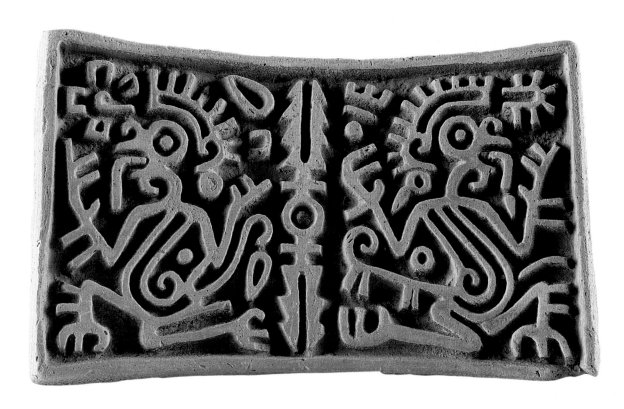

66 Squash

c. 1300–1521, Aztec
Aragonite, 12 × 8 cm

Trustees of the British Museum, London,
Ethno. 1952 Am 18.1

68 Cactus

c. 1500, Aztec
Stone, 99 × 28 cm

Museo Nacional de Antropología,
Mexico City, CONACULTA-INAH,
10-220928

Below: underside of cat. 68,
showing a relief of Tenoch,
founder of Tenochtitlan

67 Pumpkin

c. 1500, Aztec
Diorite, 16 × 36 × 17 cm

Museo Nacional de Antropología, Mexico City,
CONACULTA-INAH, 10-392922

70 Dog

c. 1500, Aztec
Stone, 47.5 × 20 × 29 cm

Museo Regional de Puebla,
CONACULTA-INAH, 10-203439

69 Feathered coyote

c. 1500, Aztec
Stone, 38 × 17 × 13 cm

Museo Nacional de Antropología,
Mexico City, CONACULTA-INAH, 10-47

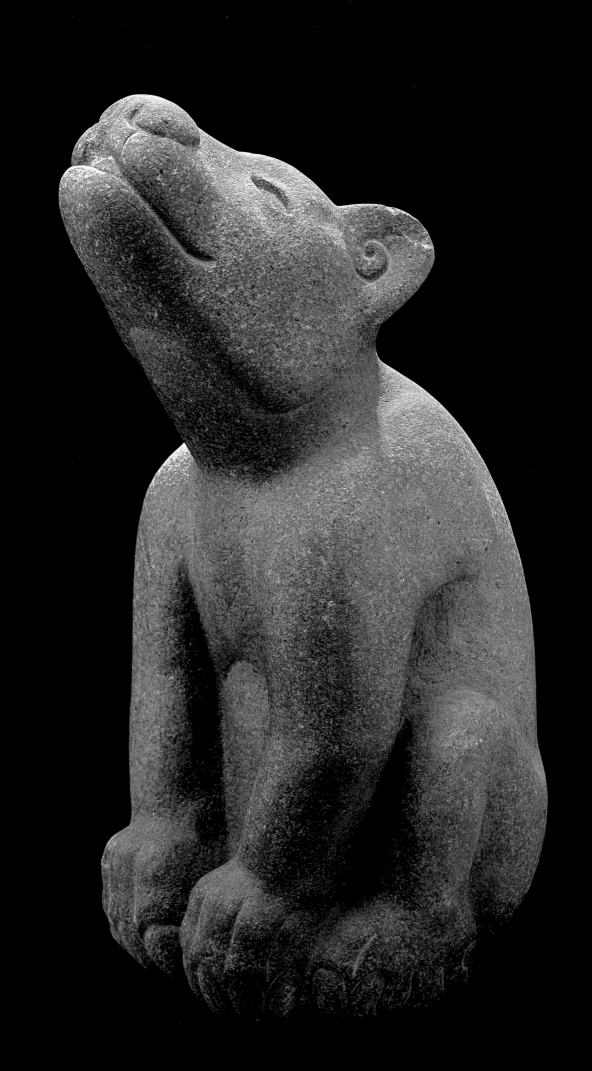

71 Reclining jaguar

c. 1440–1521, Aztec
Volcanic stone,
12.5 × 14.5 × 28 cm

Brooklyn Museum of Art,
Carll H. de Silver Fund, 38.45

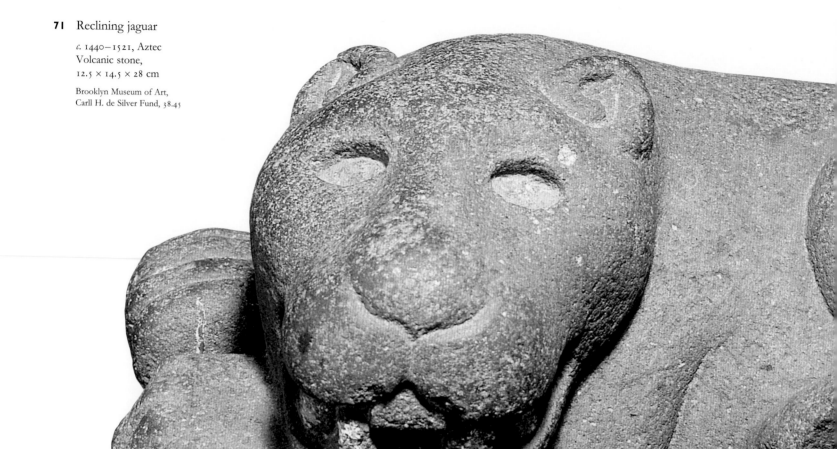

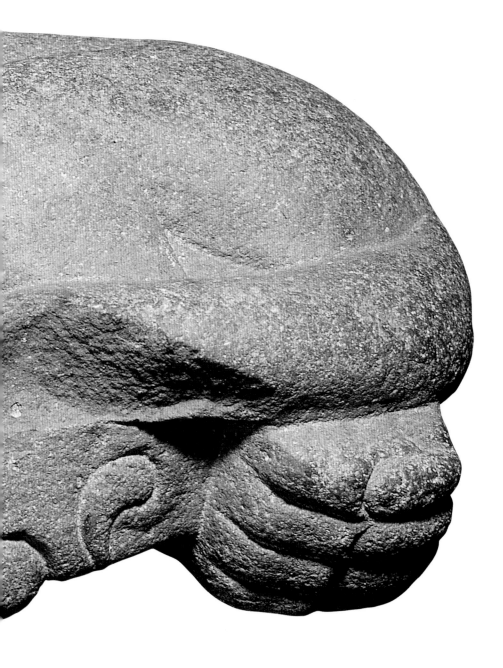

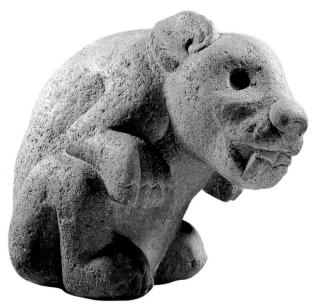

72 Rabbit

c. 1500, Aztec
Stone, 33 × 22 × 24 cm

Museo Nacional de Antropología,
Mexico City, CONACULTA-INAH,
10-81666

73 Insect

c. 1500, Aztec
Stone, 22 × 21.5 × 36.5 cm

Museo Nacional de Antropología,
Mexico City, CONACULTA-INAH, 10-594039

74 Insect

c. 1500, Aztec
Stone, 13.5 × 9.5 × 18 cm

Museum für Völkerkunde Wien
(Kunsthistorisches Museum mit MVK und
ÖTM), Vienna, 6.450, Bilimek Collection

75 Grasshopper

c. 1500, Aztec
Cornelian, 19.5 × 16 × 47 cm

Museo Nacional de Antropología,
Mexico City, CONACULTA-INAH, 10-220929

76 Fish

c. 1500, Aztec
Volcanic stone, 26.3 × 58.6 × 10.5 cm

Laboratoire d'Ethnologie, Musée de
l'Homme, Paris, M.H.87.155.17

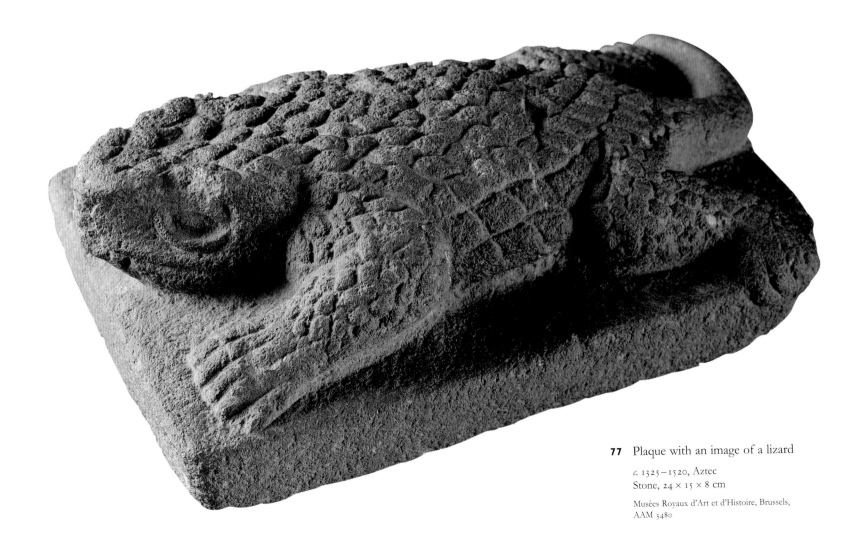

77 Plaque with an image of a lizard

c. 1325–1520, Aztec
Stone, 24 × 15 × 8 cm

Musées Royaux d'Art et d'Histoire, Brussels,
AAM 3480

78 Feathered serpent

c. 1500, Aztec
Stone, 50 × 45 × 52 cm

Colección Fundación Televisa, Mexico City,
Reg. 21 pj. 8

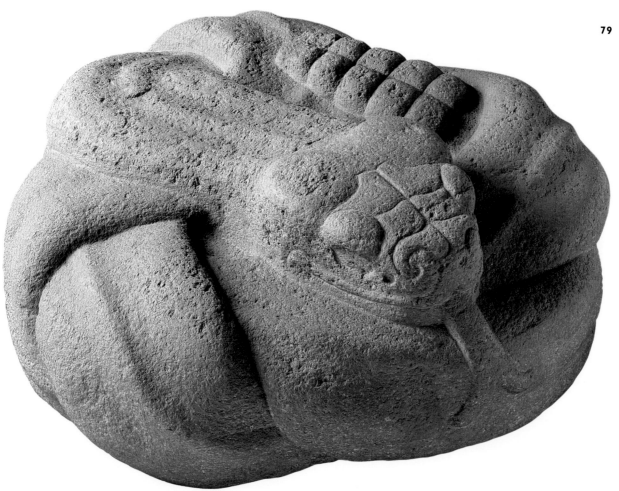

79 Serpent

c. 1500, Aztec
Stone, 31 × 82 × 80 cm

Museo Nacional de Antropologia,
Mexico City, CONACULTA-INAH, 10-220933

80 Snake

c. 1500, Aztec
Stone, 31 × 44 × 24 cm

Museo Nacional de Antropología,
Mexico City, CONACULTA-INAH,
10-220932

81 Coiled rattlesnake

c. 1300–1521, Aztec
Granite and traces of paint,
height 36 cm, diameter 53 cm

Trustees of the British Museum, London,
Ethno. 1849.6-29.1

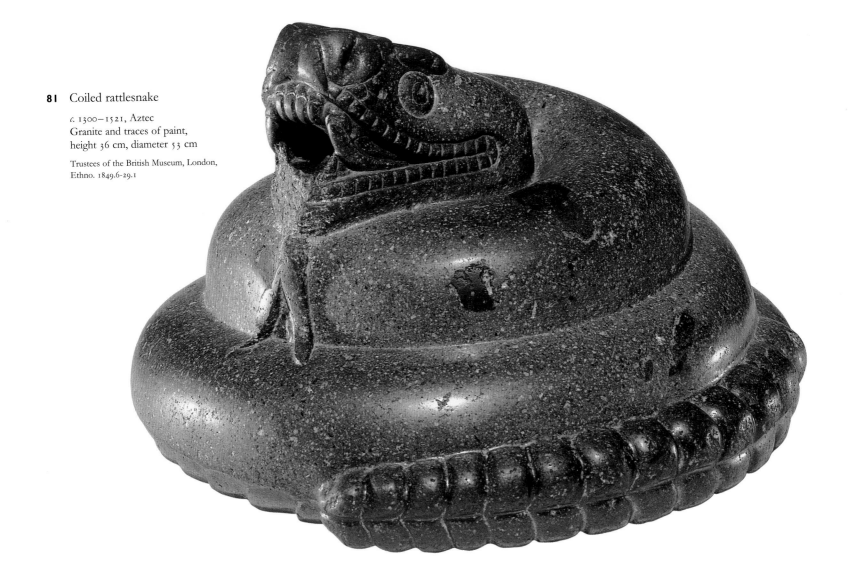

83 Eagle

c. 1500, Aztec
Stone, 41 × 20 cm

Museo Regional de Puebla,
CONACULTA-INAH, 10-203440

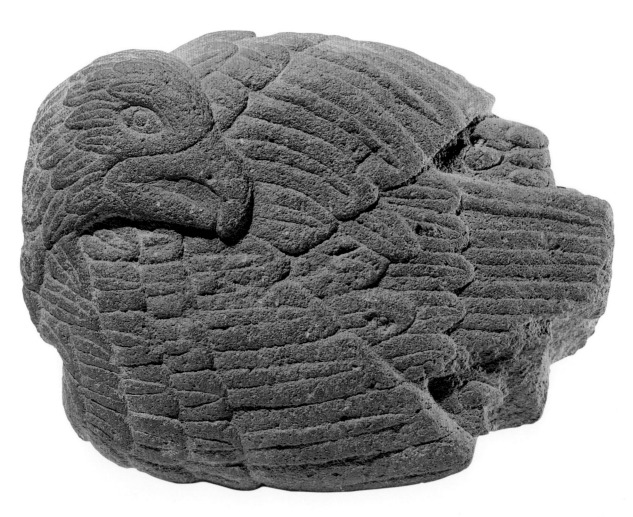

82 Relief of an eagle

c. 1300–1521, Aztec
Andesite, 20 × 28 × 8 cm

Trustees of the British Museum, London, Ethno. 8624

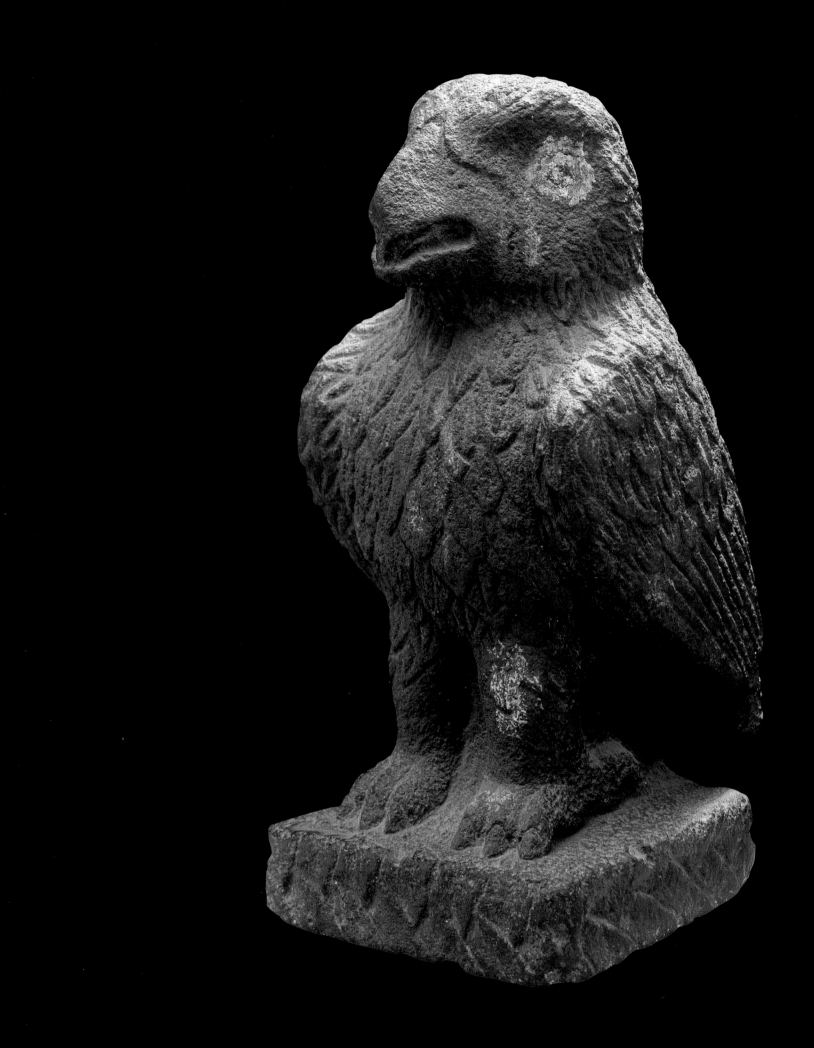

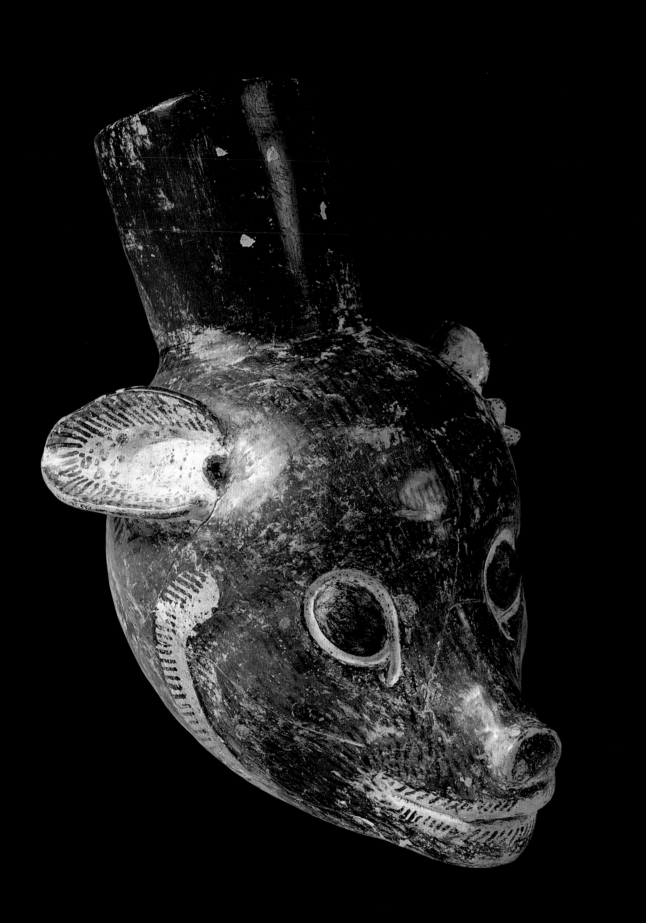

84 Vessel in the shape
of a deer's head

c. 1250–1521, Mixteca–Puebla
Fired clay and paint,
29 × 26 × 22 cm,
diameter of spout 9.5 cm

Rautenstrauch-Joest-Museum, Cologne,
Ludwig Collection, SL XCVI

85 Pipe in the form of a dog

c. 1500, Aztec
Fired clay, 7.5 × 24.5 cm

Museo Nacional de Antropología,
Mexico City, CONACULTA-INAH,
10-79507

86 Pipe in the form of a duck

c. 1500, Aztec
Fired clay, 9 × 19 cm

Museo Nacional de Antropología,
Mexico City, CONACULTA-INAH,
10-116576

87 Pipe

c. 1500, Aztec
Fired clay, 12.5 × 28 × 4 cm

Museo Nacional de Antropología,
Mexico City, CONACULTA-INAH,
10-220130

88 Flute in the form of a macaw

c. 1300–1521, Aztec
Fired clay and traces of paint,
8.3 × 11 × 14 cm

Trustees of the British Museum, London,
1865.6-10.9

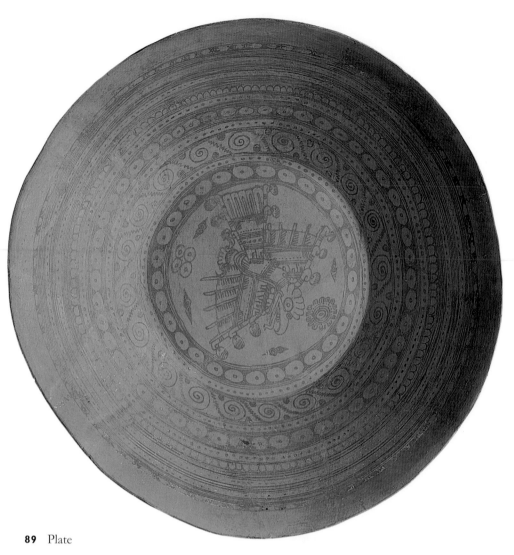

91 Vessel with an image of a centipede

1400, Totonac
Fired clay and paint,
height 16 cm, diameter 19 cm

Museo Nacional de Antropología,
Mexico City, CONACULTA-INAH, 10-78683

89 Plate

c. 1500, Aztec
Fired clay and paint, height 4.5 cm,
diameter 31 cm

Museo Nacional de Antropología,
Mexico City, CONACULTA-INAH, 10-116416

90 Two-tiered tripod plate

c. 1500, Aztec
Fired clay and paint,
height 6 cm, diameter 22.5 cm

Museo Nacional de Antropología,
Mexico City, CONACULTA-INAH, 10-1049

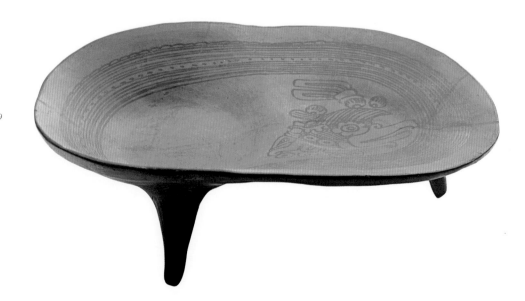

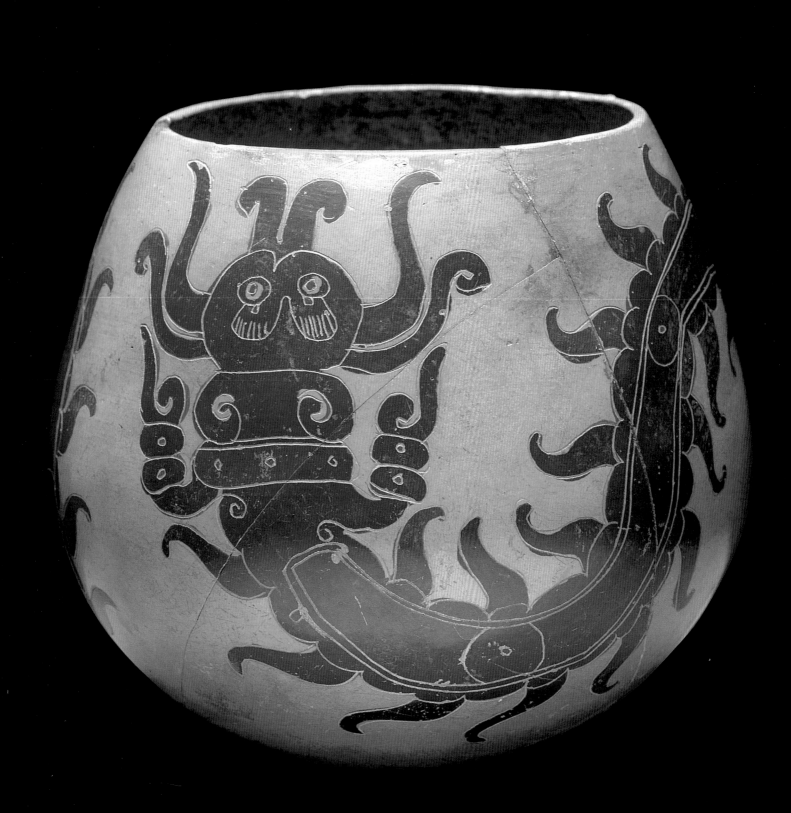

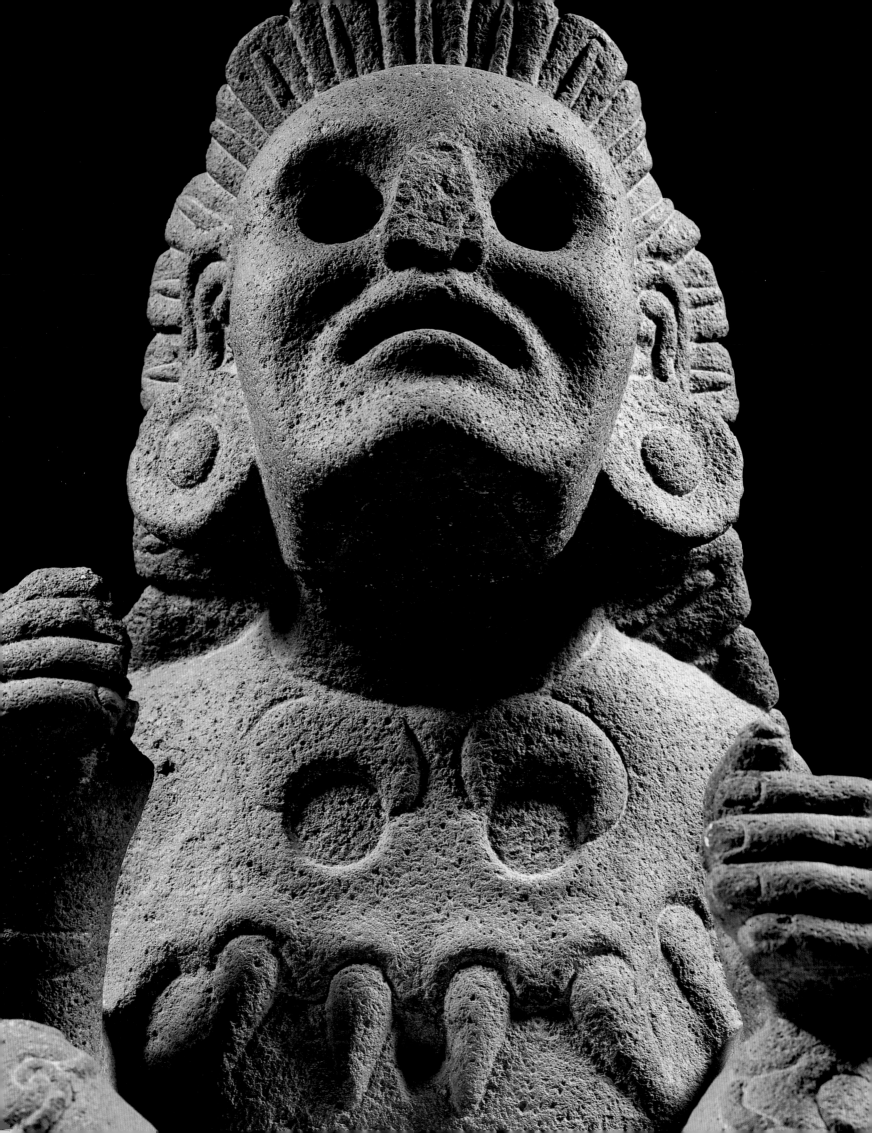

IV GODS OF LIFE

The Aztec notion of life was complex and intimately related to death and the concept of renewal. The practice of human sacrifice, for instance, was not a celebration of death but rather an act of nourishment for the gods that was designed to perpetuate life on earth. The Aztec universe was divided into three realms. The first of these, Tlalticpac (the surface of the world where man resided), represented the first plane of both Mictlan (the deepest realm, the underworld, ruled by Mictlantecuhtli, 'lord of death'), and Omeyocan (the higher realm, the upper world), where the dual god Ometeotl, creator of the calendar, presided and dispatched the souls of those about to be born. The upper world comprised thirteen distinct planes, each of which was presided over by a specific god and which, in addition, received individuals who had died an unnatural death. The fourth plane, Ilhuicatl Tonatiuh, 'heaven of the sun', for example, received warriors killed on the battlefield and women who died in childbirth. For the Aztecs, the idea of rebirth was epitomised by snakes shedding their skins, a reference to the notion that in order to create life there must first be death. In Aztec creation myths, for instance, Quetzalcoatl created a new generation of humans from the bones of a previous race, and the gods sacrificed themselves at Teotihuacan in order to give life to the Fifth Sun, or fifth world-era. The concept of life through death is perhaps best represented by the god Xipe Totec ('our flayed lord'; cats 92–96, 98–99). Xipe Totec was generally depicted as an individual wearing the flayed skin of a sacrificial victim, graphically represented hanging from his shoulders. It is thought that some sculptures were ritually dressed in this manner. Festivities associated with Xipe Totec, patron of goldsmiths, marked the beginning of the agricultural season and the germination of seeds.

Xipe Totec, like various other deities such as Tlaloc, god of rain (cats 112–13), had held sway in previous Mesoamerican cultures. The Aztecs adopted existing deities and integrated them into their pantheon, which

also included their own specific gods. Chief among these was Huitzilopochtli ('left-sided hummingbird'), a legendary figure attributed with guiding the migration of the Aztecs on their mythical journey from Aztlan to the site of Tenochtitlan over a period of some two hundred years. It was Huitzilopochtli who foresaw their final destination as the place where an eagle would be seen perched on a cactus growing out of a stone. Images of the god are rare and known mainly through representations in painted books, including the Florentine Codex (cat. 344); sculptures of him, made from organic materials such as amaranth seeds, copal and resin, have not survived, although this type of object is represented by a similar sculpture of Tlaloc (cat. 241).

The Aztecs boasted a large number of gods, many of whom had more than one aspect. They were represented in various media, including painted books, polychrome ceramics and free-standing three-dimensional sculptures in stone (which was then covered in stucco and painted), wood and other organic substances, and precious materials, among them turquoise, jade and gold. Virtually every aspect of human culture and nature was represented by a god, although generally they were organised around a small number of central themes such as creation, death, agriculture, rain and war. Sculptural representations of deities were ritually interred as offerings to the gods, especially the fire god Xiuhtecuhtli (cats 244–46), who is specifically linked to such offerings at the Templo Mayor. Others were deliberately encased during the building stages of the Templo Mayor (cat. 265). Xiuhtecuhtli is closely associated with Huehueteotl ('old, old god'), whose likeness is to be found on Teotihuacan braziers (cat. 5). He was re-created by Aztec stonemasons (cat. 229), although they portrayed him as a youthful god instead of as an old man. Sculptures were also used to decorate the exterior of temples; restrictions of interior space meant that public rituals took place outside.

Most gods were perceived as having human form and animal counterparts. For this reason, many sculptural representations of deities appear to be individuals, most probably priests, who are impersonating the gods, whereas those depicted in the Pre-Hispanic codices are often more conceptual and less obviously human. Examples of the former include the large representation of Ehecatl, god of wind (cat. 103), or the cross-legged image of Xochipilli, god of flowers and poetry, seated on his throne (cat. 105). Elaborate costumes were prepared for deity impersonators and these are captured in the realistic form of Aztec sculpture, especially the large temple headdresses made of paper worn by Chicomecoatl ('seven serpent'), goddess of seed corn (cat. 109). Religious ritual was accompanied by music performed on drums, seen here copied in stone and ceramic (cats 125–26), and flutes (cats 159–62), and by dancing. Chalchiuhtlicue ('she of the jade skirt'; cats 120–22), goddess of water (precious liquid), was associated with agriculture and human birth and is here represented as a kneeling woman with a tasselled headdress.

In some cases the gods were interchangeable with animal counterparts, which were also used to represent them. A clear example is that of Ehecatl, who is often shown as a monkey wearing either a characteristic 'beak' (cat. 102) or a shell pendant (cat. 100). Ehecatl was one of the aspects of Quetzalcoatl, 'the feathered serpent' (cat. 114), one of the creator-gods who is also associated with Teotihuacan and the Toltecs of Tula (where he was priest-ruler). Tezcatlipoca ('smoking mirror') was an omnipotent god of rulers, characterised by bands across his face (seen on a fine turquoise mosaic mask [cat. 304]) and by one leg ending in a protruding shinbone. He was associated with the jaguar and, like Quetzalcoatl, was a creator-god; the two fought during the creation of the world.

92 Xipe Totec

c. 1350–1521, Aztec
Volcanic stone and paint,
46 × 26.3 × 27.4 cm

Museum der Kulturen Basel, Basle,
IVb 647

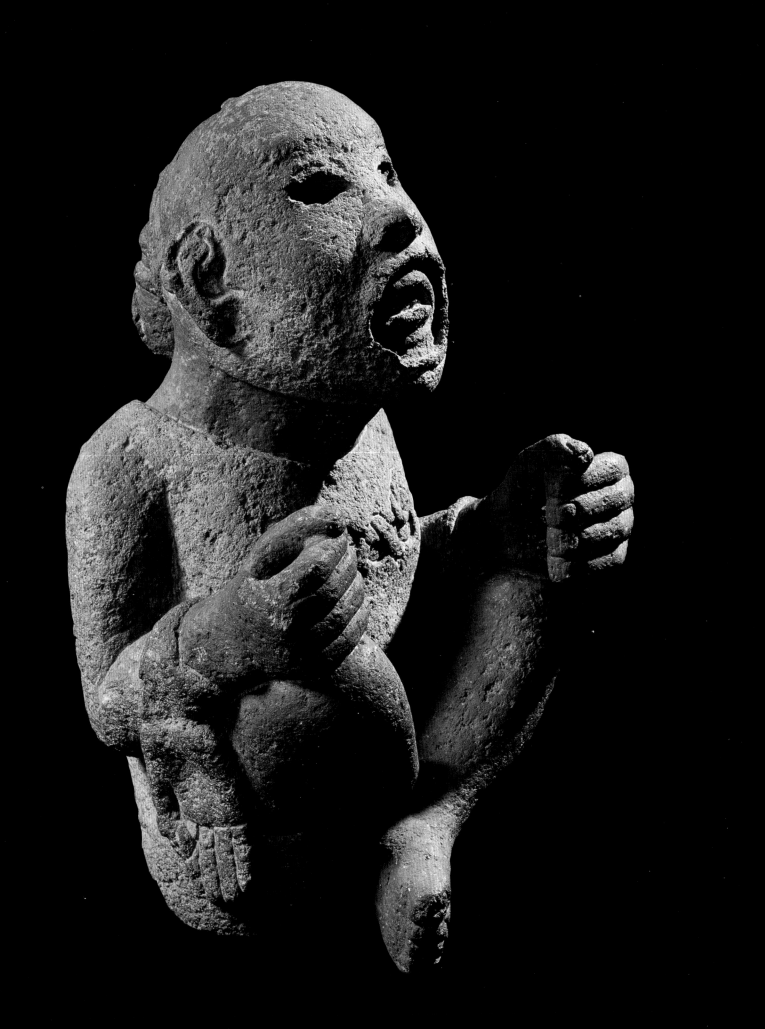

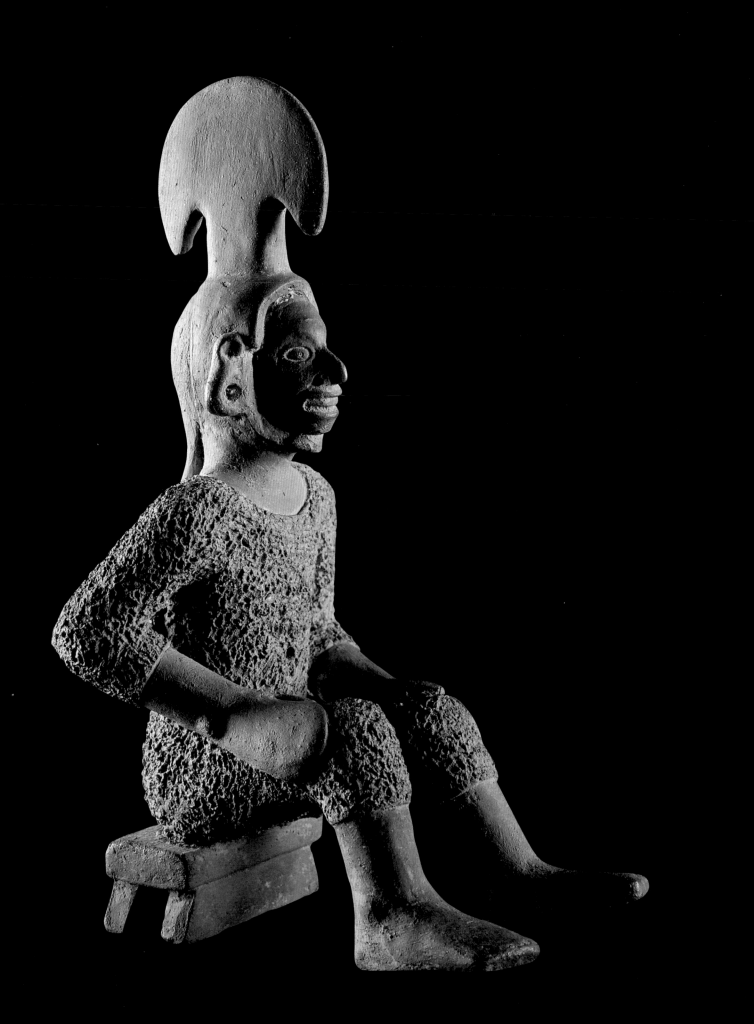

93 Xipe Totec

c. 1500, Aztec
Fired clay, 15 × 4 × 6.5 cm

Museo Nacional de Antropología,
Mexico City, CONACULTA-INAH, 10-333885

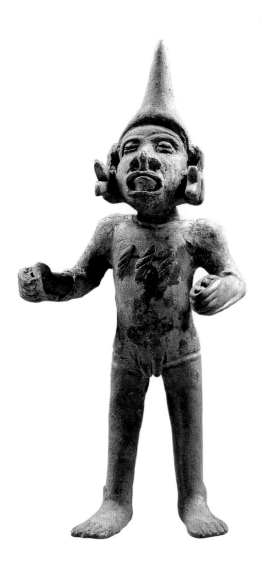

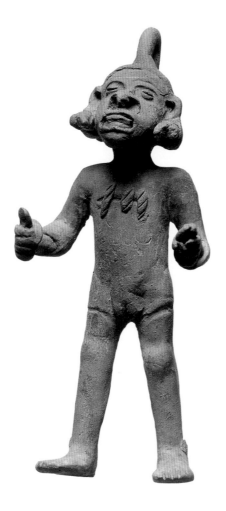

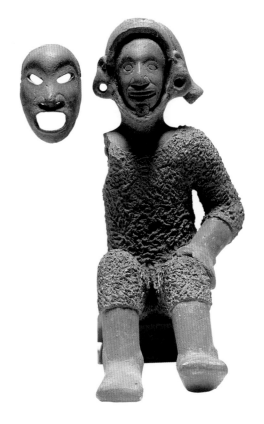

94 Xipe Totec

c. 1500, Aztec
Fired clay, 15.5 × 5 × 3 cm

Museo Nacional de Antropología,
Mexico City, CONACULTA-INAH,
10-333856

95 Xipe Totec

c. 1500, Aztec
Fired clay, 14.5 × 6 × 3.5 cm

Museo Nacional de Antropología,
Mexico City, CONACULTA-INAH,
10-116779

96 Xipe Totec

c. 1500, Aztec
Fired clay, 12 × 5.5 × 8 cm

Museo Nacional de Antropología,
Mexico City, CONACULTA-INAH,
10-116778 2/2

99 Xipe Totec

c. 1500, Aztec
Fired clay and paint,
97 × 43 × 20 cm

Museo Regional de Puebla,
CONACULTA-INAH, 10-203061

97 Container for flayed skin

c. 1500, Aztec
Fired clay, height 25 cm,
diameter 48.5 cm

Museo Nacional de Antropología,
Mexico City, CONACULTA-INAH, 10-594908

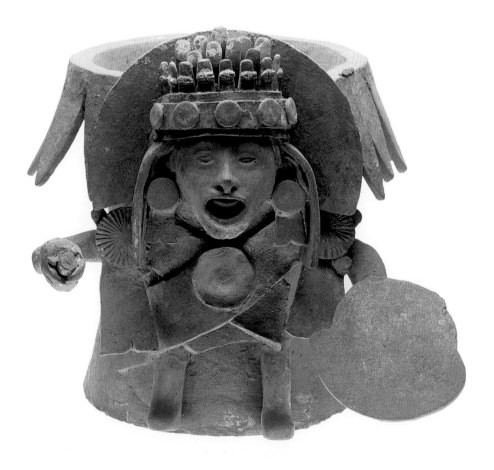

98 Brazier with an image
of Xipe Totec

c. 1500, Aztec
Fired clay, 36 × 40 cm

Museo Nacional de Antropología,
Mexico City, CONACULTA-INAH, 10-220143

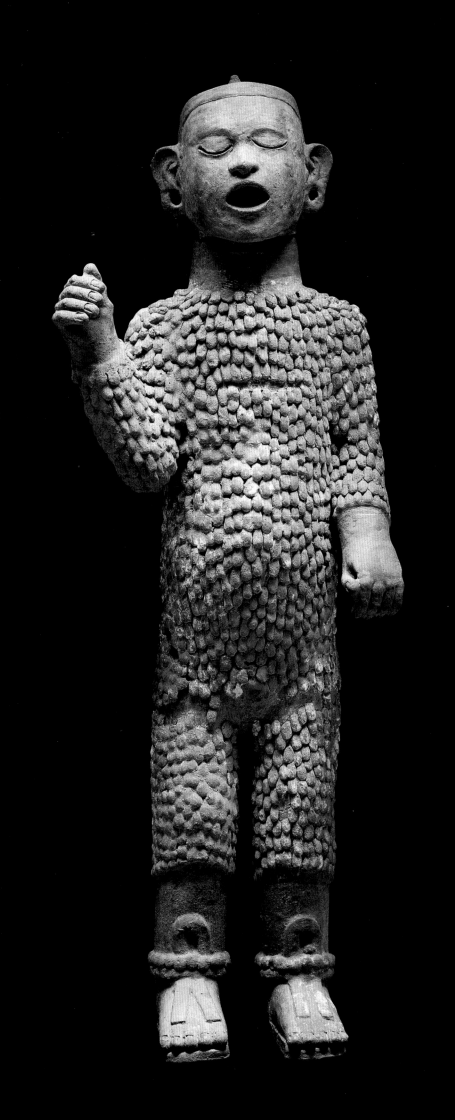

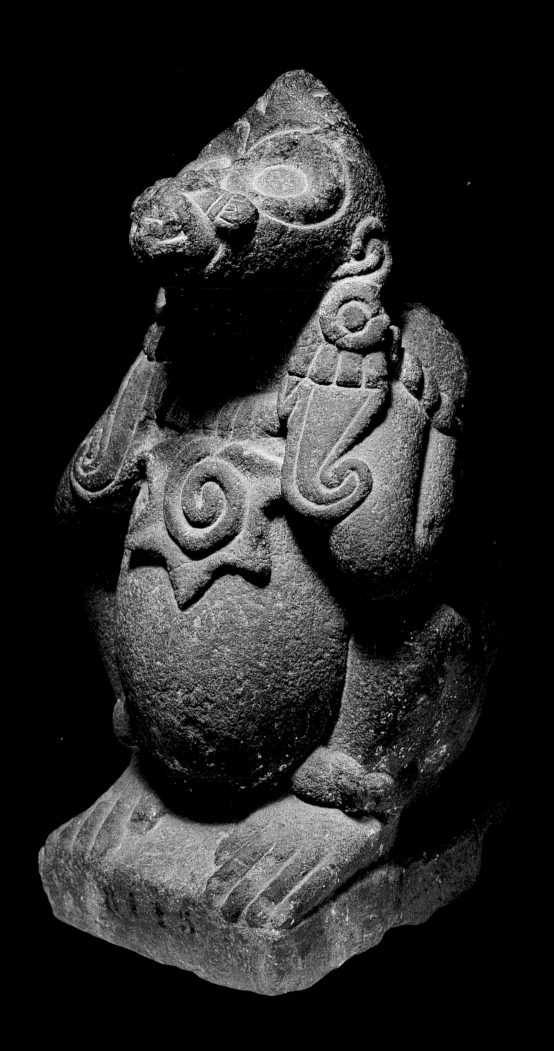

100 Spider monkey with ornaments relating to Ehecatl-Quetzalcoatl

c. 1500, Aztec
Volcanic stone,
43.5 × 24.6 × 24.4 cm

Laboratoire d'Ethnologie, Musée de l'Homme, Paris, M.H.78.1.89

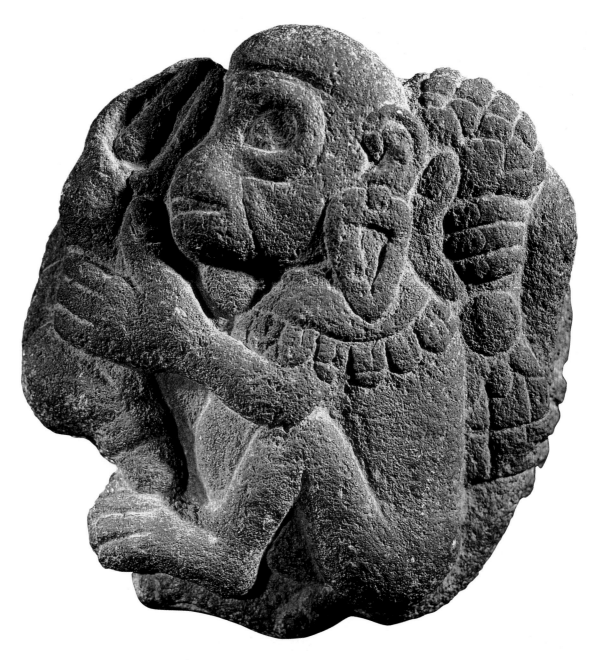

101 Spider monkey with ornaments relating to Xochipilli

c. 1500, Aztec
Volcanic stone, 19.5 × 18.5 × 8.5 cm

Laboratoire d'Ethnologie, Musée de l'Homme, Paris, M.H.87.159.143

102 Dancing monkey

c. 1500, Aztec
Stone, 60 × 37 × 33 cm

Museo Nacional de Antropología, Mexico City, CONACULTA-INAH, 10-116784

103 Ehecatl-Quetzalcoatl

c. 1480–1519, Aztec
Andesite, 195 × 40 × 50 cm

Rautenstrauch-Joest-Museum,
Cologne, Ludwig Collection, SL CVII

104 Mask with an image
of Ehecatl-Quetzalcoatl

c. 1350–1521, Aztec
Stone, 14 × 14 × 10 cm

Staatliche Museen zu Berlin:
Preußischer Kulturbesitz,
Ethnologisches Museum,
IV Ca 26077

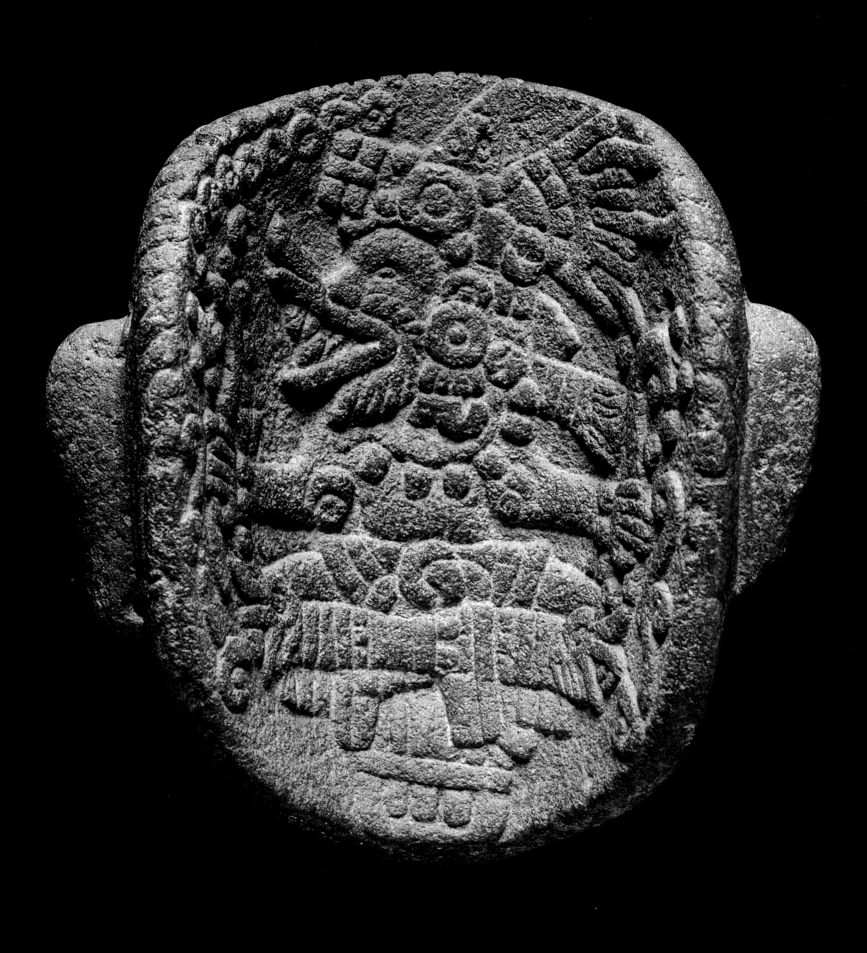

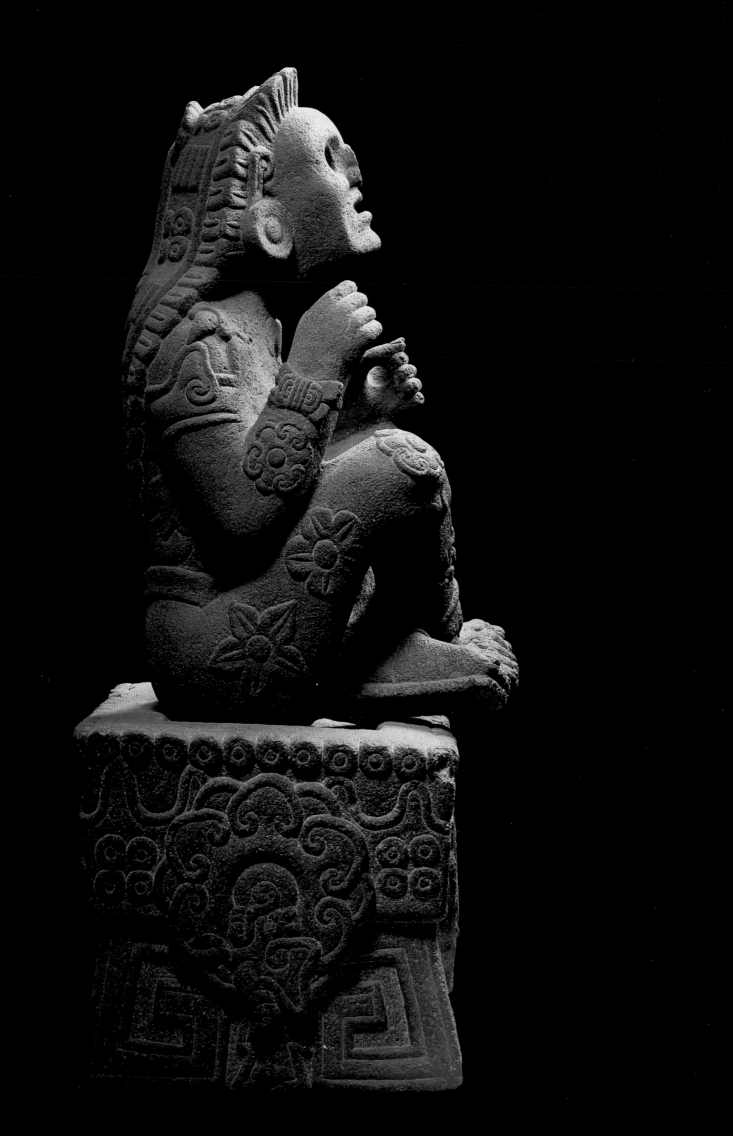

105 Xochipilli

c. 1500, Aztec
Stone, 115 × 53 × 43 cm

Museo Nacional de Antropología,
Mexico City, CONACULTA-INAH,
10-222116 0/2

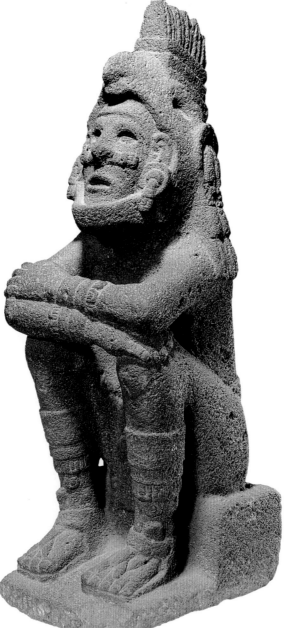

106 Xochipilli

c. 1500, Aztec
Fine-grained volcanic stone,
74.5 × 31 × 26 cm

Völkerkundliche Sammlungen Reiss-
Engelhorn-Museen, Mannheim, V Am 1085

107 Figure with flowers and maize

c. 1325–1521, Aztec
Stone and traces of paint,
27.7 × 25.2 × 29.9 cm

The Cleveland Museum of Art,
The Norweb Collection, 1949.555

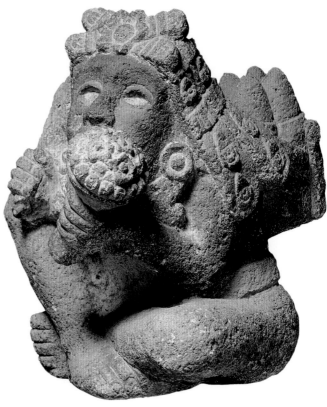

108 Xilonen

c. 1500, Aztec
Stone, 52 × 20 cm

Museo Nacional de Antropología,
Mexico City, CONACULTA-INAH, 10-82209

109 Chicomecoatl

c. 1350–1521, Aztec
Stone, 68 × 27 × 14 cm

Staatliche Museen zu Berlin:
Preußischer Kulturbesitz,
Ethnologisches Museum,
IV Ca 46167

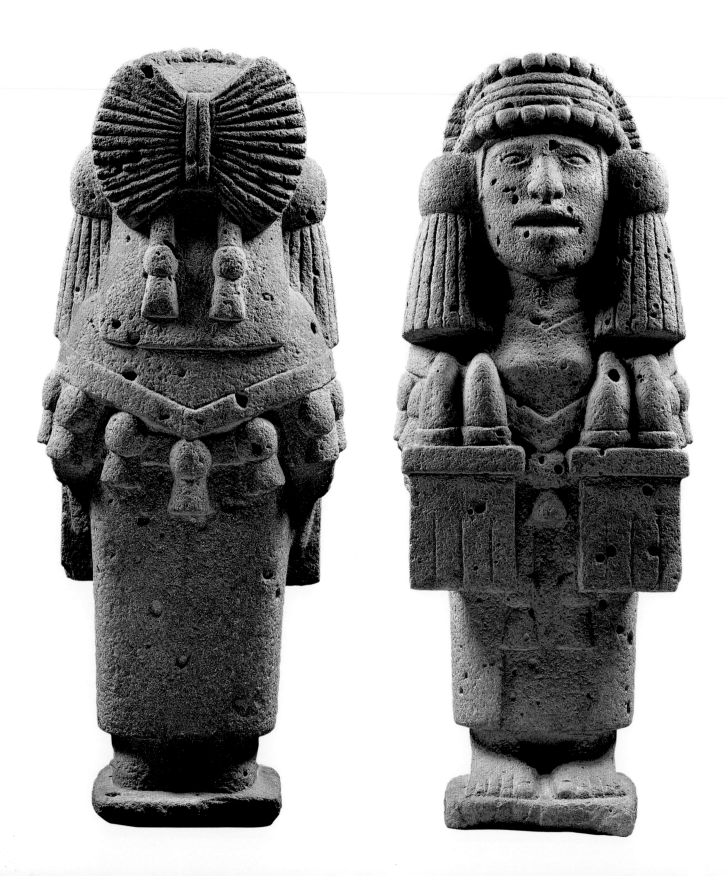

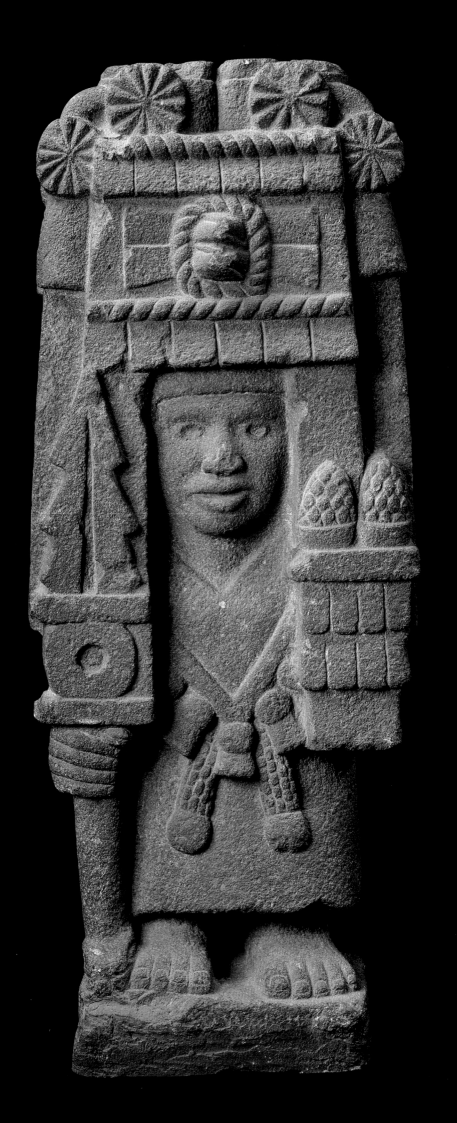

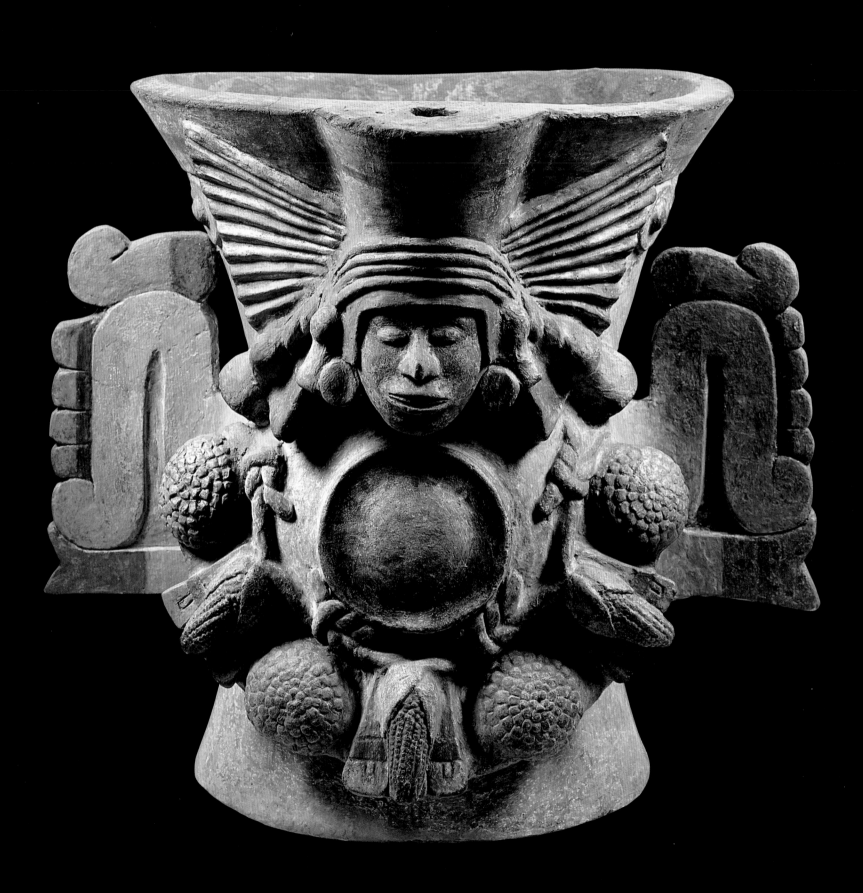

110 Brazier in the form
of Chalchiuhtlicue

c. 1500, Aztec
Fired clay and paint,
54.5 × 64 × 55 cm

Museo Nacional de Antropología,
Mexico City, CONACULTA-INAH, 10-1125

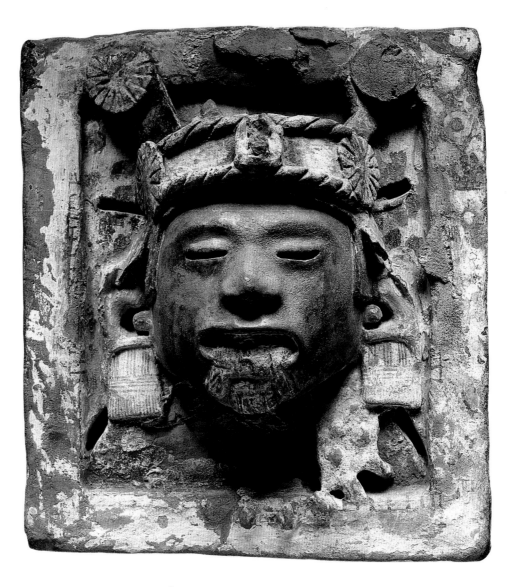

111 Plaque representing the
Ochpaniztli festival

c. 1500, Aztec
Fired clay and paint, 32 × 29 × 12.5 cm

Museo Nacional de Antropología, Mexico City,
CONACULTA-INAH, 10-1069

113 Tlaloc

c. 1500, Mixtec–Istmeña (Huave)
Fired clay, height 88 cm,
diameter 37.5 cm

Museo Nacional de Antropología,
Mexico City, CONACULTA-INAH,
10-76360

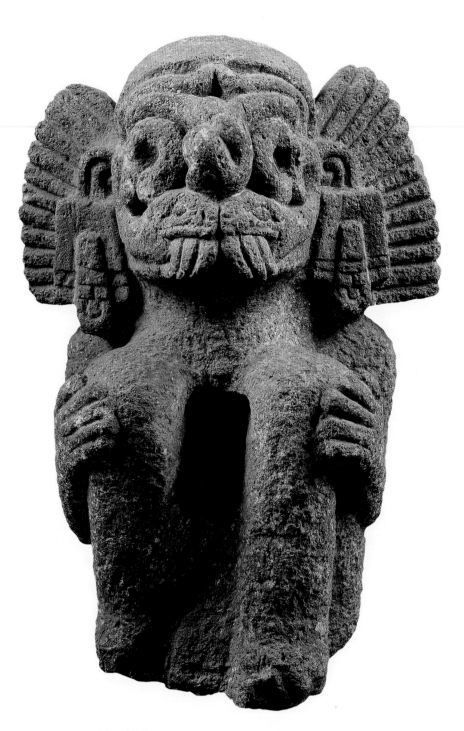

112 Tlaloc

c. 1350–1521, Aztec
Stone, 40 × 27 × 22 cm

Staatliche Museen zu Berlin: Preußischer Kulturbesitz,
Ethnologisches Museum, IV Ca 3721

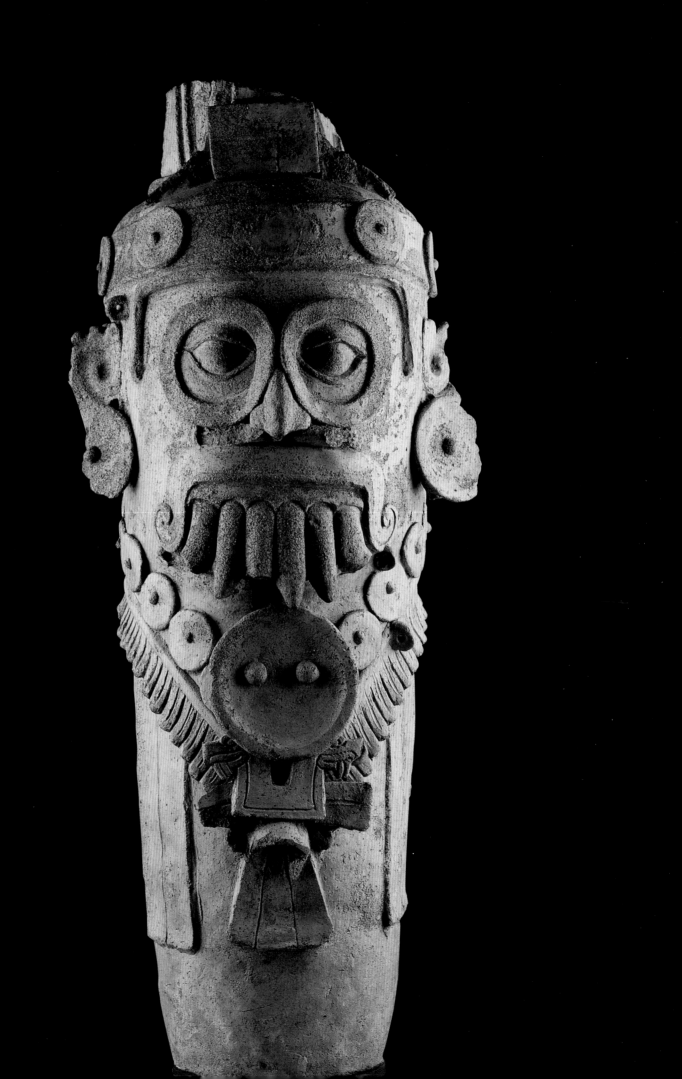

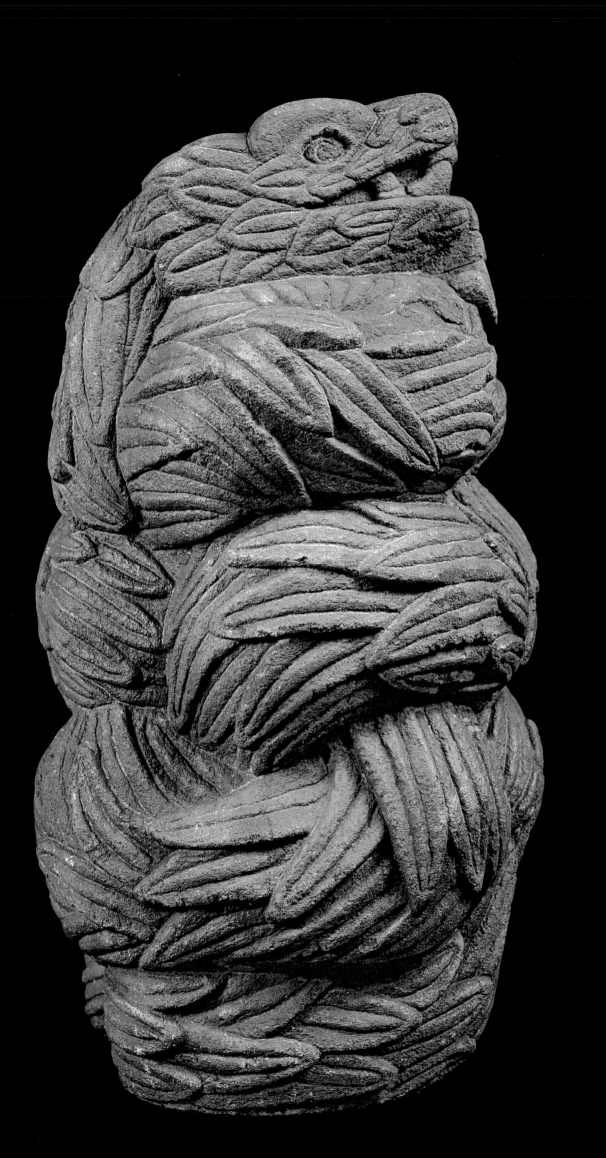

114 Serpent

c. 1250–1521, Aztec
Reddish stone, 53 × 24 × 25 cm

Vatican Museums, Vatican City, AM 3296

115 Feathered serpent with
an image of Tlaltecuhtli

c. 1500, Aztec
Stone, 28 × 45 × 45 cm

Museo Nacional de Antropología,
Mexico City, CONACULTA-INAH, 10-81678

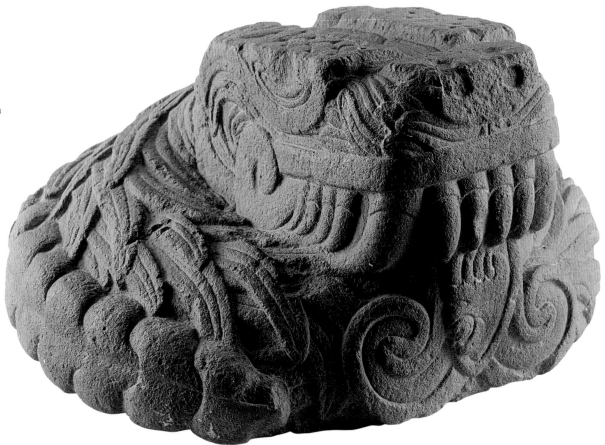

116 Tripod incense burner

c. 1500, Aztec
Fired clay, height 10.5 cm,
diameter 10 cm

Museo Nacional de Antropología,
Mexico City, CONACULTA-INAH,
10-78292

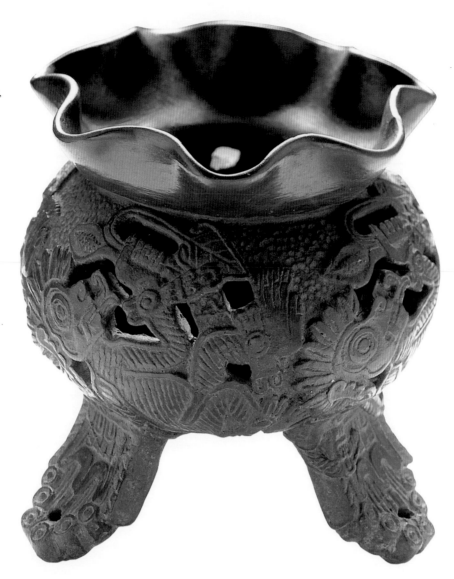

117–18 Pipes in the form of macaws

c. 1500, Aztec
Fired clay, 12 × 17.5 × 5.5 cm
and 14 × 21 × 5.5 cm

Museo Nacional de Antropología,
Mexico City, CONACULTA-INAH, 10-79956
and 10-223669

119 Vessel in the form of a rabbit

c. 1500, Aztec
Fired clay, 24 × 27 × 42.5 cm

Museo Nacional de Antropología,
Mexico City, CONACULTA-INAH, 10-564023

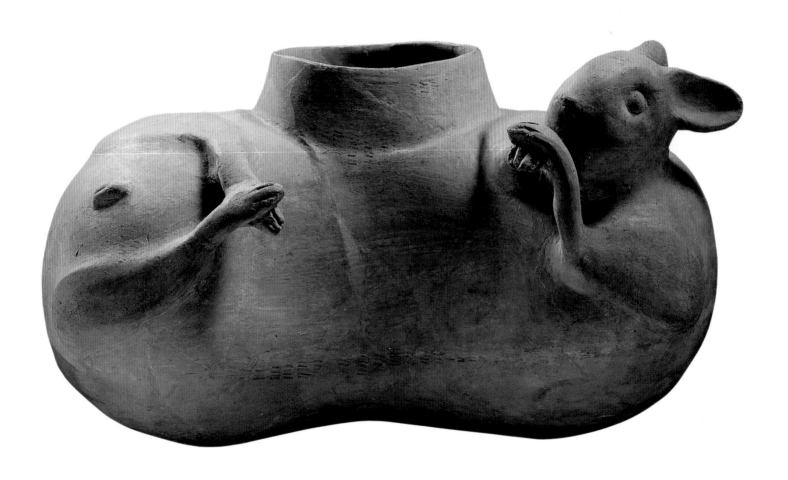

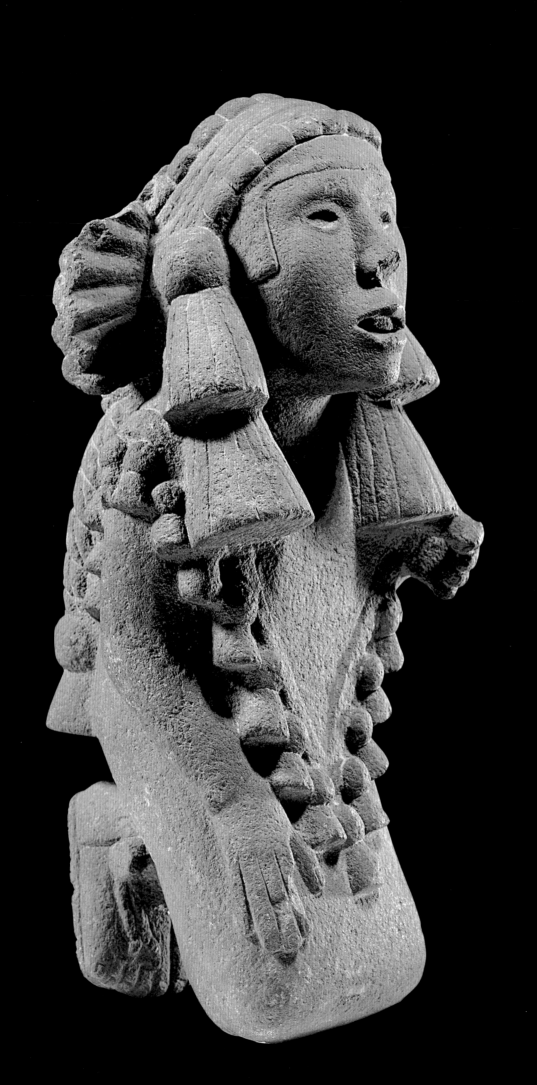

120 Chalchiuhtlicue

c. 1500, Aztec
Fine-grained volcanic stone,
53 × 25 × 20 cm

Völkerkundliche Sammlungen
Reiss-Engelhorn-Museen,
Mannheim, V Am 1084

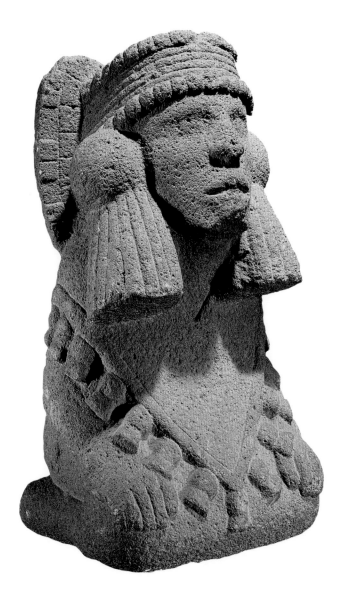

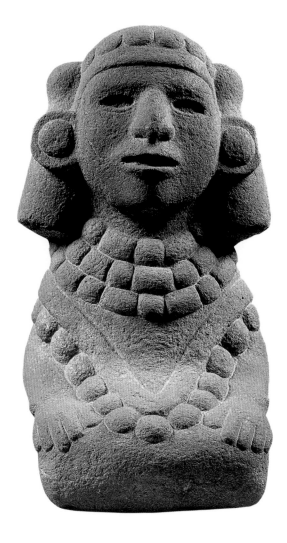

121 Chalchiuhtlicue

c. 1300–1521, Aztec
Andesite, 37 × 19.5 × 20 cm

Trustees of the British Museum, London,
Ethno. St. 373

122 Chalchiuhtlicue

c. 1500, Aztec
Stone, 32 × 20 × 15 cm

Museo Nacional de Antropología, Mexico City,
CONACULTA-INAH, 10-1103

124 Slab with an image of Chalchiuhtlicue

c. 1500, Aztec
Volcanic stone,
107 × 40 × 10 cm

Museo Nacional de Antropología,
Mexico City, CONACULTA-INAH,
10-613348

123 Mask of Chalchiuhtlicue

c. 1500, Aztec
Diorite, 33 × 17.5 × 10 cm

Museo Nacional de Antropología,
Mexico City, CONACULTA-INAH, 10-15717

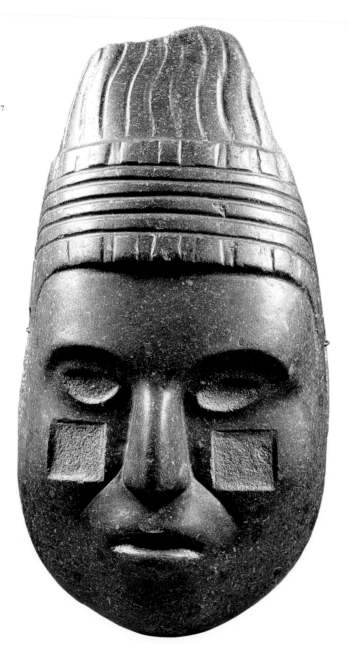

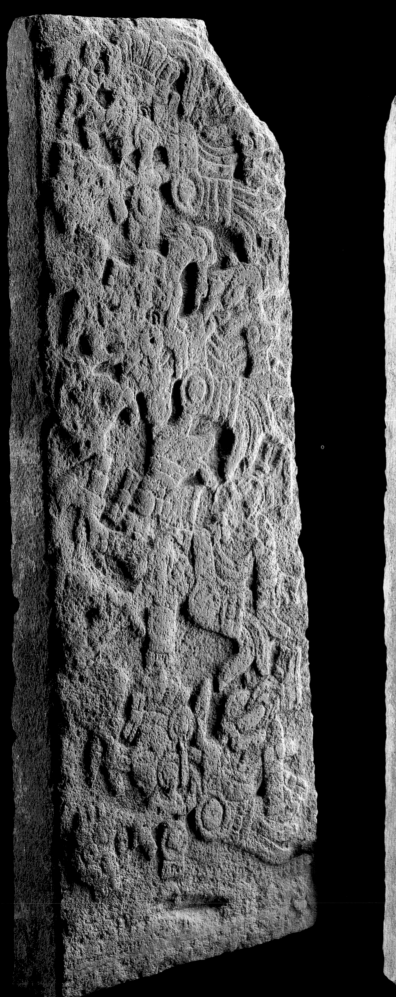
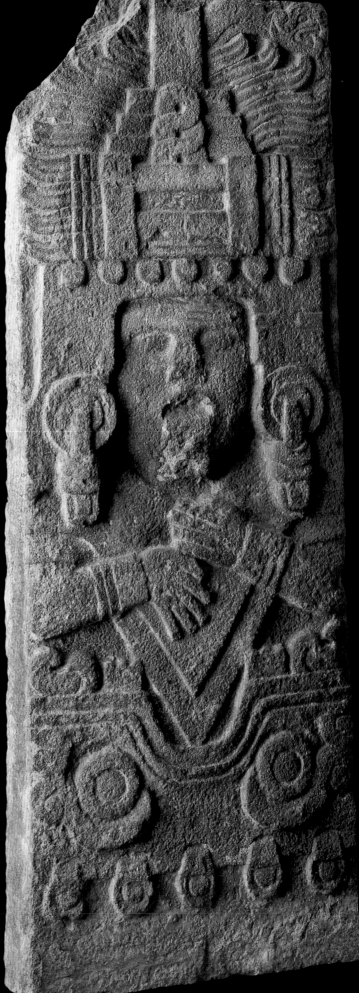

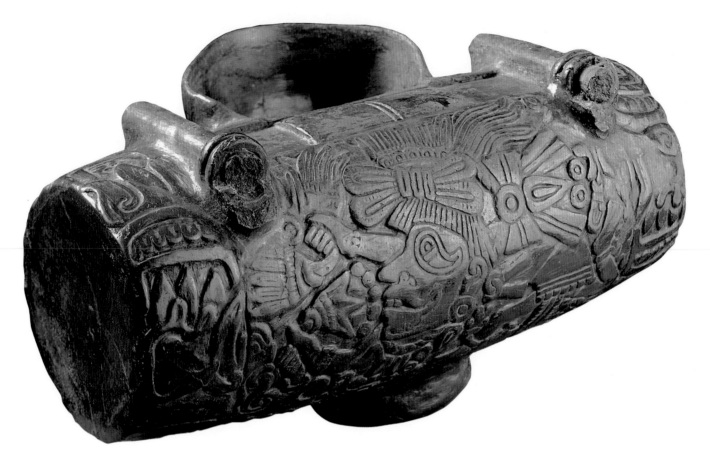

125 Vessel in the form of a drum

c. 1500, Aztec
Fired clay, 15.5 × 25 × 10.5 cm

Museo Nacional de Antropologia, Mexico
City, CONACULTA-INAH, 10-116789

126 Votive drum

c. 1500, Aztec
Stone, 35 × 72 × 26 cm

Museo Nacional de Antropología,
Mexico City, CONACULTA-INAH,
10-78329

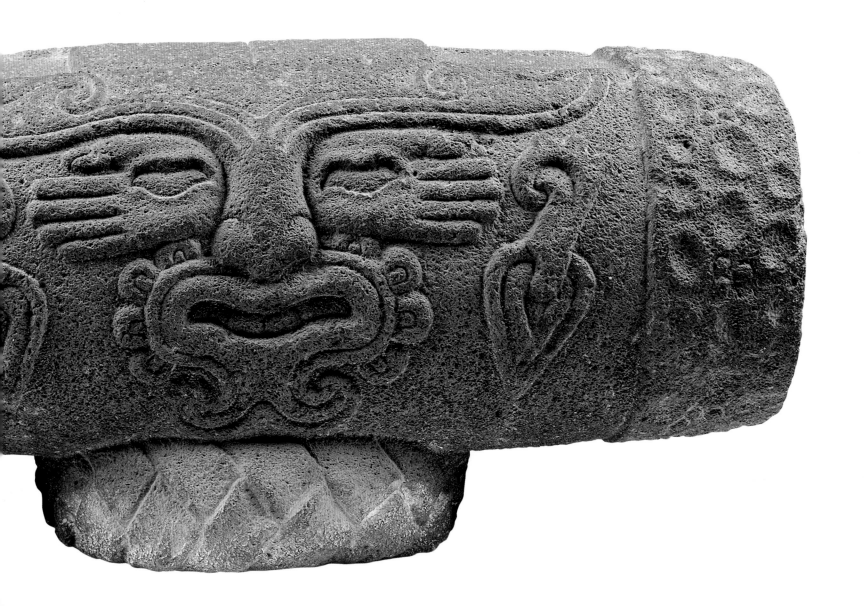

129 Solar ray

c. 1500, Aztec
Basalt, 110 × 26.5 × 15 cm

Instituto Mexiquense de Cultura:
Museo Arqueológico del Estado
de México 'Dr Román Piña Chan',
Teotenango, A-52215

127 Mirror with a depiction
of Ehecatl-Quetzalcoatl

c. 1500, Aztec
Pyrite, 6 × 5.5 × 3 cm

Laboratoire d'Ethnologie, Musée de l'Homme,
Paris, M.H.78.1.61

128 Huitzilopochtli

c. 1500, Aztec
Greenstone,
6.7 × 4.1 × 4.7 cm

Laboratoire d'Ethnologie,
Musée de l'Homme, Paris,
M.H.30.100.43

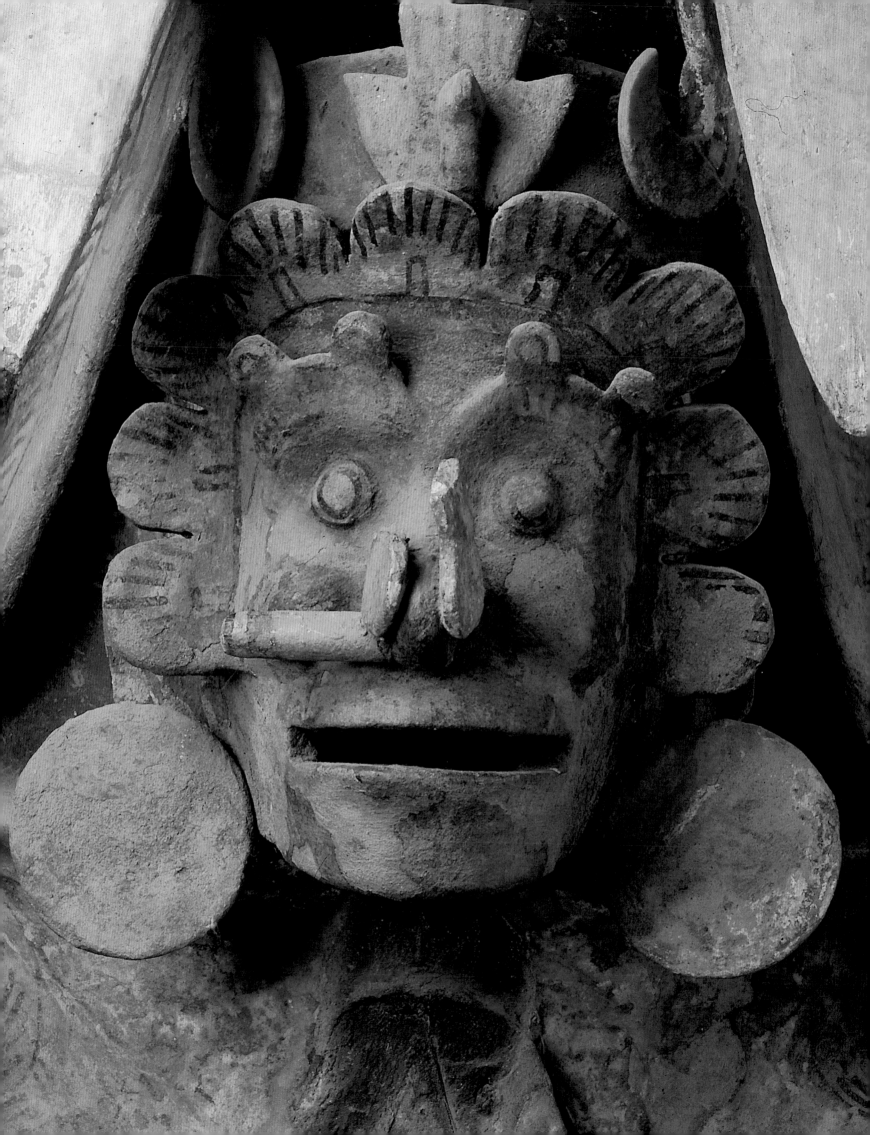

V | GODS OF DEATH

The concept of death and its representation in art played a central role in Aztec religion and culture. 'Death's head', for example, was one of the twenty multivalent signs associated with the 260-day ritual calendar, the *tonalpohualli*. The 365-day Aztec yearly calendar, the *xiuhpohualli*, comprised eighteen 'months' of twenty days, each of which was celebrated every year with a specific festival. Huey Miccailhuitl ('great feast of the dead'), celebrated from 13 August to 1 September, included sacrifices to fire, to Huehueteotl ('old, old god') and to the fire god Xiuhtecuhtli. The correlation of fire with death relates to the origins of the Fifth Sun, or fifth world-era, of the Aztecs, as recorded by the Franciscan friar Bernardino de Sahagún. At a ceremony held at Teotihuacan in the darkness of a world without a sun, Nanauatzin, an impoverished deity, and Tecuciztecatl, a wealthy deity, immolated themselves in an act of supreme self-sacrifice in order to bring the sun and moon into being. The remaining gods followed them into the fire and, with the aid of Ehecatl, god of wind, gave the hitherto stationary sun and moon movement. In another account of the creation, chronicled by Gerónimo de Mendieta, Quetzalcoatl, the feathered serpent of whom Ehecatl is one aspect, descended into Mictlan, the underworld, accompanied by the dog Xolotl, whose colossal head can be seen here (cat. 140), to collect the bones of past generations, which he then ground and mixed with his own blood to create a new human race. There is, therefore, a strong association among the Aztecs between death and rebirth and regeneration. For this reason, skulls or skull masks, like those decorating the pair of polychrome goblets (cat. 134), can often be seen with bright shining eyes, representing the continuity of life after death.

The presence of life in death can be seen in the magnificent representations of the *cihuateteo* (sing. *cihuateotl*; cats 143–45), female spirits associated with the west, place of the sunset. These were women who

died in childbirth and were equivalent to male warriors who lost their lives on the battlefield. As demons of the night, they stole children and induced men to commit adultery. They are menacingly portrayed as kneeling women with skull heads, complete with large bright eyes, and outstretched arms. Another, more complex sculpture shows a kneeling woman wearing a necklace of alternating skulls and hands (as well as a crown of skulls) similar to those of the monumental sculpture of Coatlicue ('serpent skirt'), mother of the supreme Aztec deity Huitzilopochtli. These features also appear on the intricate piece once known as the 'Coatlicue of the Metro' (cat. 132) and now thought to represent the earth monster Tlaltecuhtli ('earth lord or lady'). The seated, cross-legged figure leans her head back and braces her arms as if she were supporting the world's surface. Tlaltecuhtli was invoked by women during difficult labour and can be found represented on the bases of many sculptures, where they made unseen contact with the earth. The presence of skulls on images of Tlaltecuhtli is perhaps indicative of her mediation between the worlds of the living and the dead. A fine stone representation of Teteoinnan-Toci (cat. 135), goddess of the earth, stands erect with shell inlays representing her eyes.

The Aztecs believed that the nine planes of Mictlan ('place of the dead') were presided over by gods associated with death. The first plane was Tlalticpac, the surface of the world, which was mediated by Tlaltecuhtli. The journey to Mictlan was a dangerous one with many obstacles to overcome. The dead carried with them the objects with which they had been buried. They offered these on arrival to Mictlantecuhtli ('lord of Mictlan') and his consort. Mictlantecuhtli is usually represented with a skeletal head and the characteristic 'living' eyes. He wears vestments of paper, like those depicted on the small greenstone vessel excavated from the Templo Mayor (cat. 141). The underworld was associated with dogs and Mictlantecuhtli was the patron of the day *itzcuintli* ('dog', like 'death's head', one of the twenty signs), one of only two animals domesticated by the Aztecs (the other was the turkey). Dogs accompanied the dead on their journey to Mictlan, acting as protectors and guides. Although the Spanish associated Mictlan with the Christian concept of Hell, it was not a place of punishment for immoral or evil people, but rather the destination of all those who died a natural death. Those who died unnaturally, such as warriors, entered one of the thirteen planes of the upper world, of which Omeyocan, the place of duality presided over by Ometeotl, was uppermost.

The striking, finely carved greenstone *pulque* vessel (cat. 142) is thought to have been made for a specific historical event. Its combination of a skeletal head with the earth monster has strong links with death. What is perhaps the ultimate symbol of death, the skull and crossed bones, which is also featured on Aztec ceramics, is seen on the base. Opposing skulls are also encountered on several *cuauhxicalli*, ceremonial receptacles associated with human sacrifice (cat. 151).

The altar decorated on four sides with spider, scorpion, bat and owl (cat. 131) – creatures all associated with darkness, such as the night or solar eclipse – has a base similarly decorated with Tlaltecuhtli. Collectively referred to as the *tzitzinime*, the star demons of darkness were among the most feared of all supernaturals. The most important of them was Itzpapalotl, the obsidian moth. These creatures of destruction were thought to be stars and constellations that transformed themselves into demons during certain calendrical and celestial events and descended from the sky to wreak havoc. *Tzitzinime* was another name for the *cihuateteo*, who were transformed into spectres equivalent to the living dead.

130 Figure with three faces

c. 250–700, Teotihuacan (?)
Fired clay and traces of paint,
18 × 22 × 9 cm

Col. Museo Universitario de Ciencias y Arte, Universidad Nacional Autónoma de México, Mexico City, 08-741814

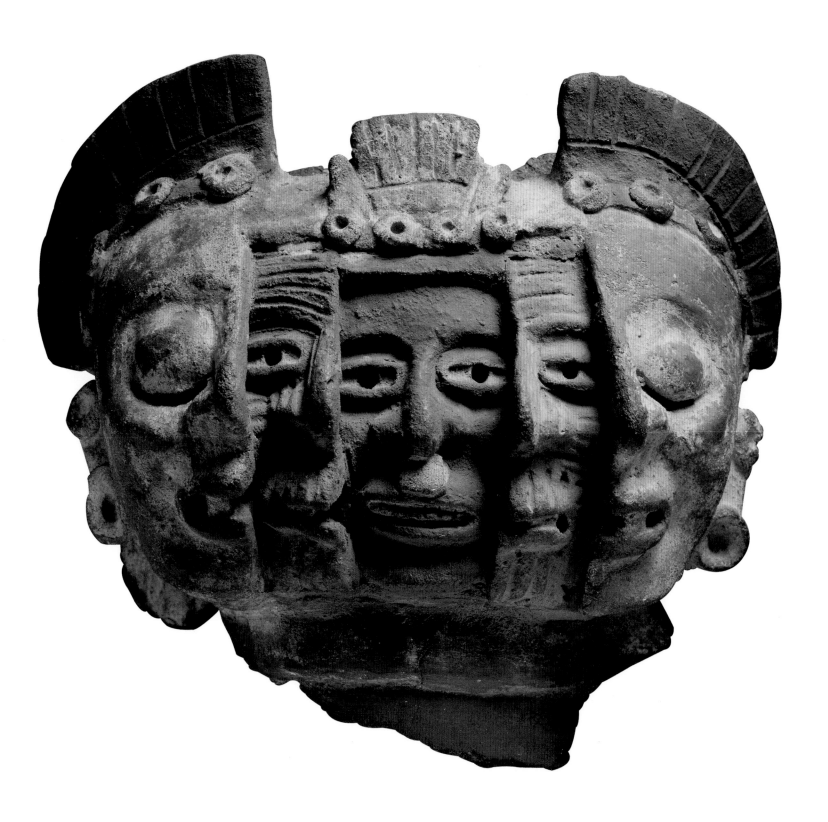

131 Altar of nocturnal animals

c. 1500, Aztec
Stone, 56 × 67 × 62 cm

Museo Nacional de Antropología,
Mexico City, CONACULTA-INAH,
10-220921

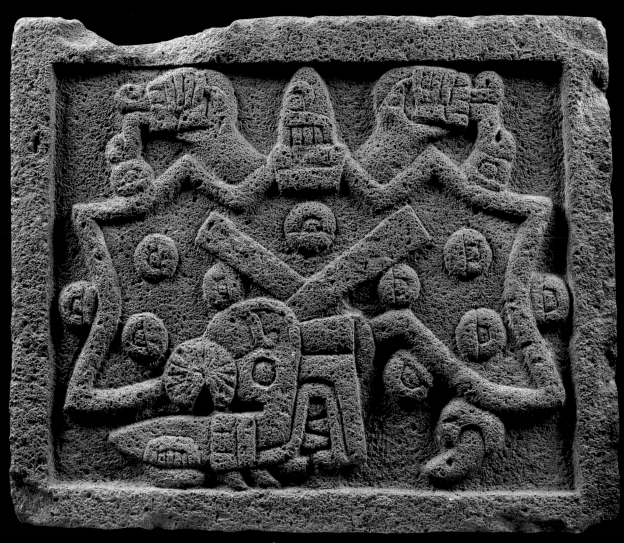

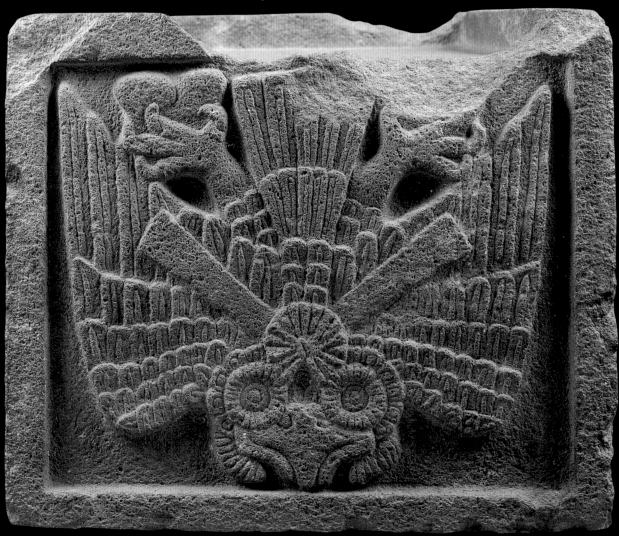

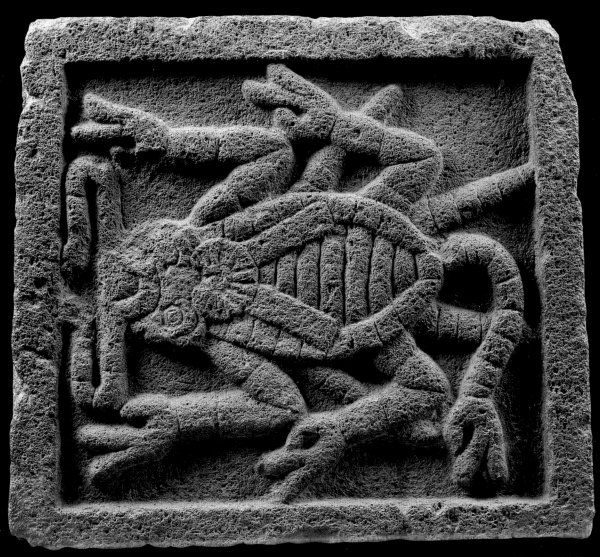
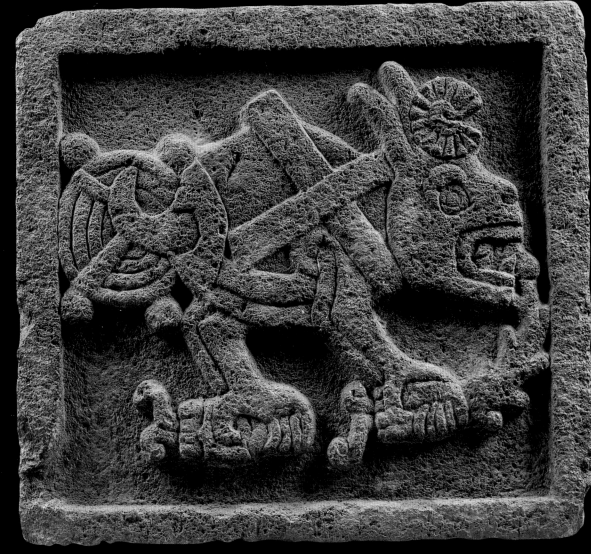

132 Tlaltecuhtli

c. 1500, Aztec
Stone, 93 × 57 × 34 cm

Museo Nacional de Antropología,
Mexico City, CONACULTA-INAH, 10-81265

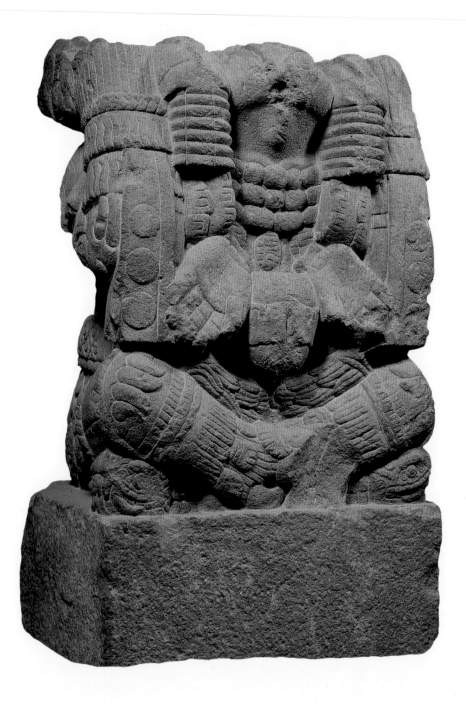

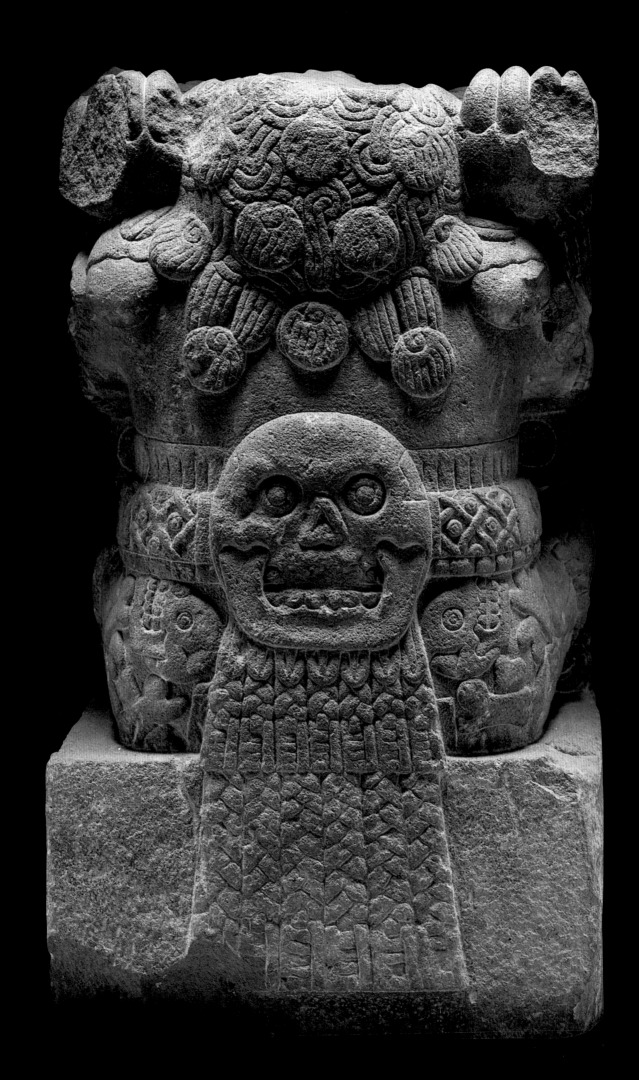

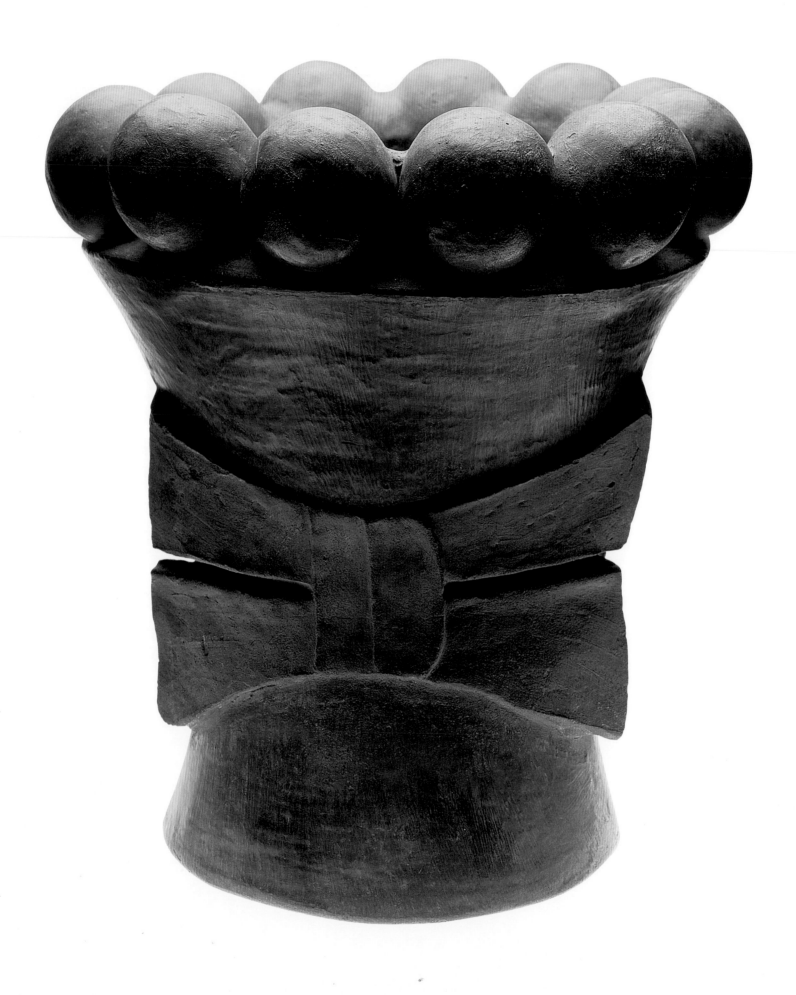

133 Brazier

c. 1500, Aztec
Fired clay, height 45.5 cm,
diameter 45 cm

Museo Nacional de Antropología,
Mexico City, CONACULTA-INAH, 10-223665

134 Goblets with images of skulls

c. 1500, Mixtec
Fired clay and paint,
height 30 cm each,
diameter 12.5 cm each

Museo Nacional de Antropología,
Mexico City, CONACULTA-INAH, 10-77820,
10-3344

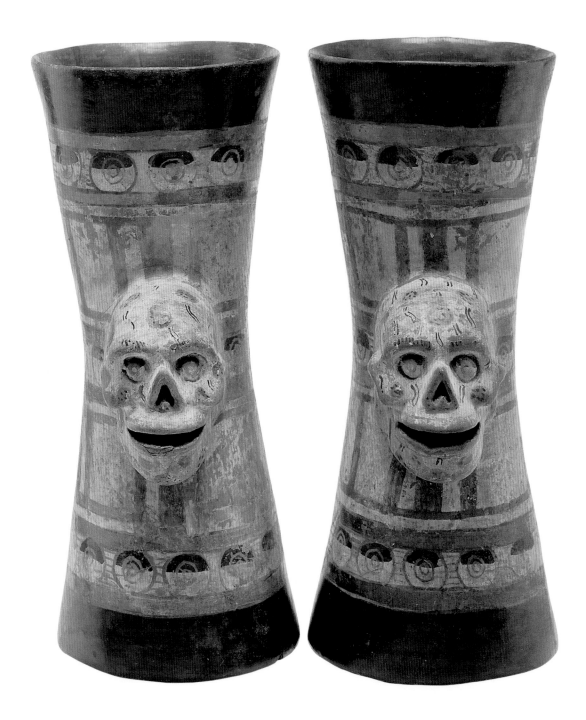

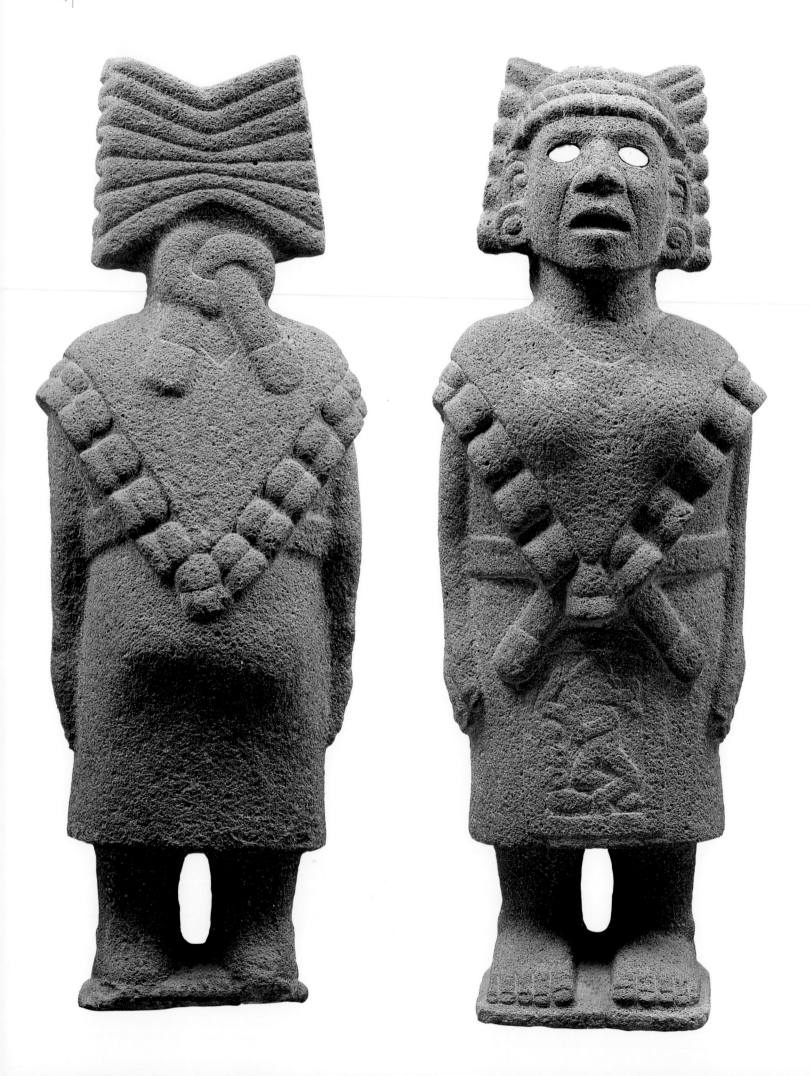

135 Teteoinnan-Toci

c. 1500, Aztec
Stone and shell, 107 × 41 × 26 cm

Museo Nacional de Antropología, Mexico
City, CONACULTA-INAH, 10-1077 0/2

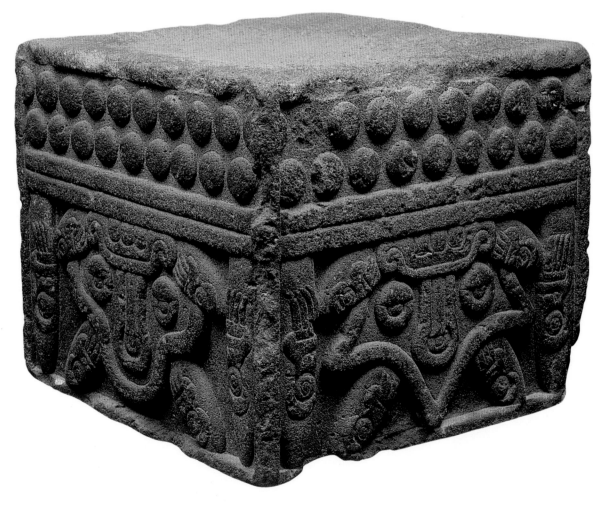

136 Altar of the planet Venus

c. 1500, Aztec
Stone, 58 × 63 × 64 cm

Museo Nacional de Antropología,
Mexico City, CONACULTA-INAH, 10-357224

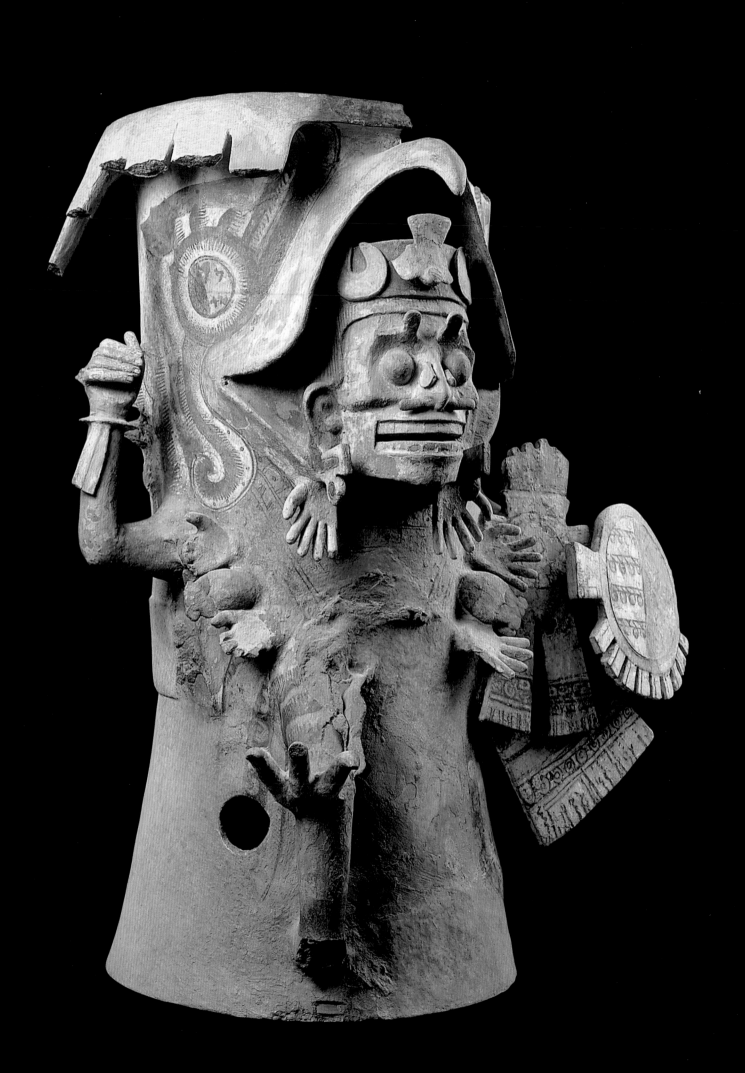

137 Brazier with an image
of a dead warrior

c. 1500, Aztec
Fired clay and paint, height 99 cm,
diameter 88 cm

Museo Nacional de Antropología, Mexico
City, CONACULTA-INAH, 10-116586

138 Anthropomorphic brazier

c. 1500, Aztec
Fired clay and paint, 91 × 76 × 57.5 cm

Museo Nacional del Virreinato, Tepotzotlan,
CONACULTA-INAH, , 10-133646

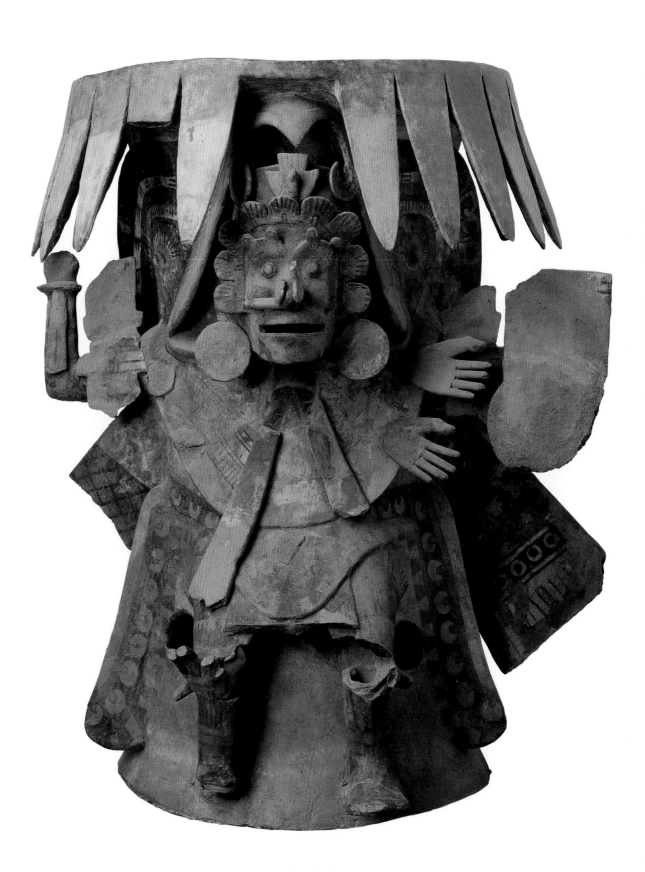

139 Coyote

c. 1500, Aztec
Stone, 28 × 46 × 45 cm

Museo Nacional de Antropología, Mexico City,
CONACULTA-INAH, 10-81642

140 Head of Xolotl

c. 1500, Aztec
Stone, 48 × 59 × 70 cm

Museo Nacional de Antropología, Mexico City,
CONACULTA-INAH, 10-116545

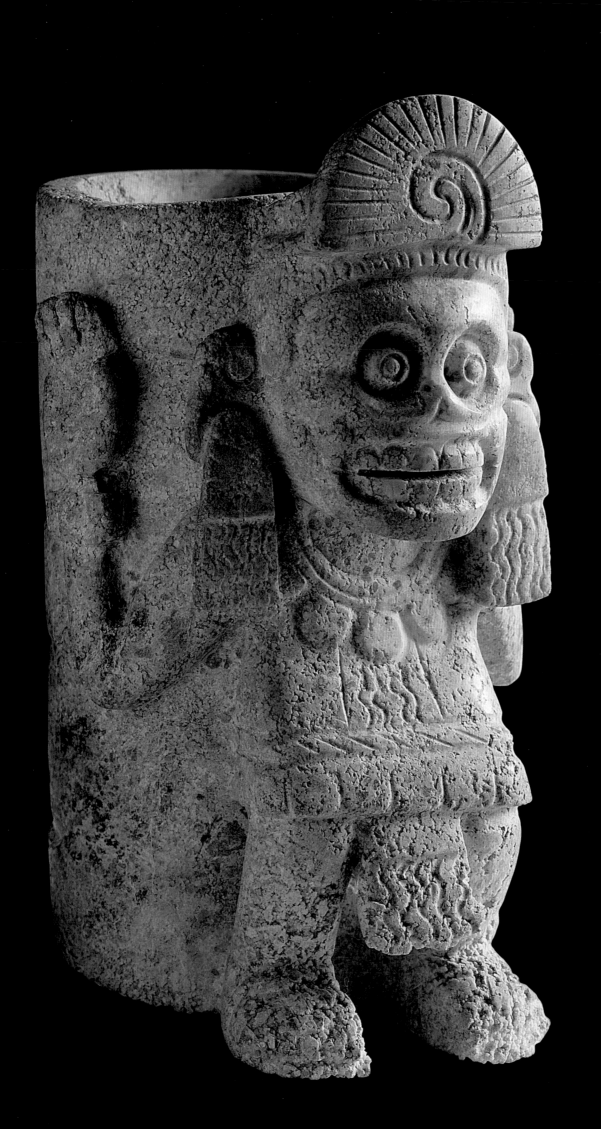

141 Urn with an image
of Mictlantecuhtli

c. 1500, Aztec
Alabaster, height 16.5 cm,
diameter 11 cm

Museo Nacional de Antropología,
Mexico City, CONACULTA-INAH, 10-168816

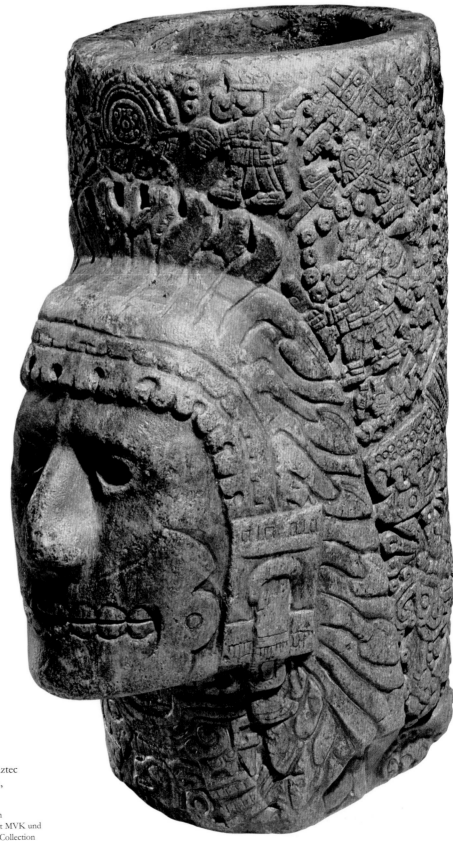

142 *Pulque* vessel

Early sixteenth century, Aztec
Greenstone, height 36 cm,
diameter 26 cm

Museum für Völkerkunde Wien
(Kunsthistorisches Museum mit MVK und
ÖTM), Vienna, 6.096, Bilimek Collection

143 *Cihuateotl*

c. 1300–1521, Aztec
Andesite, 74 × 45 × 42 cm

Trustees of the British Museum, London,
Ethno. 1990. Am. 10.1

144 *Cihuateotl*

c. 1500, Aztec
Stone, 73 × 48 × 43 cm

Museo Nacional de Antropología, Mexico City,
CONACULTA-INAH, 10-220920

145 *Cihuateotl*

c. 1500, Aztec
Stone, 112 × 53 × 53 cm

Museo Nacional de Antropología,
Mexico City, CONACULTA-INAH, 10-9781

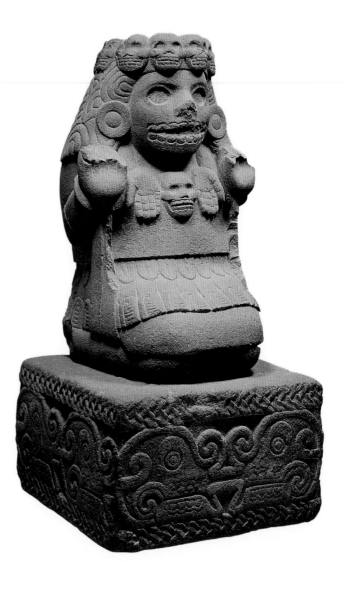

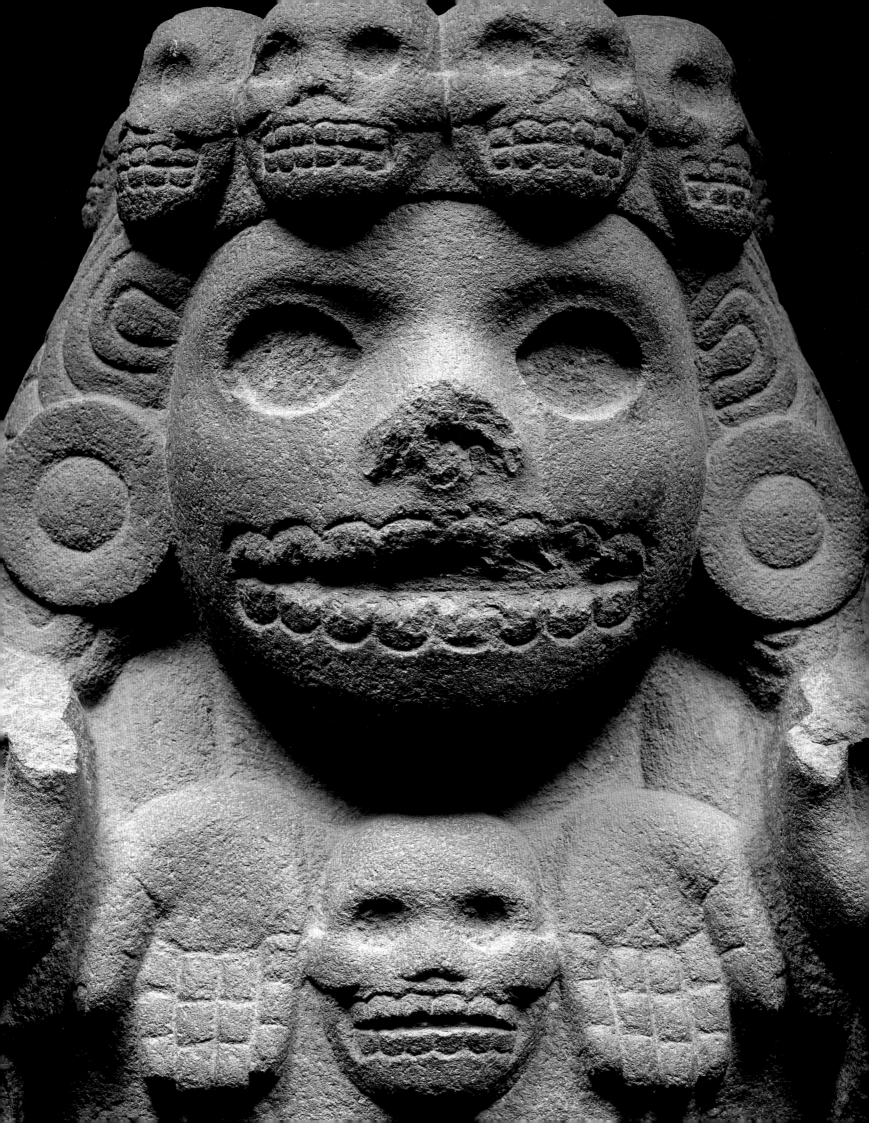

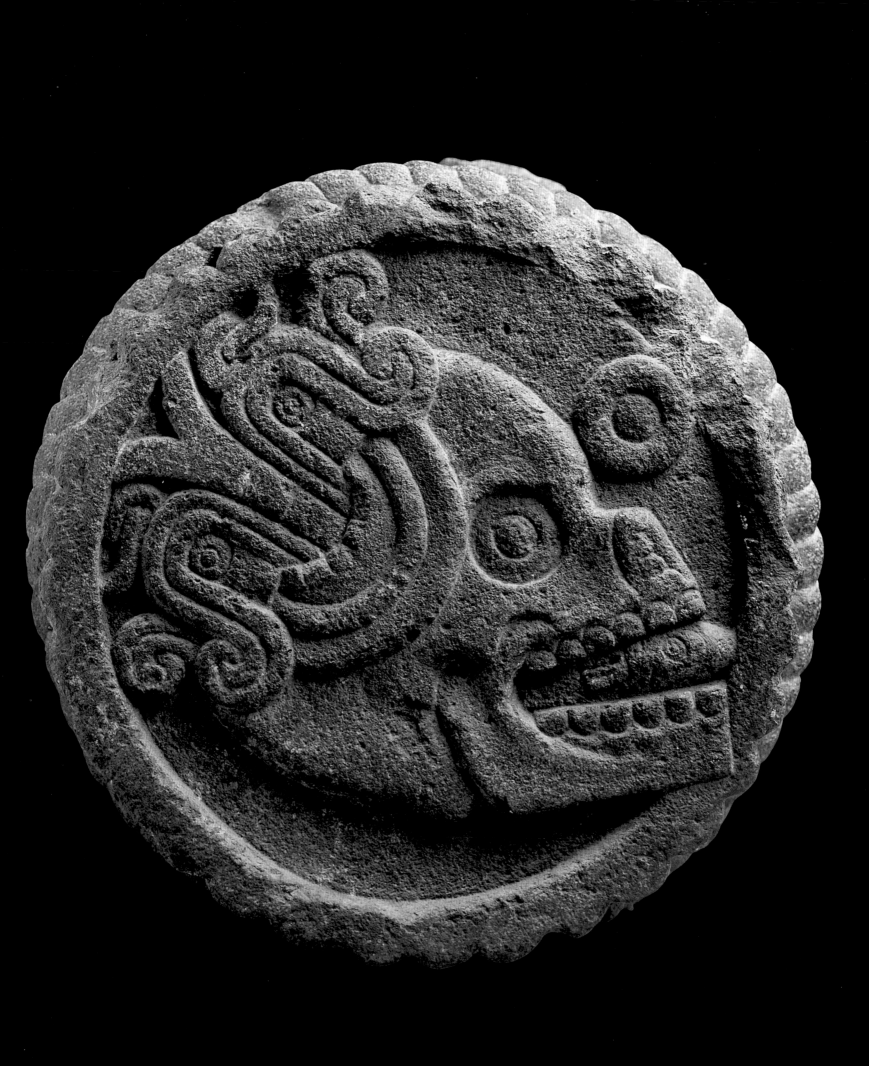

VI | RELIGION

Native speakers of Nahuatl who inhabited the central region of Mexico from the thirteenth to the sixteenth century inherited various religious traditions from the time of the Olmecs and particularly from Teotihuacan, the probable place of origin of the principal creation myths portrayed in their monumental architecture and urban design. Aztec religious thought was mythological in character and used various stories to explain the genesis of the universe, the birth of the gods and the creation of mankind. The supreme couple, Ometecuhtli and Omecihuatl, were thought to have given birth to the four Tezcatlipocas, an act that resulted in the division of the cosmos into four parts. Quetzalcoatl and Tezcatlipoca, both offspring of the primordial couple, were responsible for creating the planes of existence, a process that they began by breaking the body of Tlaltecuhtli-Cipactli, a creature that inhabited the universal waters. Thus the earth, or Tlalticpac – inhabited by men, plants and animals – was separated from the sky and the underworld.

This essentially dualistic explanation is a dialectic confrontation between opposing forces that combat each other and then unite, lighting a vital spark that triggers a new process of existence, displaying the dynamics of light and shade, masculinity and femininity, dryness and humidity and the eternal cycle of life and death. The last era of existence began with the creation of the Fifth Sun, when Nanauatzin and Tecuciztecatl faced one another and threw themselves into the sacred fire in an act of self-sacrifice. Nanauatzin became the 'king star', which gives light and heat, while Tecuciztecatl became his celestial nemesis, the moon. The sun then required the rest of the gods to be sacrificed so that he could feed on their blood and, sustained by it, start his journey across the sky to illuminate the world. As he did so, order was brought to the cosmos, which was inhabited not only by the gods of creation but also by the deities of life

and the lords of death. This polytheism formed the basis of the Aztec religion and created a complex system of rituals to celebrate the actions of the gods and receive benefits from them.

Quetzalcoatl's mission was to travel through the underworld searching for the bones of ancient generations. He ground these bones, added his own blood to them and modelled human beings from the mixture. He then set out to find food for humankind, maize, for which purpose he had to transform himself into an ant. Because of these actions, Quetzalcoatl was considered the ultimate civilising numen, in opposition to Tezcatlipoca, the patron of discord, who fostered war, dragging men into a cycle of creation and destruction within a cosmic cycle.

Meanwhile, the form of the universe was determined by the establishment of four corners and four paths that met at a central point. Movement was limited by time, a factor whose purpose was to measure and record the future. This system gave rise to the calendar, which was also dualistic. It comprised both a solar calendar of 360 working days (plus five ill-fated days known as *nemontemi*), mainly intended to assist farmers by indicating the right time for sowing crops and the right time for war, and the *tonalpohualli*, which consisted of 260 days divided into thirteen-day periods and was essentially divinatory in function. The solar calendar, or *xiuhpohualli*, was split into eighteen 'months' of twenty days. The 'months' constituted the annual rituals. Chief among these were those devoted to Huitzilopochtli ('left-sided hummingbird'), the sun of war and the Aztecs' guide and patron, during the Panquetzaliztli festival, when captives were sacrificed in his honour. Another important 'month' was Tóxcatl, dedicated to Tezcatlipoca, the ancestral god of darkness, war and masculinity, who was offered as a sacrifice the young man who had previously personified him in life. Rituals were performed during other 'months' in honour of many different deities: Tlaloc and Chalchiuhtlicue, both agricultural deities; Xiuhtecuhtli, the god of fire; Xipe Totec, the patron of goldsmiths; and Xochipilli and his companion Xochiquetzal, deities associated with the flowering of nature and humanity. Images of these gods were housed in the sacred precinct at Tenochtitlan, the Aztec capital, where pyramids and temples were built in their honour and a complex organisation of priests was charged with performing various rites involving human and animal sacrifice. The priests were led by the Quetzalcoatl Totec *tlamacazqui* and the Quetzalcoatl Tlaloc *tlamacazqui*, who attended the temples of Huitzilopochtli and Tlaloc respectively.

Because, according to their myths, the world had been created by the self-sacrifice of their gods, the Aztecs undertook to repay this sacred offering with an oblation of the blood and hearts of prisoners captured in battle. Ritual celebrations involving human sacrifice guaranteed the victims permanence in the universe. It is worth remembering that all the peoples of ancient Mexico, and those of most other civilisations around the world, were involved in similar practices at some point during their history. During colourful rituals, victims were laid on the *téchcatl* (cat. 155), a sacred stone slab set into the ground in front of the entrance to the temple and aligned with the image of the god within. Their backs were arched to facilitate the extraction of the heart, an operation carried out using a flint-bladed knife (cat. 153) with a finely carved wooden handle decorated with a turquoise mosaic inlay. The offering – mainly blood – was placed in the *cuauhxicalli* (cats 150–52), a stone container decorated with images that evoked death or represented animals of war, such as eagles and jaguars.

The lavish rites performed in the Templo Mayor and in the various sacred buildings scattered around Tenochtitlan had modest equivalents in the domestic surroundings of the commoners. Here, small clay figurines of the gods were set up on altars and asked to provide health, plentiful harvests and continuity of lineage. Offerings consisted of seeds, food and blood provided by self-sacrifice to absorb the primordial energy of the cosmos.

146 Figure

c. 1350–1521, Aztec
Fired clay, height 18 cm

Staatliche Museen zu Berlin: Preußischer Kulturbesitz,
Ethnologisches Museum, IV Ca 36407

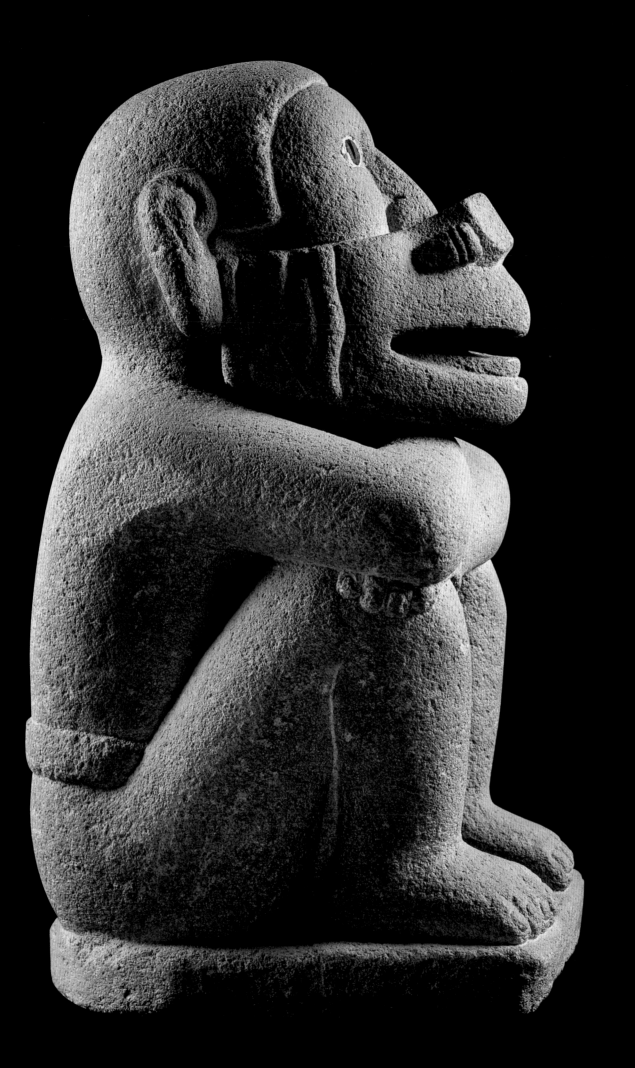

147 Ehecatl-Quetzalcoatl

c. 1500, Aztec
Stone and obsidian, 41 × 23 × 18 cm

Museo Nacional de Antropología,
Mexico City, CONACULTA-INAH, 10-48

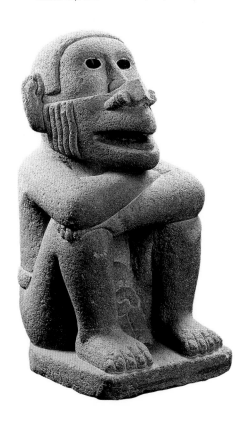

148 Macuilxochitl

c. 1500, Aztec
Stone, 36 × 43 × 54 cm

Museo Nacional de Antropología,
Mexico City, CONACULTA-INAH, 10-1102

149 Tonatiuh

c. 1350–1521, Aztec
Volcanic stone and traces of paint,
31.5 × 16.2 × 24.5 cm

Museum der Kulturen Basel, Basle, IVb 634

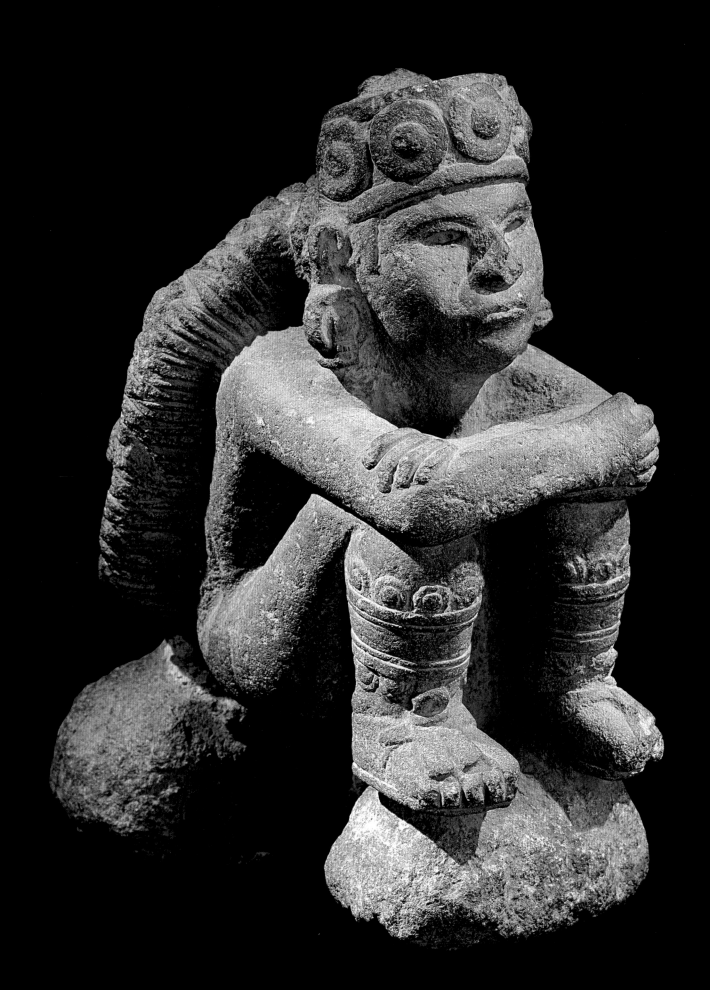

150 *Cuauhxicalli*

Late fifteenth or early sixteenth
century, Aztec
Greenstone, height 6.4 cm,
diameter 15.5 cm

Museum für Völkerkunde Wien
(Kunsthistorisches Museum mit MVK und
ÖTM), Vienna, 59.896, Becker Collection

153 Sacrificial knife

c. 1500, Aztec
Wood and flint, 7 × 31 × 5 cm

Museo Nacional de Antropología,
Mexico City, CONACULTA-INAH,
10-559650

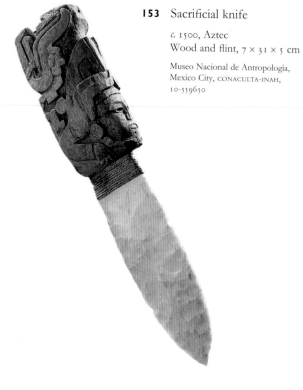

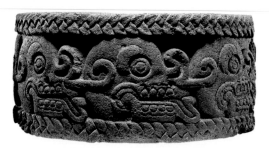

151 *Cuauhxicalli*

c. 1500, Aztec
Stone, height 17.5 cm,
diameter 40 cm

Museo Nacional de Antropología,
Mexico City, CONACULTA-INAH,
10-220916

152 *Cuauhxicalli*

c. 1500, Aztec
Basalt, height 56 cm,
diameter 30 cm

Trustees of the British Museum,
London, Ethno. +6185

154 Heart

c. 1500, Aztec
Greenstone, 24 × 20 × 11 cm

Museo Nacional de Antropología,
Mexico City, CONACULTA-INAH,
10-392930

155 *Téchcatl*

c. 1500, Aztec
Stone, 94 × 80 × 28 cm

Museo Nacional de Antropología,
Mexico City, CONACULTA-INAH, 10-81578

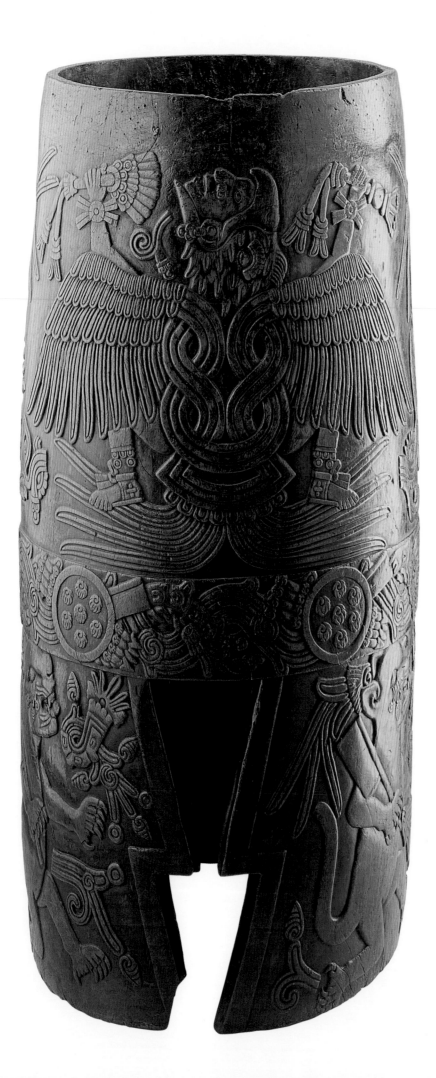

156 Drum

c. 1500, Aztec
Wood, height 98 cm, diameter 52 cm

Instituto Mexiquense de Cultura: Museo
de Antropología e Historia del Estado de México,
Toluca, A-362300 10-102959

159–62
Flutes

c. 1500, Aztec
Fired clay, lengths 25.5 cm,
26 cm, 17.5 cm
and 18.5 cm,
diameters 6 cm, 4.5 cm,
7 cm and 5.5 cm

Museo Nacional de Antropología,
Mexico City, CONACULTA-INAH,
10-2431, 10-5325, 10-150350 and
10-559559

157 Drum

c. 1500, Aztec
Wood, shell and obsidian, 14 × 15 × 60 cm

Museo Nacional de Antropología, Mexico City,
10-81663

158 Drum

c. 1250–1521, Aztec
Wood, 66 × 20 × 22 cm

American Museum of Natural History, New York,
30/9756

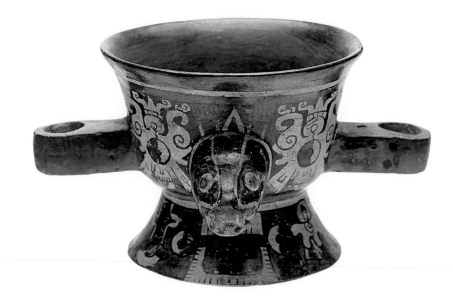

163 Brazier

c. 1500, Aztec
Fired clay and paint,
12 × 23.5 × 20 cm

Museo Nacional de
Antropología, Mexico City,
CONACULTA-INAH, 10-78081

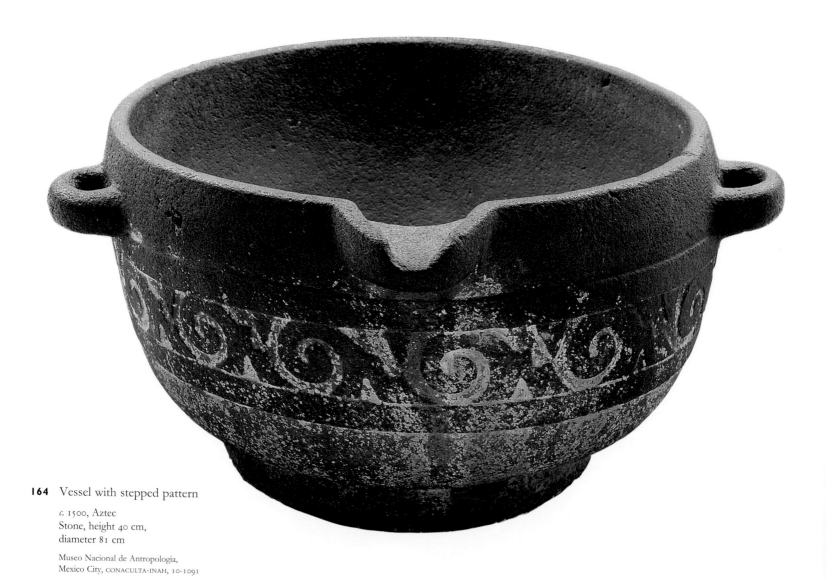

164 Vessel with stepped pattern

c. 1500, Aztec
Stone, height 40 cm,
diameter 81 cm

Museo Nacional de Antropología,
Mexico City, CONACULTA-INAH, 10-1091

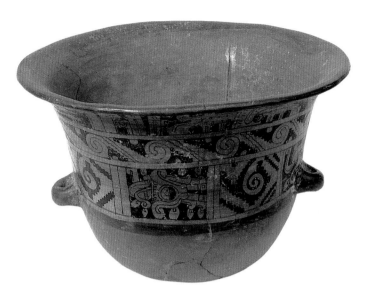

166 Two-handled bowl

c. 900–1521, Mixtec
Fired clay and paint,
23.5 × 38 cm

Didrichsen Art Museum, Helsinki,
acc. no. 822

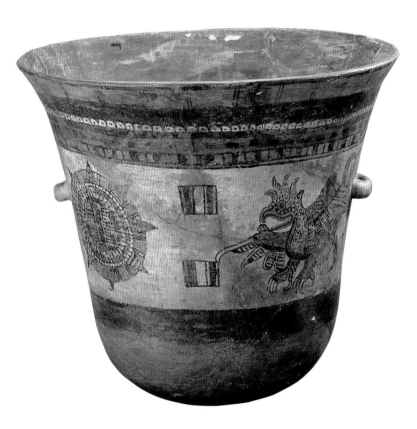

165 Urn

c. 1250–1550, Totonac (?)
Fired clay and paint, height 41.5 cm,
diameter 47 cm

Fowler Museum of Cultural History, UCLA,
Anonymous gift, X75.1531

167 Two-handled polychrome urn

c. 1500, Mixtec
Fired clay and paint,
35.5 × 40 cm

Colección Fundación Televisa, Mexico City,
Reg. 21 pj. 35

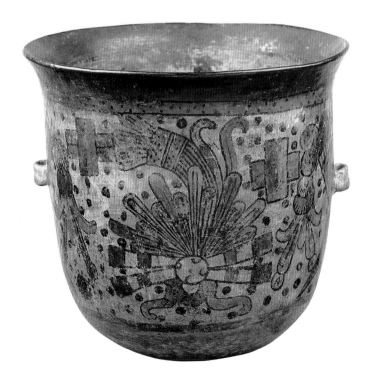

169 *Tepetlacalli*

c. 1500, Aztec
Stone, 21 × 32 × 32 cm

Museo Nacional de Antropología,
Mexico City, CONACULTA-INAH, 10-466061

168 Casket

c. 1350–1521, Aztec
Stone, 29.5 × 25.5 × 20 cm

Staatliche Museen zu Berlin: Preußischer Kulturbesitz,
Ethnologisches Museum, IV Ca 26921 a-b

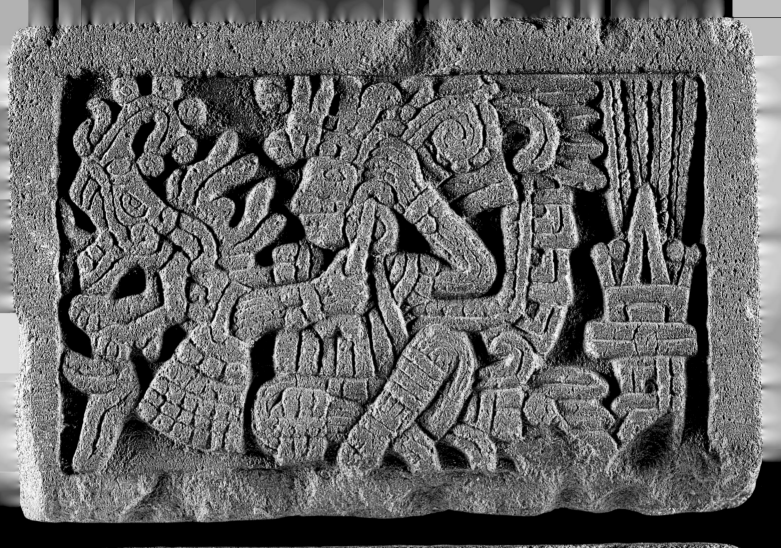
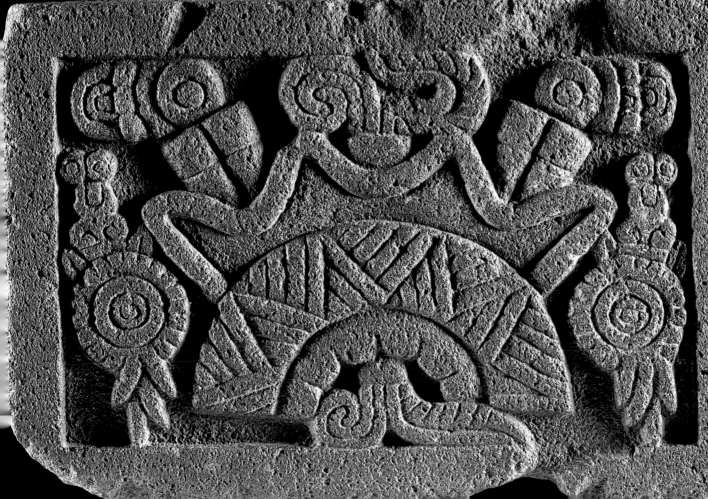

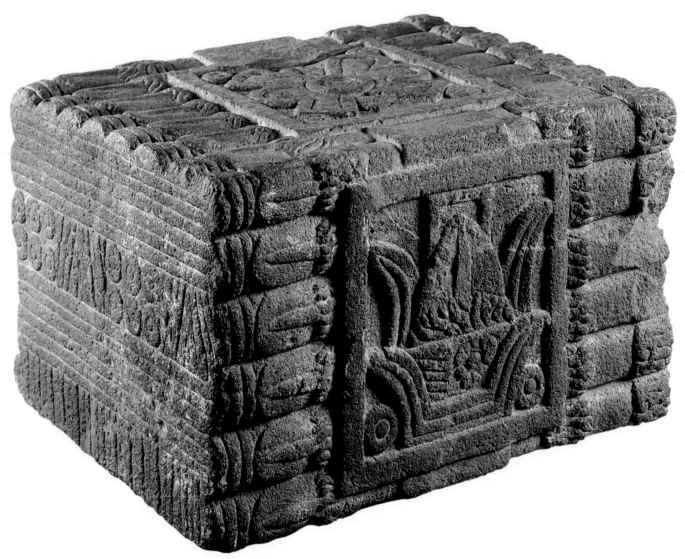

170 Altar of the 52-year
calendrical cycle

c. 1500, Aztec
Stone, 38.3 × 30 × 22.3 cm

Colección Fundación Televisa,
Mexico City, 21 Pj.9

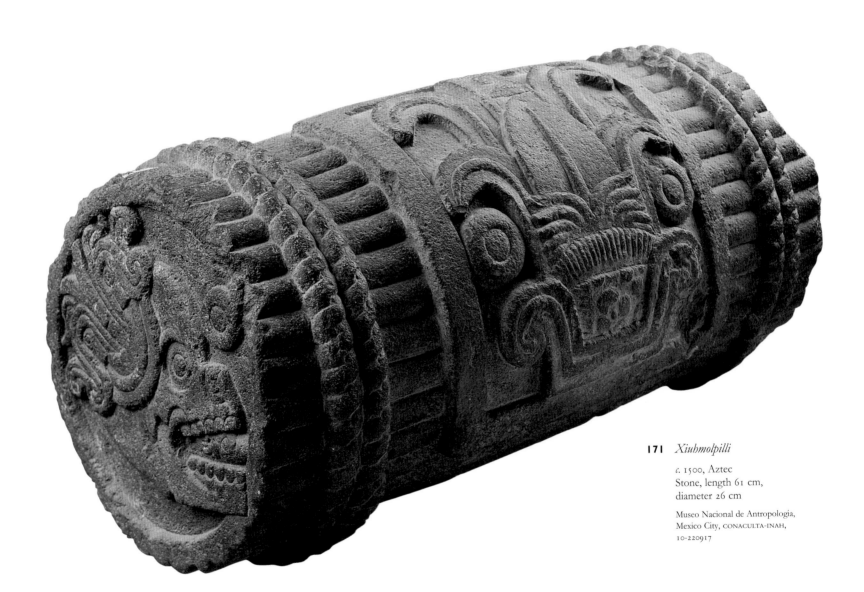

171 *Xiuhmolpilli*

c. 1500, Aztec
Stone, length 61 cm,
diameter 26 cm

Museo Nacional de Antropología,
Mexico City, CONACULTA-INAH,
10-220917

174 Calendar stone

c. 1500, Aztec
Stone, 24 × 24 × 9.5 cm

Museo Nacional de Antropología,
Mexico City, CONACULTA-INAH,
10-223606

172 Calendar stone

c. 1500, Aztec
Stone, 31 × 37 × 15 cm

Museo Nacional de Antropología,
Mexico City, CONACULTA-INAH, 10-46541

173 Date stone

c. 1469, Aztec
Volcanic stone, 33 × 32 × 7.6 cm

Philadelphia Museum of Art: The Louise and Walter
Arensberg Collection, 1950, 1950-134-374

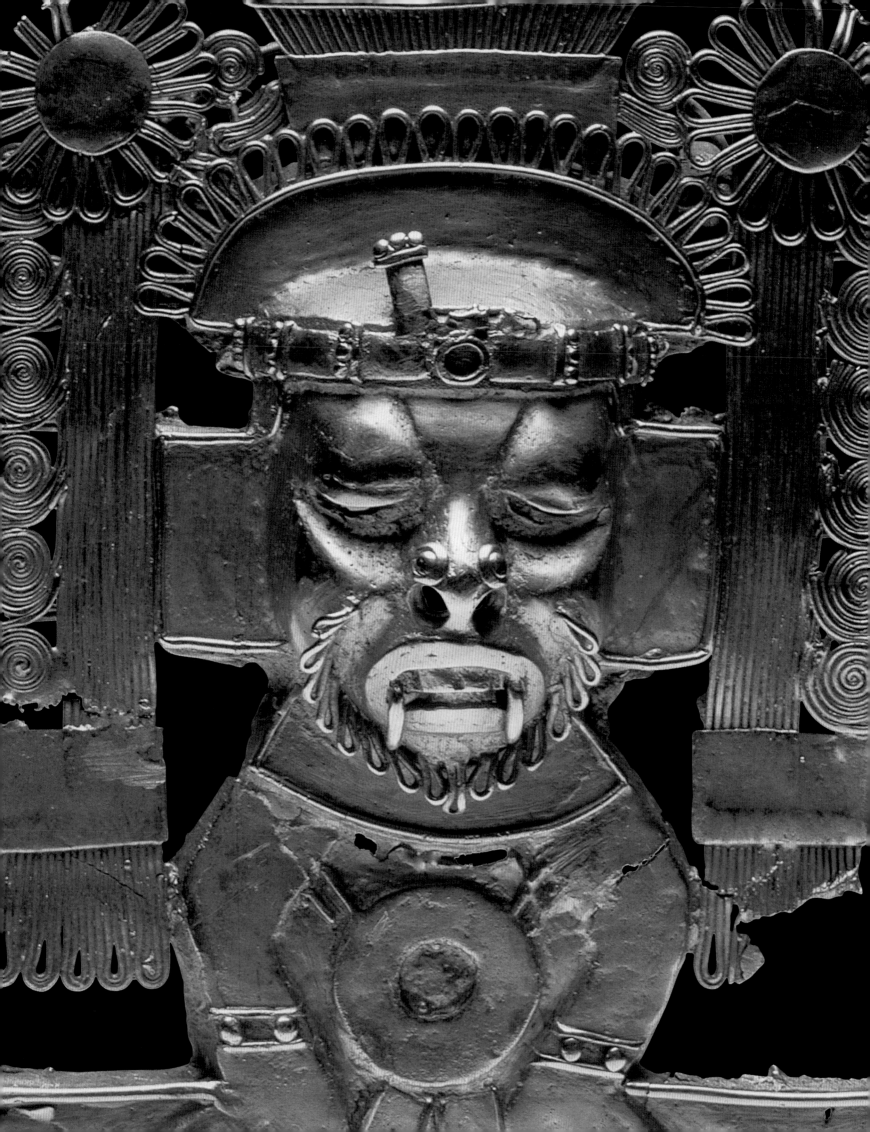

VII | GOLD AND SYMBOLS OF STATUS

During its transformation from wandering tribe to imperial power, the original Aztec community of farmers and fishermen developed into a hierarchical society in which power and wealth were concentrated in the hands of a hereditary nobility, the *pipiltin*. Under the patronage of the ruler, the *pipiltin* monopolised the important positions in the army, the civil service and the priesthood, and their ostentatious lifestyle set them apart from the commoners, in death as in life (cat. 201). Most of the objects in this section can be linked with the nobility, either in their private lives or, indirectly, through their public roles as administrators, warriors and priests. To emphasise their status they demanded expensive and exotic materials (gold, jade, tropical feathers, turquoise, jaguar skins) and also the highest quality of craftsmanship.

The ruling élite employed various stratagems to distance itself from the rest of the people, and class distinctions were rigidly enforced. The law code of Motecuhzoma I prohibited, on pain of death, all commoners from wearing sandals in the city, using cotton clothing or wearing expensive jewellery. This simplicity contrasts with the extravagance of aristocratic dress. Bernardino de Sahagún lists some of the items of dance attire stored in the royal treasury: artefacts of jade and amber, a cylindrical lip-plug of crystal with cotinga feathers in a gold setting (cat. 187), a greenstone eagle set in gold (cat. 192), a gold-mounted turquoise disc and gold representations of pelicans, eagles, fire serpents and plants. The pictorial manuscripts show that gold, coloured stones, patterned textiles and iridescent feathers were used in combination to create 'multimedia' costumes for both men and gods, and these costumes are also represented in sculpture (see, for example, cats 200 and 205, both of which wear necklace discs engraved with the symbol for gold).

After the Conquest, Aztec artefacts were shipped to Europe as curiosities. In his first letter from Mexico, Hernán Cortés mentions 'four animal heads, two wolves and two tigers, with painted skins from which hang metal bells…another headdress of blue stone mosaic work with 25 gold beads above each bell…with some elements of wood plated with gold, and a bird of green plumage with feet, beak and eyes of gold'. The bells, which tinkled with every movement of the wearer (cats 178, 180), added the element of sound to the visual impact of aristocratic costume.

Another well-documented consignment is the gift sent by Motecuhzoma to Cortés a few days after the Spanish fleet reached Mexico. Bernal Díaz del Castillo, who served under Cortés, describes a pair of discs as big as cartwheels, one of gold and one of silver, 'engraved with many sorts of figures', and also gold ornaments in the shapes of dogs, tigers, deer and monkeys, as well as bows and arrows, golden staffs, gold and silver crests and 'many other things that I cannot remember'. In 1520 the painter Albrecht Dürer examined these same items in Brussels and described the discs in his diary, together with 'all sorts of their weapons, armour…shields [cat. 208], rare clothing, feathers [fig. 51] and all sorts of wonderful things…All the days of my life I have seen nothing that so rejoiced my heart as these things, for I have seen among them wonderful works of art…'. Unfortunately, none of the items surviving from European cabinets of curiosities (the embryonic beginnings of today's national collections) can be reliably linked to Cortés, and most Aztec goldwork was melted down, either in Mexico or in Spain.

There is also a problem in deciding which artefacts are 'Aztec' in the strict sense of the term. Members of the Aztec élite were cosmopolitan in their tastes, and many high-prestige goods came from tropical lands outside the Basin of Mexico, either as tribute from conquered provinces (see fig. 37, with its illustration of chocolate beans, jaguar pelts, bundles of feathers, gold and jade jewellery) or as trade items brought by long-distance merchants (see pp. 42–43). As the imperial capital, Tenochtitlan attracted craftsmen from all over Mexico, and access to foreign products became an indicator of high status. Bernal Díaz, for example, reports that even the finest Aztec pottery (cats 210, 212, 214, 218–19, 221–22) was not good enough for Motecuhzoma, who ate his dinner from Mixteca–Puebla vessels imported from the city of Cholula (cats 217, 220). Mixtec artisans from Oaxaca were encouraged to settle in Tenochtitlan, and Mixtec-style gold jewellery (cats 176–80, 184–85) undoubtedly circulated in the city alongside pieces in the local Aztec style (cat. 186). Through their connections with the nobility, merchants and senior craftsmen also became rich, though, as commoners, they were careful not to flaunt their wealth.

The 'internationalisation' of jewellery and costume items is not reflected in large-scale sculpture. Most surviving sculpture was commissioned for temples or public spaces, and was designed to remind the citizenry of the glories of the Aztec state. Carvings contain overt references to rulers (Ahuizotl, for instance, in cat. 203), to military themes (cats 188, 208) or to the official religion (cats 184, 202), and, as state propaganda, are unambiguously Aztec in style and subject matter.

This propaganda art reminds us that the lifestyle of the nobility was sustained largely by warfare. Success in war brought tribute to the royal treasury and captives to be sacrificed on temple altars or at the *temelácatl* stone (cat. 209). These sacrifices ensured the favour of Huitzilopochtli, the warrior patron god of the Aztecs, and also reaffirmed the power of the ruler, who, as commander-in-chief, distributed presents and insignia of rank to his officials and to warriors who had proved their bravery in battle. Success and status, or the lack of these, were publicly visible in everything a person wore and in the accoutrements he was permitted to carry (cat. 198). Torn from their original contexts, these items appear to us, as they did to Dürer, as works of art. To the Aztecs they carried social and political messages which everyone would have understood.

175 Ring with a feline head in relief

c. 1200–1521, Mixtec
Cast gold, diameter 2 cm, thickness 1.1 cm

Trustees of the British Museum, London, Ethno. +1914 3-28.1

176 Ring

c. 1250–1521, Mixtec
Gold, maximum height 1.5 cm, diameter 1.7 cm

Museo Civico di Arte Antica, Palazzo Madama, Turin, 730

177 Ring with an image of a bird's head

Fifteenth century, Mixtec
Gold, 2.16 × 3.47 × 1.83 cm

Bayerische Verwaltung der Staatlichen Schlösser, Gärten und Seen: Residenz, Munich, Schatzkammer, Res. Mü. Schk. 1257 (WL)

178 Pendants

c. 1300–1521, Aztec
or Mixteca–Puebla
Cast gold, 8 × 3 × 2.5 cm each

Dumbarton Oaks Research Library
and Collections, Washington DC, B-104

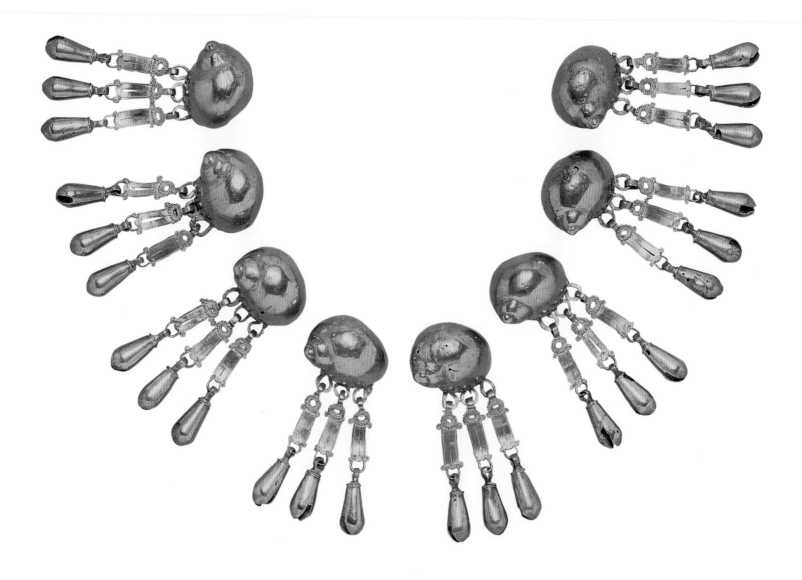

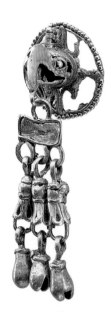

180 Pair of ear ornament frontals

c. 1400–1521, Aztec–Mixtec
Cast gold, height 6 cm

Lent by The Metropolitan Museum of Art, The Michael
C. Rockefeller Memorial Collection, Purchase, Nelson
A. Rockefeller Gift, 1967, 1978.412.200a, b

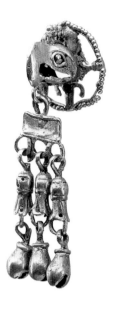

179 Pendant with an
image of Xiuhtecuhtli

c. 1500, Mixtec
Gold, 6 × 4 × 1.5 cm

Museo de las Culturas de Oaxaca,
CONACULTA-INAH, 10-105429

181 Pendant in the form of
an image of Xiuhtecuhtli

c. 1500, Aztec–Mixtec
Gold, 4 × 3.5 × 2 cm

Museo Nacional de Antropología,
Mexico City, CONACULTA-INAH, 10-8543

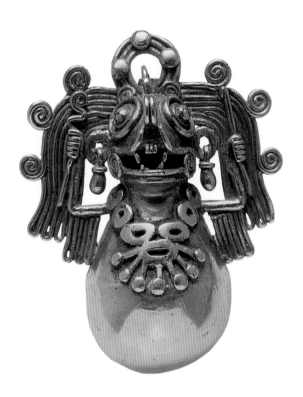

182 Rattle

c. 1500, Mixtec
Gold, 5.5 × 4.5 cm

Museo de las Culturas de Oaxaca,
CONACULTA-INAH, 10-105430

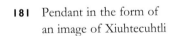

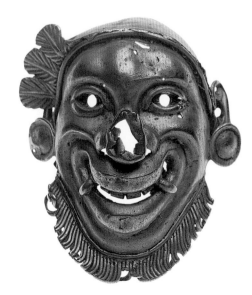

183 Pendant bell

c. 1500, Aztec
Gold, 9 × 7.5 × 3.8 cm

The State Hermitage Museum, St Petersburg, DM 321

184 Pectoral with an image of Xiuhtecuhtli

c. 1500, Mixtec
Gold, 10.5 × 7.5 × 2 cm

Museo Nacional de Antropología, Mexico City, CONACULTA-INAH, 10-9676

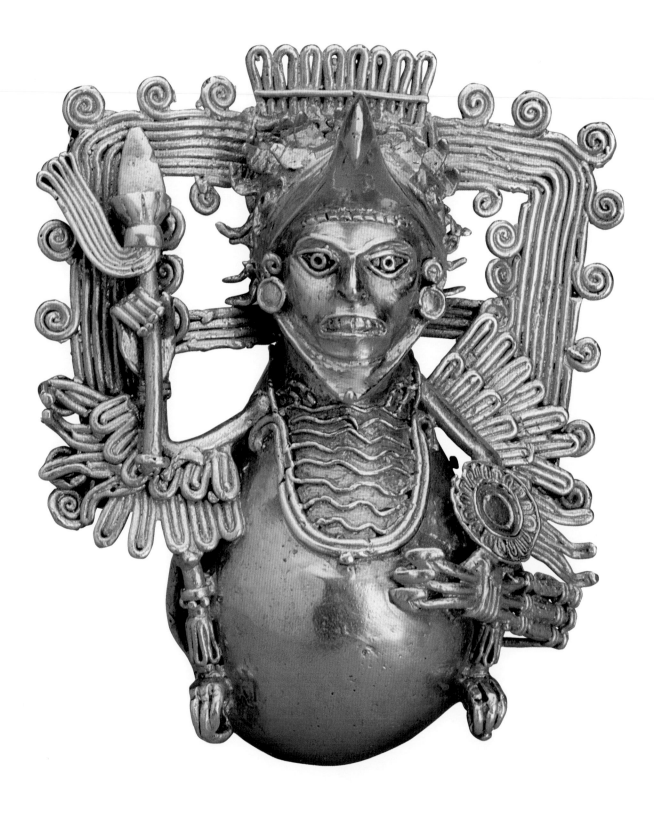

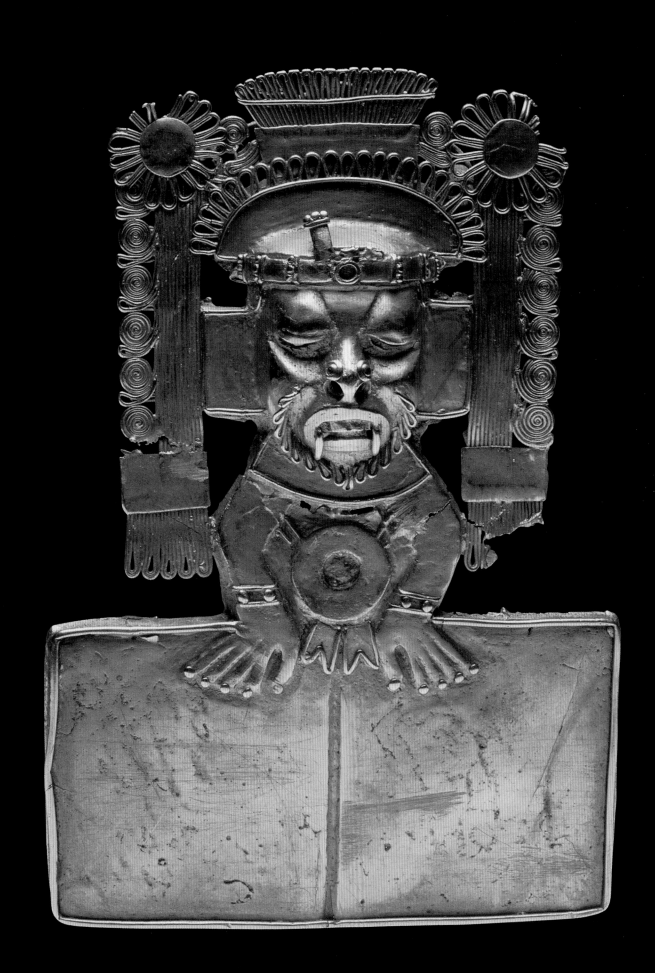

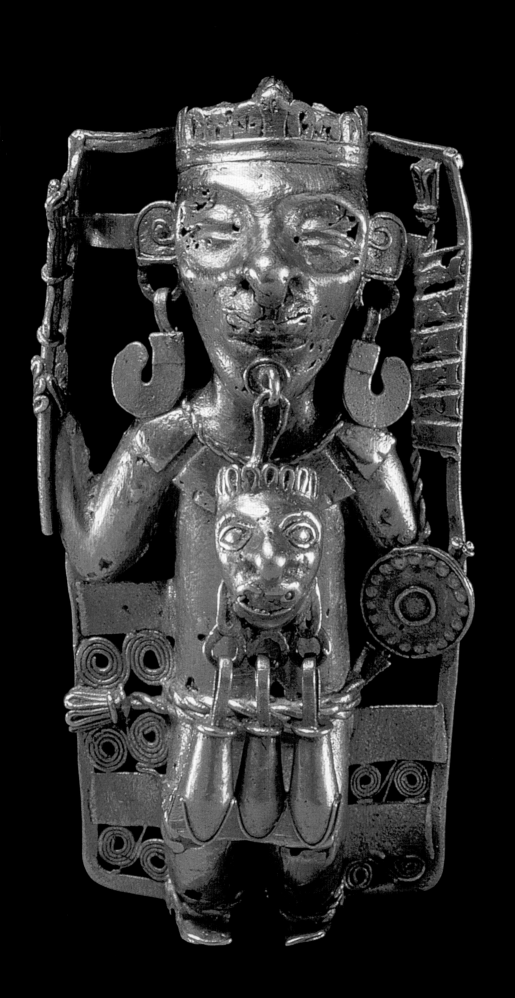

185 Pendant depicting a
warrior-ruler with ritual regalia

c. 1200–1521, Mixtec
Cast gold, 8 × 4.5 × 1.5 cm

Trustees of the British Museum, London,
Ethno. +7834

186 Warrior

After 1325, Aztec
Cast gold-silver-copper
alloy, 11.2 × 6.1 cm

The Cleveland Museum of Art,
Leonard C. Hanna, Jr Fund,
1984.37

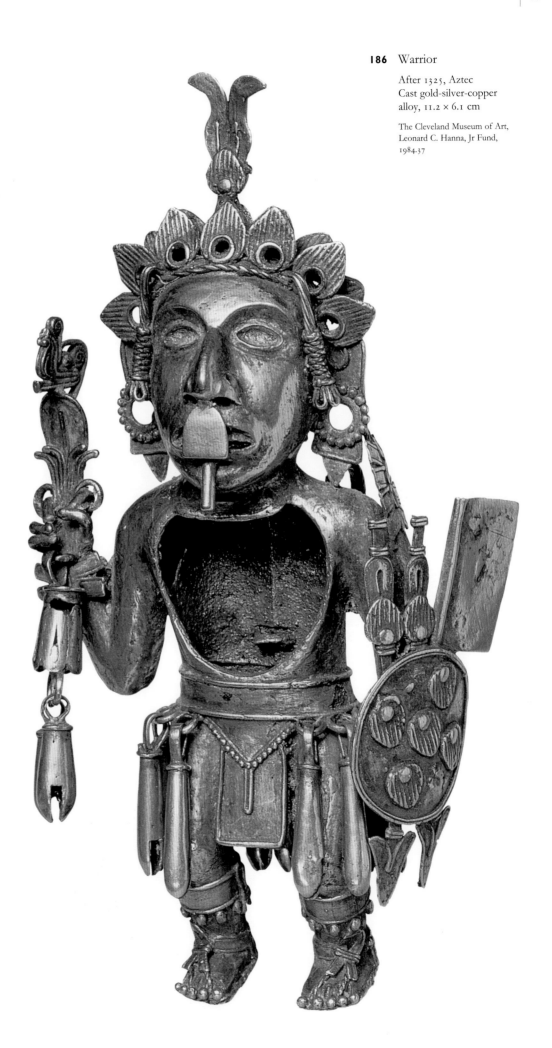

187 Lip-plug

Fifteenth or sixteenth century,
Mixtec–Aztec
Gold alloy and rock crystal,
length 6.2 cm

Museum für Völkerkunde Wien
(Kunsthistorisches Museum mit MVK und
ÖTM), Vienna, 59.989, Becker Collection

188 Lip ornament

c. 1200–1521, Mixtec
Gold, 2.2 × 5.4 × 4.7 cm

Museo Civico di Arte Antica,
Palazzo Madama, Turin, 732

189 Lip-plug

c. 1500, Mixtec
Cast gold, 1.6 × 3.2 × 3.8 cm

The Saint Louis Art Museum,
Gift of Morton D. May, 275:1978

190 Pendant

c. 1250–1521, Mixtec
Gold, 3.4 × 2 × 1.8 cm

Museo Civico di Arte Antica,
Palazzo Madama, Turin, 733

192 Ornament

c. 1300–1521, Aztec
Diopside-jadeite,
4.7 × 5.4 × 5.8 cm

Dumbarton Oaks Research Library
and Collections, Washington DC,
B-61

193 Pendant

Sixteenth century (?),
Aztec or colonial
Amethyst and malachite,
3.1 × 1.2 × 1 cm

Museum für Völkerkunde Wien
(Kunsthistorisches Museum mit
MVK und ÖTM), Vienna, 10.407,
Ambras Collection

194 Ear ornaments

c. 1500, Mixtec
Gold, diameter 3.9 cm,
depth 1.3 cm (each)

Museo de las Culturas de Oaxaca,
CONACULTA-INAH, 10-105428 0/2

191 Pendant in the form
of an image of Xiuhtecuhtli

c. 1500, Aztec
Greenstone, 7.5 × 4.5 × 3.5 cm

Museo Nacional de Antropología, Mexico
City, CONACULTA-INAH, 10-594485

195 Ear-spool

c. 1300–1521, Aztec
Obsidian and gold,
diameter 3.7 cm, depth 1 cm

Dumbarton Oaks Research Library
and Collections, Washington DC,
B-88

196 Lip-plugs

c. 1500, Mixtec
Black obsidian, 2.5 × 4.1 × 1.9 cm;
black obsidian, 1.6 × 3.2 × 1.6 cm;
black obsidian with turquoise inlay,
2.5 × 4.1 × 1.9 cm; and red chert,
2.5 × 4.1 × 1.9 cm

The Saint Louis Art Museum, Gift of Morton
D. May, 138:1980, 139:1980, 140:1980 and
141:1980

198 Fan

Grip *c.* 1500, Aztec; feathers 1999
Wood with parakeet and
hummingbird feathers,
40 × 10.5 × 4.5 cm

Museo Nacional de Antropología,
Mexico City, CONACULTA-INAH, 10-393455

197 Plaque or pectoral

c. 800–1000, Mixtec
Jade, 17 × 8 cm

Didrichsen Art Museum, Helsinki, acc. no. 822

201 Funerary casket

c. 1500, Aztec
Stone, 22 × 24 × 24 cm

Museo Nacional de
Antropología, Mexico City,
CONACULTA-INAH, 10-223670 0/2

199 Lid of a casket with a
sculpture of an *ahuizotl*

Late fifteenth century, Aztec
Andesite, 13 × 33 × 30 cm

Staatliche Museen zu Berlin, Preußischer
Kulturbesitz, Ethnologisches Museum,
IV Ca 3776

200 Casket

Late fifteenth century, Aztec
Andesite, 33 × 18 cm

Trustees of the British Museum,
London, Ethno. Q82 Am 860

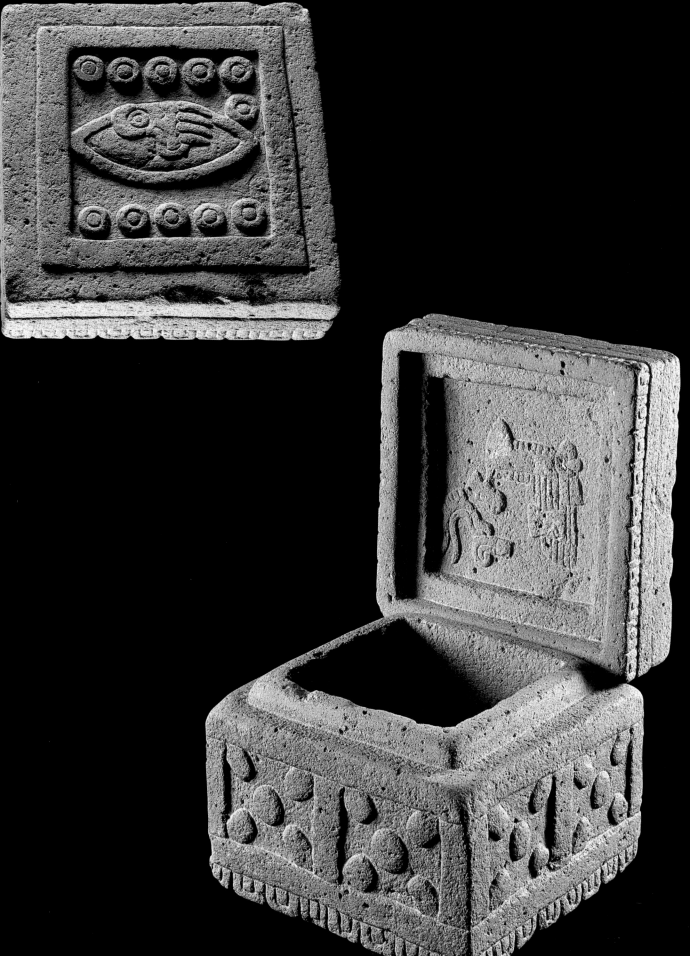

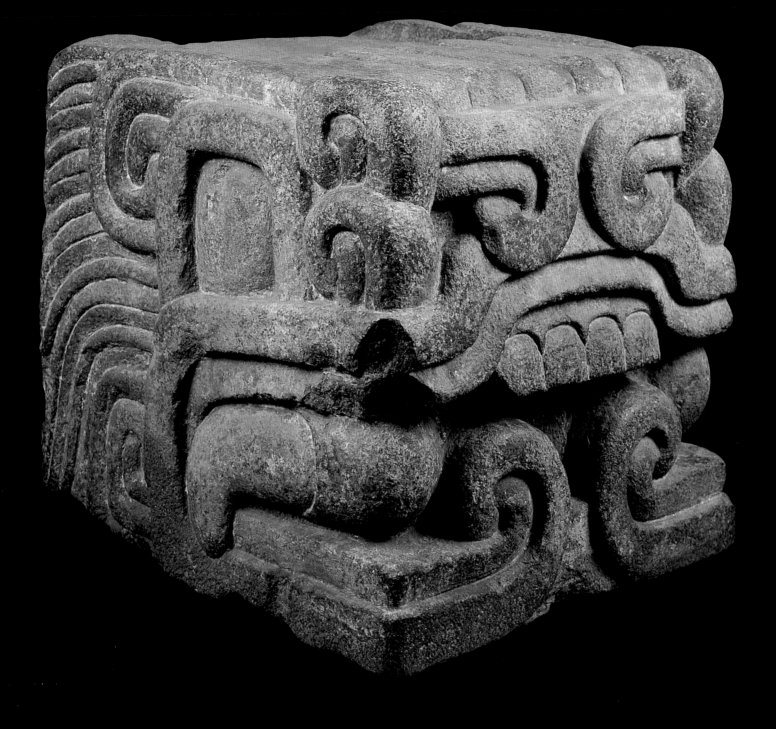

202 Head of a feathered serpent

c. 1500, Aztec
Stone, 54 × 55 × 61 cm

Museo Nacional de Antropología, Mexico
City, CONACULTA-INAH, 10-81558

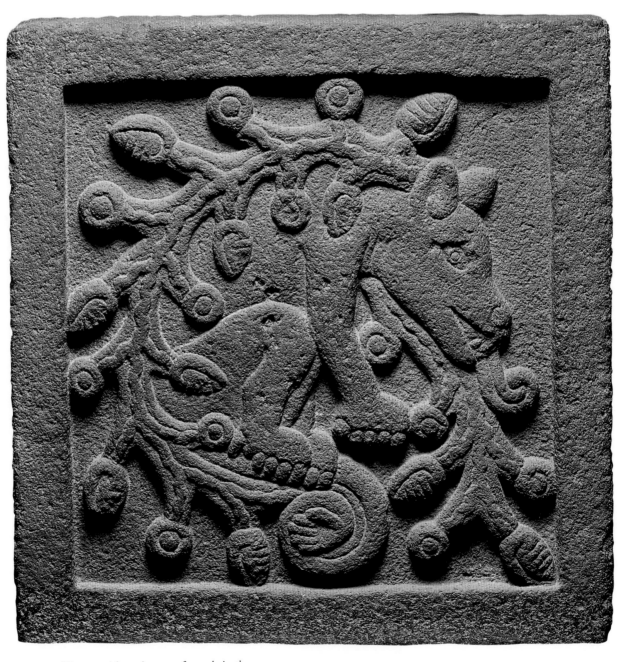

203 Plaque with an image of an *ahuizotl*

c. 1500, Aztec
Stone, 73.5 × 72 × 24 cm

Museo Nacional de Antropología,
Mexico City, CONACULTA-INAH, 10-81550

204 Tezcatlipoca

c. 1500, Aztec
Basalt, 10 × 10 × 6 cm

Museo Nacional de Antropología,
Mexico City, CONACULTA-INAH,
10-9682

207 Standard-bearer

c. 1500, Aztec
Basalt, 52.5 × 29 × 19 cm

Instituto Mexiquense de Cultura: Museo
Arqueológico del Estado de México
Dr Román Piña Chan, Teotenango, A-52207

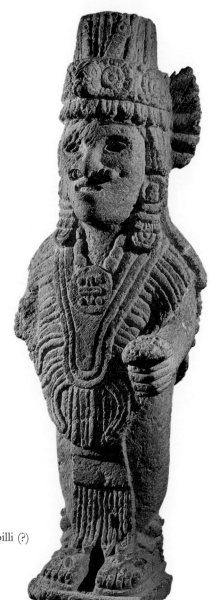

205 Piltzintecuhtli-Xochipilli (?)

c. 1350–1521, Aztec
Stone and paint,
72.5 × 26 × 21 cm

Museum der Kulturen Basel,
Basle, IVb 650

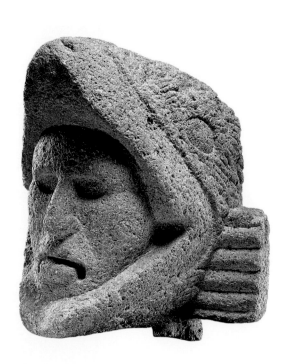

206 Head of an eagle warrior

c. 1500, Aztec
Stone, 32 × 30 × 26 cm

Museo Nacional de Antropología,
Mexico City, CONACULTA-INAH, 10-94

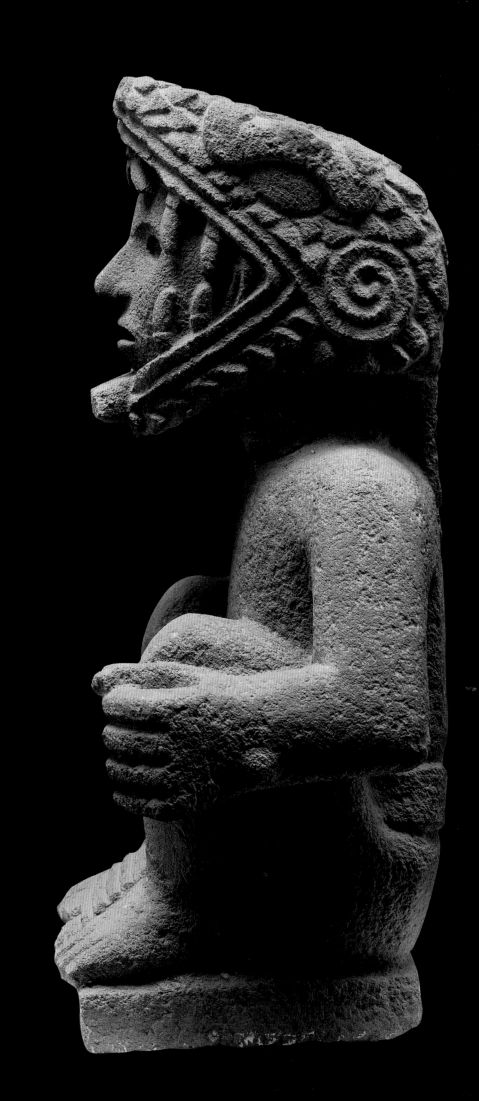

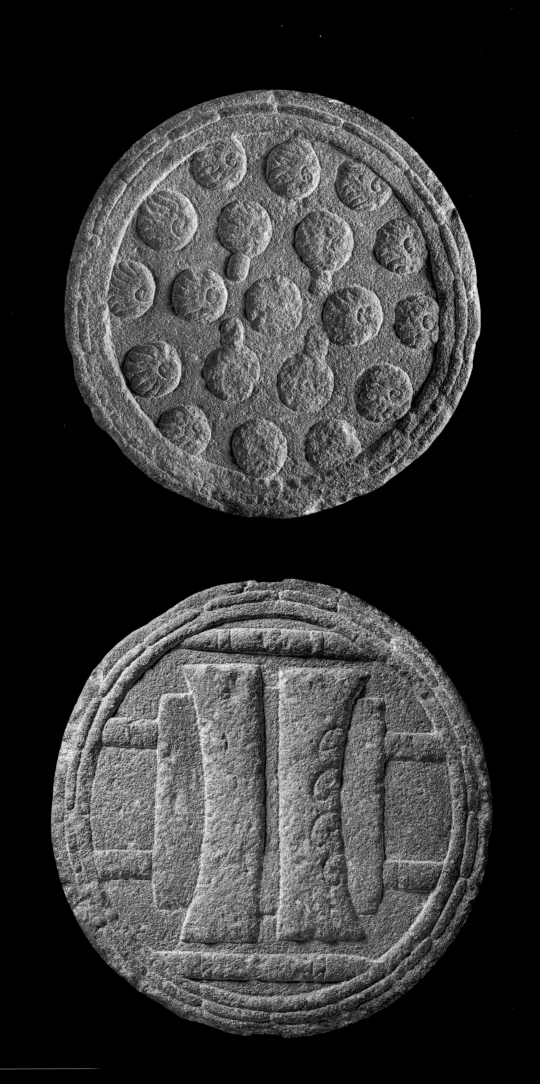

208 Round shield

c. 1350–1521, Aztec
Stone, diameter 17 cm,
thickness 5.5 cm

Staatliche Museen zu Berlin: Preußischer
Kulturbesitz, Ethnologisches Museum,
IV Ca 3982a

209 *Temelácatl*

c. 1500, Aztec
Stone, height 24 cm,
diameter 92 cm

Museo Nacional de Antropología,
Mexico City, CONACULTA-INAH,
10-46485

211 Pot in the form of a head
of Tezcatlipoca

c. 1500, Aztec
Fired clay and paint,
height 18 cm, diameter 13 cm

Colección Fundación Televisa,
Mexico City, Reg. 21 pj. 71

210 Cup with images of a warrior

c. 1500, Aztec
Fired clay, height 15.5 cm, diameter 15 cm
Museo Nacional de Antropología, Mexico City,
CONACULTA-INAH, 10-116788

212 Cup in the form of a flower

c. 1500, Aztec
Fired clay, height 28.5 cm, diameter 18 cm

Museo Nacional de Antropología, Mexico City,
CONACULTA-INAH, 10-116786

213 Cup

c. 1521–1600, colonial
Fired clay and paint,
height 16.8 cm, diameter 12.5 cm

Staatliches Museum für Völkerkunde, Munich, 10.3555

214 Pitcher

c. 1500, Aztec
Fired clay, paint and wickerwork,
height 27 cm, diameter 15 cm

Museo Nacional de Antropología, Mexico City,
CONACULTA-INAH, 10-607774

215 Pitcher

c. 1500, Aztec
Fired clay and paint, 20.3 × 14.6 × 7.6 cm

The Saint Louis Art Museum, Gift of Morton D. May,
135:1979

216 Tripod plate

c. 1500, Aztec
Fired clay and paint,
height 15 cm, diameter 27 cm

Museo Nacional de Antropología,
Mexico, CONACULTA-INAH,
10-580947

217 Tripod plate

c. 1500, Mixtec
Fired clay and paint,
height 13.5 cm, diameter 34.6 cm

Museo Nacional de Antropología,
Mexico City, CONACULTA-INAH, 79133

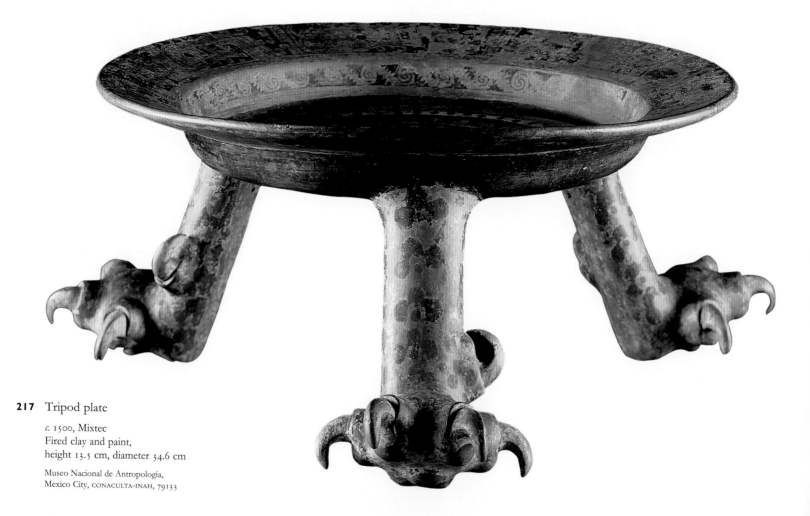

218 Tripod bowl

Sixteenth century, Aztec
Fired clay and paint,
height 6.2 cm,
diameter 18.5 cm

Staatliche Museen zu Berlin:
Preußischer Kulturbesitz,
Ethnologisches Museum,
IV Ca 32143

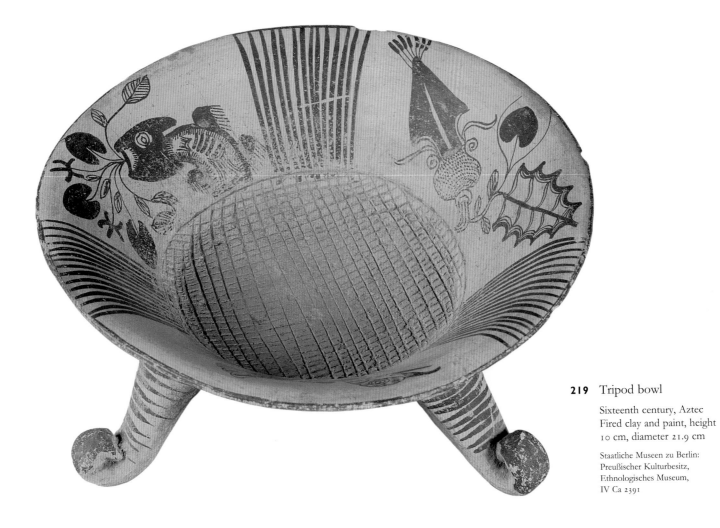

219 Tripod bowl

Sixteenth century, Aztec
Fired clay and paint, height
10 cm, diameter 21.9 cm

Staatliche Museen zu Berlin:
Preußischer Kulturbesitz,
Ethnologisches Museum,
IV Ca 2391

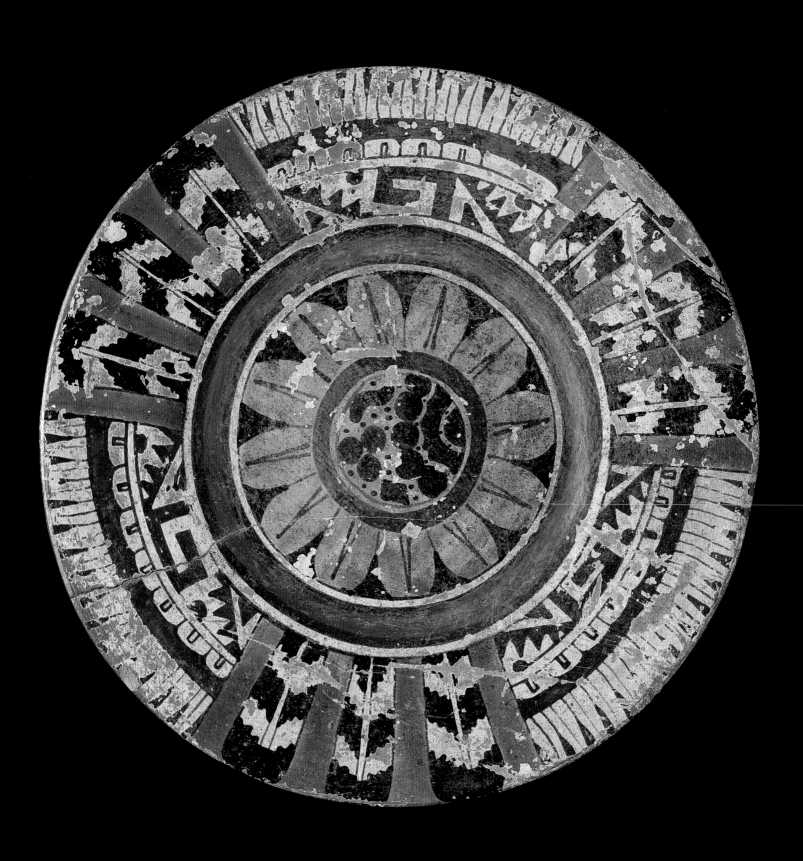

220 Plate

Fifteenth or sixteenth century, Mixtec
Fired clay and paint, diameter 21.7 cm

Staatliches Museum für Völkerkunde,
Munich, 10.3565

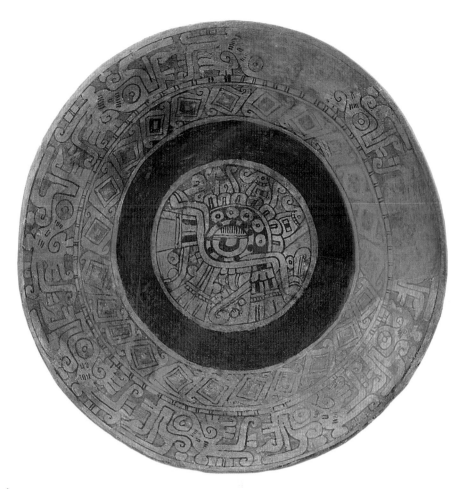

221–22 Two tripod plates

c. 1500, Aztec
Fired clay and paint,
heights 7 cm and 4 cm,
diameters 32 cm and 22 cm

Museo Nacional de Antropología, Mexico,
CONACULTA-INAH, 10-223671, 10-116504

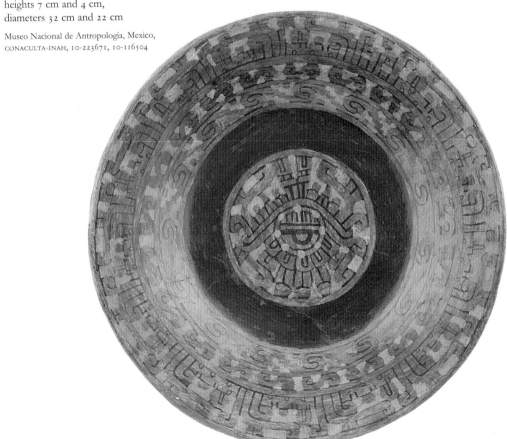

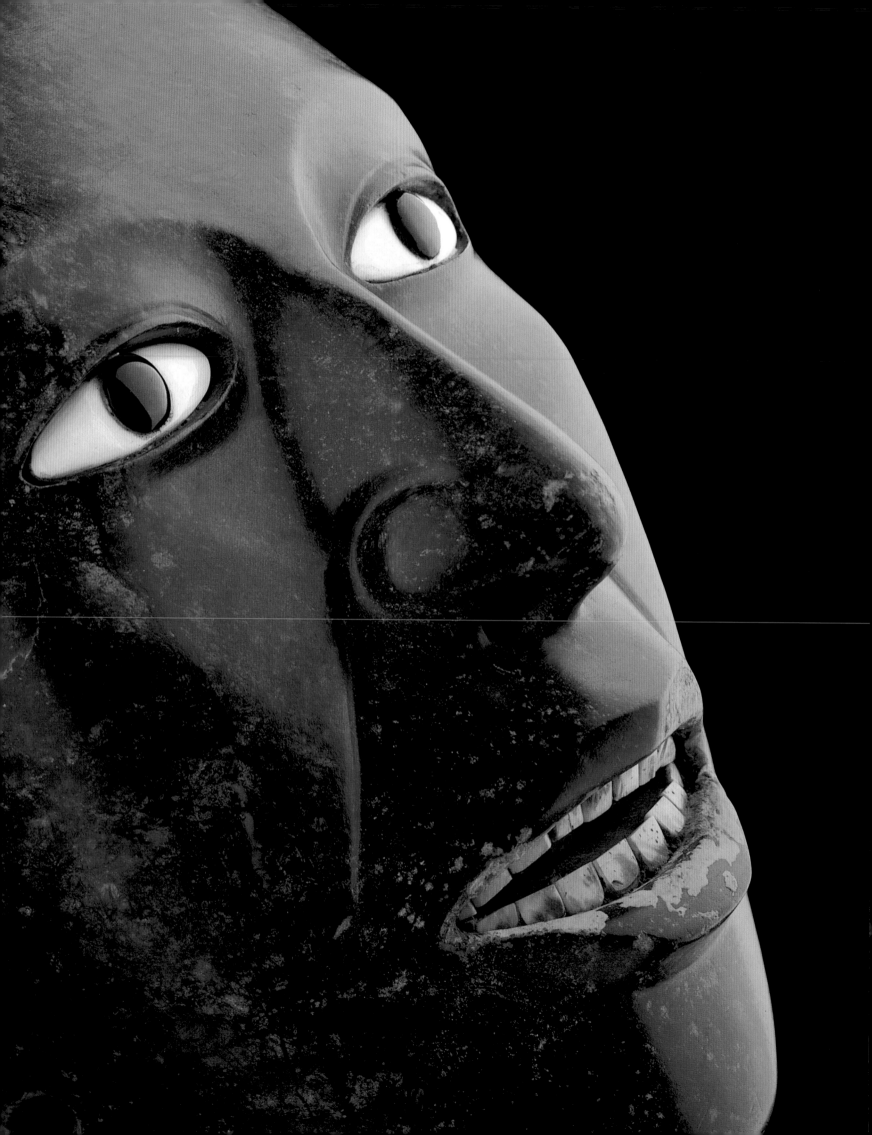

VIII | THE TEMPLO MAYOR AT TENOCHTITLAN

The great sacred square in the Aztec capital was nearly 500 metres long. According to the Franciscan friar Bernardino de Sahagún, it enclosed 78 buildings. The Templo Mayor, or Huey Teocali as it was called in the native Nahuatl language, was the most important of these, occupying the main section of the square and facing west. It was surrounded by several other buildings, the most significant being the temple to the god Tezcatlipoca on the left, which also faced west. Its archaeological remains have been found under what in colonial times was the Archbishop's palace. Another important temple, dedicated to Ehecatl-Quetzalcoatl, god of wind, was circular and lay opposite the Templo Mayor according to sixteenth-century sources. A building with these characteristics has been found beneath the tabernacle of the Cathedral of Mexico City. The *tzompantli*, a structure in which skulls of sacrificial victims decapitated for ceremonial reasons were kept, has been discovered opposite the Templo Mayor (fig. 42). Next to it were ball-game courts. Sahagún mentions the two that were found behind the Cathedral in the course of excavations carried out in the 1990s. Beneath the Cathedral at least seven buildings have recently been discovered, some very large, such as the Sun Temple, and others that suggest the south-east corner of the square was densely occupied by religious buildings.

Another building, found beneath the Casa del Marqués del Apartado opposite the Templo Mayor, was excavated at the beginning of the twentieth century and revealed several important Aztec finds, among them a sculpture of a bird, possibly an eagle, on whose back was a circular indentation for offerings (cat. 249).

Because these archaeological remains lie beneath a colonial city as well as what is now Mexico City, to obtain further information about Tenochtitlan we must take advantage of building work to undertake

excavations. In 1978 construction work permitted the unearthing of part of the monument of the goddess Coyolxauhqui (fig. 10), and this prompted archaeologists to widen their excavations until the whole of the Templo Mayor was discovered. Thus the Proyecto Templo Mayor began, allowing us to excavate not only the temple itself but also a fair number of adjacent buildings, including the four shrines to the north, the House of Eagles, the Red Temple to the south and part of what might be the House of Jaguars. Archaeologists have by now been able to locate nearly 40 of the 78 buildings mentioned by Sahagún.

There can be no doubt that during the last period of Spanish redevelopment of this site Hernán Cortés razed the Templo Mayor to its foundations: it was, after all, the centre of the Aztec universe. Parts of previous phases of construction survived because they lay at greater depth.

The first person to find a corner of the Templo Mayor was Don Manuel Gamio. Until his discovery in 1914 there had been much speculation about where the main Aztec temple was situated. Although he had little evidence to go on, Gamio's sound judgement established that the traces he had found belonged to that building. Over half a century was to pass before his opinion was confirmed.

The work of the Proyecto Templo Mayor, begun in 1978, brought to light the two stairways to the upper storeys with their shrines to the god of water and the god of war. They belonged to a very early period in the building's construction, known as Stage II, c. 1390. Other architectural and sculptural elements matched representations of the temple known since the sixteenth century. Thus both archaeological work and historical sources united in contributing to our knowledge of the Templo Mayor.

The religious symbolism of the Templo Mayor made it the most important building in the Aztec world. Objects have survived from over one hundred offerings left by the Aztecs in the temple. Offerings (cat. 265) – single objects or groups, some of over three hundred objects – were placed under floors or between one stage of construction and the next.

Objects were deposited in one of three ways: in stone receptacles with their own lids; directly into the stone and mud filling that separated each stage of construction; or in small chambers. Their placement was not left to chance: offerings have complex meanings related to the part of the building where they were placed, to the course of the universe, and to the position of the component objects within the offering. Some offerings showed the three realms of the universe (underworld, earth and heavens) whereas others faced south, a direction related to Huitzilopochtli, the god of sun and war. The majority faced west, following the sun's movement.

Above all, the Templo Mayor symbolised two sacred mountains: Tonacatepetl, where the Aztecs kept the maize that fed them (associated with Tlaloc, god of rain), and Coatepec ('serpent hill'), the place where Huitzilopochtli fought with Coyolxauhqui and the '400 southerners', or southern stars. The building is the centre of the Aztecs' view of the universe, and the god of rain and the god of war, occupants of the upper storeys, furnish their basic needs: water and war were the foundations of agricultural production and the taxes imposed on conquered peoples, the two sources of funding that supported the Aztec economy.

The building is replete with symbolism both horizontally and vertically. The platform on which it sits symbolises the plane of the earth, while the four vertical sections may indicate celestial planes. Each side of the building faces one of the four points of the compass; its westerly face mirrors the sun's movement; and the entire building acts as an astronomical observatory. At the top the two shrines of the gods of rain and of war represent the supreme duality of the Pre-Hispanic world: life and death.

223 Commemorative plaque

1487, Aztec
Diorite, 92 × 62 × 30 cm

Museo Nacional de Antropología, Mexico City, CONACULTA-INAH, 10-220919

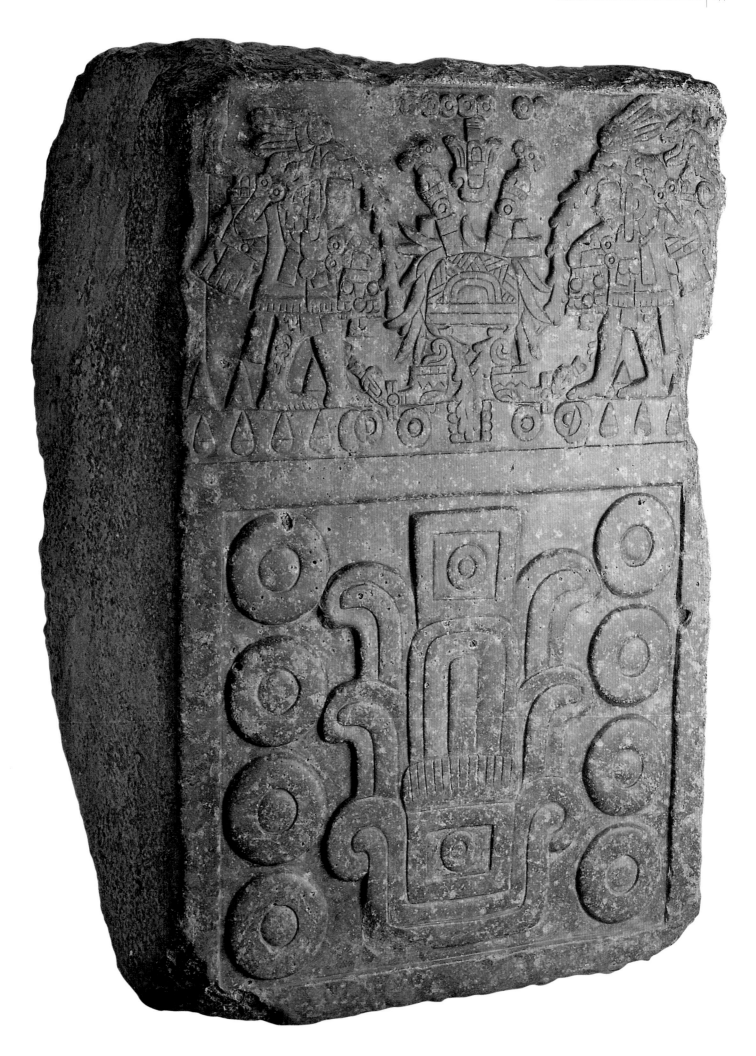

224 Relief showing the five
world-eras

c. 1400–1521, Aztec
Grey basalt,
54.6 × 45.7 × 25.6 cm

Peabody Museum of Natural
History, Yale University, New
Haven, YPM 19239

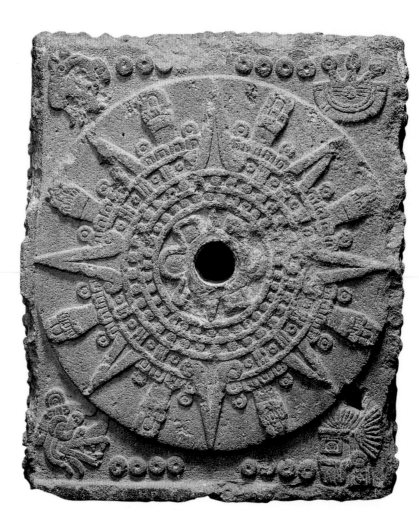

226 Coronation stone
of Motecuhzoma II

1503, Aztec
Basalt, 22.8 × 67.3 × 57.7 cm

The Art Institute of Chicago,
Major Acquisitions Fund, 1990.21

225 Sacrificial altar

c. 1500, Aztec
Greenstone, height 49.5 cm,
diameter 83.8 cm

Philadelphia Museum of Art:
The Louise and Walter Arensberg
Collection, 1950, 1950-134-403

227 Altar of the four suns

c. 1500, Aztec
Stone, 60 × 63 × 59 cm

Museo Nacional de Antropología,
Mexico City, CONACULTA-INAH, 10-46617

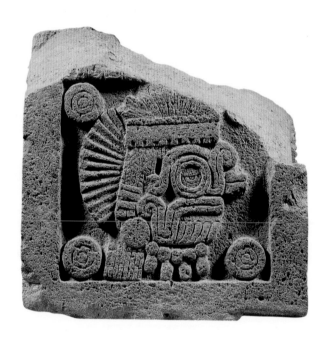

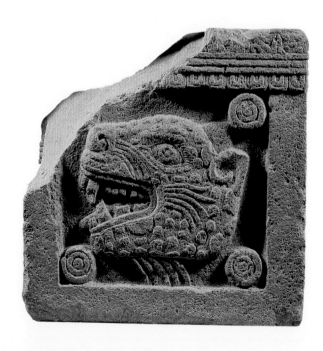

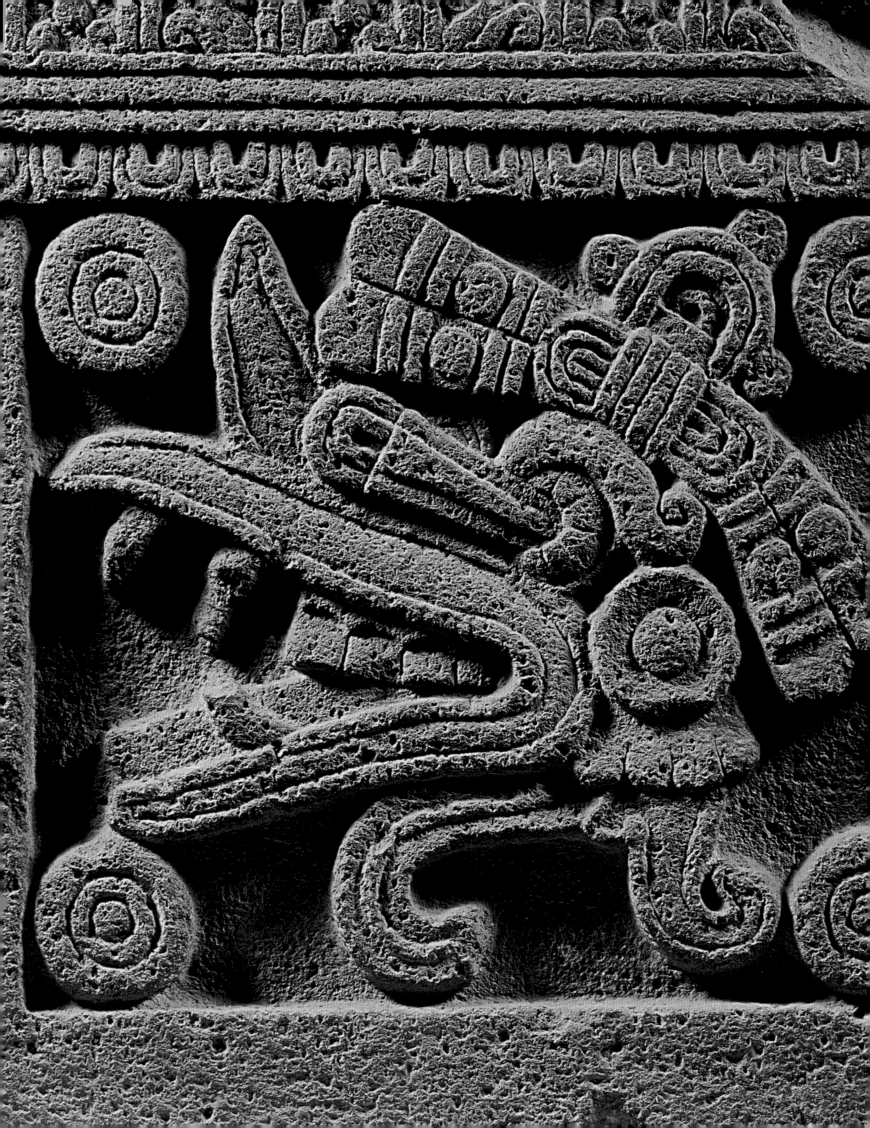

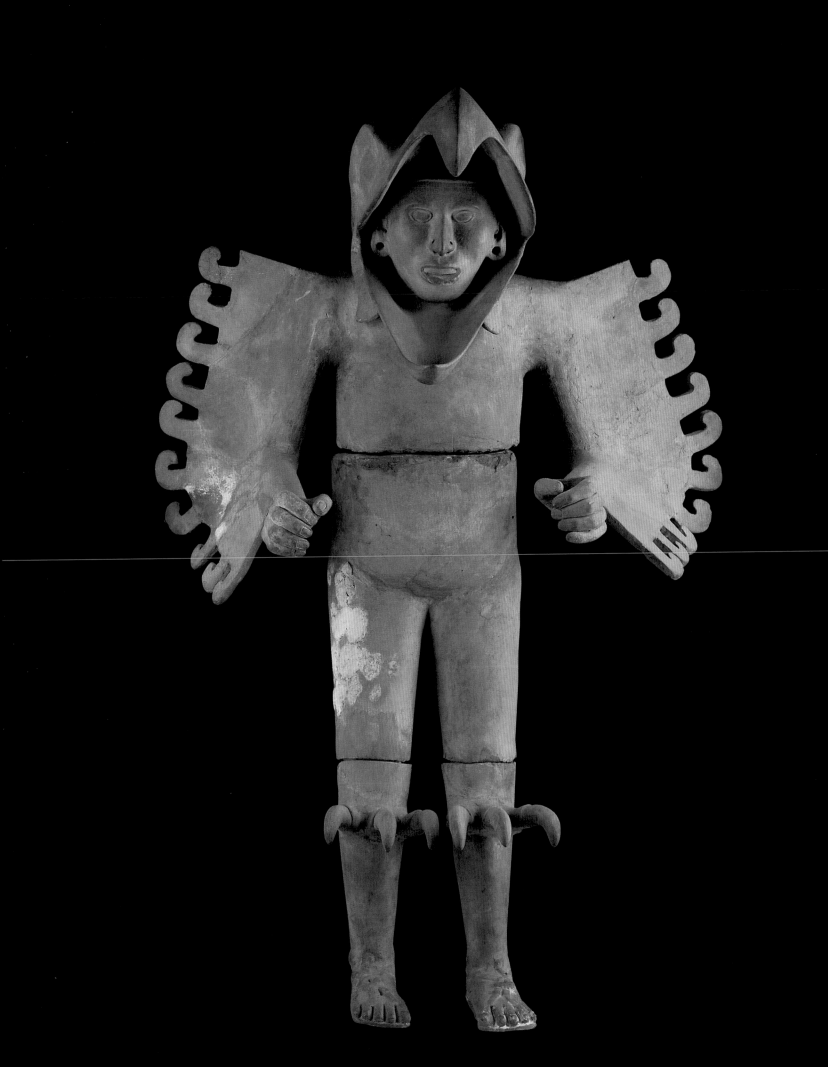

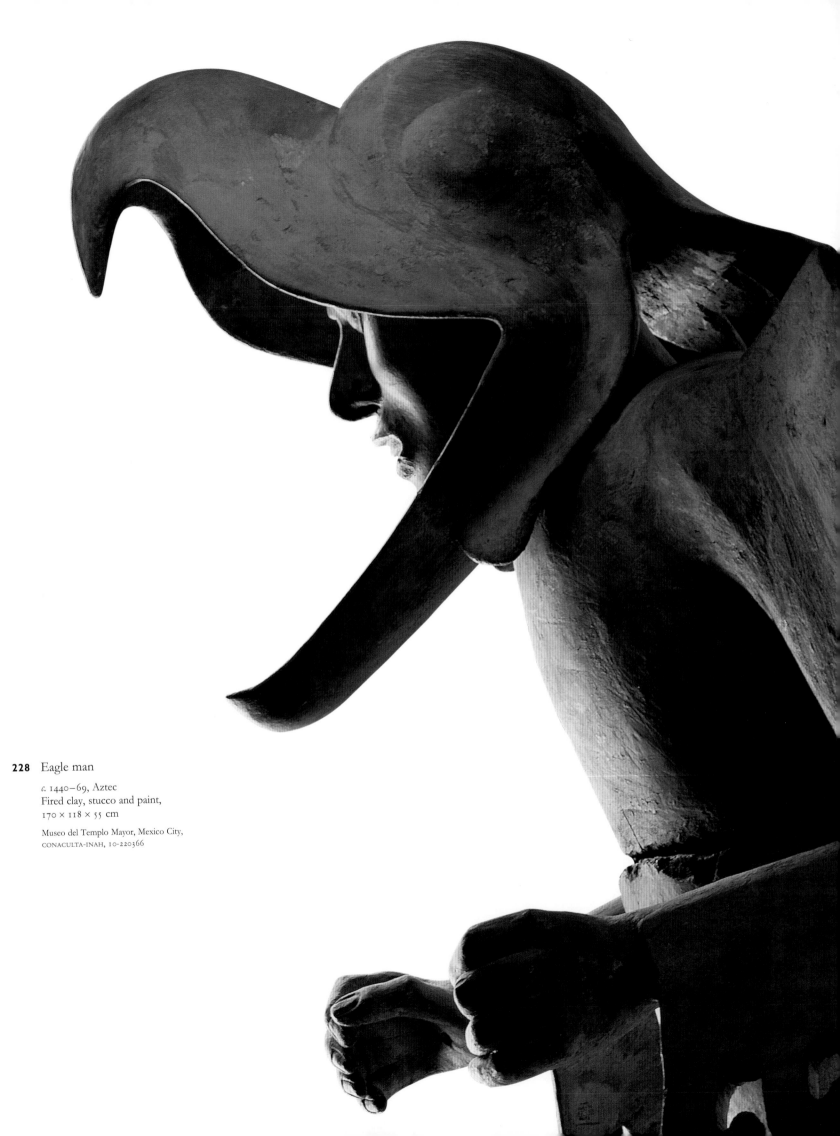

228 Eagle man

c. 1440–69, Aztec
Fired clay, stucco and paint,
170 × 118 × 55 cm

Museo del Templo Mayor, Mexico City,
CONACULTA-INAH, 10-220366

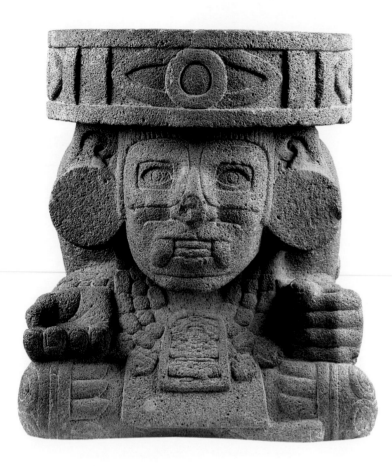

230 Seated god

c. 1350–1521, Aztec
Basalt, 34 × 21.6 × 24.5 cm

Museum der Kulturen Basel,
Basle, IVb 649

229 Huehueteotl

c. 1486–1502, Aztec
Basalt, 66 × 57.3 × 56 cm

Museo del Templo Mayor, Mexico City,
CONACULTA-INAH, 10-212978

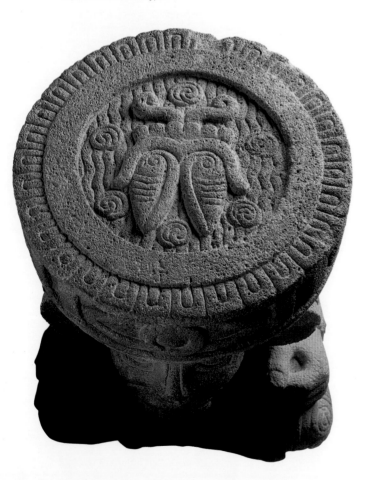

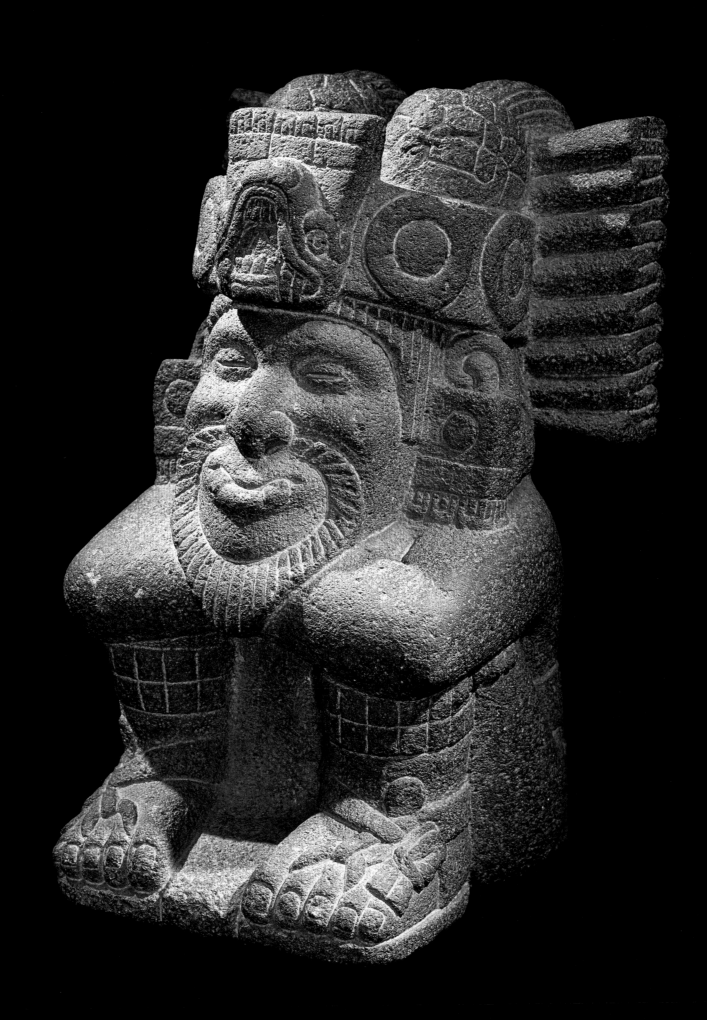

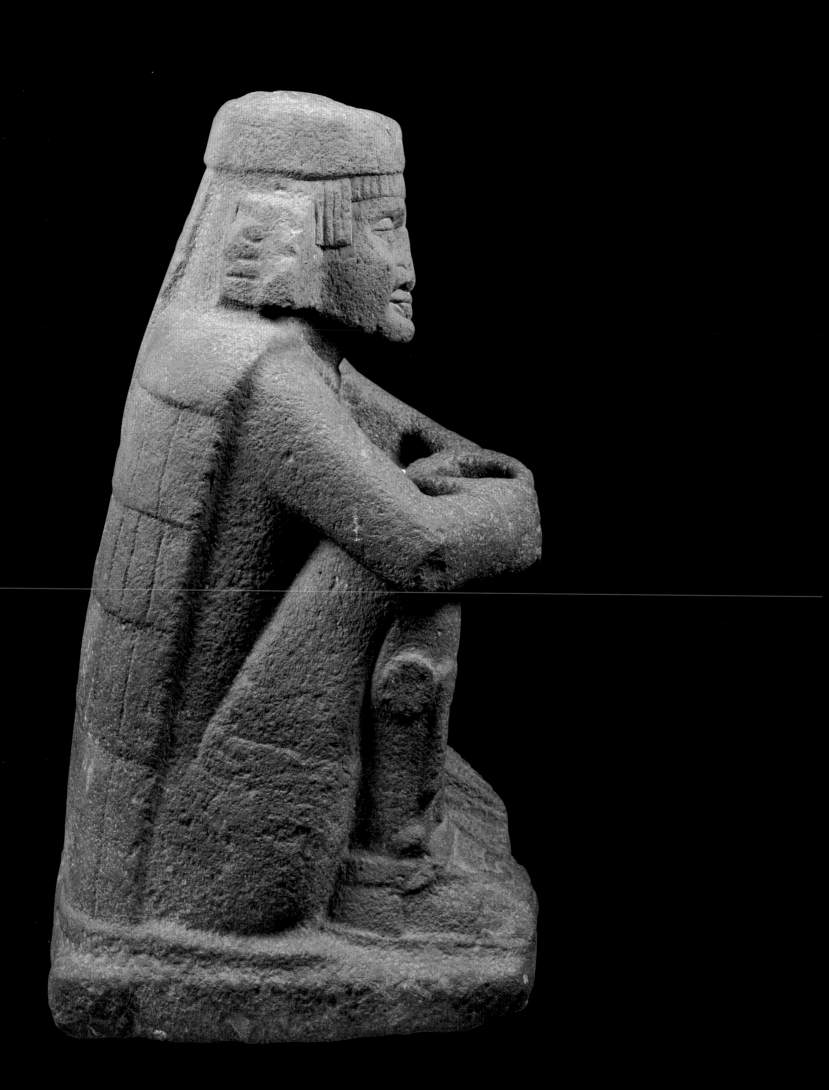

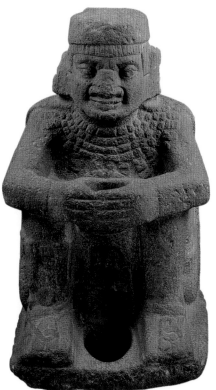

231 Standard-bearer

c. 1500, Aztec
Stone, 105 × 60 × 57 cm

Museo Nacional de Antropología,
Mexico City, CONACULTA-INAH, 10-81660

232 *Chacmool*

c. 1500, Aztec
Stone, 74 × 108 × 45 cm

Museo Nacional de Antropología,
Mexico City, CONACULTA-INAH,
10-10941

233 Mictlantecuhtli

c. 1480, Aztec
Fired clay, stucco and paint,
176 × 80 × 50 cm

Museo del Templo Mayor, Mexico City,
CONACULTA-INAH, 10-264984

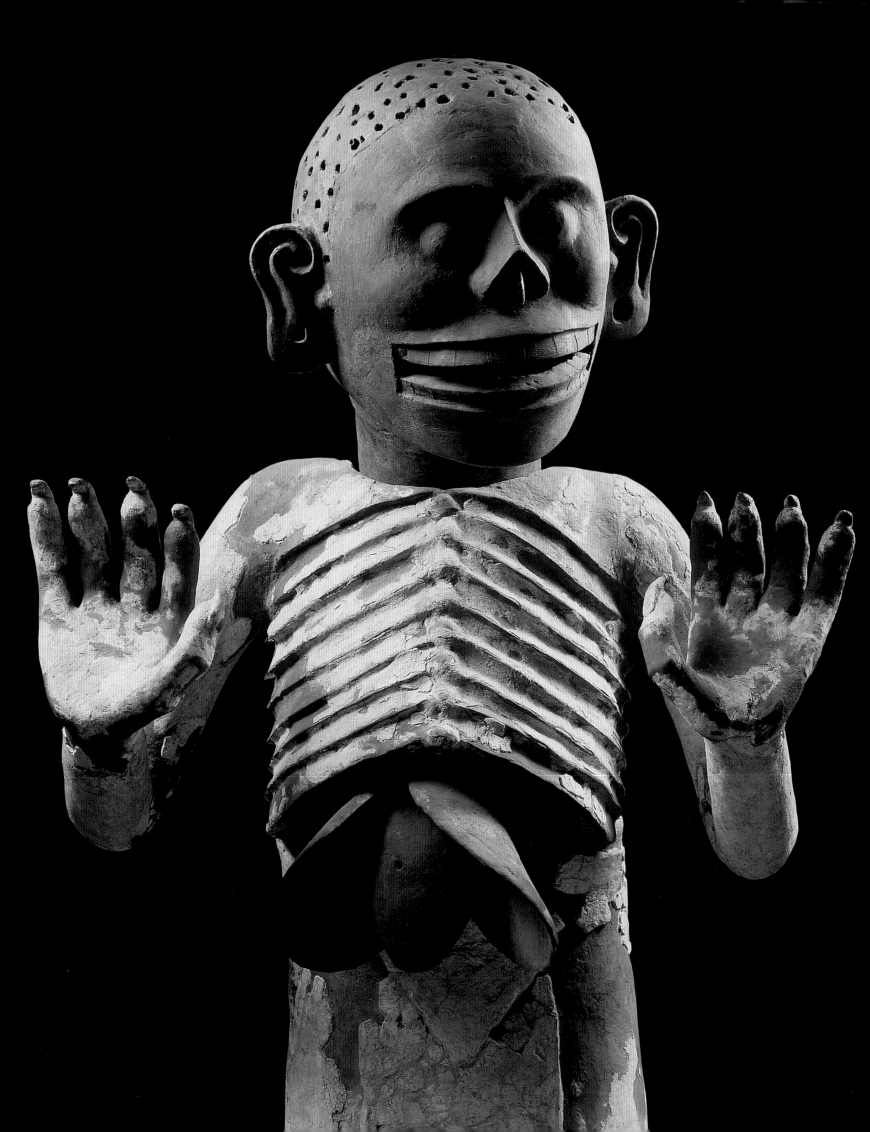

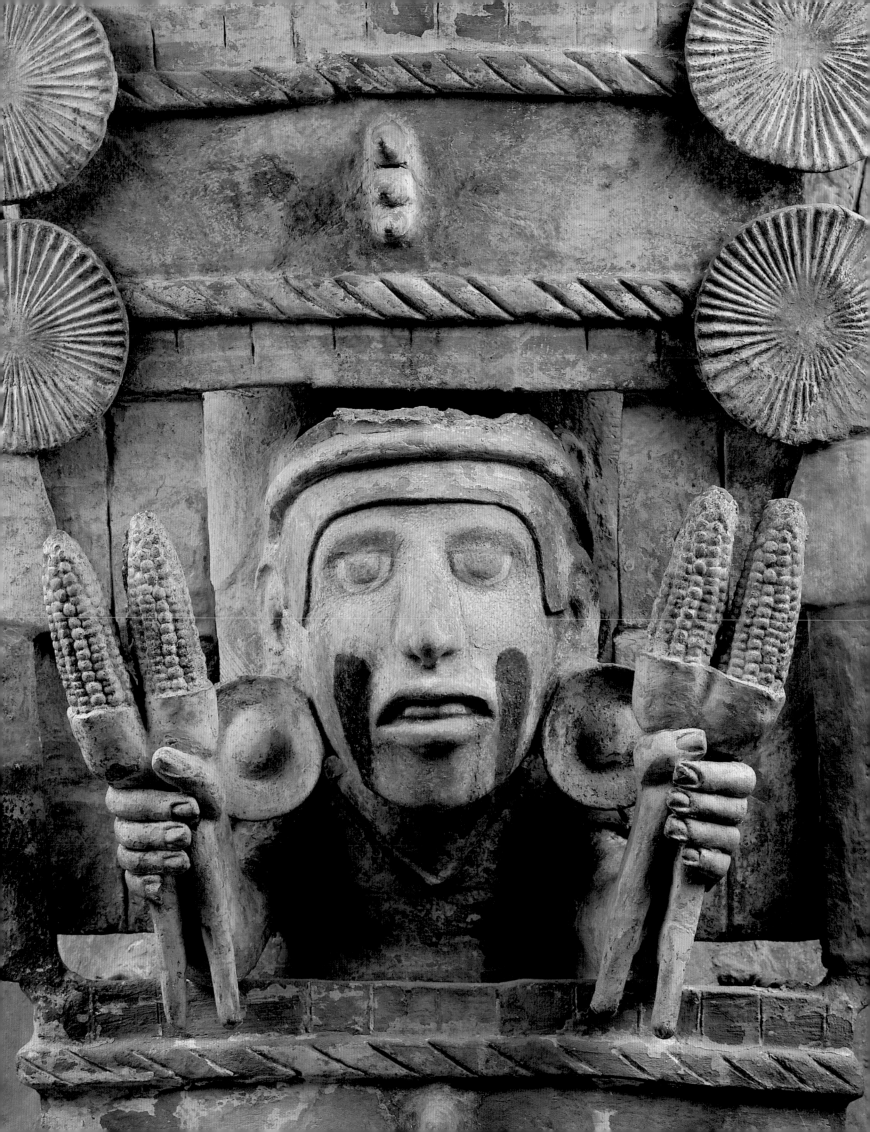

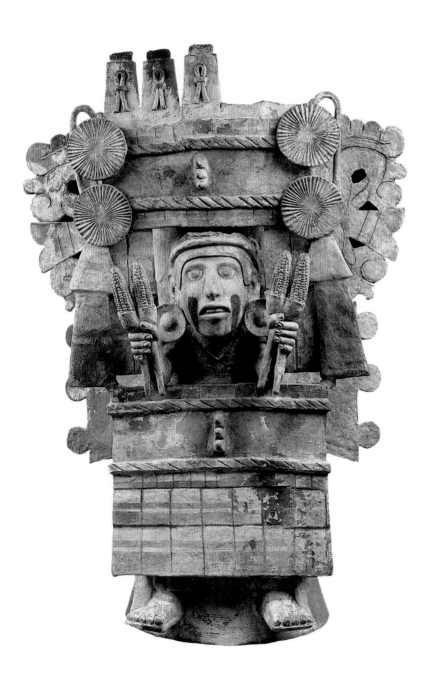

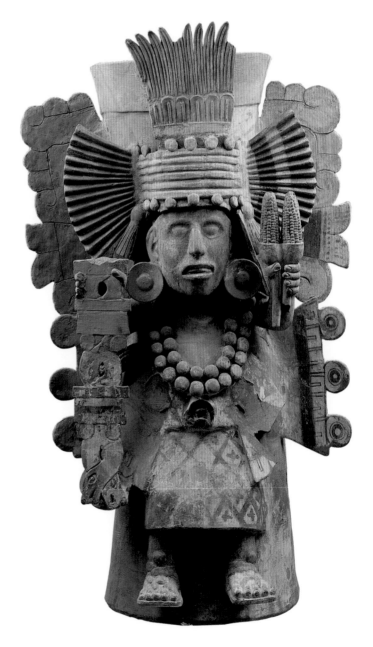

234 Votive vessel with an image
of Chicomecoatl

c. 1500, Aztec
Fired clay and paint,
106 × 74 × 51 cm

Museo Nacional de Antropología,
Mexico City, CONACULTA-INAH, 10-571544

235 Votive vessel with an image
of Xilonen

c. 1500, Aztec
Fired clay and paint,
99 × 65 × 49 cm

Museo Nacional de Antropología,
Mexico City, CONACULTA-INAH, 10-583437

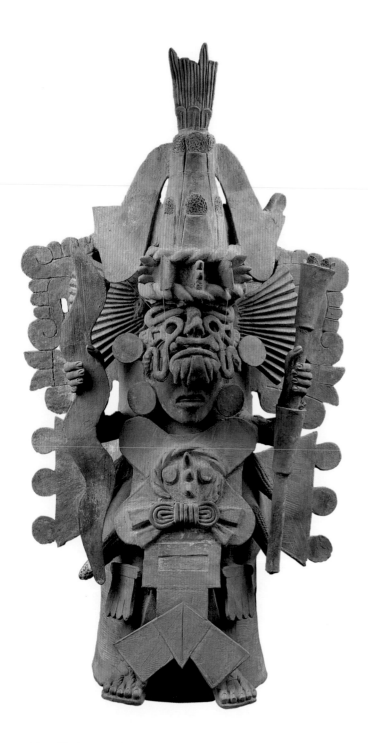

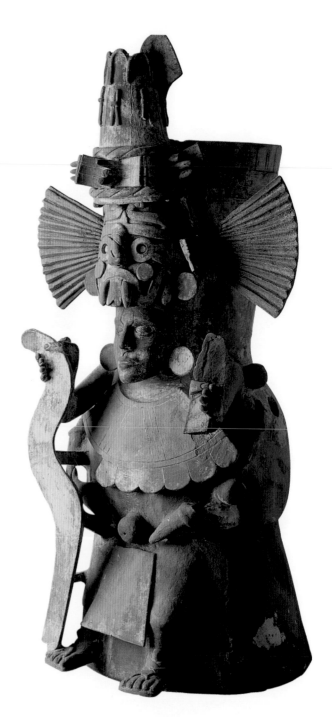

236 Votive vessel with an image
of Napatecuhtli

c. 1500, Aztec
Fired clay and paint, 121 × 65 × 48 cm

Museo Nacional de Antropología, Mexico City,
CONACULTA-INAH, 10-571285

237 Votive vessel with an image of Tlaloc

c. 1500, Aztec
Fired clay and paint, 112 × 53 × 51 cm

Museo Nacional de Antropología, Mexico City,
CONACULTA-INAH, 10-575578

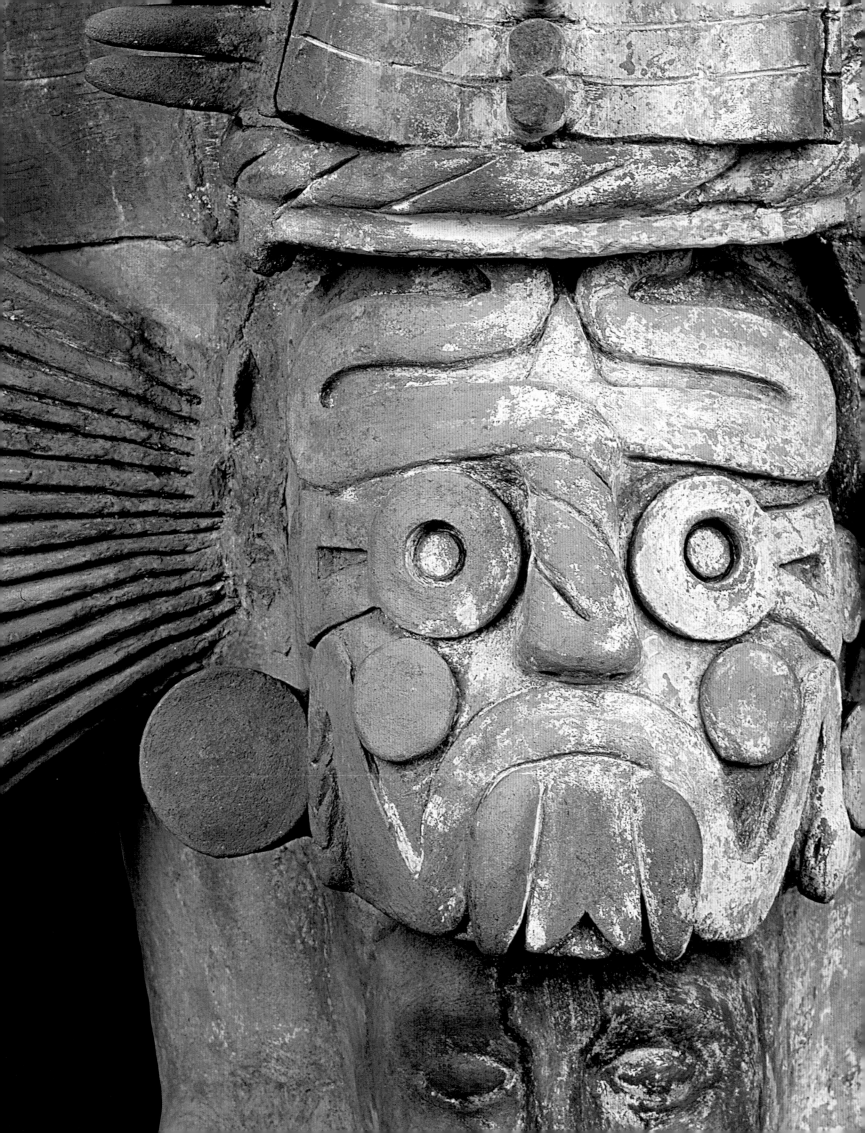

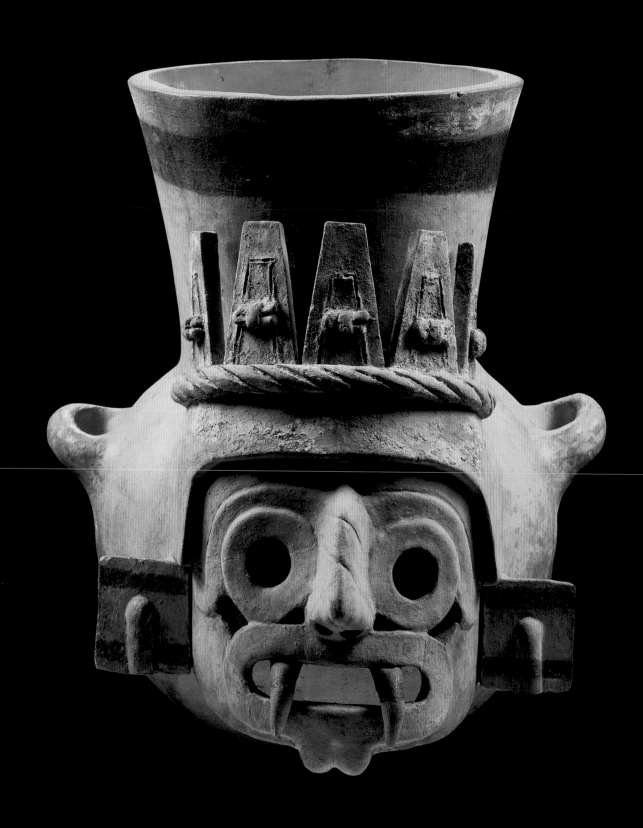

238 Vessel with a mask of Tlaloc

c. 1440–69, Aztec
Fired clay and paint, 35 × 35.5 cm,
diameter including the mask 31.5 cm

Museo del Templo Mayor, Mexico City,
CONACULTA-INAH, 10-220302

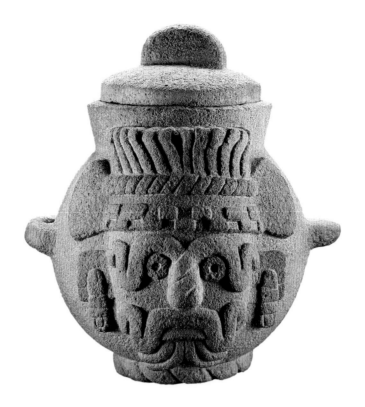

239 Tlaloc

c. 1469–81, Aztec
Greenstone, obsidian and shell,
32 × 19.5 × 16 cm

Museo del Templo Mayor, Mexico City,
CONACULTA-INAH, 10-168826

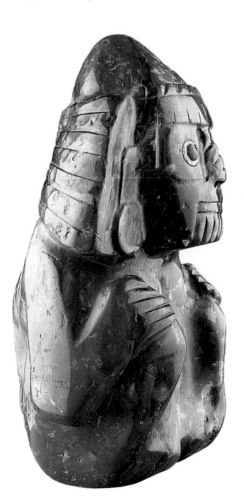

240 Lidded pot with an image of Tlaloc

c. 1469–81, Aztec
Basalt and traces of paint, height 28 cm,
diameter 24.5 cm

Museo del Templo Mayor, Mexico City,
CONACULTA-INAH, 10-219815 1/2

241 Tlaloc

c. 1500, Aztec
Wood, resin and copal,
34 × 19 × 20.5 cm

Museo Nacional de Antropología,
Mexico City, CONACULTA-INAH,
10-392920

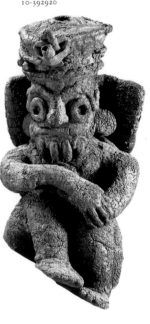

243 Votive vessel with
an image of Tlaloc

c. 1500, Tepanec
Fired clay and traces of
paint, 116.5 × 40 × 47 cm

Museo Nacional de Antropología,
Mexico City, CONACULTA-INAH,
10-357182

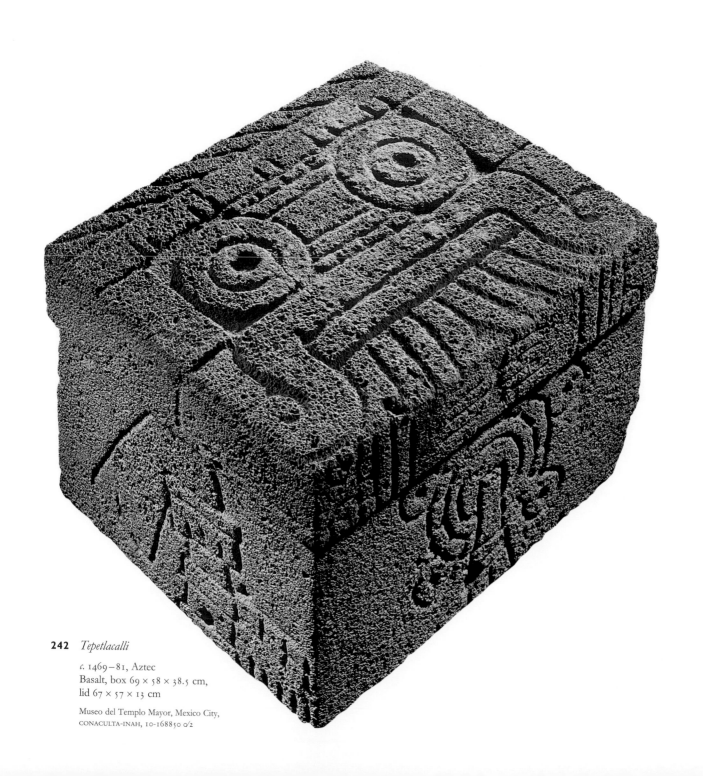

242 *Tepetlacalli*

c. 1469–81, Aztec
Basalt, box 69 × 58 × 38.5 cm,
lid 67 × 57 × 13 cm

Museo del Templo Mayor, Mexico City,
CONACULTA-INAH, 10-168850 0/2

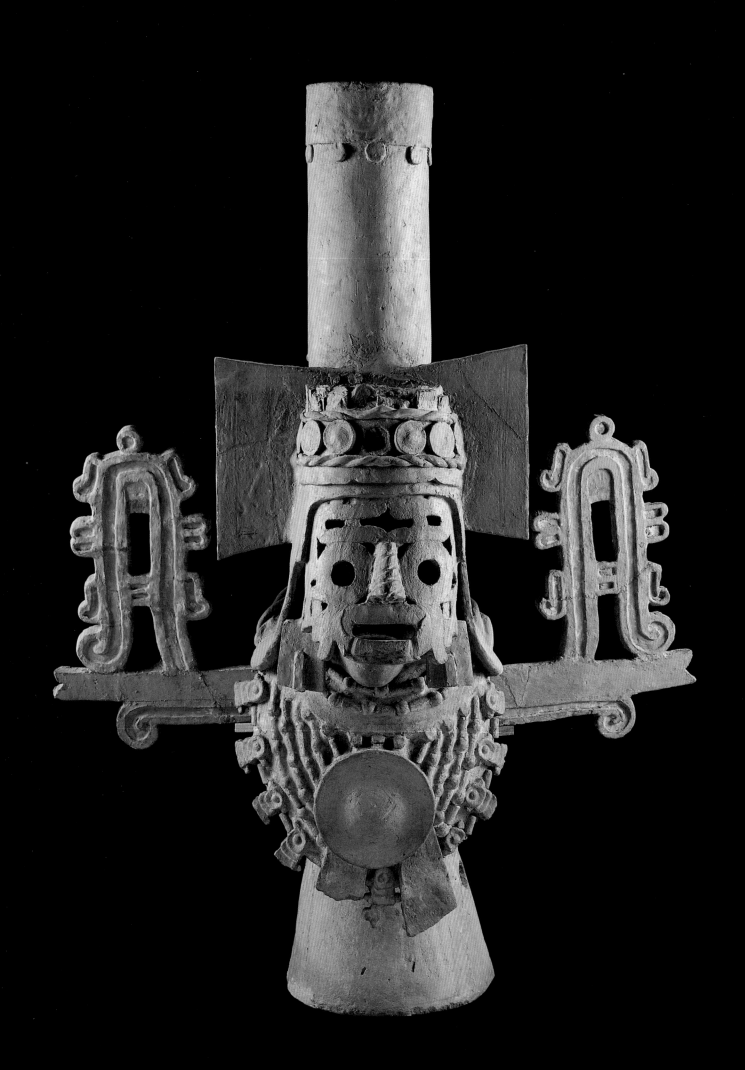

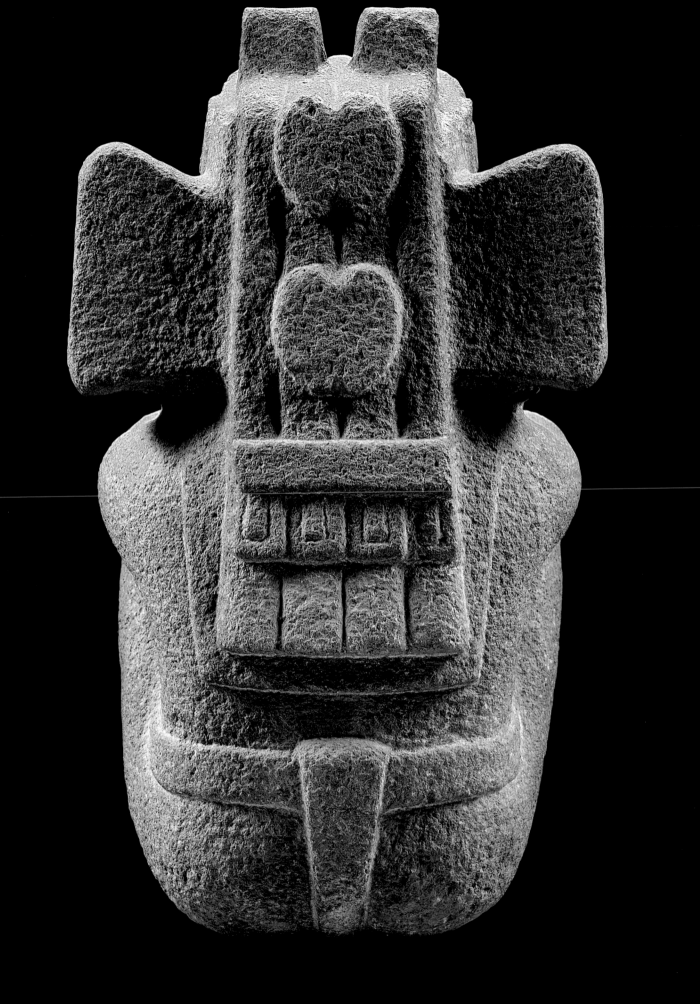

247 *Pulque* deity

c. 1469–81, Aztec
Basalt and traces of paint,
36.5 × 23 × 20 cm

Museo del Templo Mayor, Mexico City,
CONACULTA-INAH, 10-162940

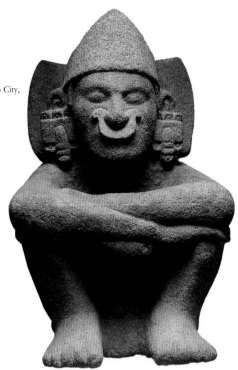

244–46 Xiuhtecuhtli

c. 1469–81, Aztec
Basalt, 36.6 × 21.9 × 21.2 cm,
37 × 21.8 × 20 cm and
31.5 × 19 × 19 cm

Museo del Templo Mayor,
Mexico City, CONACULTA-INAH,
10-220304, 10-220305 and 10-220357

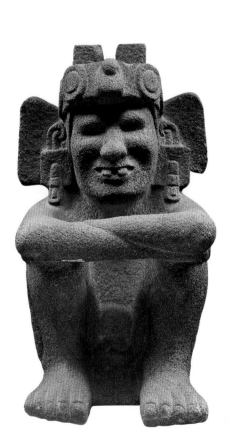
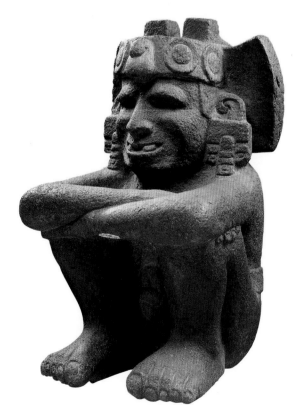
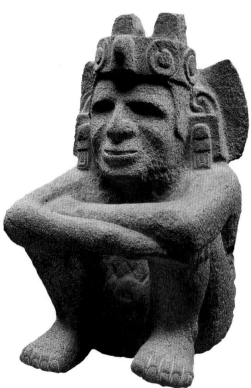

248 Relief with an image
of an eagle and a snake

c. 1450–1521, Aztec
Olivine basalt, 59 × 27 × 12 cm

Museum der Kulturen Basel, Basle, IVb 732

251 Serpent's head

c. 1500, Aztec
Stone, 90 × 92 × 155 cm

Museo Nacional de Antropología,
Mexico City, CONACULTA-INAH,
10-280936

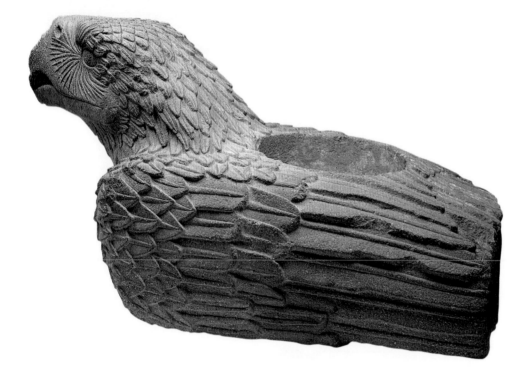

249 *Cuauhxicalli*

c. 1502–20, Aztec
Basalt, 139 × 82 × 76 cm

Museo del Templo Mayor, Mexico City,
CONACULTA-INAH, 10-252747

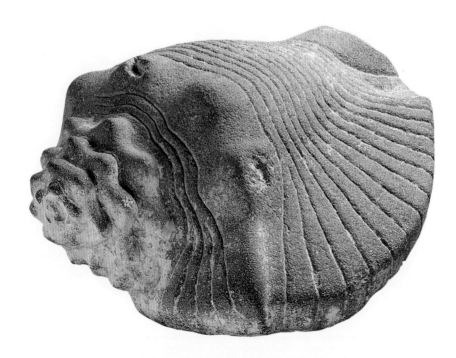

250 Snail shell

c. 1500, Aztec
Stone and traces of stucco and paint,
105 × 75.5 cm

Museo Nacional de Antropología,
Mexico City, CONACULTA-INAH, 10-213080

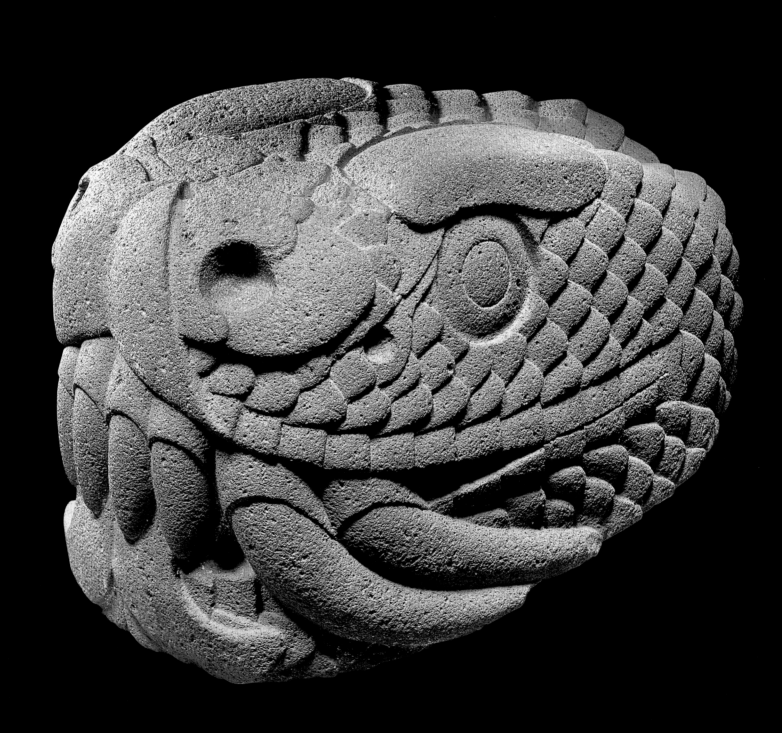

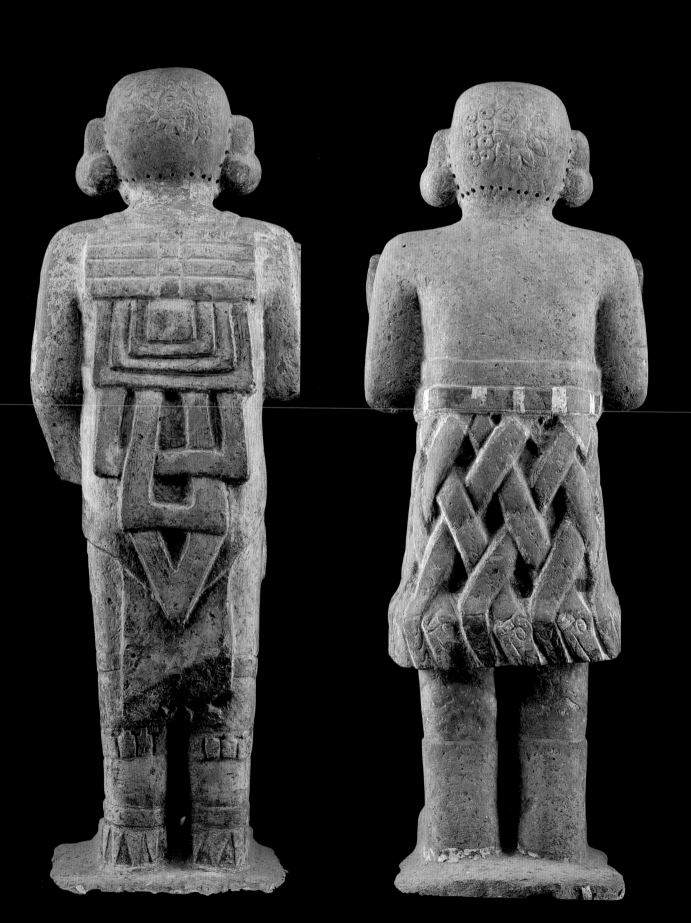

252 Coatlicue

c. 1500, Aztec
Stone, red shell, turquoise and traces of paint,
115 × 40 × 35 cm

Museo Nacional de Antropología, Mexico City,
CONACULTA-INAH, 10-8534

253 Xiuhtecuhtli-Huitzilopochtli

c. 1500, Aztec
Stone, white shell and obsidian,
112 × 38 × 31 cm

Museo Nacional de Antropología, Mexico City,
CONACULTA-INAH, 10-9785

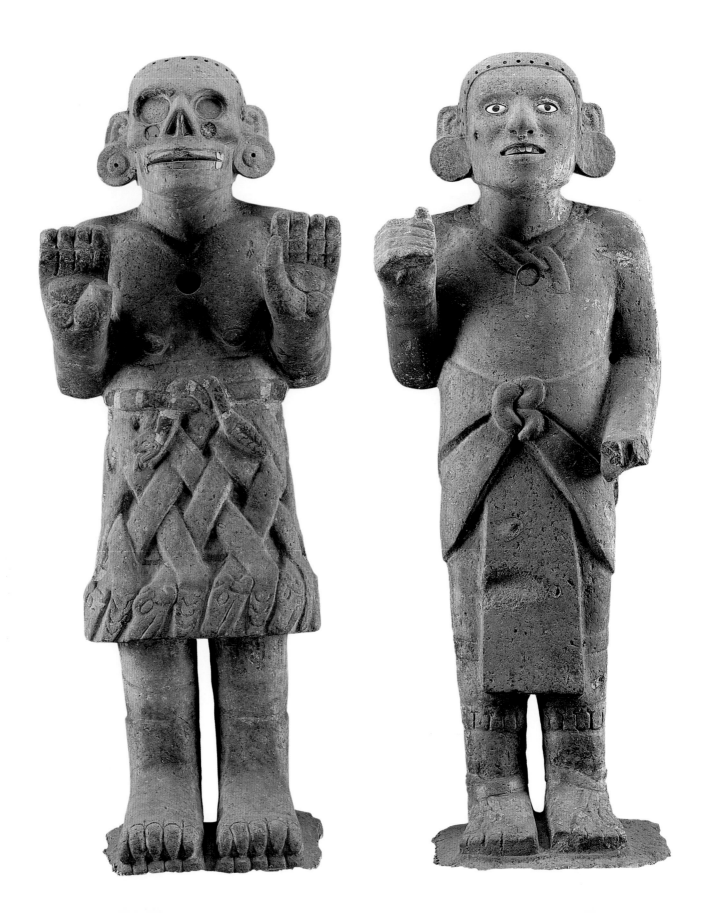

255 Head of Coyolxauhqui

c. 1500, Aztec
Diorite, 80 × 85 × 68 cm

Museo Nacional de Antropología,
Mexico City, CONACULTA-INAH,
10-2209118

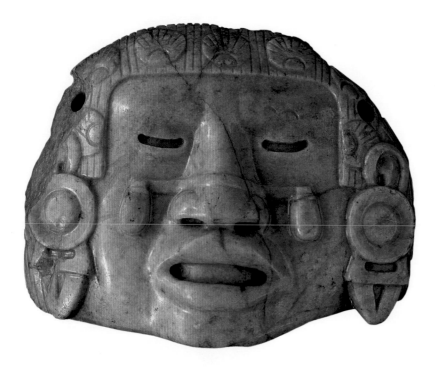

254 Mask of Coyolxauhqui

c. 1500, Aztec
Greenstone, 10.5 × 14.5 × 4 cm

Peabody Museum of Archaeology and Ethnology,
Harvard University, Anonymous gift, 28-40-20/C10108

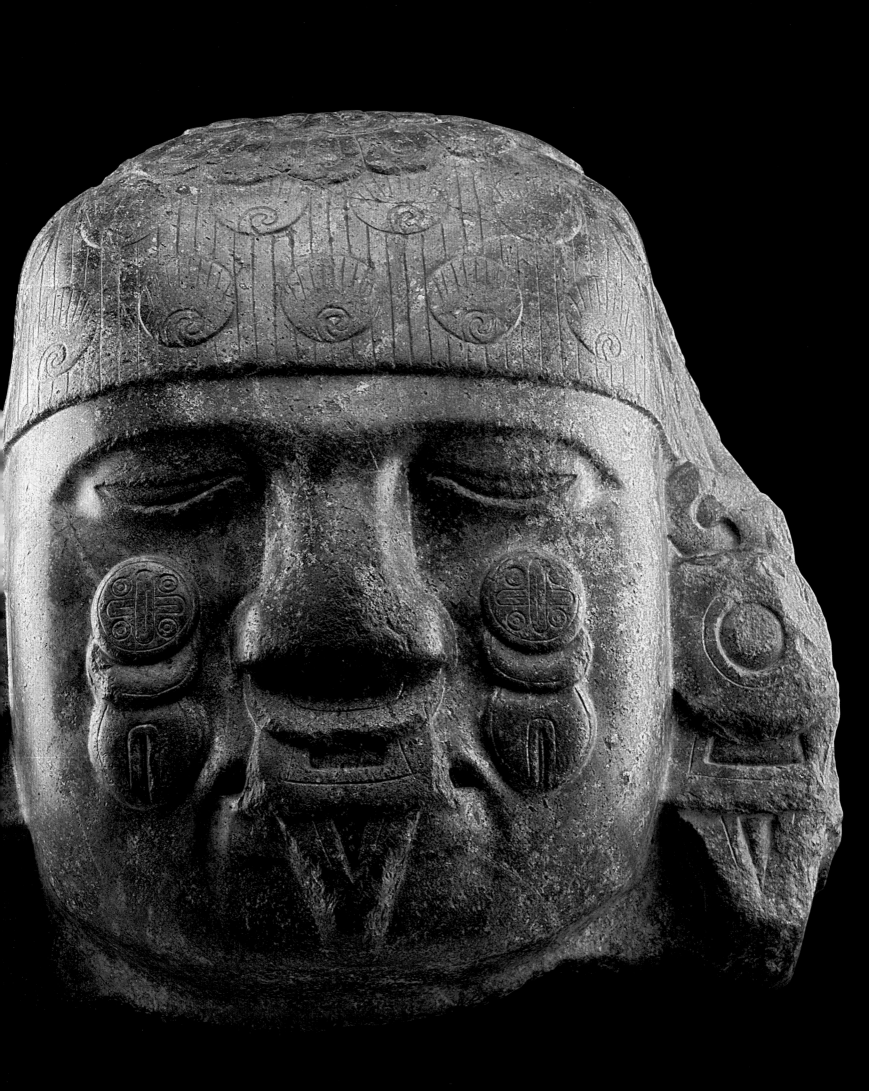

256 Mask

c. 1100–600 BC, Olmec
Greenstone, 10.2 × 8.6 × 3.1 cm

Museo del Templo Mayor, Mexico City,
CONACULTA-INAH, 10-168803

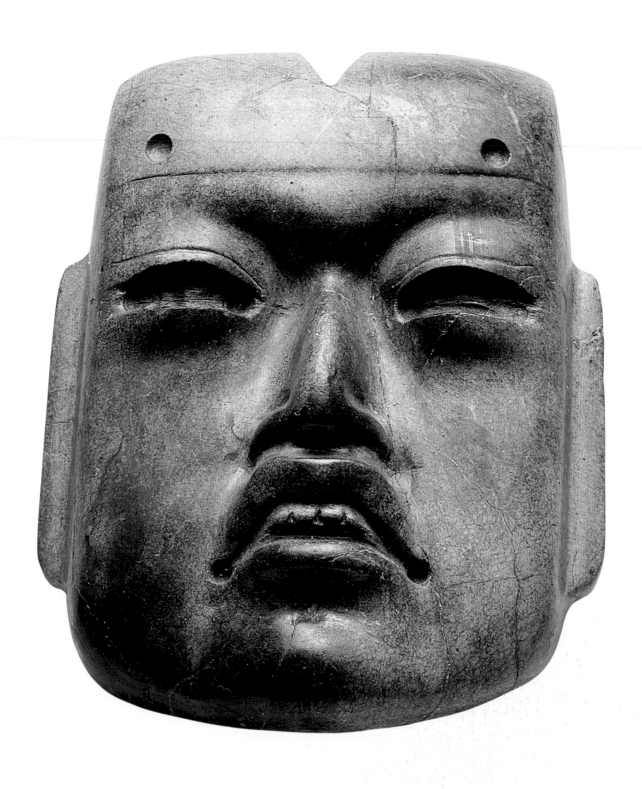

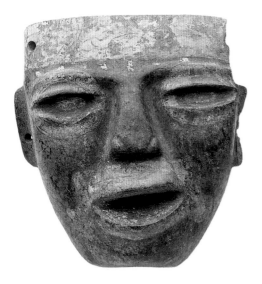

257 Mask

c. 1200–1481, Mezcala
Greenstone and paint,
15.4 × 14.4 × 4.12 cm

Museo del Templo Mayor, Mexico City,
CONACULTA-INAH, 10-220264

259 Mask

c. 1200–1481, Mezcala
Greenstone and paint,
19.9 × 18 × 2.9 cm

Museo del Templo Mayor, Mexico City,
CONACULTA-INAH, 10-220316-168796

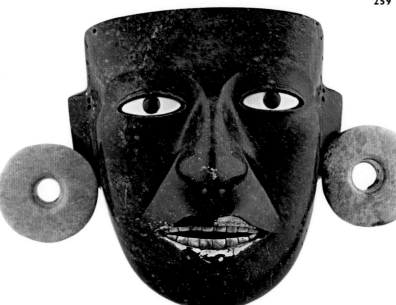

260 Mask

c. 300–600, Teotihuacan
Greenstone, shell, obsidian and coral,
21 × 20.5 × 14 cm

Museo del Templo Mayor, Mexico City,
CONACULTA-INAH, 10-220037 (ear ornaments)
and 10-220032 (mask)

258 Mask

c. 1200–1481, Mezcala
Greenstone and paint,
12 × 17.4 × 4.52 cm

Museo del Templo Mayor, Mexico City,
CONACULTA-INAH, 10-220266

261 Mask

c. 1200–1481, Mezcala
Greenstone and paint,
14.8 × 15 × 4.8 cm

Museo del Templo Mayor, Mexico City,
CONACULTA-INAH, 10-220267

262 Pectoral with an image of a moth

c. 1500, Aztec
Greenstone, diameter 13.5 cm

Museo Nacional de Antropología,
Mexico City, CONACULTA-INAH,
10-162943

265 Offering 106

c. 1325–1502, Aztec
Various materials and dimensions

Museo del Templo Mayor, Mexico City,
CONACULTA-INAH, 10-252003

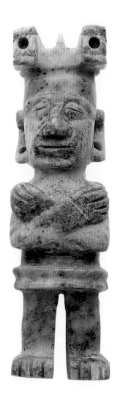

263 Figurine

c. 1200–1481, Mezcala
Greenstone and paint,
25.4 × 5.7 × 4.2 cm

Museo del Templo Mayor, Mexico City,
CONACULTA-INAH, 10-220316

264 Figurine

c. 1469–81, Mixtec
Greenstone, 11.25 × 3.38 × 3.03 cm

Museo del Templo Mayor, Mexico City,
CONACULTA-INAH, 10-168804

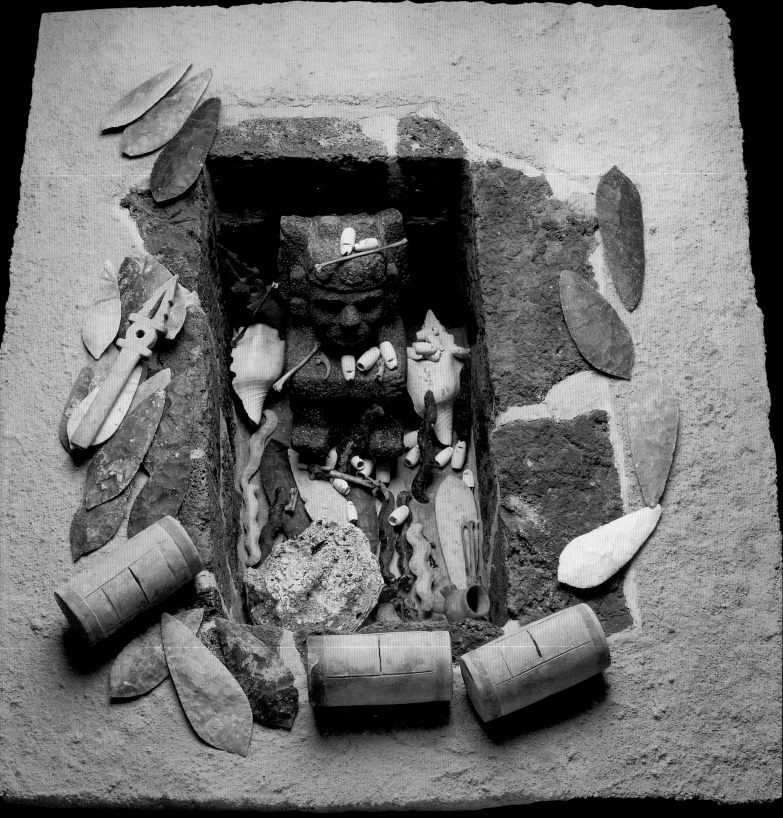

266 Sceptre

c. 1325–1481, Aztec
Obsidian, 55 × 5.86 × 1.7 cm

Museo del Templo Mayor, Mexico City,
CONACULTA-INAH, 10-250354

268 A serpent's head and rattle

c. 1325–1481, Aztec
Green obsidian, 6.3 × 2.5 × 1.5 cm,
7.3 × 0.9 × 1.3 cm

Museo del Templo Mayor, Mexico City,
CONACULTA-INAH, 10-262756 o/2

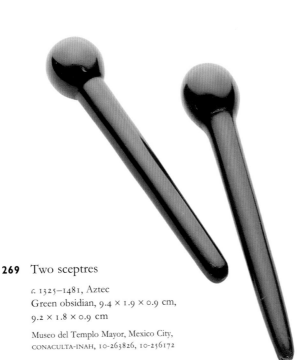

267 Eccentric flint

c. 1500, Aztec
Flint, 44 × 22.5 × 10 cm

Museo Nacional de Antropología,
Mexico City, CONACULTA-INAH, 10-393945

269 Two sceptres

c. 1325–1481, Aztec
Green obsidian, 9.4 × 1.9 × 0.9 cm,
9.2 × 1.8 × 0.9 cm

Museo del Templo Mayor, Mexico City,
CONACULTA-INAH, 10-263826, 10-256172

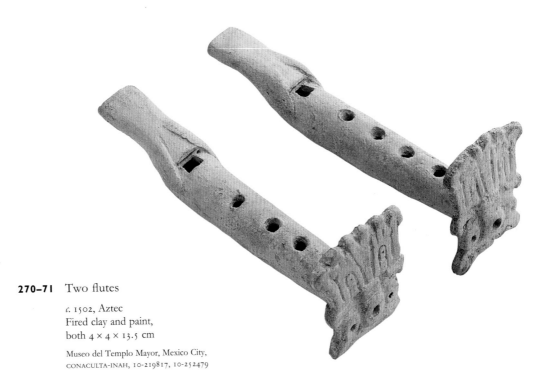

270–71 Two flutes

c. 1502, Aztec
Fired clay and paint,
both 4 × 4 × 13.5 cm

Museo del Templo Mayor, Mexico City,
CONACULTA-INAH, 10-219817, 10-252479

272 Nose-ring in the form
of a butterfly

c. 1500, Aztec
Gold, 7.5 × 7.5 × 0.1 cm

Museo Nacional de
Antropología, Mexico City,
CONACULTA-INAH, 10-220922

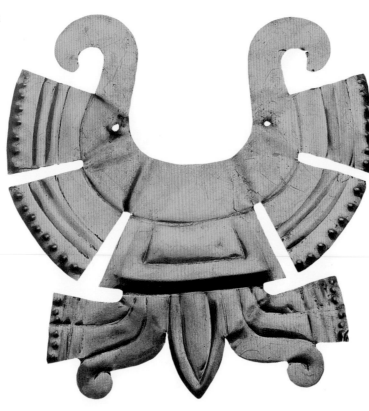

275 *Chicahuaztli*

c. 1469–81, Aztec
Alabaster, 11.9 × 2.6 × 0.9 cm

Museo del Templo Mayor, Mexico City,
CONACULTA-INAH, 10-266040

276 Staff in the form
of a deer's head

c. 1469–81, Aztec
Alabaster, 9.4 × 3.2 × 0.9 cm

Museo del Templo Mayor, Mexico City,
CONACULTA-INAH, 10-265825

277 Knife blades with
an image of a face

c. 1325–1521, Aztec
Coffee-coloured and white flint
and green obsidian,
23 × 6.3 × 1 cm,
23.2 × 6.7 × 1.2 cm,
26.5 × 7.3 × 1.1 cm,
23.1 × 7.3 × 0.9 cm,
16.5 × 6.4 × 4.4 cm
and 15 × 5 × 3.9 cm

Museo del Templo Mayor, Mexico City,
CONACULTA-INAH, 10-220282, 10-220280,
10-220284, 10-220291 and 10-253024

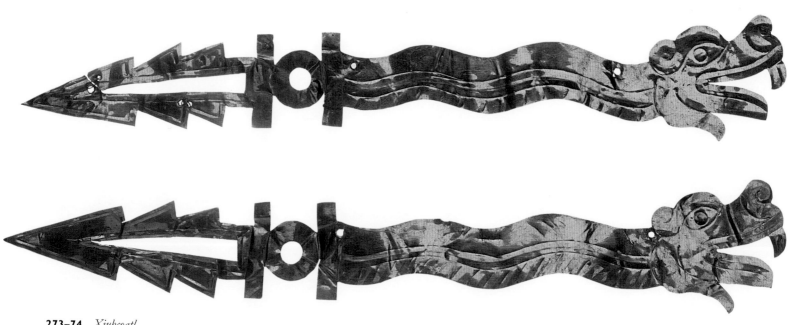

273–74 *Xiuhcoatl*

c. 1500, Aztec
Gold, both 16 × 1 cm

Museo Nacional de Antropología,
Mexico City, CONACULTA-INAH, 10-594810
and 10-3302

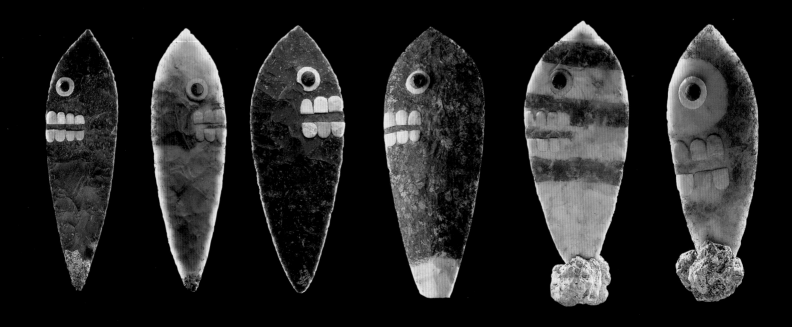

279 Funerary urn with an
image of Tezcatlipoca

c. 1470, Aztec
Fired clay, height 53 cm,
diameter 17 cm

Museo del Templo Mayor, Mexico City,
CONACULTA-INAH, 10-168823 0/2

278 Votive pot with images
of Xiuhtecuhtli and
Tlahuizcalpantecuhtli

c. 1500, Aztec
Fired clay and paint, height 25.5 cm,
diameter 22.5 cm

Museo Nacional de Antropología, Mexico City,
CONACULTA-INAH, 10-10918

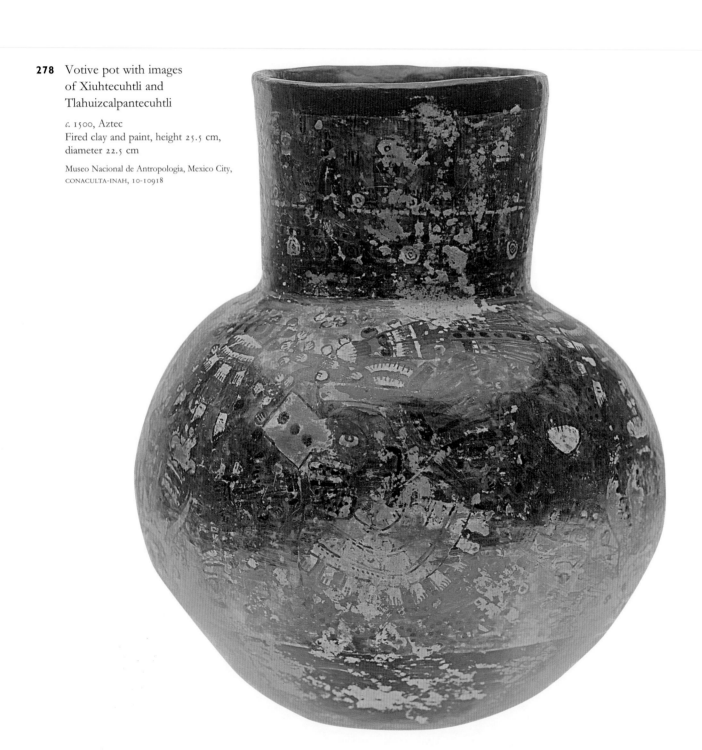

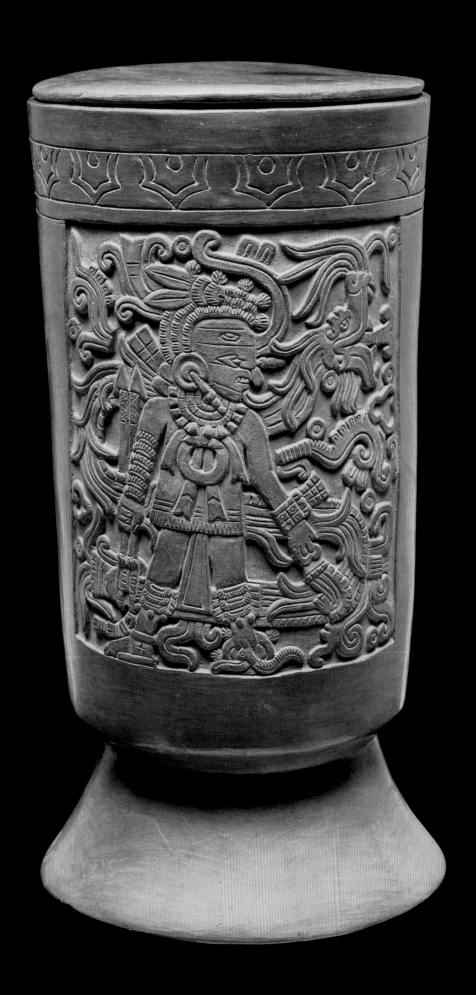

A necklace of beads, shaped like ducks'
heads and made of obsidian, found in
the funerary urn (cat. 279).

280 Fish

c. 1469–81, Aztec
Greenstone, 3.6 × 15.6 × 3 cm

Museo del Templo Mayor, Mexico City,
CONACULTA-INAH, 10-168782

281 Seven fish

c. 1325–1481, Aztec
Mother-of-pearl (*Pinctada mazatlanica*),
approx. 2 × 6 × 1.5 cm each

Museo del Templo Mayor, Mexico City,
CONACULTA-INAH, 10-252244, 10-263416,
10-263411, 10-263622, 10-263417, 10-263267
and 10-263415

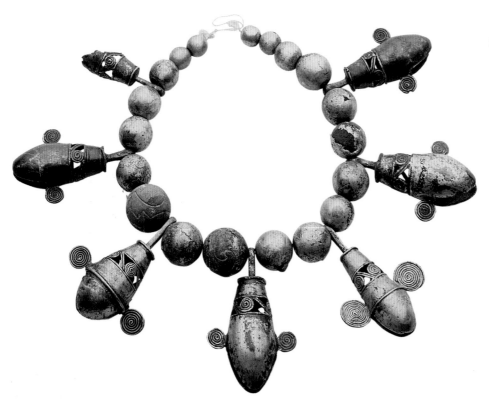

282 Necklace

c. 1325–1521, Mixtec (?)
Gold and silver; beads, diameter
approx. 1.1 cm each; rattles approx.
3.8 × 1.5 × 2.7 cm each

Museo del Templo Mayor, Mexico City,
CONACULTA-INAH, 10-252891

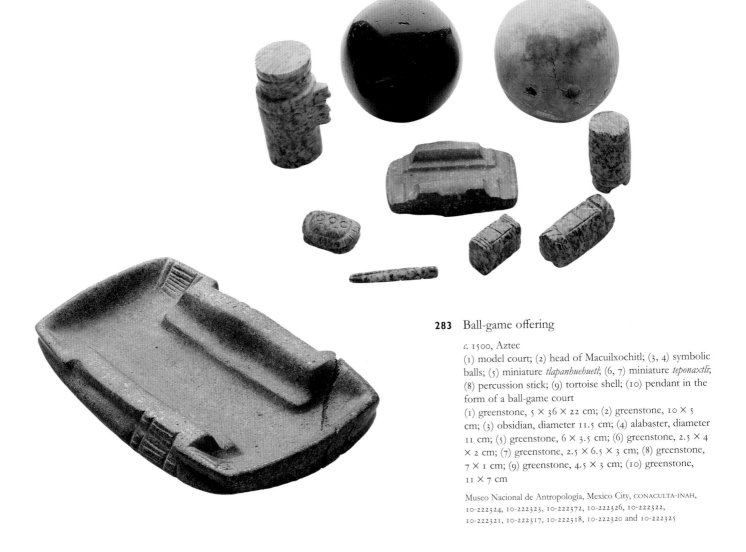

283 Ball-game offering

c. 1500, Aztec
(1) model court; (2) head of Macuilxochitl; (3, 4) symbolic
balls; (5) miniature *tlapanhuehuetl*; (6, 7) miniature *teponaxtli*;
(8) percussion stick; (9) tortoise shell; (10) pendant in the
form of a ball-game court

(1) greenstone, 5 × 36 × 22 cm; (2) greenstone, 10 × 5
cm; (3) obsidian, diameter 11.5 cm; (4) alabaster, diameter
11 cm; (5) greenstone, 6 × 3.5 cm; (6) greenstone, 2.5 × 4
× 2 cm; (7) greenstone, 2.5 × 6.5 × 3 cm; (8) greenstone,
7 × 1 cm; (9) greenstone, 4.5 × 3 cm; (10) greenstone,
11 × 7 cm

Museo Nacional de Antropología, Mexico City, CONACULTA-INAH,
10-222324, 10-222323, 10-222372, 10-222326, 10-222322,
10-222321, 10-222317, 10-222318, 10-222320 and 10-222325

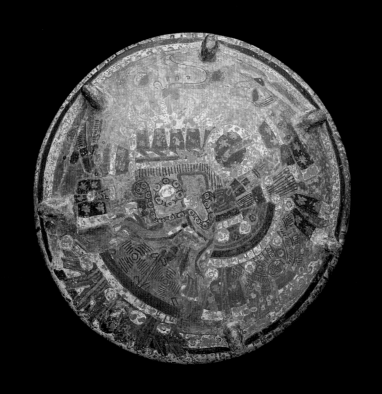

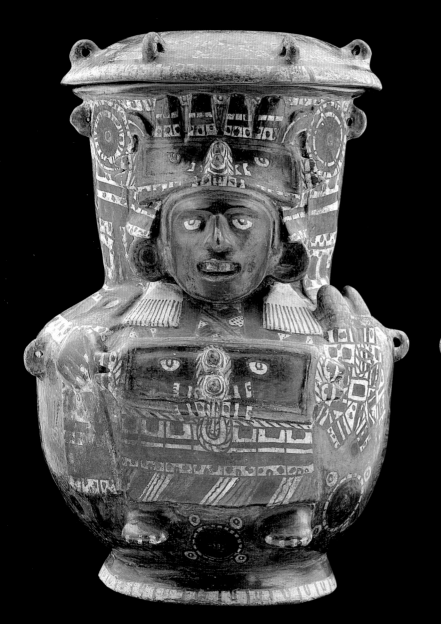

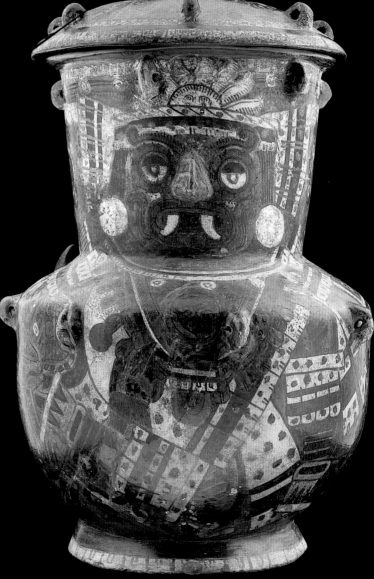

284 Pot with images of
Chicomecoatl and Tlaloc

c. 1469–81, Aztec
Fired clay and paint, 45.5/34.5 cm,
diameter 36.5 cm

Museo del Templo Mayor, Mexico City,
CONACULTA-INAH, 10-212977 0/2

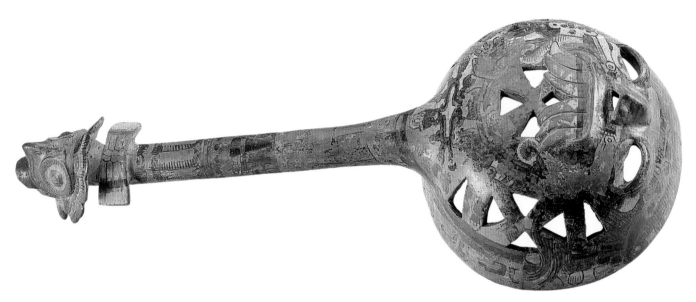

285 Censer

c. 1500, Aztec
Fired clay and paint, length 63 cm,
diameter of container 22.5 cm

Museo Nacional de Antropología,
Mexico City, CONACULTA-INAH,
10-220158

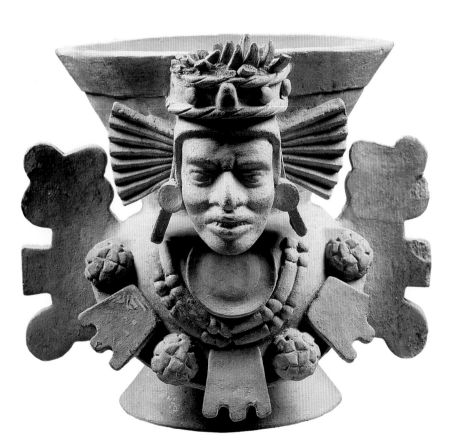

286 Brazier with an image
of a fertility god

c. 1325–1481, Aztec
Fired clay and traces of paint,
25 × 27.5 cm, diameter inside
the mouth 23 cm

Museo del Templo Mayor,
Mexico City, CONACULTA-INAH,
10-220048

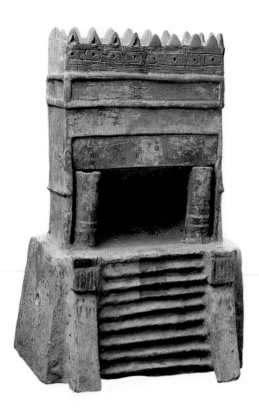

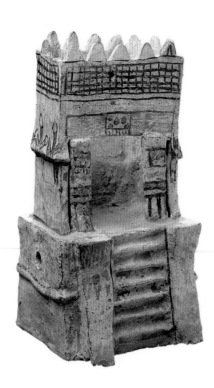

287–88, 291 Models of temples

c. 1500, Aztec–Mixtec
Fired clay and paint, 39.5 × 23 cm,
28 × 14.5 cm and 39 × 24 × 15.5 cm

Museo Regional de Puebla, CONACULTA-INAH,
10-496916; Museo Nacional de Antropología,
Mexico City, CONACULTA-INAH, 10-496914 and
10-496915

290 Model of a temple

c. 1500, Aztec
Fired clay and traces of paint,
32 × 15.5 × 19.5 cm

Museo Nacional de Antropología,
Mexico City, CONACULTA-INAH,
10-223673

289 Model of a twin temple

c. 1350–1521, Aztec
Fired clay, 20 × 18.2 × 17.2 cm

Staatliche Museen zu Berlin: Preußischer Kulturbesitz,
Ethnologisches Museum, IV Ca 2429

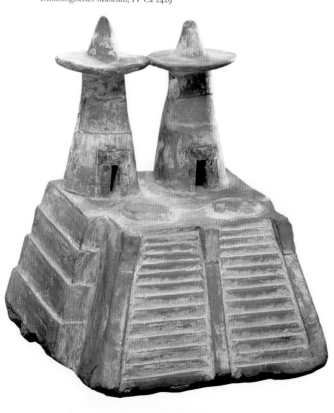

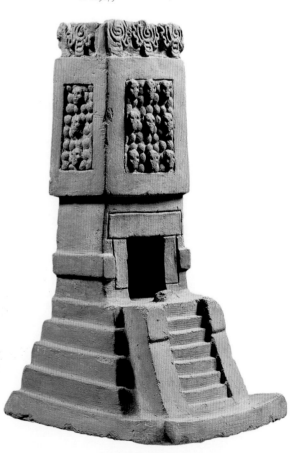

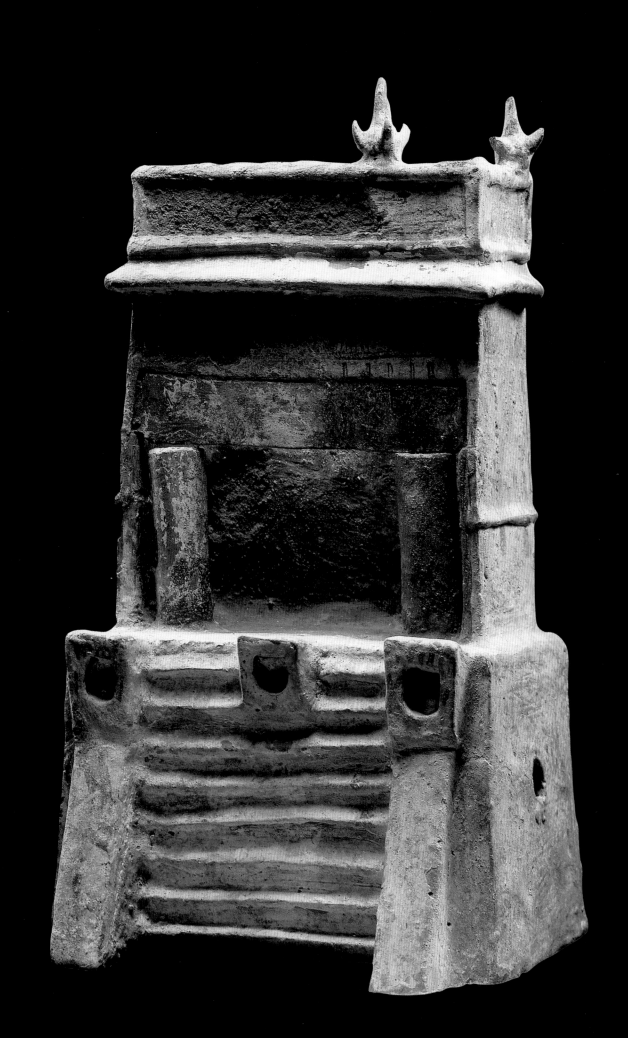

IX | TREASURES

In 1519 many gifts were sent by Motecuhzoma II to Hernán Cortés. They included greenstones (jade and turquoise), quetzal feathers, items of clothing and gold ornaments. Some 30 years earlier, the same kinds of object had been brought from throughout the realm for the dedication of the renovated Templo Mayor. Offerings empowered the temple as a centre of death and regeneration and employed symbolic complexes of water, earth, sky and sun within Aztec religious frameworks. Statuettes and masks were included with shells, coral, beach sand, a crocodile skull and a jaguar skeleton.

The preciousness of gifts and offerings lay in their rarity, their distant origins and their embodiments of life itself, the most precious treasure of all, offered in sacrifice. Of all material things, jade was the most highly valued: shining and green, it evoked water and maize, the two substances upon which human life depended.

Treasures were offered to the gods but also prized by mortals. Aztec society was mercantile, militaristic and hierarchical. Quills filled with gold dust and cacao beans were units of measure in the markets. The *pochteca* (professional merchant) class specialised in procuring luxuries from afar while being kept under tight control by the military aristocracy, all following strict sumptuary laws. Much of the *raison d'être* of Aztec imperialism was the control of luxury goods and the raw materials from which to make them. Wealth poured into Tenochtitlan from throughout the known world: turquoise from New Mexico; jade and quetzal feathers from Guatemala; rubber from the lowlands on the Gulf of Mexico; cotton from the Pacific coast. Many turquoise mosaics (cats 294–96, 298, 300–05), items of gold jewellery and other objects (cat. 315) were made by subject Mixtec artisans for the Aztecs.

Long removed from their social contexts, the objects that we treasure today as Aztec art may have had varying lives as temple offerings, ritual paraphernalia or sumptuary goods. While the uses made of them may have differed, we can approach them through an understanding of the aesthetics by which they were made and valued.

The Aztec aesthetic embraced the irony of the contradictions of existence. Tlazolteotl (cat. 320) was the goddess of filth, but also of purification and rebirth; both high-priestess of lust and the telluric *ur*-mother. The 'beauty' of motherhood could be terrible. So too, the terrible – sacrificial knives (cats 295–96) and death skulls (cat. 304) – could be beautiful. The use of masks (cats 300–04) may have been particularly favoured by the Aztecs because they expressed the concept of multi-layered reality.

So many of the original contexts of Aztec objects are lost to us that we are often uncertain of how these precious things were used. The size of Tlazolteotl suggests that it may have been made for private devotion. The smooth, polished surfaces of some objects (cats 306–09, 312–14) contrast sharply with the dense intensities of mosaics, featherwork and more intricate carvings. The bones of humans and deer, closely linked in the ideology of sacrifice, were elaborated and transformed through inscribing their surfaces with designs (cats 316–18) or shaping them into the claw of an eagle (cat. 317) or a human hand (cat. 319). The specific historical circumstances that called for the transformation of these bones, and not others, into objects of art are nonetheless lost to us, though again, their sizes suggest a close, personal relationship between these transformed remnants of former life and their later owners.

The smoothness of stones and the complexities of mosaics express the same aesthetic impulse of a celebration of craft and a fascination with surfaces. Craft and surface are manifest as the eye travels over the intricacies of the piecework of turquoises meticulously cut and laid into place, or the smooth surfaces of hard stone painstakingly ground and polished to a lustre. The two-dimensionality of the bicephalic serpent (cat. 294) is accented by its undulations, ready to spring outwards, left and right. Some surfaces are so densely packed that details are lost in the overall pattern (cats 297–98).

This celebration of surface emphasises deeper truths within. The carved bones and antlers never lose their qualities as fragments of formerly living beings. The carvings upon them heighten the existential fact that death so easily converts subject to object: a skull encrusted with turquoises and obsidian (cat. 304) is still clearly a skull and yet is transformed. The god Xipe Totec's spring festival was celebrated by the donning of the skin of a slain captive (cats 313–14). Like gold sheathing or the husk around a germinating seed, the true, living essence of the god and his human vehicle lay beneath the surface, ready to burst forth in new life. The same message is sometimes rendered more blatantly than in the subtle undulations of highly polished stone or shell. The Aztecs could call for contemplation but equally were masters of shock art.

Small treasures delight in details and in playing with surfaces and depths. Even the smooth surfaces of stone carvings were covered in layers of textile. Public monuments worked differently, generally emphasising mass, line and simple forms so that sculptures could be 'read' from a great distance by the viewer. Aztec artists controlled their media so that, if they wanted, small objects (cats 306–09, 312) could take on the massive proportions of large-scale works.

Surface and depth, intricate decoration and smooth, plain surfaces, life and death, stability found only in constant cycles of transformation, were at the heart of the Aztec world-view and the treasures with which they celebrated their lives and their beliefs. Mastery of technique, rarity of material and embellishment of form all came into play. The trope of true reality hidden beneath surfaces is perhaps most eloquently expressed in the obsidian mirror (cat. 292). It probably served divinatory purposes as a window into the dark world, the realm of Tezcatlipoca, on the other side of this shining reality called life. Aztec life was loved so much that it was given to the gods reluctantly under the sacrificial blade (cats 295–96) and enjoyed to the full by adorning it through poetry, song, flowers, dances, festivals and objects of beauty.

292 Mirror and frame

c. 1250–1521 and Post-Conquest,
Aztec and colonial
Polished obsidian and wood,
diameter 35 cm

American Museum of Natural History,
New York, 30.0/6253

293 Casket with lid

c. 1470, Aztec
Granite, 15 × 33.5 × 21 cm

Museum für Völkerkunde Hamburg, B.3767

294 Double-headed serpent
pectoral

c. 1400–1521, Aztec–Mixtec
Wood, turquoise and shell,
20.5 × 43.3 cm

Trustees of the British Museum,
London, Ethno. 94-634

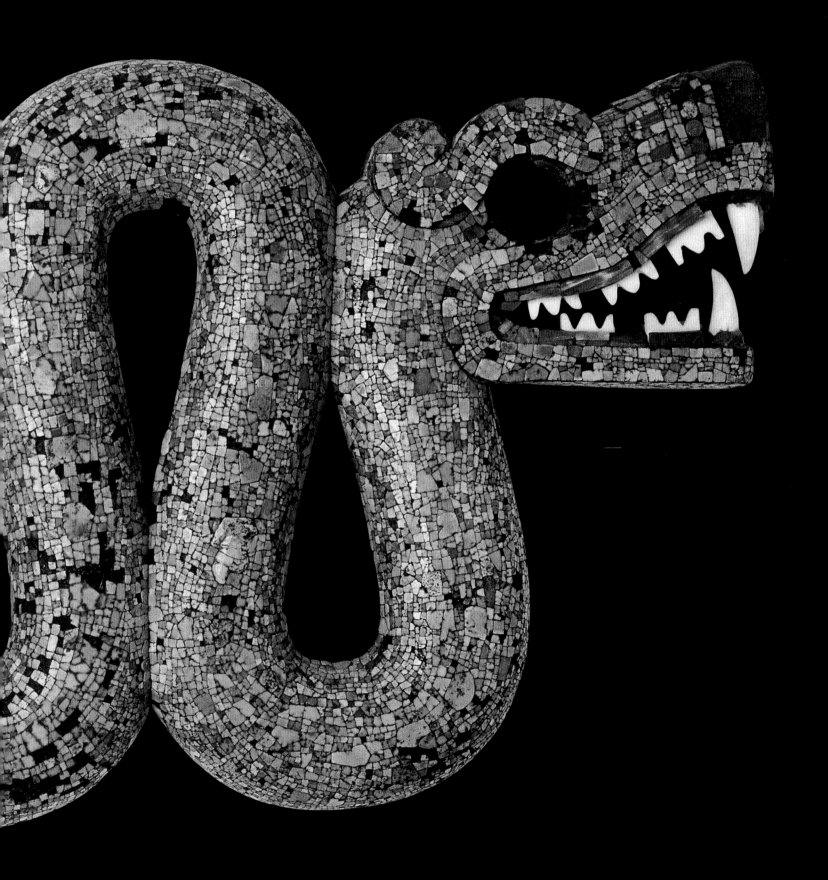

295 Handle of a sacrificial knife

c. 1500–21, Aztec–Mixtec
Wood, turquoise, malachite,
mother-of-pearl and shell, 5 × 12.5 cm

Museo Nazionale Preistorico-Etnografico
'L. Pigorini', Rome, inv. no. 4216

297 Tlaloc (?)

c. 1500, Aztec–Mixtec (?)
Wood, turquoise, jade,
malachite, mother-of-pearl
and red and white shell,
29 × 12 × 17 cm

The National Museum of Denmark,
Copenhagen, Department of
Ethnography, ODIh.41

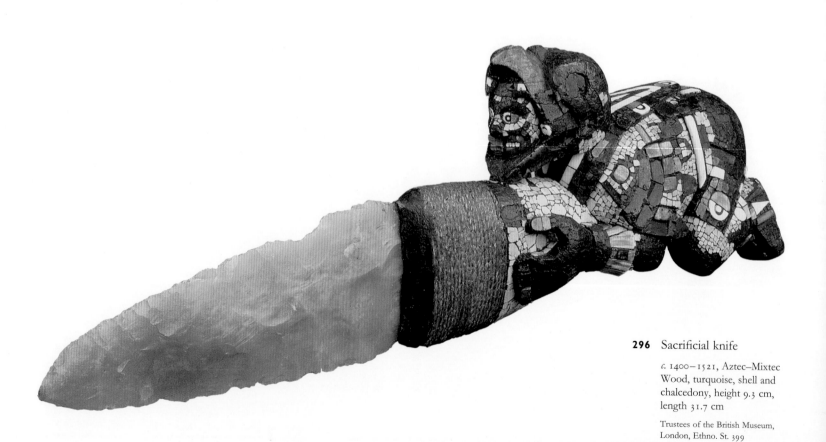

296 Sacrificial knife

c. 1400–1521, Aztec–Mixtec
Wood, turquoise, shell and
chalcedony, height 9.3 cm,
length 31.7 cm

Trustees of the British Museum,
London, Ethno. St. 399

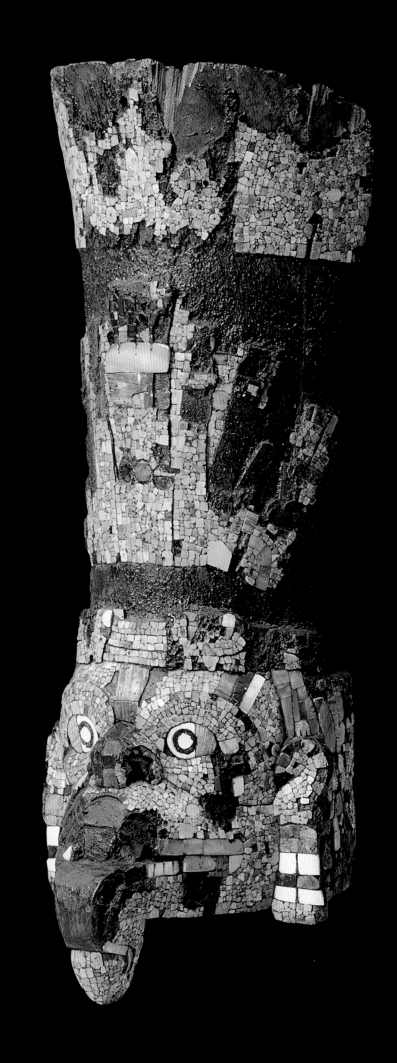

299 Shield

c. 1500, Aztec
Feathers, sheet-gold, agave
paper, leather and reed,
diameter 70 cm

Museum für Völkerkunde Wien
(Kunsthistorisches Museum mit
MVK und ÖTM), Vienna, 43.380,
Ambras Collection

298 Shield with mosaic decoration

c. 1250–1521, Mixtec
Wood, turquoise and shell,
diameter 45.5 cm

Musées Royaux d'Art et d'Histoire,
Brussels, AAM 68.11

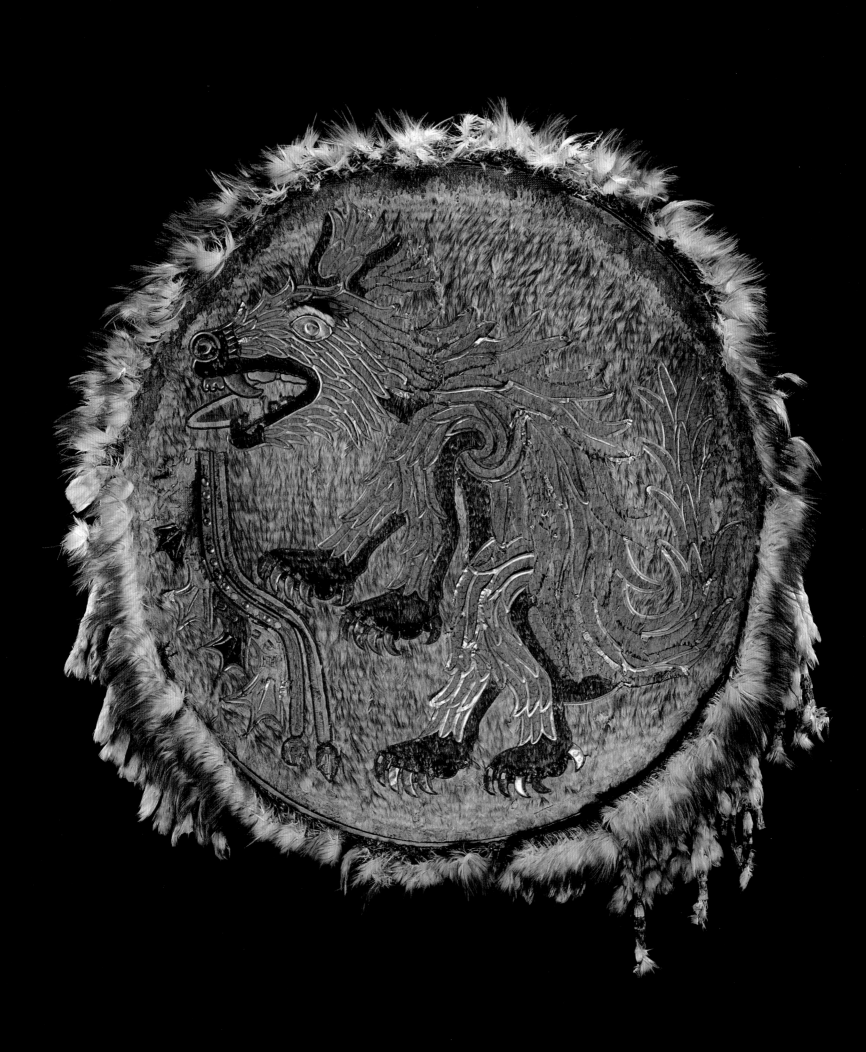

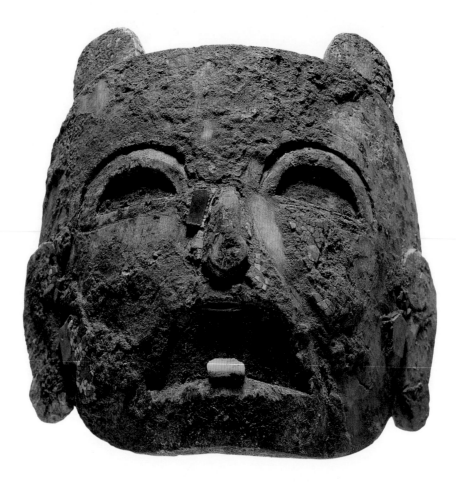

300–02 Masks

c. 1500, Aztec–Mixtec
Wood, turquoise and onyx,
17 × 16 cm, 15 × 7 cm and 15.5 × 15 cm

Museo Regional de Puebla, CONACULTA-INAH,
10-373011, 10-373014 and 10-373009

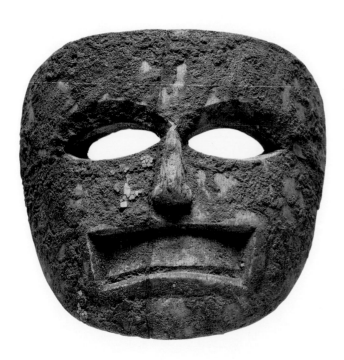

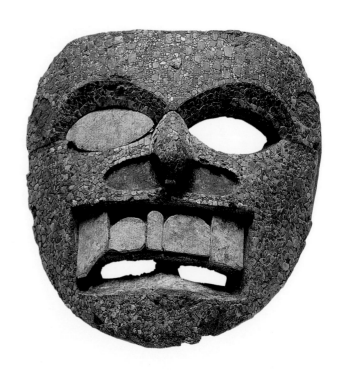

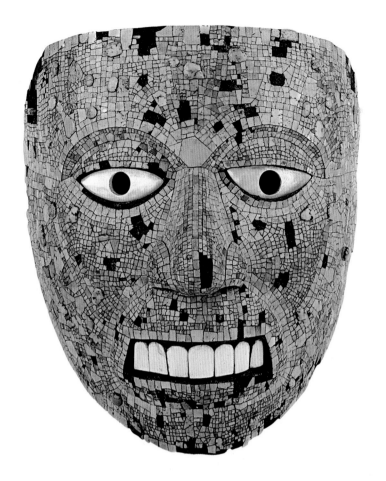

303 Mask

c. 1400–1521, Aztec–Mixtec
Wood, turquoise and shell,
16.5 × 15.2 cm

Trustees of the British Museum,
London, Ethno. St. 400

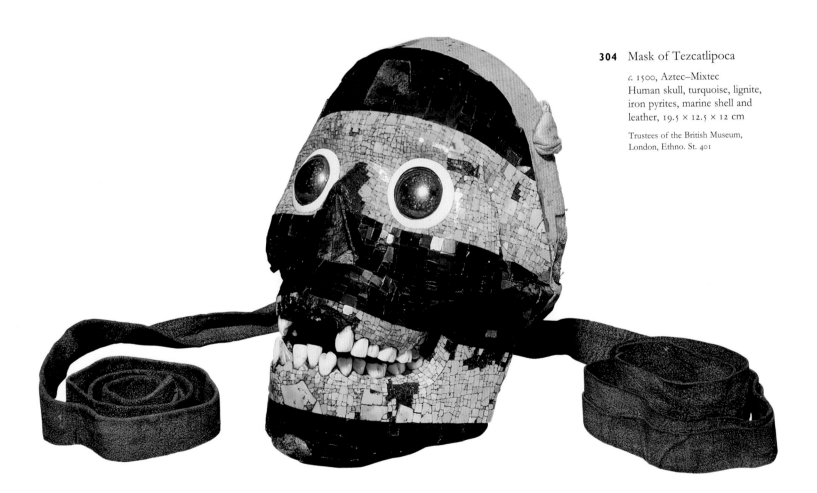

304 Mask of Tezcatlipoca

c. 1500, Aztec–Mixtec
Human skull, turquoise, lignite,
iron pyrites, marine shell and
leather, 19.5 × 12.5 × 12 cm

Trustees of the British Museum,
London, Ethno. St. 401

305 Jaguar pectoral

c. 1500, Mixtec
Wood, stone and shell,
7.6 × 17.1 × 3.2 cm

The Saint Louis Art Museum,
Gift of Morton D. May, 163:1979

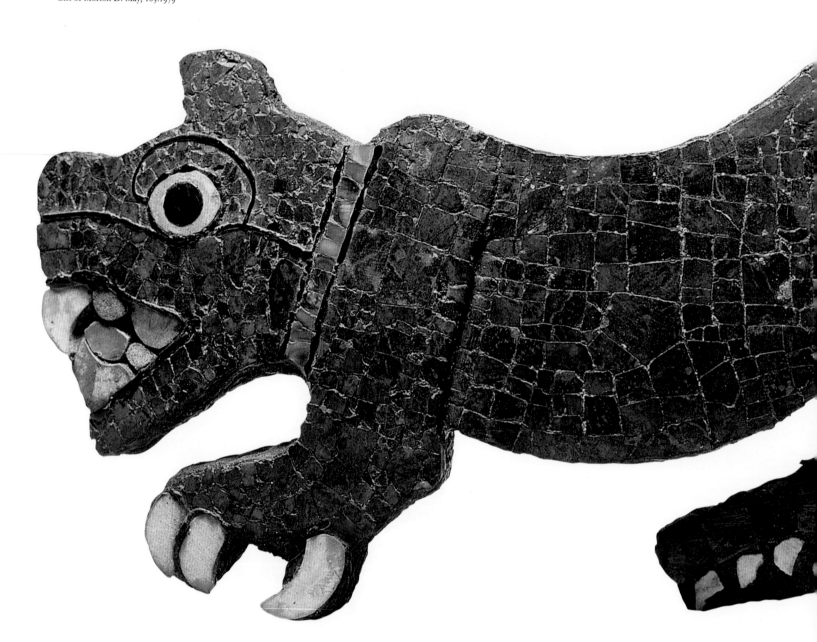

306–09 Zoomorphic ear ornaments

c. 1500, Aztec
Bone, 1.5 × 6.5 × 1 cm;
shell, 2 × 1.1 × 1.8 cm;
stone, 1.8 × 1.8 × 2.2 cm;
obsidian, 3.5 × 2 × 6 cm

Museo Nacional de Antropología,
Mexico City, CONACULTA-INAH,
10-607770, 10-594833, 10-7717
and 10-594798

310 Pectoral

c. 1500, Aztec
Greenstone, 8 × 4.5 × 0.5 cm

Museo Nacional de Antropología,
Mexico City, CONACULTA-INAH, 10-8153

312 Mirror frame

c. 1500, Huexotzingo
Obsidian, 9.8 × 9.8 × 7.1 cm

Museum für Völkerkunde Wien
(Kunsthistorisches Museum mit
MVK und ÖTM), Vienna, 59.253,
Becker Collection

311 Pectoral or pendant
with engraved images

c. 1500, Aztec
White shell, 3.5 × 12 × 0.3 cm

Museo Nacional de Antropología,
Mexico City, CONACULTA-INAH, 10-275

313 Mask

c. 1500, Aztec
Greenstone, 21.5 × 19.5 × 10.5 cm

Museum für Völkerkunde Wien (Kunsthistorisches
Museum mit MVK und ÖTM), Vienna, 12.415

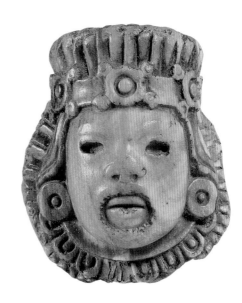

314 Pendant

c. 1300–1521, Aztec
Spondylus shell, 5.5 × 4.6 × 3 cm

Dumbarton Oaks Research Library and Collections,
Washington DC, B-82

315 *Átlatl*

c. 1500, Mixtec
Wood and traces of paint,
length 57.5 cm

Staatliches Museum für
Völkerkunde, Munich, 27-12-1

319 Human hand holding
a deer's head

c. 1500, Aztec
Deer's antler,
21.2 × 9.6 × 7.9 cm

Laboratoire d'Ethnologie,
Musée de l'Homme, Paris,
M.H. 87.101.714

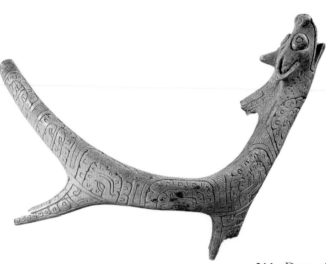

316 Drumstick

c. 1350–1521, Aztec
Deer's antler,
length 22 cm

Staatliche Museen zu Berlin:
Preußischer Kulturbesitz,
Ethnologisches Museum,
IV Ca 41046

317 Fly-whisk handle

c. 1500, Aztec
Bone, 12 × 2 × 3 cm

Museo Nacional de
Antropología, Mexico City,
CONACULTA-INAH, 10-81623

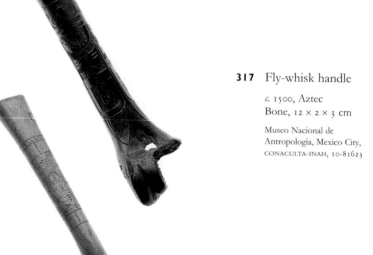

318 Femur with
inscriptions

c. 1500, Aztec
Bone, 35 × 4.8 cm

Museo Nacional de
Antropología, Mexico City,
CONACULTA-INAH, 10-594025

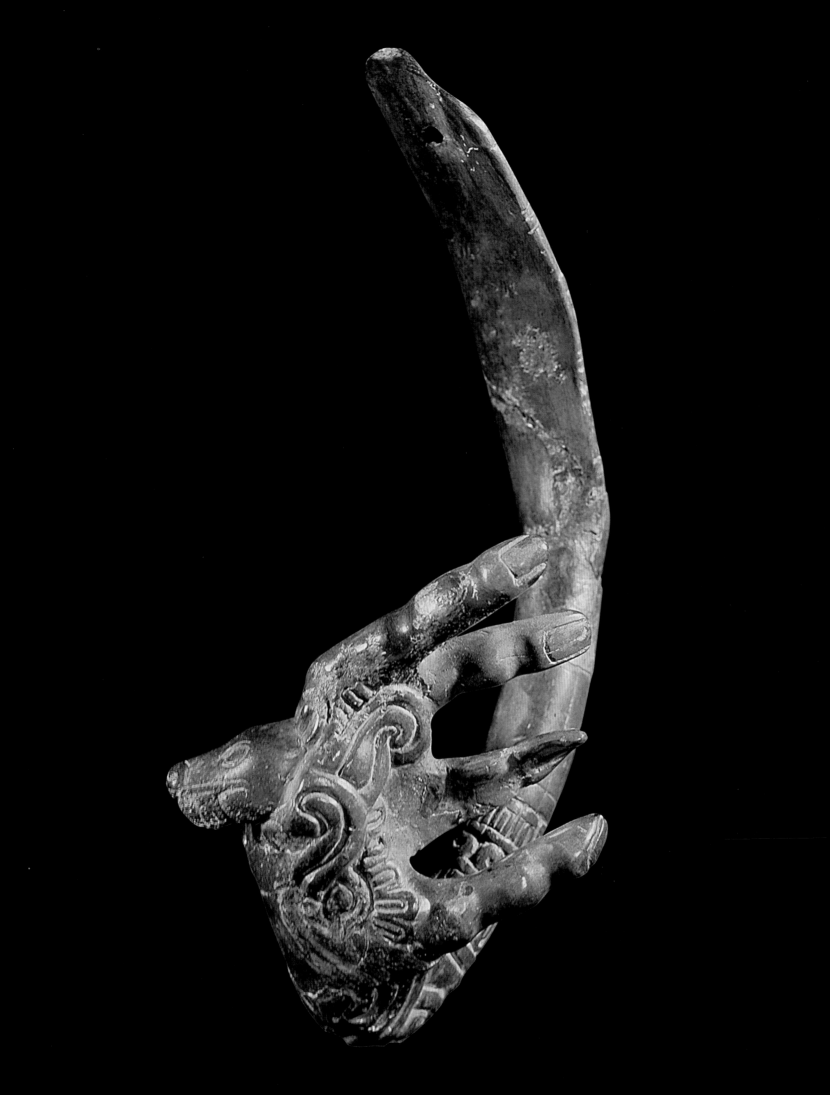

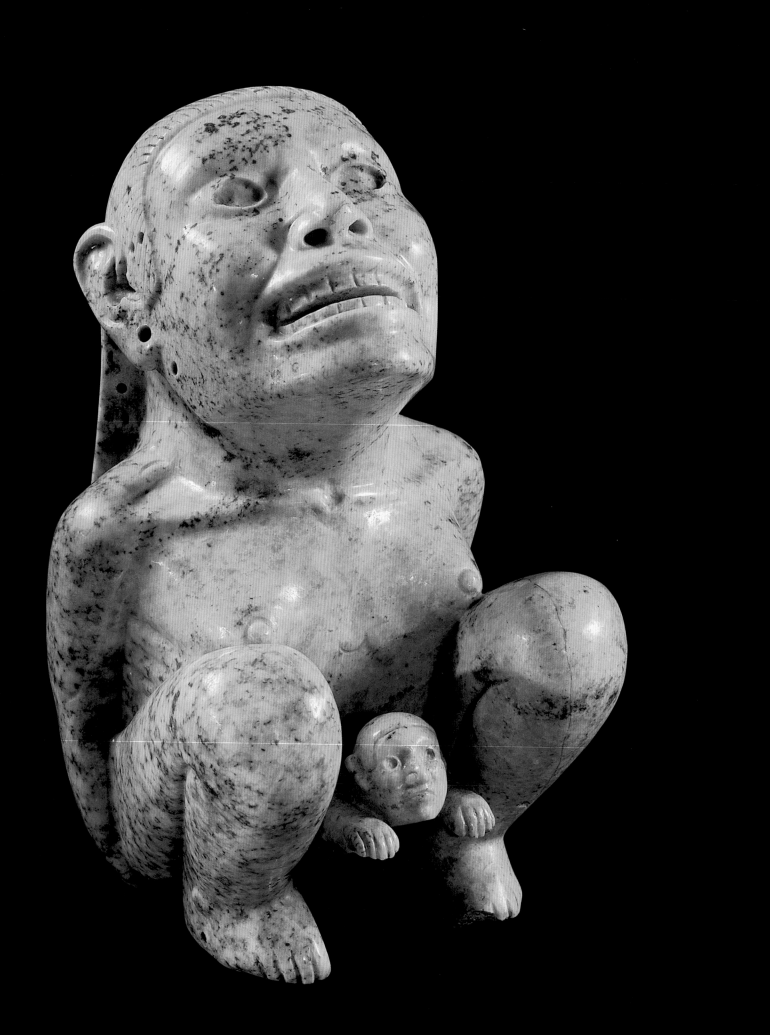

320 Tlazolteotl

c. 1300–1521, Aztec
Aplite, 20.2 × 12 × 15 cm

Dumbarton Oaks Research Library
and Collections, Washington DC,
B-71

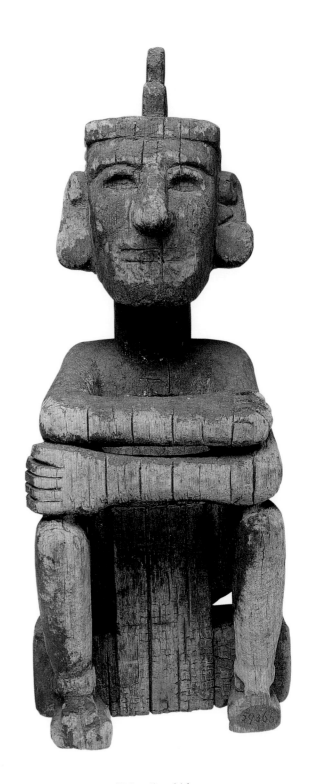

321 Figure of Macuilxochitl

c. 1500, Aztec (?)
Wood and traces of paint, 44 × 18 × 15 cm

Museum für Völkerkunde Wien (Kunsthistorisches
Museum mit MVK und ÖTM), Vienna, 59.866,
Becker Collection

X | CONTACT: INDO-CHRISTIAN ART

If the pictorial writing systems of the Aztecs survived the Spanish conquest – albeit in a much changed form – other areas of artistic endeavour were less fortunate. This is especially true in the religious sphere: native architecture and imagery were wholly unacceptable to the Catholic Church, not just because of their close associations with the old religion, but also at the level of aesthetics. However, the invaders were not slow to recognise the potential of the technical skills behind their production. Special workshops were established to train native artists and artisans in the principles of Renaissance art and to impose on them the iconography of the Christian tradition. The models from which they worked were, in the main, engravings and woodcuts appearing as illustrations in bibles and similar imported theological works. Innovation was discouraged, above all in thematic art (portraits of the Saints or the Holy Family, representations of Christ's Passion and other biblical stories), in which, through error or intent, the 'signs of the Devil' might appear.

The greater part of surviving examples of contact native artwork comes in architectural sculpture and mural painting, which still grace churches and monastery buildings. The large stone crosses carved with the symbols of Christ's Passion that stood at the centre of their courtyards are also not uncommon. Portable objects, such as silver-, gold– and feather-worked crucifixes, chalices, wall hangings, altar cloths and ecclesiastical apparel, complemented these permanent fixtures not only in terms of workmanship, but also in that they were quite obviously the trappings of Christianity. As such, these edifices and the symbols and accessories that they housed might appear to announce a cultural and religious point of no return for Aztec 'art' and its executors, those scribes of old whose task was to 'write' the sacred, rather than illustrate or beautify it.

The Indian sacred was perceived as an abstract entity, manifest in the power and awesome living beauty of the natural world. To write the sacred, therefore, was not just a case of reproducing its signs and symbols in, or through manipulation of, a particular medium, but the nature of the medium itself. Where, according to the Post-Conquest Nahuatl text known as the Florentine Codex (cat. 344), rock crystal was 'cherished, esteemed, precious, venerated', this was not due to its visual or tactile qualities, but rather because these denoted the presence of the sacred. Gold and silver were defined as the yellow and white excrement of the sun: with them, 'I make things beautiful…I make things give off rays'. That is, the finished vessel or jewel was an embodiment of the divine celestial orb. Above all, perhaps, the presence of divinity was sought in the sensual touch and shimmering colours of 'all the precious feathers', those of the hummingbird, the resplendent trogon, the golden oriole and many more.

Colour also played an important role in writing the sacred. The iridescent feathers of the resplendent trogon, for example, 'very green, fresh green, turquoise-coloured', symbolised the regeneration of life in the springtime, the freshness of young vegetation and the water which made it grow. Crimson and turquoise dominated Pre-Hispanic art and may be explained as a dual metaphor for a series of complementary opposites that constituted the fundamentals of cosmic vitality: fire and water, sun and water, earth and water, but also blood and water, precious liquids that gave life to man and the sacred landscape respectively. Colonial feather mosaics (cats 325–26) were undoubtedly based on European prints in monochrome; choice of colour was, then, a native initiative.

Viewed in this manner, native artwork of the contact period takes on rather different attributes. Through use of traditional media and chromatic symbolism, Euro-Christian forms became tangible manifestations of the Indian sacred within which, it follows, Christianity was accorded a place. This cannot be seen as circumstantial, however, for the same artwork also offers us an insight into the way in which Christianity came to be perceived as a part of the Indian divine.

Early associations between Christ and maize, the native Tree of Life, are well documented in both Nahua devotional literature and the art of the period. The stone churchyard crosses, for example, never carry the body of Christ. His presence is restricted to the crown of thorns, or an image of his face at the axis of the cross (cat. 322); gaping wounds from which his blood flows replace his feet and hands. Christ *is* the Tree of Life; he bleeds life onto the earth. The wounds of Christ were often represented on the stone crosses or the insignia of the Franciscan order (cat. 335) in the form of concentric circles, or the *chalchihuitl*, the graphic symbol for precious liquid, that is, blood and water. In addition, the reed sceptre of the ridiculed King of the Jews frequently takes the form of a maize plant, identifiable by its widely spaced, alternating leaves. On churchyard crosses, it is often superimposed on the vertical shaft, as if to represent his body, which is also the tree.

Following these lines of interpretation, we cannot but note on the bishop's mitre (cat. 323) the exuberance of Christ's cross as a foliage-laden tree. Raised in a verdant setting (which barely equates to the Golgotha of biblical renown), the cross is surrounded by water-blue gems reminiscent of the *chalchihuitl* in both colour and form. On the front of the mitre, the cock, symbol of Peter's denial, has been transformed into a different species of bird. Stepping gracefully along the arms of the cross, it now more closely resembles the type of celestial bird placed at the top of native cosmic trees. Inserted at the base of the cross in a scene showing the mass of St Gregory, the dead Christ rises from his tomb – that is, from the maws of the earth monster. This arrangement echoes the traditional positioning of Tlaltecuhtli, devourer of the dead, at the base of the same trees.

Nahua mythology tells us that native life trees supported the sky, in the sense that they separated the celestial and sub-terrestrial planes so that human life might be perpetuated on earth. We might speculate, then, that it was for this reason that the columns supporting the house of the Christian God on earth, with its own promise of eternal life, retained the image of Tlaltecuhtli at their bases (cat. 339). God's home in Mexico, as Nahua poets often described the church, also stood within the embrace of the Indian sacred.

322 Cross

c. 1600, colonial
Stone, 156 × 91 × 36 cm

Museo Regional de Tlaxcala,
CONACULTA-INAH, 10-341001

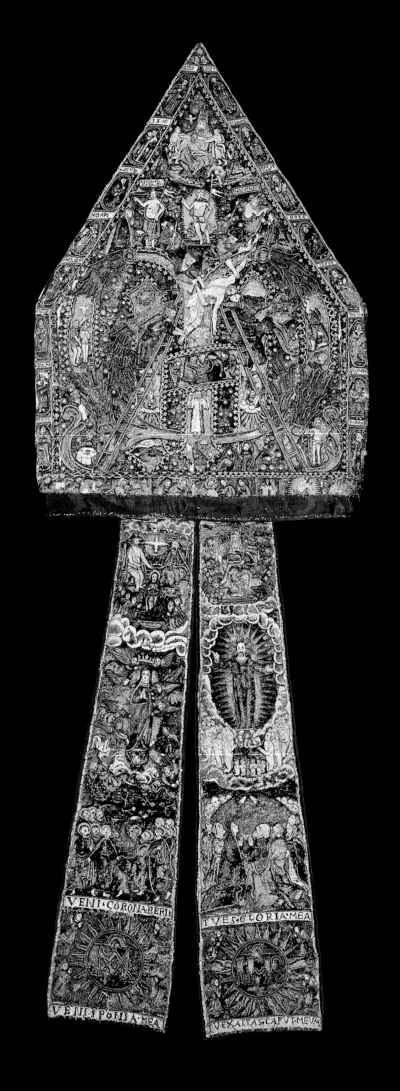

323 Mitre

Second third of the sixteenth century,
colonial
Feather mosaic on maguey paper
and cotton fabric, 82.5 × 28.5 cm

Patrimonio Nacional, Monasterio de
San Lorenzo de El Escorial, 10050202

324 Triptych

Late sixteenth century, colonial
Silver-gilt, boxwood and humming-
bird feathers, 8 × 8 × 0.5 cm

Victoria and Albert Museum, London,
226-1866

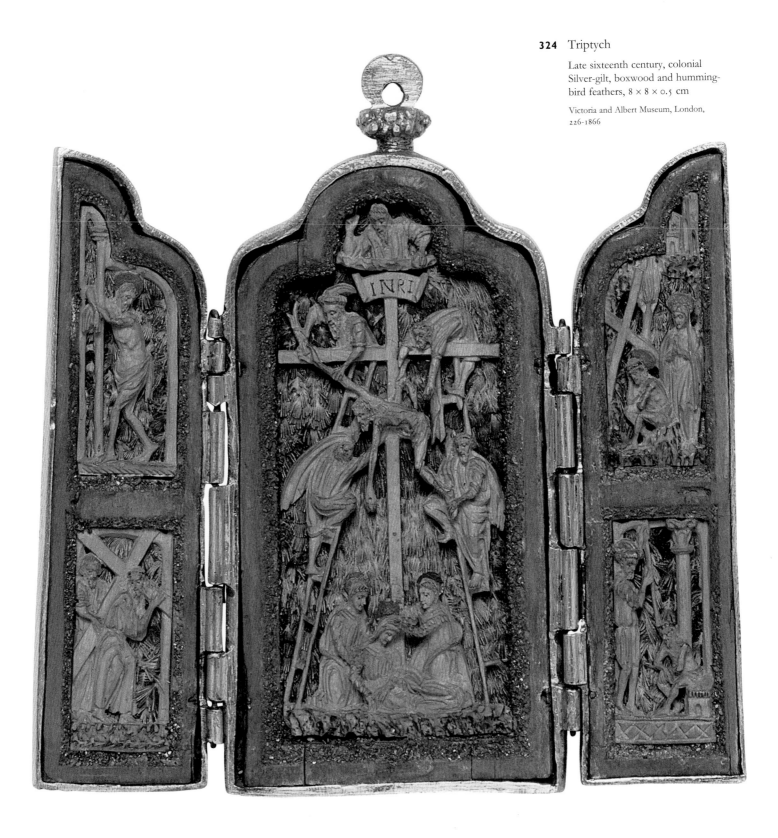

326 Christ the Saviour

Sixteenth century, colonial
Feathers, 105 × 90 cm

Museo Nacional del Virreinato,
Tepotzotlan, CONACULTA-INAH,
10-28966

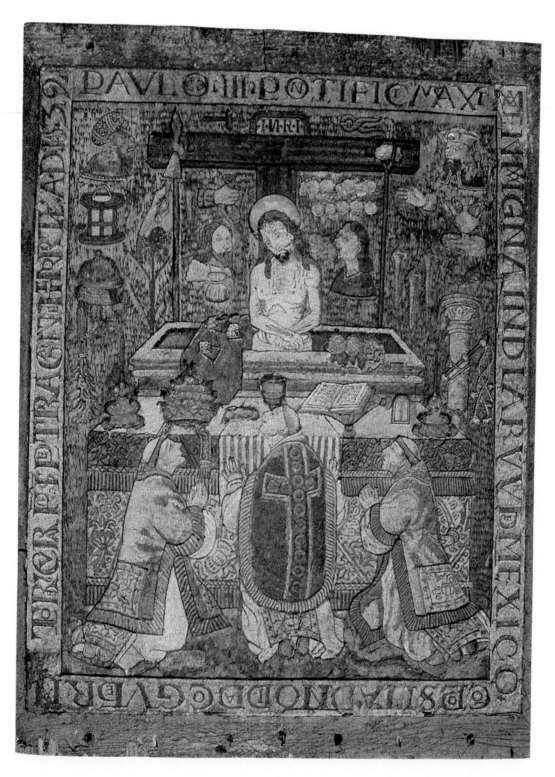

325 *The Mass of St Gregory*

1539, colonial
Feathers on panel, 68 × 56 cm

Musée des Jacobins, Auch, 986.1.1

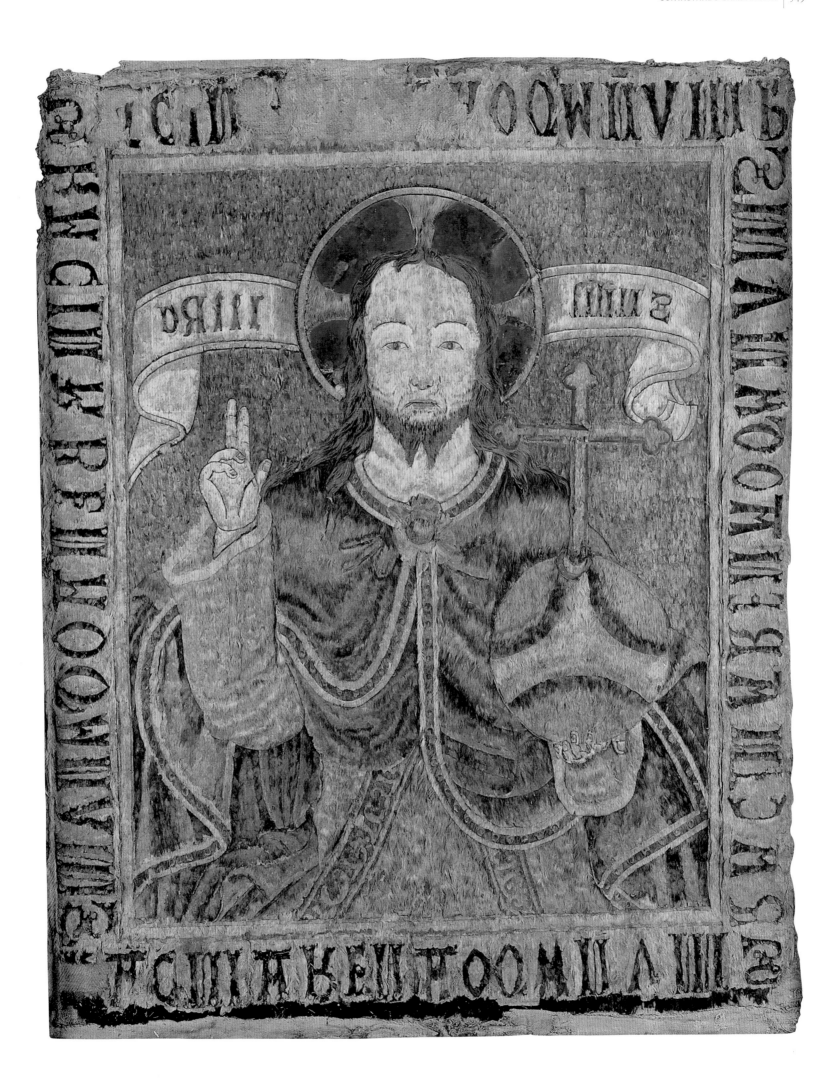

328 Chalice cover

c. 1540, colonial
Feathers and bark,
diameter 28 cm

Museo Nacional de Antropología,
Mexico City, CONACULTA-INAH,
10-220923

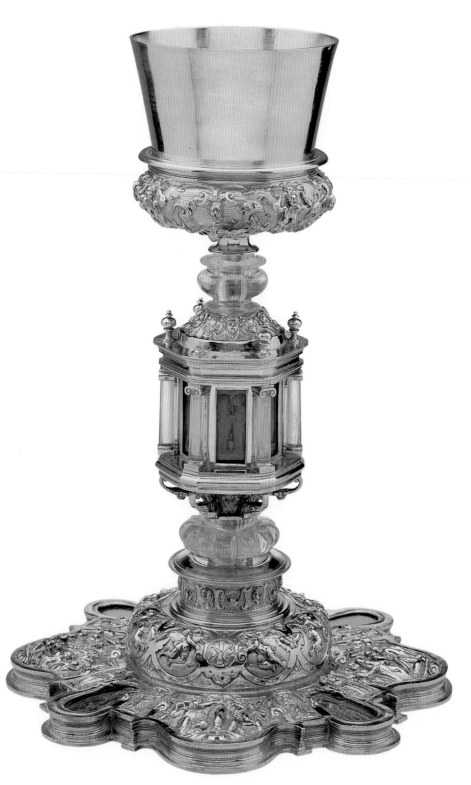

327 Chalice

c. 1575–78, colonial
Silver-gilt, rock crystal,
boxwood and hummingbird
feathers, height 33 cm

Los Angeles County Museum
of Art, William Randolph Hearst
Collection, 48.24.20

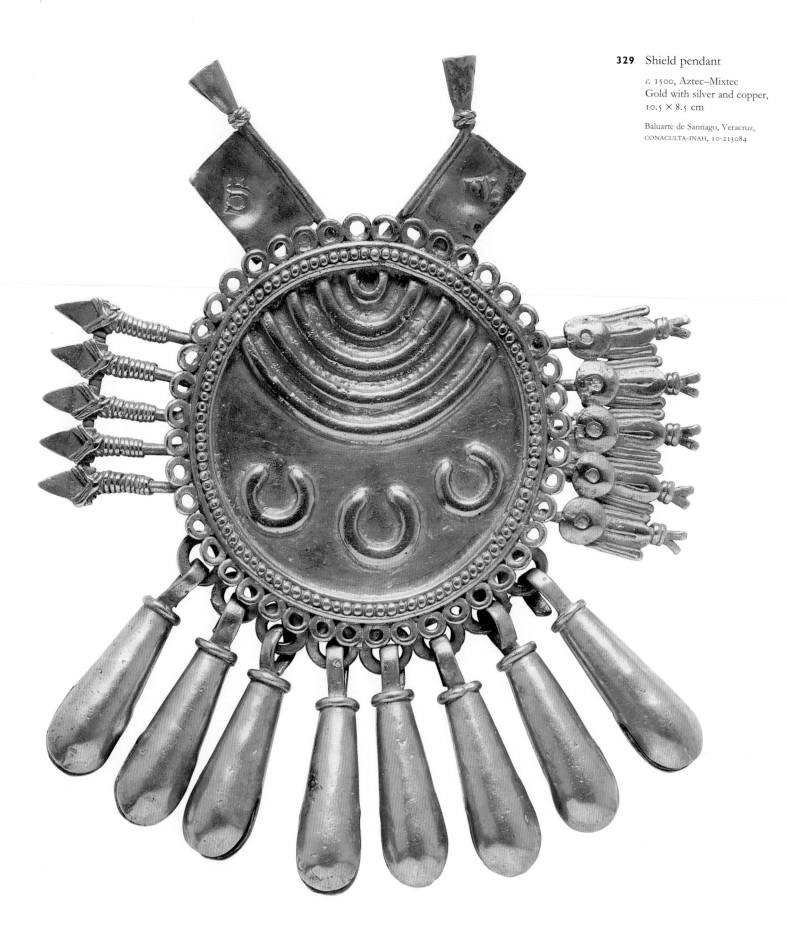

329 Shield pendant

c. 1500, Aztec–Mixtec
Gold with silver and copper,
10.5 × 8.5 cm

Baluarte de Santiago, Veracruz,
CONACULTA-INAH, 10-213084

330–32 Bracelets

c. 1500, Aztec–Mixtec
Gold with silver
and copper,
8 × 2.8 × 1 cm,
7 × 4.8 × 1.7 cm and
8.2 × 3 × 1 cm

Baluarte de Santiago,
Veracruz, CONACULTA-INAH,
10-213110, 10-213113 and
10-213111

333 Gold ingot

c. 1521, early colonial
Gold, 5.5 × 26.5 × 1.5 cm

Museo Nacional de Antropología,
Mexico City, CONACULTA-INAH,
10-220012

334 Mirror frame

Sixteenth century, Aztec
Wood, resin, turquoise, jade,
glass, shell and iron wire,
9.7 × 8.5 × 5.2 cm

Museum für Völkerkunde Wien
(Kunsthistorisches Museum mit
MVK und ÖTM), Vienna, 43.382,
Ambras Collection

336 Vitzliputzli

Second half of the sixteenth
century, Mexico
Silver-gilt, pearls and pyrite,
7.5 × 6 × 6.5 cm

Museen der Stadt Nürnberg,
Nuremberg, Gemälde und
Skulpturen, Pl. 1248

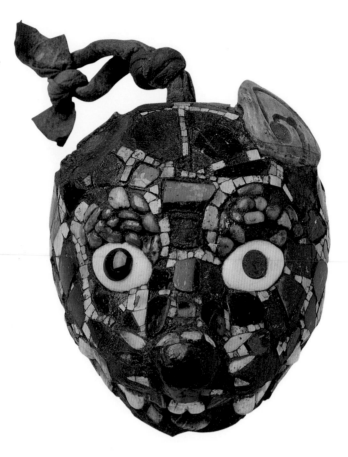

335 Mirror or portable altar

c. 1520–30 (?), colonial
Obsidian, wood, paint
and gilding; mirror,
25.5 × 23.4 cm,
frame 31.5 × 28.5 × 2.8 cm

Dumbarton Oaks Research Library
and Collections, Washington DC,
B-78

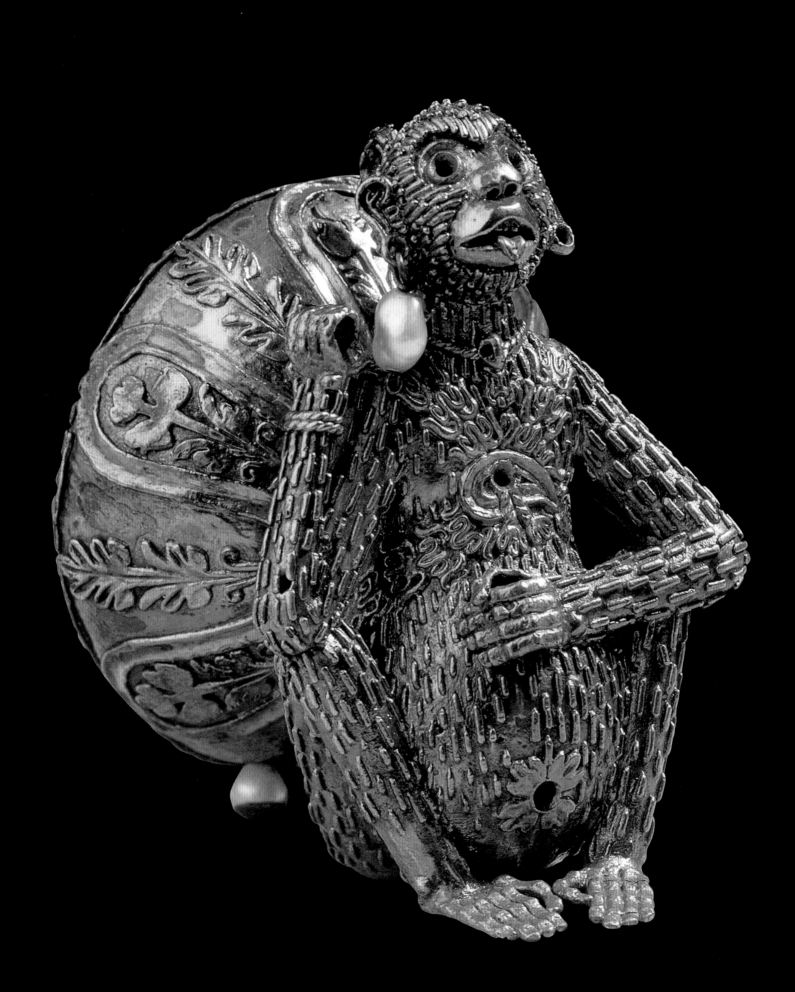

337 Tripod ceremonial plate

c. 1530, Aztec
Fired clay, height 10 cm,
diameter 23.5 cm

Museo Nacional de Antropología,
Mexico City, CONACULTA-INAH,
10-81584

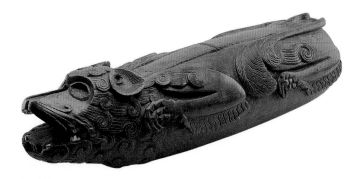

338 Drum

c. 1521, early colonial
Chicozapote wood and animal molars,
22 × 88 × 25 cm

Museo Nacional de Antropologia, Mexico City,
CONACULTA-INAH, 10-220924

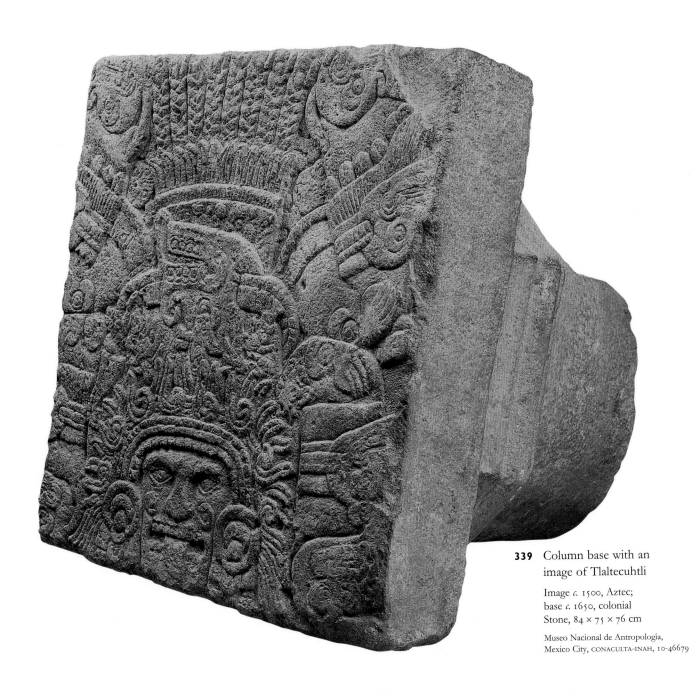

339 Column base with an
image of Tlaltecuhtli

Image *c.* 1500, Aztec;
base *c.* 1650, colonial
Stone, 84 × 75 × 76 cm

Museo Nacional de Antropología,
Mexico City, CONACULTA-INAH, 10-46679

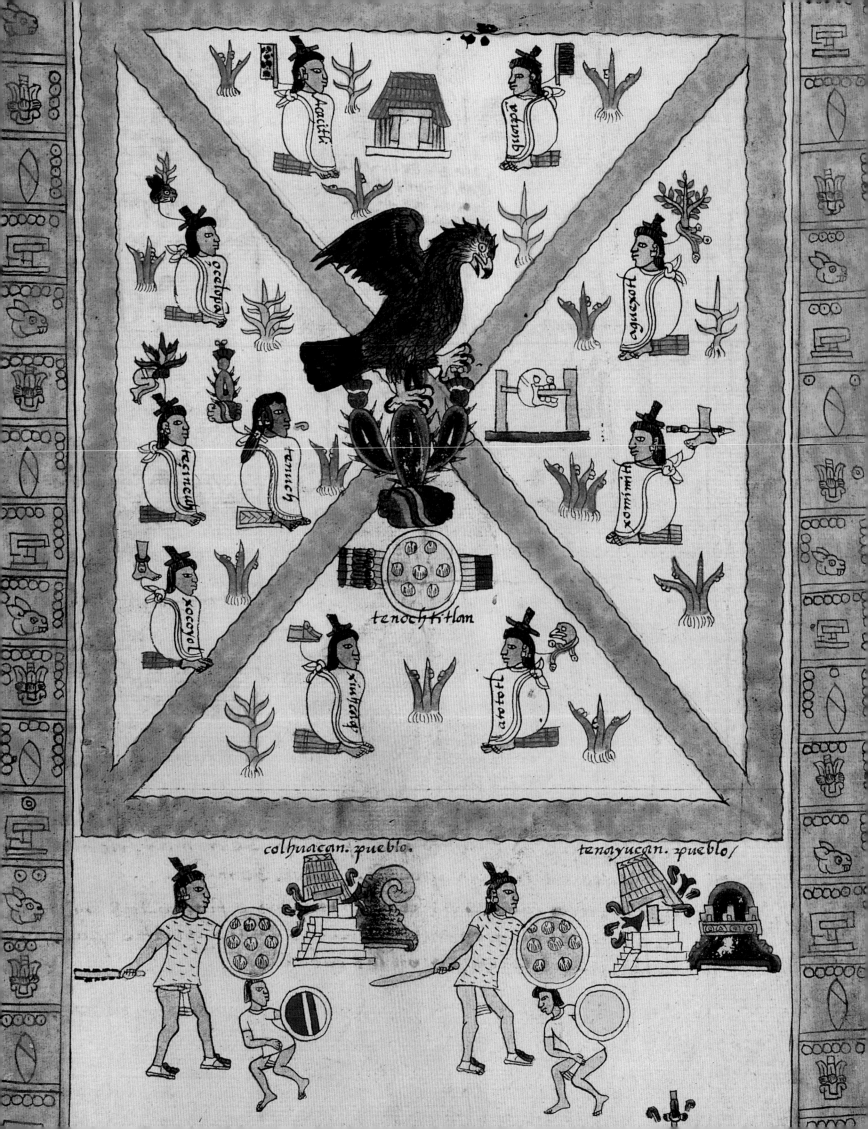

tenochtitlan

colhuacan. pueblo. tenayucan. pueblo

XI | CODICES

In European usage the word codex refers to a manuscript comprised of gatherings of paper sewn along the edge. In Mesoamerican studies this word has been applied since the nineteenth century to the wide variety of books and documents produced in the native tradition before and after the arrival of the Spanish. These codices bear the name either of the place in which they are currently kept, the persons who commissioned or produced them, or their place of provenance. Most examples here come from the predominantly Nahuatl-speaking area of central Mexico and date from Pre-Hispanic times (like the Codex Fejérváry-Mayer, cat. 341) to the end of the sixteenth century. The art of the native painter-scribe (*tlacuilo*, pl. *tlacuiloque*) was already ancient at the time of European contact. *Tlacuiloque* were men and women who, from a young age, demonstrated a natural talent for writing. The men were trained in special schools called *calmecac*, where they learned to write in iconic script, which they called *tlacuilloli*, 'to write-painting'. This complex system, sometimes called 'Aztec–Mixtec', combines pictographic, ideographic, phonetic and even mathematical elements and, like other Mesoamerican writing systems, is closely linked to the yearly and ritual calendars. Iconic script was read in Nahuatl, although it was understood by those who spoke other languages. As well as writing, *tlacuiloque* were instructed in other matters, such as religion, and therefore probably wrote as well as copied texts, although their work was largely anonymous.

It is likely that *tlacuiloque* specialised in different kinds of document. From extant examples and Spanish accounts we know that there were Pre-Hispanic manuscripts relating to land, law, history and tribute as well as dreams, religious feasts and prognostication. The material of which the manuscript was made and its format were closely linked to its content. For example, annals (*xiuhamatls*) and ritual books (*tonalamatls*) usually took the form of screenfolds made from strips of deerskin glued together, covered in a thin layer

of gesso and folded accordion-style. Screenfolds were painted on both sides with fine brushes and rich pigments and were generally read from right to left in meander form. Examples of ritual screenfolds include the Codex Féjérvary-Mayer and the Codex Cospi (cat. 340). Made from the bark of the fig tree, *amatl* paper, which is still produced in parts of Mexico, was used to make *tiras*, long scrolls or strips that record the migrations of different groups, an example of which survives in part of the Post-Conquest Codex Telleriano-Remensis (cat. 348). Single sheets of *amatl* paper were used to record administrative information and for making maps. The latter also took the form of large sheets of cotton called *lienzos*, such as the Lienzo of Quetzpalan (cat. 352) which, as well as marking out territory, also recorded genealogical information.

Painted manuscripts were an important part of Pre-Hispanic life and, although it is unlikely that everyone knew how to read and write, documents were produced in large numbers for use at every level of society. Only fifteen Pre-Hispanic examples remain. After the Conquest the Spanish destroyed many archives and hundreds of other documents, especially those of a ritual nature. Aware of their power, the Catholic Church burned many ritual books, as is shown in the *Descripción de la ciudad y provincia de Tlaxcala* (cat. 356). Friars such as Bernardino de Sahagún and Diego Durán, however, commissioned indigenous scribes and informants to copy these ancient texts in order to understand native customs. The resultant documents, the Florentine Codex (cat. 344) and the Codex Durán (cat. 343), were produced on European paper, in manuscript form and with Nahuatl and Spanish commentary. Many missionaries shared the same Pre-Hispanic sources and copied each other's manuscripts, resulting in cognate documents such as the Magliabechiano group. Apart from the Codex Magliabechiano (cat. 342), this group includes the Codex Tudela and is possibly related to the Codex Durán, the Tovar Codex (cat. 347) and even the Codex Mendoza (cat. 349). The Codex Ríos (cat. 346) is a copy of the Codex Telleriano-Remensis made in Italy by an non-Indian artist.

Other, more practical documents were tolerated and even actively encouraged by the Spanish. These included maps and tribute documents like the second part of the Codex Mendoza. With the establishment of the first viceroyalty under Antonio de Mendoza (1535–50) manuscript art flourished, especially at the Colegio de Santa Cruz de Tlatelolco, in Mexico City, which the viceroy helped to establish in 1536 for the instruction of the sons of indigenous nobles. The Spanish colonial authorities also commissioned indigenous scribes to produce reports of the land, peoples and customs of New Spain. An example of this interest in local life is the Cochineal Treatise (cat. 357), which describes the production process of this red dye. The viceroy was also responsible for ensuring justice in the colony, and to this end the courts of the Real Audiencia accepted documents produced in iconic script. This led to a proliferation of legal documents such as the Codex Tepotzotlan (cat. 350), the Codex Tepetlaoztoc (cat. 351) and the *Descripción de la ciudad y provincia de Tlaxcala*. Created by particular indigenous groups, they were aimed at the Spanish authorities, often against the abuses of the *encomenderos*, Spaniards entrusted with the Christian welfare of indigenous groups in return for labour and tribute.

Indigenous colonial documents often made use of European formats, alphabetic writing, imagery and style. On the whole, however, they continued to present information according to traditional conventions, adapting old elements and adopting new ones as necessary. The Codex Aubin (cat. 354), for example, continues to record history year by year in the traditional annals genre until 1608. The Codex Azcatitlan (cat. 355) includes a traditional dynastic chronicle similar to that in the first part of the Codex Mendoza. The skill and adaptability of the colonial *tlacuiloque* was such that they even invented new forms of pictorial writing, such as that found in the Testerian manuscripts used in the indoctrination of indigenous populations. These combine traditional pictorial forms with Christian imagery, as in the Doctrina Cristiana (cat. 358). The iconic script tradition continued until the late sixteenth century, when the absence of trained *tlacuiloque* meant that it was replaced by alphabetic script. Indigenous communities, however, kept some ancient documents and continued to record and maintain their traditions in other forms.

340 Codex Cospi

c. 1350–1500, Mixtec
Screenfold codex, deerskin, 17.4/18.2 × 364 cm; parchment cover, seventeenth century

Biblioteca Universitaria di Bologna, Ms 4093

OPENINGS ILLUSTRATED: pages 10, 12 and 13

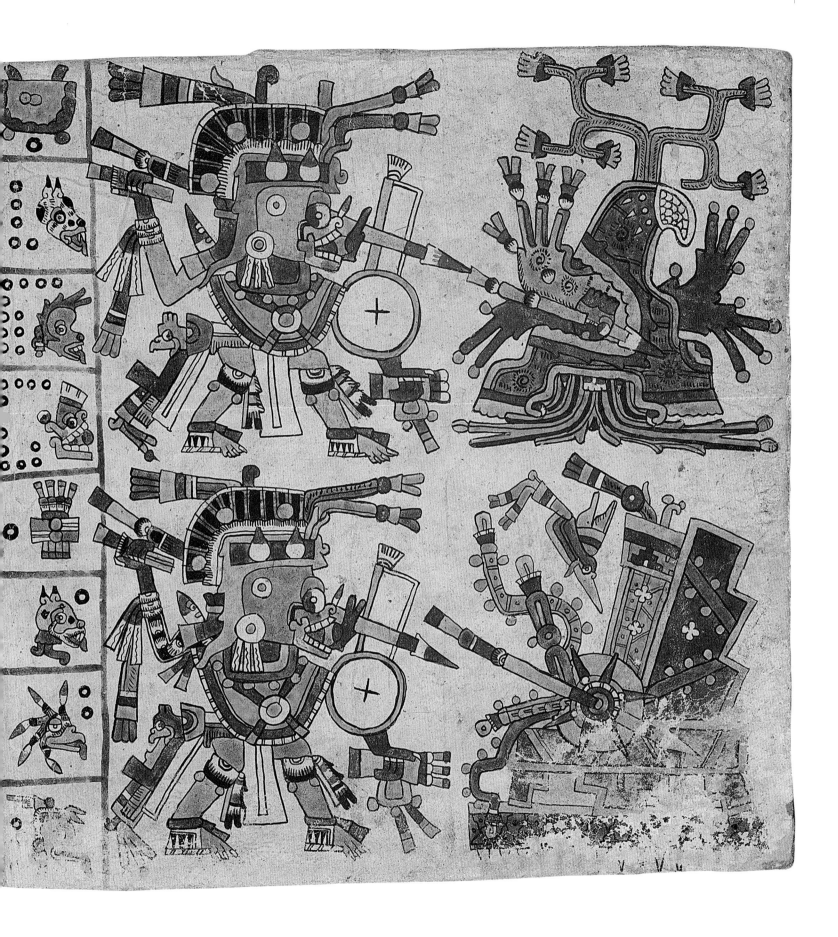

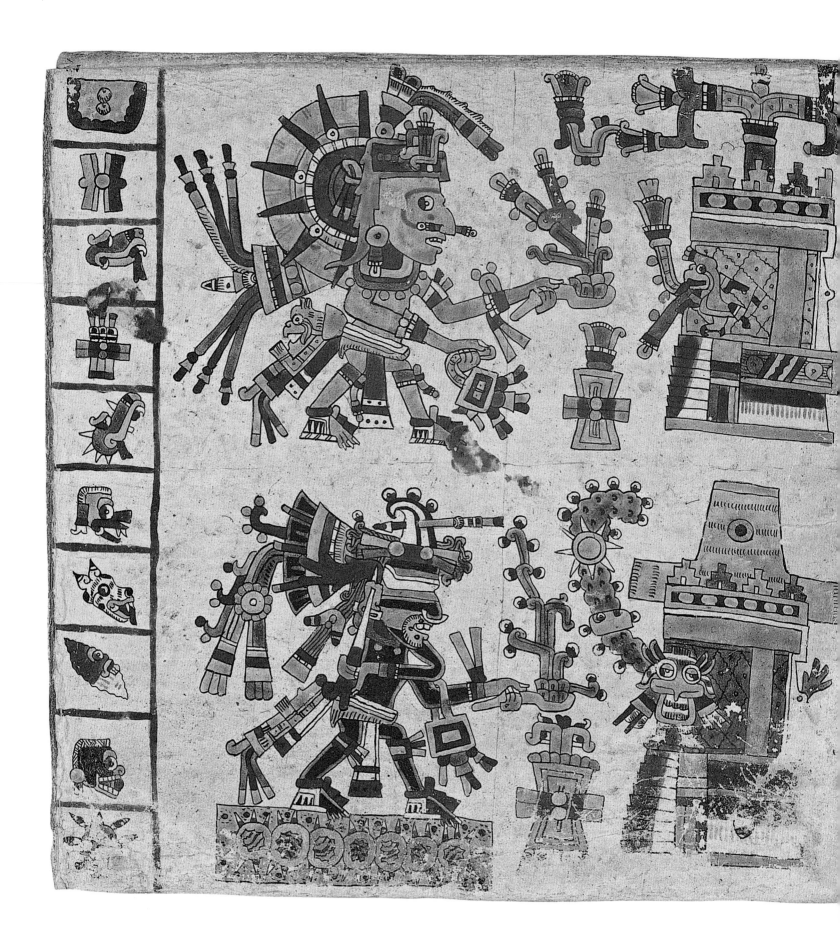

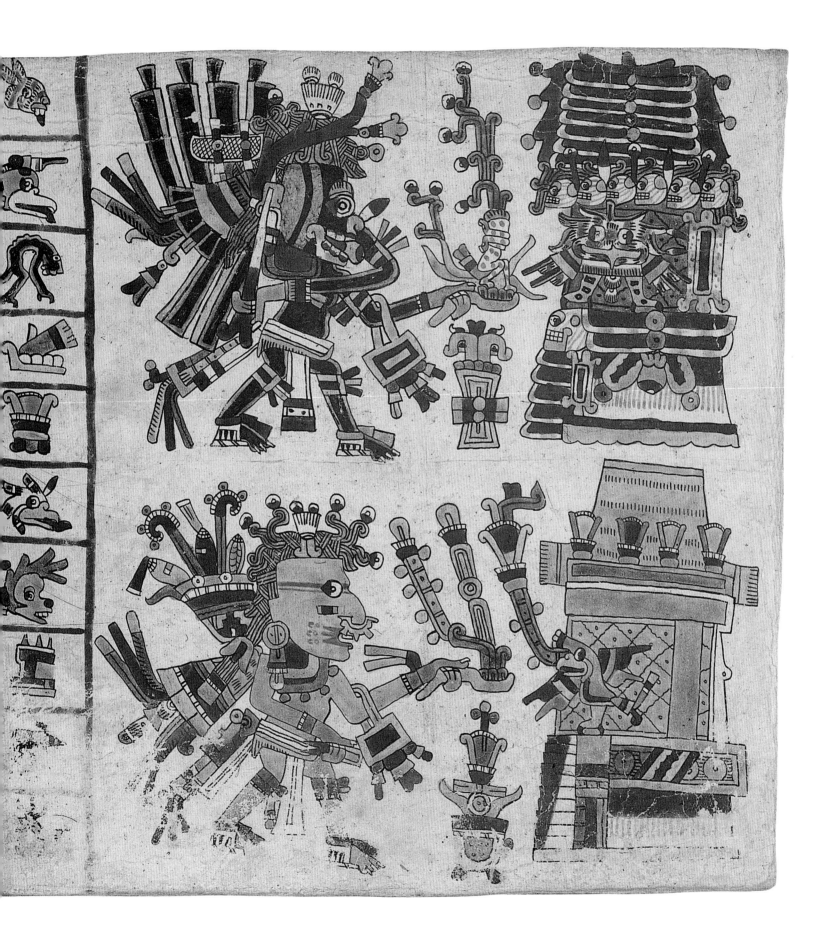

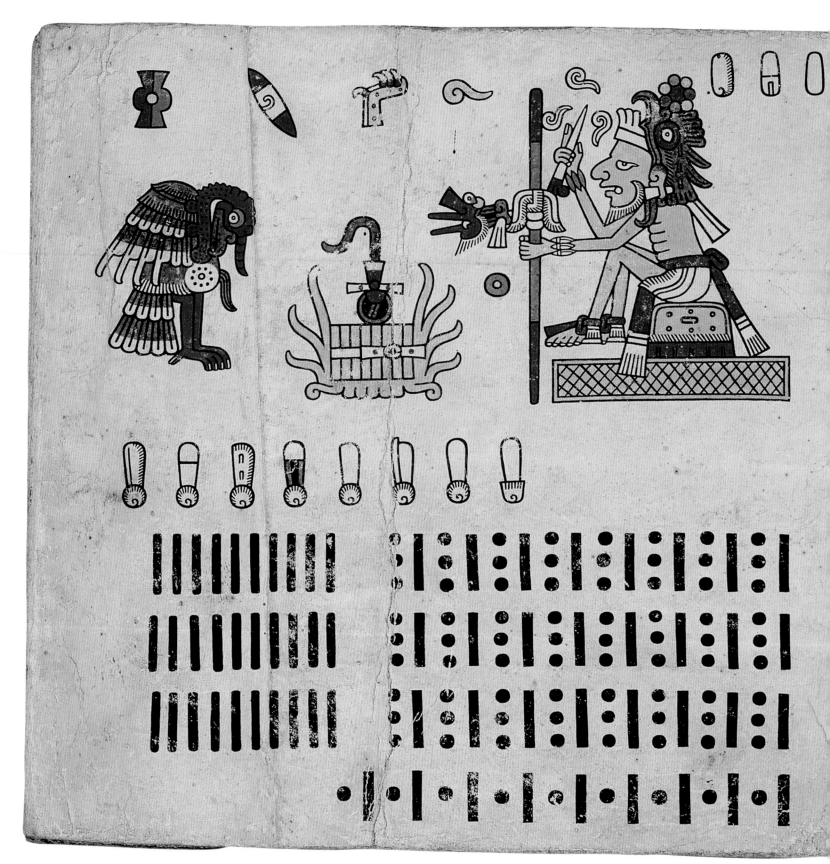

341 Codex Fejérváry-Mayer

Before 1521, Mixtec style with Aztec
and Gulf of Mexico influence
Screenfold codex, four strips of animal skin
glued together, covered with white lime (gesso)
and painted, 22 double-sided pages plus covers,
each page 17.5 × 17.5 cm, full length 403 cm

OPENING ILLUSTRATED:
pages 6–5

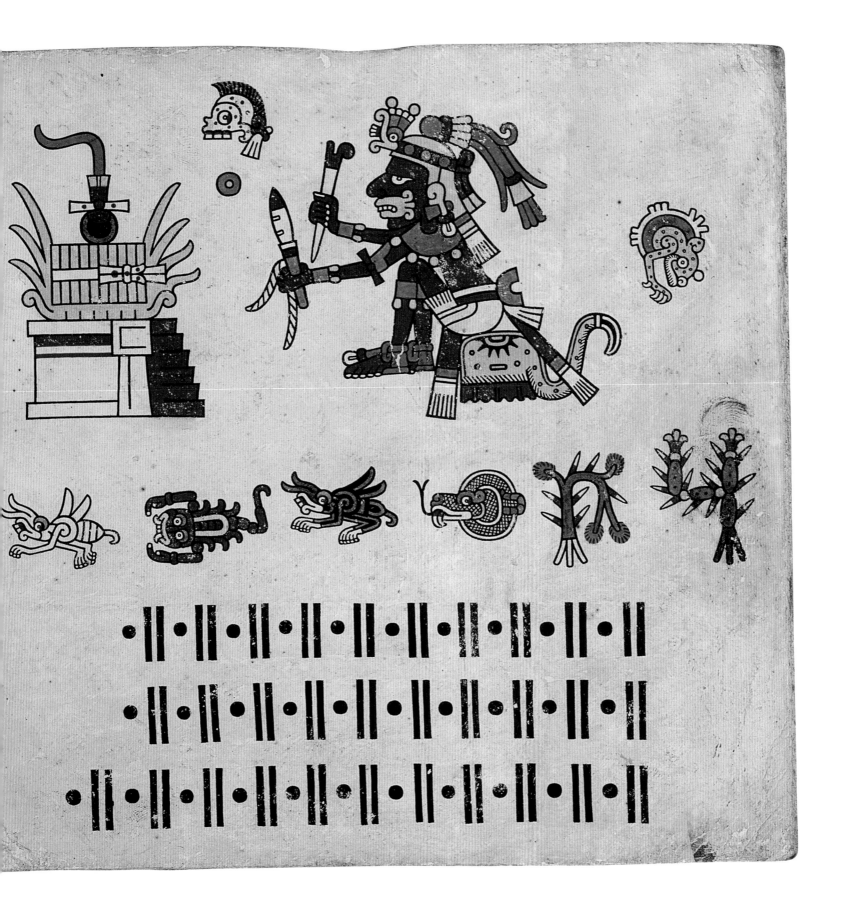

✝

¶ Este es vn diablo muy solemnizado ensus ritos / el qual siempre tenja gran sed por sã g[?]
vmana y agi cada y quan do q̃ se ofrecia tiempo v oportunj dad pa ser adorado no avia
de aver njn gun ỹm pedimen to / yase denotar q̃ Juntamente cõ ser comun atoda
las oras este sacrificio deste demonjo avia vna lei q̃njnguno avia de en trar ensu ten
plo sino sacrificaba vna escudilla desan gre vmana y Juntamente cõ esto abia delle
bar ensan grentada la mano derecha el q̃ lo yva asacrificar / yesto hazian porq̃ este di
les
blo fuese fabora ble al tpõ desu muerte en cuia me moria ponjan agus fres des te demonj
y enestan do ofrecida esta sangre ponjan vn escalera de rias del y subian porella y s
cra ma Vangela en cima dela cabeça en señal q̃recebia y ponja sobre su cabeça este sacr
ficio panoco olbidar al tpõ dela muerte deaquel q̃lo ofrecia // el tener la boca abierta ye
lengua sacada y en carnjçada sygnjfica Zamas dezur denos asacrificio q̃ les frecießen

342 Codex Magliabechiano

*Libro de la vida que los Yndios antiguamente
hazian y supersticiones y malos ritos que
tenian y guardavan*

Sixteenth century, colonial
Codex, 92 folios, European paper,
16.5 × 22.5 cm

Biblioteca Nazionale Centrale di Firenze,
Florence, BR 232 (Magl. XIII, 3)

OPENING ILLUSTRATED: folios 87v–88r

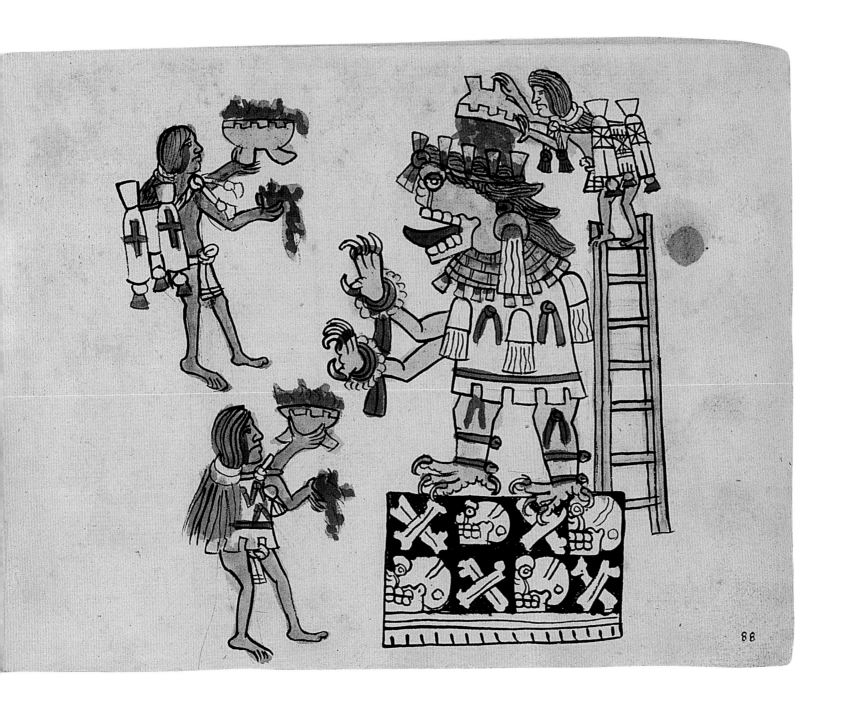

343 Codex Durán

Diego Durán, *Historia de las Indias de Nueva España e Islas de Tierra Firme*

1579–81
Codex, 344 folios, European paper, 28 × 19 cm; nineteenth-century leather binding

Biblioteca Nacional, Madrid, Vit. 26-11

OPENINGS ILLUSTRATED:
folios 91*v*–92*r*, detail of folio 208*v*

¶ Capitullo xxxj de cómo El rrey mõ
tecuma. se hizo. esculpir. en vna. peña. En
el cerro de Chapultepec y de su fin y mu
erte

¶ passadas los tres años de la Sanbre y beni
dos. Lus Años abundosos. sintiendose El
Tley montecuma y a. muy biejo y quesus
dias. Seran. pocos. descoso de dexar su
memoria y figura para. sienpre. mando
llamar. a Tlacaelel. su Sermano quien
menus Sijo qual. Sera y dixole. Sermano
ya beis que los trabajos y aflixiones.
con que asta. el Dia de oy. Semos susten
tado esta. republica y como Semos ensan
çado. y engrandecido. la nación mexica
na benciendo muchas. guerras. Justo. sera
que de memoria. de bos y de mi. para lo
qual. tengo determinado. de que se labre
dos. estatuas. Vna. mia y otra buestra
dentro. En el cercado de chapultepec

y que. alli en la peña. que mejor pareciere. al
cantews. que de mos. esculpidos. para po
tua memoria. en premio. de nuestros tra
Jos. para que biendo. alli nra figura se
ceden. nros Sijos y nietos. de nuestros gra
des Señores. y se esfuerçen. a Seymitarnos
ca el El rrey pon dio. al rrey que le pare
muy bien. el. acuerdo. que Sabia tomar
y que el. tomaua A su cargo El mandalo
Sacer. pues su gran balor. Sera digno
semejante. memoria. y luego. mando llar
todos. los maestros. entalla dores y can
que Studae. las prouincias se pudieron a
para. que muy al bibo. esculpiesen la fi
del rrey y suya. a los quales dixo. des t
manera. El gran Tley montecuma mi
mano bien dos eya bieja. y que sus dias
mios. son. y aquesto. quiere. y es su bolun
para que de. ambos que de memoria. que co
pays. nros. retratos. en las mejores vi
as que En chapultepec se allaren y que
to no aya. Que remimiento sino quel

92

se ponga por obra y juntamente señaleys
el año de çetos/este rey donde enpeço la hi-
storia passada y luego y buscad la piedra
que mejor os pareçiere para el efeto y rres-
pondieron los chantres que les plaçia de lo
tal conçluio hazer y que se les manda-
ba diçiendo que aquel sera su ofiçio y lo
que esperauan que les çessauan las ma-
nos y con ello y salidos de su presençia fueron-
se sin ninguna dilaçion al çerçado de cha-
pultepeç y vista la piedra ser muy apropia-
da para el efeto enpeçaron la alabear y
a esculpir en ella la figura de los dos herma-
nos las quales esculpieron muy al propio
y con tanta presteza que cassi no fue sentido
cauadas las figuras y fueron al rey a da-
lle notiçia de como las figuras seran aca-
badas diçiendole de esta manera poderoso se-
ñor aestos tus siervos y bassallos les fue
mandado que esculpir tu rreal figura y la de
tu hermano tlacaellel las quales estan ya
estan hechas y acauadas con toda la per-
feçion que hemos podido aunque no confor-
me al mereçimiento si fueres seruido de lo
yr a uer podras todas las veçes que quisie-
res el rey se espanto de la breuedad con
que se auia hecho vna obra que assi pa-
reçer se le haçia dificultossa y agradeçiendo-
selo los mando bestir y dar algunas pre-
seas de honrra en pago de su trabajo y soli-
çitud y les dio ditados de honrra como entre
ellos hasta el dia de oy duran y tlacaellel di-
xo al rey señor vros bassallos han hecho lo
que les mandaste justo sera que bamos a uer
nuestras estatuas la hechura que tienen
y vna mañana sin ser bistos de nadie y sin

Ninguna Conpañia salieron dela çiudad
y fueron al çerçado de chapultepeç y des-
pues de consideradas las estatuas y hallaron que
estauan muy al propio assi en el adereço
como en el modo de sus personas y assi dixo
el rey a su hermano tlacaellel contentado me
han estas figuras las quales seran me-
moria perpetua de nuestra grandeça como tene-
mos memoria de que tzicoalcoatl y de topil-
tzin de los quales esta escrito que quan-
do se fueron dexaron esculpidas sus figu-
ras en palos y en piedras en quien ado-
ran la gente comun y si sauemos que se-
ran hombres como nosotros lleuemos
nosotros esta gloria por delante
y bueltos a la çiudad estando los dos
hermanos juntos sin ser bistos de nadie
dixo el rey hermano yo quiero hazer vn
conçierto contigo y es que pues ambos
a dos hemos gobernado y sustentado es-
ta naçion mexicana y la hemos engran-
deçido que es yo muriere primero que tu
que te quede por rey de la tierra pues te
fue hecho tan antiguo lo mereçes y que
ningun hijo mio ni hermano ni deudo çer-
cano lo pueda pretender pues lo tienes
tan mereçido y si tu murieres prime-
ro que yo lo sere vno de tus hijos
el que tu señalares y quel se siente en
la silla y trono de nuestros antepasa-
dos el rey acamapichi vitzilouitl chi-
malpopoca y zerate reyes y señores
de este mundo tan grande de cuya
memoria los quales con no menos tra-
bajos fundaron esta çiudad y la en-
noblecieron derramando su sangre en

344 Florentine Codex
Bernardino de Sahagún,
*Historia general de las cosas
de Nueva España*

1575–77, colonial
3 vols, 353, 375 and 495 folios,
paper, 31.8 × 21 cm;
contemporary Spanish binding

Biblioteca Medicea Laurenziana,
Florence, Mediceo Palatino 218–220

OPENINGS ILLUSTRATED:
vol. 1, folios 73v–74r,
vol. 2, folios 369v–370r

libro. 2 *de las cerimonjas.*

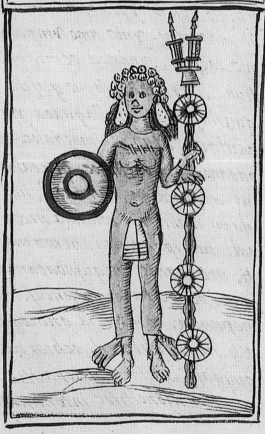

qujtoznequj, amo mictlan iau
yoan ipampa inqujtzoncaja, q
mopialtiaia ynitzon: ichica ca
oqujmomaceuj, in mavizcotl,
zuchitl ynietl, intilmatli: yn
amo can nenpoliuiz itiiacau
io: iuhqujnma ic contleiocuj.
aia malli. Auh intlamanj vr
pa muchichioa inteeanma,
nochtitla, iztac totolihujtl, yn
mopotonja, injuh omoteneul
ipan quaujtleoa. Auh invnca
momanaia tototecti, tecpanti ma
vipantimanj ticapan, anoco ca
pan: ipampa caticatl antoca inv
can momanaia. Auh incana al
petl ipan, cacatl motzetzeloa, yn
pan qujnoalmana, qujnoalquetz
qujnoalteittitia: Haixco qujnoalma
na inxipeme, ynonmaqujaia tla
coatl. Auh ynaqujque, mihi
vintia, iauhtauelilo que, mixtlapa
loanj, acan ixmauhque, iollott
paltique, iollochicaoaque, qui pop
anj ynjntia cauhio, moqujchnene
quj, qujmonpe peoaltia, qujmonth
he calhuja; oia iaopcoa, qujmoia
iaopeoaltia. Auh inic vel qujnth
uelcujtiaia, ynic vel qujmolimp
ja, ynic vel intlauel, inqualan
qujcuja, qujmonxiccuja, qujm
xiccuj, qujmonxiccotona: ic nj
man in xipeme tlapaynaltiaia
ymjcampa inteputzco icatiuh co

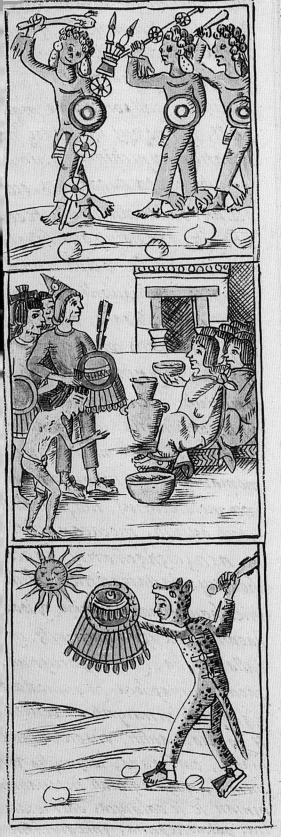

totec, itoca iooallaoan, quyntoca quyntlaiehecalhujtiuh, in muchintin tototecti: ic njman intech ietiquiça, quyntlalochtoca, quiniaochiuhtiuj, quyma aciti uj, quyn mamacuytiuj, iuhqn incoztitech ietiuj, intecaloanj: auh oalmocueptiuj, oalmomala cachotiuj, ocoquauhtica quin oallaheecalhuytiuj. Auh intla ceme anoia, intecaloanj, quyn ujujtequj inxipeme, inchicaoaztica quyixixilia, vel quyncocoltia. Auh iopico conujcaia, amo can nen oalquyçaia, amocan nen caoaloia, itla ic moquyxtiaia, itla iconanoia, aço totoli, aço quachtli quytemacaia. εtcͣ Ynoiuh mito ipan itlatollo xippe, çanie noiuh mochioaia: çatepan, inonte totocaque, ynonteauj celtique, ynontlapactique toto tecti, xipeme: njman ic peoa intlaoaoano, tecpantimanj in mamalti, quyn nanamjctima ni, quyujujcatimanj intlamanj: njman no oalquyça intlaoaoan que, yiacatiujtz, geyiacatiti uitz, inteiacantiujtz ocelutl ipan quiztiujtz, conjttitia, conj aujlia ynichimal, ynimaqua

74

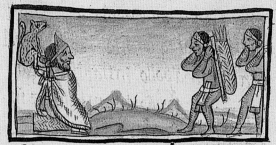

Capitulo veinte, de los instrumentos, con que labran los officiales de la pluma,

En esta letra, se ponen todos los instrumentos, que vsauan estos officiales, de la pluma: y tambien agora los vsan; do de quijera, que estan: por eßo no se declara, en la Lengua española: quien quijsiere ver los, y saber sus nombres, delos mesmos officiales, lo podra saber, y verlos conjus ojos.

tomecahoan mochiuhque puch teca, inic iancuican qui pettaqua anaoaca tlalli, icoac quinnoiuian quinestique quiiocusque quinene milique.

¶ Inic cempoalli capitulo: itechpa tlatoa inic tlachichi oa iniehoantin amanteca intlachichiuhque inqui chioa ihuitl inic tlachi chihoa

¶ Inisquich intlachichioa ia: intepuzuictli, tepuztlateco mi, inic motequi ihuitl, ioan ino mihuictli inicmocaloa, ioan in tlacuiloloni, intlapalcaxitl inic quicuiloa, quitlilania inin machi ouh, ioan inquauhtlatecoini ini pan motequi ihuitl quinamicti que intepuztli tlaquaoac qua uitl intlatlauhqui. Auh inie quine uelueis tultecaiotl: inih uitlacuilolli iemochioa, quinipã immotecuçoma: ipampa inicauc tlatocatia, icuel ipan totocac, inic oallacia quetzalli; ioan inie

mochi tlaço ihuitl vel ipan tlapiuis:
icnonqua quintecac, quincalten cen
tetl calli quinmacac iniscoian iiamã
tecahoan catca imtech pouia: nepanis
toca in tenochtitlan amanteca ioan
in tlatilulco amanteca. Auh miehoan
tinzi, çanquiscahuiaia mquichioaia
itlatqui vitzilobuchtli inquitoca
iotiaia teuquemitl, quetzalquemitl
initzitzilquemitl, xiuhtotoquemitl,
ic tlatlacuiлolli, ic tlatlatla machilli
in iemochi inizquican icac tlaçoih-
uitl. yoan quichioaia iniscoian
itlatqui motecuçoma: inquinmaca-
ia, inquin tlauhtiaia icoahoan in
altepetl ipan tlatoque, icmonotzaia
motenehoaia tecpan amanteca
itul tecahoan in tlacatl. Auh in ce
quintin, motenehoaia calpiscan
amanteca, itechpouia inizquitetl
icaca icalpiscacal motecuçoma:
iehoatl quichioaia, intlein imaceh
çallatqui motecuçoma inipan ma
cehoaja, mitotiaia: inicoac ilhuitl
quiçaia, quitlatlattitia, quitlane
nectiaia, mçaço catlehoatl queleuiz
inipan mitotiz: caceentlamantli
iecauia, ce鸡entlamantli quichioaia

345 Historia Tolteca-Chichimeca

1550–70, Cuauhtinchan, Puebla
Codex, 50 folios, European paper, 31.5 × 22.5 cm; modern parchment binding

Bibliothèque Nationale de France, Paris, MS Mexicain 46–58

OPENING ILLUSTRATED: folios 15r and 16r

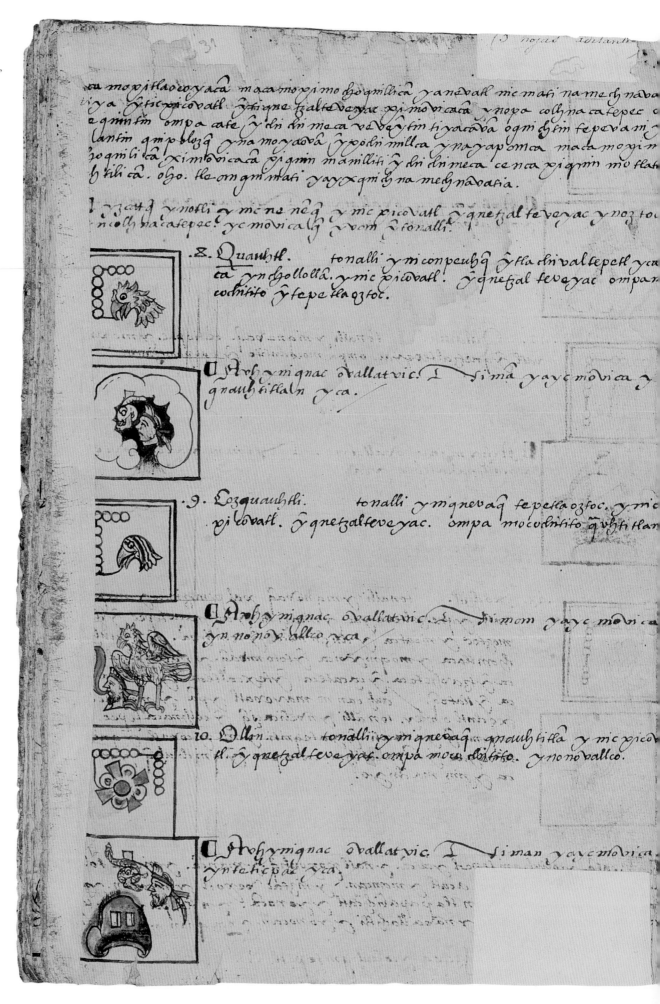

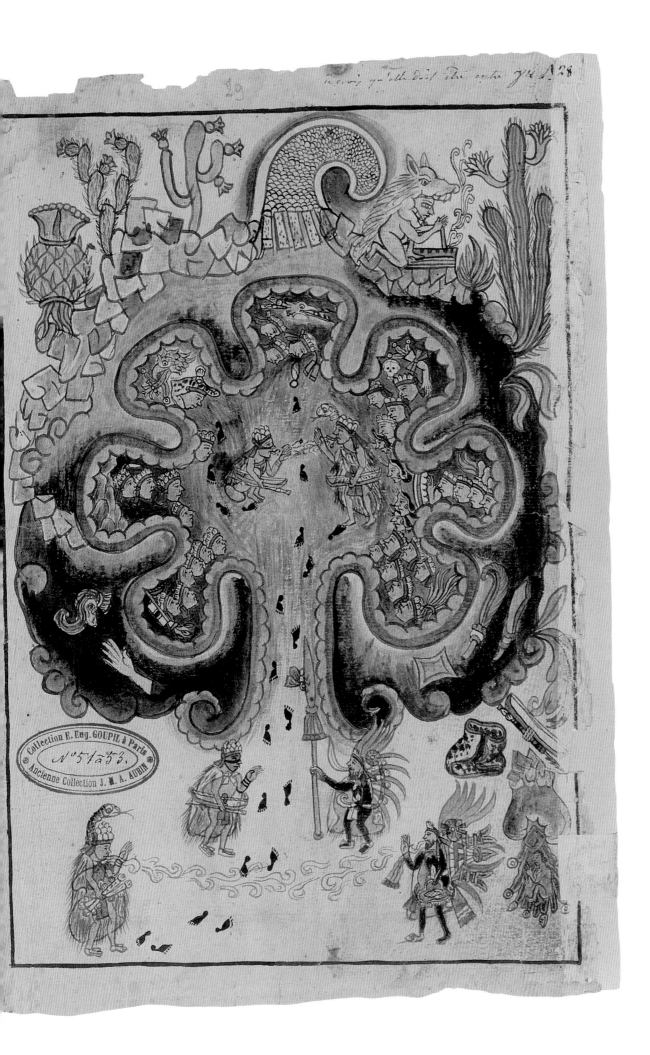

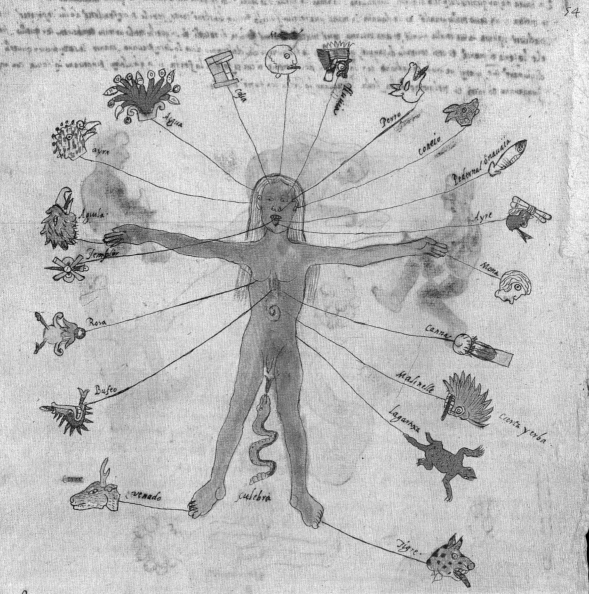

Queste sono le xx sterre ò figure le quali eglino usauano, per suer i lor numeri. le quali dicono che teniano dominio soura gli huomini, come qui si rappresenta: et di questo modo lor medicauano, qn alcuni s'ammalaua: o ueramente le dolia qualche parte del corpo. Buseo soura il fegado. Rosa nelle mamelle, temblor, nella lingua, Aguila nel braccio destro, Ayra nell'uchio destro, coneio, nell'uchio sinistro Pedernal nè denti, ayre' nel fiato, Mona nel braccio sinistro, cane nel cuore, Malinalle nelle bodellia, Lagartixa nella madrice delle donne, Tigre nel pie sinistro, culebra nel membro uirile dell'huomo come cosa dalla quale è uenuta l'origine del suo male: en questo modo tengono eghino la culebra, da qual si uoglia parte ch'ella uenga per il maggior augurio di tutti ghastri. et così ancora i medicij usauano questa figura gn curauano et secondo il giorno et l'hora nella quale alcuno s'informaua, così uedeuano se l'infermità era conforme con il segno che regnaua: et alla qual cosa si conosce c'è questa gente non era così bestiale, come alcuni la faceuano, poiche' teniano tanti conti et ordine' nelle cose loro, et usauano il medesimo mezo c'è usano ghi astrologi, et i medici fra noi altri, c'è ancora si tiene questa figura, et così si trouerà nè reserpcij

346 Codex Ríos ('Codex
Vaticanus Latinus A',
'Codex Vaticanus
3738')

c. 1570–95, Rome
95 folios, European paper,
approx. 46.5 × 29.5 cm
each; red leather binding
(replacing original black
leather), 1869–89

Biblioteca Apostolica Vaticana,
Vatican City, A3738

OPENING ILLUSTRATED: folio 54r

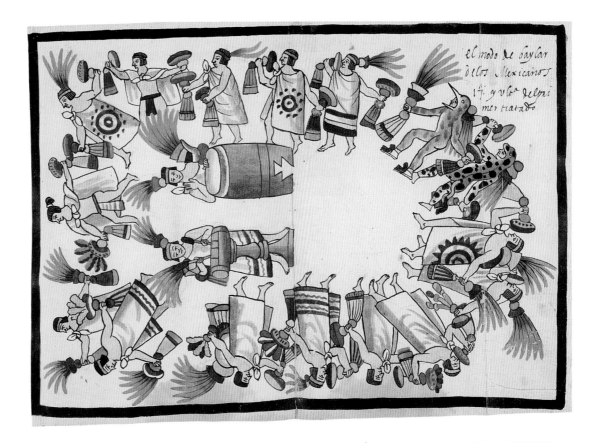

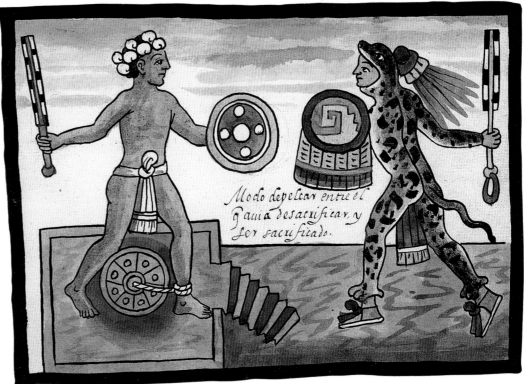

347 Juan de Tovar, *Relación del origen de
los Yndios que havitan en esta Nueva
España según sus historias*

1583–87, colonial
Ink and watercolour on European
paper, 21.2 × 15.6 cm

The John Carter Brown Library at Brown
University, Providence, Rhode Island

OPENINGS ILLUSTRATED: folios 119 and 134

348 Codex Telleriano-
Remensis

1555–61, Tlatelolco
50 folios, European
paper, 31.3 × 22 cm;
modern
parchment binding

Bibliothèque Nationale
de France, Paris,
MS Mexicain 385

OPENINGS ILLUSTRATED:
folios 40v–41r

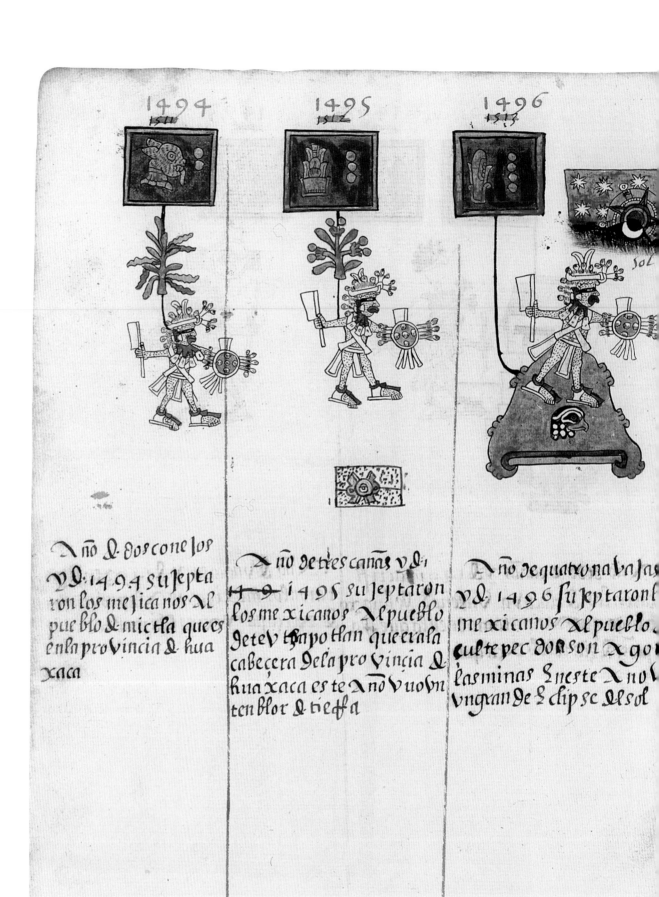

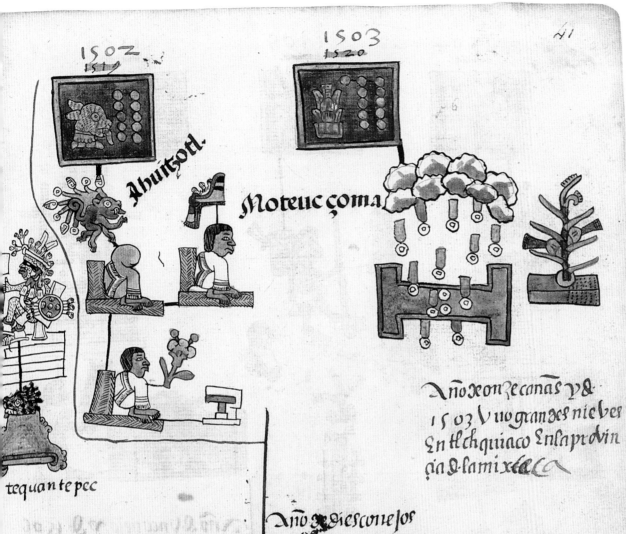

1502
1519

1503
1520

41

Ahuitzotl.

Moteuc çoma

tequan te pec

Año xon Re cañas y d̄
1503 vuo grandes nie ves
En tlchquiaco Enla provin
çia d̄ la mixteca

Esta hi ja d̄ monteçuma d̄spues
que tuvo hi jos d̄el señor d̄ ete
quan te pec Aviso A su mari do
que su padre no se la Avia dado
sino para tener Amistad con el
y tener lugar pa entrar Enla ti
erra y su jeptarlos lo qual como
los upo pro veyo que no len tro mas
me xicano Ensu tierra has que vi
nieron los cristianos que la su jey
taron

Año d̄ dies con ejos
y d̄ mill quinientos
y dos. murio A hui
tzol y eli jeron por
señor A montecu
ma El que hallo el
marques quando vi
no A la tierra

349 Codex Mendoza

c. 1541, Aztec

71 folios, European paper,
30–31.5 × 21–21.5 cm;
seventeenth-century binding

Bodleian Library, University of Oxford,
Ms Arch. Selden A.1

OPENING ILLUSTRATED: folios 24*v*–25*r*

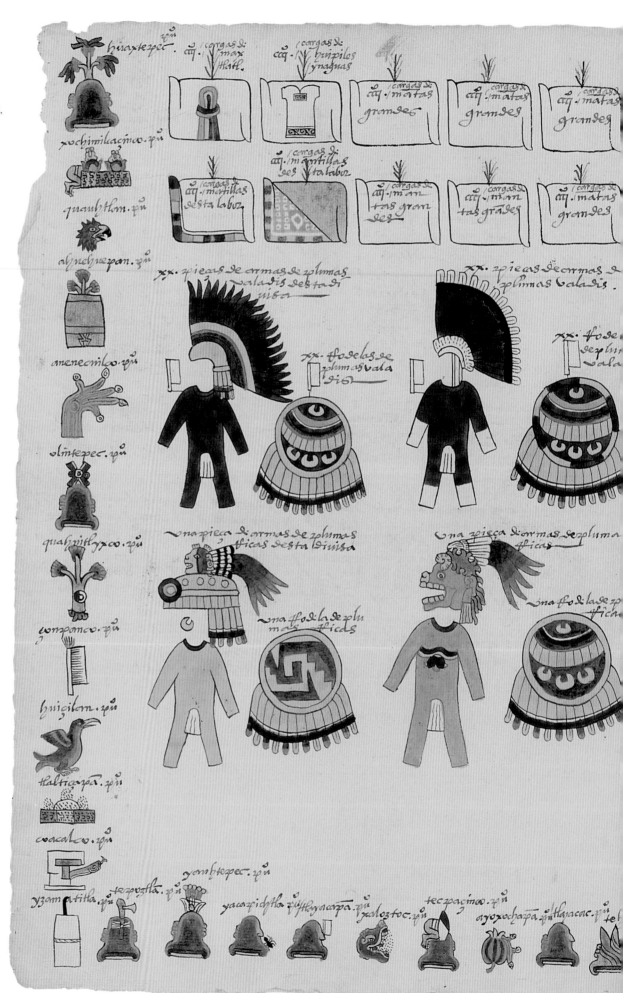

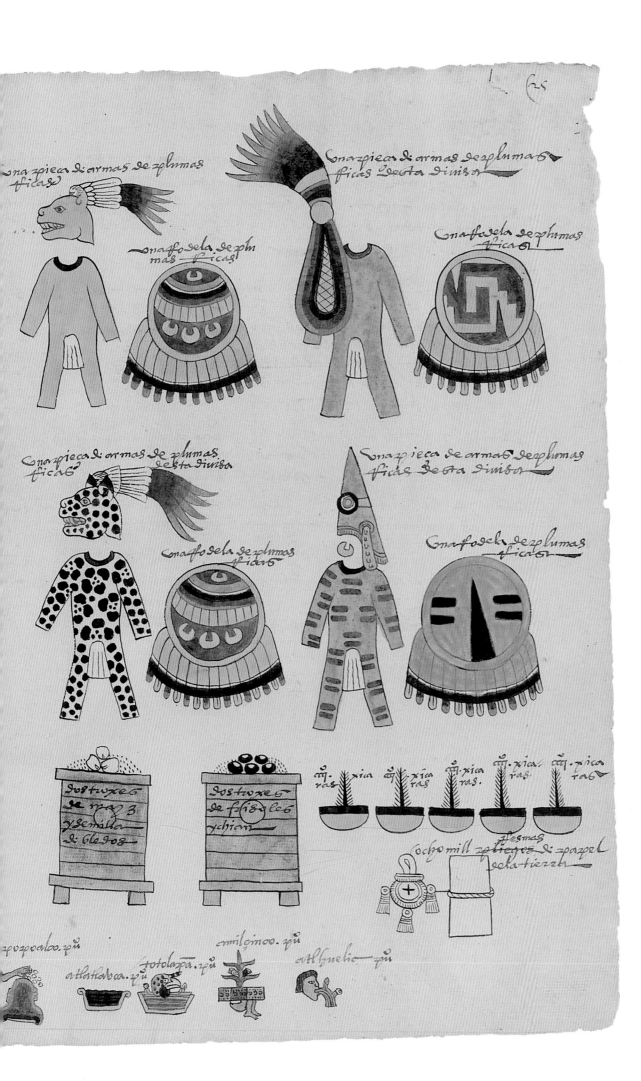

350 Codex Tepotzotlan

c. 1555–56, Tepotzotlan
Amatl paper, 40 × 110 cm

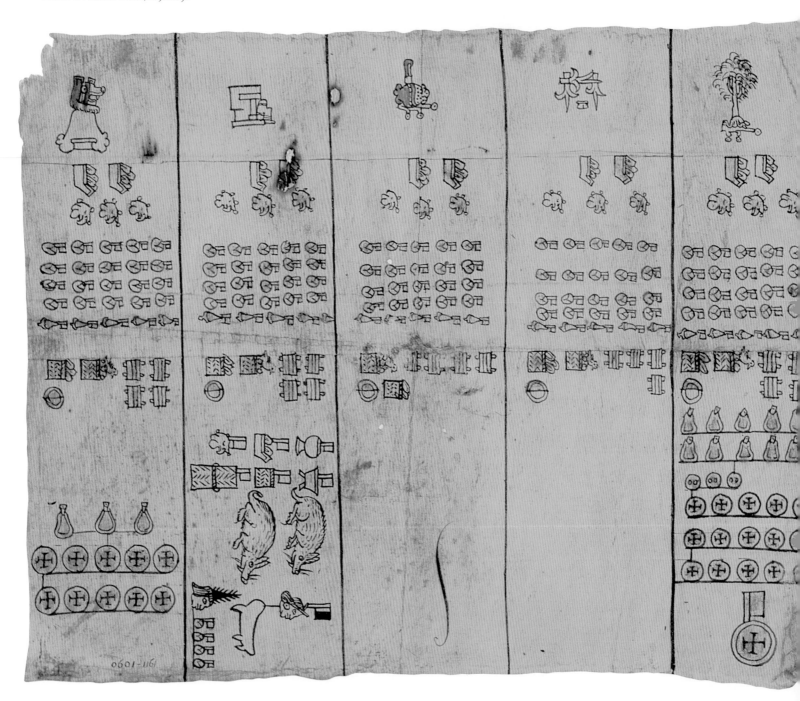

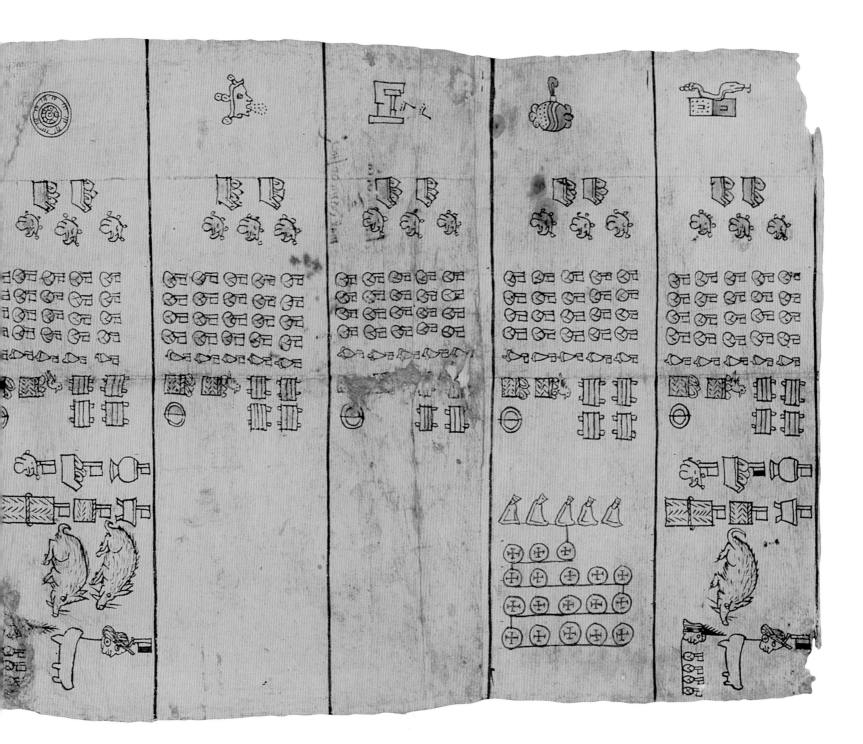

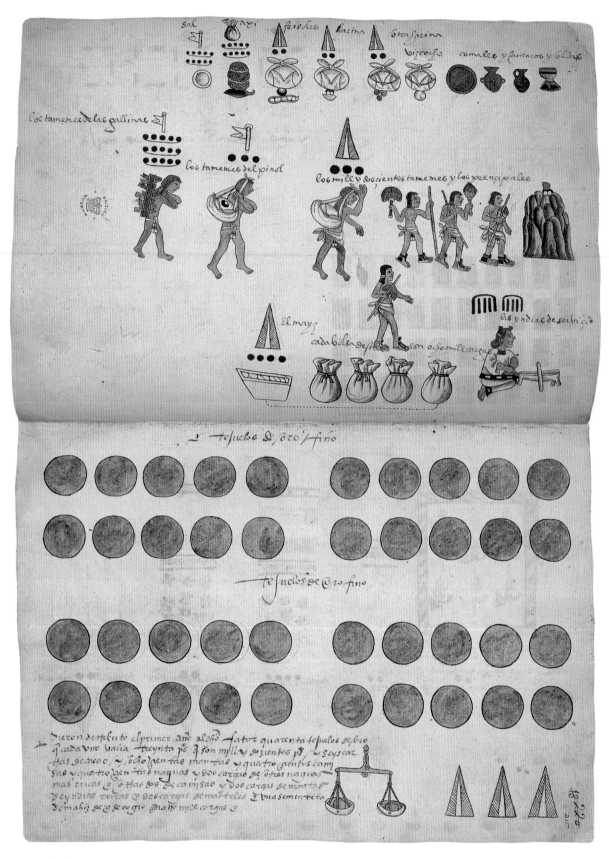

352 Lienzo of Quetzpalan

Second half of sixteenth century, colonial
Paint on fabric,
154 × 183 cm

Colección Fundación Televisa,
Mexico City, 403

351 Codex Tepetlaoztoc

c. 1555, colonial
72 folios, European paper,
29.8 × 21.5 cm; unbound

Trustees of the British Museum,
Add. Ms 43795 (part)

OPENING ILLUSTRATED: folios 214*v*–215*r*

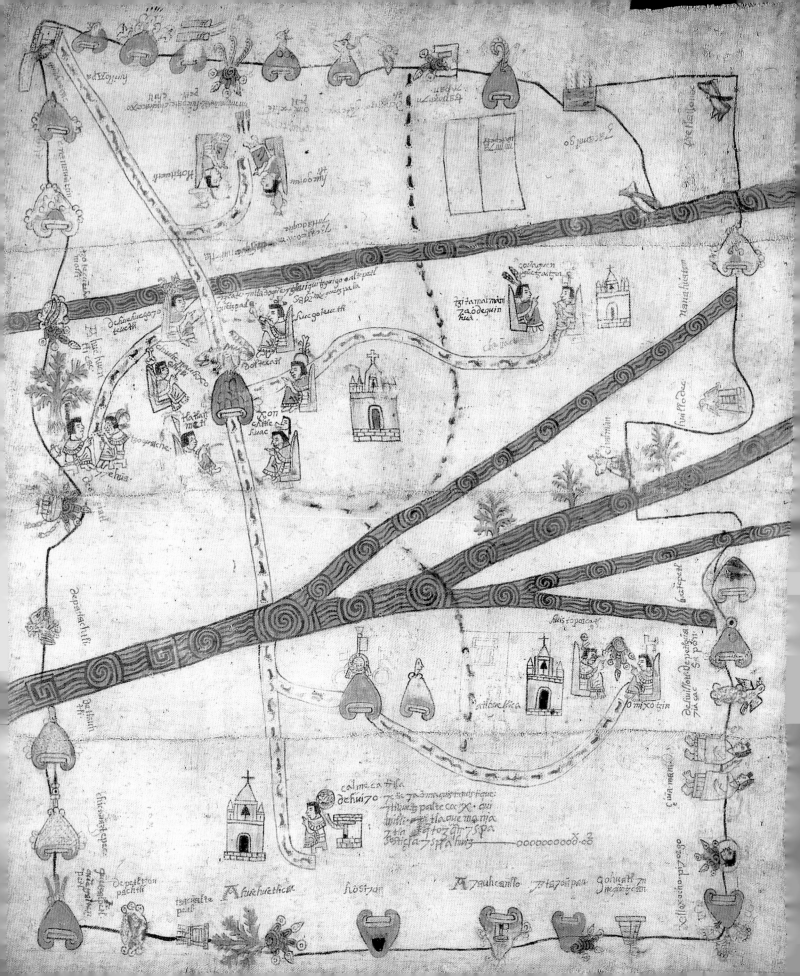

353 Digital representation
of the Map of Mexico City

Original: 1550s, Spanish
Ink and watercolour on
parchment (two sheets),
75 × 114 cm

Uppsala University Library

354 Codex Aubin

c. 1576–96, 1608, colonial
81 folios, European paper,
15 × 11 cm; red leather binding

OPENINGS ILLUSTRATED: main picture,
folios 58*v*–59*r*; bottom left, folios
25*v*–26*r*; bottom right, folios 41*v*–42*r*

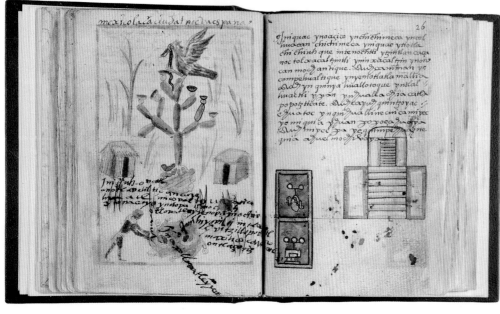

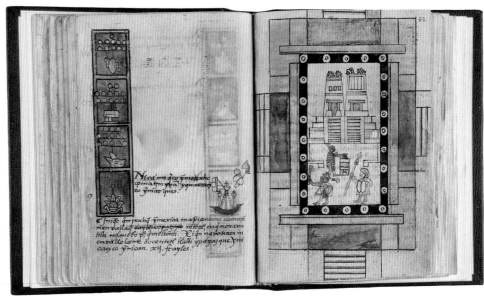

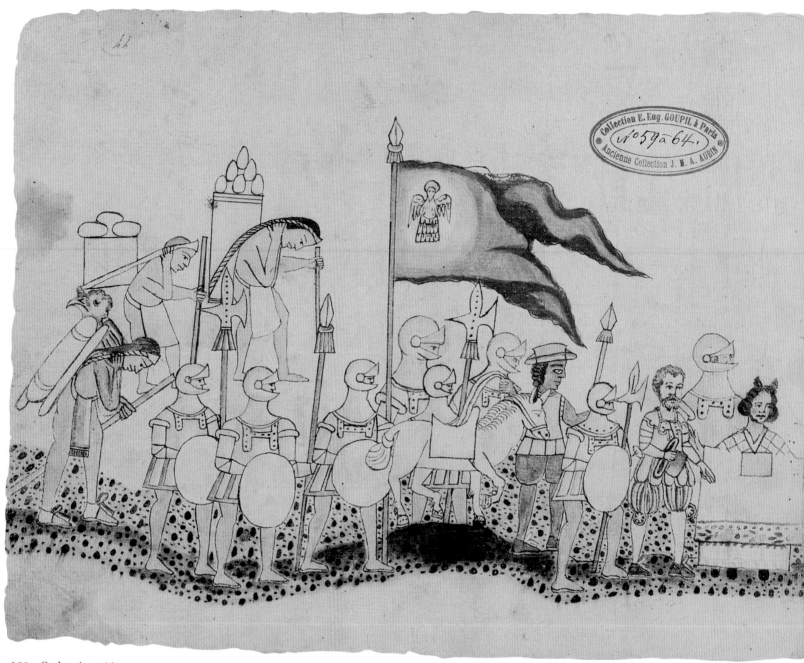

355 Codex Azcatitlan

Late sixteenth century, colonial
25 folios, European paper, 22.5 × 29.5 cm;
modern red demi-shagreen binding

Bibliothèque Nationale de France, Paris,
MS Mexicain 59-64

OPENING ILLUSTRATED: folios 22v–23r

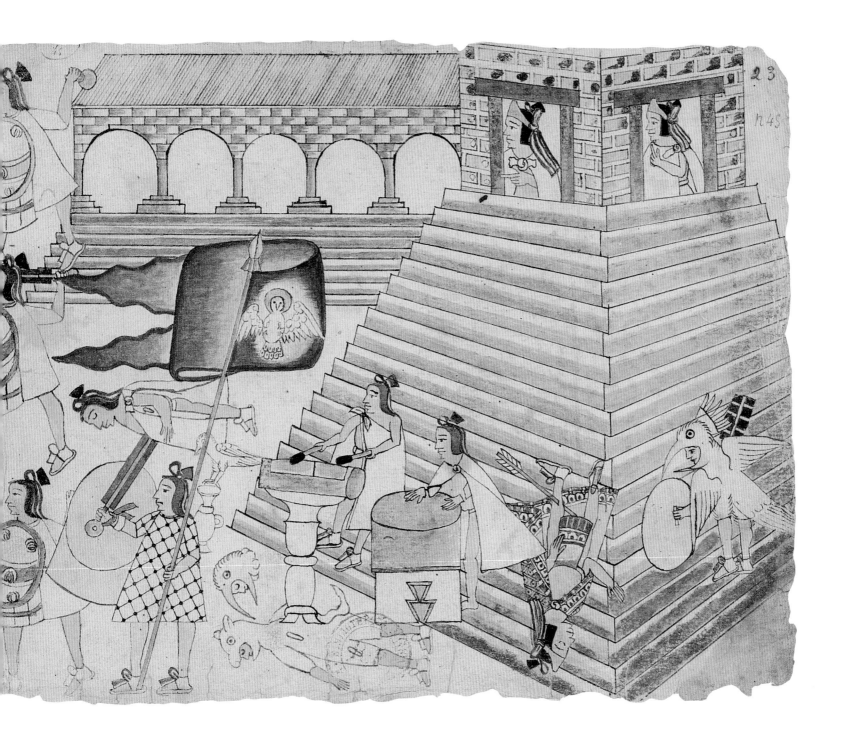

356 Diego Muñoz Camargo

Descripción de la ciudad y provincia de Tlaxcala de las Yndias y del Mar Océano para el buen gobierno y ennoblecimiento dellas
1581–84
Codex, 327 folios, European paper, 29 × 21 × 3.5 cm; original binding of limp vellum

Special Collections Department, Glasgow University Library, MS Hunter 242 (U.3.15)

OPENING ILLUSTRATED: folios 241v–242r

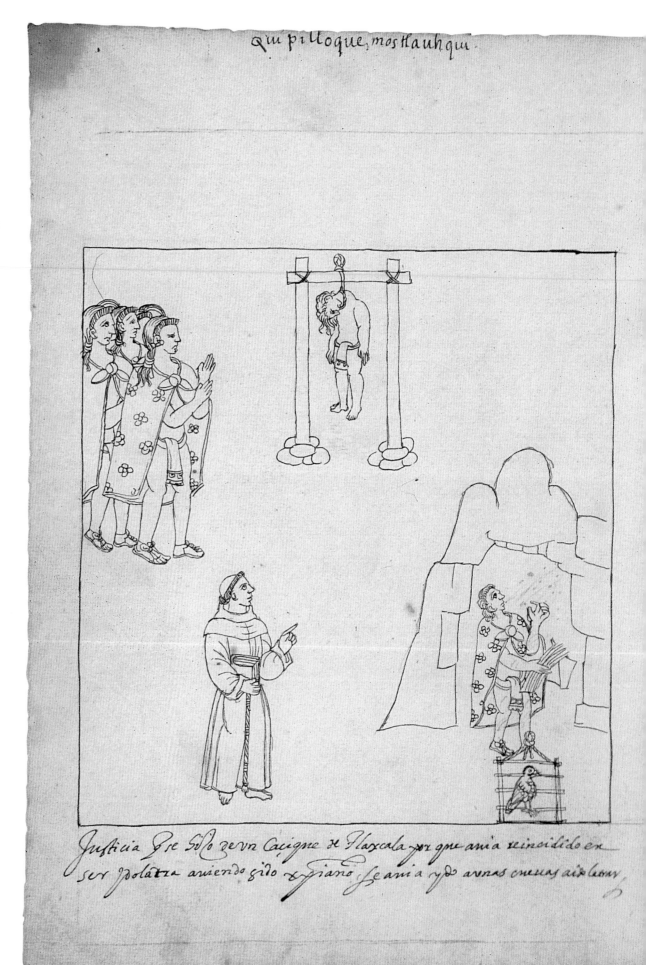

ymican. quin tlahtique. tlatlaca tecollo teopisque.

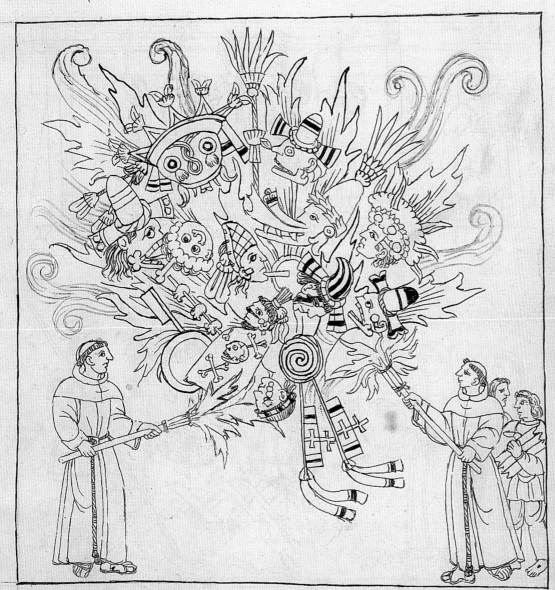

Incendio de todas las ropas y libros y atavios de los sacerdotes ydolatricos
que se los quemaron los frayles.

357 Cochineal Treatise

c. 1599, colonial
4 folios, European paper,
29.8 × 21.5 cm, unbound

LEFT: Scene 3, *'Estas son nuevas plantas puestas de las que seccan ha podaron han se de poner por diciembre y enero para que con la primavera se lo nescan'* and scene 4, *'Aqui se pone la cochinilla en las nuevas plantas passados seis meses y más que se plantaron la semilla se pone por marzo y abril a los árboles viejos que a los nuevos, es bien no poner se la hasta que tengan más edad de seis meses o un año'*

RIGHT: *'Relacion de la Plata Reales Oro Joias que se a llevado a su magestad desta Nueva España a los Reinos d. Castilla desde el año de mil quinientos y vein y dos que fue recien descubierta y ganada esta tierra hasta el año presente de mil quiniëtos y noventa y nueve ques quando este memorial se haze &'*

Relacion dela

Plata Reales oro Ioias que se alleuado a su
magestad desta nueua españa a los Reinos d
Castilla desde el año de mil y quinientos y vein
y dos que fue rreci en descubierta y ganada es
ta tierra hasta el año presente de mil y quinie
tos y nouenta y nueue ques quando este me

morial se haze &

	AÑOS	TESORO
Gouernando Hernando Cortes EMBIO	IUDXXII Años	LijUDCC.IX.Pś.iiij Tś.IX.Gr.
	IUDXXiii.ANOS	No se lleuo nada.
	IUDXXiiii.años	xcixUcc.Lxiiii Pś.v.Tȯ.viij.Gr.
	IUDXXV.años	xxxUDCCIxxx vi.Pś.
	ORO EN OJA	—UDCCCxxxviii Pś.II.Tś.
	ORO EN IOIAS	—UD xc.ii.Pś.
	ORO SIN LEY	—Uc xL.v.Pś.iiTś.
Gouernando Alonso de estrada emvio.	IUDXXVI Años Oro sin Ley.	xxUccc Lxxx vii Pś.iTś.I.Gr. v.UD.xLii Pś.
	IUD.XXVII.	xlviiUD—v.Pś.viTś.vii Gr
	oro Sin LEY.	xviU—xLix Pś.iiiiTś.
	Oro en Ioyas	—Uccc xxx.Pś.
Gouernan dola Real Audiencia	IUDXXVIII. Oro sin Ley	xxxiiiiU—xv Pś.iiiTś.vj Gr. xviUD.Lviii.Pś.

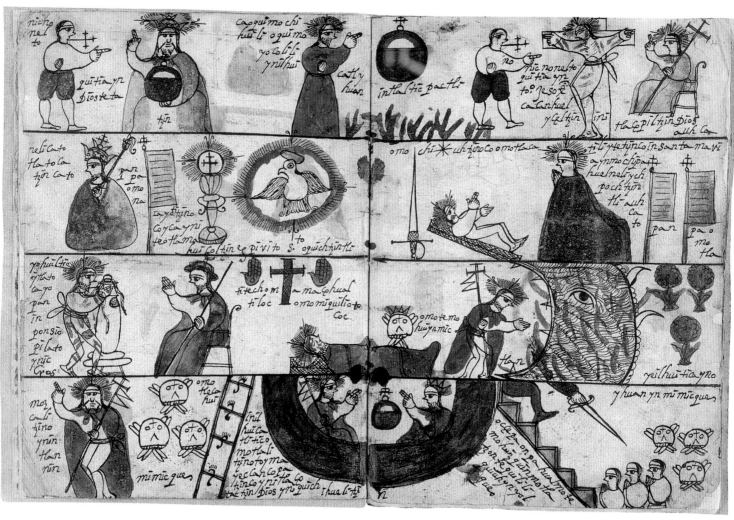

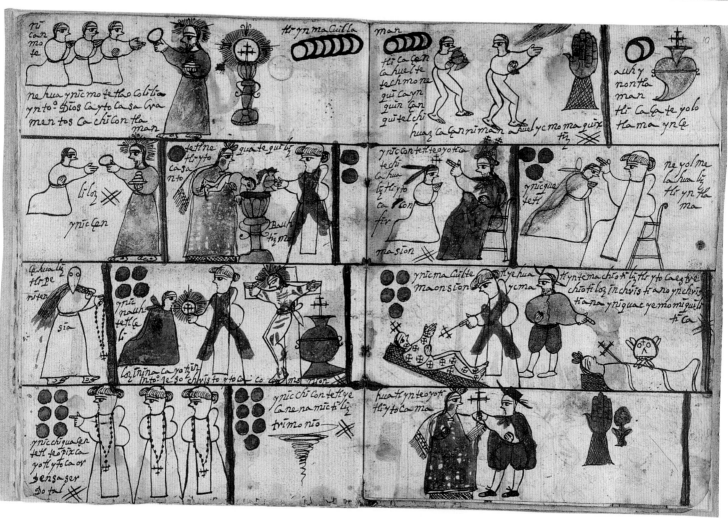

358 Doctrina Cristiana

c. 1714, colonial
30 leaves (15 double folios),
European paper, 24 × 16.5 cm;
skin binding

Trustees of the British Museum, London,
Egerton Ms. 2898

OPENINGS ILLUSTRATED: leaves 4, 10 and 19

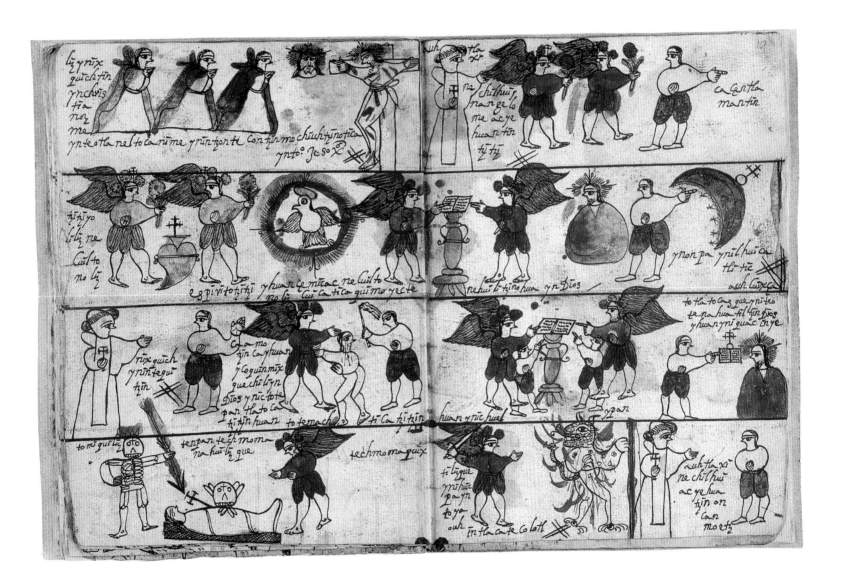

359 Christoph Weiditz,
Trachtenbuch

1529–30
Codex, 154 folios, paper,
19.4 × 14.5 cm; twentieth-century
leather binding

Leihgabe, Germanisches
Nationalmuseum, Nuremberg, Hs 22474

OPENINGS ILLUSTRATED: folios 12*v*–13*r*
and 9*r*

Allso Lupfacht Er Jder das
Holtz auff die wies, so ers auff
geworffen hat.

CATALOGUE

CONTRIBUTORS

AB	Alexander Brust
AG	Angel Gallegos
AL	Adrian Locke
BD	Berete Due
CE	Christina Elson
CK	Cecelia Klein
CMcE	Colin McEwan
CN	Carlo Nobile
CP	Carla Pinzauti
CR	Corinna Raddatz
DC	David Carrasco
DGV	Daniel Granados Vázquez
DW	David Weston
DZ	Daniela Zanin
EMH	Ellen M. Hoobler
EMM	Eduardo Matos Moctezuma
ES	Eberhard Slenczka
FFJ	Fabien Ferrer-Joly
FS	Felipe Solís

GC	Giorgio Careddu
GGG	Gillet G. Griffin
GMF	Gary M. Feinman
GvB	Gerard van Bussel
HK	Heidi King
IGR	Ida Giovanna Rao
JH	Joanne Harwood
JLVM	José Luis Valverde Merino
JO	Joanna Ostapkowicz
JT	Jyrki Talvitie
JWN	John W. Nunley
LDK	Lily Díaz-Kommonen
LK	Lily Kassner
LLL	Leonardo López Luján
LM	Linda Manzanilla
LOL	Lars-Olof Larsson
LT	Loa Traxler
MAM	Martín Antonio Mondragón
MCE	Massimo Ceresa
MCo	Monique Cohen
MD	Mariam Dandamayeva

MDC	Michael D. Coe
MFFB	Marie-France Fauvet-Berthelot
MG	Maria Gaida
MM	Marilena Mosco
MT	Michael Tellenbach
NJS	Nicholas J. Saunders
NR	Nancy Rosoff
PHA	Pilar Hernández Aparicio
RDT	Rita De Tata
RFT	Richard F. Townsend
RML	Ruben Morante López
RVA	Roberto Velasco Alonso
SEB	Susan E. Bergh
SH	Sabine Heym
SM	Sonja Marzinzik
SP	Sergio Purin
ST	Stefanie Teufel
UKR	Ursula Kubach-Reutter
VF	Virginia Fields
WG	Winifred Glover
WLF	William L. Fash

1 ANTECEDENTS

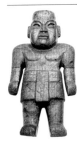

1
Anthropomorphic figure

c. 800 BC, Olmec

Jade and cinnabar, 52 × 29 cm

Museo Regional de Puebla,
CONACULTA-INAH, 10-203321

PROVENANCE: probably Puebla State;
José Luis Bello collection, deposited with
the Banco de Comercio; passed to the state
government and the Puebla museum, 1970

SELECTED REFERENCES: Berdan et al. 1996,
pp. 208–09; Amsterdam 2002, p. 86–87,
no. 3

In the nineteenth century this
sculpture belonged to José Luis
Bello, an avid collector from
Puebla who devoted a large part
of his considerable fortune to
acquiring paintings, furniture,
glass, weapons and other items.
His house near the main square
of the city of Puebla became
an informal museum, visited
by travellers and other interested
people. Bello considered the figure
to be of Chinese origin, because
it has full cheeks and because it is
made of jade, a material thought to
be especially abundant in the Far
East. In his day little if anything
was known of Olmec culture.
When its specific characteristics
eventually came to be recognised,
at the round-table meeting of the
Mexican Society of Anthropology
in 1940, the present piece was
added to the collection of Puebla's
Museo Regional and became one
of its most important items.

The sculpture depicts a high-
ranking person, robust in stature
and with the angular cranium
typical of Olmec figures. He
wears a short skirt held in place
by a wide belt, a strip of which
hangs down at the front. Among
the symbols engraved in the
clothing are a torch, which has
been interpreted as an emblem
of status, and signs standing
for the four cardinal directions.
FS, RVA

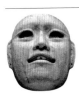

2
Mask

c. 900–400 BC, Olmec

Jade, 15.5 × 13 × 7 cm

Museo de Antropología de Xalapa
de la Universidad Veracruzana, Veracruz,
Reg. Pj. 49-4013

PROVENANCE: Arroyo Pesquero, Veracruz,
1969; donated to the museum, 1969

SELECTED REFERENCES: Medellín Zenil 1983,
p. 63; Coe 1992, p. 62; Berdan et al. 1996,
pp. 235–37, no. 77; Amsterdam 2002,
pp. 177–78

The mask, with its half-open
mouth and empty eyes, has a
number of motifs engraved in its
lower section. They relate to a
mythical toad-like animal whose
eyes contain a St Andrew's cross.
This symbol, widely used by the
Olmecs, has been interpreted as
representing solstitial points on
the horizon. Above the 'toad'
are four motifs recalling Olmec
images of infants, who were
depicted with an incision in their
skull and were possibly connected
with maize deities.

Such masks fulfilled three
functions. Initially worn in rituals,
they were placed over the face
of their owner when he died and
buried with him. Centuries later,
they could be recovered and
used as offerings in shrines at
springs, streams and mountain
localities.

The mask was among a major
deposit of archaeological objects
discovered in 1969 at Arroyo
Pesquero, near Las Choapas
in south-east Veracruz. The find
included other masks, figurines
and axes, all finely carved from
hard stones such as serpentine
and jade. RML

3
Plaque in the form
of a Maya warrior

c. 250–700, Maya

Shell, 9.5 × 5.8 × 0.8 cm

Collections of The Field Museum,
Chicago, 95075

PROVENANCE: Tula, Hidalgo; purchased
from the Antonio Peñafiel collection
by Frederick Starr, who sold the piece
to the museum in 1905

SELECTED REFERENCES: Charnay 1885;
Fort Worth 1986, pp. 78, 89;
Chicago 1993, pp. 67, 83;
McVicker and Palka 2001

This carved and incised plaque
of Pacific pearl oyster (*Pinctada
mazatlanica*) was first published
in 1885 by Charnay, who noted
that it had been found at Tula,
Hidalgo, in central Mexico.
The piece shows an elaborately
attired and seated Maya lord on
one side and Late Classic-period
Maya hieroglyphs on the reverse.
The few readable glyphs may refer
to specific individuals.

The glyphs and the iconography
make this the only definitively
lowland Maya artefact found at
Tula. Stylistically, the piece most
resembles a number of small
carved jade plaques depicting
Maya lords that were crafted in
the Usumacinta area but then
exchanged, perhaps as gifts to
seal alliances among the social
élite. Many such items have been
found far away from their likely
place of manufacture. This plaque
appears to have been carved more
than once, possibly because it
changed hands several times
before reaching Tula. GMF

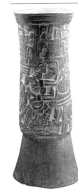

4
Goblet

c. 1100, Maya

Fired clay, height 31 cm, diameter 12.5 cm

Museo Regional de Antropología Carlos
Pellicer, Villahermosa, 64

PROVENANCE: Emiliano Zapata,
Tabasco, first half of the twentieth century

SELECTED REFERENCE: Amsterdam 2002,
p. 270, no. 235

The Chontales, also called
Putunes, were a Tabasco-based
group of Mayan people who
dominated an extensive area
of the coastal region of the Gulf
of Mexico between Veracruz
and Yucatan from the end of the
Classic to the Early Postclassic
period (900–1250). In the wake of
several important military victories
they established a complex trading
network and introduced to central
Mexico numerous features of the
culture prevailing in the south-
east. Among these were elegant
'orange' ceremonial vessels,
notably goblets with straight sides
and truncated conical bases. The
surfaces of these vessels bear relief

decoration, sometimes impressed
using moulds, that depicts
mythological scenes centring on
rulers and warriors. The present
example shows a warrior with
a clay nose-ring and pendant
with the glyph *ahau*, which
denoted a lord in the Mayan
world. Among the Toltecs such
vessels were much sought after as
status symbols, and tradition has
it that the Aztecs commissioned
a pair to commemorate the
creation of the monolith of the
goddess Coyolxauhqui (fig. 10)
during Stage IV(b) in the
construction of the Templo Mayor
in Tenochtitlan, along with images
of their principal war deities,
notably Tezcatlipoca. FS, RVA

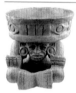

5

Huehueteotl

*c.*450, Teotihuacan

Stone, height 74.5 cm, diameter 80 cm

Museo Nacional de Antropología,
Mexico City, CONACULTA-INAH, 10-79920

PROVENANCE: Teotihuacan, Mexico State,
1963

SELECTED REFERENCE: Bernal and Simoni-
Abbat 1986, p. 148

From the beginnings of civilisation
in Mesoamerica, Huehueteotl
('old, old god') was worshipped
as the deity of fire and the heat
of the earth. The earliest physical
evidence of this cult dates from
the times of Cuicuilco in the Late
Preclassic era (600–100 BC), but
the definitive iconography of the
deity was not established until the
Teotihuacan era (AD 200–750).
Sculptures of the god show him
seated crossed-legged with both
hands resting on his knees, one
clenched, the other palm up.
Resting on his head and arched
back is a large brazier decorated
with four vertical bars and four
rhomboid shapes, symbols
associated with fire and the
cardinal directions. He has the
face of an old man, with wrinkled
skin and only two teeth. His
body, however, is full of vigour,
indicating his commitment to
keep alight forever the fire that
illuminates the earth. FS, AG

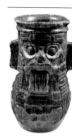

6

Urn

*c.*400, Teotihuacan

Greenstone, 24.5 × 14 cm

Museo Nacional de Antropología,
Mexico City, CONACULTA-INAH, 10-9626

PROVENANCE: Nanchititlán, Mexico State;
purchased by the museum from the first
collection of Francisco Plancarte y
Navarrete, first half of the twentieth century

SELECTED REFERENCES: Pijoán 1946, p. 104,
no. 165; Bernal 1967, p. 87, no. 49;
Solís Olguín 1991B, p. 56, no. 71

The rain-god cult was a constant
feature of Mesoamerican
cultures from the Classic
period (*c.*250–900) onwards,
when the region's chief cities
were Teotihuacan and Monte
Albán. Images of the deity showed
a fantastical face with rings and
bands around the eyes, prominent
jaws and threatening fangs.
Nahuatl-speakers called the god
'Tlaloc', the Zapotecs of Oaxaca
'Cocijo'. In the early years of the
twentieth century the present
ritual urn was given by a peasant
to Francisco Plancarte y Navarrete
(1856–1920), Archbishop of
Monterrey and the possessor of
a vast collection of archaeological
artefacts. It would appear to
combine the two iconographical
traditions in the depiction of the
rain god, those of Teotihuacan
and the Zapotec region. The
spherical body and the high
neck recall the Tlaloc vessels
characteristic of the Central
Highlands (see cat. 243). The face
of the god has bulging eyes and
the eyebrows intertwine to form
the nose in the Teotihuacan
manner. On the other hand, the
face-mask is similar to those
found on urns from the early
Classic period in Monte Albán
and the most striking feature,
the projecting fangs, likewise
recalls urns with images of
Cocijo. Another element alien
to Teotihuacan is the bar across
the forehead, a distinctive feature
of the Oaxacan numbering system.
FS, RVA

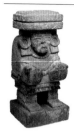

7

Standing goddess

*c.*250–650, Teotihuacan

Volcanic stone and traces of paint,
height 91.4 cm

Philadelphia Museum of Art, The Louise
and Walter Arensberg Collection, 1950,
1950-134-282

PROVENANCE: Louise and Walter Arensberg
collection, 1950

SELECTED REFERENCES: Santa Barbara 1942,
no. 137; Philadelphia 1954, no. 2;
Townsend 1992, pp. 140, 142; Uriarte 1994,
p. 113

The standing goddess is very
similar to the monumental statue
from Teotihuacan now in the
Museo Nacional de Antropología,
Mexico City. However, the
present figure is much smaller
and not as finely detailed, and
was perhaps intended for
devotional use by a small group,
such as the inhabitants of one
of Teotihuacan's apartment
complexes. The basic iconography
of the two figures is the same: the
large square headdress identifies
her as the deity of water, which
was crucial to a large urban area
that depended on rainfall for
successful crops and could be
devastated by drought. Her
benevolence and generosity are
indicated by the large, open,
outstretched hands. The
sculpture bears traces of red
and green paint. These colours,
with black and white, are typical
of Teotihuacan fresco panels and
ceramics. The art of Teotihuacan
tends to emphasise abstract visual
formulas, and here this creates
a pleasing contrast between the
blocky form of the figure and the
curves of her ear-spools, eyes
and fingers.

The Arensbergs probably
acquired the figure from the dealer
Earl Stendahl, between *c.*1935 and
1950. They enjoyed juxtaposing
Pre-Hispanic and modern works,
and displayed the goddess in their
home as a counterpoint to the
rounded forms of sculptures
by Constantin Brancusi. EMH

8
Tripod bowl

*c.*450, Teotihuacan

Fired clay, stucco and paint, height 15 cm, diameter 16.5 cm

Museo Nacional de Antropología, Mexico City, CONACULTA-INAH, 10-79930

PROVENANCE: grave 14, Tetitla palace, Teotihuacan, Mexico State, late 1950s

SELECTED REFERENCES: Séjourné 1966, pp. 108–17, nos 75, 92; San Francisco 1993, p. 252; Amsterdam 2002, pp. 100–01, no. 20

The residential precincts of Teotihuacan, called palaces, were multi-family dwellings whose occupants participated in the main religious, political and economic activities of the capital. Artefacts found among ritual offerings in the palaces provide a wealth of information on the life of the inhabitants. The present tripod bowl, for example, discovered by the archaeologist Laurette Séjourné in the late 1950s, represents a prime piece of evidence for the importance of sacrifice and self-sacrifice in the Teotihuacan period (*c.* 200–750). The vessel was painted in a technique similar to that used for murals. A thin layer of stucco mixed with an adhesive substance, often sap from the nopal tree, was applied to the wall of the vessel. The design was then drawn on the stucco, which was dampened to receive the painting. The figure of a walking priest, his apparel notable for its abundance of blue feathers, appears twice on the vessel. He wears goggles, linking him with Tlaloc, the god of rain, and he carries a large curved obsidian knife, holding its point at a human heart that drips three streams of blood. A scroll (the symbol for speech or song) evokes the sacrificial chant. FS, RVA

9
Tripod vessel

c. 500, Teotihuacan

Fired clay and stucco, height 25 cm, diameter 28 cm

Museo de Sitio de Teotihuacan, CONACULTA-INAH, 10-336713

PROVENANCE: San Francisco Mazapa, Teotihuacan, 1984

SELECTED REFERENCES: New York 1990, p. 108; Mexico City 1995, pp. 169–70

This tripod vessel was found during excavations directed by the archaeologist Patricia Cruz in the village of San Francisco Mazapa, in the immediate vicinity of the archaeological zone of Teotihuacan. It contained the bones of a child and must therefore have been a funerary urn. The most striking feature of the decoration incised on this highly polished, coffee-coloured vessel is the face of a man with puffed-out cheeks and half-closed eyes – a sign relating to death in Mesoamerican art. Scholars specialising in the religion of the Teotihuacan era recognise in the face the 'god with puffed-out cheeks', a deity associated with plenty and thus with agricultural feasts. Ceramic vessels continued to be used as funerary urns in the Aztec era, the finest example being the pair of fine orange urns from Stage IV(b) in the construction of the Templo Mayor that contained the cremated bones of those sacrificed in honour of the gods of Tenochtitlan. FS, RVA

10
Mask

c. 450–650, Teotihuacan

Stone, 22.5 × 28 cm

Museo Nacional de Antropología, Mexico City, CONACULTA-INAH, 10-9628

PROVENANCE: probably Teotihuacan

SELECTED REFERENCE: San Francisco 1993, pp. 184–85

The artefacts produced at Teotihuacan, approximately 35 km north-east of Tenochtitlan, embodied the ideals of a pre-Aztec society in Mesoamerica during the Classic period (200–650). Extant masks, all of them depicting the face of a young, presumably male, adult, give sophisticated expression to those ideals (see also cat. 12). Holes at the sides and the top enabled the masks to be attached to mortuary bundles containing the remains of the deceased: a clay model of such a bundle has survived that shows how the masks were positioned. For these masks, Teotihuacan sculptors favoured hard or semi-precious stones, which might be very highly polished. Examples are known in basalt, diorite serpentine and alabaster, and some bear traces of the original red paint on a stucco ground. The eye-sockets of the present mask contain remnants of the glue used to attach inlays, probably of shell. FS, RVA

11
Mask

c. 250–600, Teotihuacan

Granitic stone, iron pyrite and shell inlay, 21.6 × 24 × 10 cm

Philadelphia Museum of Art, The Louise and Walter Arensberg Collection, 1950, 1950-134-947

PROVENANCE: Louise and Walter Arensberg collection, 1950

SELECTED REFERENCE: Philadelphia 1954, no. 18

This mask, with its extremely simplified facial features, is typical of the Teotihuacan aesthetic. Such square masks of approximately the same size have been found in large numbers. The present example is remarkable in that it retains the inlays in its eyes, softening its features and giving it an almost personal quality.

Masks like this may have been attached to mortuary bundles (see cat. 10) or they may have been placed on ceramic busts used as devotional objects by the inhabitants of Teotihuacan. They have holes for the attachment of ear-spools and could have been adorned with the salient features of different deities as desired.

The Aztecs considered Teotihuacan a sacred place. Centuries after its fall they scavenged objects there for ritual use in their capital, Tenochtitlan. Hence, masks of this kind have been found in many of the caches of ritual offerings discovered on the site of Teotihuacan's Templo Mayor.

The clean lines and smooth, glossy surfaces of these masks appealed to Western collectors in the nineteenth and twentieth centuries. Walter Arensberg owned more than a dozen, yet was far from their most prolific

collector at the time. The present piece is probably the mask purchased by Arensberg from the dealer Josef Smilovits on 11 December 1950. EMH

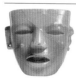

12

Mask

*c.*250–600, Teotihuacan

Greenstone, 15.8 × 17.3 × 5 cm

Museo degli Argenti, Florence, Gemme 824

PROVENANCE: Grand Dukes of Tuscany, passed to the museum, 1921

SELECTED REFERENCES: Heikamp 1972, pp. 25, 48, figs 54, 55; Guarnotta 1980, p. 170, fig. 314; Florence 1997, p. 127, no. 90

This mask dates from the third phase of Teotihuacan civilisation. The forehead shows a horizontal incision along the upper edge; the eyes will originally have been inlaid with white shells for the whites and black obsidian for the pupils. The mouth is half open, allowing a glimpse of white painted teeth and of the inside of the mouth, which is painted red. The left ear is pierced for the attachment of an ornament. A similar Teotihuacan mask is in the Birmingham Museum of Art, Alabama (see also cat. 10).

Like other Pre-Hispanic artefacts in the Medici collections, this piece was no doubt found by gold-seekers in the Central Highlands of Mexico. It appears as 'a mask of jade stone' in the inventory made at the death of Antonio de' Medici, the son of Francesco I, Grand Duke of Tuscany, in 1621 (Archivio di Stato, Florence, Guardaroba medicea 39, c. 30r). The mask must therefore have been in Antonio's residence, the Casino di San Marco, by the first decades of the seventeenth century. It passed to the Uffizi in 1723, and to the Museo degli Argenti in 1921. MM

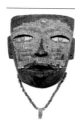

13

Mask

*c.*450, Teotihuacan

Stone, turquoise, obsidian and shell, 21.5 × 20 cm

Museo Nacional de Antropologia, Mexico City, CONACULTA-INAH, 10-9630

PROVENANCE: Malinaltepec, Guerrero, 1921–22

SELECTED REFERENCES: Pijoán 1946, pp. 106–08, nos 168–69; Soustelle 1969, p. 53; Solís Olguín 1991B, p. 59, no. 79

When this mask was discovered between August 1921 and January 1922 its unusualness and excellent state of preservation led some scholars to doubt its authenticity. Eventually, it was acknowledged as one of the great treasures of Pre-Hispanic art in Mesoamerica. Its formal qualities link it with the style of Teotihuacan, and it was probably carried from there to its findspot near the Pacific coast by traders or by members of religious or military expeditions. The piece owes its compelling power to inlays of shell and obsidian in the eyes and to the blue of the turquoise that covers most of the face. Red *Spondylus* shell was used for the nose-ring (shaped like a geometrical *greca* pattern), the curved line of the eyebrows and part of the glyph on the forehead. This last feature, comprising what seems to be a vessel with four white, feather-like protuberances made of shell, no doubt relates to the identity of the personage depicted, which has not been established. According to those who discovered the mask, it graced a funerary image and the red shell necklace formed part of the deceased's adornments. FS, RVA

14

Plaque with an image of a goddess with a reptile-eye glyph

*c.*250–700, Teotihuacan

Pale green, translucent onyx, 29 × 16 × 3 cm

Collections of The Field Museum, Chicago, 23913

PROVENANCE: unearthed during construction of an irrigation canal in Ixtapaluca near Chalco in the Basin of Mexico; sold by W. W. Blake as part of a collection purchased for the museum by A. V. Armour, 1897

SELECTED REFERENCES: Holmes 1897, pp. 304–09; Berlo 1992; Chicago 1993, pp. 1–2, 23, 78; San Francisco 1993, pp. 274–75

This engraved onyx plaque was first published by William H. Holmes, who described a series of biconical perforations along the upper margin. Despite these holes, Holmes reasoned that the piece was too large to have been worn regularly as a pendant and may have had a more special use. When first unpacked in Chicago more than a century ago, the plaque was found to be broken. A longitudinal perforation exposed in section by the fracture revealed the end of a tubular bone drill used to make the holes.

Although polished on all sides, the plaque is engraved on only one face. The engraving depicts a figure in a fully frontal pose wearing an elaborate headdress, ear ornaments and a nose-bar. Both hands are open. Images of this type have been noted with emblematic regularity at Teotihuacan and are thought to represent a key female supernatural being, denoted by a reptile-eye glyph, with fertility associations. GMF

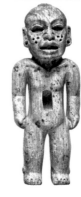

15

Anthropomorphic figure

*c.*400, Teotihuacan

Greenstone, 25.5 × 10 cm

Museo Nacional de Antropologia, Mexico City, CONACULTA-INAH, 10-2562

PROVENANCE: Covarrubias collection, donated to the museum, first half of the twentieth century

SELECTED REFERENCES: Lothrop 1964, p. 43; Solís Olguín 1991B, p. 57, no. 73

In the 1940s many intellectuals and show-business personalities in Mexico began collecting items of Pre-Hispanic art, impressed by their appearance, rare materials or unusual shapes. The present figure, for example, was acquired, reportedly in Guerrero or Oaxaca, by Miguel Covarrubias, a famous caricaturist who became a leading authority on Pre-Hispanic art and the author of a classic book on the subject. The medium-sized sculpture, carved from veined

greenstone, probably depicts a naked man. The sculptor shaped the parts of the figure with great subtlety, softening the facial features and body and emphasising the collarbone and eyelids by incisions. The holes on the cheekbones formerly held inlays, the large cavity in the belly a small piece of jade symbolising the figure's heart. Although the sculpture has been attributed to Teotihuacan, its formal qualities do not conform to the classical canons of the Teotihuacan style.
FS, RVA

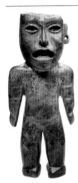

16
Anthropomorphic figure

c. 400–600, Teotihuacan

Serpentine, height 34 cm

Museum für Völkerkunde, Hamburg, B264

PROVENANCE: donated to the museum by C. W. Lüders, 1880

SELECTED REFERENCE: Hildesheim 1986, vol. 2, p. 126

Tool marks on the head of this standing figure indicate that the sculpture is unfinished. The two holes in the right leg were probably for attaching a foot. The right ear has been broken off. The figure was no doubt buried in this state as an offering, either in a tomb or as part of a deposit in, say, the floor of a building.

The figure dates from the Xolalpan phase of Teotihuacan culture, but the glyphs incised in its breast – '1-flint' and '3-movement' – were probably added in Aztec times. The first date relates to the year of birth of Huitzilopochtli, the patron god of the Aztecs, who evidently valued this product of an earlier culture.
CR

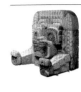

17
Mythological feline

c. 400, Teotihuacan

Volcanic stone, stucco and paint, 96.5 × 97.5 × 74.5 cm

Museo Nacional de Antropología, Mexico City, CONACULTA-INAH, 10-626269 0/10

PROVENANCE: Xalla compound, Teotihuacan, Mexico State, 2001

SELECTED REFERENCES: Benson 1972; Winning 1987, vol. 1, pp. 97–109; Saunders 1998; López Luján and Manzanilla 2001

The jaguar and the puma were of deep political and religious significance from the time of the Olmecs to that of the Aztecs. Mesoamericans symbolically linked felines with the night, the underworld, the earth and fertility because of their nocturnal habits, with war and sacrifice because of their ferocity and with magic and sorcery because of their furtive manner and their excellent night-time vision. For this last reason, the jaguar was considered the most effective ally of transforming shamans and, by extension, the ultimate patron and symbol of élites and governments.

The sculpture depicts a mythical feline emerging from a doorway that is decorated with starfishes, zigzag patterns signifying light and fringe feathers. The image symbolises the passage from the 'other world'. It was discovered in 2001 by members of the Xalla project in the ruins of what appears to be a gigantic palace situated north of the Pyramid of the Sun. The feline's head has bird's eyes: round, feathered, with serrated edges. The block supporting the head is missing, but similar representations suggest that the feline originally had the forked tongue of a serpent. The paws have large claws, hooked and extremely sharp. Two additional slabs show scrolls and flowers sprouting from the doorway. In Teotihuacan iconography mythical felines often emerge from water and are frequently associated with the storm god, the emblem of the city and its power. Similar felines and portals were found in the Pyramid of the Sun, indicating a close relationship between this building and the Xalla compound.
LLL, LM, WLF

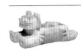

18
Offering vessel in the form of an ocelot

c. 400–600, Teotihuacan

Calcite onyx, 16 × 31 × 33.5 cm

Trustees of the British Museum, London, Ethno. 1926-22

PROVENANCE: purchased with the Christy Fund from Miss L. H. Wake, 1926

SELECTED REFERENCE: McEwan 1994, p. 69

Ceremonial vessels and other objects were sculpted in stone that was carefully selected for its visual qualities and symbolic value. This striking vessel is carved from translucent white stone called *tecalli* (calcite onyx in this case) that was quarried in the town of Tecalco in the Mexican Highlands. It is fashioned in the form of an ocelot (*Panthera pardalis*), a species of feline native to highland Mexico that has a distinctive spotted pelt. Like the larger and much-feared jaguar, this creature habitually emerges at dusk to hunt its prey by night. The marked rectangular geometry of the vessel emphasises the planar surfaces and formal elements evident in public architecture at Teotihuacan. Even the outstretched front and rear paws of the animal obey this rigid symmetry. The same aesthetic is expressed in the impassive features of large stone masks (cats 10, 12) and imparts a distinctive 'corporate' style to Teotihuacan sculpture. The eyes and mouth were probably once inlaid with semi-precious shell or stone, and the two depressions hollowed in the back were used to place offerings. CMcE

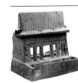

19
Model of a temple

c. 1500, Aztec

Fired clay and stucco, 31.5 × 35 × 23 cm

Museo de Sitio de Tula, CONACULTA-INAH, 10-215143

PROVENANCE: Tula, Hidalgo, 1947–48

Archaeological excavations of the Burnt Palace in Tula (see cat. 20) provided important evidence of the Aztec reoccupation of the ancient Toltec city after it had been abandoned for a long time. In the main room of the palace

Jorge R. Acosta found a large deposit of rubbish containing shards of pottery in imperial Aztec style and the present model of a temple, which doubtless depicts the type of ritual architecture that existed in the city in Aztec times. The whole structure stands on a broad, rectangular platform. This was reached through a patio surrounded by four walls and entered via a defensible entrance on one side. A broad stairway flanked by balustrades leads to the temple, the entrance of which is framed by six square-based columns supporting a long lintel. The exterior walls are decorated with medial moulding. The ceiling of the temple, supported by beams, is flat – the form traditionally favoured in the Mexican Highlands. It is crowned by a pitched roof, with side entrances, in which to store the possessions of the deities. FS, RVA

20
Chacmool

c. 1100, Toltec

Stone, 85 × 120 × 54 cm

Museo de Sitio de Tula, CONACULTA-INAH, 10-215198

PROVENANCE: Burnt Palace, Tula, Hidalgo, 1954

During fifteen field seasons from 1940 to 1960 the archaeologist Jorge R. Acosta and a distinguished team of collaborators explored Tula, the so-called city of Quetzalcoatl that had been the capital of the Toltecs. The present sculpture was found during the tenth season facing an altar in the Burnt Palace, a major building comprising three patios to the north of the main square and named thus because evidence exists that it was destroyed by fire. It is the only *chacmool* to have been found in Tula with its head intact; all others had been decapitated and mutilated in other ways. It was found in its original position in front of an altar and, like all *chacmools*, consists of a male figure reclining in a pose that gives it

a markedly horizontal silhouette from the shoulders down. In a manner impossible in real life, the shoulders are twisted so that the head is turned to the left, facing the spectator, while the body remains in profile. The figure wears a triangular skirt-like garment characteristic of warriors and holds a knife in its left hand. The obsidian butterfly pectoral recalls the deified militia, while the diadem links the figure with the governing élite. The *chacmool* is thought to have been invented in Toltec times and was associated with fire. FS, RVA

21
Vessel

*c.*950–1150, Toltec

Fired clay, height 24.5 cm, diameter 19 cm

Museum für Völkerkunde Wien (Kunsthistorisches Museum mit MVK und ÖTM), Vienna, 60.303, Becker Collection

PROVENANCE: Cerro del Tesoro, Tula Grande, Hidalgo; Philipp J. Becker collection, acquired by the museum, 1897

SELECTED REFERENCES: Nowotny 1959, p. 132–37; Vienna 1992, no. 147

This orange vessel bears two moulded panels, each depicting the same two contrasting figures: an elderly dignitary and a younger man. Both figures, their legs unusually long, wear the back shield typical of the Toltecs. A speech scroll in front of the mouth of one of them indicates that he is talking or singing. The vessel was probably used in a ceremonial context. GvB

22
Vessel

*c.*1250–1521, Toltec–Mixtec

Fired clay, height 24.7 cm, diameter 15.3 cm

Museum für Völkerkunde Wien (Kunsthistorisches Museum mit MVK und ÖTM), Vienna, 14.698, Bilimek Collection

PROVENANCE: Dominik Bilimek collection, acquired by the museum, 1882

SELECTED REFERENCE: Nowotny 1959, pp. 132–37

The body of this Postclassic vessel rests on a flared foot and bears two moulded rectangular panels. Each panel depicts the same two

scenes, one above the other. The upper scene shows three men armed with spears. The man on the left is either speaking or singing; his companion in the centre is surrounded by a feathered serpent. Below, four figures, two of them speaking, are accompanied by day-glyphs in the Aztec–Mixtec style. One of the figures in the lower scene holds a vessel comparable to that shown here, which was no doubt employed in a ceremonial context.

Like other items included here (cats 74, 142), the vessel belonged to Dominik Bilimek, who accompanied Maximilian of Habsburg to Mexico as his father confessor when Maximilian became Emperor of the country in 1864. Bilimek became curator of the new Museo Nacional in Mexico City and amassed a collection of archaeological artefacts that eventually passed to the Museum für Völkerkunde in Vienna. GvB

23
Atlantean figure

*c.*950–1150, Toltec

Volcanic stone and paint, 81 × 36 × 31 cm

Museum für Völkerkunde Wien (Kunsthistorisches Museum mit MVK und ÖTM), Vienna, 59.143, Becker Collection

PROVENANCE: Tlaxcala, Mexico; Philipp J. Becker collection, acquired by the museum, 1897

SELECTED REFERENCE: Vienna 1992, no. 148

Sculptures such as this, generally called Atlantean figures, bore the slabs of seats or the tables of altars, as can be seen in the Temple of the Warriors at Chichén Itzá. Larger versions supported the roofs of temples. Prominent examples of the latter type are to be seen in Tula, the capital of the Toltecs.

The polychromed figure depicts a warrior. His headdress surrounds his entire face and he wears a nose ornament, blue clothing, knee bands and a back shield. GvB

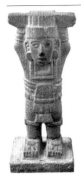

24

Atlantean figure

c. 1100, Toltec

Stone and paint, 94.5 × 38.5 × 34 cm

Museo de Sitio de Tula,
CONACULTA-INAH, 10-215119

PROVENANCE: Tula, Hidalgo

SELECTED REFERENCES: Acosta 1961, p.50,
no. 25; Prem and Dyckerhoff 1986, p. 101

Sculptures giving material
expression to myths and cults
involving warriors and gods
supporting the universe with
their power and physical strength
emerged in both the Mayan world
and the Central Highlands of
Mexico during the Early
Postclassic era (900–1250).
The most complete example of
these atlantean figures to have
survived from Mesoamerica, the
present piece was discovered by
the archaeologist Jorge R. Acosta
during excavations in Tula. Along
with other sculptures, it probably
supported an altar table, as can
be seen in the Temple of the
Warriors at Chichén Itzá. The
hands are raised to the level of
the feathered headdress, and the
figure wears a square-shaped
garment or ornament on the
chest and a loincloth with strips
hanging from the front. Warriors
dominated Tula and Chichén Itzá,
cities that flowered at the same
time and possessed close artistic
links, so it is scarcely surprising
to encounter them in sculptures,
reliefs and murals, depicted
with the jewellery and other
adornments that they doubtless
wore in real life: feathered sandals,
along with bracelets and ear
ornaments with copper, shell and
turquoise mosaic. With its traces
of red, blue, yellow and white
paint, the atlantean figure shown
here is an example of the common
practice of painting directly on
stone with mineral-based
pigments. FS, RVA

25

Eagle reliefs

c. 1000–1300, Toltec

Volcanic stone (andesite/dacite)
and remains of paint, 69.8 × 74.9 cm
and 69.8 × 77.5 cm

The Metropolitan Museum of Art,
New York, Gift of Frederic E. Church,
1893, 93.27.1, 2

PROVENANCE: gift of Frederic E. Church,
1893

SELECTED REFERENCES: Jones 1987, p. 129;
Braun 1993, p. 37

Two raptors are depicted in profile
on these panels. Their heads bent
down, they appear to be pecking
at trilobed objects held in their
massive talons. The motif is
believed to represent eagles
devouring human hearts. In
ancient Mexican thought eagles,
soaring high into the sky, were
symbols of the sun, which,
according to myth, had been
created through the self-sacrifice
of a god. To survive the dangerous
nightly journey through the
darkness of the underworld and to
rise each morning the sun needed
strength. It was humankind's
obligation to provide nourishment
for the sun in the form of human
hearts and blood.

Panels with this image decorate
the base of Pyramid B, a major
structure at Tula, capital of the
Toltecs, whom the Aztecs claimed
as their ancestors and who
dominated central Mexico during
the first centuries of the second
millennium BC. The Temple of the
Eagles and Jaguars at Chichén Itzá
also features such motifs. The
present panels are said to have
been found in the northern part
of the Mexican state Veracruz.
They were among the first Pre-
Hispanic works of art to enter the
Metropolitan Museum's collection,
donated to it in 1893 by the
renowned American landscape
painter Frederic E. Church, who
travelled widely in Mexico and
South America. HK

26

Plaque with an image of a bleeding heart

c. 1100, Toltec

Stone and stucco, 61.5 × 60 × 7 cm

Museo Nacional de Antropología,
Mexico City, CONACULTA-INAH, 10-81752

PROVENANCE: Building B, Tula, Hidalgo,
1947–48

SELECTED REFERENCES: Acosta 1956;
Bernal 1967, p. 117, no. 57; Solís Olguín
1991B, p.79, no. 108; López Luján 1995,
p.77

Jorge R. Acosta's excavations
at Tula revealed, first, a court
for ritual ball games in the north,
which Acosta called Pyramid A,
and then a pyramidal platform,
which he called Pyramid B.
The latter became better known
because of the atlantean figures
discovered buried there like an
offering. A slightly later building,
known as Superimposition IIb,
was constructed against the north-
eastern section of the base, partly
covering the carved panels
representing processions of
jaguars, coyotes, eagles devouring
hearts and other motifs. In 1947,
during the seventh season of
excavations, examination of
various stages in the construction
of this second building brought
to light three rectangular plaques
carved from soft volcanic rock.
The best-preserved of the plaques,
all of which demonstrate the
importance of war during the
Toltec era, is the present piece.
The warlike motif of a bleeding
heart pierced by three bundles
of three arrows is surrounded
by spirals of smoke and flowers.
The position of the bundles,
one vertical, the others forming
a cross, may have identified
Pyramid B in its early phase as
a temple devoted to the supreme
deity. FS, RVA

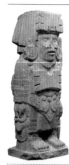

27

Deified warrior

c. 1500, Aztec

Stone, 119 × 48 × 34.5 cm

Museo Nacional de Antropología,
Mexico City, CONACULTA-INAH, 10-48555

PROVENANCE: Ceremonial Precinct of the
Templo Mayor, Mexico City, 1944

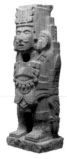

28

Deified warrior

c. 1500, Aztec

Stone, 120 × 42 × 37 cm

Museo Nacional de Antropología,
Mexico City, CONACULTA-INAH, 10-81768

PROVENANCE: Ceremonial Precinct of the
Templo Mayor, Mexico City, 1944

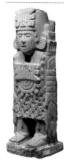

29

Deified warrior

c. 1500, Aztec

Stone, 120 × 41 × 39 cm

Museo Nacional de Antropología,
Mexico City, CONACULTA-INAH, 10-9774

PROVENANCE: Ceremonial Precinct of the
Templo Mayor, Mexico City, 1944

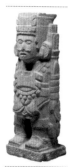

30

Deified warrior

c. 1500, Aztec

Stone, 119 × 38 × 34 cm

Museo Nacional de Antropología,
Mexico City, CONACULTA-INAH, 10-81769

PROVENANCE: Ceremonial Precinct of the
Templo Mayor, Mexico City, 1944

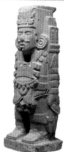

31

Deified warrior

c. 1500, Aztec

Stone, 122 × 42 × 39 cm

Museo Nacional de Antropología,
Mexico City, CONACULTA-INAH, 10-81767

PROVENANCE: Ceremonial Precinct of the
Templo Mayor, Mexico City, 1944

SELECTED REFERENCES: Townsend 1979,
p. 18; Pasztory 1983, p. 178, pl. 144;
Umberger 1987, pp. 75–76; Bernal and
Simoni-Abbat 1986, p. 264; Solís Olguín
1991, pp. 60–92

In Tenochtitlan there must have
existed a sacred building
representing the Aztec vision of
the cosmos, and no doubt these
five sculptures, depicting the
warriors who support the gods'
creation by their military actions,
formed part of it. A building of
this type survives in the Plaza de
la Luna in front of the Pyramid of
the Sun in Teotihuacan and may
have provided the Aztecs with a
model. Four of the sculptures are
male, the fifth (cat. 29) female.
Three of the male figures possibly
mark the cardinal points east,
north and south, their female
counterpart west, the 'place of
women'. The bearded figure
(cat. 27) would then indicate the
centre of the universe, the
'crossroads' of the four directions.
As on the Tizoc Stone (fig. 6),
these images of deified warriors
supporting the sun in its celestial
plane wear stylised butterfly
pectorals of Toltec origin, a
pattern repeated on their helmets.
The male figures' military vocation
is indicated not only by their
spear-throwers (see cat. 315) and
spears, but also by the triangular
cloth worn over their loincloth
and by their clay nose-bars. The
woman wears an unusual skirt
made of interwoven arrows. The
four warriors are holding sacrificial
knives, while the female warrior
brandishes a *tzotzopaztli* (weaving
batten), emblem of her femininity.

FS, RVA

II THE HUMAN FIGURE

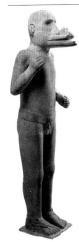

32
Ehecatl-Quetzalcoatl

c. 1500, Aztec

Basalt, 176 × 56 × 50 cm

Instituto Mexiquense de Cultura: Museo de Antropología e Historia del Estado de México, Toluca, A-36229, 10-109262

PROVENANCE: Calixtlahuaca, Mexico State, 1938

SELECTED REFERENCES: Pijoán 1946, pp. 26–28; García Payón 1979, p. 200; Bernal and Simoni-Abbat 1986, p. 320; Solís Olguín 1991, pp. 86–87

One of the most important Aztec gods, Quetzalcoatl took several guises. As a deity of duality (expressed in his name, which means 'feathered serpent'), he became the main symbol of fertility. As an image of the planet Venus, he was Tlahuizcalpantecuhtli, the morning star, and Xolotl, the evening star. Depicted as Ehecatl-Quetzalcoatl, as in the sculpture shown here, he was the god of wind, capable of blowing storm clouds to produce the rain that fertilised the fields. The chief attribute of Ehecatl-Quetzalcoatl is the bird-like mask, commonly painted in red, with its beak half opened to reveal the tongue. Here, the mask covers the mouth and nose of a virtually naked young man, who wears the dress of a *macehual* (commoner): a *máxtlatl* (loincloth) and *huaraches* (sandals).

The sculpture was found among the debris inside a round temple at Calixtlahuaca. MAM

33
Young man

c. 15, Aztec

Stone, 55 × 20 × 15 cm

Museo Nacional de Antropología, Mexico City, CONACULTA-INAH, 10-1121

PROVENANCE: Tetzcoco, Mexico State; Augusto Genin collection, donated to the museum in the nineteenth century

SELECTED REFERENCES: Pijoán 1946, p. 152; Bernal 1967, p. 161, no. 87; Solís Olguín 1991, p. 78; Mexico City 1995, p. 42, no. 16

This sculpture of a young man with an erect penis is among the extremely rare examples of erotic sculpture in Pre-Hispanic Mesoamerica. Very few instances of completely naked figures are known in Aztec art (they include cats 35 and 40), which suggests, on the one hand, that the present figure was clothed with real garments and ornaments (as indicated by the perforations in the ears) during certain ceremonies and, on the other, that it was intended to celebrate the transition from childhood to adulthood. Between the ages of fifteen and twenty, young people were separated from their family and lived in schools run by the state. During this period, men learned to become active members of society. The erect member symbolises their fertility in the cosmic scheme of things. FS, RVA

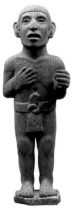

34
Young man

c. 1500, Aztec

Stone, 80 × 28 × 19 cm

Museo Nacional de Antropología, Mexico City, CONACULTA-INAH, 10-220926

PROVENANCE: Mexico City, first half of the twentieth century

SELECTED REFERENCES: Alcina Franch 1983, no. 296; Washington 1983, pp. 80–81; Solís Olguín 1991, pp. 80–81, no. 45a, b

During the reign of Motecuhzoma II (1502–21) commoners (*macehualtin*) wore clothes made solely from the fibre of the henequen, a plant of the agave family. They were forbidden to wear sandals and to own or decorate themselves with jewels made of precious metals and jade, so they generally adorned themselves with simple clay ear ornaments and necklaces. The present figure is considered to exemplify Aztec ideals of the *macehual*, the male commoner: young and strong, he was responsible for sustaining the Aztec world with his might. The Indian artist, who produced a simplified image, also fulfilled an apparent aesthetic requirement – that the head of an individual be one quarter of his overall height.

Such figures functioned as mannequins, clothed and adorned with feathers and real jewels (see also cat. 35). FS, AG

35
Standing male nude

c. 1400–1521, Aztec

Grey basalt, height 107.5 × 37 × 25 cm

Peabody Museum of Natural History, Yale University, New Haven, ANT.008525 (Avery Judd Skilton collection)

PROVENANCE: purchased, 1881

Nudity of any sort is very rare in Aztec art, so this naturalistic image of a boy or adolescent male may well have been dressed and fitted with a distinguishing headdress during festivals. It may even have functioned as a kind of mannequin for various male gods. The faintly visible black stripes passing vertically through the eyes suggest that at its last appearance in public rituals the figure represented Xipe Totec ('our flayed lord'), a god of springtime and the renewal of vegetation at the start of the rainy season who was impersonated each year by priests wearing the skins of flayed captives. The ears are pierced for attaching ornaments, and the partly open mouth indicates that the figure is singing. Originally, the eyes will have been inlaid with shell for the whites and jet or obsidian for the pupils. The figure possibly held banners or flowers in his hands.

The sculpture once belonged to Avery Judd Skilton, US Consul in Mexico, and was reportedly collected in 'the mountains of Puebla'. It was purchased by the Peabody Museum in 1881, with a partial donation from Julius A. Skilton. According to accession records, some of Avery Skilton's statues had been in the private collection of Maximilian, Emperor of Mexico from 1864 to 1867. MDC

36

Male head and torso

c. 1500, Aztec

Stone and white shell, 63 × 20 cm

Museo Nacional de Antropología, Mexico City, CONACULTA-INAH, 10-40607

PROVENANCE: Mexico City, early twentieth century

SELECTED REFERENCE: Amsterdam 2002, pp. 168–69, no. 103

The Aztecs viewed early adulthood as the most precious time in the life of men, the age when they fulfilled their destiny as fathers, warriors and public servants. The masculinity of the present naked male figure is emphasised by the *máxtlatl*, the loincloth knotted in the front. The eyes are made of white shell inlays; the holes in the ears are for attaching ornaments; and the cavity in the chest will originally have been filled with greenstone, a 'heart' that gave the figure life. The lower part of the sculpture, which for over 50 years was thought to have been lost, was rediscovered in time for the opening of the new Mexican Hall in the Museo Nacional in 1999. FS, RVA

37

Huehueteotl

c. 1500, Aztec

Stone, 48 × 23 cm

Museo Nacional de Antropología, Mexico City, CONACULTA-INAH, 10-220145

PROVENANCE: Covarrubias collection, donated to the Museo Nacional, late 1930s

SELECTED REFERENCES: Solís Olguín 1991, pp. 78–79, no. 44; Mexico City 1995, p. 42, no. 15

The figure, which contrasts with the youthful ideal frequently embodied in Aztec sculpture (see cat. 36), depicts Huehueteotl, the 'old, old god' of fire. The signs of old age – the wrinkles on the face and the missing teeth – contrast with the vigorous movement of the body. The position of the hands, and the cavities in them, indicate that the god is shown as a standard-bearer: he will have held a sceptre and a bag of copal resin or flowers. He is dressed in a simple loincloth tied at the front. FS, RVA

38

Chalchiuhtlicue

c. 1500, Aztec

Diorite, 85 × 37 × 25 cm

Museo Nacional de Antropología, Mexico City, CONACULTA-INAH, 10-82215

PROVENANCE: Mexico City, 1824

SELECTED REFERENCES: Pasztory 1983, p. 211; Solís Olguín 1991, pp. 94–96, no. 57a, b; Amsterdam 2002, p. 108, no. 28

The sculpture has elements that link it with both Chalchiuhtlicue, the water goddess, and the cult of the maize deities. The characteristic headdress of Chalchiuhtlicue, consort of Tlaloc, the rain god, is combined with a strap wrapped round her head and with two large cotton tassels framing her face. At the back is the familiar pleated paper bow, from under which hang two long strips of interwoven fabric. The edges of the *quechquémitl* (cape) are decorated with a strip of *chalchiuhitl* (symbols for jade) and end in small cotton tassels. The designs woven into the fabric of the goddess's skirt and the sash holding up the skirt (which is shaped like a rattlesnake, the symbol both of the earth goddess Coatlicue and of the maize deities) provide important evidence of Aztec dress, and the sculpture as a whole no doubt reveals the ideal of elegance to which aristocratic women aspired. The high quality of the carving is apparent despite the mutilation of the face, hands and feet by the Spanish. FS, RVA

39

Man carrying a cacao pod

c. 1200–1521, Aztec

Volcanic stone and traces of paint, 36.2 × 17.8 × 19.1 cm

Brooklyn Museum of Art, Museum Collection Fund, 40.16

PROVENANCE: Amatlán, Veracruz; purchased from G. M. Echániz, Mexico City, with funds from the Museum Collection Fund, 1940

SELECTED REFERENCES: Brooklyn 1938–41; New York 1976, fig. 44; Anawalt 1981, pp. 21–23; Pasztory 1983, p. 209, pl. 156; Townsend 1992, p. 173; Smith 1996, p. 265, fig. 10.7

The figure exemplifies the skill of Aztec stoneworkers at carving delicate and graceful figures from coarse volcanic stone. Carved in the round, with a compact body and rounded limbs, it is a characteristic example of Aztec sculpture. While most Aztec figurative sculpture is religious in nature, many examples, including the present piece, appear to be purely secular. The man is portrayed wearing a traditional loincloth (*máxtlatl*) and headdress. Traces of red paint are visible around his mouth, his ears and the central headdress ornament.

Chocolate, made from the beans of the cacao pod, was a very popular drink among the Aztecs. It was prized so highly that cacao beans were a greatly valued item of long-distance trade and were used as tribute and currency. Perhaps this figure represents a professional merchant (*pochteca*) who brought cacao beans from the hot and humid coastal lowlands to the Basin of Mexico.

The figure was acquired from G. M. Echániz (see also cat. 71). NR

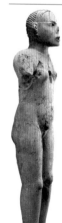

40

Female nude

c. 1500, Aztec

Stone, 146 × 40 × 25 cm

Museo Nacional de Antropología, Mexico City, CONACULTA-INAH, 10-81543

PROVENANCE: Tetzcoco, Mexico State

SELECTED REFERENCES: Pasztory 1983, pp. 212–15; Solís Olguín 1991, p. 96, no. 58

Despite its damaged state, this female nude reveals the heights Aztec sculpture had reached by the time of the Conquest. Classically proportioned, the figure has been compared since its discovery with the sculptures of ancient Greece and Rome and was once known as the 'Venus of Tetzcoco'. It exhibits a strikingly naturalistic sensuality in the stomach and thighs, while the face and the breasts appear more geometric and rigid and were no doubt carved by another sculptor. Human hair will have been attached to the ridges on top of the head, and the cavity in the chest will have contained a greenstone 'heart'. FS, RVA

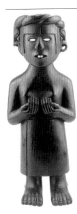

41

Fertility goddess

c. 1500, Aztec

Cedarwood and white shell, 40 × 15 × 10 cm

Museo Nacional de Antropología,
Mexico City, CONACULTA-INAH, 10-74751

PROVENANCE: Coatepec Harinas, Veracruz,
nineteenth century

SELECTED REFERENCES: Saville 1922,
pp. 80–81; Bernal 1967, p. 185, no. 109;
Solís Olguín 1991, pp. 71–72; Solís Olguín
1991B, p. 250, no. 382

Despite the systematic burning of idols and the heavy punishments meted out to offenders, in three centuries of Spanish rule in Mexico the colonial authorities never succeeded in eradicating the worship of Pre-Hispanic deities. Offerings of candles, maize cobs and bottles of *aguardiente*, and animal sacrifices, particularly of chickens, were still being made to the present figure of a fertility goddess when it was discovered in the nineteenth century in a cave in the remote region of Coatepec Harinas, south-west of the Toluca Valley in Veracruz. Easy to carve and transport, wooden figures of deities, known generically as *cuauhximalli*, must have been very numerous in Pre-Hispanic times, but most were subsequently burned or succumbed to the effects of weathering and/or insect attack. This figure is therefore a rare survival. It shows the goddess as a young woman supporting her full breasts, a gesture that emphasises her maternal role as one who brings nourishment to humankind. She wears her hair in a plait, the customary style for married women. Remains of the shell inlays indicating the eyes and teeth can still be seen. FS, RVA

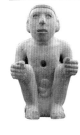

42

Xiuhtecuhtli

c. 1500, Aztec

Stone, 80 × 32 × 18 cm

Museo Nacional de Antropología,
Mexico City, CONACULTA-INAH, 10-81575

PROVENANCE: Apapaxco, Churubusco,
early twentieth century

SELECTED REFERENCES: Alcina Franch
1978, p. 389, no. 294; Solís Olguín 1991,
pp. 65–66

The sculpture depicts the god Xiuhtecuhtli, lord of the *tlatoque*, the Aztec rulers. *Tlatoque* are believed to have been dressed in his costume on their day of enthronement. The figure wears ritual attire: the *xicolli*, a kind of open waistcoat; the triangular cloth of warriors, worn over the loincloth; the sandals with heels decorated with solar rays; and the *xiuhuitzolli*, a diadem of gold and turquoise. The circular ear discs and the nose ornament denote nobility of spirit, while the fangs are a reminder of the link between Aztec rulers and Huehueteotl, the toothless god of fire and patron of turquoise and the day.

This sculpture was found at Apapaxco (formerly Ahuitzilopochco) in Churubusco, a place south of Mexico City where some of the most important celebrations of the main rites of Huitzilopochtli, the Aztec patron deity, took place. FS, RVA

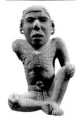

43

Young man

c. 1500, Aztec

Stone, 63 × 20 cm

Museo Nacional de Antropología,
Mexico City, CONACULTA-INAH, 10-620964

PROVENANCE: Mexico City, first half of the
twentieth century

SELECTED REFERENCES: Solís Olguín 1991,
p. 78, no. 43; Mexico City 1995, p. 42;
Amsterdam 2002, pp. 170–71, no. 104

The system of education in Tenochtitlan required all boys over the age of fifteen to leave home and live in schools provided for them. They entered either the *calmecac* (priestly schools) or, if they were the offspring of commoners (*macehualtin*, sing. *macehual*), the *tepochcalli*. In these institutions they learned the fundamentals of their people's history and of the complex world of the gods who had created the universe. They left the schools aged twenty, those who had attended the *calmecac* to become rulers, priests, warriors and teachers, the others to work as farmers and craftsmen.

The figure depicted in the sculpture has traditionally been identified as a *macehual*, seated with his hands on his knees. His social status is indicated by his closely cropped hair, by his bare feet and by his clothing, which consists only of a loincloth. The Aztecs held youth to be the golden age in the life of man, and such images represent their ideal of strong young men whose military prowess and hard work maintained the empire. FS, RVA

44

Hunchback

c. 1500, Aztec

Stone, 33 × 16 × 12 cm

Museo Nacional de Antropología,
Mexico City, CONACULTA-INAH, 10-97

PROVENANCE: Mexico City, nineteenth
century

SELECTED REFERENCES: Bernal 1967,
pp. 136–37; Pasztory 1983, pp. 231–32;
Solís Olguín 1991, p. 82, no. 48a, b

Nanauatzin ('he [covered] with pustules'), who, according to the myth, created the Fifth Sun in Teotihuacan, was distinguished not only by an illness – syphilis – but also by deformities. He was therefore considered to be the patron god of deformed humans, such as the man represented here, who has two humps, one on the backbone, the other on the ribcage. With remarkable realism the sculptor depicted the figure with short arms and legs. He wears a loincloth and sports the hair arrangement characteristic of warriors, with a lock of hair hanging on the right side of his head and tied with cotton tassels. According to the Spanish chroniclers, men affected by deformity, including albinos, were fed and cared for until a solar eclipse took place, when they were the first to be sacrificed. At these critical times for the survival of the universe, Nahui Ollin reclaimed his children, who resembled him in his original deformity. FS, RVA

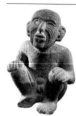

45

Seated male figure

c.1350–1521, Aztec

Basalt, 31 × 21.5 × 18 cm

Museum der Kulturen Basel, Basle, IVb 627

PROVENANCE: Lukas Vischer collection, donated to the museum, 1844

SELECTED REFERENCES: Basle 1985, p.61; Bankmann and Baer 1990, p.130; Miller and Taube 1993, p.92

The sculpture is thought to represent Huehueteotl, the 'old, old god' of the Aztecs. The iconography of Huehueteotl, a god of fire, changed very little from the first millennium BC to the end of Aztec culture. He is depicted here seated and leaning slightly forward, his hands resting on his bent knees. He wears only a loincloth. His forehead and cheeks are covered with wrinkles. Both ear lobes are pierced. The mouth is open and the slightly damaged lower lip has an incision in the middle, which may be a perforation for a lip-plug. The right eye retains its white inlay. Anatomical details, including the collarbone, the wrists and ankle joints, are depicted with the realism typical of Aztec sculpture. The spine, too, is clearly delineated and is curved as a sign of the god's advanced age. AB

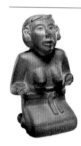

46

Kneeling woman

c.1250–1521, Aztec

Stone and traces of paint, 54 × 34 × 22 cm

American Museum of Natural History, New York, 30.1/1201

PROVENANCE: Ixtapalapan, Mexico; purchased from Lawrence Higgins, 1931

SELECTED REFERENCE: Durán 1971, pp.221–28

The statue, said to represent a maize goddess, comes from the Aztec town of Ixtapalapan, located on the southern lake shore of the Basin of Mexico. Deities personifying maize appeared in several forms. Xilonen ('young maize ear'), for example, was associated with the first tender corn of the harvest season, Chicomecoatl ('seven serpent') with dried seed corn. According to the sixteenth-century Franciscan

friar Diego Durán, adolescent girls were chosen to represent the maize goddess in celebrations that took place in September. In the temple of Chicomecoatl in Tenochtitlan the goddess was represented as an adolescent with open arms. The cheeks of the statue were coloured red and it was richly robed in bright red, finely made garments and adorned with gold and featherwork.

George Vaillant, curator and an early expert on the Aztecs, acquired this statue for the museum while directing archaeological fieldwork in Mexico in June 1931. CE

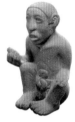

47

Seated male figure

c.1350–1521, Aztec

Stone, 30.5 × 19 × 15.5 cm

Staatliche Museen zu Berlin: Preußischer Kulturbesitz, Ethnologisches Museum, IV Ca 4401

PROVENANCE: Carl Uhde collection, purchased by the museum, 1862

SELECTED REFERENCES: Washington 1983, pp.82–83; Solís Olguín 1993, pp.69–74

The Aztecs, masters of stonework, created an unmistakable image of the human form. Along with deities they sculpted figures such as this *macehual* (commoner; see also cat. 43), obviously guided by a need to convey an idealised image of vigorous, youthful members of their society.

The unadorned figure, wearing only the characteristic loincloth, is seated on the ground. His left hand rests on the knee of his left leg, which is bent inwards; he appears to be holding an object in his other hand. His facial expression is rigid and expressionless. This no doubt reflects the strict upbringing of young Aztecs, who were prepared in schools for a life as fierce warriors and active members of society. MG

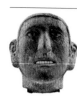

48

Head of a youth

c.1500, Aztec

Stone, red shell and obsidian, 19.5 × 15.5 cm

Museo Nacional de Antropología, Mexico City, CONACULTA-INAH, 10-92

PROVENANCE: Mexico City, 1940

SELECTED REFERENCES: Caso 1950, p.8; Toscano 1940, pp.86–89; Madrid 1992, p.191

Two similar sculptures depicting the heads of young Aztecs were discovered by chance in 1940 during the construction of a building in the historic quarter of Mexico City. Both pieces, of which this is one, have the original pyrite, red and white shell inlays, which accentuate the vivid representation of men in a state of drunkenness. *Pulque*, a mildly alcoholic beverage made from the sap of the maguey cactus mixed with psychotropic plants, is known to have been consumed during certain festivities. An incision in the base of the neck permitted both sculptures to be attached to the body. Hence, they were probably used as substitutes for living victims in ceremonial decapitation rituals. FS, RVA

49

Mask

c.1450–1521, Aztec

Stone, 20 × 17 × 8 cm

American Museum of Natural History, New York, 30/11847

PROVENANCE: collected by Teobert Maler in the vicinity of Castillo de Teayo, Veracruz, 1903; given to the museum by the Duke of Loubat

SELECTED REFERENCES: Ekholm 1970, p.61; Matos Moctezuma 1988, p.112

Ethnohistorical accounts of Aztec religious practices document the pervasive use of masks in temple ceremonies. Masks made of stone or clay have been preserved from Pre-Hispanic times, but many others were probably made of wood or other perishable materials and have not survived. Masks no doubt played a central role in ceremonies involving deity impersonation. The present example does not have perforated eyes, making it unlikely that it was

worn, but it does have holes drilled in the back for hanging. In addition, the ears are perforated so that ornaments could have been attached to the lobes. Stone masks similar to this have been found among offerings in the Aztec Templo Mayor in Mexico City. CE

50

Anthropomorphic mask

c. 1500, Aztec

Obsidian, 15 × 13.5 × 11 cm

Museo Nacional de Antropología, Mexico City, CONACULTA-INAH, 10-9681

51

Anthropomorphic mask

c. 1500, Aztec

Obsidian, 20.5 × 17 × 9 cm

Museo Nacional de Antropología, Mexico City, CONACULTA-INAH, 10-96

52

Anthropomorphic mask

c. 1500, Aztec

Alabaster, 22 × 23 × 11 cm

Museo Nacional de Antropología, Mexico City, CONACULTA-INAH, 10-223664

PROVENANCE: probably Basin of Mexico and Mexico City, nineteenth and twentieth centuries

SELECTED REFERENCES: Caso 1950; Bernal 1967, no. 120; Solís Olguín 1991B, p.250, no. 379; Belém 1995, pp.94–95

Masks carved from semi-precious stones are among the innovations in Mesoamerican art introduced towards the end of the Aztec empire. Examples in jade and greenstone (particularly diorite) have survived along with the present pieces, made of obsidian and alabaster. Such objects have traditionally been connected with funerals, related to certain passages in chronicles and to images in codices indicating that the deceased wore masks. The masks survived the cremation of the dead, giving them an eternal face. Like most Aztec masks, these are notably realistic. The sculptor has depicted the face of a strong young man, with wide nostrils and pronounced cheekbones that emphasise the lines from the nostrils to the

mouth. The polished surfaces contrast with the cavities representing the eyes and mouth, which were designed to be inlaid with shell and obsidian. FS, RVA

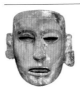

53

Mask

c. 1500, Aztec

Wood and traces of stucco and gold leaf, 20 × 20.5 × 11.4 cm

Princeton University Art Museum, Gift of Mrs Gerard B. Lambert, Y 1970-111

PROVENANCE: museum purchase, gift of Mrs Gerard B. Lambert, 1970

This may be the only surviving wooden mask in pure Aztec, rather than Mixtec, style. The mask is not made for wearing: neither the eyes nor the mouth are punctured, nor is the back hollowed to fit a human face. It does not represent a deity, but possibly a noble, which is unusual.

In its original form the mask certainly had inlaid eyes of shell and obsidian and shell teeth. There are traces of gold leaf over a thin coating of stucco. The ear lobes have platforms, which undoubtedly supported ear-flares of stone or gold.

Such a mask may have been placed over the face of the deceased in a tomb or it may have been displayed in a sanctuary. It is said to have been found in a dry cave in the Mexican state of Oaxaca, the homeland of Mixtec culture. Most surviving wooden masks are of Mixtec style and are often covered with mosaic designs. It is remarkable that the only wooden mask in pure Aztec style should have been found in Mixtec territory. GGG

III THE NATURAL WORLD

54

Solar disc

*c.*1500, Aztec

Stone, height 11 cm, diameter 46 cm

Museo Nacional de Antropología, Mexico City, CONACULTA-INAH, 10-13570

PROVENANCE: Xochimilco, Mexico City, 1964

SELECTED REFERENCES: Mexico City 1995, p.43, no. 17; Seville 1997, pp.90–91

The solar disc was the emblem of the sun, known to the Aztecs as Tonatiuh, whom they imagined as a vigorous youth covered in red body paint and with ochre and yellow face paint. They believed that he was guided in his passage across the sky by Xiuhcoatl, the legendary fiery serpent that was also the deadly weapon that Tonatiuh used against his enemies in the underworld, the stars and the moon. The best-known representations of the sun take the form of discs, most notably that commonly (and erroneously) known as the 'Aztec Calendar' (fig. 5). This documents the five world-eras, or 'suns', and the present disc is a simplified version of it. The sun is represented here by four rays and by four sacred cactus thorns on the outside that make it appear like a monumental *zacatapayolli*, the ball of straw into which sacrificial blood-letters were inserted. In the centre is the calendrical number of the Fifth Sun, Nahui Ollin ('4-movement'). The date '6-rabbit' appears in the border. It may refer to the year in which the stone was carved or to that of a historical event. FS, RVA

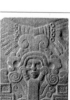

55

Cihuacoatl

*c.*1500, Aztec

Stone, 61 × 44.5 × 15 cm

Museo Nacional de Antropología, Mexico City, CONACULTA-INAH, 10-81787

PROVENANCE: Mexico City, first half of the twentieth century

SELECTED REFERENCES: Pasztory 1983, p.249; Solís Olguín 1991B, p.85, no. 121

The relief depicts Cihuacoatl, the powerful earth deity and goddess of fertility, the giver of life and the keeper of the souls of the departed. In keeping with her name, which means 'woman serpent', she is shown as half human, half serpent. Gaping reptilian jaws frame her face. The creature is depicted as a fantastic mask, with circular eyes, curving brows and a large forked tongue hanging from the mouth. A second forked tongue forms the goddess's headdress, from which rise two groups of quetzal feathers, known as *ome quetzalli* ('2-feather'). This is also an attribute of Xochiquetzal, goddess of flowers, so that this figure is also associated with the fertility of the feminine aspect of the universe. At the lower corners of the slab are stepped meander patterns alluding to the serpent's undulating movement. FS, RVA

56

Casket

*c.*1500, Aztec

Stone, jade, stucco and paint, 19.5 × 20 × 20 cm

Museo Nacional de Antropología, Mexico City, CONACULTA-INAH, 10-28018 0/2

PROVENANCE: Tizapaan, Mexico City, 1930

SELECTED REFERENCES: New York 1990, pp.227–28, no. 108a, b; Solís Olguín 1991B, p.242, no. 360; Madrid 1992, p.349, no. 115; Mexico City 1995, p.40, no. 13

This casket, designed to take ritual offerings, is a three-dimensional representation of the Aztec concept of the cosmos. For them, the universe was a flat square at the centre of which the four cardinal directions met. East, north, west and south – the colours of which are yellow, white, red and green respectively – are the dwelling places of the deities who are identified by these colours, the primary colours of creation. In the casket the centre of the universe appears at the bottom, in the form of Chalchihuitl ('navel of the world'). The four inner sides bear images of maize, the sacred plant that supports the roof of the heavens. The latter is represented by the lid of the casket. On its underside are painted the *tlaloque*, assistants of the rain god, Tlaloc, who are charged with directing water to the four points of the universe. The jade figure of the goddess of sustenance and fertility placed inside the casket gives a three-dimensional quality to this map of the native cosmos. FS, RVA

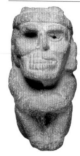

57

Life–death figure

*c.*1200–1521, Aztec

Volcanic stone, 26.7 × 14 × 15.6 cm

Brooklyn Museum of Art, Purchased with funds given by The Henfield Foundation, 64.50

PROVENANCE: purchased from John A. Stokes with funds from the Henfield Foundation Fund, 1964

SELECTED REFERENCES: Pasztory 1983, pp.223, 225, pl. 195; Baquedano 1984, p.47; Smith 1996, p.215

The sculpture is believed to depict Xiuhtecuhtli, god of fire, identified by the circles on his headdress, which are symbols of fire, and the two horn-like protruberances on top of his head. Xiuhtecuhtli was associated with both life and fire. Fire played a prominent role in many rituals and a sacred fire was always kept burning at the temples. The god was also associated with the household hearth, where food was prepared and household rituals were performed. Old gods such as Xiuhtecuhtli were often depicted with a beard and missing teeth, but in this unusual version part of the deity's human face is a skull, perhaps attesting to his dual and ambivalent nature.

Esther Pasztory points out that, while the Aztec élite and rulers worshipped Xiuhtecuhtli, there are few major monuments from Tenochtitlan that include this deity, except in burial offerings. She suggests that the preponderance of crude carvings may indicate a popular cult that perhaps emphasised fertility. NR

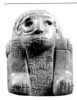

58

Figure representing the duality

c. 1500, Aztec

Greenstone, 9.5 × 8 × 9 cm

Museo Nacional de Antropología,
Mexico City, CONACULTA-INAH, 10-9683

PROVENANCE: Mexico City, second half
of the twentieth century

SELECTED REFERENCE: García Moll et al. n.d.,
pp. 93–99, 133, no. 124

The Mesoamerican concept of
duality relates to the meeting of
and conflict between opposing
forces of comparable power and
importance. The alternating
control exercised by one force
over its opposite manifests itself in
a cyclical equilibrium from which
comes the continuity of life and
death. The earliest evidence of
this concept dates from the eighth
century BC, in the shape of two-
headed or two-faced figurines
discovered at Tlatilco and of a
well-known anthropomorphic
mask, one half of which is covered
with skin, the other bare (Museo
Nacional de Antropología, Mexico
City, 10-2513). The representation
of duality in this mask also appears
in Aztec iconography. In the
present example one half of the
face is smooth and youthful, while
the other depicts the mask of
Tlaloc, the rain god, with a 'goggle'
eye, an undulating brow and a
fanged serpent's jaw. By virtue
of its colour, which alludes to
vegetation, the greenstone figure
symbolises the two seasons of
the Mesoamerican agricultural
year, the rainy and the dry. The
year '8-reed' is inscribed on this
sculpture as it is on the
commemorative plaque from
the Templo Mayor (cat. 223).
In both instances it relates to
the expansion of sacred buildings.
FS, RVA

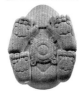

59

Toad with an image
of Chalchihuitl

c. 1500, Aztec

Stone, 19 × 51 × 34 cm

Museo Nacional de Antropología,
Mexico City, CONACULTA-INAH, 10-1097

SELECTED REFERENCES: Bernal and Simoni-
Abbat 1986, p. 371; Solís Olguín 1991,
pp. 114–15

Because toads emerged from
their burrows in the earth at the
onset of the rainy season in
Mesoamerica, they were not only
associated with the earth, but also
became the prime symbol of
water. The Aztecs therefore
pictured Tlaltecuhtli, lord of
the earth and patron of water,
crouching like a toad, with his
legs outstretched as he supports
the universe on his shoulders.
On the base of the present
sculpture – the toad's stomach –
is a relief of the chief water
goddess, Chalchihuitl, which re-
creates the quincunx, the five parts
of the cosmos, with the animal at
its centre. The naturalistic
depiction of the toad clearly shows
the protuberances on the head in
which it stores a highly toxic
substance to protect it from its
enemies. Native shamans knew of
this substance's psychotropic
properties and used it to prepare a
ritual hallucinogenic drug. FS, RVA

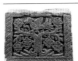

60

Altar of the sacred tree

c. 1300, Aztec

Stone, 58 × 72 × 67 cm

Museo Nacional de Antropología,
Mexico City, CONACULTA-INAH, 10-81641

PROVENANCE: Chalco, Mexico State,
nineteenth century

SELECTED REFERENCES: Bernal 1967, p. 193,
no. 124; Pasztory 1983, pp. 212–13, pls
163–65; Mexico City 1995, p. 36, no. 8

Sculptural traditions existed in the
Basin of Mexico long before the
arrival of the Aztecs, most notably
in the Xochicalco region and in
Tlaxcala, where some of the most
important surviving Pre-Hispanic
codices were also produced. Such
antecedents are reflected in the
present altar. The main image
is a tree full of flowers in which
a bird perches. The tree closely
resembles depictions of the
cardinal points of the universe
in the Codex Borgia (Biblioteca
Apostolica Vaticana). The other
three sides of the altar show large
cartouches containing glyphs:
a seven-petalled flower
representing the fertility of nature;
a combination of fire and water
with the number five and a

prominent year-symbol; and a
flower-like motif with the bar-sign
characteristic of the numerical
system used at the city of
Xochicalco. The top of the altar
is carved with various signs, set
against a background that evokes
the surface of water. A large cavity
was cut out of the altar in colonial
times. FS, RVA

61

Stamp

c. 1500, Aztec

Fired clay, 5.5 × 13.5 × 5 cm

Museo Nacional de Antropología,
Mexico City, CONACULTA-INAH, 10-5383

PROVENANCE: Mexico City, 1936

62

Stamp

c. 1500, Aztec

Fired clay, 5 × 18.5 × 6.5 cm

Museo Nacional de Antropología,
Mexico City, CONACULTA-INAH, 10-78298

PROVENANCE: Mexico City, 1967

63

Stamp

c. 1500, Aztec

Fired clay, 6 × 7.5 × 9.5 cm

Museo Nacional de Antropología,
Mexico City, CONACULTAH-INAH, 10-79936

PROVENANCE: Mexico City, 1964

64

Stamp

c. 1500, Aztec

Fired clay, 4.5 × 11 × 15.5 cm

Museo Nacional de Antropología,
Mexico City, CONACULTA-INAH, 10-116493

PROVENANCE: Mexico City, 1938

65

Stamp

c. 1500, Aztec

Fired clay, 5 × 8 × 4 cm

Museo Nacional de Antropología,
Mexico City, CONACULTA-INAH, 10-532896

PROVENANCE: Malinalco, Mexico State, 1936

SELECTED REFERENCES: Enciso 1947, pp. 13,
82, 120; Westheim 1962, no. 77

Stamps (*pintaderas*) had been used
in Mesoamerica since *c.* 1500 BC
to print patterns on textiles and,
especially, the face and body with
dyes made from charcoal, cinnabar
and other substances. By the time
of the Aztecs, stamps were

popular at all levels of society, and decoration produced by means of them must have played a considerable part in the various annual festivals. Some *pintaderas* were cylindrical, rolled on the fabric or skin. Others were curved, used to decorate thighs and legs (cats 63–65). The motifs on these became extremely stylised, depicting interlaced flowers, eagle heads, snakes and monkeys dancing in pairs to some irresistible rhythm. Perhaps the most attractive are the flat stamps that show images of animals, such as the two snakes included here, one of which (cat. 61) represents the *xiuhcoatl* ('fire serpent'), its tail taking the form of a sun disc with rays. FS, RVA

66
Squash

c. 1300–1521, Aztec

Aragonite, 12 × 8 cm

Trustees of the British Museum, London, Ethno. 1952 Am 18.1

PROVENANCE: reportedly a grave at Mitla, Oaxaca; bequeathed to the museum by Miss Amy Drucker, 1952

SELECTED REFERENCES: New York 1970, p. 289; Washington 1983, p. 114, pl. 41

Among the naturalistic stone sculptures fashioned by Aztec artisans are a few that accurately represent important staple fruits and vegetables. In this example, the lifelike rendering of a particular variety of squash (*Cucurbita mixta*) reflects an intense interest in the cultivation of such crops. In the course of thousands of years of experimentation and innovation indigenous people accumulated the blend of deep knowledge and practical skills to plant, harvest and process corn, beans, squash, avocados, chillis, tomatoes, cacao and a host of other crops. Along with maize and beans, various species of squash, including the common Mexican pumpkin (*Cucurbita pepo*), comprised a significant part of the Aztec diet. Squash seeds could be stewed or parched and count among the most common items of food tribute. These formed part of an impressive

arsenal of staple cultigens as well as more exotic seeds, fruits and spices upon which Pre-Hispanic Mesoamerican societies depended. In due course they came to play an integral role in myths, rituals, calendars, customs and performances in Aztec life. There is very little direct information about the functions and uses of vegetative sculptures. They may have served as offerings dedicated to agricultural deities. CMcE

67
Pumpkin

c. 1500, Aztec

Diorite, 16 × 36 × 17 cm

Museo Nacional de Antropología, Mexico City, CONACULTA-INAH, 10-392922

PROVENANCE: unknown

SELECTED REFERENCES: New York 1970, p. 305, no. 288; Kubler 1985, p. 221, no. III-12; Amsterdam 2002, p. 240, no. 195

Along with maize, the staple foods of the Aztecs and other Mesoamerican peoples included chillis, beans and gourds, which were esteemed for their nutritional value. The present sculpture is a faithful representation of the pumpkin variety *Cucurbita pepo* in which the sculptor has made skilful use of diorite, a very hard stone of a greenish colour with veins that look like the marks on the skin of a pumpkin. FS, RVA

68
Cactus

c. 1500, Aztec

Stone, 99 × 28 cm

Museo Nacional de Antropología, Mexico City, CONACULTA-INAH, 10-220928

PROVENANCE: Mexico City; Alfredo Chavero collection, donated to the museum in the nineteenth century

SELECTED REFERENCES: New York 1970, no. 287; Amsterdam 2002, p. 240, no. 194; Solís Olguín forthcoming

The *marginatus* variety of *Cereuss* cactus has been used since time immemorial by various peoples to create natural fences or walls. In sculpted form, it was employed by the Aztecs to mark the boundary between the capital, Tenochtitlan, and the

neighbouring town of Tlatelolco. The present example reproduces faithfully the elongated shape of the plant and depicts its roots. On the base is a relief of Tenoch, founder of Tenochtitlan, who, according to legend, had been guided to the site by the Aztecs' patron god, Huitzilopochtli. Other, similar sculptures have survived, four of which may have marked the sacred precincts of the capital. FS, RVA

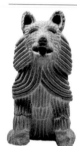

69
Feathered coyote

c. 1500, Aztec

Stone, 38 × 17 × 13 cm

Museo Nacional de Antropología, Mexico City, CONACULTA-INAH, 10-47

PROVENANCE: unknown

SELECTED REFERENCES: Pijoán 1946, pp. 158–64; Amsterdam 2002, p. 251, no. 212

The coyote was considered the most sexually potent of animals in the Pre-Hispanic Nahuatl world and was associated with Tezcatlipoca, god of masculinity and of war. Aztec men prayed to Huehuecoyotl ('old coyote') for health and long life. The present sculpture shows the dog sitting on its hindquarters and covered in a thick fur of plumes that imitates feathers in motion. FS, RVA

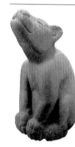

70
Dog

c. 1500, Aztec

Stone, 47.5 × 20 × 29 cm

Museo Regional de Puebla, CONACULTA-INAH, 10-203439

PROVENANCE: Ruiz de Tepeaca collection, acquired by the Puebla State government, nineteenth century; Museo de la Universidad, Puebla, 1939; Museo Regional de Puebla, 1976

SELECTED REFERENCES: New York 1970, p. 300, no. 279; Washington 1983, pp. 120–21; Mexico City 1995, p. 171

In ancient Mesoamerica dogs were prized for their closeness to humankind, their loyalty and their watchfulness, which helped protect homes and crops. Moreover, they were closely associated with rituals relating to fire and the sun's rays.

The sculpture shows the dog in a characteristic position, sitting on its hind legs, supporting itself on its front legs and raising its head as if to look at its master. Although its mouth is closed, some scholars believe the animal may be howling at the moon.

The Aztecs and other Nahuatl-speakers called all species of dog known to them *itzcuintli*. It has been claimed that they also referred to dogs affectionately as *xochcóyotl*, *tehuítzotl*, *tetlami*, *tehui* and *chichi*. *Itzcuintli* was one of the twenty glyphs in the Mesoamerican agricultural calendar (the *xiuhpohualli*), while the fourteenth thirteen-day period in the ritual calendar (*tonalpohualli*) began with the glyph *ce izcuintli* ('1-dog'). It was thought that people born during this period would be lucky, especially if they were rulers. FS, RVA

71
Reclining jaguar

c. 1440–1521, Aztec

Volcanic stone, 12.5 × 14.5 × 28 cm

Brooklyn Museum of Art, Carll H. de Silver Fund, 38.45

PROVENANCE: purchased from G. M. Echániz, Mexico City, with funds from the Carll H. de Silver Fund, 1938

SELECTED REFERENCES: Brooklyn 1938–41; Pasztory 1983, p. 233, pl. 214; Washington 1991, pp. 569–70, pl. 402; Smith 1996, p. 266, fig. 10.9; Brooklyn 1997, pp. 81–82

This reclining jaguar is an excellent example of Aztec naturalistic sculpture. Every part of the animal is carefully rendered, including the underside, where the paw pads are carved in low relief. To the Aztecs, the jaguar symbolised power, courage and war. Hence the highest-ranking warriors were called either jaguar or eagle warriors, and rulers associated themselves with Tezcatlipoca ('smoking mirror'), a deity who sometimes took the guise of this predator. Rulers were also depicted wearing and sitting on jaguar skins. In addition, the jaguar, as a night hunter, was associated with danger and darkness.

Michael D. Coe (in Washington 1991) suggests that, while we do not know why or for whom naturalistic representations of animals and plants were carved, they may have been placed in temples, palaces or the homes of élite families. He also proposes that the present sculpture may have adorned a military academy at which jaguar warriors were trained.

The Brooklyn Museum's archives state that, like cat. 39, the sculpture was purchased in 1938 from Mr G. M. Echániz, a dealer who owned an antiquarian bookstore and gallery in Mexico City. NR

72
Rabbit

c. 1500, Aztec

Stone, 33 × 22 × 24 cm

Museo Nacional de Antropología, Mexico City, CONACULTA-INAH, 10-81666

PROVENANCE: possibly Mexico City

SELECTED REFERENCES: Bernal 1967, p. 164, no. 93; Solís Olguín 1991, pp. 112–13; Mexico City 1995, p. 138, no. 146

Among Nahuatl-speakers the rabbit (*tochtli*) was closely associated with the moon and with the intoxicating effects of *pulque*. These peoples explained the silhouette of a rabbit seen on the moon's surface with reference to the punishment that Tecuciztecatl (the god who became the moon) was thought to have received for his cowardice when he did not instantly perform the self-sacrifice necessary for him to become the sun: a rabbit was flung in his face. Ome Tochtli ('2-rabbit') was god of drunkenness and commander of the Centzon Totochtin ('400 rabbits'), i.e. the countless attitudes that drunkards adopt as they run the gamut from happiness to sadness and from lechery to madness. This remarkably naturalistic sculpture depicts a graceful creature, hunched up with its front paws raised, alert to danger. FS, RVA

73
Insect

c. 1500, Aztec

Stone, 22 × 21.5 × 36.5 cm

Museo Nacional de Antropología, Mexico City, CONACULTA-INAH, 10-594039

PROVENANCE: Mexico City, nineteenth century.

SELECTED REFERENCES: Covarrubias 1961, pp. 366–67; Pasztory 1983, p. 234, pl. 230

In their art the Aztecs meticulously reproduced the salient features of the plants and animals that formed part of their natural surroundings. The present sculpture, for example, which probably depicts a flea, includes the mouth part that the insect uses to suck blood from humans and other mammals. Among the insects represented in Aztec art are some that have been identified as water-fleas, animals associated with the gods of rain and flowing water, Tlaloc and Chalchiuhtlicue. FS, RVA

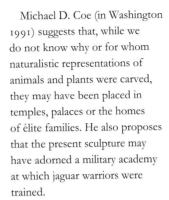

74
Insect

c. 1500, Aztec

Stone, 13.5 × 9.5 × 18 cm

Museum für Völkerkunde Wien (Kunsthistorisches Museum mit MVK und ÖTM), Vienna, 6.450, Bilimek Collection

PROVENANCE: Dominik Bilimek collection, acquired by the museum, 1878

SELECTED REFERENCE: Vienna 1992, no. 158

The sculpture has been thought to depict a grasshopper, fly or cicada, but the species of insect cannot be established beyond doubt. Its symbolic meaning is almost equally obscure. The 'shell' decoration on the chest is a characteristic of Quetzalcoatl, a god whom several creation myths describe as having dealings with insects, including bees, ants and butterflies, and with spiders.

Close to Tenochtitlan, the Aztec capital, lay Chapultepec ('grasshopper hill'), where the Mexica-Aztecs first tried to found their capital. This was also where Topiltzin, the *quetzalcoatl*, or priest-ruler, of the Toltecs, resided for a while after abandoning the Toltec capital, Tula. The present piece may possibly be an image of Chapultepec. GvB

75

Grasshopper

c. 1500, Aztec

Cornelian, 19.5 × 16 × 47 cm

Museo Nacional de Antropología, Mexico City, CONACULTA-INAH, 10-220929

PROVENANCE: Chapultepec, Mexico City, nineteenth century

SELECTED REFERENCES: Pasztory 1983, p. 234, pl. 231; Kubler 1985, p. 222, no. III-13; Solís Olguín 1991, p. 116

The Aztecs migrated from Aztlan to the Basin of Mexico and settled on the hill called Chapultepec. Pictograms show this with a grasshopper on its summit and it is therefore known as 'grasshopper hill'. A sweet-water spring on the mountain was later channelled to provide Tenochtitlan with drinking water. In Chapultepec the Aztecs built a system of reservoirs and canals. A sculpture of a grasshopper was discovered in the main reservoir towards the end of the nineteenth century. Grasshoppers are abundant in the fields in Mesoamerica after the rainy season.

The present piece was carved in a red volcanic rock called cornelian. The creature is depicted in all its anatomical detail and its legs are flexed as if it is ready to jump. FS, RVA

76

Fish

c. 1500, Aztec

Volcanic stone, 26.3 × 58.6 × 10.5 cm

Laboratoire d'Ethnologie, Musée de l'Homme, Paris, M.H.87.155.17

PROVENANCE: Latour Allard collection, on loan from the Musées nationaux

SELECTED REFERENCES: Nicholson 1971, p. 129, fig. 45; Pasztory 1983, p. 234, pl. 229; Baquedano 1984, p. 77, fig. 48; López Luján 1991, pp. 219–20; Espinosa Pineda 1996, pp. 115–29; Seler 1996, pp. 305–09

This sculpture and a bas-relief in the British Museum (Ethno. St. 371) are among the few representations of fish in Aztec sculpture. Fish are rare in Aztec art as a whole and difficult to identify in taxonomic terms. The present example has a round eye, an open mouth and large hexagonal scales, along with two fins on the back, one on the chest, one at the front of the pelvis and

one at the anus. The number and position of the fins correspond to the species *Chirostoma jordani* and *Chirostoma regani* (*charal*), which are some 5 cm long, and *Chirostoma humboldtianum* (*pescado blanco*), which is approximately 16 cm in length. Once common in the lakes of Mexico, these fish were staples of the Aztec diet. The biologist Ana Fabiola Guzmán has pointed out, however, that the proportions of the scales indicate that the sculptor intended to represent a saltwater fish. The piece might therefore depict a *tlacamichi*, an edible sea fish described by the Spanish chronicler Friar Bernardino de Sahagún in the sixteenth century.

For the Aztecs, fish symbolised the world of water and fertility. They were associated with the gods Chalchiuhtlicue, Cipactli, Mayahuel, Quetzalcoatl, Xochipilli and Xochiquetzal. At the end of the fourth world-era, Nahui Atl ('4-water'), all human beings were thought to have been turned into fish following a flood. LLL, MFFB

77

Plaque with an image of a lizard

c. 1325–1520, Aztec

Stone, 24 × 15 × 8 cm

Musées Royaux d'Art et d'Histoire, Brussels, AAM 3480

PROVENANCE: gift of Auguste Génin, 1930

SELECTED REFERENCE: Lavachery and Minnaert 1931, p. 25

The shape and dimensions of the plaque would seem to suggest that it was the lid of a receptacle, yet the majority of surviving decorative motifs on Aztec stone receptacles are executed in low relief. The object was collected by Auguste Génin on his travels in Mexico during the rush to acquire Pre-Hispanic works in the first quarter of the twentieth century, but the notes he made at the time have been lost, so no clue as to its function can be gained from that quarter.

In Mexica iconography the lizard occurs only in connection with the *tonalpohualli*, the sacred or ritual calendar, where it is one

of the twenty day-signs that are grouped with the numbers 1 to 13 as a means of indicating the time of the year. In the Florentine Codex (cat. 344), by the chronicler Friar Bernardino de Sahagún, it features prominently on pl. XXI–5, where it is associated with the number 11. Sahagún calls it *cuetzpali* or *cuetzpallin*.

Auguste Génin's donation formed the basis for the Mexican collections at the Musées Royaux d'Art et d'Histoire in Brussels. SP

78

Feathered serpent

c. 1500, Aztec

Stone, 50 × 45 × 52 cm

Colección Fundación Televisa, Mexico City, Reg. 21 pj. 8

PROVENANCE: unknown, acquired through Manuel Reyero, late 1960s

SELECTED REFERENCE: Reyero 1978, pp. 143–44

Quetzalcoatl, the mythical 'feathered serpent', was among the most important Pre-Hispanic deities in Mesoamerica. The present sculpture of the coiled reptile shows the rings that allow it to slither over the ground and its skin covered in long quetzal feathers. The oldest known image of Quetzalcoatl comes from Tlatilco and dates from *c.* 800 BC. Later, in Teotihuacan, his cult grew in importance and he was associated with the fertilising power of water. A sculpture of him adorned the main pyramid of the Ciudadela (citadel) there. The Toltecs believed that this supernatural reptile protected processions of warriors, as can be seen in images surviving on benches in Teotihuacan. The Aztecs considered his image to be divine and the counterpart of Quetzalcoatl as a man. FS, RVA

79

Serpent

c. 1500, Aztec

Stone, 31 × 82 × 80 cm

Museo Nacional de Antropología, Mexico City, CONACULTA-INAH, 10-220933

The serpent played a versatile and crucial role in the mythology of ancient Mexico. It is identified both with the sun's rays, which are the weapons of the *xiuhcoatl* ('fire serpent'), and with driving rain, which resembles water-snakes falling from the sky during heavy storms. Moreover, the earth itself is Cihuacoatl ('serpent woman'), the creative female force. The present sculpture shows a further aspect of serpents: their mysteriousness. The artist has captured the sense of power emanating from a coiled rattlesnake, its muscular tension and its intimidating effect as it shakes its rattle and shows its forked tongue. FS, RVA

80
Snake

c. 1500, Aztec

Stone, 31 × 44 × 24 cm

Museo Nacional de Antropología, Mexico City, CONACULTA-INAH, 10-220932

Today snakes generally arouse feelings of terror and revulsion, but for the people of ancient Mesoamerica, not least the Aztecs, they symbolised fertility and plenty. The fact that snakes reproduce especially abundantly led people to believe that the top layer of the earth consisted of interlaced snakes, forming a sacred 'carpet' from which men, plants and other animals had grown.

The body of the snake depicted here engulfs itself, conveying a sense of the animal as a life-generating nucleus. The dynamic movement that informs the entire body comes to a halt at the head: the snake looks at the spectator, hypnotising him with eyes that are now missing their shell inlays. The oversized forked tongue

contrasts with the realistic dimensions of the rest of the animal. FS, RVA

81
Coiled rattlesnake

c. 1300–1521, Aztec

Granite and traces of paint, height 36 cm, diameter 53 cm

Trustees of the British Museum, London, Ethno. 1849.6-29.1

The Aztecs carved naturalistic sculptures of reptiles, birds and insects, suggesting that they observed the life cycles and habits of these creatures closely. The imposing presence of this rattlesnake (*Crotalus horridus*) is enhanced by the foreshortening of the coiled body compared to the size of its head and rattle. Key anatomical details, such as the fangs and bifurcated tongue, are accurately recorded. Small circular cavities on either side of the head between the nostrils and the eyes are the external openings to highly effective heat sensors, enabling the snake to locate and strike at prey in complete darkness. The hole visible on the floor of the mouth is the trachea. In snakes these are movable, so that when they are digesting their prey, the trachea moves forward to enable them to continue to breathe. The traces of red pigment on the right nostril and mouth and the red dots on the surfaces of the ventral coils on the underside of the sculpture may allude to the coloured skin of some species of rattlesnake. The rattle itself consists of successive segments, a new one being produced each year when the snake sheds its skin, reaching, in the present case, a total of thirteen. This is perhaps not coincidental, since the 260-day ritual calendar in Mesoamerica is based on a cycle of thirteen day-numbers and twenty day-names. CMcE

82
Relief of an eagle

c. 1300–1521, Aztec

Andesite, 20 × 28 × 8 cm

Trustees of the British Museum, London, Ethno. 8624

The eagle (*cuauhtli*) was linked to the solar deity Tonatiuh and was widely used among the Aztecs to symbolise the qualities and attributes of this most important of celestial objects. According to myth, the golden eagle had a special role in the legendary founding of the Aztec capital, Tenochtitlan (see p. 14). In Nahuatl the terms for ascending eagle (*cuauhtlehuanitl*) and descending eagle (*cuauhtemoc*) referred to the archetypal diurnal movements of the sun in its daily emergence from and return to the depths of the underworld. The eagle exemplified the aggressive power to strike that inspired the military order of eagle warriors and was identified with human sacrifice. Large sculptures of eagles with circular cavities in their backs, as well as special ceremonial 'eagle vessels' (*cuauhxicalli*; see cat. 152), served as receptacles for blood offerings as nourishment for the solar deity. While much Aztec sculpture is renowned for its volumetric qualities and arresting presence, the present piece is modest in size and sculpted in low relief. The backward glance of the head is a novelty that defies the usual conventions. CMcE

83
Eagle

c. 1500, Aztec

Stone, 41 × 20 cm

Museo Regional de Puebla, CONACULTA-INAH, 10-203440

The patron gods of the supreme rulers (*tlatoque*) of the Aztec empire were the deities associated

with the sun and with war, principally Xiuhtecuhtli and Huitzilopochtli. Hence, the animals who symbolised these gods were intimately linked with the *tlatoque*. The eagle was one of them. The present sculpture depicts an eagle standing on a rectangular base, the sides of which show the wickerwork characteristic of the *tlatoani*'s throne (*icpalli*) in Tenochtitlan. The hieratic image is a metaphor of the power and sovereignty of the *tlatoani*. The eagle stands erect on its base, its wings held close to its body, in the way that the *tlatoani*, the living representative of the sun and of fire, appeared before his people on the *icpalli*. Traces of the original stucco can be seen around the eyes and on parts of the plumage. FS, RVA

85
Pipe in the form of a dog

c. 1500, Aztec

Fired clay, 7.5 × 24.5 cm

Museo Nacional de Antropología, Mexico City, CONACULTA-INAH, 10-79507

PROVENANCE: Tlatelolco, Mexico City

86
Pipe in the form of a duck

c. 1500, Aztec

Fired clay, 9 × 19 cm

Museo Nacional de Antropología, Mexico City, CONACULTA-INAH, 10-116576

PROVENANCE: Tlatelolco, Mexico City

87
Pipe

c. 1500, Aztec

Fired clay, 12.5 × 28 × 4 cm

Museo Nacional de Antropología, Mexico City, CONACULTA-INAH, 10-220130

PROVENANCE: Tlatelolco, Mexico City

SELECTED REFERENCE: Porter 1948, pp. 206–08, nos 18–20

The present vessel may have been used in rituals devoted to Quilaztli.

Although it is not known where the vessel was found, the style of the painted decoration is typical of Postclassic ceramics from Cholula and its environs. ST

Two varieties of tobacco were cultivated in Mexico: *Nicotiana tabacum* and *Nicotiana rustica*. The Aztecs and other Nahuatl-speaking people called it *yetl*. They considered tobacco to be a sacred plant created for the enjoyment of the gods and they venerated it for what appeared to be its magical powers. They either rolled the leaves into cylinders and smoked them like a modern cigar or shredded and pounded them for smoking in pipes like those shown here. Tobacco pipes were usually made of clay, and their bowls took a great variety of shapes. Archaeological excavations in Tlatelolco have unearthed large numbers of pipes, which suggests that smoking was very popular in the Aztec world. Some of the most elegant pipes have plain cylindrical bowls that are covered in red pigment and burnished to a high gloss (cat. 87). Others are shaped in the form of animals, and

84
Vessel in the shape of a deer's head

c. 1250–1521, Mixteca–Puebla

Fired clay and paint, 29 × 26 × 22 cm, diameter of spout 9.5 cm

Rautenstrauch-Joest-Museum, Cologne, Ludwig Collection, SL XCVI

PROVENANCE: Ludwig collection, donated 1983 to the Rautenstrauch-Joest-Museum

SELECTED REFERENCES: Bolz-Augenstein 1975, nos 96, 97; Hildesheim 1986, no. 237; Nuremberg 1993, p. 42, no. 11

The vessel is shaped as a deer's head with a cylindrical spout at the top. The ears of the roe-deer are white and its eyes are depicted in a fairly realistic manner. Similar images of such *mazatl* ('deer') with antlers suggest that they represent the white-tailed deer (*Odocoileus virginianus mexicanus*).

The deer was associated in Mesoamerican mythology with the female deity Quilaztli or Cihuacoatl ('woman serpent'), who was worshipped at Colhuacan on Lake Xochimilco, south of Tenochtitlan. In the form of a double-headed deer she was said to have been killed by the hunting god Mixcoatl ('cloud serpent'). Promptly changing into a woman, she was impregnated by Mixcoatl and gave birth to the hero Quetzalcoatl ('feathered serpent').

these were probably used by priests devoted to the deity whose *nahual* (spirit twin) was a particular animal. Such examples are the pipes shaped like a dog (cat. 85), an animal associated with Xolotl, god of monsters; like a duck (cat. 86) and like macaws (cats 117–18), birds that brought memories of ancestors, the effect that smoking tobacco produced in the minds of the Aztecs. FS, RVA

88
Flute in the form of a macaw

c. 1300–1521, Aztec

Fired clay and traces of paint, 8.3 × 11 × 14 cm

Trustees of the British Museum, London, Ethno. 1865.6-10.9

PROVENANCE: purchased from Charles Farris, 1865

SELECTED REFERENCE: Smith 1996, pp. 272–73

Vivid first-hand accounts as well as pictorial records preserved in codices offer glimpses of the kind of energetic communal Aztec celebrations in which music, song and dance played an indispensable role. Rhythmic chanting and drumming formed a key element in much ritual performance and were accompanied by a range of wind and percussion instruments, including flutes, whistles, drums and rattles. The sounds and cries of birds and animals could also be mimicked both by vocalisation and by playing appropriate instruments. This ceramic flute of the kind known as an *ocarina* is fashioned in the form of a macaw or parrot identified by its distinctive curved upper beak and modelled eye. It is played by blowing through an aperture at the end of the bird's tail, with the body acting as a sound chamber. The arrangement of four other openings on its back enables dextrous fingers to conjure up a haunting, melodious sound. Such instruments were thought to become animate objects when played and contributed to the cacophony of sounds, movement and colour that once characterised the seasonal festivals in the Aztec calendrical round. CMcE

89

Plate

c. 1500, Aztec

Fired clay and paint, height 4.5 cm,
diameter 31 cm

Museo Nacional de Antropología,
Mexico City, CONACULTA-INAH, 10-116416

PROVENANCE: Tlatelolco, Mexico City, 1964

SELECTED REFERENCE: Vega Sosa 1975

The decoration of the plate is full
of symbolism relating to the sun
god, Tonatiuh. His *nahual* (spirit
twin) is the eagle, which appears
in the centre of the plate with
wings and tail outstretched, as
if in full flight. Decorated with
sacrificial feathers, its tongue
hangs out in allusion to its thirst
for blood. Pointing in the cardinal
directions, four symbols are
arranged like shells around the
central disc, alternating with the
tonallo (four circles associated
with heat) and the many-petalled
chimalxóchitl (sunflower), which
some believe to be the image of
the full sun. As a whole, the design
represents the passage of the sun
from east to west, emphasising
its position at midday, when it
provides maximum light and
heat. Thirteen bands with various
geometric and linear motifs
indicating the celestial planes
appear around the central design,
reinforcing its astronomic and
calendrical character. The first
band, with 29 circles, represents
the plane of the moon, while
the third, with the *xicalcoliuhqui*
(stepped pattern), refers to the
plane on which the sun moves,
shown as twenty spirals (the
number of signs denoting the
days of the indigenous calendar).
The fifth band is associated
with fire, as indicated by its
50 circles, i.e. ten times the
quincunx. FS, RVA

90

Two-tiered tripod plate

c. 1500, Aztec

Fired clay and paint, height 6 cm,
diameter 22.5 cm

Museo Nacional de Antropología,
Mexico City, CONACULTA-INAH, 10-1049

PROVENANCE: Mexico City, 1966

SELECTED REFERENCES: Bernal 1967, p. 197,
no. 132; Solís Olguín 1991B, p. 260, no. 401

Among the everyday ceramics
typical of Tenochtitlan were
vessels made of yellowish and
coffee-coloured clay, burnished
to produce a polished surface.
Before firing they were decorated
with motifs painted with very
fine brushes. The present example
served a secular rather than
religious purpose, its two tiers
designed to keep wet food
separate from dry. The decoration
features the head of a spider
monkey with the half-mask in
the shape of a bird's beak that
identifies the figure as Ehecatl-
Quetzalcoatl, god of wind. He
wears the feathered attire of
sacrificial victims, the *cuauhpiyolli*
headdress of great warriors and
the ear ornament known as an
oyohualli. The rim is adorned with
lines indicating precious liquid –
blood – with *chalchihuitl* (symbols
for jade). FS, RVA

91

Vessel with an image
of a centipede

1400, Totonac

Fired clay and paint, height 16 cm,
diameter 19 cm

Museo Nacional de Antropología,
Mexico City, CONACULTA-INAH, 10-78683

PROVENANCE: Los Otates, Veracruz, Mexico

SELECTED REFERENCES: Lothrop 1964, p. 37;
Bernal and Simoni-Abbat 1986, p. 242

In the course of their travels
throughout Mesoamerica,
the Aztec army and *pochteca*
(professional merchants) acted
as a channel for the dissemination
of cultural influence from the
capital, Tenochtitlan. The clearest
evidence of this are the ceramics
dating from the Late Postclassic
period (1250–1521) that have been
found at various points along
military and commercial routes.
The present vessel was discovered
at Los Otates, in the coastal region
of the Gulf of Mexico. Stylistically,
it is closely related to illustrations
in codices, particularly those
produced by the Mixtecs. The
elegant, realistically depicted
centipede (*petlazolcoatl*) is painted
in orange and yellow. The Aztecs
associated centipedes with the
earth, night and the powers of
darkness, and in some reliefs
from Tenochtitlan they can be
seen among the tangled locks
of Tlaltecuhtli, the 'earth lord'.
FS, RVA

IV GODS OF LIFE

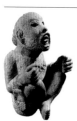

92

Xipe Totec

c. 1350–1521, Aztec

Volcanic stone and paint,
46 × 26.3 × 27.4 cm

Museum der Kulturen Basel, Basle, IVb 647

PROVENANCE: near Tetzcoco, before *c.* 1830;
Lukas Vischer collection, donated to the
museum, 1844

SELECTED REFERENCES: Nebel 1963, pl. 48;
Basle 1985, p. 77; Bankmann and Baer 1990,
p. 122; Miller and Taube 1993, p. 188

The cult of Xipe Totec ('our flayed
lord') was prominent in several
Postclassic Mesoamerican cultures
since it related to the earth,
vegetation and agricultural
renewal. During the
Tlacaxipehualiztli festival, held
before the rainy season, captives
or slaves were sacrificed by having
their hearts removed. The corpses
were then flayed and priests wore
the skins for twenty days.

The sculpture depicts Xipe
Totec wearing flayed skin, the
open mouth and the eyes revealing
those of the figure beneath.
Originally, the oval hollows of the
eyes probably contained inlays.
The ears are pierced to take
ornaments. The mask is tied with
cords at the back of the head, over
plaited hair. Human skin hangs
from the neck to the upper part of
the thighs. The long vertical cut at
the back, the pieces sewn together
in two places, indicates where the
body was flayed, while a horizontal
seam at the chest marks the point
where the skin was sewn together
after the extraction of the heart.
The skin leaves the hands
uncovered. Resting on the knees,
they are carved as hollow fists and
may have held insignia of some
kind. The hands of the flayed skin
dangle from the wrists. The legs
are bent upwards and the ankles
crossed. Those parts of the body
not covered by the skin, such as
the neck, legs and hands, are
painted red.

Carl Nebel made a drawing
of the sculpture *c.* 1830.
He mentioned that it had been
found near Tetzcoco. AB

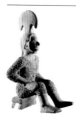

93

Xipe Totec

c. 1500, Aztec

Fired clay, 15 × 4 × 6.5 cm

Museo Nacional de Antropología,
Mexico City, CONACULTA-INAH, 10-333885

PROVENANCE: Tlatelolco, Mexico City, 1968

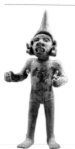

94

Xipe Totec

c. 1500, Aztec

Fired clay, 15.5 × 5 × 3 cm

Museo Nacional de Antropología,
Mexico City, CONACULTA-INAH, 10-333856

PROVENANCE: Tlatelolco, Mexico City, 1968

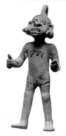

95

Xipe Totec

c. 1500, Aztec

Fired clay, 14.5 × 6 × 3.5 cm

Museo Nacional de Antropología,
Mexico City, CONACULTA-INAH, 10-116779

PROVENANCE: Tlatelolco, Mexico City, 1968

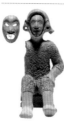

96

Xipe Totec

c. 1500, Aztec

Fired clay, 12 × 5.5 × 8 cm

Museo Nacional de Antropología,
Mexico City, CONACULTA-INAH,
10-116778 2/2

PROVENANCE: Tlatelolco, Mexico City, 1968

SELECTED REFERENCES: Solís Olguín 1991B,
p. 259, no. 396; Seville 1997, pp. 136–37;
Guilliem 1999, pp. 97–102, 302–04; Mexico
City 2001, p. 359

The four sculptures from
Tlatelolco – the twin city of
Tenochtitlan, now part of Mexico
City – re-create the rites associated
with the god Xipe Totec, a god
of spring and the patron of
goldsmiths. The figurines
represent the god's impersonators,
who may have been priests,
warriors or commoners. They all
wear the flayed skins of captives
sacrificed during the ceremonies,
which took place in the 'month' of
Tlacaxipehualiztli ('flaying of men
in honour of Xipe'). The festivities
culminated in the hand-to-hand
combat called *tlauauaniliztli*, in
which five Mexica warriors – two
each from the jaguar and eagle
orders and a fifth who had to be
left-handed – wielded *macáhuitl*
(swords with obsidian-edged
blades) against prisoners taken
in battle, all of whom ended their

days on the sacrificial stone.
The Spanish dubbed this warlike
ceremony the 'gladiatorial
sacrifice'.

Two figures in the group are
seated on a small bench (cats 93,
96). These are high-ranking
warriors. Their headdresses bear
a large copper axe on top and they
are notable for small, removable
face masks. One of them (cat. 93)
wears a lip-plug . The other pair
of figures (cats 94–95), shown in
a processional pose, wear the
flayed skin of a victim, with a
clearly visible suture on the chest
indicating that the heart has been
removed. One of the headdresses
is conical, the other curves in the
shape of a hoop. The swallow-
tailed ear ornaments resemble the
obsidian items found among the
offerings at the Templo Mayor in
Mexico City and are a distinctive
feature of Xipe Totec
iconography. FS, RVA, AG

97

Container for flayed skin

c. 1500, Aztec

Fired clay, height 25 cm, diameter 48.5 cm

Museo Nacional de Antropología,
Mexico City, CONACULTA-INAH, 10-594908

PROVENANCE: Calle de las Escalerillas,
Mexico City, 1900

SELECTED REFERENCES: Batres 1902, p. 25;
Amsterdam 2002, p. 235, no. 189

The Tlacaxipehualiztli ceremony
took place during the second
twenty-day period of the Aztec
year. The present container was
among objects used in connection
with these rites that were
discovered in the Calle de las
Escalerillas in Mexico City, in
the area of the Templo Mayor,
proving that the temple was linked
with the Yopico, a ritual building
dedicated to the worship of Xipe
Totec ('our flayed lord'). The
exterior surface of the container
is puckered like flayed human skin,
a reference to the ceremonially
flayed skins of human sacrifices
that were worn by priests and
other devotees of Xipe Totec. The
Spanish chronicler Bernardino de
Sahagún described how, during
the Tlacaxipehualiztli ceremony,

they wore the skins over their body and face for twenty days in order to resemble the god, then removed them and stored them in a chamber beneath the temple. Containers such as the present item were probably used for this purpose, since they have tight-fitting lids that would have prevented the stench of the rotting skins from escaping. FS, RVA

98

Brazier with an image of Xipe Totec

c. 1500, Aztec

Fired clay, 36 × 40 cm

Museo Nacional de Antropología, Mexico City, CONACULTA-INAH, 10-220143

PROVENANCE: Mexico City, 1982

SELECTED REFERENCE: Mexico City 1995, p. 123, no. 110

Atzcapotzalco, the part of Mexico City where the brazier was found, was once the capital of the Tepanecs, from whose yoke the Aztecs freed themselves by defeating the Tepanec ruler Maxtla to gain control of the Basin of Mexico. Following the instructions of Huitzilopochtli, the Aztecs proceeded further on their 'sacred mission' by conquering the surrounding villages. The brazier once formed part of the decoration of the ceremonial centre of Atzcapotzalco. It bears an image of a triumphant warrior dressed as Xipe Totec, who was believed by the Aztecs to have invented war. Impersonating the god, the warrior has covered his face with a mask of human skin and has adorned himself with vertical strips of paper ending in the swallow-tail design exclusive to the iconography of Xipe Totec. He wears a crenellated headdress, decorated with small bows and held in place by a band of discs like those associated with Xiuhtecuhtli, the god of fire. On his back is a large strip of bark-paper, curved and gleaming and decorated with rosettes of pleated paper. The warrior holds a round shield, which would originally have been yellow, and a sceptre, which is broken. FS, RVA

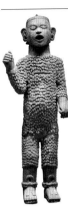

99

Xipe Totec

c. 1500, Aztec

Fired clay and paint, 97 × 43 × 20 cm

Museo Regional de Puebla, CONACULTA-INAH, 10-203061

PROVENANCE: Tepeji el Viejo, Puebla, 1975

SELECTED REFERENCES: Madrid 1990, pp. 111–12, no. 46; Mexico City 1995, p. 122

In 1975 the Mexican historian Eduardo Merlo carried out excavations at Tepeji el Viejo, an ancient fortified city in the mountains of southern Puebla State. Before it was conquered by the Aztecs, this region had been inhabited by the Popolocas, a people related to the Mixtecs. First expeditions to the area, undertaken at the behest of Charles IV of Spain in 1805 by the army officer Captain Guillermo Dupaix, brought to light a fragment of a *temalácatl* (see cat. 209) that showed evidence of having been used during Tlacaxipehualiztli, the ceremony associated with the god Xipe Totec. This was confirmed in 1975 by the discovery of an offering containing the bones of warriors or victims sacrificed to Xipe Totec along with the present striking image of a priest in the service of the god, which had also been 'sacrificed' by being broken into pieces. Despite this, the sculpture is especially well preserved. FS, RVA

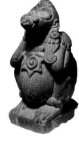

100

Spider monkey with ornaments relating to Ehecatl-Quetzalcoatl

c. 1500, Aztec

Volcanic stone, 43.5 × 24.6 × 24.4 cm

Laboratoire d'Ethnologie, Musée de l'Homme, Paris, M.H.78.1.89

PROVENANCE: Eugène Boban collection; Alphonse Pinart collection, donated to the Musée d'Ethnographie du Trocadéro, 1878

SELECTED REFERENCES: Hamy 1897, pp. 25–26, pl. 13, no. 37; Basler and Brumer 1928, pl. 104A; Pasztory 1983, p. 234, pl. 224; Washington 1983, pp. 126–27, no. 48; Gendrop and Díaz Balerdi 1994, p. 90, fig. 103; Espinosa Pineda 2001, p. 262, fig. 13

The Aztecs associated the spider monkey (*Ateles geoffroyi*), along with the opossum and certain species of duck, spider, ant and snail, with

Ehecatl-Quetzalcoatl, the god of wind. They connected this animal with air currents and whirlwinds because of its great agility, its incessant swinging through trees and its long, prehensile, spiral-shaped tail. According to Aztec cosmogony, at the end of the world-era known as Nahui Ehecatl ('4-wind') human beings were turned into monkeys as a result of violent gales.

The present sculpture, which belonged to the nineteenth-century collector and antique dealer Eugène Boban and was shown at the Exposition Universelle in Paris in 1878, depicts a monkey squatting on a quadrangular base. Its legs, adorned with knotted ribbons, rest beside its characteristically large belly; its hands, likewise decorated with knotted ribbons, are laid on its shoulders. The curled tail lies against the bottom of its back. The head, with its tuft of hair, is turned slightly upwards, and the cheeks are inflated as if the creature were blowing vigorously. Some features of the sculpture relate specifically to Ehecatl-Quetzalcoatl: the tubular nose ornament, the curved ear adornments (*epcololli*) made of shell, obsidian and pyrite, and the spiral-shaped pendant (*ehecacozcatl*) created from a sliced *Strombus* conch. LLL, MFFB

101

Spider monkey with ornaments relating to Xochipilli

c. 1500, Aztec

Volcanic stone, 19.5 × 18.5 × 8.5 cm

Laboratoire d'Ethnologie, Musée de l'Homme, Paris, M.H.87.159.143

PROVENANCE: donated by M. Franck, lent by the Musées nationaux

SELECTED REFERENCES: Nicholson 1971, p. 129, fig. 42; Manrique 1988, pp. 144–45; Seler 1996, pp. 167–73

Aztec sculptors frequently depicted the spider monkey (*Ateles geoffroyi*), one of three monkey species indigenous to Mesoamerica. This fruit-eating, tree-dwelling animal was common in the jungle regions of Maya territory, the Isthmus of

Tehuantepec, the Balsas basin, the mid-Pacific and the coastal areas of Veracruz. For the Aztecs, the good-natured spider monkey, which was regarded as the most vivacious and playful creature in the animal kingdom, symbolised gluttony, sexuality and pleasure in general. Among the deities it was associated with was Xochipilli-Macuilxochitl ('flower prince-five flower'), the god of dance, song, music, games and poetry. It was thought that those born in the thirteen-day period '1-monkey' of the divination calendar would be friendly and cheerful with an aptitude for music, painting and art, while those born on day '5-monkey' would tend to be self-indulgent and fond of joking.

The large-bellied male monkey on this disc-shaped sculpture is crouching with a tropical alcatraz flower and leaf in one hand (species *Philodendron*) and, in the other, what appears to be a sceptre made from the fruit of this climbing plant, one of the spider monkey's favourite foods. The monkey wears a necklace with seven snail shells and ear adornments known as *oyohualli*, which are associated with Xochipilli-Macuilxochitl. On the reverse is a circular mat bearing a checkerboard pattern. LLL, MFFB

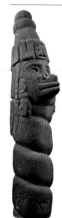

102

Dancing monkey

c. 1500, Aztec

Stone, 60 × 37 × 33 cm

Museo Nacional de Antropología, Mexico City, CONACULTA-INAH, 10-116784

PROVENANCE: Pino-Suarez Metro station, Mexico City, 1967

SELECTED REFERENCES: Bernal and Simoni-Abbat 1986, pp. 355–57; Solís Olguín 1991, p. 110

The bird-beak mask and the body twisted in a spiral dancing movement identify this pregnant monkey as Ehecatl-Quetzalcoatl, god of wind. Like the pose, the coils of the serpent creeping up the monkey's leg recall the whirlwinds that announce the arrival of the rainy season. The sculpture was discovered during archaeological excavations

at Pino-Suarez Metro station in Mexico City, where it was found in a 'circular pyramid', a form characteristic of buildings dedicated to Ehecatl-Quetzalcoatl. It had been 'sacrificed' by the Aztecs, who had broken it into several fragments and buried it. FS, RVA

103

Ehecatl-Quetzalcoatl

c. 1480–1519, Aztec

Andesite, 195 × 40 × 50 cm

Rautenstrauch-Joest-Museum, Cologne, Ludwig Collection, SL CVII

PROVENANCE: private collection, Mexico City; purchased from a dealer by Peter and Irene Ludwig, 1966; donated to the Rautenstrauch-Joest-Museum, 2002

SELECTED REFERENCES: Bolz-Augenstein and Disselhoff 1970, pp. 112–14, no. 33; Hildesheim 1986, no. 163; Cologne 1999, p. 186, no. 84

The sculpture represents Quetzalcoatl ('feathered serpent') in his manifestation as the god of wind, Ehecatl ('wind'). This deity played an important role in Aztec creation myths, for he was thought to have set the sun and moon in motion by his blowing. He was also a leading god of agriculture, producing whirlwinds that swept the roads for the rain gods and thus ensuring that the dry season ended.

Ehecatl is identified by the mouth mask, which here resembles a duck's beak and is an integral part of the face. The wide-open nostrils indicate that he is blowing through the mask. Other distinctive features are the curved ear pendant and the conical headdress; a zigzag band with a knot at the front is attached to the latter. The body seems to be formed of a coiled serpent, but the feathers characteristic of Ehecatl-Quetzalcoatl are missing. More probably, the body represents a vortex of the kind produced by the wind on the Mexican plateau before the rainy season.

It is not known where the sculpture was found. It may have come from Tenochtitlan, the Aztec capital, which became a centre of stylistic innovation *c.* 1480. ST

104

Mask with an image of Ehecatl-Quetzalcoatl

c. 1350–1521, Aztec

Stone, 14 × 14 × 10 cm

Staatliche Museen zu Berlin: Preußischer Kulturbesitz, Ethnologisches Museum, IV Ca 26077

PROVENANCE: collected by Eduard Seler, 1905

SELECTED REFERENCES: Seler 1960–61, vol. 2, pp. 953–58; Washington 1983, pp. 103–04; Miller and Taube 1993, pp. 84–85; Solís Olguín 1993, pp. 69, 74

The mask shows the clean-cut features of a youthful face and, on the concave reverse, an image in low relief of the wind god Ehecatl-Quetzalcoatl, distinguished by a conical headdress and a beak-like mouth mask through which he blows the wind that brings rain clouds. Ehecatl-Quetzalcoatl is among the guises assumed by Quetzalcoatl ('feathered serpent'), one of the most important gods in the Aztec pantheon. He is shown here seated cross-legged in a frontal view, but with his head in profile. A large pendant adorns his ear and he wears a necklace. In his hands he holds curved sceptres bearing small circles.

The nine circles above Ehecatl-Quetzalcoatl on the left permit the relief to be read as the date '9-wind', one of the god's calendrical names. Associated with wind, rain and fertility, Ehecatl-Quetzalcoatl was also the patron of the 'wind' day, the second of twenty day-glyphs in the 260-day ritual calendar. In the Aztec creation myths he plays a central role as a divine creator and bringer of culture. During the creation of the earth and the sky Ehecatl-Quetzalcoatl, together with the deity Tetzcatlipoca, rescued the bones of humans from the underworld, thereby creating present-day humankind.

In the early decades of the twentieth century Eduard Seler, who in 1903 became head of the American department at the ethnological museum in Berlin, laid the foundations of Mexican studies in the German capital. He acquired the mask for his collection on one of his six extended visits to America. MG

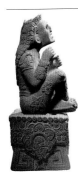

105

Xochipilli

c. 1500, Aztec

Stone, 115 × 53 × 43 cm

Museo Nacional de Antropología, Mexico City, CONACULTA-INAH, 10-222116 0/2

PROVENANCE: Tlamanalco, Mexico State; Alfredo Chavero collection, donated to the Museo Nacional in the nineteenth century

SELECTED REFERENCES: Peñafiel 1910, p. 15; Pijoán 1946, pp. 143–44; Anton 1969, p. 112, no. 193; Wasson 1983, pp. 89–107

The regenerative force of nature is present in this sculpture of Xochipilli ('flower prince'), the god of flowers and plants and the patron of dance and song. The deity sits cross-legged on a ritual seat sculpted in the form of a flower whose corolla, petals, stamens and pistils spread round all four sides of the throne. Each side shows another fully opened flower with a butterfly drinking nectar at its centre – an image invoking the flowering of the universe. Xochipilli's main item of attire is the sacred mask he wears as god of the feast celebrating the rainy season and the flowering of the earth. He also wears a necklace made of the skin of a jaguar head and a loincloth. Flowers are painted or tattooed on his limbs. Some scholars have identified these as the most important plants used to communicate with supernatural forces, i.e. as plants with hallucinatory properties.

The Mexican dramatist and historian Alfredo Chavero found the sculpture on the outskirts of Tlamanalco, a small village on the slopes of the volcano Iztaccihuatl. FS, RVA

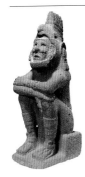

106

Xochipilli

c. 1500, Aztec

Fine-grained volcanic stone, 74.5 × 31 × 26 cm

Völkerkundliche Sammlungen Reiss-Engelhorn-Museen, Mannheim, V Am 1085

PROVENANCE: purchased in Mexico by a Mr Dohrmann, 1830; acquired by Gabriel von Max from the Schilling collection; acquired by the Reiss-Engelhorn-Museen from the Gabriel von Max collection, 1916–17

SELECTED REFERENCES: Krickeberg 1960, p. 1; Pasztory 1983, p. 225

The male figure, seated on a stool with his legs drawn towards him and his arms resting across his knees, wears only a loincloth, sandals and broad leather bands on his forearms and shins. The open helmet framing the face is shaped in the form of the bird known as *quetzalcoxcoxtli*, identifiable by the feather crest as a *tuberquel Hokko*, a tropical species that is the first to sing in the morning. This attribute helps to establish the context in which the figure was viewed, as does the rectangular stool, which in Aztec iconography was the seat of rulers and gods. The thin nose-bar ending on both sides in spheres links the wearer to the sun god, and both the human and the bird's head are adorned with rosette-shaped ear ornaments with bows. Clearly, the sculpture represents a divine being associated with the rising sun. A similar sculpture, surrounded by miniature music instruments, was found in 1900 in the former temple of Xochipilli in the centre of Mexico City, enabling the present figure to be identified as Xochipilli, the god of the rising sun, springtime, flowers and music. MT

107

Figure with flowers and maize

c. 1325–1521, Aztec

Stone and traces of paint, 27.7 × 25.2 × 29.9 cm

The Cleveland Museum of Art, The Norweb Collection, 1949.555

PROVENANCE: donated to the museum by Mrs R. Henry Norweb, 1949

SELECTED REFERENCES: Pasztory 1983, pp. 228–29; Madrid 1992, p. 157; Miller and Taube 1993, pp. 62, 78–79, 88–89, 90–91, 108, 190; Matos Moctezuma 1994, p. 198

Experts usually identify this appealingly expressive male as either Macuilxochitl ('five flower', a calendrical name) or Xochipilli ('flower prince'), two youthful Aztec deities so closely related that they often overlap. The domain of these gods – beauty, the arts and such pleasures as game-playing, dancing and sex – is signalled by their association with flowers: both names incorporate the

Nahuatl word for 'flower', and in one hand the figure holds a cone of flowers, perhaps the blossoming crown of a cactus. For the Aztecs flowers were richly metaphoric, signifying, among other things, beauty and refinement as well as fertility in general and sexuality in particular. The burden of maize cobs on the figure's back may further allude to these gods' creative energies and to Xochipilli's link to the maize god Centeotl, another vibrant young male.

Macuilxochitl and Xochipilli also meted out punishment to those who over-indulged in pleasure. Punishment often took the form of misfortune or disease – the latter, like immoderation, regarded as a dangerous imbalance – that fitted the crime. For instance, both gods sent afflictions of the reproductive organs, such as venereal disease, to those who violated a period of fast by having sex. SEB

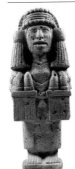

108

Xilonen

c. 1500, Aztec

Stone, 52 × 20 cm

Museo Nacional de Antropología, Mexico City, CONACULTA-INAH, 10-82209

PROVENANCE: Teloloapan, Guerrero, Mexico, 1964

SELECTED REFERENCES: Solís Olguín 1991, pp. 90–91, no. 54; Belém 1995, p. 99, no. 12; Amsterdam 2002, p. 198, no. 143

In the mid-fifteenth century the Aztec armies fell like predators on the provinces of Cihuatlan and Tepecuacuilco, territories on the Pacific coast in the present-day Mexican state Guerrero, from which they obtained greenstones, copper axes, cotton, honey, copal resin and red *Spondylus* shells, as well as rich spoils of woven cloaks, military garments and shields. Although the present sculpture of Xilonen, goddess of young maize, was discovered at Teloluapan in Guerrero, the quality of the carving suggests that it was made in a metropolitan workshop. The deity wears a headdress of cotton strips tied at the nape of the neck in a bow from which hang two

large cotton tassels – an indication of youth. She is dressed in a *quechquémitl* (cape) and a *cuéitl* (skirt) held in place by a narrow tasselled belt. In each hand she holds a *cinmáitl* (a pair of corn-cobs decorated with strips of paper). This fruit of the maize, gathered at the beginning of the harvest, was offered to the goddess. FS, RVA

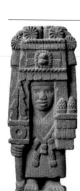

109
Chicomecoatl

c. 1350–1521, Aztec

Stone, 68 × 27 × 14 cm

Staatliche Museen zu Berlin: Preußischer Kulturbesitz, Ethnologisches Museum, IV Ca 46167

PROVENANCE: Carl Uhde collection, purchased by the museum, 1862

SELECTED REFERENCES: Eisleb 1973, p. 178; Washington 1983, pp. 76–77

The figure represents the Aztec goddess Chicomecoatl ('seven serpent'), the Nahuatl name for a day in the 260-day ritual calendar. Chicomecoatl was a fertility goddess held to be particularly responsible for maize, the most important plant cultivated by the Aztecs. As an indication of this function she wears the customary square headdress adorned with four rosettes. She is dressed in Aztec female costume: an ankle-length skirt and a *quechquémitl*, a cape with a straight-edged opening for the head. In her left hand she holds a double ear of maize, in her right a maraca with an arrow-shaped tip (*chicahuaztli*), a musical instrument played during fertility rites.

In common with most Aztec stone sculptures in the Ethnologisches Museum in Berlin (see also cats 47, 112, 199, 208, 219, 289), this item came from the collection of Carl Uhde, a merchant who lived in Mexico for many years. When brought to Europe in the first half of the nineteenth century, it was regarded as the most important Pre-Hispanic archaeological collection outside Mexico. Uhde set up a museum of Aztec-Mexican antiquities in Handschuhsheim

near Heidelberg, which was acquired in its entirety by the Berlin museum in 1862. MG

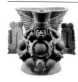

110
Brazier in the form of Chalchiuhtlicue

c. 1500, Aztec

Fired clay and paint, 54.5 × 64 × 55 cm

Museo Nacional de Antropología, Mexico City, CONACULTA-INAH, 10-1125

PROVENANCE: Tlatelolco, Mexico City; Alfredo Chavero collection, donated to the Museo Nacional in the nineteenth century

SELECTED REFERENCES: Madrid 1992, p. 112, no. 38; Códice Borbónico 1994; Belém 1995, p. 102, no. 15; Mexico City 1995, p. 135, no. 141

Alfredo Chavero (see cat. 105) amassed his collection of Aztec artefacts at a time when many fortuitous discoveries were being made in Mexico City. Among them was a pair of braziers found near the ceremonial precinct of Tlatelolco with their original bright polychroming intact. Both objects depict deities associated with vegetation. One, wearing the headdress of Xiuhtecuhtli, represents the male aspect of regeneration; the other (shown here), with a headdress with cotton tassels and bands of woven material, symbolises the female aspect identified as Chalchiutlicue. Such braziers in the shape of busts of deities were typical products of the Mexica, who depicted the god wearing a kind of pectoral bordered by a colourful necklace. They are similar in essence to the gods that rule each day in the *trecenas* of the *tonalpohualli* calendar in the Codex Borbonicus (Bibliothèque de l'Assemblée Nationale Française, Paris). Projecting from the brazier are curved bands representing clouds or steam. The goddess's headdress is enriched with paper adornments and she wears a gold pendant along with a necklace of alternating maize cobs and many-petalled flowers. Such flowers (*cempoalxóchitl*) feature in present-day Mexico in the Day of the Dead celebrations. FS, RVA

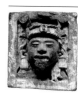

111
Plaque representing the Ochpaniztli festival

c. 1500, Aztec

Fired clay and paint, 32 × 29 × 12.5 cm

Museo Nacional de Antropología, Mexico City, CONACULTA-INAH, 10-1069

PROVENANCE: Cuihuacán, Mexico City, nineteenth century

SELECTED REFERENCES: Chavero 1958, p. 512; Pasztory 1983, p. 281, pl. 297; Bernal and Simoni-Abbat 1986, p. 274; Códice Borbónico 1994, fol. 30

A climactic moment in the Ochpaniztli ('sweeping') rites, which took place in the eleventh 'month' of the twenty-'month' Aztec agricultural calendar, was the beheading and flaying of a woman by a priest who personified the goddess Xilonen-Chicomecoatl, the female equivalent of Xipe Totec, by donning the headdress and clothes associated with her. The ceremony is depicted on folio 30 of the Codex Borbonicus (Bibliothèque de l'Assemblée Nationale Française, Paris), which shows the priest as the focal point of the scene with his face covered by a striking mask that, in fact, is the skin of the sacrificial victim's face. In the present plaque the priest/goddess wears a headdress of woven material decorated with strings and rosettes and coloured cotton tassels as ear ornaments. The victim's inexpressive face – i.e. the mask – is decorated with the spots of bitumen face paint (*chapópotl*) characteristic of fertility goddesses. Only traces remain of the bird that the codex image shows the priest holding by the neck between his teeth. FS, RVA

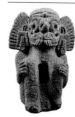

112
Tlaloc

c. 1350–1521, Aztec

Stone, 40 × 27 × 22 cm

Staatliche Museen zu Berlin: Preußischer Kulturbesitz, Ethnologisches Museum, IV Ca 3721

PROVENANCE: Carl Uhde collection, purchased by the museum, 1862

SELECTED REFERENCES: Berlin 1992, p. 81; Miller and Taube 1993, pp. 166–67

The two main characteristics of images of the rain god Tlaloc, who

was worshipped in Mesoamerica long before the arrival of the Aztecs, are large, goggle-like eyes and the fangs of a beast of prey. The present sculpture is notable for the fact that all these features are represented by two serpents. The intertwined bodies of the serpents form the eyes and nose, while their heads face each other to form the mouth with its array of sharp teeth. The bow at the back of the neck is typical both of Tlaloc and of other water gods.

The Aztecs imagined the rain god as dwelling in mountain caves. Capable of determining whether harvests were abundant or crops failed, Tlaloc was one of the most important deities in the pantheon, a fact reflected in the fact that one of the twin temples in Tenochtitlan, the Aztec capital, was dedicated to him. With his sister Chalchiuhtlicue, the goddess of seas, rivers, lakes and springs, Tlaloc presided over the *tlaloque*, the numerous lesser gods of rain, lightning and other meteorological phenomena. MG

113
Tlaloc

c. 1500, Mixtec–Istmeña (Huave)

Fired clay, height 88 cm, diameter 37.5 cm

Museo Nacional de Antropología, Mexico City, CONACULTA-INAH, 10-76360

PROVENANCE: Isthmus of Tehuantepec, Oaxaca, Mexico, nineteenth century

SELECTED REFERENCES: Belém 1995, p. 171, no. 11; Mexico City 1995, p. 35, no. 7; Seville 1997, pp. 174–75

The Isthmus of Tehuantepec was inhabited by peoples who came under the influence of both the Mixtecs and the Aztecs. Vestiges of their culture have been discovered in caves and mounds, among them two clay sculptures of Tlaloc, the god of rain, that were acquired by the Museo Nacional in Mexico City in the nineteenth century. They probably show the deity as he was impersonated by priests. The cylindrical body, made to contain amulets, sacred bones, relics and other ritual objects, is covered in strips of bark paper and clothed in a triangular piece of cloth. Over

this is placed a brightly coloured necklace consisting of circular plaques probably intended to represent jade and a large disc (originally of gold) in the centre. Below this is a wooden pendant in the form of a two-headed serpent that originally will have been covered with a mosaic of turquoise and shell. Tlaloc's mask is notably large, with 'goggle' eyes and six fang-like teeth emerging from the mouth. The god wears circular ear ornaments, and his headdress, a band with jade discs, features peaks symbolising mountains. FS, RVA

114
Serpent

c. 1250–1521, Aztec

Reddish stone, 53 × 24 × 25 cm

Vatican Museums, Vatican City, AM 3296

PROVENANCE: 'Museo Austria', 1925

SELECTED REFERENCES: New York 1983, pp. 234–35; Washington 1991, pp. 563, 569; Alcina Franch 1992, p. 392

The statue represents the 'feathered serpent' Quetzalcoatl, an ancient Mesoamerican god considered to be the bringer of enlightenment and well-being who is associated with daylight, priesthood and religious ceremonies. In the Postclassic period Quetzalcoatl took on a wider symbolic role, the creation of the Second Sun and the wind being attributed to him. Quetzalcoatl stood opposed to Tezcatlipoca, the god of night and war, but merged with other deities, such as Ehecatl, the god of wind and spreader of light in the world, and Xolotl, the god of monsters associated with duality. According to one version of Toltec mythology, Quetzalcoatl, defeated by his rival Tezcatlipoca, went to the east, promising to return at some unspecified time. This is said to be the reason why the Aztec ruler Motecuhzoma II welcomed Hernán Cortés in 1519 with open arms, mistaking him for the hero king returning from the sea.

The sculpture is made from a single block of reddish stone, slightly porous and carefully

smoothed. It represents a rattlesnake, coiled in a vertical spiral and covered with long feathers that stand out in relief; the end of the tail bears the characteristic rings of the rattle. The head is clearly outlined, with small round eyes, wide nostrils and two coils of a long forked tongue issuing from its mouth.

The provenance of this Late Postclassic sculpture is unknown. References to it in the Vatican archives date back no further than 1925, when it was recorded as having been donated by an unidentified 'Museo Austria'. DZ

115
Feathered serpent with an image of Tlaltecuhtli

c. 1500, Aztec

Stone, 28 × 45 × 45 cm

Museo Nacional de Antropología, Mexico City, CONACULTA-INAH, 10-81678

PROVENANCE: Mexico City, nineteenth century

SELECTED REFERENCES: Galindo y Villa 1903, pp. 220–21; Washington 1983, pp. 139–40

When the migrating Aztecs reached the centre of what is now Mexico they lived for some years in the ruins of the ancient city Tula, the capital of the Toltecs, amazed at the achievements of its erstwhile inhabitants. This led them to adopt the cult of the ancestral god Quetzalcoatl, the fabled founder and ruler of the city. They found the deity depicted as a serpent (his name means 'feathered serpent') and developed various versions of this image. In the present sculpture the head of the coiled snake wears a menacing expression. Its jaws are open, revealing rows of curved teeth; the large forked tongue covers part of the body. At the top appears a *tecpatl* (sacrificial knife) with the image of a face (see cat. 277). The sculpture represents an adaptation of Quetzalcoatl iconography to meet the requirements of Aztec beliefs, associating the god with human sacrifice and with the acquisition of blood, the precious liquid that the Aztecs thought was the sacred

food of the universe. Tlaltecuhtli, the lord of the earth, is depicted in relief on the underside of the sculpture. FS, RVA

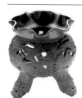

116
Tripod incense burner

c. 1500, Aztec

Fired clay, height 10.5 cm, diameter 10 cm

Museo Nacional de Antropología, Mexico City, CONACULTA-INAH, 10-78292

PROVENANCE: Malinalco, Mexico State, 1936

SELECTED REFERENCES: Westheim 1962, p. 51, no. 70; Westheim et al. 1969, p. 239, no. 277; Solís Olguín 1991B, p. 259; Seville 1997, pp. 182–83, no. 67; Vienna 1997, p. 53, no. 30

This small incense burner was discovered at Malinalco, some 70 km south-west of the Basin of Mexico, where all the temples and sanctuaries glorified the birth of the sun, triumphing over its enemies of darkness. It was here that young men who had excelled in battle were subjected to difficult ritual trials to determine their eligibility for inclusion in the eagle or jaguar military orders. Three images of a monkey (*ozomatli*), a glyph of Macuilxochitl, the god of dance and music, are incised in the burner, the pierced sections of which, while fulfilling the practical function of enabling air to fan the embers, also underscore the poses and movements of the animal as it leans down, looks up and flexes its legs. The *ozomatli* holds flowers in both hands. The wavy mouth of the burner recalls an open flower and each leg has the shape of a different flower with its stamens and pistils. FS, RVA

117
Pipe in the form of a macaw

c. 1500, Aztec

Fired clay, 12 × 17.5 × 5.5 cm

Museo Nacional de Antropología, Mexico City, CONACULTA-INAH, 10-79956

118
Pipe in the form of a macaw

c. 1500, Aztec

Clay, 14 × 21 × 5.5 cm

Museo Nacional de Antropología, Mexico City, CONACULTA-INAH, 10-223669

PROVENANCE: Tlatelolco, Mexico City, 1967

SELECTED REFERENCES: Belém 1995, p. 93; Mexico City 2001, p. 359

The inhabitants of southern Mesoamerica, notably the Maya, called the macaw *mo'* and viewed it as a disguise used by the sun god Kinich K'ak'Mo. This pair of pipes, found among the offerings at the ceremonial centre of Tlatelolco, now part of Mexico City, is a rare instance of the macaw in Aztec imagery. Called *cuezallin* ('flame') by Nahuatl speakers, this bird was a *nahual* (spirit twin) of the sun. The fact that one of the present pieces is red and the other black reflects the sun's passage through the cosmos, half of it day (red), when it illuminates and warms the earth, the other half night (black), when the sun becomes the image of a dark mirror as it makes its way through the inside of the earth. Excavations carried out in 1968 along the route of a Metro line in Mexico City, crossing the Plaza Mayor and continuing behind the Metropolitan Cathedral, brought to light an extraordinary offering in front of the Templo Mayor: dozens of macaw skeletons traced the path of the sun, their wings extended in an east–west direction. FS, RVA

119
Vessel in the form of a rabbit

c. 1500, Aztec

Fired clay, 24 × 27 × 42.5 cm

Museo Nacional de Antropología, Mexico City, CONACULTA-INAH, 10-564023

PROVENANCE: Mexico City, 1994

SELECTED REFERENCES: Gonçalves de Lima 1956; Amsterdam 2002, p. 252, no. 213

The vessel takes the form of a rabbit lying on its back, revealing its legs and genitals and hiding its head behind its front paws as an expression of its characteristic timidity. During ceremonies devoted to Ome Tochtli ('2-rabbit'), patron of drunkards, priests are said to have served a powerful drink in such vessels, mixing the mildly alcoholic *pulque* (*octli* in Nahuatl) with trance-inducing drugs. The beverage

was drunk through straws, probably to evoke the mythical act of suckling from Mayahuel, goddess of the maguey plant, from the fermented sap of which *pulque* was produced. FS, RVA

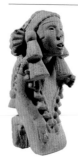

120
Chalchiuhtlicue

c. 1500, Aztec

Fine-grained volcanic stone, 53 × 25 × 20 cm

Völkerkundliche Sammlungen Reiss-Engelhorn-Museen, Mannheim, V Am 1084

PROVENANCE: purchased in Mexico by a Mr Dohrmann, 1830; acquired by Gabriel von Max from the Schilling collection; acquired by the Reiss-Engelhorn-Museen from the Gabriel von Max collection, 1916–17

SELECTED REFERENCES: Krickeberg 1960, p. 1; Washington 1983, p. 72

A young woman gazes upwards in an attitude of prayer, her mouth open. A threefold headdress edged by rows of curl-like balls is wound around her head and tied at the back in a double knot, from which dangle two thick, twisted cords ending in tassels. A pleated neck bow covers the back of the head. Large double tassels adorn both sides of the head. The elongated torso is covered by a *quechquémitl*, a rhomboid cape with a straight-edged opening for the head, that is likewise decorated with tassels at the edges. The woman's right hand rests on her tight skirt, while her left grips an object now lost. Finely elaborated sandals grace her feet.

Its attire identifies the figure as Chalchiuhtlicue ('she of the jade skirt'), a goddess of the sea, of lakes, fountains and flowing water in general and of agricultural fertility. Chalchiuhtlicue is considered the female counterpart of Tlaloc, the rain god worshipped throughout Mesoamerica. The dynamic conception of an asymmetrical figure balancing on its knees and toes, the gentle, feminine features and the elongated torso make this a masterpiece of Aztec sculpture. MT

121

Chalchiuhtlicue

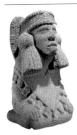

c. 1300–1521, Aztec

Andesite, 37 × 19.5 × 20 cm

Trustees of the British Museum, London, Ethno. St. 373

PROVENANCE: Henry Christy collection, donated to the museum, 1865

SELECTED REFERENCES: Pasztory 1983, pls 29, 220; Baquedano 1984, p.45, pl. 19; Miller and Taube 1993, p.60; McEwan 1994, p.73

This is one of many sculpted kneeling representations of Chalchiuhtlicue ('she of the jade skirt'), an allusion to the bluish-green depths of standing bodies of water. Images of this Mesoamerican goddess frequently feature in codices and are invariably painted blue to signal her role in mythology as the wife, mother or sister of Tlaloc, the rain god. As a beautiful young woman, she embodied the purity and preciousness of spring, lake and river water used to irrigate the fields. She also served as the patron saint of fishermen and played an important role in birth ceremonies in which newborn children were purified by being bathed in water and dedicated to her. The present sculpture depicts the goddess wearing a banded cap, adorned with a beaded fringe, and prominent dangling ear tassels. Her shoulder cape (*quechquémitl*) is also bordered by a tasselled fringe and is worn over a long skirt. Attached to the back of her head is a pleated fan made of bark paper (*amacuexpalli*) beneath which hangs a pair of neatly bound tresses. CMcE

122

Chalchiuhtlicue

c. 1500, Aztec

Stone, 32 × 20 × 15 cm

Museo Nacional de Antropología, Mexico City, CONACULTA-INAH, 10-1103

PROVENANCE: probably Basin of Mexico, first half of the twentieth century

SELECTED REFERENCES: Solís Olguín 1991, p.89, no. 53; Seville 1997, pp.138–39

In 1803–04 the German naturalist and explorer Alexander von Humboldt travelled in Mexico (then New Spain). His interest in geology led him to investigate not only the types of rock he found there, but also various archaeological objects in private collections. He illustrated such an item, owned by the Spanish army officer and explorer Guillermo Dupaix, in one of his books, describing it as the 'statue of an Aztec princess' and a typical example of Aztec sculpture. In fact, the piece depicted the kneeling Chalchiuhtlicue ('she of the jade skirt'), wife of the rain god, Tlaloc, and goddess of water as it appears in pools, lakes, rivers and the sea. Many similar images have since come to light. Like the present figure, they show the deity as a young woman wearing her characteristic headband, tied at the back and with large cotton tassels hanging over the ears like circular ear ornaments. Her clothing is that of a woman of noble birth, consisting of a *cuéitl* (skirt) and a *quechquémitl* (cape) with a border of smaller tassels, and she wears the three strings of jade beads (*chalchiuhcózcatl*) that form one of her chief attributes. FS, RVA

123

Mask of Chalchiuhtlicue

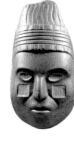

c. 1500, Aztec

Diorite, 33 × 17.5 × 10 cm

Museo Nacional de Antropología, Mexico City, CONACULTA-INAH, 10-15717

PROVENANCE: Mexico City, first half of the twentieth century

SELECTED REFERENCES: Pijoán 1946, p.130; Bernal 1967, p.189, no. 121; Solís Olguín 1991B, p.250, no. 380; Mexico City 1995, p. 118, no. 104

Friar Bernardino de Sahagún and other sixteenth-century Spanish chroniclers recorded accounts given by native people of Mesomerica of their religious practices. According to these reports, the Aztecs personified their deities by constructing sacred bundles which they dressed in colourful clothes and bedecked with jade jewellery and precious metals. Placing the mask of the deity on his or her 'body' was the culmination of the religious ceremony. The present mask of Chalchiuhtlicue ('she of the jade skirt'), goddess of water, has perforations on each side facilitating its attachment. It is finely carved from diorite, the dark green of which recalls water. The goddess's characteristic headband consists of strips of material that secure the *quetzalmiahuayo*, a crown of quetzal feathers. The hollow eye-sockets were originally inlaid with shell and obsidian; the striations on the cheeks represent the black face paint known as *xahualli*. The goddess's calendrical name, '8-grass', is engraved lightly on the back of the mask. FS, RVA

124

Slab with an image of Chalchiuhtlicue

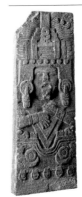

c. 1500, Aztec

Volcanic stone, 107 × 40 × 10 cm

Museo Nacional de Antropología, Mexico City, CONACULTA-INAH, 10-613348

PROVENANCE: Cerro de la Chinola, Veracruz; Dehesa collection; donated to the museum in the nineteenth century

SELECTED REFERENCES: Solís Olguín 1981, pp.89–92; Mexico City 1995, p. 117, no. 102

Eduard Seler (1849–1922) was the first to identify the image on this plaque from Cerro de la Chinola, near Castillo de Teayo in Veracruz, as that of Chalchiuhtlicue, the goddess of terrestrial water. The seven circles in the headband and the serpent behind the blue feathers worn by the figure indicate that she also embodies Chicomecoatl ('seven serpent'). The deity is shown emerging from the jaws of Cipactli ('earth monster'), who appears with his band of *ojos de la noche* ('night eyes'). The figure wears circular ear ornaments with pendants and probably (the piece is damaged) a *xiuhyacámitl* (turquoise nose-ring), both attributes of the water goddess. The plaque is likely to have been used as an altar. Four figures appear one above the other on the reverse, apparently floating as they lie down on their shoulders. They are *tlaloque*, assistants of the rain god, Tlaloc; in one hand they hold Tlaloc's pitcher and in the other the *xicahuaztli*, the rattle used to break the vessel that produces sunlight and the thunderclap that

heralds rainfall. Chalchiuhtlicue is associated with water that flows from underground springs and, as a goddess of maize, with the plant that grows during the rainy season. FS, RVA

125

Vessel in the form of a drum

c. 1500, Aztec

Fired clay, 15.5 × 25 × 10.5 cm

Museo Nacional de Antropología, Mexico City, CONACULTA-INAH, 10-116789

PROVENANCE: Mexico City

SELECTED REFERENCES: Solís Olguín 1991B, p. 259, no. 397; Madrid 1992, p. 272, no. 75

This vessel was no doubt used in rites dedicated to Macuilxochitl, patron of dance and music, for the engraved image depicts this god dancing. The piece was made in imitation of the Mesoamerican horizontal drum called *teponaxtli* (see cats 157, 338), which stands on a circular base: the two tongues of the 'xylophone' can be seen at the top and the hammers, with which the tongues were struck to produce the sound, at the sides. The mouth and spout of the vessel are at the rear of the *teponaxtli*. The figure of Macuilxochitl, the patron deity of musicians and dancers, is accommodated to the horizontal shape of the drum, with his legs bent to indicate movement. His headdress consists of bands with rounded borders, like that of the god Quetzalcoatl. Attributes special to Macuilxochitl are the pectoral and the ornaments attached to his ears. In one hand the dancing god holds the five-pistil flower of his calendrical name, '5-flower', and in the other a feather fan. FS, RVA

126

Votive drum

c. 1500, Aztec

Stone, 35 × 72 × 26 cm

Museo Nacional de Antropología, Mexico City, CONACULTA-INAH, 10-78329

PROVENANCE: Tlalmanalco, Mexico State, nineteenth century

SELECTED REFERENCES: Castañeda and Mendoza 1933, pp. 5–7; Westheim et al. 1969, p. 169

The horizontal drum known as *teponaxtli* is characteristic of Mesoamerican cultures (see also cats 125, 157, 338). The present piece is a ritual sculpture in the shape of a drum, which indicates that it was used in ceremonies devoted to Xochipilli-Macuilxochitl ('flower prince-five flower'), god of music, song and dance. The *teponaxtli* stands on a base like a fibre ring called *yahualli*; its ends are covered in jaguar skin, an expression of the deity's regal status. The nose and eyebrows of his stylised face consist of a flowering plant; he covers his eyes with the palms of both hands like a mask; the mouth is a stylised butterfly; and the ornaments characteristic of Xochipilli hang from his ears. FS, RVA

127

Mirror with a depiction of Ehecatl-Quetzalcoatl

c. 1500, Aztec

Pyrite, 6 × 5.5 × 3 cm

Laboratoire d' Ethnologie, Musée de l'Homme, Paris, M.H.78.1.61

PROVENANCE: Eugène Boban collection; Alphonse Pinart collection, donated to the Musée d'Ethnographie du Trocadéro, 1878

SELECTED REFERENCES: Hamy 1897, p. 22, pl. 11, no. 34; Chefs-d'œuvre 1947, p. 26, no. 58; New York 1970, p. 314, no. 303

The hemispherical pendant, made of pyrite (an iron ore with a golden surface), is pierced horizontally in the middle. Its flat face was used as a mirror. For the Aztecs, mirrors were magical instruments that constituted a portal to another world.

On the back of the pendant, which is convex, a bas-relief depicts Ehecatl-Quetzalcoatl, the wind god, in a squatting position. He is wearing his characteristic conical hat, decorated with a long band knotted in the middle and a horizontal snake-like emblem. A vertical stripe crosses his face, which is partly obscured by a mouth mask shaped like the beak of an *ehecatotl* ('wind bird'). Several different characteristics are combined in this mask: the sharp beak of the cormorant (*Lophodytes cucullatus* and *Mergus merganser*), the

seasonal crest of the white pelican (*Pelecanus erythrorhynchos*) and the frontal crest of the coot (*Rallus*). Below the mask we see Ehecatl-Quetzalcoatl's characteristic beard. He also wears curved ear adornments (*epcololli*), a simple necklace, a spiral pendant made of a segment cut from a conch shell (*ehecailacozcatl*) and a loincloth. In his right hand he is holding a round shield and a paper banner decorated with feathers, and in his left a hook-shaped *ehecatopilli* ('wind staff'). A rattlesnake decorated with a feather at the back of its neck moves above the figure. LLL, MFFB

128

Huitzilopochtli

c. 1500, Aztec

Greenstone, 6.7 × 4.1 × 4.7 cm

Laboratoire d'Ethnologie, Musée de l'Homme, Paris, M.H.30.100.43

PROVENANCE: on loan from the Musée Guimet, Paris

SELECTED REFERENCES: Lehman 1906; New York 1970, p. 314, no. 304; Nicholson 1988, pp. 242–47, fig. 21; Boone 1989, p. 10; Olivier 1997, pp. 80–81; Los Angeles 2001, p. 385, no. 165

Representations of Huitzilopochtli ('left-sided hummingbird'), the patron deity of the Aztecs, were apparently relatively scarce by the time the Spaniards arrived in Mexico, perhaps because he had come to be worshipped mainly among the upper echelons of society. Documents indicate that there were large sculptures of this sun god and god of war in the southern sanctuaries of the main temples of Tenochtitlan, Tlatelolco and Tetzcoco.

Of the very few images of Huitzilopochtli that survived the iconoclastic fury of the Spanish conquistadors most appear in codices or in the form of bas-reliefs. The present figure is the only known fully three-dimensional example. For many years it was mistakenly identified as Tezcatlipoca ('smoking mirror'). The two gods do indeed share a number of iconographical features, but the hummingbird disguise seen here belongs exclusively

to Huitzilopochtli. He is shown seated, wearing a headdress of two heron and two eagle feathers, two annular white shell pendants with leather ties (one on the chest, the other on the back) and a cape of skulls and crossbones. He has a serpent's head in place of his left foot and is holding a spear-thrower (see cat. 315) in his left hand. A sacrificial knife appears at his left shoulder. Obscuring his right hand is a round shield decorated with six circular feathers, three horizontal ropes and a banner. LLL, MFFB

129
Solar ray

c. 1500, Aztec

Basalt, 110 × 26.5 × 15 cm

Instituto Mexiquense de Cultura: Museo Arqueológico del Estado de México 'Dr Román Piña Chan', Teotenango, A-52215

PROVENANCE: Museum of the State of Mexico by the early twentieth century; passed to the Teotenango museum, 1975

SELECTED REFERENCE: Mexico City 1995, p. 126, no. 117

Fertility gods were commonly associated with agriculture in Mesoamerica. Earth, water and vegetation deities were often depicted carrying the staff named *chicahuaztli* (see cat. 275), a fertility symbol similar in appearance to the sculpture shown here, which has been identified as a phallic symbol. Other scholars have interpreted it as a solar ray with arrowheads (the triangular shapes at the top), indicating the fertilising action of the sun's rays as they penetrate the earth. MAM

V GODS OF DEATH

130
Figure with three faces

c. 250–700, Teotihuacan (?)

Fired clay and traces of paint, 18 × 22 × 9 cm

Col. Museo Universitario de Ciencias y Arte, Universidad Nacional Autónoma de México, Mexico City, 08-741814

PROVENANCE: donated by Ricardo Hecht, 1964

SELECTED REFERENCES: Celorio 1962; Gendrop 1981; Mexico City 1995, no. 73; Fuente 2000

The fragmented object bears remains of white, red, yellow and probably black paint. The iconography indicates that it may have formed the top of an anthropomorphic funerary urn. The three faces represent the cycle of life. In the middle appear the face of a young man, with all his teeth and wearing an ornament between the nose and upper lip, and two halves of the face of an old, toothless man; these two faces are framed by the symmetrically divided face of a corpse with its eyes closed. The thirteen decorative rings known as *chalchihuitl* (four on the young man's head, nine on the corpse's) represent the parts of a calendar cycle.

The piece may have come from Teotihuacan, but its history before entering the museum's collection in 1964 is unknown. LK

131
Altar of nocturnal animals

c. 1500, Aztec

Stone, 56 × 67 × 62 cm

Museo Nacional de Antropología, Mexico City, CONACULTA-INAH, 10-220921

PROVENANCE: Mexico City, first half of the twentieth century

SELECTED REFERENCES: Caso 1952; Washington 1983, pp. 56–59; Solís Olguín 1991, pp. 113–14, 117–19

The purpose of altars, which played a significant part in Aztec sculpture, was to support images of the most important gods. The altar of the nocturnal animals was

dedicated to Mictlantecuhtli, the deity of death and the underworld, a statue of whom no doubt stood on top of it. On its four sides are reliefs depicting nocturnal creatures, shown to be conveyors of human sacrifices by the hearts and livers they hold in their paws or claws: a bat (on the front), a scorpion, an owl and a spider. The base bears an image of Tlaltecuhtli ('earth lord') with the symbol of the five parts of the universe, the quincunx, on his stomach. FS, RVA

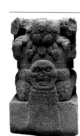

132
Tlaltecuhtli

c. 1500, Aztec

Stone, 93 × 57 × 34 cm

Museo Nacional de Antropología, Mexico City, CONACULTA-INAH, 10-81265

PROVENANCE: Mexico City, 1968

SELECTED REFERENCES: New York 1970, p. 274; Pasztory 1983, pp. 160–61; Mexico City 1995, p. 184

When the sculpture was found in 1968 during the construction of a Metro line in Mexico City its necklace of severed hands and human hearts led to it being dubbed 'Coatlicue of the Metro'. Subsequent research has corrected this identification: this is the first known three-dimensional depiction of Tlaltecuhtli ('earth lord'), previously familiar only from reliefs and illustrations in codices. His pose, gazing aloft cross-legged with his claw-like hands tilted upwards, characterises him as a devourer of human remains. Like his female counterpart, Coatlicue-Cihuacoatl, he is the embodiment of the earth, the final destination of human beings. His face recalls that at the centre of the so-called Sun Stone (fig. 5), a resemblance that links both sculptures with Tlachi-Tonatiuh ('underground sun'), i.e. the sun on the nocturnal part of its daily journey, when it travels through the earth. FS, RVA

133
Brazier

c. 1500, Aztec

Fired clay, height 45.5 cm, diameter 45 cm

Museo Nacional de Antropología, Mexico City, CONACULTA-INAH, 10-223665

PROVENANCE: acquired 1950

SELECTED REFERENCES: Hildesheim 1986, no. 171; Mexico City 1995, p. 72, no. 53

Ceremonial braziers were closely linked to the ritual architecture of Tenochtitlan, placed in front of the deities' altars or outside temples. Their embers burned offerings of human and animal remains, as well as *copalli* (a kind of aromatic incense) and balls of *hulli* (a rubber latex extracted from the tree *Castilloa elastica*). The pattern of spheres on the edge of the present brazier may refer to its function of burning balls of latex. The dense, very dark smoke this produced was believed magically to blacken the clouds until they resembled those that brought the rain much-awaited by farmers. FS, RVA

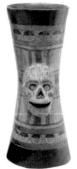

134
Goblets with images of skulls

c. 1500, Mixtec

Fired clay and paint, height 30 cm each, diameter 12.5 cm each

Museo Nacional de Antropología, Mexico City, CONACULTA-INAH, 10-77820, 10-3344

PROVENANCE: Mexico City, 1936–37

SELECTED REFERENCES: Westheim 1962, no. 48; Solís Olguín 1991B, pp. 257, 393; Amsterdam 2002, pp. 236–37, nos 190, 191

The goblets were made in the Oaxaca region and are a representative example of Mixtec polychrome ceramics. They were found, however, in Mexico City, among a large offering of vessels excavated to the south of the palace of Motecuhzoma at a place called El Volador, an area that some archaeologists believe once formed part of the palace. The goblets are practically identical. They are shaped like a double cone and have both painted and modelled decoration: three painted celestial bands that show the stars as the 'eyes of night', i.e. as half-closed eyes, and a modelled skull that evokes the rite of Tzompantli,

during which skulls were skewered and displayed in the Templo Mayor. The goblets were used to feed the gods: filled with blood, they were connected to the mouth of the idols by straws called *pópotl* in Nahuatl. FS, RVA

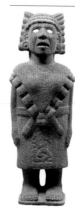

135
Teteoinnan-Toci

c. 1500, Aztec

Stone and shell, 107 × 41 × 26 cm

Museo Nacional de Antropología, Mexico City, CONACULTA-INAH, 10-1077 0/2

PROVENANCE: Tlalmanalco, Mexico State, nineteenth century

SELECTED REFERENCES: Pijoán 1946, p. 95; Bernal and Simoni-Abbat 1986, p. 246

The old goddess Teteoinnan-Toci ('mother of the deities-our grandmother') is identified by her serene countenance, the deep lines of her face and, in particular, the headdress, which consists of a plaited cotton band that fits firmly on the head and is tied at the nape of the neck. Bernardino de Sahagún and other Spanish chroniclers describe the headdress as a complicated cloth structure with knotted ends falling down the back. The pleated paper bow (*tlaquechpányotl*) at the rear is a mark of the goddess's rank and high birth. She also wears a *quechquémitl* (cape), its edge decorated with large cotton tassels, and a *cuéitl* (skirt), on which her calendrical name, '3-monkey', appears within a large square next to a rather comic image of a monkey making a ritual gesture. Although the whites of the eyes retain their original shell inlays, those depicting the irises have disappeared.

Sculptures of this kind were dressed in a variety of clothes, in accordance with the requirements of each feast celebrated at twenty-day intervals. At such times they probably held the *tlachpanoni* (broom) and *chimalli* (round shield) with which they are depicted in manuscripts. FS, RVA

136
Altar of the planet Venus

c. 1500, Aztec

Stone, 58 × 63 × 64 cm

Museo Nacional de Antropología, Mexico City, CONACULTA-INAH, 10-357224

PROVENANCE: Mexico City, first half of the twentieth century

SELECTED REFERENCE: Mexico City 1995, p.75, no. 59

The thirteen celestial planes that constituted the firmament of the Aztec universe were defined as the field of action of heavenly bodies. The sun, moon and stars were believed to move along paths of stars. Special significance was attached to Venus because its synodic span – the Venusian year of 584 days – includes two periods when it is invisible and another two when it is the first star to appear in the evening or the last to fade in the morning. On the present altar Venus is represented by a three-lobed figure, an icon that also identifies the planet in reliefs and in images in codices. The altar is a four-sided prism. Its upper band consists of a sequence of spheres symbolising the canopy of stars; Venus, with her nocturnal, half-closed eyes and monstrous jaws, can be seen in the lower band. The celestial element *tecpatl* ('flint') is flanked and framed by fantastical faces; two flint knives commemorate the sacrifice of Venus, which, according to legend, was pierced by the sun's arrow. FS, RVA

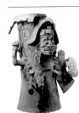

137
Brazier with an image of a dead warrior

c. 1500, Aztec

Fired clay and paint, height 99 cm, diameter 88 cm

Museo Nacional de Antropología, Mexico City, CONACULTA-INAH, 10-116586

PROVENANCE: Metro Line 2, Mexico City, 1967

SELECTED REFERENCE: Amsterdam 2002, pp.206–07, no. 152

During construction work on the Metro in Mexico City in the area of the Templo Mayor, five ceremonial braziers were found that bore images of warriors killed in battle or sacrificed to the sun.

The warriors symbolise the dead fighters who were thought to accompany the sun on its daily path across the firmament. The soldier depicted on the present brazier is magnificently attired as an eagle, the *nahual* (spirit twin) of the sun, and armed with a *chimalli* (round shield) and a *macáhuitl* (obsidian-edged sword), held aloft in his right hand in a warlike gesture. He wears a necklace of hearts and human hands, similar to that associated with the goddess Coatlicue, mother of Huitzilopochtli, the patron deity of war. The warrior's emaciated face with vivid, protruding eyes was intended to breathe new life into soldiers returning to earth four years after being sacrificed. The bone ear ornaments and the severed hands link him to the deities of the underworld, while the headdress, a band of turquoise crescents and a *xiuhtótol* (blue bird), also made of turquoise, symbolises Xiuhtecuhtli, god of fire, the day and heat. Together, the attributes suggest opposites, such as life/death and light/darkness. The columns of smoke produced by such ritual braziers were thought to lead the *tonal* (soul) of the deceased to the celestial battlefield. FS, RVA

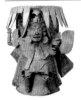

138
Anthropomorphic brazier

c. 1500, Aztec

Fired clay and paint, 91 × 76 × 57.5 cm

Museo Nacional del Virreinato, Tepotzotlan, CONACULTA-INAH, 10-133646

PROVENANCE: Metro Line 2, Mexico City, 1967

SELECTED REFERENCE: Mexico City 1995, p.185, no. 218

This is the best-preserved of the five braziers discovered during construction of the Metro in Mexico City in the former precinct of the Templo Mayor. It depicts a divine warrior crossing the threshold of death, either because he was killed in battle or because he has been sacrificed to the gods. The black, red and yellow painting, particularly the facial paint consisting of yellow bands on

a black background above the eyes and mouth, associates him with Yayauhqui Tezcatlipoca, patron of youthful energy and military victory. This sacred receptacle still preserves long, pointed ornaments which descend from the rim. We can clearly see the figure's finery and ornaments emerging from its disguise: an enormous eagle helmet with an open beak. All the warriors in the group of braziers wear the headdress characteristic of the god Xiuhtecuhtli – a band with turquoise discs bearing an image of the cotinga bird. The present figure has a 'halo' of nine feathers around the upper part of his face, evoking the planes of the underworld. He wears a chest protector with two red strips from which a pectoral once hung, the triangular apron-like garment characteristic of warriors, circular ear ornaments and a necklace made up of severed hands, recalling the sacrifice of war captives. FS, RVA

139
Coyote

c. 1500, Aztec

Stone, 28 × 46 × 45 cm

Museo Nacional de Antropología, Mexico City, CONACULTA-INAH, 10-81642

PROVENANCE: Mexico City, first half of the twentieth century

SELECTED REFERENCES: Kubler 1985, pp.220–21, no. III-12; Pasztory 1983, pp.234–35; Solís Olguín 1991, pp.110–11, no. 72

The coyote, its name derived from the Nahuatl *coyotl*, is the most common species of canine in Mexico. It occupied an outstanding place among the animals the Aztecs chose as patrons and protectors of their military activities. In the present sculpture the dog is shown alert, awaiting his prey with claws at the ready – a reflection of the ferocity with which warriors should plunge into battle. The military insignia of supreme warriors, *cuauhpiyolli*, and two white eagle feathers appear on the coyote's head. The image is unusual because the back of the animal is flayed, exposing his backbone and ribs. This evokes

the rite of flaying warriors at the
ceremony of Tlacaxipehualiztli,
held in honour of Xipe Totec.
Another such figure, a flayed
jaguar in an identical position,
is also in the Museo Nacional
de Antropología, Mexico City
(acc. no. 10-1100). FS, RVA

140
Head of Xolotl

c. 1500, Aztec

Stone, 48 × 59 × 70 cm

Museo Nacional de Antropología,
Mexico City, CONACULTA-INAH, 10-116545

PROVENANCE: Metro Line 2, Mexico City,
1967

SELECTED REFERENCE: Mexico City 1995,
p. 105

In Mesoamerican mythology
Xolotl was the twin and an
incarnation of Quetzalcoatl,
the ancient wind and storm deity.
Xolotl, the god of monsters, was
the patron deity of twins and
of all dual manifestations in
nature. He appeared in the form
of a dog because the Aztecs
thought the strangest creatures
known to them were hairless dogs
called *xoloitzcuintli*. The present
image of Xolotl, discovered during
construction of the Metro in
Mexico City, shows deep wrinkles
on the snout and forehead, a
characteristic of *xoloitzcuintli*.
The mouth is open, revealing teeth
as sharp as obsidian blades; the
tongue is hanging out. The square
bumps on the head represent
sticks rubbed to produce fire,
an element associated with dogs
in Maya culture. The human ears
are hung with *epcololli*, adornments
curved at the end that are an
attribute of Ehecatl-Quetzalcoatl.

An identical sculpture was
found nearby early in the
twentieth century. Both probably
formed part of an architectural
complex that described the sun's
movement towards the west on its
way to the underworld, led by the
fantastic beings depicted in the
sculptures in the way that
sacrificed *xoloitzcuintli* were
thought to guide their dead
owners. FS, RVA

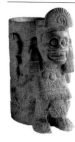

141
Urn with an image
of Mictlantecuhtli

c. 1500, Aztec

Alabaster, height 16.5 cm, diameter 11 cm

Museo Nacional de Antropología,
Mexico City, CONACULTA-INAH, 10-168816

PROVENANCE: offering 20 from the Templo
Mayor, Mexico City, 1978, on loan to the
Museo Nacional

SELECTED REFERENCES: Bonifaz Nuño 1981,
pp. 82–83; Hildesheim 1986, no. 298;
Mexico City 1995, p. 175, no. 207

Mictlantecuhtli was the fearsome
lord who reigned over the last
level of Mictlan ('place of the
dead'). His macabre figure is the
most striking aspect of such urns
as this, intended to contain the
ashes of captives sacrificed in
Tenochtitlan. Carved from
alabaster, the present piece, which
still contains cremated human
remains, depicts the god with
a cadaverous face and lavishly
attired in a headdress in the shape
of a sliced shell, ear ornaments,
bracelets, pectorals and a garment
covering part of the body like a
short skirt. The *cactli* (sandals) that
the ruler of Mictlan wore as a sign
of his high rank are still visible
on the rather weathered feet.
The most striking detail is the
aggressive gesture of the hands,
indicating that this deity tears apart
the bodies of the dead as they
come into his terrifying presence.
FS, AG

142
Pulque vessel

Early sixteenth century, Aztec

Greenstone, height 36 cm, diameter 26 cm

Museo für Völkerkunde Wien
(Kunsthistorisches Museum mit MVK und
ÖTM), Vienna, 6.096, Bilimek Collection

PROVENANCE: Dominik Bilimek collection,
acquired by the museum, 1878

SELECTED REFERENCES: Pasztory 1983,
pp. 259–60; Washington 1983, no. 14;
Vienna 1992, no. 177; Taube 1993;
Vienna 2001, pp. 337–39

The vessel, richly decorated with
imagery relating to destruction,
struggle, night and the alcoholic
beverage *pulque*, symbolises the
battle between the forces of
destruction and of life, represented
by the sun. The head protruding
from the front seems to be a

combination of a calendrical sign
and a god. With its skeletal mouth
and bony underjaw, it may
represent the day-glyph *malinalli*
('grass'), a day with connotations
of misfortune. It wears the
rectangular ear ornaments
characteristic of the *pulque* gods,
whose crescent-shaped nose
ornament appears on the rear of
the vessel. *Pulque* was associated
with the night and with the souls
of warriors killed in combat or
sacrificed. It was therefore drunk
at night.

Above the head appears a sun
disc with the sign Nahui Ollin
('4-movement'), the name given by
the Aztecs to the present world-
era, or 'sun'. The fact that the
sun is partly covered may refer
to a solar eclipse, a moment taken
advantage of by the two figures on
the left and right to attack the sun
and try to destroy the world. Six
similar figures appear round the
rim of the vessel. All eight figures
probably represent the warlike
tzitzimime – stars, constellations
or planets – who, though once
vanquished by Huitzilopochtli, the
Aztec patron deity associated with
the sun, continually return to fight
him. The *tzitzimime* pose a threat
to life at night and at the end of
certain periods. Three can be
identified on the present vessel:
Ehecatl-Quetzalcoatl, god of wind;
Tlahuizcalpantecuhtli, Venus as
the morning star; and
Xiuhtecuhtli, god of fire. The
tzitimime were associated with the
pulque deities, and the rim bears
the date '8-flint', which relates to
the maguey cactus, from the sap of
which *pulque* was obtained and the
god of which was Mayahuel. The
earth deity Tlaltecuhtli, with open
jaws and wearing a skirt bearing
a skull and bones, appears on the
bottom of the vessel together
with the date '1-rabbit', the date at
which the earth was created. The
rabbit (*tochtli*) was also associated
with the *pulque* gods.

The rear shows a female figure.
She has been interpreted as
Tlaltecuhtli; as Coatlicue, who
gave birth to Huitzilopochtli at
the moment of her death; and as
Cihuacoatl, a warlike goddess

of death who devours sacrificial victims and is associated with the night sky and completion. The figure has jaguar claws, wears two sacrificial stone knives and is dressed in a snake skirt bearing an image of two burning year bundles. Each bundle refers to a period of 52 years, an important cycle in Mesoamerican calendars. The end of such periods brought great danger, involving the *tzitzimime* in threats to creation. New fire had to be drilled to guarantee the continuation of creation and life and to support Huitzilopochtli in his battle against the forces of darkness. Streams of *pulque* flow from the present figure's breasts into a vessel between her legs. Her head is upside down when liquid is poured from the vessel: she is then 'diving' and the *pulque* flows downwards. GvB

143
Cihuateotl

c. 1300–1521, Aztec

Andesite, 74 × 45 × 42 cm

Trustees of the British Museum, London, Ethno. 1990. Am. 10.1

PROVENANCE: unknown

SELECTED REFERENCES: (similar works) Washington 1983, pp. 67–68; Shelton 1989; Solís Olguín 1991, p. 139

Fearsome figures with clenched, claw-like fists, macabre, bared teeth and gums and aggressive poses characterise *cihuateteo* (sing. *cihuateotl*), the malevolent spirits of women who died in childbirth. The spirits of these brave 'warrior-women' were thought to be the female counterparts of male warriors who were slain in battle or who had been sacrificed. They dwelt in the west (Cihuatlampa, 'place of women') and escorted the sun from its midday zenith down to its position at dusk on the western horizon. The present figure wears a long skirt fastened by a belt around her waist tied in a simple knot, above which her bare breasts with delineated nipples are exposed. Her hair has been tightly bound into an interwoven arrangement marked

by a distinctive pattern of concentric circles along the hairline. On the crown of her head is inscribed the glyph '1-monkey', this being one of the days that marked the beginning of a ritual thirteen-day period in the 260-day divinatory cycle (*tonalpohualli*). The sculpture may once have been part of a roadside shrine. Such images were so placed to propitiate marauding anguished female spirits who were believed to pose a danger to young children, since they had been deprived of the opportunity to be mothers themselves. CMcE

144
Cihuateotl

c. 1500, Aztec

Stone, 73 × 48 × 43 cm

Museo Nacional de Antropología, Mexico City, CONACULTA-INAH, 10-220920

PROVENANCE: Mexico City, 1907

SELECTED REFERENCES: Serna et al. 1953, pp. 124, 170; Washington 1983, pp. 67–68; Mexico City 1995, p. 179; Amsterdam 2002, p. 207, no. 153

In the early twentieth century foreign investment prompted considerable change in Mexico City, including the construction in 1907 of one of the capital's first department stores, Casa Boker, in the western part of the city. During work on the foundations of the building, a temple came to light that had been dedicated to women who died in childbirth, called *cihuateteo* (sing. *cihuateotl*). Five sculptures were excavated on the site, four of them identical to the present figure with the emaciated face of the living dead, the tangled hair of a corpse and claw-like hands raised aggressively. All five figures bear their calendrical name on the top of the head, here '1-eagle'. FS, RVA

145
Cihuateotl

c. 1500, Aztec

Stone, 112 × 53 × 53 cm

Museo Nacional de Antropología, Mexico City, CONACULTA-INAH, 10-9781

PROVENANCE: Calixtlahuaca, Mexico State (figure), late nineteenth century; Mexico City (base), early twentieth century

SELECTED REFERENCES: Bernal 1967, p. 71; Mexico City 1995, p. 179

Like warriors who gave their lives to take prisoners, women who died in childbirth were accorded the highest honour: they accompanied the sun on its daily journey. The women, called *cihuateteo* (sing. *cihuateotl*) were deified and, after shedding their skin, became living spectres. At their death the frightening *cihuateteo*, known as *tzitzimime* ('spooks'), captured the souls of their unborn children and were allowed to join the sun from its zenith to its setting in the west (Cihuatlampa, 'place of women').

The present figure wears a garland of skulls and a necklace including severed hands, symbolising human sacrifice and the power the *cihuateteo* wield in the world of the dead. This *cihuateotl*, her face emaciated and her hands raised in a gesture of aggression, presided in a sanctuary at Calixtlahuaca, some 75 km west of Tenochtitlan. The base on which she now stands is an altar dedicated to the earth, decorated with human skulls in profile, that was discovered in Mexico City. FS, RVA

VI RELIGION

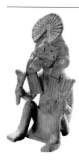

146
Figure

c.1350–1521, Aztec

Fired clay, height 18 cm

Staatliche Museen zu Berlin, Preußischer Kulturbesitz, Ethnologisches Museum, IV Ca 36407

PROVENANCE: collected by Eduard Seler, 1911

SELECTED REFERENCE: Pasztory 1983, pp. 281–82

The Aztecs are known above all as masters of stone sculpture, but they also produced large numbers of small clay figures, generally made with the help of moulds and representing, among other things, warriors, deities and women. Unlike full-scale stone images of gods, which played a central part in religious celebrations within temple precincts, small clay figures were probably installed in the homes of the lower classes of society and worshipped in connection with the frequent rituals that were a feature of Aztec life. MG

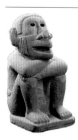

147
Ehecatl-Quetzalcoatl

c.1500, Aztec

Stone and obsidian, 41 × 23 × 18 cm

Museo Nacional de Antropología, Mexico City, CONACULTA-INAH, 10-48

PROVENANCE: acquired in the first half of the twentieth century

SELECTED REFERENCES: Westheim et. al. 1969, p. 168, no. 194; Bernal and Simoni-Abbat 1986, pp. 319–21, no. 293; Mateos Higuera 1992–94, vol. 2, pp. 185–209, nos 46–48; Mexico City 1995, p. 108, no. 90

By the time the Aztecs reached Mesoamerica in the Late Postclassic period (1250–1521), the deity Quetzalcoatl was also being worshipped in the guise of Ehecatl, god of wind. Farmers waited eagerly for the powerful gales that swept across the country announcing the rains, produced, it was believed, by Ehecatl blowing through the mask shaped like a bird's beak that is the staple item in his iconography. The

present image of the god is remarkable for its naturalism. Ehecatl sits with his legs apart, revealing the details of the loincloth, and places his crossed arms on his knees in a statuesque attitude of contemplation that draws attention to the mask. The obsidian eyes evoke the dark colour of the clouds before they release rain onto the fields. FS, RVA

148
Macuilxochitl

c.1500, Aztec

Stone, 36 × 43 cm

Museo Nacional de Antropología, Mexico City, CONACULTA-INAH, 10-1102

PROVENANCE: unknown

SELECTED REFERENCES: Castañeda and Mendoza 1933, pp. 209–10; Solís Olguín 1991, pp. 148–49, no. 104a, b

Macuilxochitl ('5-flower') is the calendrical name of Xochipilli, who, in the guise of a turtle, was the god of song, dance, music and the happiness associated with celebrations. Among the musical instruments played on such occasions were turtle shells used as drums, which were struck with deer's antlers (see cat. 316). In the present sculpture the god takes the place of the turtle inside the shell, symbolising his patronage of music. He wears a warrior's nose-bar and characteristic ear ornaments in an inverted drop-shape. On his buttocks is the flower with five pistils signifying '5-flower'. FS, RVA

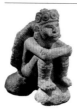

149
Tonatiuh

c.1350–1521, Aztec

Volcanic stone and traces of paint, 31.5 × 16.2 × 24.5 cm

Museum der Kulturen Basel, Basle, IVb 634

PROVENANCE: Lukas Vischer collection, donated to the museum, 1844

SELECTED REFERENCES: Basle 1985, pp. 78–79; Bankmann and Baer 1990, p. 124; Miller and Taube 1993, p. 172

The sculpture depicts Tonatiuh, the sun god of Postclassic central Mexico. His arms crossed on his knees, the god sits in a crouching position on two blocks of stone,

his feet resting on one, his buttocks and the solar disc on his back on the other. His head and oval eyes are directed slightly upwards. The front of his diadem has five circular elements representing jewels; at the back are remains of a feather headdress. Especially striking are the circular ear ornaments. Tonatiuh wears a loincloth and sandals; his thighs are decorated with ribbons and circular adornments. The solar disc on the god's back is framed by a large feather crown and reaches down the full length of the figure. The circle in the middle of the disc bears the glyph Ollin and the number Nahui. Nahui Ollin ('4-movement') is the name of the present and final era, or sun, into which Aztec mythology divided the history of the world. The body and the feather crown bear traces of red paint.

Like other items included here (cats 45, 92, 205, 230, 248), the sculpture was donated to the Basle museum in 1844 as part of the estate of the Swiss merchant and traveller Lukas Vischer, who visited Mexico between 1828 and 1837. AB

150
Cuauhxicalli

Late fifteenth or early sixteenth century, Aztec

Greenstone, height 6.4 cm, diameter 15.5 cm

Museum für Völkerkunde Wien (Kunsthistorisches Museum mit MVK und ÖTM), Vienna, 59.896, Becker Collection

PROVENANCE: Philipp J. Becker collection, acquired by the museum, 1897

SELECTED REFERENCES: Nowotny 1961, pp. 128–32; Vienna 1992, p. 215

Cuauhxicalli ('eagle vessels') were major items of Aztec material culture (see also cats 151–52, 249). When the Mexica-Aztecs reached Coatepec ('serpent hill') on their mythical journey to their future homeland, their first action was to build both a temple to their patron god, Huitzilopochtli, and a cuauhxicalli, either the name of another building or a receptacle for hearts and blood. The eagle was the spirit companion of Huitzilopochtli, the sun, and was

therefore associated with warriors. During human sacrifice, the chest of the victim dedicated to the god was opened, the heart – the precious 'eagle cactus fruit' – extracted, offered to the sun and placed in a *cuauhxicalli*. The body was then called 'eagle man'.

The outside of the present *cuauhxicalli* is decorated with a wreath of eagle feathers in reference to the name for the vessel; beneath the feathers is a row of circles indicating preciousness. The underside of the vessel is carved with the image of the earth deity Tlatecuhtli. His mouth, opened to reveal rows of teeth and a sacrificial knife, is directed upwards; his arms and legs are decorated with skulls; his hands and feet have become jaws. A further, larger skull appears on his body. This deity is often depicted on the underside of sculptures: the earth was thought to devour both the sun every night and the dead. The mirror depicted on the inside of the vessel bears a simple, stylised image of Nahui Ollin ('4-movement'; the 4 is missing here), the present world-era, or sun, the fifth in the Aztec creation cycle. Nahui Ollin is the day not only on which the present era began, but also that on which it will be destroyed by earthquakes. The sun sign is surrounded by symbols for jade or preciousness. GvB

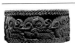

151
Cuauhxicalli

c. 1500, Aztec

Stone, height 17.5 cm, diameter 40 cm

Museo Nacional de Antropología, Mexico City, CONACULTA-INAH, 10-220916

PROVENANCE: Tláhuac, Mexico City, 1913

SELECTED REFERENCES: Anton 1969, p. 196; Washington 1983, pp. 38–39; Mexico City 1995, p. 68

Sacred containers such as this, called *cuauhxicalli* ('eagle vessels'), held the food of the gods. While this consisted primarily of the blood and hearts of sacrificial victims, usually captives, all members of Aztec society were

expected to contribute to the maintenance of the universe by sacrificing some of their own blood. The cactus thorns used for such sacrifices were burned in *cuauhxicalli*, a function indicated in the present example by the *zacatapayolli*, the ball of straw into which the instruments of sacrifice were inserted, that is carved in the bottom with two thorns on the sides. An offering of blood was thought to ensure the continuing existence of the universe: the row of skulls on the outside of the vessel evokes the cycle of life and death. FS, RVA

152
Cuauhxicalli

c. 1500, Aztec

Basalt, height 56 cm, diameter 30 cm

Trustees of the British Museum, London, Ethno. +6185

PROVENANCE: reportedly found in a village near Puebla; purchased from Consul Doormann, Hanover, with the Christy Fund, 1893

SELECTED REFERENCES: Joyce 1912, pl. IIb; Pasztory 1983, p. 236, pl. 243; Baquedano 1984, p. 84, pl. 55; McEwan 1994, p. 77; see also Washington 1983, p. 37

The chronicles record how *cuauhxicalli* ('eagle vessels') such as this served as receptacles for sacrificial offerings and were used in the solemn state ceremonies of investiture and enthronement of new rulers. The shape of the vessel echoes that of pottery storage jars used to hold *pulque*. Its upper part is composed of encircling superimposed bands of human hearts, feathers and jade. The front bears a solar disc and the glyph Nahui Ollin ('4-movement'), the symbol for the fifth world-era in the Aztec creation cycle. On the base beneath this is the glyph '1-rain'. On the obverse a symbol for the moon is found together with the glyph '2-rabbit', one of the calendrical names of a *pulque* god. This opposition expresses a deep-rooted Mesoamerican concern with the opposed, complementary forces governing the rhythmic relationship between seasonal change and human affairs. The hollow basin on the top of the vessel and some details of the

exterior surface were never completed. The object also shows signs of intentional defacement, particularly at the sides. This suggests that an unexpected event, perhaps the arrival of the Spanish, intervened before it could be finished. CMcE

153
Sacrificial knife

c. 1500, Aztec

Wood and flint, 7 × 31 × 5 cm

Museo Nacional de Antropología, Mexico City, CONACULTA-INAH, 10-559650

PROVENANCE: Mexico City, first half of the twentieth century

SELECTED REFERENCES: Pazstory 1983, p. 264; Mexico City 1995, p. 67

Sacrificial knives (*tecpatl*) were an essential feature of Aztec rituals, used to cut open the chests of captives and extract their hearts as nourishment for the gods. The hafts of the few surviving examples bear images of the gods symbolised by the knife. The carved figure in the present instance wears the large plume and the circular ear ornaments typical of the sun god Tonatiuh. The arms are supporting the blade, a pose similar to that shown on two further knives, their hafts covered with turquoise mosaic (cats 295–96). Emerging from the top of the head, the *xiuhcoatl* ('fire serpent'), the weapon of Huitzilopochtli, god of the sun and war, bares its fangs. No evidence remains of any further decoration on the knife. The haft was found in the foundations of a colonial building in southern Mexico City. The blade, also Pre-Hispanic, was added in modern times. FS, RVA

154
Heart

c. 1500, Aztec

Greenstone, 24 × 20 × 11 cm

Museo Nacional de Antropología, Mexico City, CONACULTA-INAH, 10-392930

PROVENANCE: Mexico City, 1977

SELECTED REFERENCES: Dahlgren et al. 1982; Solís Olguín 1991, pp. 24–27, no. 7a, b; Solís Olguín 1991B, p. 250, no. 381

In 1977 excavations on the site of a building in northern Mexico City, adjacent to the Templo Mayor precinct, unearthed a complex of buildings of a religious nature that had possessed its own landing stage in Pre-Hispanic times, connected to the main canal on the northern side of the ritual precinct. The archaeologists found a central patio surrounded by several dwellings, one of which was probably the *tlillancalco* mentioned in early chronicles, i.e. a temple dedicated to the cult of the night gods, particularly Tezcatlipoca. The present sculpture was recovered from the remains of this building. It consists of a heart with a face similar to that found on sacrificial knives. The *teoyóllotl* (heart) was central to Aztec religious belief: it was the sacred food of the gods and it enabled the Fifth Sun (the sun of the present world-era) to move because, according to the Tenochtitlan creation myth, the heart of Copil (a legendary foe of the early Mexica immigrants) sustained the cactus that produced prickly-pear hearts to feed the eagle, the sun's *nahual* (spirit twin). The Mixtecs had erected a sanctuary to the 'heart of the people', in which an object similar to the present sculpture was worshipped. FS, RVA

155

Téchcatl

c. 1500, Aztec

Stone, 94 × 80 × 28 cm

Museo Nacional de Antropología, Mexico City, CONACULTA-INAH, 10-81578

PROVENANCE: probably from the coastal region of the Gulf of Mexico, nineteenth century

SELECTED REFERENCES: Madrid 1992, p. 361, no. 89; Mexico City 1995, p. 66

The *téchcatl* (sacrificial stone) was the altar on which human sacrifices were made by extracting the hearts of the victims. It was built into the floor in front of the temple entrance, where it faced the figure or face of the god installed at the far end of the interior (see cat. 290). The present example differs from other known

téchcatl in that it consists of the body of a two-headed serpent, the heads emerging from the sides with the mouths opened to reveal fangs. The upper part of the serpent's curved body supported the back of the victim, who was forced down by five priests pulling at his hands, feet and head. With the victim's back arched, a further priest was able to sink the sacrificial knife under the rib cage to extract the heart, which was thought to be the food of the gods. FS, RVA

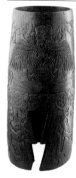

156

Drum

c. 1500, Aztec

Wood, height 98 cm, diameter 52 cm

Instituto Mexiquense de Cultura: Museo de Antropología e Historia del Estado de México, Toluca, A-36230, 10-102959

PROVENANCE: Malinalco, Mexico State, late nineteenth century

SELECTED REFERENCES: Castañeda and Mendoza 1933, pp. 101–06, nos 53–56; Amsterdam 2002, p. 116, no. 35

The vertical drum (*huehuetl*) is covered with reliefs relating to war. It is divided horizontally by a band containing two undulating bands, five round shields adorned with circles, arrows and a flag. On one side of the upper section the symbol of the present world-era, Nahui Ollin ('4-movement'), is flanked by two warriors in the costume of a jaguar and an eagle respectively; the *atl-tlachinolli* ('burnt water'), the symbol of sacred war, emerges from their mouths and tears drop from their eyes. The design is completed on the opposite side by a man dressed as an eagle, probably Tonatiuh (the sun). The lower section of the drum shows two jaguar warriors and one eagle warrior carrying flags as they walk in procession, singing or shouting. All the figures wear the feather headdress characteristic of warriors.

The drum comes from Malinalco, approximately 60 km south-west of Mexico City, where it was still being used during the most important religious ceremonies in the late nineteenth century. In 1894 the former

governor transferred the instrument to the Toluca city museum. In 1975 it entered the collection of the museum at Teotenango and in 1987 was returned to Toluca. DGV

157

Drum

c. 1500, Aztec

Wood, shell and obsidian, 14 × 15 × 60 cm

Museo Nacional de Antropología, Mexico City, CONACULTA-INAH, 10-81663

PROVENANCE: Tlaxcala, nineteenth century

SELECTED REFERENCES: Castañeda and Mendoza 1933, pp. 8–10; Chavero 1958, p. 796

The *teponaxtli*, a horizontal drum still in use, is described by specialists as a double-tongued xylophone, the tongues produced by slits in a hollowed piece of wood that serves as the sound box (see also cats 126, 158, 338). Tones are produced by striking the tongues with hammers in the form of sticks tipped with rubber. Pre-Hispanic societies revered this instrument, an attitude that persists in Mesoamerica today. The present *teponaxtli* takes the shape of a reclining Tlaxcalan warrior. His head appears at one end, resting on one arm and adorned with the distinctive military insignia of his people. The body of the warrior is twisted so that the instrument is played, as it were, on his side. His flexed limbs appear at the other end of the instrument. His weapons are the jaw of a sawfish and an axe with a copper blade. The eyes are inlaid with shell and obsidian. FS, RVA

158

Drum

c. 1250–1521, Aztec

Wood, 66 × 20 × 22 cm

American Museum of Natural History, New York, 30/9756

PROVENANCE: Puebla State, late nineteenth century; purchased by J. Dorenburg and donated by him to the museum, April 1901

SELECTED REFERENCES: Ekholm 1970, p. 62; Vaillant 1941, p. 146

Two types of wooden drum, both cylindrical, are known to have

existed in Aztec society, one vertical (*huehuetl*; cat. 156) with the top covered in skin, the other horizontal (*teponaxtli*). This is an example of the latter. It consists of a hollowed log with its top slotted to form two tongues, each of which produced a different note. Making drums such as this required great skill. Fire was used to hollow the interior, which was then finely chiselled. The exterior of the present example depicts a crouching jaguar. Originally, the jaguar's face had inlaid eyes and fangs attached to its upper and lower jaws.

The drum was collected in the late nineteenth century by Carlos Bauer in a town in Puebla State, where it was regarded as a sacred object and, as such, was still being used in ceremonies. CE

connected with the deities being worshipped. Long, thin flutes ending in the shape of a flower (cat. 159) were used during the feast of Toxcatl when the individual personifying Tezcatlipoca played melancholy tunes on his way up the temple steps to be sacrificed. Other flutes, notably those excavated at Cerro de la Estrella, end either in the face of a god, such as Huehueteotl-Xiuhtecuhtli, who appears as a bearded old man (cat. 162), or of the eagle-tortoise, a mythical animal associated with celestial fire (cat. 161). The largest instrument included here (cat. 160) has an elegant expanded end decorated with step-fret designs reminiscent of those found on Aztec-Mixtec gold rings. FS, RVA

SELECTED REFERENCES: Beyer 1965B, pp. 53–104; Pasztory 1983, pp. 236–48; Solís Olguín 1991, pp. 149–51

This large stone container imitates the delicate vessels, made of gourd halves, that are called *xicall* in Nahuatl. The function of the container, with its three horizontal handles and single spout, is obscure. In the days when it was exhibited in the Gallery of Monoliths in the old Museo Nacional it was generally thought to be a *cuauhxicalli* (a vessel in which the hearts and blood of sacrificial victims were stored) from the Templo Mayor in Tenochtitlan, but no evidence exists to support this assumption. The band on the outside bearing the stepped pattern called *xicalcoliuhqui* is believed by some to represent the body of a serpent in motion. FS, RVA

159
Flute

c. 1500, Aztec

Fired clay, length 25.5 cm, diameter 6 cm

Museo Nacional de Antropología, Mexico City, CONACULTA-INAH, 10-2431

160
Flute

c. 1500, Aztec

Fired clay, length 26 cm, diameter 4.5 cm

Museo Nacional de Antropología, Mexico City, CONACULTA-INAH, 10-5325

161
Flute

c. 1500, Aztec

Fired clay, length 17.5 cm, diameter 7 cm

Museo Nacional de Antropología, Mexico City, CONACULTA-INAH, 10-150350

162
Flute

c. 1500, Aztec

Fired clay, length 18.5 cm, diameter 5.5 cm

Museo Nacional de Antropología, Mexico City, CONACULTA-INAH, 10-559559

PROVENANCE: probably Basin of Mexico and Cerro de la Estrella, Ixtapalapan, Mexico City, 1974–75

SELECTED REFERENCE: Madrid 1992, p. 273, no. 78

Clay flutes were the most commonly played instruments during Aztec festivities. The shape and especially the decoration at the end of the flute were closely

163
Brazier

c. 1500, Aztec

Fired clay and paint, 12 × 23.5 × 20 cm

Museo Nacional de Antropología, Mexico City, CONACULTA-INAH, 10-78081

PROVENANCE: Cholula, Puebla State, first half of the twentieth century

SELECTED REFERENCES: Gendrop 1979, p. 224; Belém 1995, p. 91

During important Aztec ceremonies priests perfumed the images of the gods and purified worshippers by burning copal resin in ritual braziers. Cords could be passed through the horizontal handles at either end to enable the priest to move the burner from side to side with one hand, fanning the fire and spreading the smoke. The head of the ocelot on the present polychrome example evokes the *nahual* (spirit twin) of Tezcatlipoca, the god of fate, while the butterflies symbolise the souls of dead warriors. FS, RVA

164
Vessel with stepped pattern

c. 1500, Aztec

Stone, height 40 cm, diameter 81 cm

Museo Nacional de Antropología, Mexico City, CONACULTA-INAH, 10-1091

PROVENANCE: Mexico City, nineteenth century

165
Urn

c. 1250–1550, Totonac (?)

Fired clay and paint, height 41.5 cm, diameter 47 cm

Fowler Museum of Cultural History, UCLA, Anonymous gift, X75.1531

PROVENANCE: anonymous donation, 1975

SELECTED REFERENCES: Noguera 1954; Müller 1970; Ramsey 1975; Lind 1994; Pohl 2002

The urn is an example of the large containers of food and drink commonly used in Late Postclassic Mexico during ceremonial feasts cementing political and social alliances. The famous Classic-period *bebedores* ('drinkers') mural at Cholula, Puebla State, depicts individuals drinking from tankards dipped in such urns, and similar vessels appear in the context of ritual offerings in the Late Postclassic Codex Borgia (Biblioteca Apostolica Vaticana), thought to have been painted in the Puebla-Tlaxcala area.

The present urn, with its red bands at rim and base, rows of small abstract designs, small lugs that served as handles and Mixteca–Puebla style of decoration, closely resembles in size and shape Catalina-style urns from the Mártir phase of the Late

Postclassic period that were found at Cholula and neighbouring sites. Since the paintings on the exterior of this urn lack the technical mastery and fine detail seen on the Cholula-style vases, the urn may have been painted in Veracruz by local artists imitating the Cholula polychrome style. The two large, rather carelessly painted eagles that appear on opposite sides of the vessel alternate with two large solar discs containing a seemingly poorly understood version of the *ollin* ('movement', or earthquake) sign as it is represented on an urn from Puebla now in the Museo Nacional de Antropología, Mexico City. Eagles, which were closely associated with the sun in Nahua thought, commonly appear on such urns. The pairs of vertically striped rectangles separating the eagles from the solar discs on the urn shown here may represent *mantas*, multi-purpose pieces of cloth that were used as gifts and ritual offerings. CK

166
Two-handled bowl

c. 900–1521, Mixtec

Fired clay and paint, 23.5 × 38 cm

Didrichsen Art Museum, Helsinki, acc. no. 822

PROVENANCE: purchased by Gunnar and Marie-Louise Didrichsen from Frank Elmer, New York, 1974

The Postclassic polychrome clay bowl is of Mixtec origin. Although the Mixtecs are best known for their goldwork, they also made a range of attractive pottery, from pitchers with handles to large funerary jars. The present bowl is a fine example. The significance of the decorative motifs has not been established. JT

167
Two-handled polychrome urn

c. 1500, Mixtec

Fired clay and paint, 35.5 × 40 cm

Colección Fundación Televisa, Mexico City, Reg. 21 pj. 35

PROVENANCE: unknown, acquired through Manuel Reyero, late 1960s

SELECTED REFERENCE: Reyero 1978, p. 116

During the Late Postclassic period (1250–1521) a tradition of ritual ceramics developed in the regions of Puebla and Oaxaca that produced polychrome funerary urns with a wide mouth, two handles at the sides and painted decoration. Most of these objects are from the area known as 'Mixtequilla veracruzana', which lies in the south of what is now the state of Veracruz, on the border with Oaxaca. The main decorative motif on the present urn consists of bunches of eagle feathers hanging from a disc with four strips of paper evoking the *zacatapayolli*, the ball of straw into which sacrificial instruments were inserted. At the centre is an ornament with a striped section, showing how the extremities of sacrificial victims were adorned. This culminates in four feathers, recalling the arms and legs severed during the ritual. Finally, there is pendant consisting of large sacrificial feathers and a disc of smaller feathers, next to which appears a cruciform design consisting of strips of paper – a reference to the four cardinal directions. FS, RVA

168
Casket

c. 1350–1521, Aztec

Stone, 29.5 × 25.5 × 20 cm

Staatliche Museen zu Berlin: Preußischer Kulturbesitz, Ethnologisches Museum, IV Ca 26921 a-b

PROVENANCE: Bauer collection, purchased by the museum, 1904

SELECTED REFERENCES: Washington 1983, p. 66; Solís Olguín 1993, p. 78

The casket, complete with its lid, is a particularly fine example of Aztec stonework. Two attributes of a Mesoamerican ruler, symbols of his power and sovereignty, are carved on one of the long sides: the diadem known as *xihuitzolli* and a nose ornament. The lid bears the date-glyph '6-reed'. Various ethnohistorical sources state that such stone caskets were used as funerary urns, in which case the date may be that of a ruler's death. MG

169
Tepetlacalli

c. 1500, Aztec

Stone, 21 × 32 × 32 cm

Museo Nacional de Antropología, Mexico City, CONACULTA-INAH, 10-466061

PROVENANCE: Mexico City; donated by General Riva Palacio, nineteenth century

SELECTED REFERENCES: Galindo y Villa 1903, pp. 207–09, no. 2; Madrid 1992, p. 213; Amsterdam 2002, p. 233, no. 186

Self-sacrifice was widespread throughout Mesoamerica, the ritual of shedding their own blood enabling practitioners to commune with the gods. People learned to draw blood from specific areas of their body in childhood. Carried out with sacred instruments, such as maguey thorns, obsidian knives, sharpened human and jaguar bones, and sting-ray spines, this act of devotion was equivalent to the primordial act of the gods when they created the Fifth Sun and humankind.

The *tepetlacalli*, a stone casket designed to contain items associated with self-sacrifice, bears the image of a richly adorned warrior drawing blood from his ear with a sharpened human bone. The man has a fleshless jaw and is missing his left foot, a possible reference to Huitzilopochtli, the god of war. The *xiuhcoatl* ('fire serpent') behind him underlines his relationship with Huitzilopochtli, for whom the *xiuhcoatl* acts as a weapon. Other identifiable symbolic features on the casket are the *zacatapayolli*, the ball of straw containing two pairs of bloody thorns surrounded by flowers and smoke, and, on the bottom, the figure of Tlaltecuhtli ('earth lord'), who was fed by the ritual of self-sacrifice. FS, RVA

170
Altar of the 52-year calendrical cycle

c. 1500, Aztec

Stone, 38.3 × 30 × 22.3 cm

Colección Fundación Televisa, Mexico City, 21 Pj.9

PROVENANCE: unknown, acquired through Manuel Reyero, late 1960s

SELECTED REFERENCE: Reyero 1978, pp. 150–52

Monuments commemorating the end of the 52-year cycle in the Aztec calendar generally take the form of a cylinder representing a bundle of reeds – 'year bundles' (see cat. 171) – and bearing several numbers, in particular the date '2-reed', the year in which the rites marking the beginning of a new cycle took place. The present cuboid altar also relates to these rites, focusing on the warring actions of the Aztecs to sustain the Fifth Sun (i.e. the present world-era), the provider of light. The reeds of the year bundles have been replaced by arrows. The top of the altar bears the calendrical name of the Fifth Sun, Nahui Ollin ('4-movement'); the date '2-reed' appears on the front.

The Spanish no doubt saw to it that the altar was converted into a simple container. Apparently, those who performed this operation were Indians, for they were careful to open the altar at the bottom, thus preserving its sacred message for posterity – eloquent testimony to the value they attached to it. FS, RVA

171
Xiuhmolpilli

c. 1500, Aztec

Stone, length 61 cm, diameter 26 cm

Museo Nacional de Antropología, Mexico City, CONACULTA-INAH, 10-220917

PROVENANCE: probably Mexico City, nineteenth century

SELECTED REFERENCES: Caso 1967, pp. 129–40; Bernal and Simoni-Abbat 1986, pp. 305–06

Mesoamerican peoples arrived at their calendars by measuring the revolution period of the main heavenly bodies, particularly the sun. Among the Aztecs the most celebrated cycle of time, marked by the New Fire, consisted of 52 years, i.e. thirteen times the journey of the four bearers of the year: *acatl* ('reed'), *tecpatl* ('flint'), *calli* ('house') and *tochtli* ('rabbit'). At the end of this period all fires were extinguished in houses, palaces and temples, for fear that the order established by the gods, and therefore the world as the Aztecs knew it, would collapse.

During the New Fire ceremony, called Toxiomolpilia, a young captive was sacrificed, 52 bundles of reeds were burned and the same number bound together to form a *xiuhmolpilli* ('year bundle'). The present sculpture represents one such *xiuhmolpilli*. The main panel contains the date *ome acatl* ('2-reed'), which indicates the year in which the New Fire rite took place, while the dates '1-death' and '1-flint' appear on the ends along with the mirror that links them with Tezcatlipoca ('smoking mirror'), the god of fate. The last New Fire ceremony took place in 1507, twelve years before the arrival of the Spanish. FS, RVA

172
Calendar stone

c. 1500, Aztec

Stone, 31 × 37 × 15 cm

Museo Nacional de Antropología, Mexico City, CONACULTA-INAH, 10-46541

PROVENANCE: probably Mexico City, nineteenth century

SELECTED REFERENCES: Galindo y Villa 1903, pp. 213–14; Umberger 1981, p. 142

In the 1840s José Fernando Ramírez identified the date commemorated on this calendar stone as the year '3-flint' and the day '12-lizard'. Inside the square is the sacred knife (flint) bearing a ghostly face that seems to emerge from a *cuauhxicalli* (the container used to store the hearts and blood produced by human sacrifices) with an edging of plumes and *chalchihuitl* (symbols for jade). Three strips emerge from the nose, one of them curved in the shape of a comma – perhaps a speech scroll indicating speech or song. The number is indicated by three *chalchihuitl* in a line above and below the strips. On the left, under the knife and smaller in size, is the image of a lizard with twelve *chalchihuitl* giving the number of the day. Some authors believe that the date corresponds to 1456 and commemorates the end of the famine in that year of Motecuhzuma II's reign. FS, RVA

173
Date stone

c. 1469, Aztec

Volcanic stone, 33 × 32 × 7.6 cm

Philadelphia Museum of Art: The Louise and Walter Arensberg Collection, 1950, 1950-134-374

PROVENANCE: Louise and Walter Arensberg collection, 1950

SELECTED REFERENCE: Philadelphia 1954, no. 46

This date stone records the year-name '3-house', depicted by three dots and the glyph for 'house'. It is more finely executed than, but iconographically similar to, a relief set into the Templo Mayor in Mexico City, which apparently commemorated the additions made to the complex upon the accession of Axayacatl as *tlatoani* (ruler) in 1469. It seems probable that other projects sponsored by Axayacatl in the year of his coronation were also symbolically marked by reliefs, including the present piece. Use of the calendar was part of the Aztecs' strategy of legitimising and documenting their domination of central Mexico. They set great store by astrology, and people's destiny and profession were supposedly determined by their birth date. The Aztecs may also have organised rituals and battles on calendrically auspicious days.

The piece is made from the volcanic stone that is common in central Mexico and relatively easy to work. It was carved in three planes, which enabled detail to be added to the house doorway and the crenellation above it.

The Arensbergs probably purchased the stone sometime during the 1940s from their neighbour in Los Angeles and principal dealer in Pre-Hispanic art, Earl Stendhal. EMH

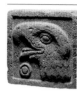

174

Calendar stone

c. 1500, Aztec

Stone, 24 × 24 × 9.5 cm

Museo Nacional de Antropología,
Mexico City, CONACULTA-INAH,
10-223606

PROVENANCE: Ocotlán, Jalisco, Mexico,
nineteenth century

SELECTED REFERENCE: Serna et al. 1953,
vol. I, p. 170

In Pre-Hispanic Mesoamerica
the calendar was used not only
to date mythological events and
supernatural occurrences in the
life of humankind, but also to
assign a secret name to gods and
newborn babies. This identity
determined the energy they
received with their first breath,
establishing their destiny and
actions. The present calendar
stone bears the date '1-eagle':
an eagle head seen in profile is
accompanied by the number in
the shape of one large symbol
for jade. Information on the Pre-
Hispanic calendar collected by
Jacinto de la Serna in his manual
of 1687 for the eradication of
indigenous religious beliefs
indicates that '1-eagle' was
considered to bring bad luck
because its advent marked the
descent to earth of the *cihuateteo*,
frightening women who had died
giving birth and now terrorised
humanity. This is corroborated by
the fact that the stone was found
in Jalisco in western Mexico:
women were thought to reside in
the west, in Cihuatlampa ('place of
women'), which was therefore also
the home of the *cihuateteo*. FS, RVA

VII GOLD AND SYMBOLS OF STATUS

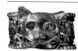

175

Ring with a feline head in relief

c. 1200–1521, Mixtec

Cast gold, diameter 2 cm, thickness 1.1 cm

Trustees of the British Museum, London,
Ethno. +1914 3-28.1

PROVENANCE: given by Miss Thornton, 1914

SELECTED REFERENCES: McEwan 1994, p. 67;
Carrasco 1998, p. 179; La Niece and Meeks
2000, figs 11.17, 18

The Nahuatl name for gold,
teocuitlatl, means 'excrement of the
gods', perhaps referring to the way
in which veins of gold and nuggets
of alluvial gold might appear to be
extruded from the bowels of the
earth. The artisans who worked
gold depended upon raw material
rendered as tribute from distant
provinces. They reworked this into
jewellery and adornments worn
by prestigious rulers, nobles and
merchants, as well as by priests as
part of the costumes they donned
when personifying the gods. The
finger ring shown here boasts
finely wrought images in cast false
filigree of a frontal feline head
flanked by two profile heads of
a double-headed serpent, the body
of which encircles the ring.
Powerful felines, especially jaguars,
were seen as intermediaries
between the supernatural and
mundane worlds and were widely
used as emblems of authority and
rank. The deployment of this
potent imagery on the ring is
intended to reflect the qualities
of the wearer. CMcE

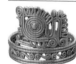

176

Ring

c. 1250–1521, Mixtec

Gold, maximum height 1.5 cm,
diameter 1.7 cm

Museo Civico di Arte Antica, Palazzo
Madama, Turin, 730

PROVENANCE: Zaverio Calpini collection,
donated to the museum, 1876

SELECTED REFERENCES: Fumagalli 1932,
pp. 175–78; Faldini 1978, p. 72, no. 46;
Hildesheim 1986, no. 245; Genoa 1992,
p. 420, no. 526

The ring is decorated with a series of horizontal S-shaped scrolls bounded on either side by double horizontal bands. One section is surmounted by a crown consisting of scrolls and spirals that may be either an abstract decorative motif or a depiction of a serpent with a feathered body and a head seen in profile from which a forked tongue protrudes.

Mixtec culture flourished during the Late Postclassic period (1250–1521). Unlike the Zapotecs, who were known for monumental architectural works, the Mixtecs produced their finest work in the form of precious objects: mainly illustrated books, polychrome ceramics and small gold and hardstone jewels.

Like other items shown here (cats 189, 190), the ring formed part of the collection that Zaverio Calpini of Piedmont put together during his 30-year residence in Mexico, a collection comprising over one thousand pieces from the various cultures of Mesoamerica, including stone sculptures, ceramics, jewellery, weapons, figurines and small terracotta objects. Calpini initially offered to sell the collection to the city of Turin, but decided two years later to donate it in exchange for a ring as reimbursement for the cost of packing and shipping the items from America. GC

177
Ring with an image of a bird's head

Fifteenth century, Mixtec

Gold, 2.16 × 3.47 × 1.83 cm

Bayerische Verwaltung der Staatlichen Schlösser, Gärten und Seen: Residenz, Munich, Schatzkammer, Res. Mü. Schk. 1257 (WL)

PROVENANCE: collection of the dukes of Bavaria, by 1598

SELECTED REFERENCES: Brunner 1970, no. 1257; Heikamp 1970, p. 214; Hildesheim 1986, no. 352; Toorians 1994, p. 66; Vienna 2000, no. 304; Munich 2001, no. 148

The shield-like section rising at the front of the finger ring takes the form of a feather diadem crowning the head of a bird, perhaps an eagle. Originally, the

bird probably held a pendant with bells or a disc in its beak. The body of the ring shows a snake framed by beaded strips and spiral ornaments.

The ring was cast in the lost-wax technique (see cat. 282), partly soldered and worked with a cutting implement. Its place of origin is not known, but it is stylistically related to items found in tombs at Monte Albán, Oaxaca, and is a typical piece of Mixtec goldwork. It probably formed part of the ritual finery of a high-ranking dignitary.

The ring belongs among the few gold objects not melted down by the Spanish following their conquest of ancient Mexico. It was probably bought in 1566 on behalf of Duke Albrecht V of Bavaria at the Lisbon branch of the Augsburg banking and trading house of Fugger, along with two ivory chests from Ceylon. It is first described, however, in the 1598 inventory of the ducal *Kunstkammer* in the Residenz, Munich. The ring was in the private gallery of Elector Maximilian I at the Residenz c. 1635, and in 1745 was listed in the inventory of the treasury, where it has remained ever since. SH

178
Pendants

c. 1300–1521, Aztec or Mixteca–Puebla

Cast gold, 8 × 3 × 2.5 cm each

Dumbarton Oaks Research Library and Collections, Washington DC, B-104

PROVENANCE: acquired from Earl Stendahl, 1958

SELECTED REFERENCES: Munich 1958, no. 241; Dumbarton Oaks 1963, no. 130; Washington 1983, no. 73; Hildesheim 1986, no. 262

Aztec goldsmiths used a natural snail shell to create the mould for these cast-gold pendants. Cast-gold straps and elongated bells complete the decorative elements. The pendants formed an elaborate necklace once sewn to a fine cloth backing or joined in a complex strand with other bead elements. Motifs from aquatic life, such as turtles and other shell creatures, were common in jewellery in

Mexico of the Late Postclassic period (1250–1521).

The Aztecs extracted gold as tribute from communities as far afield as the Soconusco region in western Chiapas. Aztec and Mixtec goldsmiths processed the tribute and created some of the finest adornments worn by the rulers and nobility of Tenochtitlan. So impressed were the Spanish with their craftsmanship that Hernán Cortés remarked in a letter to Charles V: 'no smith in the world could have done better'.

During the conquest, the Spanish collected vast quantities of gold from Tenochtitlan and reduced the spoil to bullion in order to transport it to Europe. In a few instances gold jewellery worn by nobility in the distant provinces of the empire survived. Hence, some of the finest pieces of gold jewellery known today, including the present pendants, come from the burial sites of prominent individuals in Chiapas and Oaxaca. LT

179
Pendant with an image of Xiuhtecuhtli

c. 1500, Mixtec

Gold, 6 × 4 × 1.5 cm

Museo de las Culturas de Oaxaca, CONACULTA-INAH, 10-105429

PROVENANCE: tombs of Coixtlahuaca, Oaxaca; purchased by the Museo Nacional, Mexico City, from Fernando Sologuren, 1907

SELECTED REFERENCE: Solís Olguín and Carmona 1995, pp. 119–85

In the course of the fifteenth century, with the Aztec armies conquering large areas of Mesoamerica, a supra-ethnic artistic style developed that made images of deities recognisable to people belonging to widely differing civilisations even if the names varied from language to language. A case in point is the god shown on this pendant, Xiuhtecuhtli, the patron of fire among the Mixtecs and Aztecs. He wears his characteristic headdress: a band of rectangular plates supporting two cylindrical projections that symbolise the

sacred sticks which were rubbed together to produce fire. Prominent facial features are the large beard, created in false filigree, and the two fangs, which mark the figure out as a primeval deity, one who has lost his teeth with age. Also notable are the huge circular ear ornaments ending in solar rays, symbols that relate the fire at the centre of the universe to the heat of the sun. FS, RVA

180

Pair of ear ornament frontals

c. 1400–1521, Aztec–Mixtec

Cast gold, height 6 cm

The Metropolitan Museum of Art, The Michael C. Rockefeller Memorial Collection, Purchase, Nelson A. Rockefeller Gift, 1967, 1978. 412.200 a, b

PROVENANCE: The Michael C. Rockefeller Memorial Collection, gift of Nelson A. Rockefeller, 1967

SELECTED REFERENCES: Hildesheim 1986, no. 258; Jones and King 2002, p. 54

Gold ornaments were symbols of power and prestige among many ancient American peoples who worked gold, and wearing them was strictly regulated. In Aztec society only members of the nobility and accomplished warriors were entitled to adorn themselves with necklaces, ear and nose ornaments, and lip-plugs.

The Mixtecs, the most skilled goldworkers in Pre-Hispanic Mexico, cast their gold ornaments by the lost-wax method (see cat. 282) and liked to link a number of dangling elements, which would swing and tinkle with each movement of the wearer. On the present ornaments, originally attached to backings, two bird heads project from stylised solar discs (partly miscast). A series of articulated tassels and small bells hangs from the strong, curved beaks. The heads have three pronged crests and may depict *coxcoxtli*, a species of woodland bird associated with Xochipilli, the god of spring, music, games and pleasure. Since he also had solar associations, his animal symbol is shown emerging from the solar disc.

The bird heads, tassels and bells are hollow cast. Some core material, a mixture of charcoal and clay, remains in places. HK

181

Pendant in the form of an image of Xiuhtecuhtli

c. 1500, Aztec–Mixtec

Gold, 4 × 3.5 × 2 cm

Museo Nacional de Antropología, Mexico City, CONACULTA-INAH, 10-8543

PROVENANCE: Mexico City

SELECTED REFERENCES: Seville 1997, pp. 114–15; Vienna 1997, pp. 69–70

In Pre-Hispanic Mexico gold (*cuitlatl*) was believed to be an excrescence of the sun. Its possession among the Aztecs was restricted to the *tlatoani* (rulers), who made gifts of gold objects to outstanding warriors and to members of the nobility who had otherwise distinguished themselves. Goldsmithing, introduced to Mesoamerica *c.* AD 800, was practised with the greatest skill by the metallurgists of the Mixtec realms. When the Aztecs conquered the Oaxaca region they took many local goldsmiths to Tenochtitlan. Such artisans probably made the present pendant, which was cast by the lost-wax method (see cat. 282). It takes the form of an image of Xiuhtecuhtli, the god of fire, identifiable by his fangs, which accentuate his smiling expression. He has a beard, circular ear ornaments, a headdress of feathers and an unusually prominent nose, which has been damaged. FS, RVA

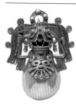

182

Rattle

c. 1500, Mixtec

Gold, 5.5 × 4.5 cm

Museo de las Culturas de Oaxaca, CONACULTA-INAH, 10-105430

PROVENANCE: Oaxaca State

SELECTED REFERENCE: Solís Olguín and Carmona 1995, pp. 118, 185

Goldsmithing developed late in Mesoamerica compared to South America, where goldworked objects have been discovered that

date from earlier than 2000 BC. By *c.* AD 800 metal technology had been introduced from South America into western Mexico and, probably after 1000, metallurgy reached southern and central Mexico as a result of contact with the Isthmus of Central America. Mixtec goldwork belongs to the second tradition, and the Mixtecs became the great metalworkers of southern Mexico, masters of the technology known at the time. The rattle was made by the lost-wax technique (see cat. 282). It combines the image of a bat with a spherical section that contained the clapper. The bat was regarded as a sacred animal because it inhabited caves, anterooms of the underworld. Maize seeds were thought to enter the underworld before growing, which is why the Pre-Hispanic people of Oaxaca associated the bat with the god of maize, whom they called Pitao Cozobi. The face here includes characteristic features of the bat: round eyes, prominent incisors and a spiral between the nose and the forehead that looks like a small horn. FS, RVA

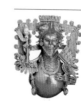

183

Pendant bell

c. 1500, Aztec

Gold, 9 × 7.5 × 3.8 cm

The State Hermitage Museum, St Petersburg, DM 321

PROVENANCE: Stroganoff collection; passed to the Hermitage, 1935

SELECTED REFERENCES: Kinzhalov 1960; New York 1990, pp. 229–31, no. 110

This pendant bell is shaped like a warrior in eagle attire. The two halves of the beak serve as a kind of helmet, opened to reveal a finely modelled, severe-looking human face. The top of the helmet is adorned with feathers. The pear-shaped body is hollow; a copper pellet inside it rattles at every movement. The breast is decorated with a plaque, a delicate golden bow on the reverse indicating that such plaques were attached with a cord. The thin human arms are covered with feathers; the hands hold a kind

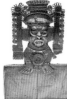

of a staff, three darts and a small round shield trimmed with feathers. Eagle claws protrude from the lower part of the body. The upper part of the piece is surrounded by a rectangular frame of gold wire with spirals at the edges. Two large loops at the back of the head show that the pendant was worn on a chain or a thick cord. The bell was made by the lost-wax technique (see cat. 282).

Representations of warriors in eagle attire were quite common in Aztec art (see cat. 206), but the present ornament seems to be unique. It is believed to have been worn by a prominent member of the order of eagle warriors, which consisted of representations of aristocratic Aztec families. MD

184

Pectoral with an image of Xiuhtecuhtli

c. 1500, Mixtec

Gold, 10.5 × 7.5 × 2 cm

Museo Nacional de Antropología, Mexico City, CONACULTA-INAH, 10-9676

PROVENANCE: Papantla, Veracruz, nineteenth century

SELECTED REFERENCES: Aguilar et al. 1989, pp. 164, 166; Solís Olguín and Carmona 1995, pp. 58–59; Seville 1997, pp. 110–11

Purchased at Papantla, a coastal town near the ruins of Tajín in Veracruz, this piece of jewellery made by Mixtec metalworkers using the lost-wax technique (see cat. 282) is generally known as the 'Papantla pectoral'. It represents the Aztec god Xiuhtecuhtli, the equivalent of the Mixtec deity Iha Ndikandii, who was worshipped as the sun god in the Oaxaca region. Bearded, he bares his two characteristic fangs. His headdress combines Aztec and Mixtec features, consisting of a band above the forehead with two protruding vertical elements (one is broken) and a large construction, made of false filigree, that includes feathers, rosettes and spirals. The pectoral takes the form of the disc typically worn by warriors. The calendar combination '1-reed' and '4-serpent' appears on the reverse

of the rectangular panels at the bottom.

In 1940 the piece was stolen and broken into two sections. Traces of the rudimentary repair work carried out after its recovery are visible on the reverse. FS, RVA

185

Pendant depicting a warrior-ruler with ritual regalia

c. 1200–1521, Mixtec

Cast gold, 8 × 4.5 × 1.5 cm

Trustees of the British Museum, London, Ethno. +7834

PROVENANCE: San Sebastian, Tehuantepec; purchased with the Christy Fund, 1880

SELECTED REFERENCES: Young-Sánchez 1993, p. 144, fig. 1; McEwan 1994, p. 65

Claims to hereditary nobility depended upon tracing ancestral lineage and proclaiming military prowess in dress and ornament. Mixtec metalsmiths fashioned gold into prestigious objects that signalled their owners' status in life, and upon death accompanied them as tomb offerings. The present image of a warrior-ruler was fashioned by a process of lost-wax casting (see cat. 282) incorporating finely detailed false filigree work that defines the Mixtec gold style. Its relatively small size makes the complexity of detail all the more remarkable. The figure sports a headband with embellishments running round its circumference and is richly adorned with dangling ear ornaments, what appears to be a nose-piece, and pendant plaques strung across his chest. In his left hand he grasps a circular shield and in his right brandishes a serpent-headed sceptre or spear-thrower (see cat. 315). From a lip-plug hangs a disembodied head – perhaps a war trophy – beneath which hang three pendant bells. The whole assemblage was itself apparently worn suspended as a chest or lip ornament. The framing armature may represent a formal backdrop used on ceremonial occasions or have served the more prosaic purpose of facilitating the fabrication and durability of the object. CMcE

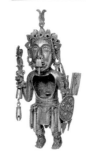

186

Warrior

After 1325, Aztec

Cast gold-silver-copper alloy, 11.2 × 6.1 cm

The Cleveland Museum of Art, Leonard C. Hanna, Jr Fund, 1984.37

PROVENANCE: Tetzcoco (?); European private collection, early 1960s; Edward Merrin, 1983; purchased by the museum, 1984

SELECTED REFERENCES: Hassig 1988; Young-Sánchez 1993; Young-Sánchez 1996

Unusual in several respects, including its size and survival, the figurine represents a warrior who clutches a serpent-headed spear-thrower (see cat. 315) in one hand and a shield, darts and banner in the other. His élite status is revealed both by the gold from which he is made and by his accoutrements, especially the jewellery – ear, nose and lower lip ornaments – and sandals, all reserved for nobles or great warriors. As the figurine implies, military accomplishment was prized by the Aztecs, whose imperial expansion was fuelled by political and economic ambition as well as by belief in themselves as a people chosen to uphold cosmic order through war and sacrifice.

The openings in the chest and back of the head remain unexplained; perhaps a precious stone was set in the chest, anchored via a small metal loop inside the body cavity. The eyes may have been inlaid with obsidian and shell. Two stylistically peculiar glyphs on the figure's back can be read as '2-rabbit [or jaguar]' and '3-water'; the glyphs' significance is unclear. Also on the back are two loops from which the figurine may have been suspended as a pendant. A sample of the casting core yielded a thermoluminescence date indicating manufacture some time between 1346 and 1570.

The figurine reportedly belongs to a group of gold objects found in Tetzcoco. The group was photographed and recorded in 1961 and shortly thereafter entered the European private collection from which it was acquired by Edward Merrin in 1983. SEB

187

Lip-plug

Fifteenth or sixteenth century, Mixtec–Aztec

Gold alloy and rock crystal, length 6.2 cm

Museum für Völkerkunde Wien
(Kunsthistorisches Museum mit MVK und
ÖTM), Vienna, 59.989, Becker Collection

PROVENANCE: Coxcatlán, near Tehuacan,
Puebla State; Philipp J. Becker collection,
acquired by the museum, 1897

SELECTED REFERENCES: Hildesheim 1986,
no. 254; Vienna 1992, no. 155; personal
communication, Dr Anita Gamauf,
Naturhistorisches Museum, Vienna, 1997;
Vienna 1997, no. 20

Ornaments such as this were
attached through a hole in the
lower lip. The plug consists of
three parts: a golden mouthpiece;
a bird's head of the same material;
and, between the two, a piece of
rock crystal hollowed out to make
the ornament more comfortable
to wear by reducing its weight. It
is not known whether the three
parts belonged together originally
or were assembled at a later date.
The bird's head was cast by the
lost-wax method (see cat. 282).
The gold alloy contains 37.2%
silver and 4.5% copper.

Metallurgy was not introduced
to Mesoamerica until c. AD 800.
Silver and gold products never
attained the importance of objects
made from jade or feathers, but
were valued highly. Together with
dress, jewellery proclaimed the
status, sex, class and age of the
wearer. As tokens of honour, lip
and nose ornaments were reserved
for dignitaries, such as celebrated
warriors and rulers. Gods were
also thought to wear them.

The large beak with its sharp
bend, the curve of the 'blade'
of the beak, the eyes and the
'eyebrows' call to mind a bird of
prey, possibly an eagle. Some
scholars have identified the
creature as a carrion bird or
scavenger, but animals of this kind
do not possess such prominent
'eyebrows' and beaks. On the
other hand, the bird's head
resembles those of two ear
ornaments in the Metropolitan
Museum of Art, New York (cat.
180), which have been identified
as a species of woodland bird
(*Cracidae*) associated with the
god Xochipilli ('flower prince').
In this interpretation, the four
protuberances on the head would
represent the crest typical of such
birds. However, these animals
have neither bones above the
eyes nor a bent beak. If the four
protuberances are viewed not
as belonging to a specific species
of bird, but as purely symbolic
elements – a not uncommon
feature of Pre-Hispanic art – they
might refer to the gods Xochipilli
and Macuilxochitl. These were
held to be one of the many aspects
of the sun, which again suggests
that the bird depicted here
is an eagle. Like gold, the eagle
was closely associated in
Mesoamerican cultures with the
sun and with human sacrifice.
One of the two exclusive military
orders in the Aztec army that
served the sun was known as the
eagle warriors. Moreover, if the
crest is interpreted as *chalchihuitl*
(jade), i.e. as a metaphorical
reference to preciousness, the
lip-plug acquires a wide range of
meanings involving the eagle and
the sun, preciousness and status.

Like other items included here
(cats 21, 23, 312, 321), the lip-plug
came from the collection of
Philipp J. Becker, a merchant
active in Mexico in the mid-
nineteenth century who retired
to Darmstadt. GvB

188

Lip ornament

c. 1200–1521, Mixtec

Gold, 2.2 × 5.4 × 4.7 cm

Museo Civico di Arte Antica, Palazzo
Madama, Turin, 732

PROVENANCE: Zaverio Calpini collection,
donated to the museum, 1876

SELECTED REFERENCES: Callegari 1924,
p. 456; Fumagalli 1932, pp. 178–84; Faldini
1978, p. 72, no. 45; Hildesheim 1986,
no. 242; Washington 1991, p. 555, no. 376;
Genoa 1992, p. 424, no. 543

The hollow lip-plug, cast by the
lost-wax technique (see cat. 282),
is shaped like an eagle's head.
The ornament was inserted
through a hole in the lower lip;
the curved base plate is designed
to fit against the gums of the lower
jaw. The bird of prey's head is
framed by a double border with
a succession of tiny spheres and
scrolls. The head, notably the eyes,
feathers and beak, is rendered
realistically. The strength of the
beak, slightly open to reveal the
tongue, is emphasised by its size
in relation to the rest of the head.

Among the Aztecs lip-plugs
were the prerogative of high-
ranking dignitaries and warriors.
Some were fashioned from semi-
precious stones, such as rock
crystal, obsidian and greenstone.
The present example was probably
made by Mixtec craftsmen, who
were so renowned for their ability
to create precious objects that
they were sometimes deported to
Tenochtitlan to make jewellery
ordered by Aztec conquerors or
were forced to pay high taxes in
the form of gold wares. GC

189

Lip-plug

c. 1500, Mixtec

Cast gold, 1.6 × 3.2 × 3.8 cm

The Saint Louis Art Museum, Gift
of Morton D. May, 275:1978

PROVENANCE: gift of Morton D. May, 1978

SELECTED REFERENCES: Boston 1968, p. 142;
Parsons 1980, p. 121; Washington 1983,
p. 155

Metallurgy was most probably
introduced into Mesoamerica from
areas further south by c. AD 800,
but most of the fine goldwork
of central and southern Mexico
belongs to the final centuries
before the Conquest.
Metalworking appears in the
region fully mature in technique
and artistry, with no
developmental phase. The Mixtecs
received the technology and the
Aztecs greatly appreciated their
talents. The present lip-plug was
produced by the lost-wax method
(see cat. 282), permitting exquisite
detailing in the feather
arrangement around the head and
the prominently featured eyes and
the creation of the menacing claw-
like beak.

The Aztec military élite was
divided into the orders of the
eagles and jaguars. Eagles
represented the sun as it crossed
the sky giving life to flora and
fauna. The diurnal cycle of the sun

is symbolised by the eagle also because this bird is a daytime hunter. Eagles symbolically offering the blood of their victims to the sun during the day were complemented in the Aztec view by jaguars, who at night were said to supply blood to the sun as it crossed the underworld. The eagle, like the sun, travels in both spheres, preferring to fish and live near water, an element associated with the earth.

An Aztec eagle warrior would have worn the lip-plug for battle or ritual. Empowered by the mask-like object extending across his lower lip and chin and reflecting the sun in its golden radiance, the warrior was prepared to fulfil his mission. JWN

190
Pendant

c. 1250–1521, Mixtec

Gold, 3.4 × 2 × 1.8 cm

Museo Civico di Arte Antica, Palazzo Madama, Turin, 733

PROVENANCE: Zaverio Calpini collection, donated to the museum, Turin, 1876

SELECTED REFERENCES: Fumagalli 1932, pp. 184–87; Faldini 1978, p. 72, no. 47; Hildesheim 1986, no. 241; Genoa 1992, p. 285, no. 105

The pendant takes the form of a jumping frog. The head is raised, the broad mouth is open and the eyes are swollen. The flattened body has a groove along its back; the lower section is hollow. With the exception of the ring used to attach the pendant and the filigree legs, the piece was produced by the lost-wax technique (see cat. 282). Frogs were connected with ceremonies held in honour of the god of rain, Tlaloc.

Metalworking techniques spread to Mesoamerica from the south *c.* AD 800. The Mixtecs were its greatest exponents, making jewellery chiefly in gold, copper and, to a lesser extent, silver. In some cases they created items from gold and silver alloy, extremely difficult to produce at the time. The techniques they employed ranged from simple beating to lost-wax casting.

The pendant forms part of the Calpini collection (see cat. 176), which the first guide to the Museo Civico of Turin (1884) mentions in connection with the museum's ethnographic holdings, acquired from the second half of the nineteenth century onwards through bequests and donations as well as by exchange with the Museo Egizio. From 1895 to 1929 these holdings were displayed in the Museo di Antichità by request of that museum. They then passed to Turin University's Museo di Antropologia for about a year before being returned to the Museo Civico. GC

191
Pendant in the form of an image of Xiuhtecuhtli

c. 1500, Aztec

Greenstone, 7.5 × 4.5 × 3.5 cm

Museo Nacional de Antropología, Mexico City, CONACULTA-INAH, 10-594485

PROVENANCE: possibly Mexico City, first half of the twentieth century

SELECTED REFERENCE: Mateos Higuera 1992–94, vol. 1, pp. 93–108

This greenstone pendant, a symbol of preciousness called *chalchihuitl*, bears an image of Xiuhtecuhtli ('turquoise lord'), the god of fire. The deity is wearing his characteristic diadem with jade discs and the blue bird *xiuhtótol*. The holes in the ears were once filled with ornaments. This precious item must have been reserved for the god or for use by a ruler: Xiuhtecuhtli was the patron deity of Aztec rulers, who were considered to be his living image at their enthronement. The Aztecs believed that they owed the heat in their bodies to Xiuhtecuhtli, who, as god of fire, benefited them in many ways. They used fire to cook their food and make salt, for example, and it made washing and bleaching clothes easier. Fire was also essential for steam baths and for producing charcoal and lime. In gratitude to Xiuhtecuhtli, the Aztecs flung their first mouthful of food into the embers of a fire,

threw *pulque* in the four cardinal directions and poured it in the centre of their homes. FS, RVA

192
Ornament

c. 1300–1521, Aztec

Diopside-jadeite, 4.7 × 5.4 × 5.8 cm

Dumbarton Oaks Research Library and Collections, Washington DC, B-61

PROVENANCE: found at San Gerónimo, Guerrero; acquired from Earl Stendahl, 1943

SELECTED REFERENCES: Washington 1947, no. 41; Lothrop 1957, no. 42, pl. 30; Dumbarton Oaks 1963, no. 147; Hildesheim 1986, no. 257

This carved eagle head is one of a pair created as ornaments to decorate sturdy objects. A socket hole on the underside enabled it to be affixed to a sceptre or piece of furniture. Lateral drill-holes in the hard igneous stone allowed feathers, gold or other materials to be attached to it. The eyes were once inlaid with stone or volcanic glass that would have flashed in the bright sunlight. The style of the piece is reminiscent of sculpture dating to the Early Postclassic period (900–1250) and of earlier sculpture from Teotihuacan. The raptor beak and head shape, however, exemplify the forceful geometric aesthetic of Aztec art.

Described by Friar Diego Durán in the sixteenth century as among the most valiant birds, the eagle represented one of the two military orders of the Aztecs. The eagle and its downy feathers were also closely associated with human sacrifice, and the mouth of this bird was once painted with a deep red pigment symbolic of blood – the essential nourishment of the sun. LT

193
Pendant

Sixteenth century (?), Aztec or colonial

Amethyst and malachite, 3.1 × 1.2 × 1 cm

Museum für Völkerkunde Wien (Kunsthistorisches Museum mit MVK und ÖTM), Vienna, 10.407, Ambras Collection

PROVENANCE: Ferdinand II, Archduke of Tyrol (1529–1595), Ambras castle near Innsbruck; passed to the Natural History Museum as part of the imperial collections, 1880

SELECTED REFERENCE: Feest 1990, fig. 19

This pendant has the shape of a duck's head. One eye is inlaid with a malachite bead. The Aztecs associated ducks with the rain god, Tlaloc. Attempts to establish the symbolic meaning of Aztec duck images, which have remained inconclusive, have centred on the animal's ability to fly, walk, swim and dive and thus to act as a mediator between three, partly supernatural, spheres and their denizens: the sky, the earth and the world beneath the waters. GvB

194

Ear ornaments

c. 1500, Mixtec

Gold, diameter 3.9 cm, depth 1.3 cm (each)

Museo de las Culturas de Oaxaca, CONACULTA-INAH, 10-105428 0/2

PROVENANCE: Oaxaca State, 1925

SELECTED REFERENCES: Solís Olguín and Carmona 1995, p. 160; Seville 1997, pp. 138–39; Amsterdam 2002, p. 106, no. 26

From Preclassic times (2000–100 BC) members of Mesoamerican village communities had adorned their ears with cylindrical objects made from all kinds of material. In due course, ear ornaments came to serve not simply as decoration but also as signs of status. Commoners wore ear ornaments made of fired clay, wood or bone. Initially, those worn by the supreme ruler, army chiefs, priests and the nobility were made of obsidian, rock crystal or greenstone (including jade). Later, when precious metals began to be worked, such ornaments were produced for these social classes mainly in repoussé sheet gold. Spool-shaped ear ornaments like the pair shown here were inserted in the ear lobes using the groove formed by the two flat sections, flanking the face with two resplendent golden discs. FS, RVA

195

Ear-spool

c. 1300–1521, Aztec

Obsidian and gold, diameter 3.7 cm, depth 1 cm

Dumbarton Oaks Research Library and Collections, Washington DC, B-88

PROVENANCE: acquired from Earl Stendahl, 1941

SELECTED REFERENCES: Washington 1947, no. 118; Lothrop 1957, no. 68, pl. 50; Dumbarton Oaks 1963, no. 118; Hildesheim 1986, no. 261

Aztec mastery of stone and metalworking are combined in this delicate obsidian ear-spool. A flawless piece of obsidian was ground into a thin spool shape and then polished. A hammered disc of gold, attached with an organic adhesive, accentuates the black of the obsidian. The brilliant flash of gold in sunlight was a quality sought by Aztec and Mixtec craftsmen, who fashioned many types of jewellery by juxtaposing gold and other materials. The combination of obsidian and gold in this manner is unusual. Strict sumptuary laws governed Tenochtitlan and ensured that only wealthy nobles and rulers could wear adornments such as this ear-spool, which was probably one of a pair. LT

196

Lip-plugs

c. 1500, Mixtec

Black obsidian, 2.5 × 4.1 × 1.9 cm; black obsidian, 1.6 × 3.2 × 1.6 cm; black obsidian with turquoise inlay, 2.5 × 4.1 × 1.9 cm; and red chert, 2.5 × 4.1 × 1.9 cm

The Saint Louis Art Museum, Gift of Morton D. May, 138:1980, 139:1980, 140:1980 and 141:1980

PROVENANCE: gift of Morton D. May, 1980

SELECTED REFERENCE: Parsons 1980, p. 121

These four stone lip-plugs demonstrate the highest development of the lapidary artistry for which the Mixtecs were well known. Each lip-plug was produced by drilling and cutting with string, using an extremely abrasive sand that may have contained quartz. The slightly trapezoidal hollow cylinders are perfectly round and feel as though they were machine-milled. Each cylinder sits on a slightly bowed

flange platform with elliptical ends. These works are most striking as abstract forms, yet their purpose was not purely aesthetic: they served to convey the power, prestige, spirituality and beauty of the wearer and owner.

The Aztecs saw the world in transformational terms. Nature was governed by shifting, mutable shapes, and all things had multiple personalities and appearances. One of the black obsidian lip-plugs has a turquoise insert in the cylinder, making it in every sense weightier than the other three. Turquoise symbolised water and sky and, by association, the rain god Tlaloc. By wearing this object, its owner may have been revealing his Tlaloc side and rain-god personality. Similarly, the black-rimmed cylinder may have represented his underworld and death aspect. That the other lip-plugs lack a stone inlay makes no aesthetic sense, since without it they would have been largely invisible from the front. These ornaments may have been designed to contain a variety of stones, conveying multiple spiritual aspects of their owners on different occasions. JWN

197

Plaque or pectoral

c. 800–1000, Mixtec

Jade, 17 × 8 cm

Didrichsen Art Museum, Helsinki, acc. no. 822

PROVENANCE: Milton Arno Leof collection (?); purchased by Gunnar and Marie-Louise Didrichsen from Stolper Galleries, Amsterdam, 1967

The Mixtecs were the finest workers of turquoise in ancient Mexico. Greenstone was more precious than gold to the peoples of Mesoamerica, and jade was a coveted material. The present Early Postclassic jade plaque or pectoral, which is preserved intact despite its large size, is one of only a very small number of comparable pieces to have survived. The use of jade, rather than the less highly valued serpentine, and the outstanding workmanship suggest that the

item belonged to the ceremonial attire worn by a prominent Mixtec. The seven drilled holes may have formed part of a pattern involving the cord that passed through them to hold the piece in place. The main decorative motif consists of four intertwined serpents. The Musée de l'Homme in Paris and the Ethnologisches Museum in Berlin each possess a similar, though smaller, plaque. JT

198
Fan

Grip *c.* 1500, Aztec; feathers 1999

Wood with parakeet and hummingbird feathers, 40 × 10.5 × 4.5 cm

Museo Nacional de Antropología, Mexico City, CONACULTA-INAH, 10-393455

PROVENANCE: Mango de Madera, Mexico City, first half of the twentieth century

In Pre-Hispanic times fans were a mark of both the nobility and the high-ranking travelling *pochteca* (professional merchants). The *tlatoani* (rulers) and their families in the major cities were notably elegant and distinguished, finishing touches to their appearance being provided by a bunch of flowers, a mouthpiece to inhale aromatic tobacco smoke, and a fan. The present example, carved from wood with a tip in the form of a richly attired warrior's head, was discovered by chance in Mexico City, in a field to the north of the Tlaloc Pyramid in what had been the sacred precincts of Tenochtitlan. In the course of a recent reorganisation of the Mexica gallery in the Museo Nacional de Antropología it was decided to employ an *amanteca* (featherworker) to restore the fan to its original splendour using new feathers. FS, RVA

199
Lid of a casket with a sculpture of an *ahuizotl*

Late fifteenth century, Aztec

Andesite, 13 × 33 × 30 cm

Staatliche Museen zu Berlin: Preußischer Kulturbesitz, Ethnologisches Museum, IV Ca 3776

PROVENANCE: Carl Uhde collection, purchased by the museum, 1862

SELECTED REFERENCES: Seler 1960–61, vol. 4, pp. 513–18; Pasztory 1983, pp. 164–65

The quasi-mythical animal known as the *ahuizotl* ('water-thorn beast') appears here in a crouching position with its tail coiled and water symbols on its back. The *ahuizotl*, which dwells by watercourses, springs and river banks, was said by the Aztecs to seize people who came too close to the water's edge with its long tail, pull them down into the depths and hold them there until they drowned.

The image of this beast was the glyph of the Aztec ruler who bore its name, Ahuizotl (reigned 1486–1502), who dedicated the new Templo Mayor of Tenochtitlan on day '7-reed' of the year 1487. As this date is carved on the underside of the lid, the stone casket from which it comes may have been deposited, full of sacrificial offerings, in the temple precinct during the dedication. Eduard Seler noted that the cover most probably belongs to a casket in the British Museum (cat. 200). MG

200
Casket

Late fifteenth century, Aztec

Andesite, 23 × 33 × 18 cm

Trustees of the British Museum, London, Ethno. Q82 Am 860

PROVENANCE: presented by A.W. Franks, 1872

SELECTED REFERENCES: Joyce 1912, fig. 9; Pasztory 1983, pls 122, 123, 164; Washington 1983, p. 120; Baquedano 1984, pp. 89–91, pl. 59; Lopez Lujan 1994, p. 221

This stone casket bears the image of a quasi-mythical aquatic creature, perhaps a water possum (*ahuizotl*), carved on the inside bottom surface and may once have belonged to the eighth Aztec ruler named Ahuizotl (reigned 1486–1502). This animal was believed to eat the eyes, nails and entrails of people who died by drowning, and Ahuizotl himself is reputed to have drowned in a flood caused by the catastrophic

collapse of the Acuecuexcatl aqueduct. The casket was apparently originally paired with a lid now in Berlin (cat. 199). The uppermost side of the lid bears a three-dimensional sculpture of an *ahuizotl*, while the underside is inscribed with the date '7-reed', which perhaps corresponds to a dedication offering made at the Templo Mayor of Tenochtitlan during Ahuizotl's reign. Ahuizotl was a formidable military leader and ruler. Upon completing each campaign of strategically planned and ruthless conquest, he earned a fearsome reputation for human sacrifice on an unprecedented scale.

On the front of the casket the rain god Tlaloc is shown holding a large jar adorned with the symbol for jade (*chalchihuitl*). Streams of water and ears of maize pour from the vessel, each rivulet terminating in *chalchihuitl* and conch shells offered in propitiation to ensure the continued productivity and fruitfulness of the earth. A pectoral with a symbol for gold hangs from Tlaloc's neck. The casket itself may have been used to hold the special sacrificial instruments used to draw blood offerings to the earth deity who is depicted in reliefs carved on the underside and inside bottom. CMcE

201
Funerary casket

c. 1500, Aztec

Stone, 22 × 24 × 24 cm

Museo Nacional de Antropología, Mexico City, CONACULTA-INAH, 10-223670 0/2

PROVENANCE: probably Tetzcoco, Mexico State, nineteenth century

SELECTED REFERENCES: Peñafiel 1910, pp. 124–26; Umberger 1981; Pasztory 1983, p. 247, pl. 255a,b; Solis Olguin 1991, pp. 152–53; Belém 1995, p. 98

Stone caskets with calendrical inscriptions were a characteristically Aztec creation (see cats 168, 293). They were made either in connection with specific rites for particular deities or, as in the present case, for the use of certain rulers, whose names

appear on them together with significant dates from their reign. The shape of the present casket is an almost perfect cube, with eight quincunxes on the outside representing the universe. Some scholars think it may have held the remains of Motecuhzoma II, the last Aztec *tlatoàni* (ruler), because the relief on the inside of the lid shows his name-glyph, the *xihuitzolli o copilli* (royal insignia) with a schematic depiction of his hair, a turquoise nose-ring and a highly ornate comma-shaped speech scroll (the symbol of *tlatoani*, which means 'he who speaks'). All the elements clearly symbolise the political power of Tenochtitlan. Other inscriptions on the casket suggest that it was associated with another ruler. The dates '5-serpent' and '11-flint' appear on the base and on the lid respectively. According to Antonio Peñafiel, '11-flint' was the year in which Netzahualpilli, prince of Tetzcoco, died. Emily Umberger suggests that the box may have been a gift from the Aztec ruler on the death of the lord of the Acolhua, an ethnic group in the Basin of Mexico. FS, RVA

when the construction of a third storey on the Palacio Nacional, seat of the Mexican Federal Government, necessitated digging deeper foundations. It came as no surprise to find such a depiction in this Pre-Hispanic palace, since Quetzalcoatl ('feathered serpent') was one of the deities protecting Aztec rulers and their families. There is a similar piece in the Rautenstrauch-Joest-Museum in Cologne, which must have been found during nineteenth-century excavations under what is now the Palacio Nacional. FS, RVA

203

Plaque with an image of an *ahuizotl*

c. 1500, Aztec

Stone, 73.5 × 72 × 24 cm

Museo Nacional de Antropología, Mexico City, CONACULTA-INAH, 10-81550

PROVENANCE: Temple of Tepozteco, Tepoztlan, Morelos, nineteenth century

SELECTED REFERENCES: Marquina 1964, pp. 218–20; Pasztory 1983, pp. 134–35

On the summit of a mountain in the Tepoztlan range in Morelos the Aztec conquerors built one of the most important Pre-Hispanic temples. The building commemorates the victories of Ahuizotl, the eighth Aztec ruler, whose many roles included that of supreme military commander of the army from the royal house of Tenochtitlan. The present plaque shows his name glyph, the *ahuizotl* ('water-thorn beast'), a quasi-mythical creature represented here in profile, sitting on his hindquarters and with a very long tail ending in a human hand. According to legend, this hand seized men and held them at the bottom of water to drown them. The beast's aquatic associations are illustrated by the stream of water issuing from its throat and flowing over its shoulders and by marine snails alternating with *chalchihuitl* (jades). The comma-shaped speech scroll identitifes the anthropomorphic figure as an Aztec ruler, whose title, *tlatoani*, means 'he who speaks'. FS, RVA

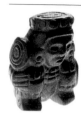

204

Tezcatlipoca

c. 1500, Aztec

Basalt, 10 × 10 × 6 cm

Museo Nacional de Antropología, Mexico City, CONACULTA-INAH, 10-9682

PROVENANCE: unknown

SELECTED REFERENCES: Mateos Higuera 1992–94, vol. 2, pp. 20–26; Mexico City 1995, p. 101, no. 81

Images of Tezcatlipoca, one of the four children of the primordial creators, Tonacatecuhtli and Tonacacíhuatl, can be recognised by their black faces and bodies, for he was the patron god of everything that happens at night, particularly theft and adultery. His name means 'smoking mirror', a reference to the obsidian mirror that was thought to reflect the black actions and purposes of the dark side of nature.

The sculpture shows Tezcatlipoca as a young warrior presiding over a ceremony being held in his honour during the month of drought (*tóxcatl*). He wears the triangular apron characteristic of warriors and is adorned with bracelets and bead necklaces. The headdress consists of a string of hemispheres symbolising the stars and, above that, the day-glyph *ce miquiztli* ('1-death'), Tezcatlipoca's feast day in the sixth thirteen-day period in the 260-day ritual calendar. In his left hand he holds a shield and other military insignia, in his right the *tlachialoni*, a disc-shaped sceptre with a hole in the middle through which he could see the real faces and hearts of human beings. FS, RVA

202

Head of a feathered serpent

c. 1500, Aztec

Stone, 54 × 55 × 61 cm

Museo Nacional de Antropología, Mexico City, CONACULTA-INAH, 10-81558

PROVENANCE: Mexico City, 1929

SELECTED REFERENCES: Bernal 1967, p. 148, no. 84; Hildesheim 1986, p. 142

When Hernán Cortés and his companions in arms stayed in the palace of Motecuhzoma in Tenochtitlan they were amazed by the beauty and size of the royal residence. Unfortunately, Cortés's description does not contain sufficient detail for us to reconstruct the ornamental elements of the building. The present feathered serpent's head, of an unusual geometric style, may give some idea of how such items of decoration looked. It was discovered in Mexico City in 1929

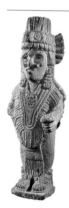

205

Piltzintecuhtli-Xochipilli (?)

c. 1350–1521, Aztec

Stone and paint, 72.5 × 26 × 21 cm

Museum der Kulturen Basel, Basle, IVb 650

PROVENANCE: Lukas Vischer collection, donated to the museum, 1844

SELECTED REFERENCES: Basle 1985, p. 73; Bankmann and Baer 1990, pp. 126–27; Miller and Taube 1993, p. 190

The sculpture stands on a rectangular base. Multi-linked ear ornaments and a cylindrical

nose-plug adorn the face. The conical headdress consists of feathers; rosettes and the face of an animal, possibly a bird, decorate the band at the front. A horizontal, fan-like ornament of pleated bark paper (*amacuexpalli*)adorns the back of the head. The figure wears a cape, decorated with feathers, that resembles a *quechquémitl*, a typical item of female clothing. The necklace consists of a chain with a disc bearing a cross-like symbol with four points. The objects carried by the figure in its left hand may be flowers; the right hand is damaged. A long garment emerges below the cape, falling to the feet and decorated with feathers at the bottom. The deity wears sandals.

The polychromy is remarkably well preserved. The face, arms and legs are painted red, while some of the clothes and ornaments, including the nose-plug, the rosettes on the headband and the *amacuexpalli*, are coloured turquoise-blue.

The figure has been identified as Piltzintecuhtli-Xochipilli ('flower prince'), a deity associated with certain afflictions, including venereal diseases, as well as being the god of flowers, song, dance and games. AB

206
Head of an eagle warrior

c. 1500, Aztec

Stone, 32 × 30 × 26 cm

Museo Nacional de Antropología, Mexico City, CONACULTA-INAH, 10-94

PROVENANCE: probably Tetzcoco, Mexico State, nineteenth century

SELECTED REFERENCES: Soustelle 1969, p. 190; Madrid 1990, p. 108, no. 36; Solís Olguín 1991B, p. 235, no. 345

The higher ranks of the Aztec army comprised two orders, that of the eagle and that of the jaguar. Eagle warriors were associated with the sun and with daytime warfare. Their duty was to feed the sun, so their training emphasised sacrificing their own blood, making them resistant to pain and encouraging them to risk their life unconditionally. The present

sculpture, the fragment of a larger piece, shows the head of a young eagle warrior. He is wearing a helmet shaped like the head of an eagle which in reality would have been made of wood and covered with eagle feathers. Originally, the eyes will have been inlaid with shells and dog's teeth inserted into the holes at the corners of the mouth. These fangs stressed the warrior's ferocity and linked him with the fire god Xiuhtecuhtli, a connection also made by the paper bow on the nape of the neck – a mark of distinguished lineage appropriate to an eagle or a jaguar warrior because only members of the nobility could belong to these orders. FS, RVA

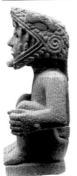

207
Standard-bearer

c. 1500, Aztec

Basalt, 52.5 × 29 × 19 cm

Instituto Mexiquense de Cultura: Museo Arqueológico del Estado de México Dr Román Piña Chan, Teotenango, A-52207

PROVENANCE: Teotenango, Mexico State, 1975

SELECTED REFERENCE: Amsterdam 2002, p. 115, no. 34

The sculpture was found near the Serpent Pyramid at Teotenango, a walled, hilltop town built by the Matlatzinca Indians, occupied by them from 900 to 1450 and given its present name by the Aztecs when they conquered it in the fifteenth century. The figure, a fine example of sculpture during the Aztec occupation, functioned as a standard-bearer: his left hand is carved so as to grasp a banner, which no doubt related to an order of serpent warriors. The warrior's helmet takes the form of a snake's head, the reptile's skin depicted in considerable detail, as is the anatomy of the figure. The warrior wears a loincloth, the end of which rests on his feet. MAM

208
Round shield

c. 1350–1521, Aztec

Stone, diameter 17 cm, thickness 5.5 cm

Staatliche Museen zu Berlin: Preußischer Kulturbesitz, Ethnologisches Museum, IV Ca 3982a

PROVENANCE: Carl Uhde collection, purchased by the museum, 1862

SELECTED REFERENCES: Durán 1971, p. 73; Codex Mendoza 1992, vol. 3, fol. 2r

Warriors played a central part in Aztec society. All boys were prepared in schools for their later life in the military. Important items of equipment for high-ranking commanders in the Aztec army were shields decorated with coloured feathers in various patterns, with which we are familiar from illustrations in codices.

This round shield from the Postclassic period is an imitation in stone of a shield with little balls made of eagle feathers. Seven feather balls on a light background adorn the emblem of the Aztec capital, Tenochtitlan. A shield with eagle feathers was also an attribute of the war god Huitzilopochtli and only Aztec rulers were allowed to bear such shields. The reverse of the present piece faithfully reproduces the handles of an original shield, which consisted of reeds tied together. MG

209
Temalácatl

c. 1500, Aztec

Stone, height 24 cm, diameter 92 cm

Museo Nacional de Antropología, Mexico City, CONACULTA-INAH, 10-46485

PROVENANCE: unknown

SELECTED REFERENCES: Marquina 1960, p. 88; Durán 1995, vol. 2, pp. 103–12

Tlacaxipehualiztli, the 'flaying of men' in honour of the vegetation deity Xipe Totec, was called 'gladiatorial sacrifice' by the Spanish. In this ceremony captives and five Aztec warriors faced each other in combat. The former were given symbolic weapons covered in feathers instead of flints and were prevented from escaping by having a white cord tied around their waist (according to some

accounts, around one foot) and fastened to a *temalácatl*, a sacred disc-shaped stone with a hole in the centre for attaching the cord. The present *temalácatl* shows a relief of the sun with four rays interspersed with four spikes and eight *chalchihuitl* (symbols for jade). During the symbolic battle blood flowed from the captives' wounds over the image of the sun. One side of the stone bears a St Andrew's cross repeated four times – the symbol of fire – with two *chalchihuitl* flanking it. The emphasis on the number four and its multiples relates to the Aztecs' conception of the universe as quatripartite. FS, RVA

210

Cup with images of a warrior

c. 1500, Aztec

Fired clay, height 15.5 cm, diameter 15 cm

Museo Nacional de Antropología, Mexico City, CONACULTA-INAH, 10-116788

PROVENANCE: Mexico City, 1967

This cup was among the many objects found during construction of the Metro in Mexico City, one line of which passes through the centre of what had been Tenochtitlan, the Aztec capital. Shaped like the ritual drinking bowl known as a *jicara*, it combines impressed decoration with fine painting, both techniques that originated in the Oaxaca region. The two decorative bands at the top show *ilhuitl*, signs symbolising the day or the daytime sky, alternating with three parallel vertical bars, signifying fire. The lower section bears a *xicalcoliuhqui* – stepped pattern – in the style of Mixtec manuscripts. Of particular note is the raised design repeated four times round the body of the vessel. A heart-shape encloses the upside-down image of a warrior wearing a coyote helmet, feathers and a mask in the form of a bird's beak, features associating him with Tezcatlipoca, god of war at night, and Huitzilopochtli, sun warrior of the day. FS, RVA

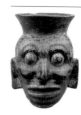

211

Pot in the form of a head of Tezcatlipoca

c. 1500, Aztec

Fired clay and paint, height 18 cm, diameter 13 cm

Colección Fundación Televisa, Mexico City, Reg. 21 pj. 71

PROVENANCE: unknown, acquired through Manuel Reyero, late 1960s

SELECTED REFERENCE: Reyero 1978, p.117

The polychrome anthropomorphic pot is the most enigmatic of the few surviving representations of Tezcatlipoca because it shows the deity in a form that combines life and death in a single entity. The face has the characteristic horizontal bands of face paint: three very narrow black bands (one across the chin, one crossing the cheekbones and the tip of the nose, one across the forehead) alternating with two wide sections painted yellowish red. Missing its eyelids and part of its lips, the head shows bulging eyes and both rows of teeth. Other faces in Aztec art, such as those on ceramic braziers and in sculptures of *cihuateteo* from Calixtlahuaca (see cat. 145), are also missing eyelids and lips, which has been interpreted as being the destiny of people who die in childbirth or battle and achieve permanence as a result of their death. The present pot probably exalts the eternal youth granted Tezcatlipoca by the sacrifice of young people, which took place at the end of the year. FS, RVA

212

Cup in the form of a flower

c. 1500, Aztec

Fired clay, height 28.5 cm, diameter 18 cm

Museo Nacional de Antropología, Mexico City, CONACULTA-INAH, 10-116786

PROVENANCE: Mexico City, 1968

SELECTED REFERENCE: Solís Olguín 1991B, p.258, no. 394

The ceremonial cup, discovered during construction of the Metro in Mexico City, is of a unique kind. It evokes the privileged life of the Aztec nobility – particularly the leaders of Tenochtitlan and Tetzcoco – who were said to live among 'in cuícatl in xóchitl' ('songs and flowers'). Certainly, members of the nobility often held bunches of flowers in their hands in order to enjoy their scent. The grip of the cup consists of four stems. Their spiralling movement ends at the foot of the bowl, which takes on the character of a corolla from which the coloured petals emerge. FS, RVA

213

Cup

c. 1521–1600, colonial

Fired clay and paint, height 16.8 cm, diameter 12.5 cm

Staatliches Museum für Völkerkunde, Munich, 10.3555

PROVENANCE: reportedly found in a grave at Acatzingo, Puebla State; acquired by the museum from the Schenk and Nohl collection, 1910

SELECTED REFERENCES: Munich 1968, p.59, no. 76; Hildesheim 1986, no. 238

The shape of this richly decorated cup with hollow foot is unusual in Mesoamerican pottery. It would seem that a Christian communion cup was copied and adorned with Pre-Hispanic symbols. The inside is painted with two birds and various kinds of flower, which are repeated on the outside. The foot bears ancient geometric patterns, including an S-shaped motif and a design including concentric rings that probably symbolises *chalchihuitl* ('precious greenstone'). The painting is in the Mixteca-Puebla style, although the choice of motifs and the shape of the vessel reveal European influence. Thus the cup probably dates from early colonial times. ST

214

Pitcher

c. 1500, Aztec

Fired clay, paint and wickerwork, height 27 cm, diameter 15 cm

Museo Nacional de Antropología, Mexico City, CONACULTA-INAH, 10-607774

PROVENANCE: Tlatelolco, Mexico City, 1993

SELECTED REFERENCE: González Rul 1988, pp.74–77

After the conquest of Tlatelolco by the *tlatoani* Axayacatl in 1473 the Aztecs made it all but

impossible for their neighbours in this city to offer the gods objects made of such precious materials as jade, turquoise, gold, silver and so forth. Henceforth ritual burials contained mainly ceramic objects, such as this two-coloured jug with a handle and a tubular spout. The vessel, which was never intended for domestic use, belongs to the Texcocan tradition of 'polished red' pottery and is painted delicately in white with stylised symbols resembling *chalchiuhuitl* and feathers. FS, RVA

215

Pitcher

c. 1500, Aztec

Fired clay and paint, 20.3 × 14.6 × 7.6 cm

The Saint Louis Art Museum, Gift of Morton D. May, 135:1979

PROVENANCE: gift of Morton D. May, 1979

SELECTED REFERENCE: Parsons 1980, p. 123

The pitcher belongs to an Aztec tradition of redware pottery with black designs that originated at Tetzcoco in the Basin of Mexico. The conquistadors who accompanied Hernán Cortés noted beautiful displays of pottery in the great market of Tenochtitlan. Objects such as this pitcher were purchased at markets for home use. The designs on these vessels are generally described as hastily rendered geometric patterns with shell-like forms, yet I believe that in the present instance their iconography relates to the function of the vessel: to pour *pulque*.

The scallop design on one side may well represent a cross-section of a leaf of the maguey, the cactus from which *pulque* is obtained. Moreover, the land snail in the centre of this motif symbolises water and by extension *pulque*. The opposite side of the vessel features four black, comb-like designs that strongly resemble the pistils of the agave, along with curling, tail-like motifs that no doubt refer to the pollen. Hence, the sexuality of the plant is represented on the pitcher. The Aztecs associated the drinking of *pulque* with heightened sexuality.

The front view of the vessel, which is notably phallic in shape, reinforces this sexual reference, as does the phallic allusion in what has been called a double S on this side but may well depict a snake. The artist who decorated this vessel thus employed an iconographical programme that referred to its function of pouring *pulque* and to the sexual benefits accruing to those who drank the beverage. JWN

216

Tripod plate

c. 1500, Aztec

Fired clay and paint, height 15 cm, diameter 27 cm

Museo Nacional de Antropología, Mexico City, CONACULTA-INAH, 10-580947

PROVENANCE: Mexico City, 1967–68

SELECTED REFERENCE: Belém 1995, p. 90

Food was served to the Aztec nobility in the same types of vessel as those used for offerings to the gods and as burial objects. This pottery differed from popular wares in the refinement of its polychrome decoration, in a style derived from the Cholula region of the Mixtec realm. Its most elegant form was a tripod plate supported on discs with painted decoration of flowers with open petals. The stepped patterns on the inside recall those found in manuscripts. The bases were decorated with highly stylised heads of animals important in Mesoamerican mythology, especially eagles and serpents with open beaks and jaws. FS, RVA

217

Tripod plate

c. 1500, Mixtec

Fired clay and paint, height 13.5 cm, diameter 34.6 cm

Museo Nacional de Antropología, Mexico City, CONACULTA-INAH, 79133

PROVENANCE: tombs 1-2, Zaachila, Oaxaca, 1962

SELECTED REFERENCES: Solís Olguín 1991B, p. 166, no. 244; Amsterdam 2002, p. 104, no. 24

Archaeological discoveries in the royal tombs at Zaachila in Oaxaca included a group of polychrome vessels that attest to the high quality of Mixtec ceramic wares. The present tripod plate, its legs in the shape of jaguar claws, was intended to contain precious objects, particularly gold jewellery, as is indicated by the image of a stylised butterfly painted on the floor of the bowl: the Museo Nacional de Antropología, Mexico City, contains items of jewellery similar to this. Polychrome ceramic pieces of this type reached Tenochtitlan via the trading networks maintained by professional Aztec merchants, the *pochtecas*. FS, RVA

218

Tripod bowl

Sixteenth century, Aztec

Fired clay and paint, height 6.2 cm, diameter 18.5 cm

Staatliche Museen zu Berlin: Preußischer Kulturbesitz, Ethnologisches Museum, IV Ca 32143

PROVENANCE: acquired by Eduard and Caecilie Seler in Huexotla for the museum, 1907

SELECTED REFERENCES: Pasztory 1983, pp. 292–99; Washington 1983, p. 163, fig. 77

The motif in the centre of the bowl resembles a many-petalled flower. This rosette is surrounded by two concentric bands. The first contains alternating S- and ring-shaped patterns, the second intertwined S-shaped markings. At the edge of the bowl, separated from the centre by three circular lines, is a flame pattern, a feature suggesting that this piece of black-on-orange pottery dates from the late Aztec era, probably Post-Conquest. The feet of the tripod are painted with horizontal lines and each is divided into three smaller feet bearing stylised floral motifs. MG

219

Tripod plate

Sixteenth century, Aztec

Fired clay and paint, height 10 cm,
diameter 21.9 cm

Staatliche Museen zu Berlin: Preußischer
Kulturbesitz, Ethnologisches Museum,
IV Ca 2391

PROVENANCE: Carl Uhde collection,
purchased by the museum, 1862

SELECTED REFERENCES: Sanders, Parsons
and Santley 1979, pp.466–67; Pasztory
1983, p.296; Washington 1983, p.162

The incised criss-cross lines in the
centre are evidence of the piece's
function as a *molcajete* (grating
bowl). Stylistically, this item of
black-on-orange ware probably
belongs to the brief Aztec IV
period, which may possibly
lie entirely within the early
colonial era. This late pottery is
characterised by realistic depiction
of flowers, birds and sea creatures.
The freely ranging motifs in the
present example are separated
from one another by sequences
of parallel lines. The feet of the
plate take the shape of butterflies'
tongues with coiled ends and are
adorned with parallel horizontal
lines. MG

220

Plate

Fifteenth or sixteenth century, Mixtec

Fired clay and paint, diameter 21.7 cm

Staatliches Museum für Völkerkunde,
Munich, 10.3565

PROVENANCE: acquired from the Schenk
and Nohl collection, 1910

SELECTED REFERENCE: Hildesheim 1986,
no. 239

A flower surrounded by
concentric circles appears in the
centre of the plate. Outside the
circles a pattern of three single
feathers alternates in a broad
band with a typical Pre-Hispanic
geometric design, known as the
step-fret motif, accompanied
by feather ornaments.

The highly ornate painting
and the use of various colours,
including orange, red and black,
on a white ground indicate that
the plate was made in the city
of Cholula, probably at the end
of the Late Postclassic or in the
early colonial period. In Pre-

Hispanic times Cholula was a
major trading centre noted for
ceramics, and the conquistador
and chronicler Bernal Díaz del
Castillo reports that the Aztec
ruler Motecuhzoma II ate from
coloured dishes produced in
Cholula. ST

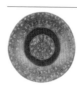

221

Tripod plate

*c.*1500, Aztec

Fired clay and paint, height 7 cm,
diameter 32 cm

Museo Nacional de Antropología,
Mexico City, CONACULTA-INAH, 10-223671

222

Tripod plate

*c.*1500, Aztec

Fired clay and paint, height 4 cm,
diameter 22 cm

Museo Nacional de Antropología,
Mexico City, CONACULTA-INAH, 10-116504

PROVENANCE: Mexico City

SELECTED REFERENCE: Belém 1995, p.90

See cat. 216.

VIII THE TEMPLO MAYOR AT TENOCHTITLAN

223

Commemorative plaque

1487, Aztec

Diorite, 92 × 62 × 30 cm

Museo Nacional de Antropología, Mexico City, CONACULTA-INAH, 10-220919

PROVENANCE: Mexico City, nineteenth century

SELECTED REFERENCES: Umberger 1981, pp. 127–29; Washington 1983, pp. 52–55; Bernal and Simoni-Abbat 1986, pp. 304–05

The Aztecs thought that human beings gained immortality through their deeds, especially acts of devotion performed in honour of the gods. The duty of every *tlatoani* (ruler) was to expand the Templo Mayor in Tenochtitlan, which was dedicated to the supreme Aztec deities, Huitzilopochtli and Tlaloc. The present plaque records such an act of devotion. It comprises two sections. The lower contains a square with the date '8-reed' (i.e. 1487), when the rebuilding work was finished. The upper section shows two rulers of Tenochtitlan standing in the territory of the monster Tlaltecuhtli: Tizoc (reigned 1481–86), who is holding his symbol, a human leg; and Ahuizotl (reigned 1486–1502), whose spirit-name is 'water dog'. They are performing a sacrifice that involved offering to mother earth cactus thorns covered in their own blood and inserted in a ball of straw (*zacatapayolli*), here marked with the date '7-reed'. The equivalent of this date in the Gregorian calendar has not been established. FS, RVA

The upper surface of this stone represents the cycle of the five world-eras, or 'suns', of the Aztec creation myth, according to which the universe passed through four ages before culminating in our own, the fifth. Each of these epochs ended in destruction, as will ours. The calendrical name of the first era, Nahui Ocelotl ('4-jaguar'), which finished in destruction by giant jaguars, appears at the upper left. Nahui Ehecatl ('4-wind'), the era terminated by hurricanes, is shown at the lower left. A rain of fire destroyed the third era, Nahui Quiahuitl ('4-rain'), seen at the lower right, while the fourth era, Nahui Atl ('4-water'), at the upper right, finished with a flood. The sign of the present era, Nahui Ollin ('4-movement'), appears in the centre of a rayed solar disc. Our age is fated to perish in earthquakes. A hole lined with a brass tube perforates the centre of the sign and was cut in Post-Conquest times, perhaps to support a banner or flagpole. Each of the four rectangular sides has an upper band representing the stars of the night sky and a lower band showing a *tzitzimitl* – a descending star, constellation or planet – flanked by anthropomorphic sacrificial knives.

The stone is a simpler version of the great calendar stone in Mexico City (fig. 5). At one time exhibited in a travelling 'Aztec Fair' organised by Orrin Brothers and Nichols, it was purchased in 1887 at a sheriff's sale in New Haven by Othniel C. Marsh, the Peabody Museum's first director. MDC

SELECTED REFERENCES: Philadelphia 1954, no. 51; Townsend 1992, pp. 195, 375; Los Angeles 2001, no. 160

Altars such as this are described in Spanish texts as having been used in major Aztec ceremonies, principally coronation rites. The precious greenstone underscores its importance. Iconographically, the altar is related to the Sun Stone in Mexico City (fig. 5). Its top is decorated with the calendrical symbol for the current world-era, Nahui Ollin ('4-movement'), surrounded by the rays of the sun disc. Around the top half of the stone are circles in relief, probably representing stars. The bottom half is carved with discs standing for jade and preciousness in general. Jade was usually associated in Mesoamerica with water, the deity of which was the fanged and goggle-eyed Tlaloc. Tlaloc was also associated with the earth, and the bottom part of the stone depicts his mask, surrounded by obsidian sacrificial knives. The mask is shown upside down, as though the god were crouching under the stone.

The Arensbergs seem to have sensed the ritual importance of the altar, for the Registrar of the Philadelphia Museum of Art recorded their half-serious statement that it had been '[u]sed on the main altar in Mexico City and damaged by Spaniards when rolled down the staircase'. They may have purchased it from their main dealer of Pre-Hispanic art, Earl Stendahl, between *c.* 1935 and 1950. EMH

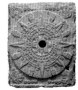

224

Relief showing the five world-eras

c. 1400–1521, Aztec

Grey basalt, 54.6 × 45.7 × 25.6 cm

Peabody Museum of Natural History, Yale University, New Haven, YPM 19239

PROVENANCE: purchased, 1887

SELECTED REFERENCE: MacCurdy 1910

225

Sacrificial altar

c. 1500, Aztec

Greenstone, height 49.5 cm, diameter 83.8 cm

Philadelphia Museum of Art: The Louise and Walter Arensberg Collection, 1950, 1950-134-403

PROVENANCE: Louise and Walter Arensberg collection, 1950

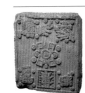

226

Coronation stone of Motecuhzoma II

1503, Aztec

Basalt, 22.8 × 67.3 × 57.7 cm

The Art Institute of Chicago, Major Acquisitions Fund, 1990.21

PROVENANCE: purportedly found in Mexico City, early 1960s (?); private collection, Los Angeles, 1971; purchased by The Art Institute from The Time Museum, Rockford, Illinois, 1990

SELECTED REFERENCES: Townsend 1982; Washington 1983; Townsend 1987; Townsend 2000, pp. 135, 168, figs 106, 107; Townsend 2000B

Recording relationships between mythical happenings and historical events, this monument affirms the legitimacy of the state through sacred power stemming from the time of genesis. In Aztec belief four imperfect world-eras preceded the present fifth age. Each past era ended in destruction and was named accordingly with a calendrical hieroglyph. The signs appear as masks and number-dots at the corners of the carved relief, to be read in counter-clockwise sequence. Beginning at the lower right, Nahui Ocelotl ('4-jaguar') refers to a plague of ocelots or jaguars; Nahui Ehecatl ('4-wind'), a wind-god mask, refers to hurricanes; Nahui Quiahuitl ('4-rain'), a rain-god mask, refers to a fiery rain; and Nahui Atl ('4-water'), shown as the head of a water goddess, represents a great flood. The present era, Nahui Ollin ('4-movement'), appears in the centre as an X with a circle, predicting an end by earthquakes. Below, the year *ce acatl* ('1-reed') corresponds to 1503; above, the day *ce cipactli* ('1-alligator') indicates 15 July. This is probably the coronation date of Motecuhzoma II. The hieroglyphic text continues on all other surfaces of the stone. The sides, covered with four squatting earth monsters, represent the body of the earth. The underside displays the hieroglyph *ce tochtli* ('1-rabbit'), the date of the earth's initial creation. The monolith becomes a three-dimensional cosmogram, identifying Motecuhzoma II as ruler of the present age, who has been consecrated by the earth, and the earth itself as the Aztec empire. RFT

227
Altar of the four suns

c. 1500, Aztec

Stone, 60 × 63 × 59 cm

Museo Nacional de Antropología, Mexico City, CONACULTA-INAH, 10-46617

PROVENANCE: Mexico City, nineteenth century

SELECTED REFERENCES: Peñafiel 1910, pp. 35–39; Ekholm and Bernal 1971, pp. 398–400; Barjau 1998, pp. 63–64

The altar of the four suns, or world-eras, is of major importance for an understanding of the Aztec view of the cosmos, complementing and adding to the information conveyed by the Sun Stone (fig. 5). The altar originally supported a statue of the Fifth Sun, representing the present era. This must have been destroyed during the Spanish conquest of Tenochtitlan, when one corner of the altar was severely damaged. Each side of the altar bears a glyph representing the god who presided over one of the previous eras: Nahui Ocelotl ('4-jaguar'), the glyph of Tezcatlipoca; Nahui Ehecatl ('4-wind'), the glyph of Quetzalcoatl; Nahui Quiahuitl ('4-rain'), the glyph of Tlaloc (which is understood as a rain of fire) and Nahui-Atl ('4-water'), the glyph of Chalchiuhtlicue. FS, RVA

228
Eagle man

c. 1440–69, Aztec

Fired clay, stucco and paint, 170 × 118 × 55 cm

Museo del Templo Mayor, Mexico City, CONACULTA-INAH, 10-220366

PROVENANCE: House of Eagles, Templo Mayor archaeological area, Mexico City, 1980

SELECTED REFERENCE: López Luján 1998

The House of Eagles, erected in a Neo-Toltec style, lies north of the Templo Mayor in Mexico City and was used for ceremonies of prayer, spiritual communing, penance and self-sacrifice. The present sculpture is one of two monumental ceramic figures discovered in a room in the building, where they stood on polychrome benches bearing images of warriors marching towards a *zacatapayolli*, the ball of straw into which the instruments of self-sacrifice were inserted. Both sculptures were initially thought to represent eagle warriors, members of one of the two highest-ranking Aztec military orders, but their significance is much greater. Recent studies of the symbolism and uses of the House of Eagles indicate that these 'eagle men' probably

represent the sun at dawn. The sculpture shown here consists of four joined sections: the head with its eagle-shaped helmet; the trunk with arms covered in wings; the area from the waist to the thighs; and the knees adorned with claws, the calves and the feet. The sculpture bears traces of stucco and white paint that depicted the bird feathers on the warrior's clothing. EMM

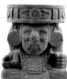

229
Huehueteotl

c. 1486–1502, Aztec

Basalt, 66 × 57.3 × 56 cm

Museo del Templo Mayor, Mexico City, CONACULTA-INAH, 10-212978

PROVENANCE: near Building C, Stage VI of the Templo Mayor (north side), Mexico City, 1980

SELECTED REFERENCES: Matos Moctezuma 1988, pp. 99–101; Mexico City 1995, pp. 39–40

In the period 600–200 BC various settlements existed in the Basin of Mexico, ranging from simple villages to urban centres with monumental architecture. Among the latter was Cuicuilco, which was seriously damaged *c.* 200 BC by an eruption of Xitle volcano, south of Mexico City. The city's inhabitants fled to what was to become Teotihuacan. Evidence of this is provided by two small clay sculptures, discovered between 1922 and 1925 in Cuicuilco, that represent an old, wrinkled, toothless man bending over in a sitting position with a large brazier on his shoulders. These are salient features of the iconography of the Aztec fire god Huehueteotl, known to previous cultures as 'lord of the year' or 'turquoise lord', who inhabited the centre of the universe and kept the cosmos in equilibrium. Since no comparable images have been found elsewhere, it may be assumed that Huehueteotl as worshipped by the Aztecs originated at Cuicuilco.

The basic look of the god of Cuicuilco was retained in Teotihuacan, but rhomboid symbols similar to eyes were added to the brazier and the figure

was now shown with both hands resting on his knees, one with the palm facing upwards, the other closed. These two features can be seen in the present Aztec depiction of Huehueteotl, which combines a number of symbols relating to fire, water and death and is thus probably a synthesis of more than one deity. The god wears a mask with the characteristic traits of Tlaloc: goggle eyes, 'moustache' ornament and fangs. His elbows and knees display masks with sharp teeth, similar to those that adorn other deities, such as Coyolxauhqui and Tlaltecuhtli, and apparently signifying passage to the underworld. The schematic representation of the brazier includes four eye-like symbols alternating with pairs of bars, comparable to those that had first appeared on sculptures of Huehueteotl in Teotihuacan. On the upper part of the disc, in the area occupied in earlier images by the hollow part of the brazier, is a relief showing conch shells and whirlpools, all surrounded by little feathers. The Aztecs clearly copied sculptures in Teotihuacan to produce this representation of a deity whose name means 'old, old god'. EMM

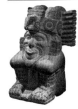

230
Seated god

c. 1350–1521, Aztec

Basalt, 34 × 21.6 × 24.5 cm

Museum der Kulturen Basel, Basle, IVb 649

PROVENANCE: Barrio San Sebastian, Mexico City; José Telles Girón; José Luciano Castañeda, by 1826–32; Lukas Vischer collection, donated to the museum, 1844

SELECTED REFERENCES: Waldeck 1866; Dietschy 1941; Washington 1983, pp. 86–88; Basle 1985, p. 75; Bankmann and Baer 1990, pp. 112–15

The god sits in a compact pose, his arms crossed over his knees and his head resting on his arms. The beard surrounds the mouth and is shaped like a heart. Two upper teeth protrude from the open mouth – a common symbol of old age. The eyes are carved as narrow slits. The rectangular ear ornaments have a circle carved in

the middle and end with a border, the symbol for preciousness. The god wears a headband with four circular adornments thought to represent jade stones or jewels and, at the front, carved decoration of the type seen on the border of the ear ornaments and the head of a reptile, its mouth opened to reveal fangs. The hair above the headband is partly covered by two tortoise shells. A pleated paper ornament (*amacuexpalli*) appears at the nape of the neck. The hair falls the full length of the back, apparently tied together towards the bottom by cords rendered as horizontal lines. A third tortoise shell, larger than the others, is placed over the hair. The thighs bear carved horizontal and vertical lines. The god wears sandals and the usual loincloth, which is indicated solely by a strip on either side of the sculpture.

This major work of Aztec stone sculpture, which has been variously identified as Quetzalcoatl-Tonacatecuhtli, Huehueteotl, Tepeyollotl and Omateotl, belongs among the earliest documented antiquities found in Mexico. An unpublished engraving of the figure was produced in 1792 in connection with a study of the famous Coatlicue statue by the Mexican astronomer Antonio León y Gama. Jean Frédéric de Waldeck made a drawing of the sculpture sometime between 1826 and 1832, while it was owned by José Luciano Castañeda. AB

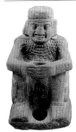

231
Standard-bearer

c. 1500, Aztec

Stone, 105 × 60 × 57 cm

Museo Nacional de Antropología, Mexico City, CONACULTA-INAH, 10-81660

PROVENANCE: Mexico City, nineteenth century

SELECTED REFERENCES: Peñafiel 1910, pp. 16–17; Bernal 1967, p. 161, no. 154

This sculpture, one of the early finds at the Templo Mayor, used to be known as 'The Sad Indian', a title derived from derogatory stereotypes of indigenous people

protecting themselves from the harsh climate by sitting on the floor dressed in only a mantle and hat. The position of the figure's hands and the hollow between his feet indicate that he is a standard-bearer, one of those at the entrance to the temple who held banners bearing the name of its dedicatee, Huitzilopochtli. He wears a precious necklace of bells and jade beads, a cape made of rectangular strips and a diadem resembling that known as *xihuitzolli*. A direct link with the patron god of the Aztecs is the decoration on the left leg, a reminder that Huitzilopochtli means 'left-sided hummingbird'. The deity's tongue hangs out as if he were thirsty, just as the sun thirsts for the blood of sacrificial victims. FS, RVA

232
Chacmool

c. 1500, Aztec

Stone, 74 × 108 × 45 cm

Museo Nacional de Antropología, Mexico City, CONACULTA-INAH, 10-10941

PROVENANCE: Mexico City, 1943

SELECTED REFERENCES: Pasztory 1983, pp. 173–74; Mexico City 1995, p. 120; López Austin and López Luján 2001

Auguste Le Plongeon gave the name *chacmool* to the first figure in this striking pose that he discovered in Chichén Itzá in the nineteenth century. The sculpture shows a man with a large feather headdress and wearing necklaces, bangles and bracelets of jade with gold and copper bells attached. *Chacmool* images are characterised by a mask over the eyes and mouth, which identifies the figure as Tlaloc, god of rain (see cats 240–41). The same type of mask can be seen on the upper part of the sacred vessel that rests on the stomach of the present figure, where it is surrounded by human hearts. The hearts and the relief on the base of the vessel, which likewise shows the god in the pose of Tlaltecuhtli ('earth lord'), surrounded by aquatic animals and snails, associate him with the

sacred liquids of the cosmos: blood and underground water. FS, RVA

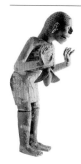

233
Mictlantecuhtli

c. 1480, Aztec

Fired clay, stucco and paint, 176 × 80 × 50 cm

Museo del Templo Mayor, Mexico City, CONACULTA-INAH, 10-264984

PROVENANCE: House of Eagles, Templo Mayor archaeological area, Mexico City, 1994

SELECTED REFERENCES: Mexico City 1995, p.187; López Luján and Mercado 1996

In 1991–92 and 1994–96 excavators at the House of Eagles north of the Templo Mayor, led by the archaeologist Leonardo López Luján and a team of specialists in various fields, opened two tunnels under Calle Justo Sierra. They found two large rooms decorated with murals and approximately 30 metres of benches identical to those discovered previously at this site. In August 1994 two monumental ceramic figures of Mictlantecuhtli, the god of the dead, were found on the benches. The present piece is one of these.

Made from five pieces of clay fired at a low temperature, the sculpture shows Mictlantecuhtli stripped of half his flesh and wearing a loincloth. His hands are enormous claws and his large head has holes in which to insert the curly hair characteristic of all deities of the earth and death. From the god's stomach hangs a huge liver, the organ inhabited by the *ihíyotl* (spirit) and one of the three entities of the body (the others being the head, the seat of destiny, and the heart, the home of consciousness). Since ancient times the liver had been associated with death and Mictlan, the lowest part of the universe, damp and cold, where Mictlantecuhtli lived. In the horizontal view of the universe the north was called Mictlampa ('place of the dead') and was cold and dry; it was related to the colours yellow or black and its symbol was the sacrificial knife. In the vertical view Mictlan, situated on the ninth

and lowest plane, was the region inhabited by the god stripped of half of his flesh, whose black curly hair was adorned with stellar eyes. Mictlan was also the universal womb, where the remains of dead humans were housed and where Mictlantecuhtli and his consort Mictlancíhuatl lived as opposites and complementary beings of Ometecuhtli and Omecíhuatl, the lords of duality and givers of life who inhabited Omeyocan, the thirteenth celestial plane. EMM

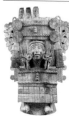

234
Votive vessel with an image of Chicomecoatl

c. 1500, Aztec

Fired clay and paint, 106 × 74 × 51 cm

Museo Nacional de Antropología, Mexico City, CONACULTA-INAH, 10-571544

PROVENANCE: Tláhuac, Mexico Federal District, 1996

SELECTED REFERENCES: Alcina Franch 1983, p.320; Mateos Higuera 1992–94, vol. 1, pp.165–69

The votive vessel with an image of Chicomecoatl ('seven serpent'), goddess of seed corn, retains its original, brightly coloured painted decoration, which is dominated by red, the colour associated with this deity, and is also notable for the pitch stripes on her cheekbones. Her headdress is a huge *amacalli* ('paper house'), a name derived from the material of such rectangular items of headgear, which were constructed from twigs or large reeds covered with strips of bark paper and adorned with rosettes and pointed elements, made of the same material, that resembled battlements. Chicomecoatl wears a long tunic and a foot-length skirt that, together with her sandals, identifies her as a goddess of sustenance. An illustration in the Aubin *tonalamatl* (book of days; formerly Bibliothèque Nationale de France, Paris, BNP 18–19) shows this deity, who appears as second patron of the seventh 'month', with ornaments and clothing very similar to those on the vessel. In the present image she holds a pair of corn cobs. FS, RVA

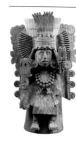

235
Votive vessel with an image of Xilonen

c. 1500, Aztec

Fired clay and paint, 99 × 65 × 49 cm

Museo Nacional de Antropología, Mexico City, CONACULTA-INAH, 10-583437

PROVENANCE: Tláhuac, Mexico Federal District, 1996

SELECTED REFERENCE: Códice Borbónico 1994, pp.228–30

Urban growth in the southern part of the Basin of Mexico has transformed the appearance of areas that in Aztec times consisted of a series of populated islands. Excavations in the historic centre of one such area, Tláhuac, have uncovered five votive vessels connected with ceremonies pertaining to human sustenance (see cats 234–47). The present example shows Xilonen (or Chicomecoatl), goddess of maize, dressed similarly to the image of her on fol. 36 of the Codex Borbonicus (Bibliothèque de l'Assemblée Nationale, Paris), where she appears during the Tititl festival, held in the seventeenth Aztec 'month'. The deity is wearing a brightly coloured skirt with a red rhomboidal pattern. Her headdress includes a band with pompoms hanging from it and is capped by a bunch of quetzal feathers, their preciousness signifying the importance of her protection. She holds a pair of cobs in her left hand and, in her right, a double sceptre of interlaced serpents (damaged) topped with what is probably a solar ray. The majesty of the image is enhanced by the motifs at the sides of the vessel – ornaments called *tilmatzi* to adorn the back and a *tlaquechpányotl*, a bow made of pleated paper. The vessel largely retains its original painted decoration. FS, RVA

236

Votive vessel with an image of Napatecuhtli

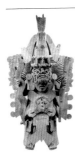

*c.*1500, Aztec

Fired clay and paint, 121 × 65 × 48 cm

Museo Nacional de Antropología, Mexico City, CONACULTA-INAH, 10-571285

PROVENANCE: Tláhuac, Mexico Federal District, 1996

SELECTED REFERENCES: Códice Matritense 1906, fol. 265r; Mateos Higuera 1992–94, vol. 3, pp.168–71

The ritual vessel portrays a deity associated with the rain god, Tlaloc: Napatecuhtli, patron of reed weavers, craftsmen who made mats and wicker thrones. The iconography of the image is very similar to that painted for the Spanish friar and chronicler Bernardino de Sahagún by the *tlacuiloque* (painter-scribes) of Tepeapulco. The god wears a very high headdress topped by a *quetzalmiahuayo*, a bunch of quetzal feathers, and with strips of bark paper hanging from a band bearing ornaments made of the same material. Nowhere is the skill of the potter more apparent than in the mask of Tlaloc, which, its facial features formed of serpents, was made from interlaced strips of clay and possesses a striking lightness. An *amaneapanalli*, a band of bark paper hanging from the shoulders, reaches from Napatecuhtli's chest to his feet and consists of wide interlaced bands bearing circular ornaments tied with cords. In his right hand he holds a serpent sceptre and in his left the *oztopilli* (reed staff), which originally had strips of paper painted white and stippled with drops of rubber. This pattern originally covered all the god's clothing and adornments. FS, RVA

237

Votive vessel with an image of Tlaloc

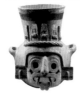

*c.*1500, Aztec

Fired clay and paint, 112 × 53 × 51 cm

Museo Nacional de Antropología, Mexico City, CONACULTA-INAH, 10-575578

PROVENANCE: Tláhuac, Mexico Federal District, 1996

SELECTED REFERENCES: Sahagún 1988, vol. 1, pp.147–52; Códice Borbónico 1994, fol. 30; Mexico City 1997, p.44

During the Ochpaniztli festival, a general sweeping and cleaning that took place in the eleventh 'month' of the Aztec year and was dedicated to the goddess Teteoinnan-Toci ('mother of the deities-our grandmother'), numerous rites were performed related to the cultivation and harvesting of maize. According to an image on fol. 30 of the Codex Borbonicus (Bibliothèque de l'Assemblée Nationale, Paris), one of the priests personifying Tlaloc, god of rain, would perform a ritual before the image of the god wearing a complex costume, notably his characteristic mask, and carrying a serpent sceptre and a bag of copal incense. The present votive vessel features all these attributes. The high, cone-shaped headdress has a number of strips hanging from it, a band with *amatl*-paper cords and a ritual mask of Tlaloc, with its typical 'goggles'. The eyebrows, coiled nose and 'moustache' are formed from rattlesnakes, a reminder that Tlaloc is responsible for storms (see cat. 79). The priest wears a loincloth, *cózcatl* (chest protector) and a necklace of beads and peppers. In his right hand he holds the serpent sceptre, symbolising a ray of light, and in his left the remains of the bag of copal. FS, RVA

238

Vessel with a mask of Tlaloc

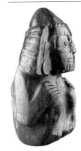

*c.*1440–69, Aztec

Fired clay and paint, 35 × 35.5 cm, diameter including the mask 31.5 cm

Museo del Templo Mayor, Mexico City, CONACULTA-INAH, 10-220302

PROVENANCE: offering 56, Tlaloc building, Stage IV of the Templo Mayor, Mexico City, 1980

SELECTED REFERENCES: Washington 1983, no. 142; López Luján 1993, pp.369–70; Mexico City 1995, pp.112–13

The cult of Tlaloc, the rain god, dates back to the Olmec culture of La Venta (800–400 BC), now on the border of the Mexican federal states Veracruz and Tabasco. The Mayas called him Chac, the Zapotecs Cocijo and the Totonacs Tajín. The Aztecs placed his main temple beside that of Huitzilopochtli in the Templo Mayor of Tenochtitlan.

Pots symbolise the uterus, containing the liquid essential to fertility. The present example displays the chief iconographical attributes of Tlaloc, fertiliser of the earth. The god wears 'spectacles' consisting of two serpents that intertwine in the centre to form the nose, a serpent frames his mouth as a 'moustache' and two fangs emerge from the mouth. Other characteristic features are the large ear ornaments with a central pendant and the white headdress, which may represent the hills where the god was thought to keep his water.

The pot formed part of offering 56 at the Templo Mayor, which was placed in a box of volcanic stone with a stone slab base so that it faced north, towards the temple of Tlaloc. The box also contained four mother-of-pearl shells, four greenstone beads (both symbols of water) and, next to the pot, remains of marine and land animals (including quails, rattlesnakes and the rostral cartilage of a swordfish) along with a sacrificial knife and two bowls of copal on either side of the god's image. EMM

239

Tlaloc

*c.*1469–81, Aztec

Greenstone, obsidian and shell 32 × 19.5 × 16 cm

Museo del Templo Mayor, Mexico City, CONACULTA-INAH, 10-168826

PROVENANCE: Chamber II, Tlaloc building, Stage IV(b) of the Templo Mayor, Mexico City, 1979

SELECTED REFERENCE: López Luján 1993, pp.332–34

The fertilising power of Tlaloc, the god of rain, contrasted with his negative ability to endanger crops by producing lightning, frosts, floods and hail. The present sculpture shows Tlaloc in a monolithic block, seated with his legs bent. His hands rest on his knees and his face displays the

typical goggle eyes, coiled nose, 'moustache' ornament and fangs. The eyes contain shell and obsidian inlays (one of the irises is missing). The god wears a paper bow at the nape of his neck, a conical hat and ear ornaments.

The sculpture was placed in a stone box in Chamber II of the Templo Mayor of Tenochtitlan as part of an offering to Tlaloc notable for its complexity and richness. The bottom layer consisted of large quantities of greenstone beads and material of marine origin. The second layer revealed 98 complete figurines and 56 masks from the region of Mezcala (including cats 257–59, 261, 263), 57 large conches, numerous pieces of coral, 60 greenstone beads, the remains of a feline with a greenstone sphere in its mouth and many other objects. In the uppermost layer the image of Tlaloc shown here presided over the offering with that of another deity, carved from alabaster. EMM

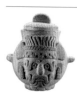

240
Lidded pot with an image of Tlaloc

c. 1469–81, Aztec

Basalt and traces of paint, height 28 cm, diameter 24.5 cm

Museo del Templo Mayor, Mexico City, CONACULTA-INAH, 10-219815 1/2

PROVENANCE: offering 60, Huitzilopochtli building, Stage IV(b) of the Templo Mayor, Mexico City, 1980

SELECTED REFERENCE: López Luján 1993, pp. 323–30

Ometecuhtli, the dual god, created Tlaloc and his companion Chalchiuhtlicue. To the former he assigned water from the sky, to the latter terrestrial water, i.e. that in rivers, lakes, lagoons and the sea. During Alcahualo, the ceremony devoted to Tlaloc, children and young people were sacrificed to these two deities to ensure that rains would fall to provide good harvests. People who drowned or who died from being struck by lightning, and those who suffered from leprosy or other illnesses related to water, were said to pass to Tlalocan, the

place of eternal summer where everything is fertile.

The pot was found in offering 60 of the Templo Mayor. The lowest layer consisted of an irregular arrangement of shells and small conches, greenstone beads, copper rattles and sea urchins. The next layer comprised a variety of marine materials, including red and brain coral, *Xancus* and *Strombus* conches, while the layer after that consisted of osteoderms and crocodile phalanxes, the rostral cartilage of a swordfish, remnants of various species of fish and incomplete remains of the bones of rabbits, pumas, cats and snakes. The final layer contained a *tecpatl* ('flint', i.e. sacrificial knife), five skulls, projectile heads, nine flint knives, fourteen self-sacrifice perforators arranged in a radial pattern, fourteen quails and, among many other objects, two bowls of copal in front of an image of Xiuhtecuhtli and that of Tlaloc shown here. The god has his characteristic 'goggles', coiled nose, 'moustache' ornament and fangs. The lid bears traces of blue pigment. EMM

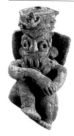

241
Tlaloc

c. 1500, Aztec

Wood, resin and copal, 34 × 19 × 20.5 cm

Museo Nacional de Antropología, Mexico City, CONACULTA-INAH, 10-392920

PROVENANCE: Iztaccíhuatl, San Rafael, Mexico State, 1959

SELECTED REFERENCE: Navarrete 1968

A fantastical face, ear ornaments and prominent fangs are among the constant features of the varied iconography associated with Tlaloc, god of rain. His characteristic headdress was a kind of crown with points representing the mountains where he kept water. The *tlaquechpányotl*, a folded paper bow on the back of his neck, indicated the god's noble ancestry.

The present sculpture, produced by applying resin and copal to an armature of sticks, was discovered in a cave in Iztaccíhuatl volcano together with an image of Tlaloc's consort, Chalchiuhtlicue. Both

pieces show that not only clay and stone, but also perishable materials were used for images of the gods. It is highly probable that these sculptures were burned after Tlaloc's favour had been gained by intense worship: it was believed that the smoke issuing from the resin and copal would blacken the clouds and cause them to release their fertilising load over the fields. FS, RVA

242
Tepetlacalli

c. 1469–81, Aztec

Basalt, box 69 × 58 × 38.5 cm, lid 67 × 57 × 13 cm

Museo del Templo Mayor, Mexico City, CONACULTA-INAH, 10-168850 0/2

PROVENANCE: offering 41, Tlaloc building, Stage IV(b) of the Templo Mayor, Mexico City, 1980

SELECTED REFERENCE: López Luján 1993, pp. 409–12

Most archaeological objects found in the Templo Mayor were housed in offerings. As a form of communication between humankind and the gods, the contents of such offerings fulfilled a specific symbolic function. Archaeologists have grouped the offerings according to the time each was made, its location in the temple, the type and dimensions of the container, the position of the objects and the richness of their materials.

Offering 41 was a box made of blocks of volcanic stone, with a stone slab base and lid. It contained the present *tepetlacalli* (stone casket) surrounded by a large quantity of conches, shells, mother-of-pearl, sea urchin jaws, fragments of greenstone objects and a ceramic pot. The walls of the *tepetlacalli* are painted blue inside and decorated with reliefs outside. Two of the outside faces show a number of half-bent legs, with ornaments round the ankles and sandals on the feet. One of the remaining faces bears the calendar glyphs '13-rain' and '13-reed', the other an unidentified glyph. On the lid is a mask of the rain god Tlaloc, with his characteristic 'goggles',

'moustache' ornament, coiled nose and fangs. Taken together, the lid with the facial features, the box and the two sides with the legs might be interpreted as a complete representation of Tlaloc's body.

Unlike other *tepetlacalli*, the present casket contained no items associated with self-sacrifice, but instead a large number of objects relating to water – beads, small greenstone sculptures, shells, conches, two model canoes, two oars, a rudder – along with things more often included in offerings, such as Mezcala-style figurines and masks. Other notable objects were a spear-thrower (*átlatl*) carved from white stone and some items included elsewhere in this publication (cats 280–81). EMM

243

Votive vessel with an image of Tlaloc

*c.*1500, Tepanec

Fired clay and traces of paint, 116.5 × 40 × 47 cm

Museo Nacional de Antropología, Mexico City, CONACULTA-INAH, 10-357182

PROVENANCE: Azcapotzalco, Mexico City, first half of the twentieth century

SELECTED REFERENCE: Solís Olguín 1991B, p. 255, no. 388

Following their victory over the Tepanecs, the Aztecs destroyed virtually all evidence of Tepanec cultural identity, a process continued by the Spaniards during their occupation – the nineteenth in the history of the region. The present vessel bearing an image of the rain god Tlaloc, the best preserved of two found in the area, thus belongs among the few artefacts to have survived from the former Tepanec domain of Azcapotzalco. The ornamentation around the sides of the vessel, which depicts the steam that was thought to have created the clouds in the sky, was made separately and attached to the body after firing. Tlaloc is identified by his characteristic mask. According to myth, he ordered his helpers, the *tlaloque*, to collect water from the mountains in vessels like this: the *tlaloque* raised them to the height of the sky and the precious liquid

poured down. The god's benevolent role is indicated by the beads and pendants on his chest and by the circular plaque symbolising gold. FS, RVA

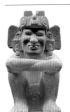

244

Xiuhtecuhtli

*c.*1469–81, Aztec

Basalt, 36.6 × 21.9 × 21.2 cm

Museo del Templo Mayor, Mexico City, CONACULTA-INAH, 10-220304

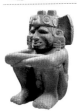

245

Xiuhtecuhtli

*c.*1469–81, Aztec

Basalt, 37 × 21.8 × 20 cm

Museo del Templo Mayor, Mexico City, CONACULTA-INAH, 10-220305

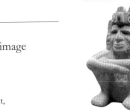

246

Xiuhtecuhtli

*c.*1469–81, Aztec

Basalt, 31.5 × 19 × 19 cm

Museo del Templo Mayor, Mexico City, CONACULTA-INAH, 10-220357

PROVENANCE: offerings 17, 20 and 61, between the Tlaloc and Huitzilopochtli buildings (cats 245–46) and Tlaloc building (cat. 244), Stage IV(b) of the Templo Mayor, Mexico City, 1979

SELECTED REFERENCES: Matos Moctezuma 1988, p. 92; López Luján 1993, pp. 172–92

Xiuhtecuhtli, the ancient god of fire, also known as Huehueteotl, was represented as an old, toothless man with blind or closed eyes, sitting with his arms crossed over his knees. Sculptures of this type were found in 26 of the over 120 offerings excavated on the site of the Templo Mayor in Mexico City, most of them near the Tlaloc building, in which gods representing contrary but complementary elements, such as fire and water, were united. Fire was associated with the male and celestial half of the universe, where all is light and warmth, while water was the female side: dark, damp, cold and earthly. Accordingly, Xiuhtecuhtli was the patron of the day called *atl* ('water') and *atl-tlachinolli* ('burnt water') was the symbol of sacred war.

The present images of Xiuhtecuhtli show his main attributes. He is naked but for

a simple loincloth, two rectangular ear ornaments with a pendant in the centre, a paper bow at the nape of the neck (the last two features typical of gods of water and fertility) and a *xiuhuitzolli* diadem decorated with concentric circles, probably representing precious stones, the most distinctive aspect of which is the fire bird (*xiuhtototl*) at centre. Likewise characteristically, the lower half of his face is painted black, the areas around his ears and mouth red. Crowning his head are two protuberances representing the sticks rubbed together to produce fire.

In his guise of 'lord of the year', Xiuhtecuhtli-Huehueteotl ruled over time and the recording of time. He was celebrated during two feasts, Xocolhuetzi and Izcalli, and every 52 years he presided over the New Fire rites. As the god of fire, Xiuhtecuhtli lived at the centre of the universe, from which the three vertical levels and the four horizontal directions started. He was at the centre, just as fire was at the centre of the home and the temple. As 'turquoise lord', he was worshipped for inhabiting the navel of the world, enclosed by turquoises. The attributes of Xiuhtecuhtli are expressed in a song recorded on folio 34 of the Florentine Codex (cat. 345): 'Mother of the gods, father of the gods, the old god / lying in the navel of the earth, / placed in an enclosure of turquoises. / He who is in water the colour of bluebirds, / He who is enclosed in clouds. / The old god, he who lives in the shadows of the region of the dead / The lord of fire and of the year.' EMM

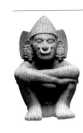

247

Pulque deity

*c.*1469–81, Aztec

Basalt and traces of paint, 36.5 × 23 × 20 cm

Museo del Templo Mayor, Mexico City, CONACULTA-INAH, 10-162940

PROVENANCE: offering 6, Huitzilopochtli building, Stage IV(b) of the Templo Mayor, Mexico City, 1978

SELECTED REFERENCE: Nicholson 1991

The name of the eighth day of the ritual calendar was *tochtli* ('rabbit'), represented by the common Mexican rabbit (*Sylvalagus cunicularius*) and associated with drunkenness. The patron of *tochtli* was Mayahuel, goddess of maguey, the fermented sap of which is combined with the root of a bush popularly known as '*pulque* wood' or 'wood of the devil' (*Acacia angustissima*) to produce the alcoholic beverage *pulque*. The Aztecs were ambivalent in their attitude to *pulque*. On the one hand, it was a ritual drink, considered magical, highly regarded for its intoxicating power and available only to the highest-ranking individuals during certain ceremonies. On the other hand, common drunkenness was punishable by death because it caused personal, family and social disintegration.

The Aztecs referred to the gods of *pulque* as Centzon Totochtin ('400 rabbits') to indicate that they were numerous. Headed by Ometochtli ('two rabbit'), they included Patecatl, Tezcatzoncatl and Techalotl. The nose-ring called *yacameztli* ('nose moon'), shaped like a half-moon and a distinctive feature of the *pulque* gods, is Huaxtec in origin and a main attribute of Tlazolteotl, the goddess of sexual excess. The moon is the symbol of femaleness and of cycles of fertility. The gods of *pulque* thus constitute a synthesis of Aztec notions of *pulque*, the rabbit and the moon: drunkenness produces the uninhibited state associated with rabbits and induces heightened sexuality, which favours fertility, represented by the moon.

In the present sculpture the *yacameztli*, the fan-shaped *tlaquechpányotl* (paper bow at the nape of the neck, which gods of *pulque* decorated with drops of rubber), the diadem and the traces of red paint on the body (which *pulque* deities painted half red, half black) identify the figure as a *pulque* god. He wears a simple loincloth, tied in a bow large enough to be seen between his legs from the rear, and rectangular

ear ornaments with a pendant in the middle, a feature typical of Tlaloc, the rain deity associated with fertility. EMM

248

Relief with an image of an eagle and a snake

c. 1450–1521, Aztec

Olivine basalt, 59 × 27 × 12 cm

Museum der Kulturen Basel, Basle, IVb 732

PROVENANCE: Lukas Vischer collection, donated to the museum, 1844

SELECTED REFERENCES: Waldeck 1866; Basle 1985, p.64; Bankmann and Baer 1990, pp.156–57

The relief was carved from an irregularly shaped piece of dark stone, on the front, two ends and the reverse. Its main image depicts an eagle apparently holding a rattlesnake in its claws and snapping at it with its beak, which is open to reveal the tongue. The mouth of the snake, too, is open, showing its fangs. Part of the snake's body appears behind the eagle's claws; the rattle lies beneath its tail feathers. The sign *acatl* ('reed') is carved in front of the eagle's; the number associated with it can be read as a six or a seven (the stone is damaged at this point). The image probably relates to the legendary foundation of the Aztec capital, Tenochtitlan, which involved an eagle devouring a serpent on a cactus (see p.14).

Jean Frédéric de Waldeck made a drawing of the stone during his stay in Mexico from 1826 to 1832, but this was not published until 1866. AB

249

Cuauhxicalli

c. 1502–20, Aztec

Basalt, 139 × 82 × 76 cm

Museo del Templo Mayor, Mexico City, CONACULTA-INAH, 10-252747

PROVENANCE: Casa del Marqués del Apartado, Argentina no. 12, Mexico Federal District, 1984

SELECTED REFERENCE: Matos Moctezuma 1990

As the bravest and highest-flying of all birds, as the supreme warrior who combats the powers of night,

the eagle symbolised the sun in ancient Mexico. *Cuauhxicalli* ('eagle vessels') held the hearts and blood produced by human sacrifices, to which the gods descended symbolically to feed themselves. Most known *cuauhxicalli* are circular and bear various decorative motifs on their sides and on the inside and outside of their bases (see cats 150–52). Among the exceptions are the ocelot *cuauhxicalli* in the Museo Nacional de Antropología in Mexico City, discovered in 1901 together with the colossal head of the *xiuhcoatl* ('fire serpent') now in the Museo del Templo Mayor, and the present piece, found in 1984 under the Casa del Marqués del Apartado. Dating from Stage VI in the construction of the Templo Mayor, it represents an eagle, its wings attached separately to the body, its head raised and its beak half open. The position and size of the feathers covering its body imitate those of the real bird, becoming progressively smaller towards the head, forming a halo near the eyes and appearing long at the tips of the wings. The cavity that served as a receptacle for the hearts is at the top, on the back of the bird. The left side of the head has been mutilated. EMM

250

Snail shell

c. 1500, Aztec

Stone and traces of stucco and paint, 105 × 75.5 cm

Museo Nacional de Antropología, Mexico City, CONACULTA-INAH, 10-213080

PROVENANCE: Templo Mayor, Mexico City, 1981

SELECTED REFERENCES: New York 1990, p.222, no. 104; Solís Olguín 1991, pp.115–16

In the ancient Mesoamerican view of the universe a layer of water existed under the surface of the earth that was inhabited by fantastical animals such as the alligator-like *cipactli*. The present sculpture of a *caracol* (spiral snail shell), found in the subsoil of the Templo Mayor in Mexico City, relates to this belief. Archaeologists discovered three

similar depictions of the queen conch (*Strombus gigas*), a shell characteristic of the Gulf of Mexico and the Caribbean, in the north-eastern area of the former sacred precinct of Tenochtitlan. The item shown here is a fine example of the ability of sculptors during the Late Postclassic period (1250–1521) to create a naturalistic image interwoven with symbolic meaning. The *caracol* was associated with water and rain and with female genitals. As a musical instrument, it was used to announce war and festivities and, when cut transversally, it became an icon of the wind.

The sculpture shows remains of the original stucco and blue paint, linking it to the Tlaloc shrine. FS, RVA

251
Serpent's head

c. 1500, Aztec

Stone, 90 × 92 × 155 cm

Museo Nacional de Antropología, Mexico City, CONACULTA-INAH, 10-280936

PROVENANCE: Mexico City, first half of the twentieth century

SELECTED REFERENCES: Bernal 1967, p. 161, no. 82; New York 1970, p. 296, no. 273; Washington 1983, pp. 131–32

Excavations carried out in Mexico City in the twentieth century brought to light a number of sculptures that had adorned Tenochtitlan, the capital of the Aztecs. The original location of this monumental serpent's head, probably discovered during the first half of the twentieth century, is not known, but it must have been found near the Plaza Mayor. It has been identified as the head of a rattlesnake (*Crotalus horridus*). It has scales and four sharp teeth at the front and a pair of fangs at either side. Similar sculptures graced the stairs of the pyramids at Tenochtitlan, guarding the temples of the supreme Aztec deities. FS, RVA

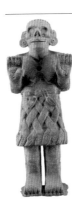

252
Coatlicue

c. 1500, Aztec

Stone, red shell, turquoise and traces of paint, 115 × 40 × 35 cm

Museo Nacional de Antropología, Mexico City, CONACULTA-INAH, 10-8534

PROVENANCE: Coxcatlán, Tehuacan, Puebla State; donated to the museum by Josefa Atecechea in the nineteenth century

SELECTED REFERENCES: Anton 1969, p. 110, no. 207; Mexico City 1995, p. 84

Together with a companion piece (cat. 253), the sculpture comes from Coxcatlán, near Tehuacan in Mixtec territory close to the border with the Aztecs. It bears witness to the artistic influence exerted by the Aztecs in the wake of their military dominance of their neighbours in the Central Highlands. The image represents Coatlicue, the mother of Huitzilopochtli, who symbolised the regenerative power of the earth. Her name, which means 'serpent skirt', is a metaphor of the earth's surface, which the Aztecs imagined covered by a network of reptiles. Coatlicue symbolises the cycle of life and death: she is the mother-goddess who feeds the sun, the moon and humankind and she collects the bodies of human beings when they die. Hence, she is shown here with an emaciated head and with clawed hands raised in an aggressive gesture, reclaiming the bodies of the children to whom she had given the breath of life. Her calendrical name, '8-grass', appears on the back of her head. Tufts of human hair will originally have been inserted in the perforations in her head. The turquoise and shell inlays representing facial decoration and teeth respectively have survived, as have, more rarely, the delicate colours of her belt and skirt. FS, RVA

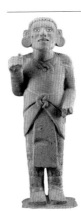

253
Xiuhtecuhtli-Huitzilopochtli

c. 1500, Aztec

Stone, white shell and obsidian, 112 × 38 × 31 cm

Museo Nacional de Antropología, Mexico City, CONACULTA-INAH, 10-9785

PROVENANCE: Coxcatlán, Tehuacan, Puebla State; donated to the Museo Nacional by Josefa Atecechea, in the nineteenth century

SELECTED REFERENCES: Galindo y Villa 1903, pp. 222–23; Caso and Mateos Higuera 1937, p. 18; Solís Olguín 1991, pp. 160–67; Mexico City 1995, p. 85

At the end of the nineteenth century excavation of a Pre-Hispanic mound on the estate of Mrs Josefa Atecechea at Coxcatlán in the Mixtec region of Tehuacan brought to light images of two deities involved in the Aztec myth of the birth of the sun: Coatlicue, with her characteristic skirt of intertwined serpents (cat. 252), and Xiuhtecuhtli-Huitzilopochtli, shown here. The god is represented as a vigorous young man, his hands designed to hold weapons or banners. He is dressed in a loincloth composed of wide rectangular strips and wears over it the triangular cloth typical of warriors; his association with the sun is indicated by sandals decorated with solar rays at the heels and by a colourful cape in the shape of the tail of the *xiuhcoatl* ('fire serpent'). The calendrical name of the figure, Nahui Cipactli ('4-alligator'), appears on the back of the head. The figure retains the original shell and obsidian inlays in the eyes and teeth, and the head, like that of its companion, is perforated for the attachment of human hair. FS, RVA

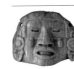

254
Mask of Coyolxauhqui

c. 1500, Aztec

Greenstone, 10.5 × 14.5 × 4 cm

Peabody Museum of Archaeology and Ethnology, Harvard University, Anonymous gift, 28-40-20/C10108

PROVENANCE: purchased, 1928

SELECTED REFERENCES: Washington 1983, no. 10; Matos Moctezuma 1991, p. 24; González Torres 2001B, p. 22

The mask represents the decapitated goddess Coyolxauhqui ('the one with bells on her face').

Her lowered eyelids indicate that she is dead and the two bells on her cheeks linked by an incised band across the nose symbolise her name. Her striated hair, or possibly a head cloth, is studded with down-feather balls that stand for light, sun and sacrifice. She wears ear ornaments consisting of circular and triangular elements from which hang what appear to be trapezoidal year symbols. The two perforations above the ears suggest that the mask was worn as a pectoral during ritual performances. Twelve pairs of perforations on the rear edge of the underside may have been used to hang other miniature objects when the mask was employed as a pectoral. This piece has striking similarities to two other images of Coyolxauhqui: an enormous diorite head unearthed in 1830 in Mexico City (cat. 255) and the colossal circular stone carving found in 1978, also in Mexico City (fig. 10).

Coyolxauhqui plays a major role in the myth of the birth of the Aztec patron deity Huitzilopochtli ('left-sided hummingbird'). She becomes enraged because her mother, Coatlicue ('serpent skirt'), conceives Huitzilopochtli while sweeping out a temple on the sacred mountain Coatepec ('serpent hill'). She leads her brothers, the Centzon Huitznahua ('400 southerners'), to attack their mother after preparing them for war through ritual dance and costuming. When Coyolxauhqui arrives at the top of Coatepec in full battle array, Coatlicue gives birth to Huitzilopochtli, who is fully grown and armed. The young warrior god slays and scatters his siblings by using his magical weapon, the *xiuhcoatl* ('fire serpent'). He then decapitates and dismembers Coyolxauhqui, whose body falls to pieces, rolling down Coatepec. This myth was symbolised in the design and location of certain sculptural objects at the Templo Mayor in Tenochtitlan. DC

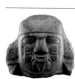

255

Head of Coyolxauhqui

c. 1500, Aztec

Diorite, 80 × 85 × 68 cm

Museo Nacional de Antropología, Mexico City, CONACULTA-INAH, 10-2209118

PROVENANCE: Convento de la Concepción, Mexico City, 1830; donated by the convent to the museum, 1830

SELECTED REFERENCES: Peñafiel 1910, p. 52; Washington 1983, pp. 48–50

The sculpture depicts the head of Coyolxauhqui ('the one with bells on her face'), goddess of the moon. Symbols on the ornaments she wears on her face indicate that the bells were made of gold. The circles on her head stand for the feathers that were attached to people about to be sacrificed, recalling the creation myth in which Huitzilopochtli, the warrior sun, decapitated his sister and enemy, the moon (see cat. 254). On the base of the sculpture is a relief of *atl-tlachinolli*, symbol of sacred war, expressed as the union of fire and water, together with date '1-rabbit'. Both elements show that the monument commemorates the earth mother Coatlicue giving birth to Huitzilopochtli.

The sculpture formed part of the Templo Mayor complex and was found in March 1830 in the old Convento de la Concepción near the street of Santa Teresa (now Guatemala Street). FS, RVA

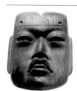

256

Mask

c. 1100–600 BC, Olmec

Greenstone, 10.2 × 8.6 × 3.1 cm

Museo del Templo Mayor, Mexico City, CONACULTA-INAH, 10-168803

PROVENANCE: offering 20, between the Tlaloc and Huitzilopochtli buildings, Stage IV(b) of the Templo Mayor, Mexico City, 1978

SELECTED REFERENCES: Matos Moctezuma 1979; López Luján 1993, pp. 323–30

Approximately 80 per cent of the objects found among offerings in the Templo Mayor in Mexico City came from towns under Tenochtitlan rule, but they included items from earlier civilisations, such as those of Teotihuacan and the Olmecs. Scientific examination of the

present Olmec mask, and the aquiline shape of its nose, suggest that it came from the border area between Guerrero, Oaxaca and Puebla. Some three thousand years old, it evokes the jaguar, a feature typical of the ancient cultures of the Gulf of Mexico, and shows the characteristic V-shaped groove in the upper part. The Aztecs, who clearly recognised the value of the mask, placed it in offering 20. The first layer of this offering contained very fine black sand, the second shells and small conches, greenstone beads, copper rattles, sea urchins and anthropomorphic figurines made of copal. The third layer consisted of larger marine objects: *Strombus* and *Xancus* conches along with 'brain', 'antler' and 'net' types of coral. The fourth layer contained the remains of various animal skins – fish, tortoise shells, rostral swordfish cartilages – and the fifth images of Tlaloc and Xiuhtecuhtli, the Olmec mask shown here, various Mezcala-type greenstone figurines and masks, Mixtec penates, sacrificial knives (*tecpatl*) and inlaid skull masks. The offering was completed by sceptres in the shape of serpents and deer's heads, a *chicahuaztli* staff (see cat. 275), spear points and nine skulls of decapitated human beings. EMM

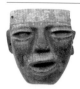

257

Mask

c. 1200–1481, Mezcala

Greenstone and paint, 15.4 × 14.4 × 4.12 cm

Museo del Templo Mayor, Mexico City, CONACULTA-INAH, 10-220264

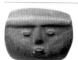

258

Mask

c. 1200–1481, Mezcala

Greenstone and paint, 12 × 17.4 × 4.52 cm

Museo del Templo Mayor, Mexico City, CONACULTA-INAH, 10-220266

259

Mask

c. 1200–1481, Mezcala

Greenstone and paint, 19.9 × 18 × 2.9 cm

Museo del Templo Mayor, Mexico City, CONACULTA-INAH, 10-220316-16879

See cat. 261.

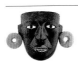

260

Mask

c. 300–600, Teotihuacan

Greenstone, shell, obsidian and coral,
21 × 20.5 × 14 cm

Museo del Templo Mayor, Mexico
City, CONACULTA-INAH, 10-220037
(ear ornaments) and 10-220032 (mask)

PROVENANCE: offering 82, Huitzilopochtli
building, Stage IV(b) of the Templo Mayor,
Mexico City, 1981

SELECTED REFERENCES: López Luján 1989;
López Luján 1993, pp. 424–25

This Teotihuacan mask was
already one thousand years old
when the Aztecs used it as an
offering in the Templo Mayor.
The Aztecs sought to link their
own history to that of previous
civilisations, such as those of
Teotihuacan and the Toltecs, in
an attempt to erase their nomadic
origins and their humble cultural
lineage. The discovery of
Teotihuacan objects in offerings
in the Templo Mayor proves
that the Aztecs carried out
excavations there.

The dark green mask retains
the shell and obsidian inlays in
its eyes and the coral used for its
teeth. It was placed in the middle
of the offering and faced south,
the direction associated with
Huitzilopochtli, the Aztec patron
deity. The bottom layer contained
an Aztec mask of white stone and
a series of greenstone objects; the
uppermost included a skull that
showed signs of decapitation.
EMM

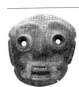

261

Mask

c. 1200–1481, Mezcala

Greenstone and paint, 14.8 × 15 × 4.8 cm

Museo del Templo Mayor, Mexico City,
CONACULTA-INAH, 10-220267

PROVENANCE: Chamber II, Tlaloc building,
Stage IV(b) of the Templo Mayor,
Mexico City

SELECTED REFERENCES: González and
Olmedo Vera 1990; Matos Moctezuma
1993

The Mezcala style of sculpture
originated in the early first
century in the vicinity of the River
Mezcala, now in the Mexican state
of Guerrero, and developed
concurrently with the Classic
period of Teotihuacan (200–650).

Among the hallmarks of the
Mezcala style, clearly visible in the
present pieces, are highly abstract
facial features that are simply
suggested by lines and variations
in surface texture. Most of the
Mezcala objects discovered in
the Templo Mayor in Mexico City
are masks, heads and complete
figurines, found in the offerings
and occasionally painted with the
attributes of the rain god Tlaloc.

All the items shown are made
of greenstone. The first mask (cat.
257) shows remains of red and
white paint and has wide oval eyes,
a triangular nose and a large open
mouth – features of the
Teotihuacan style. The second
mask (cat. 258) is notable for a
prominent bar representing the
eyebrows, which are joined to the
nose. The eyes are small and oval
and traces of red paint can be seen
under the mouth. A water-glyph is
drawn in black on the reverse. The
triangular nose and the oval eyes
of the third mask (cat. 259), which
has a rectangular forehead, are
indicated by incisions, as is the
mouth, which is decorated with
vertical bands of red. The fourth
mask (cat. 261) bears traces of
red, white, blue and black paint
and has arched eyebrows, eyes
consisting of circular holes, a
triangular nose and a 'moustache'
ornament painted above its mouth
– an attribute of Tlaloc. The
figurine (cat. 263) has inlaid eyes
and bears traces of white, black,
red and blue pigment on various
parts of the body. The head is
painted with the facial features
of Tlaloc.

Chamber II, from which these
pieces come, was among the
Templo Mayor offerings with the
largest number of Mezcala objects,
including a further 84 masks and
56 complete figures. Since it
contained the greenstone sculpture
of Tlaloc (cat. 239), it is believed
to have been dedicated to the
tlaloque, helpers of Tlaloc who
were responsible for pouring rain
from vessels bearing the image
of the god (see cat. 243). EMM

262

Pectoral with an image of a moth

c. 1500, Aztec

Greenstone, diameter 13.5 cm

Museo Nacional de Antropología,
Mexico City, CONACULTA-INAH, 10-162943

PROVENANCE: Coyolxauhqui monument,
Templo Mayor, Mexico City, 1978

SELECTED REFERENCES: García Cook and
Arana 1978, p. 65, no. 56; Solís Olguín
1991B, p. 261, no. 403; González Rul 1997,
p. 36, fig. 20

This circular pectoral with the
image of a deified moth belonged
to a group of votive objects
discovered on 23 February 1978
on the site of the circular
monument to the goddess
Coyolxauhqui in the Templo
Mayor, Mexico City. It bears
witness to the advanced
technology employed by Aztec
stoneworkers, who in the Late
Postclassic period (1250–1521)
were already using copper and
bronze tools in addition to the
traditional small axes made of hard
stones such as nephrite or basalt.
The moth is flying downwards:
its head, in the lower part, is
covered with white down-feathers,
a symbol of human sacrifice, and
its hands are held in an aggressive
gesture at the sides of the face.
The rest of the disc contains the
extended wings, each of three
lobes. The star-shaped eye, partly
covered by the eyelid, links the
creature with the night. FS, RVA

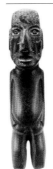

263

Figurine

c. 1200–1481, Mezcala

Greenstone and paint, 25.4 × 5.7 × 4.2 cm

Museo del Templo Mayor, Mexico City,
CONACULTA-INAH, 10-220316

PROVENANCE: Chamber II, Tlaloc building,
Stage IV(b) of the Templo Mayor,
Mexico City

SELECTED REFERENCES: González and
Olmedo Vera 1990; Matos Moctezuma
1993

See cat. 261.

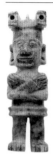

264

Figurine

*c.*1469–81, probably Mixtec

Greenstone, 11.25 × 3.38 × 3.03 cm

Museo del Templo Mayor, Mexico City,
CONACULTA-INAH, 10-168804

PROVENANCE: Chamber II, Tlaloc building,
Stage IV(b) of the Templo Mayor,
Mexico City, 1980

This figurine probably comes from
the Mixtec area, in the modern
states of Puebla and Oaxaca,
which was conquered by the
Aztecs about the second half of
the fifteenth century. This origin
has not been established beyond
doubt, however, for although the
piece has the characteristics typical
of greenstone sculptures from
this region, which show figures
standing or seated, their arms on
their knees or, as here, crossed
over their chest, it is more finely
worked and its features are more
detailed than other examples. The
eyes of the figure are closed and
he wears a large headdress in the
shape of a two-headed serpent. He
is probably dead. The sculpture
was found in Chamber II of the
Templo Mayor along with other
items included here (cats 239,
257–59, 261, 263). EMM

265

Offering 106

*c.*1325–1502, Aztec

Various materials and dimensions

Museo del Templo Mayor, Mexico City,
CONACULTA-INAH, 10-252003

PROVENANCE: house of the Ajaracas,
Calle República de Argentina, opposite
the Templo Mayor, Mexico City, 2000

Excavations carried out in 2000
as part of the Urban Archaeology
Programme of the Museo del
Templo Mayor in Mexico City
brought to light seven offerings to
Tlaloc, the god of rain. They were
found in the Calle República de
Argentina, in buildings previously
occupied by the Ajaracas and
Campanas that had been erected
on the remains of a platform
belonging to one of the last stages
(possibly VI) in the construction
of the Templo Mayor.

Among the offerings was
that shown here just as the
archaeologists found it. Aztec

priests had placed a large number
of objects in a box made of
volcanic rock with a stone slab
base. The bottom layer contained
items evoking the sea: corals,
seaweed and the saw of a sawfish.
Above this, were a sculpture of
Xiuhtecuhtli, the god of fire, a
miniature *pulque* vessel, a ceramic
glyph, masks with the face of
Tlaloc, blue flutes bearing the
image of Xochipilli-Macuilxochitl
(the god of dance and music),
copal figures, knives and the
remains of eagle, heron and
quail bones. Along the edge of
the box were flint knives and
representations of drums.
Offerings to the god of rain
frequently contained such
recurrent symbolic references
to music, fertility and plants. EMM

266

Sceptre

*c.*1325–1481, Aztec

Obsidian, 55 × 5.86 × 1.7 cm

Museo del Templo Mayor, Mexico City,
CONACULTA-INAH, 10-250354

PROVENANCE: offering 7, Huitzilopochtli
building, Stage IV(b) of the Templo Mayor,
Mexico City, 1980

See cats 268–69.

267

Eccentric flint

*c.*1500, Aztec

Flint, 44 × 22.5 × 10 cm

Museo Nacional de Antropología,
Mexico City, CONACULTA-INAH, 10-393945

PROVENANCE: Mexico City, 1940

SELECTED REFERENCES: Solís Olguín 1991b,
p.262, no. 407; Amsterdam 2002, p.232,
no. 185

In 1940 two ritual instruments
associated with human sacrifice
were discovered among the
offerings excavated in the area
of the Templo Mayor behind the
Metropolitan Cathedral in Mexico
City. They point to the use of the
tecpatl ('flint', i.e. sacrificial knife)
as a link between life and death.
Of the two, that shown here is
the more finely carved and adds
a 'nose' to what looks like the
profile of a human skull so that
it resembles a second *tecpatl*.

The design recalls the handle and
blade of a sacrificial knife, but the
present object was not actually
used to extract hearts. Rather, its
function was symbolic: to evoke
the god Mictlantecuhtli ('lord of
Mictlan [place of the dead]'), spirit
of the dead and personification of
death, through a depiction of him
and his deadly breath. FS, RVA

268

Serpent's head and rattle

*c.*1325–1481, Aztec

Green obsidian, 6.3 × 2.5 × 1.5 cm,
7.3 × 0.9 × 1.3 cm

Museo del Templo Mayor, Mexico City,
CONACULTA-INAH, 10-262756 0/2

PROVENANCE: offering 60, Huitzilopochtli
building, Stage IV(b) of the Templo Mayor,
Mexico City, 1980

269

Two sceptres

*c.*1325–1481, Aztec

Green obsidian, 9.4 × 1.9 × 0.9 cm
and 9.2 × 1.8 × 0.9 cm

Museo del Templo Mayor, Mexico City,
CONACULTA-INAH, 10-263826, 10-265172

PROVENANCE: offering 60, Huitzilopochtli
building, Stage IV(b) of the Templo Mayor,
Mexico City, 1980

SELECTED REFERENCE: Matos Moctezuma
1988, p.97

The Aztecs developed great skill in
fashioning objects from obsidian,
a hard and brittle volcanic glass
that is extremely difficult to work.
It was used in Mesoamerica from
the earliest times and continued
to grow in importance among the
various settlements in the Basin
of Mexico until the Spanish
arrived. Obsidian, which has grey,
green or golden reflections
depending on the type, was
obtained by collecting blocks of
it on the surface of the earth or
extracting it from mines. Large
deposits existed in present-day
Mexico Federal District and in the
federal states Hidalgo and Puebla,
the most important and closest to
Tenochtitlan being those in
Mexico and at Sierra de las
Navajas in Hidalgo. The material
reached the Aztec capital via trade
with these areas and in the form
of tribute paid by them.

Obsidian symbolised the
night and the cold. Tezcatlipoca
('smoking mirror'), the

omnipotent god of fate, was associated with it, one of his attributes being an obsidian mirror that reflected the night (see cat. 279). The stone was also linked to death, to the cold wind of knives that was one of the eight stages the dead had to pass through before reaching the realm of Mictlantecuhtli, lord of the land of the dead.

The offerings excavated from the Templo Mayor in Mexico City contained a vast number of objects made from obsidian, including ear ornaments, nose-rings, miniature and full-scale sceptres of various kinds, an urn bearing the face of a monkey, arrow heads, small knives and so forth. These finds have substantially increased the list of known items made from this stone. The two examples with spherical grips shown here are miniature versions of the sceptre held by Techalotl, a *pulque* deity (see cat. 247). EMM

270–71
Two flutes

c. 1502, Aztec

Fired clay and paint, both 4 × 4 × 13.5 cm

Museo del Templo Mayor, Mexico City, CONACULTA-INAH, 10-219817, 10-252479

PROVENANCE: offering 89, external patio, Stage VI of the Templo Mayor, Mexico City, 1981

SELECTED REFERENCE: López Luján 1993, pp. 353–54

Flutes are among the oldest instruments known to humankind. As in other cultures, Pre-Hispanic Mesoamericans realised that by making a hole in a clay tube or reed the sound produced was higher in pitch. Later, they discovered that by closing the hole they could reproduce the original sound of the tube. After making further holes in the tube it was found that by opening each of them in ascending order the sounds became increasingly high. In Mesoamerica flutes reached a high degree of technical perfection, and both musicians and composers were honoured and respected by the peoples and their rulers. Flutes and other wind

instruments, along with percussion instruments, played an important role in collective rites and ceremonies. The 'flower prince' Xochipilli, also known as Macuilxochitl, was the patron god of music-making and games.

The two flutes shown here were found placed in a box of volcanic rock together with three seashells, eighteen representations of *teponaxtli* drums (see cat. 157), thirteen volcanic rock sculptures of *chicahuaztli* staffs (see cat. 275) and a further ten ceramic flutes coloured blue. Completing the offering were a vessel with an image of the rain god, Tlaloc, that contained beads, pieces of greenstone and remains of copal, wood and bone in a poor state of preservation (the offering was found practically immersed in groundwater). The flutes are tubular, with a mouthpiece at one end and a decorative plaque at the other consisting of three circles with a hole in the centre and undulating scrolls – probably a reference to Tlaloc. Both have four circular finger-holes in the body and a square one near the mouthpiece, and both are painted entirely blue, the colour of water. EMM

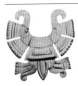

272
Nose-ring in the form of a butterfly

c. 1500, Aztec

Gold, 7.5 × 7.5 × 0.1 cm

Museo Nacional de Antropología, Mexico City, CONACULTA-INAH, 10-220922

PROVENANCE: Calle de las Escalerillas, Mexico City, 1900

SELECTED REFERENCES: Beyer 1965B, pp. 465, 468, no. 5; Seville 1997, pp. 144–45, no. 37; Vienna 1997, pp. 44–45, no. 13

The nose-ring, a ritual adornment once worn by the image of a deity in the Templo Mayor of Tenochtitlan, is among the very few examples of Aztec goldwork that survived the greed of Spanish soldiers when they discovered the treasure chamber in the palace of Axayacatl and distributed its contents among troops and officers. Found on 16 October 1900 in the course of drainage

construction carried out in Mexico City, it formed part of a find, rescued by Leopoldo Batres, that included solid discs and discs with a circular incision in the centre known as an *anahuatl*, an emblem of the patrons of war or the flowering of the fields. Butterfly-shaped nose-rings, called *yacapapalotl* in Nahuatl, characterised several deities, among them Xochiquetzal and Chalchiuhtlicue, goddesses of flowers and water respectively. The present ornament, however, is topped by the tail of the *xiuhcoatl* ('fire serpent'), evoking the celestial deities who provide light and heat, principally the sun. Hence, the nose-ring may have been an attribute of Coyolxauhqui, who is rendered as rays of light in the sculptures of her that have come down to us. FS, RVA

273–74
Xiuhcoatl

c. 1500, Aztec

Gold, both 16 × 1 cm

Museo Nacional de Antropología, Mexico City, CONACULTA-INAH, 10-594810 and 10-3302

PROVENANCE: Calle de las Escalerillas, Mexico City, 1900

SELECTED REFERENCES: Solís Olguín and Carmona 1995, p. 115, no. 91; Seville 1997, pp. 164–65, no. 54; Vienna 1997, pp. 70–72, no. 61

Gold (*cuzticteocuícatl* in Nahuatl) was thought by the Mexica to be a type of divine excrement, dropped from the sky onto the face of the earth. The goldsmiths of Tenochtitlan fashioned it into bracelets, rings, necklaces, pectorals, ear ornaments and other items of jewellery to be worn only by rulers and high-ranking nobles as a symbol of their power and social status. The supreme Aztec ruler – considered to be the owner of the precious metal – presented it as a gift to warriors who distinguished themselves in battle. The present pair of sheet gold items, discovered on the site of the Templo Mayor in Mexico City, was produced by hammering out a gold nugget until it reached the desired size and thickness.

They portray the *xiuhcoatl* ('fire serpent') in the form of the weapon thought to have been used by Huitzilopochtli, the Aztecs' patron god, i.e. a sword consisting of a reptile covered in flames, its tail a ray of sunlight. FS, RVA, AG

275

Chicahuaztli

c. 1469–81, Aztec

Alabaster, 11.9 × 2.6 × 0.9 cm

Museo del Templo Mayor, Mexico City, CONACULTA-INAH, 10-266040

PROVENANCE: offering 58, Tlaloc building, Stage IV(b) of the Templo Mayor, Mexico City, 1980

SELECTED REFERENCE: López Luján 1993, pp. 258, 340–43

The staff called *chicahuaztli* is an attribute of the god Xipe Totec ('our flayed lord'), who inhabited the eastern – the masculine – part of the universe and was associated with the colour red and the *acatl* ('reed') glyph. Images show him wearing the yellow skin of a sacrificial victim, carrying a shield of the same colour and holding the *chicahuaztli*, in which he keeps seeds. Standing for the surface of the earth and its regenerative powers, Xipe Totec participated in the creative process together with water, seeds and the sun. His festival, Tlacaxipehualiztli ('flaying of men'), was celebrated in March. During it, his priests wore the skins of the sacrificial victims over their own, signifying the renewal that allowed life to continue beyond death.

Chalchiuhtlicue, Xochiquetzal and other gods also hold this type of staff, which has thus generally been associated with deities of fertility and interpreted as symbolising the sun's rays penetrating and fertilising the surface of the earth. This phallic symbolism is clearly reflected in the shape of the staff and its contents. Alfonso Caso extended the range of the staff's applications, claiming that it was carried not only by the gods of water and vegetation, who control the fertility of agricultural land, but also by creation deities, such

as Quetzalcoatl, celestial gods, including Huitzilopochtli (the sun), the god of fire, Xiuhtecuhtli, and even the god of death, Mictlantecuhtli.

The present *chicahuaztli* was found at the bottom of offering 58, together with marine materials, greenstone beads, an animal-head staff, two serpent-shaped staffs, a Xipe Totec nose-ring and an obsidian disc. The seeds in such staffs, which were originally made of wood, produced a rattling sound when the staff was shaken. Rattles of this kind are still used in agricultural ceremonies in Mexico. EMM

276

Staff in the form of a deer's head

c. 1469–81, Aztec

Alabaster, 9.4 × 3.2 × 0.9 cm

Museo del Templo Mayor, Mexico City, CONACULTA-INAH, 10-265825

PROVENANCE: offering 24, Tlaloc building, Stage IV(b) of the Templo Mayor, Mexico City, 1978–79

SELECTED REFERENCE: López Luján 1993, pp. 254–57, 338–39

Deer were associated with the sun and with drought. Staffs in the shape of deer's heads are among the attributes of Xiuhtecuhtli, Xochiquetzal and other gods. The present model staff is made of alabaster, which the Aztecs considered a precious material because of its whiteness and translucency. Alabaster reached Tenochtitlan from Tecalco, a town in the Mixtec area of Puebla that was conquered by the Aztecs at the end of the fifteenth century; hence its Nahuatl name, *tecalli*.

A number of comparable pieces were found among the offerings of the Templo Mayor in Mexico City, complementing other items with wavy contours, which evoked serpents. The staff shown here was found in offering 24, which had six layers. The lowest consisted of a large quantity of small marine items and was followed by another containing larger objects of this kind: the shells of four turtles, mother-of-pearl shells, coral and so forth. Other items included remains of swordfish and white

herons, the skeleton of a puma, greenstone beads, a skull mask, sacrificial knives, a shell necklace, an ear ornament and, at the very top, sculptures of Xiuhtecuhtli and Tlaloc. EMM

277

Knife blades with an image of a face

c. 1325–1521, Aztec

Coffee-coloured and white flint and green obsidian, 23 × 6.3 × 1 cm, 23.2 × 6.7 × 1.2 cm, 26.5 × 7.3 × 1.1 cm, 23.1 × 7.3 × 0.9 cm, 16.5 × 6.4 × 4.4 cm and 15 × 5 × 3.9 cm

Museo del Templo Mayor, Mexico City, CONACULTA-INAH, 10-220282, 10-220280, 10-252376, 10-220284, 10-220291 and 10-253024

PROVENANCE: offering 52, Stage VII of the Templo Mayor, Mexico City, 1980

SELECTED REFERENCE: Matos Moctezuma 1988, p. 97

The Aztecs called the northern part of the universe Mictlampa ('place of the dead'), a dry region where cold winds blew. Identified with Mictlan, the region of fleshless beings, it was associated with the colour black and the glyph *tecpatl* ('flint', i.e. sacrificial knife) and was presided over by the black god Tezcatlipoca, whose attributes included an obsidian knife symbolising black wind.

Two types of knife blade were found in the Templo Mayor in Mexico City. The blade with a face, sometimes set in a copal base so that it could stand upright, represents the glyph *tecpatl*, one of the year-bearers who was considered a deity. The second type of blade is the sacrificial knife, made of flint and with no decoration or apparent grip. Various quantities of these were found in most of the Templo Mayor offerings, some of them in the mouth or nasal passages of skull masks as a symbol of death stopping the flow of air, the element of life. Inlays of white flint, and of white flint and obsidian, on both sides of the face blade shown here simulate teeth and eyes respectively, producing the image of a face seen in profile. EMM

278

Votive pot with images
of Xiuhtecuhtli and
Tlahuizcalpantecuhtli

c. 1500, Aztec

Fired clay and paint, height 25.5 cm,
diameter 22.5 cm

Museo Nacional de Antropología,
Mexico City, CONACULTA-INAH, 10-10918

PROVENANCE: Calle de las Escalerillas,
Mexico City, 1900

SELECTED REFERENCES: Batres 1902,
pp. 17–18; Peñafiel 1910, pp. 11–12,
pls 18–22

This large polychrome votive
vessel in the Cholula style was
discovered at the foot of the steps
of an ancient building in the
grounds of the Templo Mayor
on 16 October 1900, during
excavations in Calle de las
Escalerillas. The find included
another pot and, most notably,
long-handled censers (cat. 285).
The present vessel glorifies the
pair of deities that feature
prominently in the ninth 'week'
of the *tonalpohualli*, the Aztec
divinatory or ritual calendar:
Xiuhtecuhtli, identifiable
by the fact that the lower part of
the face is painted black, and
Tlahuizcalpantecuhtli, whose black
facial painting resembles a mask in
that it covers part of the forehead
and the area around the eyes. The
gods are depicted as busts, the
form in which the rulers of day
and night appear in the *tonalamatl*,
the codices containing the
tonalpohualli calendar (see cats
340–41). They are surrounded
by floral motifs, down-feathers
(the mark of sacrificial victims)
and other signs of a ritual nature.
On the neck of the vessel an icon
of the sun, consisting of rays,
alternates with sacred quills. The
images were formerly identified
as the souls of sacrificed warriors,
yet it has never been doubted that
the purpose of the vessel was to
mark an important thirteen-day
period in the ritual calendar.

FS, RVA

279

Funerary urn with an image
of Tezcatlipoca

c. 1470, Aztec

Fired clay, height 53 cm, diameter 17 cm

Museo del Templo Mayor, Mexico City,
CONACULTA-INAH, 10-168823 0/2

PROVENANCE: offering 14, Huitzilopochtli
building, Stage IV(b) of the Templo Mayor,
Mexico City, 1978

SELECTED REFERENCES: Matos Moctezuma
1983; Fuente, Trejo and Gutiérrez Solana
1988; Mexico City 1995, p. 164

During the Templo Mayor
excavation project (1978–82)
two orange-ware ceramic urns
stylistically typical of the coastal
region of the Gulf of Mexico,
made of clay from the Toluca
Valley and bearing Toltec-style
reliefs, were found a short distance
from the monolith of the goddess
Coyolxauhqui. They contained the
cremated bones of Aztec warriors
who had probably died in battle
against the people of Michoacán
during the reign of Axayacatl
(1469–81). One of them,
shown here, bears an image of
Tezcatlipoca ('smoking mirror'),
the universal god, the invisible
one who had the gift of ubiquity;
patron god of warriors, rulers and
sorcerers; god of the cold who
represented the night sky; and god
of creation who inhabited the
three levels and the four directions
of the universe.

Enclosed in a rectangle,
Tezcatlipoca is surrounded by
a feathered serpent with a forked
tongue emerging from its jaws.
The god is armed for war, his
spear-thrower (see cat. 315) in one
hand, two spears in the other. He
wears a headdress with long eagle
feathers and a huge pectoral
consisting of a four-string necklace
and a central disc – probably an
obsidian mirror – fastened by
a four-pointed bow. His nose-ring
has the shape of a spearhead;
the ear ornament consists of two
concentric discs from which
projects a sequence of one tubular
and three spherical beads. The god
wears a bracelet, and the arm
holding the spears is covered by
a protector of a type familiar from
Toltec images. He has rings
around his ankles and one of his

feet bears his principal attribute,
a smoking mirror. In addition to
ashes, the urn, the lid of which is
undecorated, contained various
obsidian objects, including a
necklace of beads shaped like
duck's heads (see p. 316), a spear
point, two tubular beads and
a bone perforator. EMM

280

Fish

c. 1469–81, Aztec

Greenstone, 3.6 × 15.6 × 3 cm

Museo del Templo Mayor, Mexico City,
CONACULTA-INAH, 10-168782

281

Seven fish

c. 1325–1481, Aztec

Mother-of-pearl (*Pinctada mazatlanica*),
approx. 2 × 6 × 1.5 cm each

Museo del Templo Mayor, Mexico City,
CONACULTA-INAH, 10-252244, 10-263416,
10-263411, 10-263622, 10-263417, 10-263267
and 10-263415

PROVENANCE: offering 41, Tlaloc building,
Stage IV(b) of the Templo Mayor,
Mexico City, 1980

SELECTED REFERENCES: Velázquez Castro
1999, pp. 78–80; Velázquez Castro 2000,
pp. 78–79; Polaco and Guzmán 2001

The shells of various molluscs
from the coasts of the Pacific, the
Mexican Caribbean and the Gulf
of Mexico were highly appreciated
for their value both as generative
symbols and as materials for
works of art. Seven of the fish
sculptures shown here (cat. 281),
all from offering 41 in the Templo
Mayor, were fashioned from
mother-of-pearl. The holes
were no doubt for threading the
individual items onto a necklace
or pectoral. The greenstone piece
(cat. 280), like the others
remarkably naturalistic, bears
traces of bitumen.

The great symbolic value
attached to fish by the Aztecs is
made clear by the fact that most
of the Templo Mayor offerings
contained remains of various
species, both freshwater and
saltwater, from the coasts of
Mexico. These show that Aztec
cultural practice involved cutting
the fish in different ways, including
the elimination of the spine and

associated muscles so as to reduce the amount of space the fish occupied in the offerings. EMM

therefore, the patron of goldsmiths was a deity associated with seeds and vegetation, Xipe Totec. EMM

represent the two main stages in the sun's journey, day and night. Players of the ritual game had to guess in which direction the sun was moving. Each round of the game ended with the decapitation of the player who had moved in a direction contrary to that of the sun. FS, RVA

282
Necklace

*c.*1325–1521, Mixtec (?)

Gold and silver; beads, diameter approx. 1.1 cm each; rattles approx. 3.8 × 1.5 × 2.7 cm each

Museo del Templo Mayor, Mexico City, CONACULTA-INAH, 10-252891

Necklaces and pectorals were not simply ornamental: they played an important role in Aztec ritual as components of the dress worn by priests and warriors. Gold, which was brought to Tenochtitlan from Oaxaca, was thought to be 'divine excrement', yet it did not have the status of the most precious of all materials that it enjoys in the Western world. Rather, Mesoamerican people regarded gold as equal in value to greenstone and the feathers of certain birds, which for them possessed great religious significance as symbols of life, water and beauty.

Metal objects were produced by lost-wax casting, hammering, filigree or, as in the present necklace, by a combination of these techniques. The necklace comprises eighteen spherical clay beads covered in a gold–silver alloy, a ceramic bead with no covering, one fragmentary and six complete rattles with spiral designs made from the same alloy.

Lost-wax casting involves creating a clay core in the shape of the object to be produced. This is then covered with a thin coating of wax and another layer of clay, into which two small holes are pierced. The molten metal is poured into one of the holes and replaces the wax, which pours out of the other. When it has cooled, the layer of clay is removed and the core is destroyed with a sharp, pointed implement. This method, with its succession of layers removed or replaced to reveal the finished work, recalls the natural process whereby the dry layers of the earth are replaced by green and fertile land. Not surprisingly,

283
Ball-game offering

*c.*1500, Aztec

(1) model court; (2) head of Macuilxochitl; (3, 4) symbolic balls; (5) miniature *tlapanhuehuetl*; (6, 7) miniature *teponaxtli*; (8) percussion stick; (9) tortoise shell; (10) pendant in the form of a ball-game court

(1) greenstone, 5 × 36 × 22 cm
(2) greenstone, 10 × 5 cm
(3) obsidian, diameter 11.5 cm
(4) alabaster, diameter 11 cm
(5) greenstone, 6 × 3.5 cm
(6) greenstone, 2.5 × 4 × 2 cm
(7) greenstone, 2.5 × 6.5 × 3 cm
(8) greenstone, 7 × 1 cm
(9) greenstone, 4.5 × 3 cm
(10) greenstone, 11 × 7 cm

Museo Nacional de Antropología, Mexico City, CONACULTA-INAH, 10-222324, 10-222323, 10-222372, 10-222326, 10-222322, 10-222321, 10-222317, 10-222318, 10-222320, 10-222325

PROVENANCE: Templo Mayor, Mexico City, 1967

SELECTED REFERENCE: Barcelona 1992, pp.218–22, nos 79–88

When the Spanish friar Bernardino de Sahagún asked his native informants to describe the ancient ceremonial precinct of Tenochtitlan, they mentioned 78 buildings. Of the two ball-game courts they spoke of, the most important was the Teotlachco. Its exact position was not discovered until work carried out in the late 1990s on the foundations of the Metropolitan Cathedral in Mexico City revealed its presence beneath the Chapel of All Souls. The present offering was found behind the Cathedral in 1967, during construction of the Metro. Macuilxochitl (2), patron god of games, presides over the ritual sport that the offering celebrates. The shape of the ball-game court was re-created in a Mezcala-style model (1). The pendant (10) also takes the form of a court, but its style is Mixtec, as is that of the miniature instruments: the tortoise shell (9), the *teponaxtli* (6, 7), the *tlapanhuehuetl* (5) and the stick (8) used to produce the sound. The balls (3, 4), one made of obsidian, the other of white alabaster,

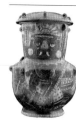

284
Pot with images of Chicomecoatl and Tlaloc

*c.*1469–81, Aztec

Fired clay and paint, 45.5/34.5 cm, diameter 36.5 cm

Museo del Templo Mayor, Mexico City, CONACULTA-INAH, 10-212977 0/2

PROVENANCE: Chamber III, Tlaloc building, Stage IV(a) of the Templo Mayor, Mexico City, 1980

SELECTED REFERENCE: Mexico City 1995, pp. 129–30

The pot bears images of Chicomecoatl and Tlaloc, two gods closely associated with fertility. In its red, orange, coffee-brown and white colouring, it is influenced by Cholula ceramics. The globular shape of the pot serves as the body of the deities. The face and feet of Chicomecoatl project from one side; the image of Tlaloc is painted on the other. Chicomecoatl, her body painted red, wears a large headdress decorated with feathers and strips of paper, held in place by a rectangular plate on her forehead that represents a bird. Her face is painted black from the cheeks to the chin. The goddess's mouth is half opened in a benign smile, revealing white teeth. Her nose is straight; her eyes are clearly demarcated. She wears a pair of ear ornaments decorated with concentric circles and dots on the outer disc, from beneath which emerge, faintly outlined on the surface, her characteristic white cotton tassels. She is dressed in a *quechquémitl* cape that repeats the motif on the forehead plate and in a short skirt tied in a knot at the waist. The skirt consists of seven vertical rectangles comprising square elements outlined in white and white borders with two dots and motifs resembling horseshoes;

the fringe takes the form of diagonal lines painted in sequences of orange, coffee-brown and white. In her left hand Chicomecoatl holds a pair of corn cobs in a basket outlined in red and white, in her right a *chicahuaztli* staff (see cat. 275). Sandals are drawn in white lines on her feet, the toes faintly outlined in coffee-brown. A number of areas bear the symbols for *chalchiuhuitl* (jade), consisting of circles surrounded by four smaller circles, and successions of white spirals with small black lines, the symbol of *pulque*. As the goddess of foodstuffs and sustenance, Chicomecoatl was the most important patron of vegetation, presiding over the maize cult. The ceremonies dedicated to her, known as Huey Tozoztli ('great vigil'), took place in the fourth Aztec 'month' (15 April – 4 May) and in the course of them domestic altars were decorated with maize plants and maize seeds were blessed in the temples.

The painting of Tlaloc on the opposite side of the vessel displays his characteristic traits – goggle eyes, a 'moustache' ornament and fangs. The lid of the pot also bears an image of this deity, holding a container in his hands and pouring water from it as a symbol of his rain-making activities. EMM

285
Censer

c. 1500, Aztec

Fired clay and paint, length 63 cm, diameter of container 22.5 cm

Museo Nacional de Antropología, Mexico City, CONACULTA-INAH, 10-220158

PROVENANCE: Calle de las Escalerillas, Mexico City, 1900

SELECTED REFERENCES: Batres 1902, p. 21; Solís Olguín 1991B, p. 257, no. 392

The polychrome censers discovered in the Calle de las Escalerillas vary in the decoration of the container for the hot coals and in the figure at the end of the long handle. The fantastical face on the container in the present example has the appearance of a mask, reminiscent of images of Tlaltecuhtli, the 'earth lord',

and linked formally to the face of the rain god Tlaloc, notably in the six curved fangs protruding from the big mouth. Air penetrated the vessel through the cross-shaped fretwork and through the eyes and nose, fanning the coals and making the copal burn faster. Such censers were used by priests to perfume the images of the gods. The eagle's head at the end of the handle in this piece assigns it a place in sun-worshipping rites. FS, RVA

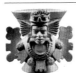

286
Brazier with an image of a fertility god

c. 1325–1481, Aztec

Fired clay and traces of paint, 25 × 27.5 cm, diameter inside the mouth 23 cm

Museo del Templo Mayor, Mexico City, CONACULTA-INAH, 10-220048

PROVENANCE: offering 23, Tlaloc building, Stage IV(b) of the Templo Mayor, Mexico City, 1979

SELECTED REFERENCES: López Luján 1993, pp. 172–92; Mexico City 1995, p. 134

The large number of deities of vegetation or fertility in ancient Mesoamerica reflects the importance of agriculture for the subsistence of the population. The gods determined the success or failure of harvests, so humankind sought to please them and be worthy of their kindness by celebrating rites that often involved sacrifices.

Two braziers with images, of which the present piece is one, were found in the middle of offering 23 in the Templo Mayor in Mexico City. The identity of the deity shown here has not been established, but certain iconographical features point to a fertility god. The headdress, crowned by a series of points resembling feathers or leaves, consists of two braided cords, between which a bird is depicted in the centre. From the headdress hang two small tassels similar to those in images of Chicomecoatl and Chalchiuhtlicue, deities of water and agriculture respectively, and the nape of the neck is adorned with a paper ornament that protrudes from the sides of the head and is likewise

a distinctive feature of gods associated with fertility. The figure wears circular ear ornaments and a double necklace of tubular and spherical beads surrounding a large disc symbolising the greenstone *chalchiuhuitl* (precious jade), which forms part of the pectoral. The decoration on the edge of the pectoral includes flowers that bloom at the beginning of the rainy season, which are among the attributes of Chicomecoatl and the goddess of young maize, Xilonen. Pieces of copal were found inside the vessel, which seems therefore to have been used as a brazier to burn resin during the rites of Tlaloc and other ceremonies related to fertility. EMM

287
Model of a temple

c. 1500, Aztec–Mixtec

Fired clay and paint, 39.5 × 23 cm

Museo Regional de Puebla, CONACULTA-INAH, 10-496916

288
Model of a temple

c. 1500, Aztec–Mixtec

Fired clay and paint, 28 × 14.5 cm

Museo Nacional de Antropología, Mexico City, CONACULTA-INAH, 10-496914

See cat. 291.

289
Model of a twin temple

c. 1350–1521, Aztec

Fired clay, 20 × 18.2 × 17.2 cm

Staatliche Museen zu Berlin: Preußischer Kulturbesitz, Ethnologisches Museum, IV Ca 2429

PROVENANCE: Carl Uhde collection, purchased by the museum, 1862

SELECTED REFERENCE: Pasztory 1983, pp. 290–91

Unlike other Mesoamerican peoples – the Maya, for example – the Aztecs often built twin temples on their pyramids. In the ritual precincts in the Aztec capital, Tenochtitlan, for instance, the main pyramid was crowned by two temples, one dedicated to the

rain god, Tlaloc, the other to the supreme deity, Huitzilopochtli. In the temples, away from the mass of the people, the priests communed with the gods and made offerings to them. Models of temple pyramids such as the present piece might be found alongside small images of the gods on domestic altars in humble dwellings, to be used in daily worship (see also cats 290–91). The gods most commonly worshipped in private surroundings, with offerings and pleas for favourable influence, were those of water and vegetation, the most important in the pantheon for the agricultural populace. MG

290

Model of a temple

c. 1500, Aztec

Fired clay and traces of paint,
32 × 15.5 × 19.5 cm

Museo Nacional de Antropología,
Mexico City, CONACULTA-INAH, 10-223673

PROVENANCE: probably Mexico City, 1948

SELECTED REFERENCES: Mexico City 1995,
p. 70, no. 48; Amsterdam 2002, p. 209,
no. 155

During their conquest of the Aztec empire and their establishment of a new colony, the Spanish destroyed or transformed indigenous buildings, both sacred and profane. Thus, illustrations in codices and clay models are the only comprehensive visual evidence concerning the shape and decoration of Pre-Hispanic architecture to have survived. The model shown here depicts the kind of temple predominant in Tenochtitlan. The pyramid base has four tiers, the stairways are flanked by balustrades ending in panels at the top and the one-room temple is capped by a tall roof decorated with human skulls and with crenellation consisting of shells. The *téchcatl*, the sacrificial stone, is clearly visible at the top of the steps. FS, RVA

291

Model of a temple

c. 1500, Aztec–Mixtec

Fired clay and paint, 39 × 24 × 15.5 cm

Museo Nacional de Antropología,
Mexico City, CONACULTA-INAH, 10-496915

PROVENANCE: Calipan, Puebla State, 1993

SELECTED REFERENCES: Merlo 1995;
Amsterdam 2002, p. 209, no. 156

Calipan, which lies at the southern end of the Tehuacan ravine in the south-eastern part of Puebla State, was an area where Mixtecs and Aztecs coexisted, although the Aztecs eventually conquered the whole region. In the final decade of the twentieth century farmworkers accidentally discovered a tomb there and recovered a number of objects from it, including these three models of pyramidal ceremonial structures topped by temples. They reproduce the temple architecture of the Late Postclassic period (1250–1521) in Puebla-Tlaxcala (cf. cat. 290), with its characteristic columns framing the entrance to the temple proper. All three models retain their polychromy, which includes depictions of mural decoration. The single-tier bases are rectangular and have a varying number of steps. A red stripe is painted down one set of steps (cat. 287): this represents the blood of sacrificial victims. The columns with their banded decoration support a heavy lintel, in the middle of which appears the quincunx. The low roofs bear crenellation of differing types and sizes, symbolising the power of the deity worshipped in the temples. The first (cat. 287) is dedicated to Xiuhtecuhtli, god of fire; the second (cat. 288) to the earth goddess Toci, the patron of weavers; and the third (cat. 291), with its sequence of skulls, to Huitzilopochtli, god of war. FS, RVA

IX TREASURES

292
Mirror and frame

c. 1250–1521 and Post-Conquest,
Aztec and colonial

Polished obsidian and wood, diameter 35 cm

American Museum of Natural History,
New York, 30.0/6253

PROVENANCE: gift of Dr W. L. Hildburgh,
Royal Anthropological Institute, London,
1923

SELECTED REFERENCES: Vaillant 1941, p. 142;
Durán 1971, pp. 98–99

Obsidian is a volcanic glass that
can be worked to produce very
sharp cutting edges. Blocks
of polished obsidian are rare
and were no doubt used in
Mesoamerica only in very special
circumstances. Mirrors are
associated with the Aztec god
Tezcatlipoca. The sixteenth-
century Franciscan friar Diego
Durán described the idol of
Tezcatlipoca in the Aztec Templo
Mayor of Tenochtitlan as made
entirely of polished obsidian. The
god carried a mirror of polished
gold. The mirror's reflection
indicated that he watched all that
took place in the world. The Aztec
word for this was *itlachiayaque*
('place from which he watches').
More commonly, mirrors were
fashioned from iron pyrite, which
could be cut thinly and polished or
burnished to produce a reflection.
Pyrite, obsidian and gold mirrors
were often ornamented with more
perishable materials, such as
feathers, shell mosaics and wood.

The present mirror and frame
probably did not belong together
originally. The wooden frame
seems to date from the colonial
period, made either to replace
an earlier frame or to protect
the mirror: in a personal
communication to the author,
Elizabeth H. Boone noted that
the repeating symbols carved into
it comprise a European-style
flower and a Post-Conquest
interpretation of the familiar
Aztec *xicalcoliuhqui* (step-fret)
motif. CE

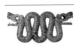

293
Casket with lid

c. 1470, Aztec

Granite, 15 × 33.5 × 21 cm

Museum für Völkerkunde Hamburg , B.3767

PROVENANCE: probably Tetzcoco; Albert
Hackmack; purchased by the museum, 1900

SELECTED REFERENCES: Pasztory 1983,
pp. 255–57; Hildesheim 1986, vol. 2, p. 214

According to the Spanish
chroniclers, the ashes of deceased
tlatoque or the sacrificial blood of
high-ranking persons were kept in
stone caskets like this. The good
condition of the present example
– only the lid is damaged – and the
high quality of its craftsmanship
have combined to make it one of
the best-known objects of its kind.

The casket is richly decorated.
On top of the lid, flanked by the
dates '7-reed' and '1-reed', appears
Quetzalcoatl, the feathered
serpent, falling from heaven.
The inside of the lid shows a skull
surrounded by concentric rings.
The skull probably represents
Tlahuizcalpantecuhtli, the planet
Venus; fourteen circles on the
concentric rings depict stars.
Inside, the bottom of the casket
bears the date '1-alligator'; the
underside shows the earth
monster Tlaltecuhtli with claws
and flint knives for teeth. On
one of the long sides a squatting
warrior is perforating his ear with
a bone spine. The scroll in front
of his mouth signifies speech
or song. Behind his head appears
a sign, composed of various
elements, that could be read as
'spirit of the deceased warrior',
because it shows the contents of
a dead warrior's mortuary bundle.
The other long side shows a
squatting figure in a jaguar
costume, an incense bag in one
hand and probably a bundle of
grass in the other. This figure, too,
has a speech scroll in front of its
mouth; the name-glyph '1-reed'
appears behind his head. The
short sides of the casket bear the
year-glyphs '1-rabbit' and '4-rabbit'
respectively. The motifs on the
casket can be read in various ways,
but a definitive interpretation has
not been established. CR

294
Double-headed serpent pectoral

c. 1400–1521, Aztec–Mixtec

Wood, turquoise and shell,
20.5 × 43.3 cm

Trustees of the British Museum, London,
Ethno. 94-634

PROVENANCE: purchased with the Christy
Fund from the Duchessa Massimo through
Lord Walsingham, 1894

SELECTED REFERENCES: Carmichael 1970,
p. 17; Townsend 1992, pp. 184–85;
Miller and Taube 1993, pp. 148–51;
McEwan 1994, p. 80

Entwined serpents and double-
headed serpents, common
symbols in Mesoamerican art
(see cat. 197), are thought to
represent the sky. The snake (*coatl*
in Nahuatl), best known in Aztec
art as Quetzalcoatl, the feathered
serpent (cats 78, 114–15), was an
extremely important creature, with
many associations. Its open jaws,
for instance, represented a cave
or the entrance to Mictlan, the
underworld. In the monumental
sculpture of Coatlicue (fig. 9)
snakes metaphorically represent
streams of blood at the points
where the goddess's arms and
head have been cut off. More
generally, the serpent, through the
act of shedding its skin, symbolises
renewal.

This magnificent turquoise
double-headed serpent is the only
one of its kind to have survived.
It is believed to have been worn
as a pectoral by a priest or noble
on ceremonial occasions.
Turquoise mosaic is laid over a
wooden base and attached using
a natural resinous gum. The two
heads are covered with mosaic
on both sides, while only the front
of the hollowed-out wooden body
is decorated. White and red shell
were used to distinguish the nose,
gums and teeth of the serpent
and it is thought that iron pyrite
was originally used for its eyes
(see cat. 304).

It is possible that the pectoral
was worn during rituals relating to
the birth of Huitzilopochtli, the
supreme Aztec god, who was born
at Coatepec, the 'serpent hill'
represented architecturally by the
Templo Mayor and the place
where he defeated his sister
Coyolxauhqui (see cat. 254). AL

295

Handle of a sacrificial knife

c. 1500–21, Aztec–Mixtec

Wood, turquoise, malachite, mother-of-pearl
and shell, 5 × 12.5 cm

Museo Nazionale Preistorico-Etnografico
'L. Pigorini', Rome, inv. no. 4216

PROVENANCE: Ferdinando Cospi collection;
acquired by exchange with the Museo
Archeologico dell'Università di Bologna,
1878

SELECTED REFERENCES: Duyvis 1935, p.365,
fig. 10; Rome 1960, p.23, no.132; Brizzi
1976, p.348, fig.77; Laurencich Minelli
and Filipetti 1983, p.218; Pasztory 1983,
p.264, fig.56; Washington 1983, pp.174–75,
no.85; Hildesheim 1986, no.345;
Laurencich Minelli 1992, pp.120–21, no.7;
Rigoli 1992, pp.479–80, no.728

The wooden handle is covered
with a mosaic of turquoise,
malachite, mother-of-pearl and
shell. The technical and artistic
skill evident in its manufacture
make this one of the finest
examples of mosaic to have
survived from Pre-Hispanic
Mexico. The handle was
produced by artists working in
the Mixteca–Puebla tradition
in the region of Oaxaca or in
Tenochtitlan to satisfy the Aztec
nobility's demand for luxury
goods.

The handle takes the form of
a kneeling human figure, who
wears an elaborate headdress,
large ear ornaments, a nose-plug,
bracelets, sandals and a skirt. The
arms embrace the point at which
the blade (now lost) was inserted;
an eye appears between the thumb
and forefinger of each hand.

The presence of both masculine
and feminine elements makes it
impossible to identify the figure
as that of a specific deity. Most
probably it represents a high-
ranking person – a priest may
have used such a knife to extract
the hearts of sacrificial victims
and offer them to the gods.

From 1677, the knife handle
belonged to Marchese Ferdinando
Cospi (Bologna, 1606–1686).
Cospi's collection was the nearest
thing in Italy to a *Wunderkammer*,
a chamber of curiosities of the
type familiar from other European
countries. CN

296

Sacrificial knife

c. 1400–1521, Aztec–Mixtec

Wood, turquoise, shell and chalcedony,
height 9.3 cm, length 31.7 cm

Trustees of the British Museum, London,
Ethno. St. 399

PROVENANCE: Henry Christy collection,
donated to the museum, 1865

SELECTED REFERENCES: Joyce 1912, fig.16;
Saville 1922, pl.38; Carmichael 1970, p.16;
Pasztory 1983, col. pl. 55

The handle of the sacrificial knife
(*ixcuac*) is fashioned in the form
of a crouching eagle warrior who
grasps the wooden haft of the
knife in front of him with both
hands. His face is framed in the
open beak of a bird-headed
costume. Eagle warriors were one
of two main military orders (the
other being the jaguar warriors)
dedicated to the sun and schooled
in the arts of war in special
precincts in the heart of
Tenochtitlan. Young men earned
recognition and enhanced status
by performing feats of bravery and
daring, notably securing captives
for sacrifice. Special insignia,
including elaborately decorated
cloaks, helmets and shields, were
awarded according to rank. The
costume worn by the warrior
shown here is adorned with
an intricate mosaic assemblage
composed of cut and polished
fragments of turquoise and marine
shell (*Spondylus princeps*) and
includes a distinctive red and white
'eye' motif. Sacrificial knives,
including personified examples
with inlaid eyes, have been found
in large numbers in offering caches
buried in the Templo Mayor in
Mexico City (see cat. 277).
Undecorated knives found
in close proximity to decapitated
individuals suggest that they were
used to kill sacrificial victims.
CMcE

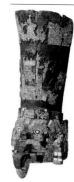

297

Tlaloc (?)

c. 1500, Aztec–Mixtec (?)

Wood, turquoise, jade, malachite,
mother-of-pearl and red and white shell,
29 × 12 × 17 cm

The National Museum of Denmark,
Copenhagen, Department of Ethnography,
ODIh.41

PROVENANCE: purchased, 1856

SELECTED REFERENCE: Roussell 1957

The carving is thought to
represent Tlaloc, the god of rain
and a central deity in the Aztec
world. The twin temples on the
Great Pyramid in Tenochtitlan,
the Aztec capital, were dedicated
to him and to Huitzilipochtli, the
war god, respectively. Tlaloc's
characteristic features are goggle-
like eyes and fangs (one of which
is missing from the present piece).
The protruding mouth and tall
headdress suggest that he is here
represented in his manifestation as
the wind god Ehecatl. The carving
probably formed part of another
object – the top of a sceptre, for
instance.

Along with a similar carving,
the piece was purchased in 1856
in Rome, 'brought there from
Mexico by a missionary', as the
museum inventory notes. BD

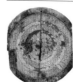

298

Shield with mosaic decoration

c. 1250–1521, Mixtec

Wood, turquoise and shell, diameter 45.5 cm

Musées Royaux d'Art et d'Histoire, Brussels,
AAM 68.11

PROVENANCE: Tehuacan region,
Puebla State, late 1950s early 1960s

This shield is one of almost two
hundred objects found in two
caves in the Tehuacan region. The
objects include other incomplete
shields, which are undecorated
or have lost their decoration, a
human mask, wooden armatures
covered in *amatl* paper and
offerings of maize and bundles
of vegetables.

The shield consists of six
concentric circles, the outermost
one of which has no decoration.
Nevertheless the perforations
around the edge strongly suggest
that it was ornamented with
feathers or *amatl*, as illustrated in

codices. The rest of the shield is covered with a mosaic decoration that has worn off in places. These gaps, notably in the central circle, make it impossible to identify the motifs, although the second circle from the perimeter shows a pattern of lines dividing the circle into equal sections. It is clear that the centre of the shield bore a more complex motif, in which a bluer shade of turquoise was used to stand out against the surrounding green background.

During Aztec rule in the Late Postclassic period (1250–1521), Mixtec shields were among the tributes paid to the Mexica empire. SP

299

Shield

c. 1500, Aztec

Feathers, sheet-gold, agave paper, leather and reed, diameter 70 cm

Museum für Völkerkunde Wien (Kunthistorisches Museum mit MVK und ÖTM), Vienna, 43.380, Ambras Collection

PROVENANCE: Ferdinand II, Archduke of Tyrol (1529–1595), Ambras castle near Innsbruck; passed to the Natural History Museum as part of the imperial collections, 1891

SELECTED REFERENCES: Anders 1978; Feest 1990, pp. 14–17; Vienna 1992, no. 179; Zantwijk 1994, pp. 17–18

The shield is listed in the inventory taken in 1596 of Archduke Ferdinand II's collection at Ambras castle. It may have been included in a Spanish shipment from Mexico *c.* 1522. A list of the contents of that shipment describes two of its many shields as showing in the centre a monster made of gold and feathers on a red ground. One of these shields was a gift from Hernán Cortés to the bishop of Palencia and, since a feather mitre from Mexico owned by a later bishop of Palencia, Don Pedro de la Gasca, also became part of the Ambras collection, it has been suggested that the present shield is Cortés's gift and that it reached Ambras together with the mitre.

The shield consists of a base of reed splints that are held together by vegetal fibre,

reinforced by wooden sticks and edged by rawhide. It retains two loops for carrying. These are attached horizontally, so that the animal on the obverse tilts upwards or downwards when the shield is carried. Pieces of agave paper are glued to the shield and covered with various kinds of feather: scarlet macaw, blue cotinga, yellow oriole and rose spoonbill. Quetzal, cotinga and spoonbill feathers are affixed to the rim. Feather tassels hang from the lower edge. The designs are outlined by pieces of sheet-gold.

The animal has been identified as an *ahuizotl*, a quasi-mythical water creature (see cat. 199), perhaps from a desire to link the shield with the eponymous Aztec ruler (reigned 1486–1502). Yet the image may represent a coyote, an animal associated with war and possibly with a military order in Pre-Hispanic Mesoamerica. The glyph or speech scroll in front of the animal supports this hypothesis. Depicting water and fire, it may be the type of Aztec sign that expressed a concept metaphorically by means of two other notions. In this case, 'the water the fire' (*in atl in tlachinolli*) would signify 'war'. GvB

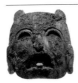

300

Mask

c. 1500, Aztec–Mixtec

Wood, turquoise and onyx, 17 × 16 cm

Museo Regional de Puebla, CONACULTA-INAH, 10-373011

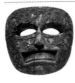

301

Mask

c. 1500, Aztec–Mixtec

Wood, turquoise and onyx, 15 × 7 cm

Museo Regional de Puebla, CONACULTA-INAH, 10-373014

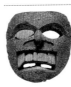

302

Mask

c. 1500, Aztec–Mixtec

Wood, turquoise and onyx, 15.5 × 15 cm

Museo Regional de Puebla, CONACULTA-INAH, 10-373009

PROVENANCE: Santa Ana Teloxtoc, Puebla, 1986

SELECTED REFERENCES: Saville 1922, pp. 60–66; Vargas 1989, pp. 122–28; Amsterdam 2002, pp. 184–85, nos 126–28

The dry caves of the semi-desert region of Tehuacan in the state of Puebla have preserved many archaeological objects made of perishable materials. During the first decades of the twentieth century the Heye Foundation's Museum of the American Indian in New York acquired an important series of wooden masks and shields from this area of Mesoamerica. A similar find was made in 1986, when the archaeologist Ernesto Vargas of the Universidad Nacional Autónoma de México acted on a report that a cave near the town of Santa Ana Teloxtoc was being ransacked and found there, in a number of chambers, masks comparable to those in the New York museum.

The turquoise mosaic covering the three masks has suffered to varying degrees. Very little remains on the first mask (cat. 300) apart from a small piece of obsidian near the nose, a piece of silex near the mouth and patches of the cement used to attach the pieces. The inlays have been removed from the eyes and mouth. The round protuberances on the head and wide ear ornaments suggest that this mask may represent a supernatural being combining human and feline elements. On the second mask (cat. 301), too, only a few fragments of turquoise and patches of cement remain. The eyes of the mask are pierced to take inlays. The large rectangular mouth no doubt also contained inlays, probably including representations of fangs. The third mask (cat. 302) is the best preserved, because it retains not only all its turquoise mosaic, but also its onyx inlays in the eyes and mouth. Moreover, the mask shows a nose-ring in the form of two small wings, painted red, on either side of the nose. FS, RVA

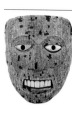

303

Mask

*c.*1400–1521, Aztec–Mixtec

Wood, turquoise and shell,
16.5 × 15.2 cm

Trustees of the British Museum, London,
Ethno. St. 400

PROVENANCE: purchased from the Bram
Hertz collection (sold by its then owner
Joseph Mayer) by Henry Christy, 1859;
bequeathed to the museum, 1865

SELECTED REFERENCES: Carmichael 1970,
p. 21; Miller and Taube 1993, pp. 189–90;
McEwan 1994, p. 70

This turquoise mask is believed
to depict Xiuhtecuhtli, the central
Mexican god of fire. The name
Xiuhtecuhtli means 'turquoise
lord', but also refers to the
Nahuatl word for year (*xihuitl*),
making him the god of the year
and, by association, of time.
In codices he is usually shown
wearing fine turquoise mosaic,
often in the form of a butterfly
pectoral. The stylised design
of a butterfly, delicately picked
out in a darker shade of turquoise
on the cheeks and forehead of the
present piece, suggests that the
mask does indeed represent
Xiuhtecuhtli.

Xiuhtecuhtli is intimately
related to the Templo Mayor
in Tenochtitlan: Eduardo Matos
Moctezuma has identified
numerous representations of the
god as a seated male with crossed
arms in offerings found there
(cats 244–46). Xiuhtecuhtli is also
linked to Huehueteotl ('old, old
god'), a Mesoamerican deity
most commonly associated
with Teotihuacan, although
Xiuhtecuhtli is usually shown
as a young being. The pieces
of turquoise mosaic are attached
to a cedar-wood base with a type
of resinous gum.

The eyes of the mask are
made of a pearl oyster shell,
which, given the central holes
where the pupils should be,
suggests that it was worn by deity
impersonators during religious
rituals. The teeth are of shell.
The mask is reckoned to be
one of the two finest surviving
examples of its kind from the
Postclassic period (1250–1521).
The other (fig. 52) represents
Quetzalcoatl. AL

304

Mask of Tezcatlipoca

*c.*1500, Aztec–Mixtec

Human skull, turquoise, lignite, iron pyrite,
marine shell and leather, 19.5 × 12.5 × 12 cm

Trustees of the British Museum, London,
Ethno. St. 401

PROVENANCE: Henry Christy collection,
donated to the museum, 1865

SELECTED REFERENCES: Joyce 1912, fig. 12;
Saville 1922, pl. 19; London 1965, p. 23;
Carmichael 1970, p. 13; Pasztory 1983,
p. 277, col. pl. 63; Miller and Taube 1993,
pp. 164–65; McEwan 1994, p. 75

The mask is thought to represent
Tezcatlipoca ('smoking mirror'),
an omnipotent deity of Postclassic
central Mexico and one of four
powerful creator gods in the Aztec
pantheon. In the creation myth of
the Five Suns, Tezcatlipoca, god
of the first sun, Nahui Ocelotl
('4-jaguar'), plays an ambivalent
role, variously assisting and
disrupting the world-creating
deeds of the cultural hero
Quetzalcoatl. His identifying
emblem, an obsidian mirror, was
used for divination and symbolises
his ability to see and control the
hidden forces of creation and
destruction.

The mask has been created by
cutting away the back of a human
skull and lining the inside with
leather. Images in codices that
show priests impersonating
Tezcatlipoca suggest that the two
leather straps attached to the skull
were probably used to tie it round
the wearer's waist. The face bears
alternating bands of bluish-green
turquoise mosaic tiles and black
lignite, and the eyes are composed
of polished spheres of iron pyrite
encircled by white shell. The
enlarged nasal opening is lined
with the distinctive red shell of
the Pacific thorny oyster (*Spondylus
princeps*). Each of these skilfully
worked exotic materials was
traded in from far-flung
territories subject to Aztec
imperial hegemony and served to
underline Tezcatlipoca's chthonic
attributes and powers. CMcE

305

Jaguar pectoral

*c.*1500, Mixtec

Wood, stone and shell, 7.6 × 17.1 × 3.2 cm

The Saint Louis Art Museum, Gift
of Morton D. May, 163:1979

PROVENANCE: gift of Morton D. May, 1979

SELECTED REFERENCE: Parsons 1980, p. 120

The Aztec military comprised two
categories of aristocratic warrior,
the eagles and the jaguars. While
the eagle represented the living
sun travelling across the sky, the
jaguar symbolised the sun passing
through the underworld in need
of human blood to bring it back
to life at dawn in the east. Thus
war was a religious as well as
a political act.

The present pectoral was
probably worn by an Aztec
warrior of the jaguar order.
The beautifully fitted stones
demonstrate the great lapidary
skills possessed by Mixtec artists,
who also created fantastic stone
mosaics on the façades of Mixtec
buildings. The pectoral is slightly
curved so as to fit comfortably
on the chest of the wearer.

As a nocturnal hunter, the
jaguar was associated with the
underworld, a connection
underscored in the minds of the
Aztecs by the fact that jaguars like
to occupy caves. Closer scrutiny
of jaguar behaviour points to the
complicated and interchangeable
nature of the world as viewed by
the Aztecs. Jaguars represented
a double duality: they were not
simply creatures of the underworld
and death; they were also thought
to provide the sun with life-giving
blood and to become eagle-like,
literally flying the sun across
(or below) the night sky. Jaguar
hunting techniques confirm this
view. As stealthy and quiet
hunters, these animals frequently
move high above the ground
from tree to tree and, like the
eagle stalking its prey from above,
reach down with their talon-like,
retractable claws to strike a
deadly blow. Sky symbolism
is also implicit in the turquoise
inlay of the pectoral, for turquoise
represents the sky and life-giving
water. The silky gold and black
skin of the jaguar also reflects its

dual day–life and night–death nature. This animal is the strongest and most dangerous of all felines in the Americas, and to be associated with it in military and ritual life must have been a highly coveted privilege. JWN

306
Zoomorphic ear ornament

c. 1500, Aztec

Bone, 1.5 × 6.5 × 1 cm

Museo Nacional de Antropología, Mexico City, CONACULTA-INAH, 10-607770

PROVENANCE: Tlatelolco, Mexico City, 1963

307
Zoomorphic ear ornament

c. 1500, Aztec

Shell, 2 × 1.1 × 1.8 cm

Museo Nacional de Antropología, Mexico City, CONACULTA-INAH, 10-594833

PROVENANCE: Jorge Enciso collection, bequeathed to the Museo Nacional, first half of the twentieth century

308
Zoomorphic ear ornament

c. 1500, Aztec

Stone, 1.8 × 1.8 × 2.2 cm

Museo Nacional de Antropología, Mexico City, CONACULTA-INAH, 10-7717

PROVENANCE: Jorge Enciso collection, bequeathed to the Museo Nacional, first half of the twentieth century

309
Zoomorphic ear ornament

c. 1500, Aztec

Obsidian, 3.5 × 2 × 6 cm

Museo Nacional de Antropología, Mexico City, CONACULTA-INAH, 10-594798

PROVENANCE: Tlatelolco, Mexico City, 1963

SELECTED REFERENCE: Guilliem 1999, pp. 100, 306

The Aztec nobility (*pipiltin*) consisted of relatives of the supreme ruler (*tlatoani*) and were distinguished from the rest of the populace by elegant garments woven from cotton fibre and by sandals (*cactli*). They wore headdresses of feathers and jaguar skin, along with jewellery made of bone, shell and semi-precious stones. The four ear ornaments shown here belonged among such jewellery. They take the form of animals common to the Mexican ecosystem. The first, a leaping rabbit, was found in Tlatelolco, during the recent construction

of a new building for the Ministry of Foreign Affairs. The fourth, a frog with eyes made of shell, was discovered during excavations of the ritual precinct of Tlatelolco in the 1960s. The other two items, a head of a Mexican turkey buzzard (*Cathartes aurea*) and a jaguar, were discovered together with approximately one hundred stone and shell ornaments by the archaeologist Jorge Enciso, who bequeathed them to the Mexican state. FS, RVA

310
Pectoral

c. 1500, Aztec

Greenstone, 8 × 4.5 × 0.5 cm

Museo Nacional de Antropología, Mexico City, CONACULTA-INAH, 10-8153

PROVENANCE: Mexico City, 1942

SELECTED REFERENCE: Solís Olguín 1991B, p. 261, no. 402

Macuilxochitl ('five flower') was the patron deity of musicians and dancers in Pre-Hispanic Mexico, comparable to Xochipilli ('flower prince'), except that Macuilxochitl was also the patron of those who lived in palaces, accompanying and serving their lords. The Codex Magliabechiano (cat. 342) describes Macuilxochitl as the deity of games, notably *patolli*, a gambling game in which participants might stake not only their goods and property, but also their freedom (see also cat. 359). Players invoked the god, who was depicted seated on a wooden throne holding the *yollotopilli* ('heart staff') and wearing a quetzal-feather headdress and an *oyohualli* (pectoral) shaped like a large sliced shell with a slightly curved point. The present greenstone *oyohualli* will have been worn as a precious distinguishing mark of one of Macuilxochitl's manifestations. As a reflection of healthy nature, the colour of the pectoral, in itself a symbol of happiness, was thought to grant it extra value. FS, RVA

311
Pectoral or pendant
with engraved images

c. 1500, Aztec

White shell, 3.5 × 12 × 0.3 cm

Museo Nacional de Antropología, Mexico City, CONACULTA-INAH, 10-275

PROVENANCE: probably Mexico City

SELECTED REFERENCES: Códice Mendocino 1964, pp. 84–85; Madrid 1992, p. 277

Shellwork was practised in the earliest Mesoamerican cultures, over three thousand years before the Aztecs, and testifies to the existence at that time of commercial ties between the peoples on the coast and those living inland. In its heyday, Tenochtitlan received marine products (particularly conches and marine snail shells) not only via *pochteca* (professional merchants), but also as a substantial part of the tribute paid by peoples subject to it. The Codex Mendoza (cat. 349) indicates that the province of Cihuatlan alone paid two loads of four hundred seashells, including coloured scallops.

Four figures are engraved in the pectoral or pendant. Probably warriors, they wear large plumes of long feathers, no doubt quetzal. The two in the centre are holding staffs resembling walking-sticks as an indication of their rank. The figure on the left has a spear-like object inserted in his head, the other a long, straight feather, an attribute of military leaders. FS, RVA

312
Mirror frame

c. 1500, Huexotzingo

Obsidian, 9.8 × 9.8 × 7.1 cm

Museum für Völkerkunde Wien (Kunsthistorisches Museum mit MVK und ÖTM), Vienna, 59.253, Becker Collection

PROVENANCE: Philipp J. Becker collection, acquired by the museum, 1897

SELECTED REFERENCE: Vienna 1992, no. 174

The mirror frame has the shape of a monkey's head, apparently covered with a mask made of skin (to which two of the four ears belong). The wide-open eyes and mouth once contained inlays. The ears are adorned with drop-like

pendants, an attribute of the god of dance and music, Xochipilli, and of several deities associated with games, singing and *pulque*.

A mirror probably occupied the space hollowed out on the reverse. Two holes have been drilled beside the cavity, facilitating hanging. GvB

313
Mask

c. 1500, Aztec

Greenstone, 21.5 × 19.5 × 10.5 cm

Museum für Völkerkunde Wien (Kunsthistorisches Museum mit MVK und ÖTM), Vienna, 12.415

PROVENANCE: Emperor Maximilian of Mexico; passed to the Natural History Museum, 1881

SELECTED REFERENCE: Vienna 1992, no. 171

Figures of Xipe Totec ('our flayed lord'), god of spring, show a human being inside the skin of another person, with the flayed hands generally hanging near the wrists and the skin tied at the back. The two sets of eyes and nostrils, and the double mouth, this mask represent both the face belonging to the skin and that of the wearer.

During Tlacaxipehualiztli, the main Aztec festival devoted to Xipe Totec, captives were flayed and their skins worn by others for twenty days, after which the rotting skins were removed and a 'new' human being appeared. This ritual signified the renewal of vegetation at the beginning of the rainy season. Xipe Totec was also the patron of goldworkers: the holes in the mask once contained ornaments. GvB

314
Pendant

c. 1300–1521, Aztec

Spondylus shell, 5.5 × 4.6 × 3 cm

Dumbarton Oaks Research Library and Collections, Washington DC, B-82

PROVENANCE: acquired from Ernest Brummer, 1947

SELECTED REFERENCES: Kelemen 1943, pp. 346–47, pl. 282b; Lothrop 1957, no. 59, pl. 46; Dumbarton Oaks 1963, no. 112; Bray 1968, p. 135, pl. 58; Washington 1983, no. 37

This pendant, carved from the highly prized *Spondylus* shell, represents a human impersonator of Xipe Totec ('our flayed lord'), the god of springtime renewal. The head reveals a human face beneath the flayed skin of a sacrificial victim.

The patron of combat, Xipe Totec presided over the Tlacaxipehualiztli festival, in which warriors wore the flayed skins of their captives and enacted mock battles throughout Tenochtitlan. These festivities lasted twenty days, during which the costumes of human skin decayed on the celebrants' bodies. At the close of the festival the young men emerged from these putrid shells like sprouts from germinating seeds. The celebrations occurred in the spring of each year, the rebirth of the warriors symbolising springtime renewal and agricultural fertility.

Brightly coloured feathers and gold jewellery often decorated the flayed skin worn by the Xipe impersonator. The present figure is adorned with an elaborate headdress, collar and ear-spools. LT

315
Átlatl

c. 1500, Mixtec

Wood and traces of paint, length 57.5 cm

Staatliches Museum für Völkerkunde, Munich, 27-12-1

PROVENANCE: acquired by a German geologist named Lenck from a family property in Tlaxiaco, 1888; donated to the museum by a Mr Benk, 1927

SELECTED REFERENCES: Seler 1960–61, vol. 2, pp. 388–90; Munich 1968, p. 59, no. 78; Hildesheim 1986, no. 273

An *átlatl* (spear-thrower) functioned as an extension of the arm when throwing spears or darts and had an effective range of 60 metres. The weapon was not only employed in everyday contexts (hunting, for example) and military campaigns, but was also carried during ceremonies.

The present *átlatl* is fashioned from a long, thick piece of wood carved to resemble a serpent. A central groove ends in a hook

at the far end, near the head of the serpent, in which the spear was placed. A grip was probably once tied through the holes near the serpent's head. The body of the serpent bears a zigzag design with snakeskin and feather markings at the neck and tail. The feathers probably refer to the god Quetzalcoatl ('feathered serpent'). In the eight spaces of the zigzag, human beings are shown lying down or in motion, some dressed elaborately. The green paint may be a reference to the *xiuhatlatl* ('green spear-thrower') associated with various gods, and the present piece may therefore have been carried by Quetzalcoatl's impersonator during ceremonies. ST

316
Drumstick

c. 1350–1521, Aztec

Deer's antler, length 22 cm

Staatliche Museen zu Berlin: Preußischer Kulturbesitz, Ethnologisches Museum, IV Ca 41046

PROVENANCE: acquired from the Schulze-Jena collection, 1929

SELECTED REFERENCE: Codex Laud 1966, p. 34

Many Aztec ceremonies were accompanied by musical performances. Ocarinas and flutes have survived in relatively large numbers, along with gourd rattles, bone rasps, wooden upright drums, hand drums, conch trumpets and tortoiseshells, which were struck with a drumstick. The present drumstick, made from a deer's antler, has been shaped as an animal with a dog-like head and covered with repeating motifs in very low relief. MG

317
Fly-whisk handle

c. 1500, Aztec

Bone, 12 × 2 × 3 cm

Museo Nacional de Antropología,
Mexico City, CONACULTA-INAH, 10-81623

PROVENANCE: probably Mexico City, 1978

The aquatic environment inhabited by the Aztecs was naturally rich in insects, particularly the flying variety. Fly-whisks were therefore common, craftsmen creating elegant examples for the nobility. The present fly-whisk handle was shaped from bone to resemble an eagle's talon. Its perforations indicate that it held feathers of different sizes. The finely engraved patterns recall the sacrificial knives carried by warriors, which were decorated with bands and circles.
FS, RVA

318
Femur with inscriptions

c. 1500, Aztec

Bone, 35 × 4.8 cm

Museo Nacional de Antropología,
Mexico City, CONACULTA-INAH, 10-594025

PROVENANCE: Mexico City, first half of the twentieth century

SELECTED REFERENCE: Caso 1967,
pp. 135–38, no. 10

Xiuhmolpilli ('binding of the years'), the ritual tying of a bundle of 52 reeds, was performed by the Aztecs and their neighbours at the conclusion of each 52-year cycle in their calendar. The ceremony, which took place on the summit of a hill named Huixachtlan (now Cerro de la Estrella), culminated in the lighting of the New Fire on the open chest of a sacrificial victim whose heart had been extracted. Sacred pieces of timber were rubbed together until a flame was kindled, thus feeding the new calendar cycle. The celebrations occurred in the year '2-reed', the date that appears on the present ritual object, which was used during the rites. Musical instruments made of human bones were widespread in the Pre-Hispanic world, the most popular being the notched rasp. The instrument shown here consists

of a femur of a young man, who may have been one of the sacrificial victims. The bone has been finely engraved to re-create the design of the earth so that it resembles a dark 'cloak of death': a vertical rectangle with small squares shows a sequence of crossbones and the profiles of human skulls framing the calendar glyph. FS, RVA, AG

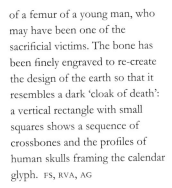

319
Human hand holding a deer's head

c. 1500, Aztec

Deer's antler, 21.2 × 9.6 × 7.9 cm

Laboratoire d'Ethnologie, Musée de l'Homme, Paris, M.H. 87.101.714

PROVENANCE: Tlatelolco, Mexico City, late nineteenth century; Labadie collection, donated to the Musée d'Ethnographie du Trocadéro, 1887

SELECTED REFERENCES: Hamy 1897, pp. 33–34, pl. 17, no. 50; Chefs-d'œuvre 1947, p. 25, no. 54; Chefs-d'œuvre 1965, p. 194, no. 71; Manrique 1988, p. 69; Madrid 1992, p. 85

Like the drumstick (cat. 316), this object is made from a deer's antler. According to the zoologist Óscar J. Polaco, the distribution of the tines on the beam reveals that the antler belonged to a male white-tailed deer (*Odocoileus virginianus*), a grey deer that roamed freely in the cold, mountainous regions of Mexico.

The piece probably formed the top of a sceptre. There is a hole and two supernatural beings with human faces at one end. The other end is carved in the shape of a human hand with long, thin-jointed fingers. The back of the hand is decorated with scrolls and feathers, while a bracelet of beads and feathers adorns the wrist. Between the thumb and forefinger is a small deer's head with long ears, almond-shaped eyes, incisions outlining the nose and mouth, and a long tongue.

In Aztec mythology the deer was a solar and igneous animal that generally symbolised drought. The Aztecs believed that those born in the 13-day period '1-deer' would be either lucky and brave or fainthearted, fearful and scared of thunder, depending on the exact day of birth. LLL, MFFB

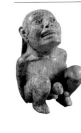

320
Tlazolteotl

c. 1300–1521, Aztec

Aplite, 20.2 × 12 × 15 cm

Dumbarton Oaks Research Library and Collections, Washington DC, B-71

PROVENANCE: acquired from Ernest Brummer, 1947

SELECTED REFERENCES: Hamy 1906; Kelemen 1943, pp. 307–08, pl. 254b; Covarrubias 1957, p. 327; Lothrop 1957, no. 52, pl. 36; Dumbarton Oaks 1963, no. 109; Townsend 2000, p. 123, fig. 85

This compelling sculpture of Tlazolteotl, goddess of childbirth, presents the dramatic moment of the birth of one of her two offspring – either Centeotl, the maize god, or Xochiquetzal, goddess of flowers, fertility and weaving. The depiction of parturition and Tlazolteotl's striking facial expression are unusual in the corpus of Aztec sculpture. The goddess's Aztec name derives from the Nahuatl word *tlazolli*, which denotes filth, disease and maladies associated with sexual excess. In this aspect Tlazolteotl was known as the goddess of filth, but her role was one of purification and curing. Individuals guilty of misdeeds confessed their transgressions to her and she devoured these evils, cleansing the penitent and spurring their rebirth.

Tlazolteotl was the mother goddess of the Huastec people from the Gulf of Mexico. The Huastecs cultivated cotton and traded textiles woven of finely spun thread, and the Aztecs extracted tribute from them in the form of capes and other elaborate garments. Depictions of Tlazolteotl in painted codices featured unspun cotton, spindles and tassels in her headdress. Adornments of cotton or feathers may once have been attached to the small holes in the ear lobes and about the head of this sculpture. LT

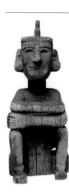

321

Figure of Macuilxochitl

c. 1500, Aztec (?)

Wood and traces of paint, 44 × 18 × 15 cm

Museum für Völkerkunde Wien
(Kunthistorisches Museum mit MVK und
ÖTM), Vienna, 59.866, Becker Collection

PROVENANCE: Tehuacan/Santa Infantita,
Puebla; Philipp J. Becker collection,
acquired by the museum, 1897

SELECTED REFERENCES: Nowotny 1961,
pp. 105–34; Vienna 1992, no. 175

This is a rare specimen of a seated,
wooden figure representing the
god Macuilxochitl ('five flower'),
wearing a loincloth and the crested
headdress that is his hallmark.
The sculpture was discovered in
a cave in which favourable climatic
conditions had ensured its
preservation. Traces of red paint
are still visible. The eyes probably
contained inlays and one of
Macuilxochitl's important features,
a mouth ornament (usually a
hand), has likewise disappeared.
Macuilxochitl was a god of
pleasure, gambling and excess,
as well as of music and dance,
and was closely related to the
deity Xochipilli ('flower prince').
GvB

X CONTACT: INDO-CHRISTIAN ART

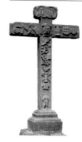

322

Cross

c. 1600, colonial

Stone, 156 × 91 × 36 cm

Museo Regional de Tlaxcala, CONACULTA-
INAH, 10-341001

PROVENANCE: probably Tlaxcala State

SELECTED REFERENCE: Monterrosa 1967

The spread of Christianity in
the New World met with many
obstacles arising from the vastly
different concepts and practices
encountered in the native religion,
not least the ritual sacrifice
of human beings. Christian
missionaries attempted to bridge
the cultural gap by depicting
Christ's Passion in terms of the
pictographic system favoured by
the indigenous population. The
most characteristic product of this
new way of spreading the gospel
were crosses such as this, which
were placed at church entrances.
At the top of the present example
from Tlaxcala are the letters INRI
(*Iesus Nazarenus Rex Iudaeiorum*,
'Jesus of Nazareth, King of the
Jews'), referring to the inscription
that was fastened to the cross on
which Christ was crucified. At the
centre of the cross appears the
face of Christ wearing the crown
of thorns. On the left is a palm
leaf, which stands for Christ's
triumph over death, and an open
hand, which symbolises the
ridicule he suffered; on the right
is a vessel, evoking the scene
of Pilate washing his hands,
and a bag of coins, representing
the money Judas was paid for
betraying Christ. Below Christ's
face is the reed sceptre (in the
form of a maize plant) given him
during his mockery, followed by
the instruments of the Passion:
nails, pincers, a ladder and a
hammer. A cock, alluding to
Peter's three denials of Christ,
appears above a sponge (a sponge
was soaked in wine and offered
to Christ on the cross) and a lance
(one of the soldiers present at the

Crucifixion pierced Christ's body with a lance), which form a St Andrew's cross behind the column to which Christ was bound during the Flagellation. Below this is Christ's tunic from the scene of the soldiers dividing his clothes among themselves. At the bottom is a depiction of a bound figure (the face has been destroyed), illustrating the episode of the Mocking of Christ. FS, RVA

323

Mitre

Second third of the sixteenth century, colonial

Feather mosaic on maguey paper and cotton fabric, 82.5 × 28.5 cm

Patrimonio Nacional, Monasterio de San Lorenzo de El Escorial, 10050202

PROVENANCE: Philip II of Spain, donated to the Monastery of El Escorial, 1576

SELECTED REFERENCES: Estrada 1937; García Granados 1946, p. 576; Maza 1971, p. 71; Toussaint 1982, pp. 20–22; Alicante and Murcia 1989, p. 31; New York 1990, p. 243; Martínez de la Torre 1992, p. 17; Checa Cremades 1997, pp. 126–27; El Escorial 1998, p. 545

The mitre symbolises the status and supernatural power of a bishop in a way similar to the plume worn by high-ranking Aztecs. A mosaic of feathers from tzinitzans, white-fronted parrots, cotingas, hummingbirds, spoonbills, starlings and macaws is pasted to a sheet of maguey and cotton. The iconography of this multicoloured composition, which was inspired by a French miniature of c. 1500 (Louvre, Paris), revolves around Christ's redemption of humanity. The front, framed by a border containing images of the Apostles and the Fathers of the Church, shows episodes from the Passion of Christ (centred on the Crucifixion), the four Evangelists and the Last Judgement. This compositional scheme is repeated on the reverse, which carries depictions of the genealogy of Christ, various scenes ranging from his descent into hell to his appearances after the Resurrection, and the Holy Trinity. The lappets (*infulae*) contain the Assumption and Coronation of the Virgin Mary and the Ascension of Christ.

The feathers are arranged so as to resemble paint, an effect enhanced by their metallic sheen when struck by light. Europeans were astonished by the skill of Mexican featherworkers, and items decorated in this way soon became collector's pieces. The Bishop of Michoacán, Vasco de Quiroga, promoted this craft, which was described in great detail by Friar Bernardino de Sahagún in the sixteenth century. The bishop's workshops produced various mitres, including this example and others now in Florence, Lyons, Milan, New York, Toledo and Vienna. JLVM

324

Triptych

Late sixteenth century, colonial

Silver-gilt, boxwood and hummingbird feathers, 8 × 8 × 0.5 cm

Victoria and Albert Museum, London, 226-1866

PROVENANCE: Lecarpentier sale, Paris, 1866

SELECTED REFERENCES: Oman 1968, no. 104a; Feest 1986, p. 176; Egan 1993, pp. 42–45; London 2000, no. 48

The triptych represents an amalgamation of the artistic skills of the Old and New Worlds. The engraved silver-gilt case and carved boxwood scenes have close parallels in sixteenth-century Europe, but the background of hummingbird feathers draws on Aztec traditions. The *amanteca* (the Nahuatl term for members of the featherworkers' guild) were highly esteemed craftsmen who created garments and objects for ceremonial use by the Aztec élite and military. Miniature boxwood carvings such as this were probably executed by Mexican craftsmen trained by Flemish and Spanish Jeronymite friars in Mexico.

Four of the scenes here are taken from the Passion. The central tableau shows the Deposition, while the wings illustrate the Flagellation, Christ carrying the Cross with the help of Simon of Cyrene, and Christ mocked by a soldier. The fifth, upper right tableau depicts an event not mentioned in the

Gospels that is known as 'Christ on the Cold Stone' or 'Christ at Rest on Calvary'. This motif first appeared in northern Europe in the late Middle Ages and may have been transmitted to Mexico by missionaries.

Similar carvings set on hummingbird feathers are in the collections of the Metropolitan Museum of Art, New York; the Louvre, Paris; the Museo Nacional de Historia, Mexico City; and the Walters Art Gallery, Baltimore. The latter piece contains a Deposition scene almost identical to that on the present triptych. SM

325

The Mass of St Gregory

1539, colonial

Feathers on panel, 68 × 56 cm

Musée des Jacobins, Auch, 986.1.1

PROVENANCE: private collection; acquired by the museum, 1986

SELECTED REFERENCE: Mongne 1994

Pope Gregory I is faced by a gathering of the faithful who question the mystery of the Eucharist. After appealing to God for help, he sees before him a vision of Christ coming forth from his tomb – the scene depicted here. This subject was chosen as an effective means of instructing the native Mexican population in the basics of the Christian faith, for the image provides a summary of the Easter mystery, with all the instruments of the Passion shown in detail and arranged on the picture plane in a manner not unlike Aztec glyphs.

A few years after the Spanish conquest of Mexico, the Franciscan friar Peter of Ghent founded a school of arts and crafts in Mexico City, which at that time was governed by Don Diego Huamitzin, the son-in-law of the last Aztec *tlatoani* (ruler), Motecuhzoma II. Teaching at the school retained indigenous techniques, in particular featherwork, which was the preserve of the native nobility. Hence, the governor of the city may well have taken a personal interest in the production of the

present work, which the inscription states was sent to Pope Paul III as evidence of the gentle methods the Franciscans were using to Christianise the population.

The *Mass of St Gregory* belongs among the oldest surviving works of art relating to the introduction of Christianity in Mesoamerica. Although its form and content are largely Western, it does contain certain elements that show native influence, such as the motifs on the chasubles and the altar frontal, which were inspired by Aztec *pintaderas*, and the pineapples that take the place of the Holy Women's jars of ointment. FFJ

326

Christ the Saviour

Sixteenth century, colonial

Feathers, 105 × 90 cm

Museo Nacional del Virreinato, Tepotzotlan, CONACULTA-INAH, 10-28966

PROVENANCE: unknown

SELECTED REFERENCE: Martínez del Río 1960, pp. 86–94

Featherwork was one of the most exquisite crafts practised in Pre-Hispanic Mexico and among the most striking traditional minor arts to survive the Conquest. A great variety of feathers of different shapes, sizes and colours was used to fashion personal adornments as well as insignia and items of ceremonial clothing. If the Catholic clergy merely tolerated the application of this craft to the production of objects needed by themselves, including mitres (cat. 323), they actively encouraged its use in the creation of images for Christian devotion. The present depiction of Christ the Saviour is an example. Christ is shown blessing humanity. In his left hand he holds an orb symbolising sovereignty. Orbs formed part of the insignia of Roman emperors in the Christian era and of Holy Roman Emperors: in the Middle Ages the orb was considered to be the attribute of divine power. The figure of Christ is framed by a border containing an inscription

in Cyrillic script, repeated on all four sides, that has not been successfully deciphered. FS, RVA

327

Chalice

c. 1575–78, colonial

Silver-gilt, rock crystal, boxwood and hummingbird feathers, height 33 cm

Los Angeles County Museum of Art, William Randolph Hearst Collection, 48.24.20

PROVENANCE: Mexico City; William Randolph Hearst collection, donated to the museum, 1948

SELECTED REFERENCES: Esteras Martín 1989; Santa Barbara 1992, p. 116

Renowned for its fine structural design and the exceptional quality of its silverwork, this chalice not only reveals Renaissance form and Mannerist motifs, but also incorporates the Pre-Hispanic techniques and materials of rock-crystal carving and feather appliqué. Feathers, which were associated with Huitzilopochtli ('left-sided hummingbird'), the Aztecs' patron deity, had a complex symbolic value that lasted into the colonial period.

In religious, political and military contexts Aztec nobles, priests and warriors wore or carried precious objects created from brilliant plumages. In the years following the Conquest, schools were established for the native nobility at which indigenous featherwork techniques were taught alongside academic subjects. In the sixteenth century Mexican artists produced a variety of objects with feather mosaic, including devotional images (see cat. 325), liturgical objects and ecclesiastical attire (cat. 323). Such items were also presented as gifts to high-ranking figures and circulated among the courts of the Spanish Empire.

Feather mosaic appears in the chalice in two places as a background for boxwood carvings, behind the twelve Apostles on the hexagonal knop of the stem and in scenes from the Passion in insets on the base. VF

328

Chalice cover

c. 1540, colonial

Feathers and bark, diameter 28 cm

Museo Nacional de Antropología, Mexico City, CONACULTA-INAH, 10-220923

PROVENANCE: Hidalgo, 1915; donated to the Museo Nacional de Antropología by Rafael García Granados

SELECTED REFERENCES: Washington 1983, pp. 150–51; Castelló Iturbide 1993, p. 63

Rafael García Granados (1893–1956) was a bibliophile collector of a wide range of Mexican artefacts dating from the colonial period. In the course of his travels in the state of Hidalgo, he discovered this example of native featherwork, which dates from the early stages of the campaign to convert the indigenous population to Roman Catholicism. A chalice cover, it was originally sewn to a piece of fabric (removed by García Granados) that was draped over the vessel. It is the only example of featherwork from the early colonial period in the Museo Nacional de Antropología. Featherworkers (*amantecas*) first cut templates from bark paper in the desired shapes and then used vegetable resins to glue the feathers to the templates, starting with the large disc, followed by the circular panel with its running-water designs and ending with the central motif. The running water symbolises holy water transmitting the word of God, who appears as a fantastic, Pre-Hispanic mask with fangs. The flame issuing from his mouth is the blood of Christ that washes away the sins of the world and is equated with the primeval water of the ancient gods. FS, RVA

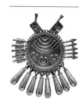

329

Shield pendant

c. 1500, Aztec–Mixtec

Gold with silver and copper, 10.5 × 8.5 cm

Baluarte de Santiago, Veracruz, CONACULTA-INAH, 10-213084

PROVENANCE: near Puerto de Veracruz on the coast of the Gulf of Mexico, 1975; seized by the Mexican Government and handed over to the INAH

SELECTED REFERENCES: Torres Montes and Franco Velásquez 1989; Solís Olguín and Carmona 1995, pp. 29–30, no. 14; Seville 1997, pp. 186–87, no. 70

This pendant comes from the 'fisherman's treasure' (see cats 330–32). It has the form of a *chimalli*, the round shield that symbolised war. It was cast by the lost-wax method (see cat. 282) and finished in several stages, during one of which eight bells were hung from it. It no doubt belonged among the insignia of the supreme *tlatoani*, head of the army, and may have formed part of the accoutrements of one of the warrior gods, Huitzilopochtli or Tezcatlipoca. The disc of the shield is bordered with small circles; the upper part of the disc is decorated with five curved bands, while the lower part has three half-moons, a motif that has survived on featherwork shields and is known from images in codices. The points and feather tips of five realistically depicted arrows are clearly visible on either side of the disc. Two flags or banners complete the upper part of the pendant, where the conquistadors have stamped the letter C for *coronada* (crowned), the monogram of Charles I of Spain (Holy Roman Emperor Charles V), indicating that royal taxes had been paid before the item was sent to Spain. FS, RVA

330–32
Bracelets

c. 1500, Aztec–Mixtec

Gold with silver and copper, 8 × 2.8 × 1 cm, 7 × 4.8 × 1.7 cm and 8.2 × 3 × 1 cm

Baluarte de Santiago, Veracruz, CONACULTA-INAH, 10-213110, 10-213113 and 10-213111

PROVENANCE: near Puerto de Veracruz on the coast of the Gulf of Mexico, 1975; seized by the Mexican government and handed over to the INAH

SELECTED REFERENCES: Torres Montes and Franco Velásquez 1989; Solís Olguín and Carmona 1995, pp. 29–30, nos 20–22; Seville 1997, pp. 184–85, no. 68

The early stages of Spanish domination of Mexico were accompanied by a number of shipwrecks along the coast of the Gulf of Mexico, some of them containing treasure looted by the conquistadors. The so-called 'fisherman's treasure' was discovered in 1975 by a diver hunting for octopuses among the coral reefs near Puerto de Veracruz. Its origin has never been identified beyond doubt: some believe it belonged to the booty taken from the palace of Axayacatl, others that it was the gold collected by Captain Figueroa, who had been sent by Hernán Cortés to Oaxaca to conquer the Mixes and to return with precious metals.

The treasure contained a rare group of gold bells, earrings, beads, bracelets and the shield pendant (cat. 329). Many items were melted down to make new jewellery, but among those that were preserved are seven bracelets and five fragments. The bracelets, cast by the lost-wax process (see cat. 282), are of a superior quality. They had been twisted, a disfigurement perhaps intended to prevent these possessions of the gods being used by mortals. The pieces were made in at least two stages. In the first, the band with four conical bosses was shaped and adorned with motifs suggesting textile warping and step-frets. Subsequently, four plaques in the shape of monkeys with coiled tails were added, along with the rosettes that convert the original bosses into floral designs. FS, RVA

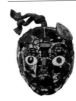

333
Gold ingot

c. 1521, early colonial

Gold, 5.5 × 26.5 × 1.5 cm

Museo Nacional de Antropología, Mexico City, CONACULTA-INAH, 10-220012

PROVENANCE: Mexico City, 1982

SELECTED REFERENCES: Solís Olguín and Carmona 1995, pp. 19, 27, no. 1; Seville 1997, pp. 188–89; Vienna 1997, pp. 78–79, no. 72

In his *Historia verdadera de la conquista de la Nueva España* (*True History of the Conquest of New Spain*) the soldier and chronicler Bernal Díaz del Castillo describes the frenzy that overcame members of the Spanish army the night they discovered the secret room in the palace of Axayacatl where the Indians had hidden the treasure of the Aztec rulers. Emperor Charles V, Hernán Cortés and his officers each received one fifth of the booty; the remainder was distributed among the soldiers, who decided to melt down the gold into long, channel-shaped ingots. Before the bars had cooled completely, the soldiers bent them slightly, taking advantage of their length (less than 30 cm) and weight (approximately 1 kg) to strap them to their bodies with cords and pieces of cloth. The present ingot bears witness to this destruction of the Aztec rulers' jewellery. Found in 1982 during excavations underneath buildings belonging to the Bank of Mexico on the northern shore of Alameda Central in Mexico City, it may well have been dropped in the lake by a Spanish soldier on the Noche Triste, the 'sad night' in 1521 in which Spanish forces were driven out of Tenochtitlan by Aztec armies. FS, RVA

334
Mirror frame

Sixteenth century, Aztec

Wood, resin, turquoise, jade, glass, shell and iron wire, 9.7 × 8.5 × 5.2 cm

Museum für Völkerkunde Wien (Kuntshistorisches Museum MVK mit ÖTM), Vienna, 43.382, Ambras collection

PROVENANCE: Ferdinand II, Archduke of Tyrol (1529–1595), Ambras castle near Innsbruck; passed to the Natural History Museum as part of the imperial collections, 1891

SELECTED REFERENCES: Nowotny 1960, pp. 60–61; Feest 1990, pp. 25–28; Vienna 1992, no. 183

This head of a predator, feline or canine, was carved from wood and inlaid first with resin, then with turquoise, jade, glass and shell. The use of glass and iron wire indicates that the piece was probably made in colonial times, testifying to the continuation of Aztec craftsmanship after the Conquest. The eyes and most of the teeth are made from white shell; the other teeth, the one extant ear and the tongue are carved from orange *Spondylus* shell. The tongue is attached with iron

wire, enabling it to move up and down. The cavity on the reverse probably held a mirror. GvB

335

Mirror or portable altar

c. 1520–30 (?), colonial

Obsidian, wood, paint and gilding; mirror 25.5 × 23.4 cm, frame 31.5 × 28.5 × 2.8 cm

Dumbarton Oaks Research Library and Collections, Washington DC, B-78

PROVENANCE: purchased in a public market in Madrid, 1961

SELECTED REFERENCES: Hildesheim 1986, no. 354; Washington 1991, p. 548; Serra Puche 1994, p. 197; Saunders 2001, p. 226; Saunders forthcoming

This block of obsidian is set in a gilt-wood surround decorated in a floral style characteristic of the early colonial period. Carved into the back of the frame is the Franciscan emblem showing Christ's stigmata within a shield, which dates the piece to the sixteenth century. Such objects, most of them unframed, are widely referred to as mirrors. More likely, they were *aras* (portable altars), commissioned by Spanish Mendicant friars from native obsidian workers. They substituted for suitable European alternatives, which were in short supply, and served as liturgical instruments for the conversion of indigenous peoples. This may explain their square or rectangular shape, which appears to be European in origin and contrasts with the typical disc-shape of Pre-Columbian examples.

In Postclassic central Mexico obsidian possessed magical as well as practical qualities. Used by the Aztecs to make divinatory mirrors, it was associated symbolically with the deity Tezcatlipoca, the omniscient, all-powerful 'smoking mirror'. This god's associations with sacrifice, blood and obsidian drew an ironic parallel between Aztec belief and Christian crucifixion imagery which is embodied in this piece. Such subtleties probably passed unnoticed by most Spanish priests. NJS

336

Vitzliputzli

Second half of the sixteenth century, Mexico

Silver-gilt, pearls and pyrite, 7.5 × 6 × 6.5 cm

Museen der Stadt Nürnberg, Nuremberg, Gemälde und Skulpturen, Pl. 1248

PROVENANCE: Stadtbibliothek, Nuremberg

SELECTED REFERENCE: Anders 1992

This piece shows a monkey squatting with its legs turned inwards and gazing upwards with its tongue hanging out. A pearl adorns its right ear and a cord has been placed around its neck. The monkey has raised its right front paw and lays its left front paw on its belly. Two pearls hang from the hemispherical shape on the back of the monkey which contains a heavily weathered piece of pyrite, formerly taken to be a mirror. A seventeenth-century illustration of the object shows more pearls on the left ear and on the cord, along with a rattle in the right front paw.

There is no record of how and when 'Vitzliputzli' found its way to Nuremberg. The earliest known mention of the piece occurs in *Prophet Schul* of 1662 by Johann Michael Dilherr (1604–1669), preacher at St Sebald's church in the city, who describes it as 'an Indian idol brought from India and donated to the library at Nuremberg' and includes an illustration. The index of Dilherr's book lists the object as 'Vitzliputzli, the Indians' idol'. The name probably derived from that of the Aztec god of war Huitzilopochtli, called Vitzliputzli in European accounts of the New World from the late sixteenth century onwards. UKR

337

Tripod ceremonial plate

c. 1530, Aztec

Fired clay, height 10 cm, diameter 23.5 cm

Museo Nacional de Antropología, Mexico City, CONACULTA-INAH, 10-81584

PROVENANCE: Tlatelolco, Mexico City, 1964

SELECTED REFERENCES: Bernal 1967, p. 197, no. 135; Pasztory 1983, pp. 298–99, pls 317–19; Solís Olguín 1991B, p. 260, no. 398

Following the Spanish conquest of Tenochtitlan in 1521, the local population congregated in Tlatelolco where, for some years, they continued to recognise rulers belonging to the old Aztec lineage. The ceremonial plate dates from the first years in this period of cultural transition and may be viewed as the swansong of past grandeur. It combines a shape presumably introduced by the Europeans – its undulating surface is alien to native ceramic traditions – with war symbolism derived from the Pre-Hispanic world. Two ferocious animals merge into one figure, forming a kind of heraldic shield in which the talons and wings of an eagle and the tail of a jaguar can be distinguished. The two heads, on the other hand, recall the double-headed eagle of the Holy Roman Empire, ruled at the time by Charles I of Spain as Emperor Charles V. The plate's three circular supports also bear eagle's heads. FS, RVA

338

Drum

c. 1521, early colonial

Chicozapote wood and animal molars, 22 × 88 × 25 cm

Museo Nacional de Antropología, Mexico City, CONACULTA-INAH, 10-220924

PROVENANCE: Malinalco, Mexico State, nineteenth century

SELECTED REFERENCES: Castañeda and Mendoza 1933, pp. 10–11; Washington 1983, p. 149

Spanish missionaries prohibited traditional ritual practices among all peoples of the Aztec empire, permitting only music and dances that they considered posed no threat to the progress of Christianisation. They thus ensured the survival of some musical instruments, including the horizontal drum (*teponaxtli*). The present *teponaxtli* bears witness to the cultural syncretism that occurred in Mexico during its first century as a European colony. The instrument takes the form of a feline, either a lion or a jaguar, shown crouching with its tail close to its left side. Recalling depictions of whirlpools in Pre-Hispanic

codices, the striking curls of the mane have led several scholars to identify the animal as an *ahuizotl* ('water-thorn beast' [see cat. 199]), yet they are closer in style to European sculpture of the fourteenth and fifteenth centuries. The *teponaxtli* retains the original feline or canine eye-teeth and molars, encrusted by its creators to make the animal look realistic and ferocious. FS, RVA

339
Column base with an image of Tlaltecuhtli

Image *c.* 1500, Aztec; base *c.* 1650, colonial

Stone, 84 × 75 × 76 cm

Museo Nacional de Antropología, Mexico City, CONACULTA-INAH, 10-46679

PROVENANCE: Mexico City, nineteenth century

SELECTED REFERENCES: Peñafiel 1910, pp. 45–46; New York 1990, p. 255, no. 117

After conquering Tenochtitlan in 1521, the Spaniards decided to build the capital of their new colony on the ruins of the Aztec city, using the materials at hand. The present Post-Conquest column base, for example, contains an Aztec relief of Tlaltecuhtli ('earth lord'), his tangled hair complete with spiders, centipedes and other insects from the underworld. The sculpture from which the relief came may have been a *temalácatl* (see cat. 209), the edge of which was cut away to produce the square piece required. The column base is notable for the fact that the colonial stonemason harnessed the symbolism associated with the image of Tlaltecuhtli to its new function: the 'earth lord' had supported images of other gods or of the universe; now it was to support a structure dedicated to the Christian faith – a building in the south-western corner of the Plaza Mayor that belonged to Augustinian monks. FS, RVA

XI CODICES

340
Codex Cospi

c. 1350–1500, Mixtec

Screenfold codex, deerskin, 17.4/18.2 × 364 cm; parchment cover, seventeenth century

Biblioteca Universitaria di Bologna, Ms 4093

PROVENANCE: Conte Valerio Zani; Marchese Ferdinando Cospi, 26 December 1665; donated to the Istituto delle Scienze, Bologna, by order of Pope Benedict XIV, 1742

SELECTED REFERENCES: Bologna 1667; Bologna 1677; Codice Cospi 1992

This is one of fifteen codices from Pre-Hispanic Mexico to have survived destruction at the hands of the Spanish. Scholars have linked it with four of the others to form the 'Borgia group' of manuscripts, all of which date from the Late Postclassic period (1250–1521): the Codex Vaticanus B (3773) and the Messicano Riserva 28 in the Vatican Library, the Codex Fejérváry-Mayer (cat. 341) and the Codex Laud (Bodleian Library, Oxford).

The pictographic text on this screenfold codex begins with the ritual calendar (pp. 1–8), followed by pages relating to the calendar of Venus (pp. 9–11) and to the first days of each quarter of the ritual calendar (pp. 12–13). The contents of the verso, which is painted in a less careful, less skilful and probably more recent hand, are still a matter of debate, but seem to describe rituals involving offerings to various deities. One area on each of these pages would appear to show how to decorate the altar and the number of items to be used.

Nothing is known of the whereabouts of the codex before it came into the possession of the learned antiquarian Conte Valerio Zani. At the time when Zani gave it to Marchese Ferdinando Cospi (1606–1686) it was not recognised as of American origin. A note on the seventeenth-century cover, though crossed out at a later date and amended to 'Libro del

Messico' (book from Mexico), clearly stated 'Libro della China' (book from China). And in 1667, when Cospi produced the first description of the collection in Bologna, he lists under no. 350 a 'Libro venuto dalla China con varij geroglifici' (book from China with various hieroglyphics) that is probably identical to the present manuscript. Not until the catalogue complied by Lorenzo Legati in 1677 was the codex identified as a 'Libro del Messico'. After passing to the Istituto delle Scienze in Bologna in 1742, it was placed in the Room of Antiquities, but did not become the subject of serious study until the following century, when, in 1818, Giuseppe Mezzofanti, a polyglot native of Bologna, attempted to decipher its contents. RDT

341
Codex Fejérváry-Mayer

Before 1521, Mixtec style with Aztec and Gulf of Mexico influence

Screenfold codex, four strips of animal skin glued together, covered with white lime (gesso) and painted, 22 double-sided pages plus covers, each page 17.5 × 17.5 cm, full length 403 cm

The Board of Trustees of the National Museums and Galleries on Merseyside (Liverpool Museum), 12014M

PROVENANCE: Gabriel Fejérváry collection (1780–1851); Joseph Mayer collection (1855–67); donated to the museum, 1867

SELECTED REFERENCES: Tonalamatl de los pochtecas 1985; Brotherston 1995

The Codex Fejérváry-Mayer is a *tonalamatl* – a 'book of days and destinies' that merges time with the course of people's lives and fortunes. Its pages combine two sophisticated and interconnected calendars: the *xiuhpohualli*, a yearly cycle of 365 days (18 months of 20 days plus 5 days), and the *tonalpohualli*, the ritual calendar of 260 days (based on a cycle of 13 numbers and 20 named day-signs). The complex interweave of these calendars with icons such as the Nine Night Lords, eleven deities and thirteen *quecholli* ('fliers', i.e. winged creatures, including birds) brings together a multivalent 'reading' of the text, providing information on a myriad of issues, from human life, labour and

behaviour to tribute and economy. The codex consummately combines the calendars with the tribute system: side 1 deals with commodity items supplied over the 365-day year, side 2 with people's labour over the 260-day calendar.

In the hands of ritual practitioners and other high-ranking individuals (such as the *pochteca*, or professional merchants) the codex became a guide for people's actions. The screenfold's internal reading structure is right to left and is determined by the number-and-sign sets of the calendar: how the images and symbols cross-referenced each other was then interpreted by the reader, who was well versed in the significance of the various icons. Although an object of great respect, the codex was also a tactile, malleable reference tool: a user could consult both sides simultaneously by folding parts of the codex onto itself. Reading it offered guidance on appropriate days to travel, to celebrate a deity's beneficence with sacrifices, to plant crops or to name a child.

Codices were of pivotal importance in the ordering of the Mesoamerican world. Histories, genealogies and tribute economies were recorded in the pages of *xiuhtlapoualli* (annals), while the *tonalamatl* dealt with the yearly and ritual calendars. As such, codices served both educational and ritual purposes. At the same time, they were objects of great cultural, literary and artistic value.

Only eight other *tonalamatl* codices are known to have survived the destruction of indigenous manuscripts by the Spanish in their efforts to pave the way for Christianity. Although *tonalamatl* are no longer made, the *tonalpohualli* continues to be of importance to some communities in Veracruz, Oaxaca, Chiapas and throughout the Guatemalan highlands. JO

342
Codex Magliabechiano

Libro de la vida que los Yndios antiguamente hazian y supersticiones y malos ritos que tenian y guardavan

Sixteenth century, colonial

Codex, 92 folios, European paper, 16.5 × 22.5 cm

Biblioteca Nazionale Centrale di Firenze, Florence, BR 232 (Magl. XIII, 3)

PROVENANCE: Antonio Magliabechi (1633–1714), who gave his library to the city of Florence, forming the basis of the present-day Biblioteca Nazionale

SELECTED REFERENCES: Codex Magliabechiano 1903, pp. III–XIX; Robertson 1959, pp. 125–33; Codex Magliabechiano 1970, pp. 9–69

This manuscript, generally known as the Codex Magliabechiano, is a copy of a Pre-Hispanic codex, written on European paper and containing drawings in pen and ink and watercolour illustrating the religious beliefs, festivals and rites of ancient Mexico. The drawings on the first 78 folios are accompanied by captions in Spanish script datable to the second half of the sixteenth century and by contemporary additions in another hand.

Reproductions of ceremonial cloaks and articles of clothing used for feasts throughout the year appear at the beginning of the codex, four to a page, with the exception of the 'manta del fuego del diablo' (cloak of the devil's fire), which has folio 7 to itself. These garments are followed by the *tonalpohualli* (ritual calendar). This comprises one sign – *cipactli* ('alligator'), *macuilxochitl* ('flower'), *tochtli* ('rabbit') and so forth – for each of the twenty days in a 'month' and a number from 1 to 13 (represented by dots within a circle) associated with each day. The combination of sign and number established a fixed chronological sequence for the thirteen 'months' of the year. This calendar formed the basis of choosing names for the new-born and of foretelling the future, a task performed by priests on such occasions as births and marriages and also in connection with commercial activities. The next four signs – *acatl* ('reed'), *tecpatl* ('flint'), *calli* ('house') and *tochtli* ('rabbit') – were likewise each

linked to a number from 1 to 13, but were used in both the ritual and the solar calendar. Repeated thirteen times, these signs denoted a period of 52 years (the Aztec 'century'), at the end of which the ritual and solar calendars coincided and the calculation of time began afresh.

The next section of the codex is devoted to the eighteen ceremonies of the solar year, many of which relate to events in the agrarian cycle and are dedicated to Tlaloc, god of rain, to fertility gods and to a series of eighteen deities of whom many are gods of *pulque* (Toltecatl, Patecatl and so on); the last is Mictlantecuhtli, god of the dead. The subsequent drawings illustrate funeral rites and other civil and religious ceremonies, including the extraction of the hearts of two sacrificial victims in a temple (fol. 70*r*), a ritual banquet at which human flesh is served (fol. 72*r*), the piercing of parts of the body (tongue, ears, limbs) with maguey thorns (fol. 79*r*) and offerings of human blood to Mictlantecuhtli (fol. 88*r*). CP

343

Codex Durán

Diego Durán, *Historia de las Indias de Nueva España e Islas de Tierra Firme*

1579–81

Codex, 344 folios, European paper, 28 × 19 cm; nineteenth-century leather binding

Biblioteca Nacional, Madrid, Vit. 26-11

PROVENANCE: unknown

SELECTED REFERENCES: Durán 1867, 1880; Sandoval 1945; Durán 1967; Robertson 1968; Milne 1984; Durán 1990–91

Diego Durán was born in Seville in 1537. While still a child he moved with his parents to New Spain and lived with them in Tetzcoco until taking his vows as a member of the Dominican Order in 1556 at the age of nineteen. Three years later he began practising as a priest and in 1561 was transferred to the monastery in Oaxaca. By his own account Durán carried out missionary work in several native villages, including Santa María Coyatepec, Coixtlahuaca and Hueyapan, where he was regional bishop in 1581. He died at the Dominican monastery in the Mexican capital in 1588, aged 51.

Durán aimed to help his fellow monks spread the gospel among the native population. He was aware that conversion of the Indians could be achieved only via a thorough understanding of their customs and beliefs. He wrote his three-volume *Historia de las Indias de Nueva España e Islas de Tierra Firme* (*History of the Indies of New Spain and Islands of Tierra Firme*) between 1570 and 1581. The first volume, completed in 1581, contains 78 chapters providing a chronological history of native Mexicans, from their origins to the Spanish conquest of Tenochtitlan, the death of Motecuhzoma II and Hernán Cortés's voyage to the Hibueras. Finished in 1570, the second volume contains a prologue in which Durán states his views on the conversion of the Indians, noting that his reason for writing the book was 'my realisation that those of us who are responsible for the religious instruction of the Indians will never succeed in teaching them to recognise the true God until we first erase from their memory all superstitions and ceremonies and the false cult of the false gods in which they formerly believed'. The first 23 chapters of this volume are devoted to the Aztecs' gods and goddesses, their temples, festivals, rites and so forth. The last four chapters describe this people's markets and slave trade, their schools and teachers, their dances and songs, and their sports. The third volume, consisting of 22 chapters, is a continuation of the second. Finished in 1579, it discusses 'the ancient Calendar governing these Indian nations', a 'brief' account because, as Durán notes, its sole aim was 'to provide sufficient detail to assist my fellows…and to eradicate superstitions'. The following inscription, erased but still legible when read against the light, appears at the end of the introduction to this volume (fol. 316): 'by Fray Diego Durán, monk of the Order of St Dominic'.

In his *Historia* Durán regrets the destruction of ancient writings and the fact that many people who could have passed on information or were able to read Aztec writings are no longer alive. Yet he had access to valuable sources, both recorded (manuscripts and paintings) and oral (Spanish and Indian witnesses to the Conquest), and was able to draw on his experiences of more than 40 years in Mexico. The result was an informative, well-researched work on Mexican history and the country's social and religious life before and after Columbus. The *Historia* contains numerous illustrations, both at the chapter beginnings and within the text. Drawn in pen and ink and colour wash, they combine Renaissance and indigenous pictorial styles in detailed depictions of the events described in the text.

Durán's work remained unpublished until 1867, when José Fernando Ramírez printed the first volume in Mexico City. The second volume was published there by Gumersindo Mendoza in 1880. PHA

344

Florentine Codex

Bernardino de Sahagún, *Historia general de las cosas de Nueva España*

1575–77, colonial

3 vols, 353, 375 and 495 folios, paper, 31.8 × 21 cm; contemporary Spanish binding

Biblioteca Medicea Laurenziana, Florence, Mediceo Palatino 218–220

PROVENANCE: Biblioteca Palatina Granducale, Florence; passed to the Biblioteca Laurenziana, Florence, 1783

SELECTED REFERENCES: Bandini 1793, pp.454–56; Sahagún 1905; Sahagún 1950–82; Robertson 1959; Sahagún 1979; Corsi 1982; Sahagún 1988; Spagnesi 1993

The codex, its original three volumes now bound in four, contains the final version of the twelve-volume *Historia general de las cosas de Nueva España* (*General History of the Things of New Spain*) by the Spanish Franciscan friar

Bernardino de Sahagún (1499–1590), who travelled as a missionary to Mexico after its conquest by Hernán Cortés in 1521. Compiled from 1558 to 1560, Sahagún's work represented an extraordinary attempt at Christianising by means of cultural understanding rather than force. Although the author's signature appears in the lower margin of folio 328r in volume 1, the manuscript was written by various scribes in Tlatelolco from the end of 1575 to the beginning of 1577, in two columns, one in Spanish, the other in Nahuatl, the language spoken most widely among the Toltecs, Chichimecs and Aztecs. The work was carried out at the request of the Franciscan Commissary General, Friar Rodrigo de Sequera, a great admirer of the *Historia*, who was implementing an order given by Juan de Ovando, President of the Council of the Indies, who was keen to discover more about this illustrated encyclopaedia of Mexican civilisation before the Conquest. Philip II of Spain (*reg.* 1556–98) opposed the liberal approach to converting the indigenous peoples and in 1577 required all the *Historia* material to be sent to Spain to prevent its dissemination. De Sequera rescued it by stealing this codex and bringing it to Europe in 1580.

In 1589 the Florentine painter Ludovico Buti (active 1560–1603) painted a ceiling fresco in the Uffizi that was inspired by the illustrations in the manuscript – a clear indication that the codex had already entered the Palatina library (either by purchase or private donation), where it complemented the wealth of Mexican objects in the non-European collections of the Medici Grand Dukes Francis I (1574–87) and Ferdinand I (1587–1609). It was not rediscovered until 1793, when the head of the Biblioteca Medicea, Angelo Maria Bandini (1757–1803), described it in the final volume of his monumental *Catalogus* along with the other codices in the Grand-Ducal library

that had been chosen for inclusion in the Biblioteca Laurenziana by order of Peter Leopold of Lorraine (*reg.* 1765–90). IGR

345

Historia Tolteca-Chichimeca

1550–70, Cuauhtinchan, Puebla

Codex, 50 folios, European paper, 31.5 × 22.5 cm; modern parchment binding

Bibliothèque Nationale de France, Paris, MS Mexicain 46–58

PROVENANCE: Alonso de Castañeda Tezcacoatl and descendants until at least 1718; acquired by Lorenzo Boturini Benaduci (1702–1755), 1737/46; acquired by Joseph Marius Alexis Aubin (1802–1891), 1830/40; Eugène Goupil (1831–1895), 1889; donated to the Bibliothèque Nationale by Goupil's widow, Augustine Elie, 23 April 1898

SELECTED REFERENCES: Glass and Robertson 1975, no. 359; Historia Tolteca-Chichimeca 1976

The Historia Tolteca-Chichimeca, the first item in Lorenzo Boturini Benaduci's *Catalogo del Museo Indiano* (1746), is a major source for the history of Pre-Hispanic central Mexico. It recounts the events of 1116 to 1547. This period saw the migration of the Toltecs, guided by Icxicouatl ('serpent's foot') and Quetzalteueyac ('great green feather'), from their mythical land of origin, Chicomoztoc ('seven caves'), and the destruction in 1168 of their capital, Tula, by the Chichimecs, whom they then followed to the Puebla region. The account moves on to the conquest of Cholula, a city inhabited by the Olmeca-Xicalanca, and the foundation of the city Cuauhtinchan ('eagle house' – the eagle was the totemic animal of the Chichimecs), where the Mexica gained power in 1471. Continuing until 1547, the chronicle gives an unadorned description of events during the early years of the colonial era: the arrival of the Spanish in 1519 (section 423) and of the Franciscans in 1524 (section 427) and the foundation of Puebla in 1531 (section 433).

The Nahuatl text, transcribed in Roman letters with headings, alternates with pictographic notations. Not all of these were

completed, some consisting merely of dates preceding the event reported or of facts recounted 'in pictures'. Others, however, are full painted pages in the tradition of the native *mapas*. One such (fol. 29r) shows a detailed depiction of Chicomoztoc, the 'seven caves' of the seven tribes of Mount Culhuacan. Each tribe is shown inside its cave, designated by its glyph and listed opposite in a Spanish inscription (section 171, fol. 28v): 'On the date 13-flower Icxicouatl [shown lower right on the painted page] and Quetzalteueyac [just above Icxicouatl] left Xalpantzinco to go to Chicomoztoc on Culhuacan, whence the Chichimec tribes had come: the Totomiuacs, the Acolchichimecs, the Cuauhtinchantls, the Moquiuixcs, the Tzauhctecs, the Texcaltecs and the Malpantlaca'. MCo

346

Codex Ríos ('Codex Vaticanus Latinus A', 'Codex Vaticanus 3738')

c. 1570–95, Rome

95 folios, European paper, approx. 46.5 × 29.5 cm each; red leather binding (replacing original black leather), 1869–89

Biblioteca Apostolica Vaticana, Vatican City, A 3738

PROVENANCE: in the Vatican Library by 1596

SELECTED REFERENCES: Codice Vaticano 3738 1900; Glass and Robertson 1975; Codex Vaticanus 3738 1979

The rarity of Pre-Hispanic manuscripts from Mexico is doubtless due to the extensive destruction of Aztec books undertaken during the first phase of the Spanish war on idolatry. Subsequently, the invaders came to realise that conversion of the native population to Christianity would be helped by learning about Aztec religious rites and that indigenous manuscripts were a valuable source of such knowledge. Missionaries enlisted the help of elders and chiefs in explaining the contents of the books, but within only a century of the Conquest very few people still understood the illustrations.

The Codex Ríos (also known as the Codex Vaticanus Latinus A or the Codex Vaticanus 3738) belongs among the rare manuscripts to contain explanations of Aztec myths and religious ceremonies, written by an unknown author in Italian beneath the illustrations. (This commentary is transcribed in its entirety, though not always accurately, in the facsimile edition of the Codex Ríos published in 1900.)

The manuscript acquired its name from Pedro de los Ríos, a Mexican Dominican friar who is twice mentioned as its illustrator (fols 4*v*, 23*r*). It is first recorded in the 1596 catalogue of manuscripts in the Vatican Library. Watermarks indicate that it was written, probably in Rome, on paper from Fabriano dating to later than 1570. One passage shows that the text was written after 1566. The manuscript must therefore date from *c.* 1570–95.

The Codex Ríos consists of four sections. The first is devoted to mythology and cosmology (fols 1*r*–11*v*), the second to the calculation of the 260-day ritual calendar (*tonalpohualli*; fols 12*v*–33*r*), of years (calendrical tables for 1558 to 1619; fols 34*r*–36*r*) and of 'months' in the solar calendar (*xiuhpohualli*; fols 42*r*–51*r*), the third to rites (comprising ethnographical sections on the day-signs attributed to various body parts, on sacrificial and mortuary customs, portraits of various types of native Mexican and miscellaneous drawings; fols 54*r*–61*r*) and the fourth to annals, both with illustrations (fols 66*r*–94*r*) and without (fols 94*v*–95*v*). The annals illustrations include an image of the Spanish military leader Nuño Beltrán de Guzmán setting off to conquer Jalisco in 1529 and a snake emerging from the sky as a bad omen to the native population, along with earthquakes (under 1530) and an eclipse of the sun (under 1531; fol. 88*r*). Other drawings relating to the first decades of Spanish rule are the arrival in 1534 of Antonio de

Mendoza as the first viceroy of New Spain (fol. 88*v*) and the death in 1538 of many Aztecs from smallpox (fol. 90*v*). The final image in the codex shows the death of the first Bishop of Mexico, Juan de Zumárraga, in 1547 (fol. 94*r*).

The drawings are very similar, though cruder and less detailed, to those in another Mexican manuscript, the Codex Telleriano-Remensis in Paris (cat. 348). Both manuscripts are considered to derive from a single source, the Vatican codex helping to provide knowledge of parts missing from the Paris volume. MCE

347

Juan de Tovar, *Relación del origen de los Yndios que havitan en esta Nueva España según sus historias*

1583–87, colonial

Ink and watercolour on European paper, 21.2 × 15.6 cm

The John Carter Brown Library at Brown University, Providence, Rhode Island

PROVENANCE: acquired from the collection of Sir Thomas Phillipps, 1946

SELECTED REFERENCES: Tovar 1951; Durán 1964; Tovar 1972

The earliest missionary ethnologists in New Spain after the Conquest, among them Andrés de Olmos, Toribio de Benavente Motolinía and Bernardino de Sahagún, were followed by a generation of historians some of whom had been born in Mexico. This group of scholars included Hernando Alvarado de Tezozómoc, the Dominican Diego Durán and two Jesuits, José de Acosta and Juan de Tovar. With the exception of Acosta, whose knowledge of ancient Mexico seems to have been based entirely on that of Tovar, most of them drew their information from living informants and from old, indigenous chronicles that have not survived.

Juan de Tovar was born in New Spain *c.* 1543–46, either in Mexico City or Tetzcoco, and died in 1626. He was ordained as a priest in 1570 and entered the Jesuit order three years later, eventually gaining fame as a missionary

preacher. He was fluent in Nahuatl, Otomí and Mazagua. Apparently basing his studies on original sources, Tovar prepared a history of Pre-Hispanic Mexico, now lost, and the work containing the present illustration.

The codex has three parts: an exchange of letters between Acosta and Tovar; a historical text entitled 'Relación del origen de los Yndios', covering Aztec history and the great ceremonies linked to the solar calendar; and the Tovar calendar, with a description of the rites and feasts of the Aztecs, including a correlation with the Christian calendar.

The second part is illustrated by 32 watercolour drawings of Aztec gods and practices. 'The Mexicans' Manner of Dancing', spread across two facing pages, shows a large anticlockwise dance of men to music provided by a horizontal and a vertical drum (*teponaztli*, *huehuetl*; see cats 156–57, 338). All the participants appear to be of very high rank, including the musicians, who wear the headdress insignia of the Aztec ruler on their shoulder. Each of the dancers is attired in a cloak knotted at the shoulder and carries a bouquet in one hand and a device topped with feathers in the other. Among the dancers are a jaguar warrior and an eagle warrior. MDC

348

Codex Telleriano-Remensis

1555–61, Tlatelolco

50 folios, European paper, 31.3 × 22 cm; modern parchment binding

Bibliothèque Nationale de France, Paris, MS Mexicain 385

PROVENANCE: collection of Charles Maurice le Tellier (1642–1710), Archbishop of Reims, donated to the Bibliothèque du roi, 1700, with 500 other MS from his collection

SELECTED REFERENCES: Glass and Robertson 1975, no. 308; Codex Telleriano-Remensis 1995

The manuscript bears striking witness to the rich and subtle pictographic tradition of the Aztecs. It was acquired by one of the great bibliophiles of his time, Charles le Tellier, Archbishop of Reims, who donated it in 1700 to the library of Louis XIV.

The codex consists of three parts. The first is a calendar of the ritual feasts of the eighteen 'months' of twenty-days each, called *veintenas* ('twenty-day periods') by the Spanish, of the solar year (fols 1–7). Ceremonies conducted in honour of the tutelary gods of each *veintena* are shown in all their splendour. The name of each *veintena* is given in both Nahuatl and Spanish, with the corresponding date in the Western calendar also specified. The year ends with the feast of Izcalli ('growth'), held under the aegis of Xiuhtecuhtli ('turquoise lord').

This part is followed by a *tonalamatl* (day book), the manual of divination for the twenty 'weeks', called *trecenas* ('thirteen-day periods') by the Spanish, into which the Aztec sacred year was divided (fols 8–24). Every *trecena* occupies two facing pages, each showing a divinity, one major and one minor. The *yoallitecutin* ('lords of the night') of each day of the *trecena* are shown in profile above that day.

The third section of the manuscript comprises a chronicle of the Aztecs. Events from their mythical migration in 1197 to the end of the first three decades of Spanish presence in 1549 are illustrated; those from the years 1550 to 1561 recounted on the final folios lack images (fols 25–50). The drawings for 1494–96 depict the last victories of Ahuizotl in Oaxaca, along with an earthquake in 1495 and a solar eclipse in 1496 (fols 40*v*/41*r*). Ahuizotl, who died following his final conquest in Tehuantepec, was succeeded in 1502 by Motecuhzoma II, the last ruler of the Pre-Hispanic era. Several folios are devoted to Motecuhzoma's military victories from his accession until 1518, yet, oddly, the years from 1519 (when the Spanish arrived in Mexico) to 1528 are missing from the chronicle. MCo

349
Codex Mendoza

c. 1541, Aztec

71 folios, European paper, 30–31.5 × 21–21.5 cm; seventeenth-century binding

Bodleian Library, University of Oxford, Ms Arch. Selden A.1

PROVENANCE: Mexico City; André Thevet, 1553; Richard Hakluyt, *c.* 1588; Samuel Purchas, 1616; John Selden *c.* 1654; entered Bodleian Library, 1659, five years after Selden's death

SELECTED REFERENCES: Glass and Robertson 1975, no. 196; Codex Mendoza 1992; Brotherston 1995; Codex Mendoza 1997; Berger 1998

The Codex Mendoza is one of the best-known early colonial pictorial manuscripts from Mexico. Seventy-two pages of its 71 folios contain Aztec iconic script written by a single, highly skilled indigenous *tlacuilo* (painter-scribe). The pictorial text is annotated with Spanish glosses by a Spanish interpreter versed in Nahuatl and accompanied by 63 pages of more extensive Spanish commentary in the same hand. Another Spanish hand has added headings that divide the manuscript into three sections. The first begins with the foundation of Tenochtitlan by the Mexica in 1325 and continues with an account of the reigns and conquests of nine Mexica rulers, ending with the reign of Motecuhzoma II (1502–20) and brief mention of the pacification of New Spain in 1521. Details of eleven imperial outposts precede the second part, which comprises a list of tribute Motecuhzoma II exacted from areas throughout the Aztec empire, whose subject towns and their tribute obligations are described in great detail. Samuel Purchas, who in 1625 published the earliest edition of the Codex Mendoza, described Part 3 as containing the public and private rites of the Mexicans 'from the grave of the wombe to the wombe of the grave'. More precisely, this section, which includes birth, education, marriage, work and justice, refers to the labour, duty and discipline of the citizens of Tenochtitlan.

Parts 1 and 2 are traditionally thought to be copies of Pre-Hispanic documents, the first an annals-type manuscript and the

second a tribute list known as the Matrícula de Tributos. Part 3, by contrast, is generally considered to be a Post-Conquest invention created in response to Spanish questions. Recent studies suggest that all three sections represent adaptations of one or more traditional documents that adhere closely to ancient ideas and modes of expression found in 'ritual' books such as the Codex Fejérváry-Mayer (cat. 341). Scholars have now also questioned the association between the Codex Mendoza and Viceroy Antonio de Mendoza (1535–50), who was thought to have commissioned the manuscript that has come to carry his name. Even if this association is tenuous, it is likely that the Codex Mendoza's indigenous authors and scribe aimed this document at the Spanish authorities, especially the courts of the Real Audiencia, as a means of protesting against the abuses of Spanish *encomenderos* (see cat. 276) entrusted with indigenous land and labour. JH

350
Codex Tepotzotlan

c. 1555–56, Tepotzotlan

Amatl paper, 40 × 110 cm

Collection Ulster Museum, Belfast, by kind permission of the Board of Trustees of the National Museums and Galleries of Northern Ireland, C1911.1090

PROVENANCE: given by Robert McCalmont to the Belfast Natural History & Philosophical Society, 1833; the collections of the BNH&PS passed to the Belfast Museum (now the Ulster Museum) by Deed of Gift, 1910–11

SELECTED REFERENCES: Brotherston and Gallegos 1988; Brotherston 1995, pp. 169–76, 183

This document represents legal evidence in a court case concerning the excessive tribute demanded by Tepotzotlan from three of its tributaries, Xoloc, Cuautlapan and Tepoxaco. Their case was judged by Francisco Maldonado of Chiconautla, appointed by the Real Audiencia, who sided with his fellow Tepotzotlan nobles against the complainants and their wards and treated them brutally. The script and signs are entirely native in

style and there is no Spanish gloss. (A European-style copy in Spanish, now called 'Codex Tepotzotlan 2' and preserved in the Archivo General de la Nación in Mexico City, lacks the subtle and succinct information contained in the original.) The verso bears two inscriptions in different hands. One names the judge, 'Maldonado juez Chiconautla', the other, in medieval Spanish, reads: 'A los agravios q a hecho Maldonado. Q Valverde aya informacion ye la embie a esta audiencia' (Let Valverde collect the evidence and send it to the Audiencia about the offences committed by Maldonado).

Each of the ten columns is headed by the place-glyph of a town or a ward. Below this are registered the items of tribute paid by it. The signs indicating quantity – flags for twenty and a fir-tree-like symbol for 400 – are in Pre-Hispanic style. Half a flag blacked represents ten, half a fir tree 200. All places paid a daily tribute of maize, turkeys, cacao, chillis, tortillas, eggs, salt and firewood, but some were required to pay further tribute, in the form of woven mats, cloth, pottery, pesos and reals, boars, male burden-bearers and female corn-grinders. The bearers were paid in cocoa beans, whereas the corn-grinders received no payment.

The codex was given to the Belfast Natural History & Philosophical Society by Robert McCalmont in 1833. He and his brother were stockbrokers in London for 53 years, but the family had a house called Abbeylands in Whiteabbey, Co. Antrim, where Robert lived for several years. Apparently, he did not travel abroad, although in 1853 he donated a drawing of a fish caught in the Bering Straits to the Society. In 1814 a relative of the family, possibly Robert McCalmont's cousin, had been slave owner in the Berbice Colony, British Guiana. This seems to have been the only family link with South America and may have been the source of the codex. Following the transfer of the collections of

the Belfast Natural History & Philosophical Society to what is now the Ulster Museum, the codex remained undiscovered for many years until the present writer found it in a box of Peruvian pottery in 1987. WG

351
Codex Tepetlaoztoc

c. 1555, colonial

72 folios, European paper, 29.8 × 21.5 cm; unbound

Trustees of the British Museum, London, Add. Ms 43795 (part)

PROVENANCE: acquired by the museum from the bookseller Rodd, 11 March 1843

SELECTED REFERENCES: Glass and Robertson 1975, no. 181; Memorial de los Indios de Tepetlaoztoc 1992; Brotherston 1995; Berger 1998, pp. 35–37

The Codex Tepetlaoztoc, also known as the Codex Kingsborough, is named after the town (whose name means 'stone mat cave') to the east of Lake Tetzcoco where it was produced. This stunning pictorial document was painted in the Tetzcocan style, with some European innovations, by an indigenous *tlacuilo* (painter-scribe) whose original tracings are still visible beneath the rich pigments. The Spanish alphabetic glosses and commentary are probably by more than one native hand and the information is organised horizontally across the breadth of two facing pages, instead of vertically down their length.

The codex was commissioned by the inhabitants of Tepetlaoztoc and its indigenous governor, Luis de Tepeda, probably for the Council of the Indies in Spain, which dealt with the affairs of New Spain. It undoubtedly formed part of a lawsuit brought by Tepetlaoztoc against the town's Spanish *encomenderos*, overlords entrusted with converting the native inhabitants to Christianity in return for tribute in the form of services and goods. The Spanish abuse of this system led to many complaints by native communities from the mid-sixteenth century. Tepetlaoztoc's first *encomendero* was Hernán

Cortés. Among Tepetlaoztoc's worst *encomenderos* was Gonzalo de Salazar, whose son, Juan Velázquez de Salazar, was in charge at the time the case was brought. The *tlacuilo*'s portrayal of the Spaniards, who have sickly grey skin, shows versatile command of European drawing techniques.

The Codex Tepetlaoztoc sets the Spaniards' excessive demands within a broader historical context, beginning in the first part with two maps of the town and its surroundings and going on to record the migration of the indigenous population's Chichimec ancestors from Chicomoztoc ('seven caves'). The first section continues with the settlement, foundation and rulers of Tepetlaoztoc and the (more reasonable) tribute exacted by these. The second part lists the daily service and yearly tribute given to the *encomenderos* between 1522–23 and 1555–56. The tribute included precious items, such as gold jewels (fol. 218*r*), obsidian mirrors (fol. 219*v*) and a gold and emerald box (fol. 220*r*), as well as foodstuffs, such as beans (*frijoles*), flour (*harina*) and chickens (*gallinas*) (fol. 214*v*), and services, such as the carrying of goods by male *tamemes*, or porters (fol. 214*v*). Spanish demands and punishment resulted in the death of large numbers of native inhabitants (shown by a horizontal shrouded figure), leading to a rapid decline in the town's population in a few decades. The second section is followed by a summary of tribute, including daily, then weekly accounts, and ends with a petition by the native inhabitants. JH

352
Lienzo of Quetzpalan

Second half of sixteenth century, colonial

Paint on fabric, 154 × 183 cm

Colección Fundación Televisa, Mexico City, 403

PROVENANCE: Quetzpalan, Puebla State; acquired through Manuel Reyero, 1980

SELECTED REFERENCE: Gómez-Haro Desdier 1994

The tradition of pictographic documents characteristic of Mesoamerican culture did not disappear with the Spanish conquest of Mexico. Such documents certainly continued to be produced in the sixteenth century, principally painted on large pieces of cloth and known as *lienzos*. The Lienzo of Quetzpalan provides a geographical, historical and economic survey of the territory occupied by the Quetzpala people, an area in the south of the present-day state of Puebla that lay under Izúcar rule. The document contains 44 place-glyphs, 36 of which mark the territorial boundaries. The glyph for the town of Quetzpala comprises the sign for 'hill' (*altepetl*) and that for 'lizard' (*quetzpallin*, the origin of the place-name). The *lienzo* clearly shows the two main rivers running from north to south, the Atila and the Ahuehuello, the latter taking its name from the ancient, sacred *ahuehuete* (a species of cypress) that still line its banks. In addition to recording the names of indigenous leaders, notably around the central place-glyph, the notes in Nahuatl tell of a dispute involving calico and textiles between the inhabitants of Quetzpala and the neighbouring town of Calmeca.

FS, RVA

353

Digital representation of the Map of Mexico City

Original: 1550s, Spanish

Ink and watercolour on parchment (two sheets), 75 × 114 cm

Uppsala University Library

PROVENANCE: Johan G. Sparwenfeld, donated to the university, early eighteenth century

SELECTED REFERENCES: Dahlgren 1889; Dahlgren 1892; Guzman 1939; Linné 1948; Cuesta Domingo 1983–84; León-Portilla and Aguilera 1986; Woodward and Lewis 1998

This is one of only two maps that give a fairly accurate picture of Mexico City and its surrounding regions in the mid-sixteenth century. It was made by Alonso de Santa Cruz, who from 1526 to 1530 took part as an accountant in an expedition up the Rio de la Plata in what is now Argentina. Becoming an expert in navigation and map-making, he was later employed as a cosmographer at Seville and in 1536 was appointed Royal Cosmographer. During his period of service he assembled a large collection of maps, which passed to his successor, Juan Lopez de Velasco, at Santa Cruz's death in 1572. Later dispersed, this collection included the present item, which was probably bought by the Swedish linguist and traveller Johan G. Sparwenfeld during his stay in Spain at the end of the seventeenth century.

The map is framed by a border painted in many colours, with ornamental ribbons on the right and left. The damaged cartouche in the lower right corner contains a dedication to Emperor Charles V, whose arms appear in the centre of the frame at the bottom between two pillars with entwined ribbons bearing his motto, 'Plus Ultra'.

The map shows Tenochtitlan surrounded by water and with canals between its buildings. The clearly drawn roads over the mountains to other parts of the country permit us to retrace the routes taken by the Spanish conquerors. The map also gives information about the ethnography and the flora and fauna of the region. The population is shown performing a variety of activities, such as woodcutting, canoeing, hunting and fishing. On the roads files of Indians are transporting heavy loads, driven by their Spanish masters. The approximately 150 glyphs on the map, representing human and animal heads, feet, hands, plants, rings, circles and stars, refer to place names.

The map is shown here in a digital facsimile produced in the Media Lab at the University of Art and Design in Helsinki. An interactive model, it uses digital technology to reconstruct sections of the original by superimposing layers of the facsimile produced by Nordenskjöld and Dahlgren in 1886 and published in 1906.

LOL, LDK

354

Codex Aubin

c. 1576–96, 1608, colonial

81 folios, European paper, 15 × 11 cm; red leather binding

Trustees of the British Museum, London, Add. Ms 31219

PROVENANCE: acquired from M. J. Des Portes, 1880

SELECTED REFERENCES: Glass and Robertson 1975, no. 14; Vollmer 1981; Brotherston 1995, p. 177; Berger 1998, p. 14

The Codex Aubin is named after the French ethnographer Joseph Marius Alexis Aubin, who published a facsimile of the document between 1849 and 1859. Four of its 81 folios are blank. The remaining folios, drawn on both sides, contain coloured pictorial information, outlined in brown ink and painted in traditional iconic script style, and Nahuatl alphabetic text in black ink. More than one indigenous hand appears to be responsible for the alphabetic text. Although adapted to a European format, the codex belongs to the annals-style genre of Pre-Hispanic document known as *xiuhamatls* (books of years). These record events year by year in relation to the *xiuhpohualli* (year count), which approximates our solar year. In these annals, of which there are many types, each year is represented by a square containing one of four year signs – *calli* ('house'), *tochtli* ('rabbit'), *acatl* ('reed'), *tecpatl* ('flint') – and a number from 1 to 13, represented by dots. In the Codex Aubin the corresponding year in the Gregorian calendar is written to the left of each indigenous year-glyph. The relevant pictorial and alphabetic text is placed to the right of the year-glyph.

The codex records the years 1168 to 1608 in Mexica history and can be roughly divided into three parts. The last of these, covering 1596 to 1608, is an addendum notable for the gradual replacement of native pictorial script by alphabetic writing. The first of the other two parts comprising the main document begins with the Aztecs' migration from their island home, Aztlan, in 1108, proceeds to the foundation of Tenochtitlan in 1325 (the same

date as that given in the Codex Mendoza [cat. 349]) and, like the Codex Mendoza, then details the reigns and conquests of the Mexica lords until 1519 and the arrival of the Spanish. Unlike the Codex Mendoza, the Codex Aubin records in its second part the events of the colonial period, documenting the introduction of European weapons, diseases, officials and religion. The *tlacuilo* (painter-scribe) invented new iconic signs for Christian symbols, such as a bald-headed figure for a friar, and shows considerable command of European drawing techniques in, for example, the representation of Christ resting while carrying the Cross on folio 59*r*. The authors of the Codex Aubin are unknown, but it is likely to have been commissioned by high-ranking indigenous officials. JH

355

Codex Azcatitlan

Late sixteenth century, colonial

25 folios, European paper, 22.5 × 29.5 cm; modern red demi-shagreen binding

Bibliothèque Nationale de France, Paris, MS Mexicain 59-64

PROVENANCE: Lorenzo Boturini Benaduci (1702–1755), 1746; Joseph Marius Alexis Aubin (1802–1891); Eugène Goupil (1831–1895), 1899; donated to the Bibliothèque nationale by Goupil's widow, Augustine Elie, 23 April 1898

SELECTED REFERENCES: Glass and Robertson 1975, no. 20; Codex Azcatitlan 1995

The uncompleted drawings and glosses of this history of Mexico, given the name Codex Azcatitlan by Robert Barlow in the facsimile edition of the manuscript first published in 1949, features in the first inventory (dating from 1746) of Lorenzo Boturini Benaduci's collection. Its folios, some of which are missing, show the great phases of Aztec history in extensive scenes, each laid out on two facing pages.

At the beginning we see the wanderings of the Mexica after they leave Aztlan, their mythical, paradisiacal land of origin; their subsequent settlement on the high plateaux of Anáhuac; and the foundation of Tenochtitlan, their

capital (fols 1–12). The latter event is depicted as a human sacrifice laid on the altar at the top of a pyramid in the shade of a *nopal* (prickly-pear) cactus in which Huitzilopochtli ('left-sided hummingbird'), the patron god of the Mexica, is hiding.

Ten scenes represent the period of almost two centuries before the Spanish arrived in 1519 (fols 13–22), from the enthronement of the first ruler, which took place in a 'rabbit' year and is portrayed by means of peaceful scenes in the life of the fishermen and hunters of the lakeside region, to that of Motecuhzoma II (1502–20). As one reign follows another, we see a succession of victories and defeats, but also major works of construction, including canals and protective walls. Every reign is represented on a double page, from the accession of the monarch, seated on the royal throne in full regalia, until the end of his life, shown in the form of a burial bundle under his name-glyph. The great reigns of Motecuhzoma I (1440–68), Axayacatl (1469–81) and Ahuizotl (1487–1502) are rich in warrior exploits and military conquests, which are indicated by rows of place-glyphs of the subjugated cities.

The final pages of the manuscript are its best known. In unfinished but vivid scenes they depict the beginnings of the colonial period. Hernán Cortés, having dismounted from his horse, is shown hat in hand as he goes to meet Motecuhzoma II in Mexico; between them, the native woman Malintzin (called 'Marina' by the Spanish) acts as interpreter (fol. 22*v*; the figure of Motecuhzoma is missing). The armour-clad conquistadors bear the banner of the Holy Ghost; the Indian porters are heavily laden with provisions. The next scene, which is missing its left-hand side, takes place in the patio of the Main Palace of Tenochtitlan (fol. 23*r*). It shows the tragic death of the last Aztec ruler, pierced by an arrow while the musicians continue to play.

The closing folios, some of which are mutilated, depict the conversion of the indigenous population to Christianity, including the construction of churches, but they also contain representations of Indian traditions, such as the rite of the *volador*, in which men with their feet tied to a rope attached to the top of a tree trunk spiralled down playing the flute. In addition we see some minor occurrences (thefts and their punishment) and historic events, including the arrival in 1528 of the first Bishop of Mexico, Juan de Zumárraga. MCo

356

Diego Muñoz Camargo, *Descripción de la ciudad y provincia de Tlaxcala de las Indias y del Mar Océano para el buen gobierno y ennoblecimiento dellas*

1581–84

Codex, 327 folios, European paper, 29 × 21 × 3.5 cm; original binding of limp vellum

Special Collections Department, Glasgow University Library, MS Hunter 242 (U.3.15)

PROVENANCE: Real Biblioteca, El Escorial; William Hunter, c. 1768–83

SELECTED REFERENCES: Muñoz Camargo 1984; Berger 1998, pp. 62–66

Diego Muñoz Camargo's *Descripción de la ciudad y provincia de Tlaxcala* (*Description of the City and Province of Tlaxcala*) is an extended *relación geográfica* supplemented here by a pictorial section. The author was an educated *mestizo* whom Alonso de Nava, the *alcalde* (magistrate or mayor) of Tlaxcala, asked to respond to a questionnaire sent to town officials by order of Philip II in 1577. The Tlaxcalans were the fiercest enemies of the Aztecs and subsequently became loyal allies of the Spanish. When Hernán Cortés arrived in Tlaxcala in 1519 he found its inhabitants confined to a small territory, vigorously defending their independence from their powerful neighbours. The codex, in addition to being a major source for Tlaxcalan history, topography and social conditions, is clearly intended to celebrate the Tlaxcalans' role in the conquest of the New World.

Two methods of computing time are described, each illustrated with a calendrical wheel. The pictorial section, the work of an unknown indigenous artist, comprises 157 pen and ink drawings with short Nahuatl captions written above the images; these are glossed in Spanish in a different hand below. Some 80 are almost identical to drawings in the *Lienzo of Tlaxcala*, a large painted cloth (now lost) that may have been a source for the present series. The pictures at the beginning of the manuscript depict the first encounters between the Spanish and the Tlaxcalans: the conversion of the population to Christianity, the destruction of cultic objects and native books, and the punishment of those not conforming to the new order. Also shown are the nine provinces subjugated by the Spanish, with their emblems and episcopal mitres. The remainder of the images includes equestrian portraits of Cortés, Christopher Columbus, Francisco Pizarro, Charles V and Philip II, and spirited evocations of the many victories and conquests of the allied forces.

Muñoz Camargo travelled to Spain in 1584 in the company of other Tlaxcalans as part of a diplomatic mission. The manuscript, which was completed and bound in Madrid, was presented to the king in 1585. It remained in the Biblioteca Real at least until the early seventeenth century, after which its fate is obscure until it was acquired by Dr William Hunter (1718–1783) for his famous museum, established in 1768 in Windmill Street, Glasgow. DW

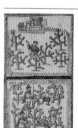

357

Cochineal Treatise

c. 1599, colonial

4 folios, European paper, 29.8 × 21.5 cm; unbound

Trustees of the British Museum, London, Add. Ms 13964, ff. 129–202

PROVENANCE: purchased by the museum from the bookseller Rodd, 11 March 1843

SELECTED REFERENCES: Glass and Robertson 1975, no. 128; Brotherston 1995, pp. 177–78; Berger 1998, p. 19

The Cochineal Treatise comprises twelve drawings and explanatory alphabetic Spanish glosses. It forms part of a larger manuscript of 76 folios containing Gonzales Gómez de Cervantes's *Memorial de Gonzalo Gomez de Cervantes para el Doctor Eugenio Salazar, oidor del real consejo de las Indias* (*Report by Gonzalo Gomez de Cervantes for Doctor Eugenio Salazar, judge of the Royal Council of the Indies*), dated 1599. This report includes information about the lives of the indigenous inhabitants of New Spain, about silver and gold mines and, under the heading 'Relación de [lo] que toca la Grana Cochinilla' (fols 129–202), about the production of cochineal.

Cochineal is a red dye obtained from the tiny *cochinilla* beetle (*Dactylopius coccus* or *Coccus cacti*) that feeds on the nopal (prickly-pear) cactus. In the Cochineal Treatise the beetles are referred to as *semilla* ('seed'), although their Nahuatl name is *noch-eztli* ('cactus blood'). In Pre-Hispanic Mesoamerica cochineal was produced in large amounts in the Oaxaca area, which paid the dye as tribute to Tenochtitlan, as recorded in the Codex Mendoza (cat. 349). *Grana cochinilla* ('cochineal red'), as it is referred to in the Cochineal Treatise, was also exported in great quantity by the Spanish during the colonial period.

The twelve scenes in the document show the stages in the cultivation of the *semilla* during the year. The cycle begins in December and January when cuttings are taken from old plants and dried to produce new ones (Scenes 1 and 2). It ends by leaving the nopal to recover for the next season (Scene 11) and showing what happens when it is neglected (Scene 12). Scene 3 depicts the new plants that have been cut, pruned and planted, and Scene 4 shows the new beetles being placed on the new plants, which must be at least six months old. The final image in the document (fol. 202) illustrates the various pests that can destroy the

nopal, with their Nahuatl names. The anonymous creator of the drawings used some European techniques, such as shading, but depicted architecture, dress, hairstyles and plants (with their roots visible) in accordance with native traditions, implying that an indigenous painter-scribe (*tlacuilo*) was involved. JH

358

Doctrina Cristiana

c. 1714, colonial

30 leaves (15 double folios), European paper, 24 × 16.5 cm; skin binding

Trustees of the British Museum, London, Egerton Ms. 2898

PROVENANCE: purchased by the museum from Ida Bühle, 13 November 1911

SELECTED REFERENCES: Glass and Robertson 1975, no. 813; Galarza 1992, pp. 7, 14; Brotherston 1995, p. 188; Berger 1998, pp. 79–81

The Doctrina Cristiana, also known as BM Egerton Ms 2898, is the finest extant example of a Mexican Testerian manuscript. These documents, around 35 of which remain, were produced by native painter-scribes (*tlacuiloque,* sing. *tlacuilo*) in Mexico from the sixteenth to the eighteenth century to instruct young indigenous neophytes in the doctrine and Catechism of the Catholic Church. The manuscripts are named after Jabobo de Testera, a Franciscan friar who arrived in New Spain in 1529 and who is thought to have invented the pictorial system by which they convey information. This system, which incorporates many Christian symbols, employs pictograms (the depiction of a sword, for example, means 'sword'), ideograms (the cross, for instance, represents Christ) and phonetic signs (the hand, *maitl*, combining, for example, with the flower, *xochitl*, to form the phrase *ma in mochihua*: 'may it be so' or 'amen'). These characteristics and the inclusion of traditional pictorial symbols, such as the lizard/scorpion to represent 'sin', suggest that the system is closely linked to Pre-Hispanic iconic script and was in fact invented

by native *tlacuiloque*. The present codex is unusual in that the *tlacuilo*, Lucas Matheo, signed the document (which bears the date 1714) and also because, instead of the more usual Otomi or Mazahua languages, the alphabetic glosses accompanying the images are written in Nahuatl. As in other Testerian manuscripts, the scribe was presumably responsible for the images as well as the glosses. The Doctrina Cristiana is probably a copy of an earlier, sixteenth-century document.

The organisation of information in the Doctrina Cristiana continues to respect indigenous traditions, arranging it across two facing pages that are divided by thick black lines into horizontal registers. The registers are read from left to right and top to bottom. Certain sections (fols 1–7) are numbered internally using the Pre-Hispanic system of dots found in documents such as the Codex Fejérváry-Mayer (cat. 341). The manuscript is also outstanding for the breadth of its content. As well as the Catechism, it contains a full set of the prayers of the Catholic Church (fols 13*v* to 20*r*). JH

359

Christoph Weiditz, Trachtenbuch

1529–30

Codex, 154 folios, paper, 19.4 × 14.5 cm; twentieth-century leather binding

Leihgabe, Germanisches Nationalmuseum, Nuremberg, Hs 22474

PROVENANCE: Presented by Johann N. Egger, Freyung near Passau, 1868

SELECTED REFERENCES: Hampe 1927; Washington 1991, pp. 517, 572, no. 406; Nuremberg 1992, p. 835, no. 5.9; Antwerp 1997, p. 259, no. 32; Ghent 1999, p. 277, no. 168; Weiditz 2001

The coloured drawings in this codex record costumes and scenes from the daily life mainly of humble people, but also of shipowners, burghers and slaves, mostly in Spain but also in other western European countries. They were made by the Augsburg medallist Christoph Weiditz (*c.* 1500–1559) on a trip to Spain via the Netherlands in 1528–29. Weiditz journeyed by sea to the court of Emperor Charles V in order to obtain a licence for the manufacture of medals in the free imperial city of Augsburg. He followed the imperial court around Spain and probably also travelled about the country independently, returning to Germany via southern France and northern Italy.

At the imperial court in Toledo, Weiditz met Hernán Cortés, the conqueror of the Aztecs, who had been summoned by the Emperor to account for his actions in Mexico. Cortés had brought back from the New World eleven Aztec acrobats, who are illustrated on the first folios of the manuscript. Folios 12*v* and 13*r* show two of these Indians playing a game, accompanied by the inscriptions 'These are the Indian people who were brought to His Majesty from India by Hernán Cortés and played thus before His Majesty with wood and ball' (fol. 12*v*) and 'With their fingers they gamble like the Italians' (fol. 13*r*). The game depicted may be *patolli*, an Aztec game similar to Parcheesi, or a kind of mora, using stones and fingers as gambling instruments (see also cat. 310). Folios 8*v* and 9*r* show Aztecs balancing a tree trunk on their feet that is comparable in length and weight to a human being, tossing it into the air and catching it as it falls.

These and the other illustrations in the codex of members of the Aztec party are the earliest known realistic representations by a European of the inhabitants of the New World. They were drawn carefully from life, reproducing the details of their clothing and their characteristic adornments of coloured stone. ES

TABLE OF RULERS

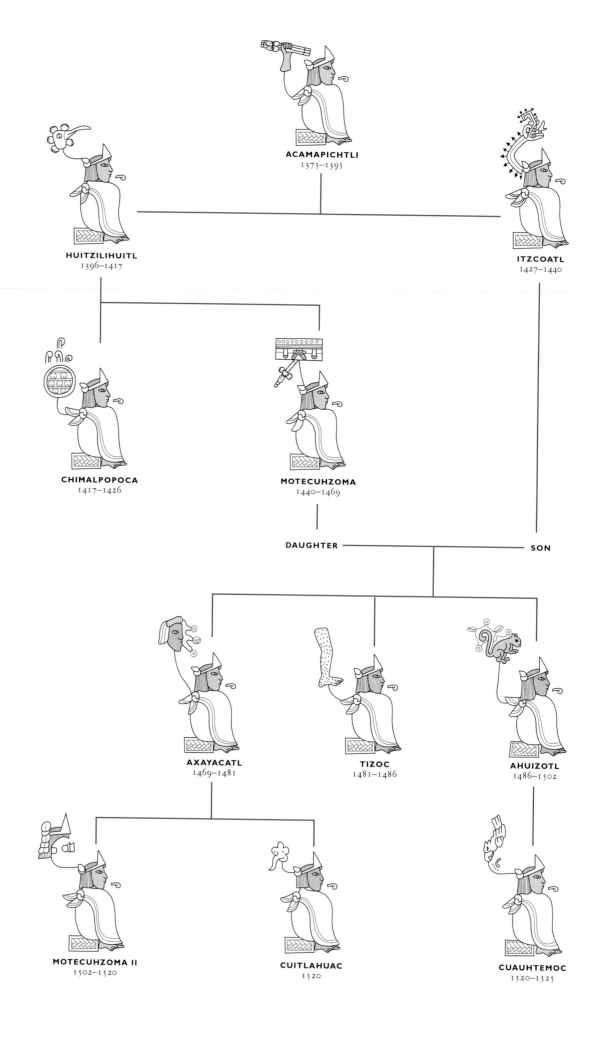

ACAMAPICHTLI
1375–1395

HUITZILIHUITL
1396–1417

ITZCOATL
1427–1440

CHIMALPOPOCA
1417–1426

MOTECUHZOMA
1440–1469

DAUGHTER

SON

AXAYACATL
1469–1481

TIZOC
1481–1486

AHUIZOTL
1486–1502

MOTECUHZOMA II
1502–1520

CUITLAHUAC
1520

CUAUHTEMOC
1520–1525

GUIDE TO GLYPHS

1

5

10

20

400

8000

CONQUEST
The burning temple

EARTHQUAKE
The sign for *ollin* 'movement'
in the midst of the earth

ECLIPSE
The broken sun disk

FAMINE

CAVE
Shown as the jaws of a
serpent, the entrance to Mitla

COMET
Shown as a flying serpent

FOOTPRINT
Denoting movement or path

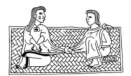

MARRIAGE CEREMONY
Literally 'tying the knot'

MAT OF POWER
Occupied by the ruler, 'he who speaks'

PLACE
Altepetl, literally 'water
mountain' or community

FERTILE YEAR

PLAGUE

RAIN

SNOWSTORM

SPEECH, SONG OR SOUND

STARS
Eyes of the night

WAR
Represented by the *chimalli*,
a shield with four darts

FIRE CEREMONY
The fire drill and board used
to start a new 52-year cycle

PRICKLY-PEAR CACTUS

WATER

GLOSSARY

Adrian Locke

ALTEPETL

Literally 'water mountain'. A term that refers primarily to territory but more specifically to a group of people, usually based on ethnic identity and governed by a ruler, who control a given territory. The amounts of territory varied enormously, ranging from a city-state such as Tenochtitlan to a ward within one. The term also refers specifically to the place itself.

CALMECAC

Special schools run by priests who instructed the sons of the nobility in the ways of Aztec religion, warfare, rulership and other such skills.

CALPULLI

A collective term that refers to the grouping of the lower class, often referred to as 'commoners' or *macehualtin*, into districts, possibly based on kinship which, at the time of the Spanish conquest, centred around a territorial unit such as the ward of a town or a temple from which they worked communal land holdings.

CHACMOOL

From the Yucatec Maya for 'great jaguar paw'. The British-born archaeologist Augustus Le Plongeon (died *c*. 1908) adopted the term in the nineteenth century to describe the three-dimensional sculptures of reclining figures with sacrificial vessels placed on their chests that were discovered at Chichén Itzá. *Chacmools* have been found across Mesoamerica but are particularly associated with Chichén Itzá, Tula and Tenochtitlan.

CHALCHIHUITL

In central Mexico the name given to jade, one of the materials most prized by the Aztecs. Owing to its colour, jade was associated with water and gave its name to Chalchiuhtlicue ('she of the jade skirt'), goddess of springs, rivers, lakes and the sea. Jade was also linked to blood. Thus jade was intimately related to these two liquids, which, because jade symbolises preciousness, were referred to as 'precious liquids'. Droplets, the representation of jade in Aztec art and literature, are therefore multivalent symbols signifying blood, water, greenstone and preciousness in general.

CHICHIMECA

Like the Aztecs, the Nahuatl-speaking Chichimec, 'the dog

people', were a nomadic group who migrated southwards into central Mexico, settling in the Toltec region. They brought with them the bow and arrow, as recorded in, for example, the Codex Xolotl and the Mapa Quinatzin. They gave their name to the highland region to the north of Tenochtitlan that is referred to as the Chichimeca. Also used as a generic term for all migrant groups.

CHINAMPA

A system of land reclamation for agricultural use still to be found in the southern part (Xochimilco) of Mexico City. Canals were cut through marshland and artificial islands created. Fertile silt was dredged from the canals and placed on the islands which were stabilised by planting willow trees and using wickerwork fences. The resultant highly productive parcels of land were expanded in size over time.

CIHUACOATL

The title of the secondary ruler of Tenochtitlan who handled the internal affairs of the city. The *cihuacoatl* worked alongside the *tlatoani* (see below). Together they represented both sides of the universe and were the ultimate authorities of all the affairs of the state. Also the name, literally 'snake woman', of one of a number of Aztec goddesses associated with the earth.

COCHINEAL

Natural red pigment obtained from the *cochinilla* beetle, which feeds on the nopal (prickly-pear) cactus, and made into a dye. Cochineal was cultivated by the Aztecs and later, during the colonial period, exported to Spain.

CODEX

Typically the term refers to a manuscript volume but it has come to be associated specifically with the painted books produced in Pre-Hispanic and colonial Mexico. Information was recorded using pictograms and ideograms on prepared animal skin, *amatl* (paper produced from the bark of the fig tree), cotton cloth, or, after the arrival of the Spaniards, European paper. Codices can be single sheets of paper or cotton; numerous sheets gathered together much like conventional European-style books; or screenfolds, which are double-sided books, folded accordion-like.

FLOWERY WARS

Xochiyaotl, or 'flowery wars', were ritual, pre-arranged battles fought between the Triple Alliance and hostile groups such as those found in Tlaxcala, Cholula and Huexotzingo, with the sole aim of capturing enemy warriors for sacrifice. The name comes from the finely dressed warriors who would fall like a rain of blossom on the battlefield.

GLYPH

A symbol used in the writing system of the Aztecs, in which pictograms and ideograms represented concepts or phonetic prompts. Thus, the curling symbol placed in front of the mouth of an individual to represent speech or sound is referred to as the speech glyph. For a basic guide to reading glyphs, see p.497.

HUEHUEHTLAHTOLLI

Traditional speeches given by Aztec elders to accompany important communal occasions such as marriages and funerals.

JADE

Term given to a hard ornamental greenstone of varying hue which refers to both nephrite (a silicate of calcium and magnesium) and jadeite (see below). Greatly prized by the Aztecs and other Mesoamerican cultures, jade was imported from western Mexico. In Nahuatl, *chalchihuitl* referred to both water, 'precious liquid', and jade.

JADEITE

The only type of jade found in Mesoamerica, a silicate of aluminium and sodium.

MACEHUALTIN

See *calpulli*.

MAGUEY

A type of cactus also known as agave, American aloe or century plant. Widespread in Mexico, the maguey continues to be cultivated for its milk (see *pulque*) and fibres. The latter were used to make a type of paper, and maguey cloth for use by commoners.

MAYEQUE

Along with slaves, the lowest social class. Although freemen, *mayeque* were landless peasants who were possibly newcomers to the region, descendants of conquered tribes or those who had fallen from grace. Thought to number up to 30% of the population, they worked on the private lands of the nobility.

MICTLAN

The 'Place of the Dead', or the underworld, was divided into nine planes that were presided over by Mictlantecuhtli, lord of Mictlan (see cat. 233). Those who died a natural death went to Mictlan, the ninth and deepest plane, having to overcome numerous hazardous obstacles to reach their destination.

NAHUATL

A Mesoamerican language adopted by the Aztecs as their *lingua franca*. Long compound forms juxtapose various roots, prefixes, suffixes and infixes, enabling complex forms to be produced. In Pre-Hispanic times, Nahuatl was an oral language but it soon began to be written down in European alphabetic script during the colonial period.

NAHUI OLLIN

Literally '4-movement', Nahui Ollin refers to the fifth and last of the mythological Aztec Suns or world-eras, marked by the creation of maize and men by the gods at Teotihuacan. The four previous Suns ('4-jaguar', '4-wind', '4-rain' and '4-water') all ended violently and it was predicted that 4-movement would end with an earthquake.

NEW FIRE CEREMONY

The New Fire ceremony marked the completion of the 365-day calendar (see *xiuhpohualli*), i.e. 52 years had to pass before it began to repeat itself (13 numbers × 4 year bearers = 52 years). This special occasion was marked by the ceremonial tying of 52 reeds in a bundle (see *xiuhmolpilli*) and the extinguishing of fires. The beginning of the new cycle was marked by a fire-drilling ceremony that provided the spark to light a great new bonfire. Fire was then taken from this and used to light the fires of waiting communities, proclaiming the beginning of a new 52-year cycle.

OBSIDIAN

A vitreous-acid, volcanic, glass-like rock highly prized in Mexico since the Early Formative period for its sharpness and beauty. Although obsidian is largely black in colour, it varies in shades and often contains smoky patterns. Pachuca, near Tula, was known for its highly prized, olive-green obsidian. The material was used in many ways by the Aztecs: opposing blades were set into wooden handles to make swords; thin sharp blades were fashioned for auto-sacrifice (individuals would draw their own blood as an offering); surfaces were polished to act as mirrors; and for beautifully finished jewellery such as labrets (lip-plugs) and ear-plugs.

OZTOMECA

Vanguard merchants, among the more important of their class, who were also involved in state-sponsored espionage (see *pochteca*).

PIPILTIN

Literally the 'sons of the nobility', the noble class who enjoyed a privileged social position, below the *tlatoani*.

PLUMBATE

A salt of plumbic (lead-based) acid used for decorating pottery. Although it gave a distinctive dark, shiny finish to kiln-fired ceramics, it was not a glaze, a glass technology that the Mexicans never knew.

POCHTECA

Merchants who maintained long-distance trade networks within the tribute empire individually, or on behalf of the Aztec nobility. There were four principal types: administrators (*pochtecatlatoque*), who oversaw the principal marketplace and the actions of other merchants; slave-traders (*tlaltani*); the personal traders of rulers (*tencunenenque*); and *naualoztomeca*, state-sponsored spies. *Pochteca* were assisted by *tlamemes*, individuals who carried goods on their backs like porters. *Pochteca* were highly esteemed and played an important role in the expansionist policies of the state.

PULQUE

Spanish for the Nahuatl *octli*. *Pulque* is a naturally fermented, mildly alcoholic drink made from the sap of the maguey (see above). It is often shown as a frothy brew in painted books such as the Codex Mendoza (cat. 349). The Aztecs had many gods associated with *pulque* who were collectively known as the Centzon Totochtin ('400 rabbits').

TELAMON

Architectural term (from the Greek) to describe a sculpted male figure used as a pillar to support an entablature. The term has been used to describe the atlantean figures associated with the Toltec site of Tula, or those that support altars.

TEZONTL

The name given to the reddish-black volcanic stone widely used throughout Tenochtitlan for the construction of buildings such as the Templo Mayor. The stone, which has many air holes, was later reused by the Spanish when they rebuilt Tenochtitlan as colonial Mexico City.

TIANQUIZTLI

An open-air marketplace, common to all communities, to which items were brought from outlying regions to be traded by count rather than weight. Such marketplaces were highly planned and administered (see *pochteca*) and also served as important social centres. The principal market was located in Tlatelolco. Up to 50,000 people gathered there and goods from all over the tribute empire were available.

TLACUILOQUE

Plural of *tlacuilo*. The learned native scribes who taught the art of *tlacuilloli*, 'to write-paintings', in the *calmecac* (see above). *Tlacuiloque* were the anonymous authors of Mexican painted books or codices.

TLALOQUE

Plural of Tlaloc. The four Tlalocs, gods of rain, each of whom had a distinctive colour and was specifically associated with one of the four Aztec world directions (often mistakenly referred to as the cardinal points north, south, east and west).

TLAMACAZOTON

Literally 'child priests', the name given to young boys entered into the *calmecac* (see above) by their parents. They went on to become priests or warriors.

TLAMACAZQUI

Head priest who, as well as undertaking religious rituals, instructed sons of the nobility at special schools (see *calmecac*).

TLAMATINIME

Plural of *tlamantini*. Teachers, literally 'wise men', the most venerated of all priests for their ability to offer counsel, interpret codices, compose and recite music, and instruct others in religious matters.

TLATOANI

The Aztec ruler, literally 'he who speaks', who is shown occupying the mat of power in, for example, the Codex Mendoza (cat. 349). Also used to refer to rulers of regions or towns.

TLATOQUE

Plural of *tlatoani* (see above).

TLAXILACALLI

The different districts or wards that made up a town or city.

TLAZOLTEOTL

A central Mexican goddess of purification who is also associated with filth. *Tlazolli* refers to both vices and diseases, especially those brought on through sexual excess or misdeed, for which Tlazolteotl was able to provide cures.

TONALAMATL

The 260-day count (see *tonalpohualli*) recorded as a 'book of days' as part of a codex, which also served as a divinatory almanac.

TONALLI

A highly complex concept intricately related to the *tonalpohualli*, with multiple meanings. It refers, for instance, to a number of cosmic forces, such as solar heat and, by association, the hot, dry summer season, and the solar day. Significantly, it also refers more specifically to individuals through their names, fates and souls. In addition, *tonalli* has links to the act of fire-drilling associated with the New Fire ceremony (see above) and the creation of man.

TONALPOHUALLI

The 260-day count which was composed of 20 signs (such as flint, rabbit, deer, grass, death) and 13 numbers (denoted by dots 1–13). When combined, these produced 260 variations (20 × 13 = 260) before the cycle was completed at the moment when the first pairing recurred. The 260-day count was sub-divided into weeks (see *trecena*). The *tonalpohualli* count was maintained in books (see *tonalamatl*) that were consulted by diviners to make prognostications for newborn children. It has been suggested that the *tonalpohualli* specifically reflected the nine-month period of human gestation. The *tonalpohualli* worked in conjunction with the *xihuitl* (see below and fig. 25).

TRECENA

Spanish term used to describe the division of the *tonalpohualli* into 20 weeks of 13 days each (20 × 13 = 260) after the Nahuatl term was lost. Each 13-day period, or *trecena*, began with the number 1 and the appropriate sign (see *tonalpohualli*) and ended with the number 13. Every combination of the *trecena* was unique, since no day in any week could be confused with that of another within the 260-day cycle. In addition, each *trecena* had its own patron deity, and every day was influenced by one of the 13 lords of the day and nine lords of the night.

TRIPLE ALLIANCE

The union of three distinct cultural groups that came together in the Basin of Mexico to increase their collective power and influence in the region. Collectively known as the Aztecs, the partners were the Mexica of Tenochtitlan, the Tepanecs of Tlacopan (also known as Tacuba) on the western side of Lake Tetzcoco, and the Acolhuacans of Tetzcoco on the eastern side of Lake Tetzcoco.

TZOMPANTLI

Skull racks, in which the decapitated heads of sacrificial victims were threaded onto wooden poles in great numbers and placed on public view. A more permanent, symbolic *tzompantli*, made of stone skulls, was discovered alongside the Templo Mayor in Tenochtitlan.

XIHUITL

A 365-day yearly calendar which comprised 18 months or feasts of 20 days, known by the Spanish term *veintenas*, with an additional five-day period of inauspicious days known as the *nemontemi* (18 × 20 + 5 = 365). Each feast was celebrated with a public ritual, dedicated to a specific god, that was also directed towards religious, social and religious issues of general importance to the community. The *xihuitl* worked in conjunction with the *tonalpohualli* (see above and fig. 25).

XIUHAMATL

The name given to the Book of Years (see *xiuhpohualli*). These native historical documents were continuous year counts in which each year was represented pictorially by one of four year-bearing signs (reed, rabbit, flint, house) with the events depicted which took place in specific years.

XIUHMOLPILLI

The ritual bundle of 52 reeds which were tied together to mark the 'binding of the years' when the 52-year cycle of the calendar had been completed (see New Fire ceremony). Aztec stone representations of these reed-bundles have been discovered in modern Mexico City (cat. 171).

XIUHPOHUALLI

Another term for *xihuitl*.

BIBLIOGRAPHY

ACOSTA 1956
Jorge R. Acosta, 'El enigma de los chacmooles de Tula', in *Estudios antropológicos publicados en homenaje al doctor Manuel Gamio*, Mexico City, 1956, pp. 159–70

ACOSTA 1956–57
Jorge R. Acosta, 'Interpretación de algunos de los datos obtenidos en Tula relativos a la época tolteca', *Revista Mexicana de Estudios Antropológicos*, 14, 1956–57, pp. 75–110

ACOSTA 1961
Jorge R. Acosta, 'La doceava temporada de exploraciones en Tula, Hidalgo', *Anales del Instituto Nacional de Antropología e Historia*, 6th ser., vol. 13, 1961, pp. 29–58

AGUILAR ET AL. 1989
P. Carlos Aguilar, Beatriz Barba, Román Piña Chan, Luis Torres, Francisca Franco and Guillermo Ahuja, *Orfebrería prehispánica*, Mexico City, 1989

AGUILERA 1985
Carmen Aguilera, *Flora y fauna mexicana*, Mexico City, 1985

ALCINA FRANCH 1978
José Alcina Franch, *L'Art précolombien*, Paris, 1978

ALCINA FRANCH 1983
José Alcina Franch, *Pre-Columbian Art*, New York, 1983

ALCINA FRANCH 1992
José Alcina Franch, *L'arte precolombiana*, Milan, 1992

ALEXANDER 1985
Edward P. Alexander, 'William Bullock: Little-remembered Museologist and Showman', *Curator*, 28, 2, 1985, pp. 117–47

ALICANTE 1989
México colonial, exh. cat., Caja de Ahorros del Mediterráneo, Museo de América y Ministerio de Cultura, Alicante, 1989

ALTICK 1978
Richard D. Altick, *The Shows of London*, Cambridge, Mass., and London, 1978

ALVA IXTLILXOCHITL 1975–77
Fernando de Alva Ixtlilxochitl, *Obras históricas 1600–1640*, 2 vols, Mexico City, 1975–77

ALVARADO DE TEZOZÓMOC 1987
Hernando Alvarado de Tezozómoc, *Crónica méxicana*, Mexico City, 1987

ALVARADO DE TEZOZÓMOC 1998
Hernando Alvarado de Tezozómoc, *Crónica mexicáyotl*, Mexico City, 1998

AMSTERDAM 2002
Art Treasures from Ancient Mexico: Journey to the Land of the Gods, Felipe Solís Olguín and Ted Leyenaar (eds), exh. cat., Nieuwe Kerk, Amsterdam, 2002; State Hermitage Museum, St Petersburg

ANAWALT 1981
Patricia R. Anawalt, *Indian Clothing Before Cortés*, Norman, 1981

ANDERS 1970
Ferdinand Anders, 'Las artes menores', in *Tesoros de México: Arte Plumario y de Mosaico*, *Artes de México*, 137, 1970, pp. 4–45

ANDERS 1978
Ferdinand Anders, 'Der altmexikanische Federmosaikschild in Wien', *Archiv für Völkerkunde*, 32, 1978, pp. 67–88

ANDERS 1992
Ferdinand Anders, 'Huitzilopochtli – Vitzliputzli – Fizlipuzli – Fitzebutz: Das Schicksal eines mexikanischen Gottes in Europa', in Nuremberg 1992, vol. 1, pp. 423–46

ANDERSON, BERDAN AND LOCKHART 1976
Arthur J. O. Anderson, Frances F. Berdan and James Lockhart, *Beyond the Codices: The Nahua View of Colonial Mexico*, Berkeley, 1976

ANDREWS 1987
E. Wyllys Andrews V, 'A Cache of Early Jades from Chacsinkin, Yucatan', *Mexicon*, 9, 1987, pp. 78–85

ANGLERÍA 1989
Pedro Mártir de Anglería, *Decadas del Nuevo Mundo*, Madrid, 1989

ANTIGÜEDADES DE MÉXICO 1964–67
Antigüedades de México, basadas en la recopilación de Lord Kingsborough, 4 vols, Mexico City, 1964–67

ANTON 1969
Ferdinand Anton, *Ancient Mexican Art*, London, 1969

ANTWERP 1992
America: Bride of the Sun. 500 Years of Latin America and the Low Countries, exh. cat., Koninklijk Museum van Schone Kunsten, Antwerp, 1992

ANTWERP 1997
De Kleuren van de Geest: Dans en Trans in Afro-Europese Tradities, Paul Vandenbroeck (ed.), exh. cat., Koninklijk Museum van Schone Kunsten, Antwerp, 1997

APENS 1947
Ola Apens, *Mapas antiguos del Valle de México*, Mexico City, 1947

ARANA 1987
Raúl Martín Arana, 'Classic and Postclassic Chalcatzingo', in *Ancient Chalcatzingo*, D. C. Grove (ed.), Austin, 1987, pp. 386–89, 395

BANDINI 1793
Angelus Maria Bandinius, *Bibliotheca Leopoldina laurentiana seu Catalogus manuscriptorum qui nuper in Laurentianam translati sunt sub auspiciis Ferdinandi III…*, vol. 3, Florence, 1793

BANKMANN AND BAER 1990
Ulf Bankmann and Gerhard Baer, *Altmexikanische Skulpturen der Sammlung Lukas Vischer, Museum für Völkerkunde Basel, Corpus Antiquitatum Americanensium*, Basle, 1990

BAQUEDANO 1984
Elizabeth Baquedano, *Aztec Sculpture*, London, 1984

BARCELONA 1992
El juego de pelota en el México precolombino y su pervivencia en la actualidad, Fernando Jordi (ed.), exh. cat., Museu Etnológic, Barcelona, 1992

BARJAU 1998
Luis Barjau, *El mito mexicano de las edades*, Mexico City, 1998

BASLE 1985
Gerhard Baer, Ulf Bankmann, Susanne Hammacher and Annemarie Seiler-Baldinger, *Die Azteken Maisbauern und Krieger*/ Berthold Reise, *Die Maya*, companion book and exh. cat., Museum für Völkerkunde und Schweizerisches Museum für Volkskunde Basel, Basle, 1985

BASLER AND BRUMER 1928
Adolphe Basler and Ernest Brumer, *L'Art précolombien*, Paris, 1928

BATRES 1902
Leopoldo Batres, *Exploraciones arqueológicas en la Calle de las Escalerillas, año de 1900*, Mexico City, 1902

BATRES 1906
Leopoldo Batres, *Teotihuacan*, Mexico City, 1906

BELÉM 1995
Tejedores de Voces, a Arte do México Antigo, Nuno Saldaña (ed.), exh. cat., Centro Cultural de Belém, Fundação das Descobertas, Belém, 1995

BENAVENTE 1971
Toribio de Benavente (Motolinía), *Memoriales, o Libro de las cosas de la Nueva España y de los naturales de ella*, Mexico City, 1971

BENSON 1972
The Cult of the Feline, Elizabeth P. Benson (ed.), Washington DC, 1972

BERDAN 1982
Frances F. Berdan, *The Aztecs of Central Mexico: An Imperial Society*, Fort Worth, 1982

BERDAN ET AL. 1996
Frances F. Berdan, Richard E. Blanton, Elizabeth H. Boone, Mary G. Hodge, Michael E. Smith and Emily Umberger, *Aztec Imperial Strategies*, Dumbarton Oaks, Washington DC, 1996

BERGER 1998
Uta Berger, *Mexican Painted Manuscripts in the United Kingdom*, London, 1998

BERLIN 1992
Amerika 1492–1992: Neue Welten – Neue Wirklichkeiten, exh. cat., Martin-Gropius-Bau, Berlin, 1992

BERLO 1992
Art, Ideology, and the City of Teotihuacan, Janet Catherine Berlo (ed.), Washington DC, 1992

BERNAL 1967
Ignacio Bernal, *Museo Nacional de Antropología, Arqueología*, Mexico City, 1967

BERNAL 1979
Ignacio Bernal, *Historia de la arqueología en México*, Mexico City, 1979

BERNAL AND SIMONI-ABBAT 1986
Ignacio Bernal and Mireille Simoni-Abbat, *Le Mexique*, Paris, 1986

BEYER 1924
Hermann Beyer, 'El origen, desarrollo y significado de la greca escalonada', *El México Antiguo*, 2, 1924, pp. 1–13

BEYER 1955
Hermann Beyer, '"La procesión de los señores", decoración del primer teocalli de piedra en México-Tenochtitlán', *El México Antiguo*, 8, 1955, pp. 1–42

BEYER 1965
Hermann Beyer, 'El llamado Calendario Azteca. Descripción e interpretación del cuauhxicalli de la Casa de las Águilas', *El México Antiguo*, 10, 1965, pp. 134–260

BEYER 1965B
Hermann Beyer, *Myth and Symbol of Ancient Mexico: El México antiguo*, Mexico City, 1965

BIERHORST 1990
John Bierhorst, *The Mythology of Mexico and Central America*, New York, 1990

BIERHORST 1992
John Bierhorst, *Codex Chimalpopoca: The Text in Nahuatl with a Glossary and Grammatical Notes; The Codex Chimalpopoca: History and Mythology of the Aztecs*, 2 vols, Tucson and London, 1992

BIOLOGIA CENTRALI-AMERICANA 1889–1902
Biologia Centrali-Americana; or Contributions to the Knowledge of the Fauna and Flora of Mexico and Central America, Frederick Du Cane and Osbert Salvin (eds), London, 1889–1902

BOLOGNA 1667
Breve descrizione del Museo dell'Illustriss. Sig. Cav. Commend. dell'Ordine di S. Stefano Ferdinando Cospi…donato dal medesimo all'Illustriss. Senato, & ora annesso al famoso Cimeliarchio del Celebre Aldrovandi, Bologna, 1667

BOLOGNA 1677
Lorenzo Legati, *Museo Cospiano annesso a quello del famoso Ulisse Aldrovandi e donato alla sua patria dall'illustrissimo signor Ferdinando Cospi…*, Bologna, 1677

BOLZ-AUGENSTEIN 1975
Ingeborg Bolz-Augenstein, *Sammlung Ludwig: Altamerika, Ethnologica*, n.s., vol. 7, Recklinghausen, 1975

BOLZ-AUGENSTEIN AND DISSELHOFF 1970
Ingeborg Bolz-Augenstein and H. D. Disselhoff, *Werke präkolumbianischer Kunst: Die Sammlung Ludwig, Aachen, Monumenta Americana*, vol. 6, Berlin, 1970

BONIFAZ NUÑO 1981
Rubén Bonifaz Nuño, *El arte en el Templo Mayor*, Mexico City, 1981

BOONE 1989
Elizabeth H. Boone, *Incarnations of the Aztec Supernatural: The Image of Huitzilopochtli in Mexico and Europe*, Philadelphia, 1989

BOONE 1993
Collecting the Pre-Columbian Past: A Symposium at Dumbarton Oaks, 6–7 October 1990, Elizabeth H. Boone (ed.), Washington DC, 1993

BOONE 2000
Elizabeth H. Boone, 'Venerable Place of Beginnings: The Aztec Understanding of Teotihuacan', in Carrasco, Jones and Sessions 2000, pp. 371–95

BOSTON 1968
The Gold of Ancient America, Allen Wardwell (ed.), exh. cat., Museum of Fine Arts, Boston, 1968

BRAUN 1993
Barbara Braun, *Pre-Columbian Art and the Post-Columbian World*, New York, 1993

BRAY 1968
Warwick Bray, *Everyday Life of the Aztecs*, London and New York, 1968

BRISTOL 1989
The Art of Ruins: Adela Breton and the Temples of Mexico, Sue Giles and Jennifer Stewart (eds), exh. cat., Bristol Museum and Art Gallery, 1989

BRIZZI 1976
Il Museo Pigorini, B. Brizzi (ed.), Rome, 1976

BRODA 1969
Johanna Broda, *The Mexican Calendar as Compared to Other Mesoamerican Systems*, Vienna, 1969

BROOKLYN 1938–41
Brooklyn Museum of Art Archives, AAPA Records, Objects offered for sale/purchases by Museum [03] (file #33), 1938–39, and [04] (file #33), 1940–41

BROOKLYN 1996
Converging Cultures: Art and Identity in Spanish America, Diana Fane (ed.), exh. cat., Brooklyn Museum, New York, 1996

BROOKLYN 1997
Brooklyn Museum of Art, New York, 1997

BROTHERSTON 1979
Gordon Brotherston, *Images of the New World: The American Continent Portrayed in Native Texts*, London, 1979

BROTHERSTON 1992
Gordon Brotherston, *Mexican Painted Books*, Colchester, 1992

BROTHERSTON 1995
Gordon Brotherston, *Painted Books from Mexico: Codices in UK Collections and the World They Represent*, London, 1995

BROTHERSTON AND GALLEGOS 1988
Gordon Brotherston and Ana Gallegos, 'The Newly-discovered Tepotzotlan Codex: A First Account', in *Recent Studies in Pre-Columbian Archaeology*, Nicholas J. Saunders and Olivier de Montmollin (eds), *British Archaeological Reports: International Series*, vol. 421, Oxford, 1988, pp. 205–27

BRUNDAGE 1979
Burr Cartwright Brundage, *The Fifth Sun: Aztec Gods, Aztec World*, Austin, 1979

BRUNNER 1970
Herbert Brunner, *Schatzkammer der Residenz München: Katalog*, Munich, 1970

BULLOCK 1824
William Bullock, *Six Months' Residence and Travel in Mexico, Containing Remarks on the Present State of New Spain*, London, 1824

BULLOCK 1991
William Bullock, *Catálogo de la Primera Exposición de Arte Prehispánico*, prologue, translation and notes by Begoña Arteta, Mexico City, 1991

CALDERÓN DE LA BARCA 1843
Marquesa de Calderón de la Barca, *Life in Mexico*, London, 1843

CALLEGARI 1924
Guido Valeriano Callegari, 'La raccolta d'oggetti precolombiani del Museo d'Antichità di Torino', *Emporium*, 40, 355, 1924, pp. 450–57

CALNEK 1972
Edward Calnek, 'Settlement Pattern and Chinampa Agriculture at Tenochtitlan', *American Antiquity*, 37, 1972, pp. 104–15

CALNEK 1976
Edward Calnek, 'The Internal Structure of Tenochtitlan', in *The Valley of Mexico: Studies in Pre-Hispanic Ecology and Society*, Eric R. Wolf (ed.), Albuquerque, 1976, pp. 287–302

CANTARES MEXICANOS 1994
Cantares Mexicanos, Miguel León-Portilla and José G. Moreno de Alba (eds), Mexico City, 1994

CARMICHAEL 1970
Elizabeth Carmichael, *Turquoise Mosaics from Mexico*, London, 1970

CARRASCO 1979
Pedro Carrasco, 'Las bases sociales del politeísmo mexicano: los dioses tutelares', in *Actes du XLIIe Congrès International des Américanistes, 1976*, Paris, 1979, pp. 11–17

CARRASCO 1990
David Carrasco, *Religions of Mesoamerica. Cosmovision and Ceremonial Centers*, San Francisco, 1990

CARRASCO 1998
David Carrasco, with Scott Sessions, *Daily Life of the Aztecs, People of the Sun and Earth*, Westport, Conn., and London, 1998

CARRASCO 1999
Aztec Ceremonial Landscapes, David Carrasco (ed.), Niwot, 1999

CARRASCO, JONES AND SESSIONS 2000
Mesoamerica's Classic Heritage: From Teotihuacan to the Aztecs, David Carrasco, Lindsay Jones and Scott Sessions (eds), Boulder, 2000

CASO 1932
Alfonso Caso, 'La Tumba 7 de Monte Albán es mixteca', *Universidad de México*, 26, 1932, pp. 117–50

CASO 1950
Alfonso Caso, 'Una máscara azteca femenina', *México en el Arte*, 9, 1950, pp. 2–9

CASO 1952
Alfonso Caso, 'Un cuauhxicalli del Dios de los Muertos', *Memorias y Revista de la Academia Nacional de Ciencias*, 57, 1–2, 1952, pp. 99–111

CASO 1953
Alfonso Caso, *El pueblo del Sol*, Mexico City, 1953

CASO 1956
Alfonso Caso, 'Los barrios antiguos de Tenochtitlan y Tlatelolco', *Memorias de la Academia Mexicana de la Historia*, 15, 1956, pp. 7–63

CASO 1967
Alfonso Caso, *Los calendarios prehispánicos*, Mexico City, 1967

CASO AND MATEOS HIGUERA 1937
Alfonso Caso and Salvador Mateos Higuera, *Catálogo de la Colección de Monolitos del Museo Nacional de Antropología*, Mexico City, 1937

CASTAÑEDA 1986
Francisco de Castañeda, 'Relación de Tequizistlan y su partido', in *Relaciones geográficas del siglo XVI*, vol. 7, René Acuña (ed.), Mexico City, 1986, pp. 211–51

CASTAÑEDA AND MENDOZA 1933
Daniel Castañeda and Vicente T. Mendoza, *Instrumental Precortesiano*, vol. 1, Museo Nacional de Arqueología, Etnografía e Historia, Mexico City, 1933

CASTELLÓ ITURBIDE 1993
Teresa Castelló Iturbide, *El arte plumaria en México*, Mexico City, 1993

CASTILLO FARRERAS 1971
Victor M. Castillo Farreras, 'El bisiesto náhuatl', *Estudios de Cultura Náhuatl*, 9, 1971, pp. 75–104

CASTILLO TEJERO AND SOLÍS OLGUÍN 1975
Noemí Castillo Tejero and Felipe Solís Olguín, *Ofrendas mexicas en el Museo Nacional de Antropología*, in *Corpus Antiquitatum Americanensium: México*, vol. 8, Mexico City, 1975

CELORIO 1962
Miguel Celorio, *Presencia del pasado, IV Congreso Mundial de Cardiología, Exposición de arqueología mexicana*, Mexico City, October 1962

CHARNAY 1885
Désiré Charnay, *Les Anciennes Villes du nouveau monde: voyages d'explorations au Mexique et dans l'Amérique centrale*, Paris, 1885

CHAVERO 1958
Alfredo Chavero,
México a través de los siglos,
Mexico City, 1958

CHÁVEZ BALDERAS 2002
Ximena Chávez Balderas,
*Los rituales funerarios del Templo
Mayor de Tenochtitlan*, BA
thesis, Escuela Nacional de
Antropología e Historia,
Mexico City, 2002

CHECA CREMADES 1997
Fernando Checa Cremades,
Las maravillas de Felipe II,
Madrid, 1997

CHEFS-D'ŒUVRE 1947
*Chefs-d'œuvre de l'Amérique
précolombienne*, Paris, 1947

CHEFS-D'ŒUVRE 1965
*Chefs-d'œuvre du Musée de
l'Homme*, Paris, 1965

CHICAGO 1993
México: la visión del cosmos,
Donald McVicker and
Laurene Lambertino-Urquizo
(eds), exh. cat., Mexican Fine
Arts Center Museum,
Chicago, 1993

CLOSS 1976
Michael Closs, 'New
Information on the European
Discovery of Yucatan',
American Antiquity, 41, 1976,
pp. 192–95

CODEX AZCATITLAN 1949
Codex Azcatitlan, facsimile,
Robert H. Barlow (ed.),
*Journal de la Société des
Américanistes*, vol. 38,
Paris, 1949

CODEX AZCATITLAN 1995
Codex Azcatitlan: facsimilé,
Michel Graulich (intro.),
Robert H. Barlow
(commentary), 2 vols,
Paris, 1995

CODEX BORBONICUS 1974
Codex Borbonicus, facsimile,
with a commentary by Karl
Anton Nowotny, Graz, 1974

CODEX CHIMALPAHIN 1997
*Codex Chimalpahin, Volume 1:
Society and Politics in Mexico and
Tenochtitlan, Tlatelolco, Texcoco,
Culhuacan and Other Nahua
Altepetl in Central Mexico*,
Arthur J. O. Anderson
and Susan Schroeder (trans.
and eds), Oklahoma, 1997

CODEX FEJÉRVÁRY-MAYER 1971
*Codex Fejérváry-Mayer (12014-M),
City of Liverpool Museums*,
facsimile, with an
introduction by Cottie A.
Burland, Graz, 1971

CODEX LAUD 1966
*Codex Laud (Ms Laud Misc.
678), Bodleian Library, Oxford*,
facsimile, Graz, 1966

CODEX MAGLIABECHIANO 1903
*The Book of the Life of the
Ancient Mexicans…An
Anonymous Hispano-Mexican
Manuscript*, facsimile,
Zelia Nuttal (trans. and ed.),
Berkeley, 1903

CODEX MAGLIABECHIANO 1970
*Codex Magliabechiano, Cl xiii.
(B.R. 232), Biblioteca Nazionale
Centrale di Firenze*, facsimile,
Ferdinand Anders (intro.
and summary), Graz, 1970

CODEX MAGLIABECHIANO 1983
*The Book of Life of the Ancient
Mexicans…An Anonymous
Hispano-Mexican Manuscript:
Introduction and Facsimile;
The Codex Magliabechiano and
the Lost Prototype of the
Magliabechiano Group: Notes
and Commentary*, Elizabeth H.
Boone (ed.), 2 vols, Berkeley,
1983

CODEX MATRITENSE 1907
*Codex Matritense of the Academy
of History: Texts of the Nahua
Informants of Friar Bernardino de
Sahagún*, facsimile, Francisco
del Paso y Troncoso (ed.),
3 vols, Madrid, 1907

CODEX MENDOZA 1992
The Codex Mendoza, facsimile,
Frances F. Berdan and
Patricia Rieff Anawalt (eds),
4 vols, Berkeley, 1992

CODEX MENDOZA 1997
The Essential Codex Mendoza,
Frances F. Berdan and
Patricia Rieff Anawalt (eds),
Berkeley, 1997

CODEX TELLERIANO-REMENSIS 1995
*Codex Telleriano-Remensis:
Ritual, Divination and History
in a Pictorial Aztec Manuscript*,
facsimile, Eloise Quiñones
Keber (commentary), Austin,
1995

CODEX TRO-CORTESIANUS 1967
*Codex Tro-Cortesianus (Codex
Madrid), Museo de América
Madrid*, facsimile,
introduction and summary
by Ferdinand Anders,
Graz, 1967

CODEX VATICANUS 3738 1979
*Codex Vaticanus 3738 ('Cod.
Vat. A', 'Cod. Ríos') des
Biblioteca Apostolica Vaticana:
Farbereproduktion des Codex in
verkleinertem Format*, facsimile,
commentary by Ferdinand
Anders, Graz, 1979

CODEX ZOUCHE-NUTTALL 1992
*Codex Zouche-Nuttall. Crónica
mixteca: el rey 8 venado. Garra de
Jaguar, y la dinastía Teozacualco-
Zaachila*, facsimile, Ferdinand
Anders, Maarten Jansen and
Gabina Aurora Pérez Jiménez
(eds), Graz and Mexico City,
1992

CÓDICE BORBÓNICO 1979
Códice Borbónico, facsimile,
E.-T. Hamy (ed.), Paris, 1899;
Mexico City, 1979

CÓDICE BORBÓNICO 1993
*Descripción, Historia y
Exposición del Códice Borbónico*,
facsimile, Francisco del Paso
y Troncoso (ed.), 3rd edition,
Mexico City, 1993

CÓDICE BORBÓNICO 1994
*Códice Borbónico. El libro del
Ciuacóatl: homenaje para el año
del Fuego Nuevo*, facsimile,
Ferdinand Anders, Maarten
Jansen and Luis Reyes García
(eds), Mexico City, 1994

CÓDICE BOTURINI 1964
Códice Boturini or *Tira de la
Peregrinación*, facsimile, in
Antigüedades de México
1964–67, vol. 2, pp. 7–29

CÓDICE CHIMALPOPOCA 1945
*Códice Chimalpopoca: anales de
Cuauhtitlan y leyenda de los soles*,
facsimile, Primo Feliciano
Velázquez (ed.), Mexico City,
1945

CODICE COSPI 1992
*Calendario e rituale precolombiani:
Codice Cospi*, L. Laurencich
Minelli (ed.), Milan, 1992

CÓDICE COSPI 1994
*Códice Cospi. Calendario de
pronósticas y ofrendas*. Ferdinand
Anders, Maarten Jansen and
Peter van der Loo, Graz and
Mexico City, 1994

CÓDICE FEJÉRVÁRY-MAYER 1994
*Códice Fejérváry-Mayer. El libro
de Tezcatlipoca, señor del tiempo*,
facsimile, Ferdinand Anders,
Maarten Jansen and Gabina
Aurora Pérez Jiménez (eds),
Graz and Mexico City, 1994

CÓDICE IXTLILXOCHITL 1996
*Códice Ixtlilxochitl. Papeles y
pinturas de un historiador*, Geert
Bastiaan van Doesburg (ed.),
Graz and Mexico City, 1996

CÓDICE LAUD 1994
*Códice Laud. Pintura de la muerte
y los destinos*, facsimile,
Ferdinand Anders, Maarten
Jansen and Alejandra Cruz
Ortiz (eds), Graz and
Mexico City, 1994

CÓDICE MAGLIABECHI 1996
*Códice Magliabechi. Libro de la
vida*, Ferdinand Anders and
Maarten Jansen (eds), Graz
and Mexico City, 1996

CÓDICE MAGLIABECHIANO 1979
*Códice Magliabechiano. Cl xiii.
(B.R. 232) Biblioteca Nazionale
Centrale di Firenze*, facsimile,
Ferdinand Anders (ed.),
Graz, 1979

CÓDICE MATRITENSE 1906
Códice Matritense, Madrid, 1906

CÓDICE MATRITENSE 1907
*Códice Matritense de la Real
Academia de la Historia (textos
en náhuatl de los indígenas
informantes de Sahagún)*, edición
facsimilar a cargo de Francisco del
Paso y Troncoso, 3 vols, Madrid,
1907

CÓDICE MENDOCINO 1964
Códice Mendocino, facsimile,
José Corona Núñez (ed.), in
Antigüedades de México
1964–67, vol. 1, pp. 1–149

CÓDICE TELLERIANO-REMENSIS 1964
Códice Telleriano-Remensis,
facsimile, in Antigüedades de
México 1964–67, vol. 1,
pp. 151–338

CODICE VATICANO 3738 1900
*Il manoscritto messicano Vaticano
3738 detto il codice Ríos, riprodotto
in fotomicrografi a spese di sua
eccellenza il duca di Loubat per
cura della Biblioteca Vaticana*,
Franz Ehrle (ed.), Rome,
1900

CÓDICE VATICANO A 1996
*Códice Vaticano A. Religión,
costumbres e historia de los
antiguos mexicanos*, facsimile,
Ferdinand Anders and
Maarten Jansen (eds),
Mexico City, 1996

CÓDICE VATICANO LATINO 1964–67
Códice Vaticano Latino (3738)
or *Códice Vaticano Ríos* or
Códice Ríos, facsimile, José
Corona Núñez (ed.), in
Antigüedades de México
1964–67, vol. 3, pp. 7–314

COE 1966
Michael D. Coe, *An Early
Stone Pectoral from South-eastern
Mexico*, Washington DC, 1966

COE 1992
Michael D. Coe, *Museo de
Antropología de Xalapa,
Gobierno del Estado de Veracruz*,
Veracruz, 1992

COE 1994
Michael D. Coe, *Mexico*,
London and New York, 1994

COLCHESTER 1992
Pauline Antrobus, Gordon
Brotherston, Valerie Fraser,
Peter Hulme and Jeremy
Theopolis, *Mapping the
Americas*, exh. cat., University
of Essex, Colchester, 1992

**COLECCIÓN DE DOCUMENTOS
INÉDITOS 1864**
*Colección de documentos inéditos
relativos al descubrimiento,
conquista y organización de las
posesiones españolas en
América…*, 42 vols, Madrid,
1864 ff.

COLOGNE 1999
*Kunst der Welt im Rautenstrauch-
Joest-Museum für Völkerkunde,
Köln*, Gisela Vögler (ed.), exh.
cat., Cologne, Rautenstrauch-
Joest-Museum für
Völkerkunde, 1999

CONRAD AND DEMAREST 1984
Geoffrey W. Conrad and
Arthur A. Demarest, *Religion
and Empire: The Dynamics of
Aztec and Inca Expansionism*,
Cambridge, 1984

CORSI 1982
Pietro Corsi, 'Il Codice
Fiorentino: nota storica',
*FMR: mensile d'arte e di cultura
dell'immagine*, 4 June 1982,
pp. 80–83, 134–35

CORTÉS 1963
Hernán Cortés, *Cartas y
documentos*, introduction by
Mario Hernández Sánchez-
Barba, Mexico City, 1963

CORTÉS 1986
Hernán Cortés, *Letters from
Mexico*, Anthony Pagden (ed.),
New Haven and London,
1986

COVARRUBIAS 1957
Miguel Covarrubias, *Indian
Art of Mexico and Central
America*, New York, 1957

COVARRUBIAS 1961
Miguel Covarrubias,
*Arte Indígena de México y
Centroamérica*, Mexico City,
1961

CUESTA DOMINGO 1983–84
Mariano Cuesta Domingo,
*Alonzo de Santa Cruz y su obra
cartográfica*, 2 vols, Madrid,
1983–84

DAHLGREN 1889
Erik Wilhelm Dahlgren,
*Något om det forna och nuvarande
Mexiko*, Stockholm, 1889,
pp. 3–30

DAHLGREN 1892
Erik Wilhelm Dahlgren, *Map
of the World by Alonzo de Santa
Cruz, 1542*, Stockholm, 1892

DAHLGREN ET AL. 1982
Barbara Dahlgren, Emma
Perez-Rocha, Lourdes Suárez
Díez and Perla Valle de
Revueltas, *Corazón de Cópil*,
Mexico City, 1982

**DEPARTAMENTO DEL DISTRITO
FEDERAL 1975**
Departamento del Distrito
Federal, *Memorias de las obras
del Sistema de Drenaje Profundo
del Distrito Federal: Atlas*, vol.
4, Secretaría de Obras y
Servicios del DDF,
Mexico City, 1975

DÍAZ DEL CASTILLO 1956
Bernal Díaz del Castillo,
*The Discovery and Conquest of
New Spain*, Arthur Percival
Maudslay (trans.), New York,
1956

DÍAZ DEL CASTILLO 1984
Bernal Díaz del Castillo,
*Historia verdadera de la conquista
de la Nueva España*, 2 vols,
Miguel León-Portilla (ed.),
Madrid, 1984

DIETSCHY 1941
Hans Dietschy, 'Zwei
altmexikanische Steinbilder
von Sonnengöttern', *Ethnos*,
6, 1–2, 1941, pp. 75–96

DRUCKER 1955
Phillip Drucker, 'The Cerro
de las Mesas Offering of Jade
and Other Materials', *Bulletin
of the Smithsonian Institution of
Washington*, 157, 1955,
pp. 25–68

DUMBARTON OAKS 1963
Handbook of the Robert Woods Bliss Collection of Pre-Columbian Art, Dumbarton Oaks, Washington DC, 1963

DUPAIX 1978
Guillermo Dupaix, *Atlas de las antigüedades mexicanas halladas en el curso de los tres viajes de la Real Expedición de Antigüedades de la Nueva España*, with an introduction and notes by Roberto Villaseñor Espinosa, Mexico City, 1978

DURÁN 1867, 1880
Diego Durán, *Historia de las Indias de Nueva España e Islas de Tierra Firme*, 2 vols, Mexico City, 1867, 1880

DURÁN 1951
Diego Durán, *Historia de las Indias de Nueva España e Islas de Tierra Firme*, 3 vols, Mexico City, 1951

DURÁN 1964
Diego Durán, *The Aztecs: The History of the Indies of New Spain (1581)*, Doris Heyden and Fernando Horcasitas (trans. and eds), Ignacio Bernal (intro.), New York, 1964

DURÁN 1967
Diego Durán, *Historia de las Indias de Nueva España e Islas de Tierra Firme*, Ángel María Garibay Kintana (ed.), 2 vols, Mexico City, 1967; 1975

DURÁN 1971
Diego Durán, *Book of the Gods and Rites and the Ancient Calendar*, Fernando Horcasitas and Doris Heyden (trans. and eds), Norman, 1971

DURÁN 1990–91
Diego Durán, *Historia de las Indias de Nueva España e Islas de Tierra Firme*, José Rubén Moreno and Rosa Camelo (intro.), 2 vols, Madrid, 1990–91

DURÁN 1995
Diego Durán, *Historia de las Indias de Nueva España e Islas de Tierra Firme*, Mexico City, 1995

DUYVIS 1935
G. E. G. Duyvis, 'Mexicaansche Mozaiken', *Maandblad voor Beeldenden Kunsten*, 12, 1935, pp. 355–66

DYCKERHOFF 1999
Ursula Dyckerhoff, in Cologne 1999

EDINBURGH 1971
Dale Idiens, *Ancient American Art*, exh. cat., Royal Scottish Museum, Edinburgh, 1971

EDMONSON 1988
Munro S. Edmonson, *The Book of the Year: Middle American Calendrical Systems*, Salt Lake City, 1988

EGAN 1993
Martha J. Egan, *Relicarios: Devotional Miniatures from the Americas*, Santa Fe, 1993

EISLEB 1973
Dieter Eisleb, 'Hundert Jahre Museum für Völkerkunde Berlin: Abteilung Amerikanische Archäologie', *Baessler-Archiv*, n.s., 21, 1973, pp. 175–217

EKHOLM 1970
Gordon Ekholm, *Ancient Mexico and Central America*, Companion Book to the Hall of Mexico and Central America, American Museum of Natural History, New York, 1970

EKHOLM AND BERNAL 1971
Archaeology of Northern Mesoamerica Part 1, Gordon Ekholm and Ignacio Bernal (eds), *Handbook of Middle American Indians*, vol. 10, Robert Wauchope (series ed.), Austin, 1971

EL ESCORIAL 1998
Felipe II: un monarca y su época – la monarquía hispánica, exh. cat., Real Monasterio de San Lorenzo de El Escorial, 1998

ENCISO 1947
Jorge Enciso, *Sellos del México antiguo*, Mexico City, 1947

ESPINOSA PINEDA 1996
Gabriel Espinosa Pineda, *El embrujo del lago: el sistema lacustre de la cuenca de México en la cosmovisión mexica*, Mexico City, 1996

ESPINOSA PINEDA 2001
Gabriel Espinosa Pineda, 'La fauna de Ehécatl: propuesta de una taxonomía a partir de las deidades, o la función de la fauna en el orden cósmico', in González Torres 2001, pp. 255–303

ESTERAS MARTÍN 1989
Cristina Esteras Martín, 'Platería virreinal novohispana: siglos XVI–XIX', in *El arte de la platería mexicana: 500 años*, Lucía García-Noriega y Nieto (ed.), Mexico City, 1989, pp. 152–55

ESTRADA 1937
Genaro Estrada, 'El arte mexicano en España', in *Enciclopedia ilustrada mexicana*, vol. 5, Mexico City, 1937

EZQUERRA 1970
Ramón Ezquerra, 'El viaje de Pinzón y Solís al Yucatán', *Revista de Indias*, 30, 1970, pp. 217–38

FALDINI 1978
Luisa Faldini, 'America', in *Africa, America, Oceania: le collezioni etnologiche del Museo Civico*, Turin, 1978, pp. 53–125

FEEST 1986
Christian F. Feest, 'Koloniale Federkunst aus Mexiko', in *Gold und Macht: Spanien in der Neuen Welt*, Vienna, 1986, pp. 173–78

FEEST 1990
Christian F. Feest, 'Vienna's Mexican Treasures: Aztec, Mixtec and Tarascan Works from Sixteenth-century Austrian Collections', *Archiv für Völkerkunde*, 44, 1990

FERNÁNDEZ 1987
Miguel Ángel Fernández, *Historia de los museos de México*, Mexico City, 1987

FERNÁNDEZ DE OVIEDO 1959
Gonzalo Fernández de Oviedo, *Historia general y natural de las Indias*, Juan Pérez de Tudela Bueso (ed.), 5 vols, Madrid, 1959; 1992

FLORENCE 1997
Christina Acidini Luchinat, Mina Gregori, Detlef Heikamp and Antonio Paolucci, *Magnificenza alla corte dei Medici. Arte a Firenze alla fine del Cinquecento*, exh. cat., Museo degli Argenti, Palazzo Pitti, Florence, 1997

FLORESCANO 1990
Enrique Florescano, 'Mitos e historia en la memoria nahua', *Historia Mexicana*, 155, 1990, pp. 607–62

FORT WORTH 1986
Linda Schele and Mary Ellen Miller, *The Blood of Kings*, exh. cat., Kimbell Art Museum, Fort Worth, 1986

FRANCK 1829
W. Franck, *Catalogue of Drawings of Mexican Antiquities/ Description feuille par feuille de la collection de dessins d'antiquités mexicaines*, original manuscript, British Museum, London, 1829

FRANKS 1868
Augustus Wollaston Franks, *Guide to the Christy Collection of Prehistoric Antiquities and Ethnography Temporarily Placed at 103 Victoria Street, Westminster*, London, 1868

FRANKS 1870
Augustus Wollaston Franks, *Catalogue of the Christy Collection of Prehistoric Antiquities and Ethnography Formed by the Late Henry Christy and Presented by the Trustees Under His Will to the British Museum*, London, 1870

FUENTE 1990
Beatriz de la Fuente, 'Escultura en el tiempo: retorno al pasado tolteca', *Artes de México (nueva época)*, 9, 1990, pp. 36–53

FUENTE 2000
Beatriz de la Fuente, 'Rostros: Expresión de vida en la plástica prehispánica', *Arqueología Mexicana*, 6, 2000, pp. 6–11

FUENTE, TREJO AND GUTIÉRREZ SOLANA 1988
Beatriz de la Fuente, Silvia Trejo and Nelly Gutiérrez Solana, *Escultura en piedra de Tula, catálogo*, UNAM, Mexico City, 1988

FUENTES 1964
Patricia Fuentes, *The Conquistadors*, London, 1964

FUMAGALLI 1932
Savina Fumagalli, 'Amuleti e oggetti d'oro della collezione precolombiana di Torino', *Atti della Società Piemontese di Archeologia e Belle Arti*, 13, 1932, pp. 165–95

GALARZA 1992
Joaquín Galarza, *Códices testerianos: catecismos indígenas, el pater noster*, Mexico City, 1992

GALINDO Y VILLA 1897
Jesús Galindo y Villa, *Catálogo del Departamento de Arqueología del Museo Nacional. Primera parte: Galería de monolitos*, 2nd edition, Mexico City, 1897

GALINDO Y VILLA 1903
Jesús Galindo y Villa, 'La escultura nahua', *Anales del Museo Nacional*, 2nd series, 1, 1903, pp. 195–234

GARCÍA COOK AND ARANA 1978
Ángel García Cook and Raúl Martín Arana, *Rescate arqueológico del monolito Coyolxauhqui: informe preliminar*, Mexico City, 1978

GARCÍA GRANADOS 1946
Rafael García Granados, 'El arte plumario', in *México prehispánico*, Mexico City, 1946, pp. 576–82

GARCÍA ICAZBALCETA 1980
Joaquín García Icazbalceta, *Colección de documentos para la historia de México*, Mexico City, 1980

GARCÍA MOLL ET AL. N.D.
Roberto García Moll, Roberto Gallegos, Daniel Juárez, Alfredo Barrera, Felipe Solís Olguín and Olivié y Flores, *Herencia recuperada*, Mexico City, n.d.

GARCÍA PAYÓN 1979
José García Payón, *La zona arqueológica de Tecaxic-Calixtlahuaca y los matlatzincas*, Mexico City, 1936; 1979

GARIBAY KINTANA 1953–54
Ángel María Garibay Kintana, *Historia de la literatura náhuatl*, 2 vols, Mexico City, 1953–54

GARIBAY KINTANA 1964
Ángel María Garibay Kintana, *Flor y canto del arte prehispánico de México*, Mexico City, 1964

GARIBAY KINTANA 1965
Teogonía e historia de los mexicanos. Tres opúsculos del siglo XVI, Ángel María Garibay Kintana (ed.), Mexico City, 1965

GENDROP 1979
Paul Gendrop, *Arte prehispánico en Mesoamérica*, Mexico City, 1979

GENDROP 1981
Paul Gendrop, 'Mesoamérica en imágenes', *Boletín del Museo Universitario de Antropología, México*, 1981

GENDROP AND DÍAZ BALERDI 1994
Paul Gendrop and Iñaki Díaz Balerdi, *Escultura azteca: una aproximación a su estética*, Mexico City, 1994

GENOA 1992
Due 'Mondi' a confronto: i segni della storia, exh. cat., Aurelio Rigoli (ed.), Palazzo Ducale, Genoa, 1992

GERBER AND TALADOIRE 1990
Frédéric Gerber and Eric Taladoire, '1865: Identification of "Newly" Discovered Murals from Teotihuacan', *Mexicon*, 12, 1990, pp. 6–9

GHENT 1999
Carolus: Keizer Karel V 1500–1558, exh. cat., Kunsthal de Sint-Pietersabdij, Ghent, 1999

GLASS AND ROBERTSON 1975
John B. Glass and Donald Robertson, 'A Census of Native Middle American Pictorial Manuscripts', in *Handbook of Middle American Indians*, vol. 14, Austin and London, 1975, pp. 81–252

GLASS AND ROBERTSON 1975B
John B. Glass and Donald Robertson, 'A Census of Middle American Testerian Manuscripts', in *Handbook of Middle American Indians*, vol. 14, Austin and London, 1975, pp. 281–96

GÓMEZ-HARO DESDIER 1994
Germaine Gómez-Haro Desdier, 'Estudio del Lienzo de Quetzpalan', unpublished thesis, Secretaría de Educación Pública, Mexico City, 1994

GONÇALVES DE LIMA 1956
Oswaldo Gonçalves de Lima, *El maguey y el pulque*, Mexico City and Buenos Aires, 1956

GONZÁLEZ AND OLMEDO VERA 1990
Carlos Javier González and Bertina Olmedo Vera, *Esculturas Mezcala en el Templo Mayor*, Mexico City, 1990

GONZÁLEZ RUL 1988
Francisco González Rul, *La cerámica en Tlatelolco*, Mexico City, 1988

GONZÁLEZ RUL 1997
Francisco González Rul, *Matériales líticos y cerámicos encontrados en las cercanías del monolito Coyolxauhqui*, INAH, Serie Arqueología, Mexico City, 1997

GONZÁLEZ TORRES 1985
Yólotl González Torres, *El sacrificio humano entre los mexicas*, Mexico City, 1985

GONZÁLEZ TORRES 1991
Yólotl González Torres, *Diccionario de mitología y religión de Mesoamérica*, Mexico City, 1991

GONZÁLEZ TORRES 2001
Yólotl González Torres, *Animales y plantes en la cosmovisión mesoamericana*, Mexico City, 2001

GONZÁLEZ TORRES 2001B
Yólotl González Torres, 'Huitzilopochtli', in *Oxford Encyclopaedia of Mesoamerican Cultures*, Davíd Carrasco (ed.), Oxford and New York, 2001, vol. 2, pp. 21–23

GRAHAM 1993
Ian Graham, 'Three Early Collectors in Mesoamerica', in Boone 1993, pp. 49–80

GRAHAM 1998
Mark Miller Graham, 'Mesoamerican Jade and Costa Rica', in *Jade in Ancient Costa Rica*, exh. cat., Julie Jones (ed.), The Metropolitan Museum of Art, New York, 1998, pp. 38–57, 105

GRAULICH 1982
Michel Graulich, *Mythes et rituels du Mexique ancien préhispanique*, Brussels, 1982

GRAULICH 1983
Michel Graulich, 'Myths of Paradise Lost in Pre-Hispanic Central Mexico', *Current Anthropology*, 5, 1983, pp. 575–88

GUALDI 1841
Pedro Gualdi, *Monumentos de México tomados del natural y litografiados*, Mexico City, 1841

GUARNOTTA 1980
Antonio Guarnotta, 'Report', in *Palazzo Vecchio: committenza e collezionismo Medicei*, Florence, 1980

GUILLIEM 1999
Salvador Guilliem, *Ofrendas a Ehécatl Quetzalcóatl en México: Tlatelolco*, Mexico City, 1999

GUSSINYER 1969
Jordi Gussinyer, 'Hallazgos en el Metro, conjunto de adoratorios superpuestos en Pino Suárez', *Boletín del INAH*, 36, 1969, pp. 33–37

GUSSINYER 1970
Jordi Gussinyer, 'Un adoratorio dedicado a Tláloc', *Boletín del INAH*, 39, 1970, pp. 7–12

GUSSINYER 1970B
Jordi Gussinyer, 'Un adoratorio azteca decorado con pinturas', *Boletín del INAH*, 40, 1970, pp. 30–35

GUSSINYER AND MARTÍNEZ 1976–77
Jordi Gussinyer and Alejandro Martínez, 'Una figurilla olmeca en un entierro del horizonte clásico', *Estudios de Cultura Maya*, 10, 1976–77, pp. 69–80

GUTIÉRREZ SOLANA 1983
Nelly Gutiérrez Solana, *Objetos ceremoniales en piedra de la cultura mexica*, Mexico City, 1983

GUZMAN 1939
Eulalia Guzman, *The Art of Map-making Among the Ancient Mexicans*, London, 1939, pp. 1–7

HAMPE 1927
Theodor Hampe, *Das Trachtenbuch des Christoph Weiditz*, Berlin, 1927

HAMY 1897
E.-T. Hamy, *Galerie américaine du Musée d'Ethnographie du Trocadéro: choix de pièces archéologiques et ethnographiques*, 2 vols, Paris, 1897

HAMY 1906
E.-T. Hamy, 'Note sur une statuette méxicaine', *Journal de la Société des Américanistes*, 3, 1, 1906, pp. 1–5

HARWOOD 2002
Joanne Harwood, 'Disguising Ritual: A Reassessment of Part 3 of the Codex Mendoza', unpublished PhD thesis, Department of Art History and Theory, University of Essex, 2002

HASSIG 1988
Ross Hassig, *Aztec Warfare: Imperial Expansion and Political Control*, Norman, 1988

HEIKAMP 1970
Detlef Heikamp with Ferdinand Anders, 'Mexikanische Altertümer aus süddeutschen Kunstkammern', *Pantheon*, 28, 1970, pp. 205–20

HEIKAMP 1972
Detlef Heikamp, *Mexico and the Medici*, Florence, 1972

HERNÁNDEZ PONS 1982
Elsa Hernández Pons, 'Sobre un conjunto de esculturas asociadas a las escalinatas del Templo Mayor', in *El Templo Mayor: excavaciones y estudios*, Mexico City, 1982, pp. 221–32

HERNÁNDEZ PONS 1996
Elsa Hernández Pons, 'Xiuhtecuhtli, deidad mexica del fuego', *Arqueología Mexicana*, 4, 20, 1996, pp. 68–70

HERNÁNDEZ PONS 1997
Elsa Hernández Pons, 'La plataforma mexica, las excavaciones de 1901 y los nuevos descubrimientos', in *La antigua Casa del Marqués del Apartado: arqueología e historia*, Mexico City, 1997, pp. 45–71

HERTZ 1851
Bram Hertz, *Catalogue of the Collection of Assyrian, Babylonian, Egyptian, Greek, Etruscan, Roman, Indian, Peruvian and Mexican Antiquities Formed by B. Hertz*, London, 1851

HEYDEN 1973
Doris Heyden, '¿Un Chicomostoc en Teotihuacan? La cueva bajo la pirámide del Sol', *Boletín del INAH (segunda época)*, 6, 1973, pp. 3–18

HEYDEN 1979
Doris Heyden, 'El "Signo del Año" en Tehuacán [*sic*], su supervivencia y el sentido sociopolítico del símbolo', in *Mesoamérica: Homenaje al doctor Paul Kirchhoff*, Barbara Dalhgren (ed.), Mexico City, 1979, pp. 61–86

HILDESHEIM 1986
Glanz und Untergang des Alten Mexiko: Die Azteken und ihre Vorläufer, Eva and Arne Eggebrecht (eds), exh. cat., 2 vols, Roemer- und Pelizaeus-Museum, Hildesheim, 1986; Haus der Kunst, Munich; Oberösterreichisches Landesmuseum, Linz; Louisiana Museum, Humlebæk; Musées Royaux d'Art et d'Histoire, Brussels

HISTORIA DE LOS MEXICANOS POR SUS PINTURAS 1965
Historia de los mexicanos por sus pinturas, in Garibay Kintana 1965, pp. 21–90

HISTORIA DE MÉXICO 1965
Historia de México (Histoire du Mechique), in Garibay Kintana 1965, pp. 91–120

HISTORIA TOLTECA-CHICHIMECA 1976
Historia Tolteca-Chichimeca, Paul Kirchhoff, Lina Odena Güemes and Luis Reyes García (trans. and eds), Mexico City, 1976

HOLMES 1897
William H. Holmes, *Archaeological Studies among the Ancient Cities of Mexico*, Chicago, 1897

HONOUR 1954
Hugh Honour, 'Curiosities of the Egyptian Hall', *Country Life*, 115, 2973, 1954, pp. 38–39

ICAZA Y GONDRA 1827
Isidro Icaza y Gondra, *Colección de las antigüedades mexicanas que existen en el Museo Nacional*, Mexico City, 1827

INAH 1956
Instituto Nacional de Antropología e Historia, *Guía oficial del Museo Nacional de Antropología*, Mexico City, 1956

INFORMACIÓN SOBRE LOS TRIBUTOS 1957
Información sobre los tributos que los indios pagaban a Moctezuma – año de 1554, France V. Scholes and Eleanor B. Adams (eds), Mexico City, 1957

JIMÉNEZ MORENO 1971
Wigberto Jiménez Moreno, '¿Religión o religiones mesoamericanas?', in *Verhandlungen des XXXVIII. Internationalen Amerikanistenkongresses*, vol. 3, Stuttgart and Munich, 1971, pp. 201–06

JONES 1987
Julie Jones, *The Metropolitan Museum of Art: The Pacific Islands, Africa, and the Americas*, New York, 1987

JONES AND KING 2002
Julie Jones and Heidi King, *The Metropolitan Museum of Art: Gold of the Americas*, Spring Bulletin of The Metropolitan Museum of Art, New York, 2002

JOYCE 1912
Thomas Athol Joyce, *A Short Guide to the American Antiquities in the British Museum*, London, 1912

JOYCE 1923
Thomas Athol Joyce, *Guide to the Maudslay Collection of Maya Sculptures (Casts and Originals) from Central America*, London, 1923

JOYCE N.D.
Thomas Athol Joyce, *Catalogue of a Collection of Mexican and Other American Antiquities (Including the Chavero Collection) in the Possession of Viscount Cowdray*, London, n.d.

KELEMEN 1943
Pál Kelemen, *Medieval American Art: A Survey in Two Volumes*, 2 vols, New York, 1943

KIDDER 1947
Alfred V. Kidder, *The Artifacts of Uaxactun, Guatemala*, Washington DC, 1947

KING 1831–48
Edward King, Lord Kingsborough, *The Antiquities of Mexico, Comprising Facsimiles of Ancient Mexican Painting and Hieroglyphs*, 9 vols, London, 1831–48

KING 1996
Jonathan King, 'William Bullock: Showman', in Mexico City 1996, pp. 119–21

KINZHALOV 1960
R. V. Kinzhalov, 'Atstekskoe zolotoe nagrudnoe ukrashenie', *Sbornik Muzeia Antropologii I Etnografii*, 19, 1960, pp. 206–20

KLOR DE ALVA 1981
Jorge Klor de Alva, 'Martín Ocelotl, Clandestine Cult Leader', in *Struggle and Survival in Colonial America*, D. G. Sweet and Gary B. Nash (eds), Berkeley, 1981

KRICKEBERG 1960
Walter Krickeberg, 'Xochipilli und Chalchiuhtlicue: Zwei aztekische Steinfiguren in der völkerkundlichen Sammlung der Stadt Mannheim', *Baessler-Archiv: Beiträge zur Völkerkunde*, n.s., 8, 1960, pp. 1–30

KRICKEBERG 1985
Walter Krickeberg, *Mitos y leyendas de los aztecas, incas, mayas y muiscas*, Mexico City, 1985

KUBLER 1963
George Kubler, *The Shape of Time: Remarks on the History of Things*, New Haven and London, 2nd edition, 1963 (1962)

KUBLER 1985
George Kubler, 'The Cycle of Life and Death in Metropolitan Aztec Sculpture', in *Studies in Ancient American and European Art*, Thomas F. Reese (ed.), New Haven and London, 1985, pp. 219–24

KUBLER 1986
George Kubler, *Arte y arquitectura en la América precolonial*, Madrid, 1986

KUBLER 1991
George Kubler, *Esthetic Recognition of Ancient Amerindian Art*, New Haven and London, 1991

LANDA ET AL. 1988
María Elena Landa et al., *La Garrafa*, Mexico City, 1988

LANGLEY 1986
James C. Langley, *Symbolic Notation of Teotihuacan: Elements of Writing in a Mesoamerican Culture of the Classic Period*, Oxford, 1986

LA NIECE AND MEEKS 2000
Susan La Niece and Nigel Meeks, 'Diversity of Goldsmithing Traditions in the Americas and the Old World', in *Pre-Columbian Gold: Technology, Style and Iconography*, Colin McEwan (ed.), London, 2000

LAS CASAS 1986
Bartolomé de las Casas, *Historia de las Indias*, Agustín Millares Carlo (ed.), Mexico City, 1986

LAURENCICH MINELLI 1992
Terra Ameriga. Il Mondo Nuovo nelle collezioni emiliano-romagnole, L. Laurencich Minelli (ed.), Bologna, 1992

LAURENCICH MINELLI AND FILIPETTI 1983
L. Laurencich Minelli and A. Filipetti, 'Per le collezioni americanistiche del Museo Cospiano e dell'Istituto delle Scienze. Alcuni oggetti ritrovati a Bologna', *Archivio per l'Antropologia e l'Etnologia*, 113, pp. 207–25

LAVACHERY AND MINNAERT 1931
Henri Lavachery and Paul Minnaert, 'La Collection d'antiquités mexicaines de M. Aug. Génin', *Bulletin de la Société des Américanistes de Belgique*, 5, 1931

'LEGEND OF THE SUNS' 1992
Anonymous, 'Legend of the Suns', in Bierhorst 1992

LEHMAN 1906
Walter Lehman, 'Die Mexikanischer Grünsteinfigur des Musée Guimet in Paris', *Globus*, 90, 1906, pp. 60–61

LEÓN-PORTILLA 1959
Miguel León-Portilla, *La filosofía náhuatl estudiada en sus fuentes*, Mexico City, 1959

LEÓN-PORTILLA 1962
Miguel León-Portilla, *The Broken Spears: The Aztec Account of the Conquest of Mexico*, Boston, 1962

LEÓN-PORTILLA 1963
Miguel León-Portilla, *Aztec Thought and Culture*, Jack Emory Davis (trans.), Norman, 1963

LEÓN-PORTILLA 2002
Miguel León-Portilla, 'A Nahuatl Concept of Art', in Amsterdam 2002, pp. 46–53

LEÓN-PORTILLA AND AGUILERA 1986
Miguel León-Portilla and Carmen Aguilera, *Mapa de México Tenochtitlan y sus contornos hacia 1550*, Mexico City, 1986

LEÓN Y GAMA 1792
Antonio León y Gama, *Descripción histórica y cronológica de las dos piedras que con ocasión del nuevo empedrado que se está formando en la plaza principal de México, se hallaron en ella el año de 1790*, 1st edition, Mexico City, 1792; 2nd edition, Carlos María de Bustamante (ed.), Mexico City, 1832

'LEYENDA DE LOS SOLES' 1945
Anonymous, 'Leyenda de los soles', in Códice Chimalpopoca 1945, pp. 119–64

LIND 1994
Michael D. Lind, 'Cholula and Mixteca Polychromes: Two Mixteca-Puebla Regional Sub-styles', in *Mixteca-Puebla: Discoveries and Research in Mesoamerican Art and Archaeology*, Henry B. Nicholson and Eloise Quiñones Keber (eds), Culver City, California, 1994, pp. 79–99

LINNÉ 1948
Sigvald Linné, *El Valle y la Ciudad de México en 1550*, Stockholm, 1948

LIVERPOOL 1973
Charles Hunt, *Men and Gods of Ancient America: An Exhibition of Treasures from Mexico and Peru*, exh. cat., Liverpool Museum, 1973

LOCKHART 1992
James Lockhart, *The Nahuas after the Conquest: A Social and Cultural History of the Indians of Central Mexico, Sixteenth through Eighteenth Centuries*, Stanford, 1992

LONDON 1824
William Bullock, *Catalogue of the Exhibition, called Modern Mexico; Containing a Panoramic View of the City, with Specimens of the Natural History of New Spain…Now Open for Public Inspection at the Egyptian Hall, Piccadilly*, exh. cat., London Museum of Natural History and Pantherion, London, 1824

LONDON 1824B
William Bullock, *A Description of the Unique Exhibition, called Ancient Mexico: Collected on the Spot in 1823…and Now Open for Public Inspection at the Egyptian Hall, Piccadilly*, exh. cat., London Museum of Natural History and Pantherion, London, 1824

LONDON 1824C
William Bullock, *A Descriptive Catalogue of the Exhibition, entitled Ancient and Modern Mexico…Now Open…at the Egyptian Hall, etc.*, exh. cat., London Museum of Natural History and Pantherion, London, 1824

LONDON 1920
Thomas Athol Joyce, *Catalogue of an Exhibition of Objects of Indigenous American Art*, exh. cat., Burlington Arts Club, London, 1920

LONDON 1947
Art of Ancient America, with a foreword by Irwin Bullock and G. H. S. Bushnell, exh. cat., Berkeley Galleries, London, June–August 1947

LONDON 1953
Exhibition of Mexican Art from Pre-Columbian Times to the Present Day Organised Under the Auspices of the Mexican Government, The Tate Gallery, London, 4 March to 26 April 1953, exh. cat., Arts Council of Great Britain, Tate Gallery, London, 1953

LONDON 1953B
Mexican Art from 1500 BC to the Present Day. Illustrated Supplement to the Catalogue of an Exhibition at the Tate Gallery, London, 4 March to 26 April 1953, Arts Council of Great Britain, Tate Gallery, London, 1953

LONDON 1958
An Exhibition of Pre-Columbian Art, exh. cat., Gimpel Fils, London, 1958

LONDON 1965
Henry Christy: A Pioneer of Anthropology. An Exhibition in the King Edward VII Gallery, exh. cat., British Museum, London, 1965

LONDON 1971
Manuel Barbachano Ponce, *Maya Sculpture and Pottery from Mexico: The Manuel Barbachano Ponce Collection*, exh. cat., Museum of Mankind, London, 1971; Museum für Völkerkunde, Frankfurt; Nationalmuseum, Stockholm

LONDON 1973
Elizabeth Carmichael, *The British and the Maya*, exh. cat., Museum of Mankind, London, 1973

LONDON 1982
The Other America: Native Artefacts from the New World, Valerie Fraser and Gordon Brotherston (eds), exh. cat., Museum of Mankind, London, 1982

LONDON 1985
Eduardo Paolozzi, *Lost Magic Kingdoms and Six Paper Moons from Nahuatl: An Exhibition at the Museum of Mankind*, exh. cat., Museum of Mankind, London, 1985

LONDON 1986
Lost Magic Kingdoms and Six Paper Moons from Nahuatl: An Exhibition at the Museum of Mankind Created by Eduardo Paolozzi from 28 November 1985, London, 1985

LONDON 1991
Elizabeth Carmichael and Chlöe Sayer, *The Skeleton at the Feast: The Day of the Dead in Mexico*, exh. cat., Museum of Mankind, London, 1991

LONDON 1992
The Art of Ancient Mexico, Marianne Ryan (ed.), exh. cat., Hayward Gallery, London, 1992; Oriana Baddeley, *The Art of Ancient Mexico: Loans from the British Museum. Supplement to the Catalogue*, London, 1992

LONDON 1992B
Gordon Brotherston, *Painted Books of Mexico*, exh. cat., British Museum, London, 1992

LONDON 2000
Gabriele Finaldi, *The Image of Christ*, exh. cat., National Gallery, London, 2000

LÓPEZ AUSTIN 1985
Alfredo López Austin, 'El texto sahaguntino sobre los mexicas', *Anales de Antropología*, 22, 1985, pp. 287–336

LÓPEZ AUSTIN 1990
Alfredo López Austin, 'Del origen de los mexicas: ¿nomadismo o migración?', *Historia Mexicana*, 155, 1990, pp. 663–75

LÓPEZ AUSTIN 1993
Alfredo López Austin, *The Myths of the Opossum: Pathways of Mesoamerican Mythology*, Albuquerque, 1993

LÓPEZ AUSTIN 1994–97
Alfredo López Austin, 'La religione della Mesoamerica', in *Storia delle religioni*, Giovanni Filoramo (ed.), vol. 5, Rome, 1994–97, pp. 5–75

LÓPEZ AUSTIN 1996
Alfredo López Austin, 'La cosmovisión mesoamericana', in *Temas mesoamericanos*, Sonia Lombardo and Enrique Nalda (eds), Mexico City, 1996, pp. 471–507

LÓPEZ AUSTIN 1997
Alfredo López Austin, *Tamoanchan, Tlalocan. Places of Mist*, Niwot, 1997

LÓPEZ AUSTIN AND LÓPEZ LUJÁN 2001
Alfredo López Austin and Leonardo López Luján, 'Los mexicas y el Chac-mool', *Arqueología Mexicana*, 49, 2001, pp. 68–73

LÓPEZ LUJÁN 1989
Leonardo López Luján, *La recuperación mexica del pasado teotihuacano*, Mexico City, 1989

LÓPEZ LUJÁN 1991
Leonardo López Luján, 'Peces y moluscos en el libro undécimo del *Códice Florentino*', in *La fauna en el Templo Mayor*, O. J. Polaco (ed.), Mexico City, 1991, pp. 213–63

LÓPEZ LUJÁN 1993
Leonardo López Luján, *Las ofrendas del Templo Mayor de Tenochtitlan*, Mexico City, 1993

LÓPEZ LUJÁN 1994
Leonardo López Luján, *The Offerings of the Templo Mayor of Tenochtitlan*, Niwot, 1994

LÓPEZ LUJÁN 1995
Leonardo López Luján, 'Guerra y muerte en Tenochtitlán: descubrimientos en el Recinto de los Guerreros Águila', *Arqueología Mexicana*, 2, 12, 1995, pp. 75–77

LÓPEZ LUJÁN 1998
Leonardo López Luján, 'Anthropologie religieuse du Templo Mayor, Mexico: la Maison des Aigles', PhD thesis, University of Paris-X, Nanterre, 1998

LÓPEZ LUJÁN 2001
Leonardo López Luján, 'Arqueología de la arqueología: de la época prehispánica al siglo XVIII', *Arqueología Mexicana*, 52, 2001, pp. 20–27

LÓPEZ LUJÁN FORTHCOMING
Leonardo López Luján, *La Casa de las Águilas: un ejemplo de arquitectura sacra mexica*, Mexico City, in press

LÓPEZ LUJÁN AND MANZANILLA 2001
Leonardo López Luján and Linda Manzanilla, 'Excavaciones en un palacio de Teotihuacan: el Proyecto Xalla', *Arqueología Mexicana*, 50, 2001, pp. 14–15

LÓPEZ LUJÁN AND MERCADO 1996
Leonardo López Luján and Vida Mercado, 'Dos esculturas de Mictlantecuhtli encontradas en el Recinto Sagrado de México-Tenochtitlan', *Estudios de Cultura Náhuatl*, 26, 1996, pp. 41–68

LÓPEZ LUJÁN, NEFF AND SUGIYAMA 2000
Leonardo López Luján, Hector Neff and Saburo Sugiyama, 'The 9-Xi Vase: A Classic Thin Orange Vessel Found at Tenochtitlan', in Carrasco, Jones and Sessions 2000, pp. 219–49

LÓPEZ LUJÁN, TORRES TREJO AND MONTÚFAR 2002
Leonardo López Luján, Jaime Torres Trejo and Aurora Montúfar, 'Los materiales constructivos del Templo Mayor de Tenochtitlan', *Estudios de Cultura Náhuatl*, 33, 2002, in press

LOS ANGELES 1963
Fernando Gamboa, *Master Works of Mexican Art from Pre-Columbian Times to the Present*, exh. cat., Los Angeles County Museum of Art, 1963

LOS ANGELES 2001
The Journey to Aztlan: Art from a Mythic Homeland, Virginia M. Fields and Victor Zamudio-Taylor (eds), exh. cat., Los Angeles County Museum of Art, 2001; Austin Museum of Art; Albuquerque Museum

LOTHROP 1957
S. K. Lothrop, *Robert Woods Bliss Collection: Pre-Columbian Art*, London, 1957

LOTHROP 1964
S. K. Lothrop, *Treasures of Ancient America*, New York, 1964

MACCURDY 1910
George Grant MacCurdy, 'An Aztec "Calendar Stone" in the Yale University Museum', *American Anthropologist*, n.s., 12, 4, 1910, pp. 481–96

MCEWAN 1994
Colin McEwan, *Ancient Mexico in the British Museum*, London, 1994

MCVICKER 1989
Mary Frech McVicker, 'From Parlours to Pyramids', in Bristol 1989, pp. 12–23

MCVICKER AND PALKA 2001
Donald McVicker and Joel W. Palka, 'A Maya Carved Shell Plaque from Tula, Hidalgo, Mexico: Comparative Study', *Ancient Mesoamerica*, 12, 2001, pp. 175–97

MADRID 1986
México antiguo, exh. cat., Museo de América, Madrid, 1986

MADRID 1990
Arte precolombino de México, Roberto García Moll, Beatriz de la Fuente, Sonia Lombardo and Felipe Solís Olguín (eds), exh. cat., Palacio de Velázquez, Madrid, 1990

MADRID 1992
Azteca-Mexica: las culturas del México antiguo, José Alcina Franch, Miguel León-Portilla and Eduardo Matos Moctezuma (eds), exh. cat., Sociedad Estatal Quinto Centenario, Madrid, 1992

MADRID 1994
Jean Paul Barbier, Iris Barry, Michel Butor, Conceição G. Corrêa, Danièle Lavallée, Octavio Paz and Henri Stierlin, *Arte precolombino en la colección Barbier-Mueller*, exh. cat., Casa de América, Madrid, 1994

MANCHESTER 1992
George Bankes and Elizabeth Baquedano, *Sañuq and Toltecatl: Pre-Columbian Arts of Middle and South America*, exh. cat., Manchester Museum, 1992

MANRIQUE 1960
Jorge Manrique, 'Introducir la divinidad en las cosas: finalidad del arte náhuatl', in *Estudios de Cultura Náhuatl*, 2, 1960, pp. 197–207

MANRIQUE 1988
Leonardo Manrique and Jimena Manrique, *Flora y fauna mexicana: panorama actual*, Mexico City, 1988

MANZANILLA AND LÓPEZ LUJÁN 2001
Linda Manzanilla and Leonardo López Luján, 'Exploraciones en un posible palacio de Teotihuacan: el Proyecto Xalla (2000–2001)', *Mexicon*, 23, 2001, pp. 58–61

MARQUINA 1951
Ignacio Marquina, *Arquitectura prehispánica*, Mexico City, 1951

MARQUINA 1960
Ignacio Marquina, *El Templo Mayor de México*, Mexico City, 1960

MARQUINA 1964
Ignacio Marquina, *Arquitectura prehispánica*, 2nd edition, Mexico City, 1964

MARTÍNEZ DE LA TORRE 1992
Cruz Martínez de la Torre, 'Obras de arte americano en el Patrimonio Nacional', *Reales Sitios*, 112, 1992, pp. 17–28

MARTÍNEZ DEL RÍO 1960
Marita Martínez del Río, 'Comentarios sobre el arte plumario durante la colonia', *Artes de México*, 17, 137, 1960, pp. 86–98

MARTÍNEZ MARÍN 1963
Carlos Martínez Marín, 'La cultura de los mexicanos durante su migración. Nuevas ideas', *Cuadernos Americanos*, 4, 1963, pp. 175–83

MATEOS HIGUERA 1992–94
Salvador Mateos Higuera, *Enciclopedia gráfica del México antiguo*, 4 vols, Mexico City, 1992–94

MATOS MOCTEZUMA 1965
Eduardo Matos Moctezuma, 'El adoratorio decorado de las calles de Argentina', *Anales del Instituto Nacional de Antropología e Historia*, 17, 1965, pp. 127–38

MATOS MOCTEZUMA 1979
Eduardo Matos Moctezuma, 'Una máscara olmeca en el Templo Mayor de Tenochtitlan', *Anales de Antropología*, 16, 1979, pp. 11–19

MATOS MOCTEZUMA 1980
Eduardo Matos Moctezuma, 'El arte en el Templo Mayor', in Mexico City 1980, pp. 13–15

MATOS MOCTEZUMA 1981
Eduardo Matos Moctezuma, 'Los hallazgos de la arqueología', in *El Templo Mayor*, Mexico City, 1981

MATOS MOCTEZUMA 1983
Eduardo Matos Moctezuma, 'Notas sobre algunas urnas funerarias del Templo Mayor', *Jahrbuch für Geschichte von Staat, Wirtschaft und Gesellschaft Lateinamerikas*, 20, 1983, pp. 17–32

MATOS MOCTEZUMA 1984
Eduardo Matos Moctezuma, 'Los edificios aledaños al Templo Mayor', *Estudios de Cultura Náhuatl*, 17, 1984, pp. 15–21

MATOS MOCTEZUMA 1986
Eduardo Matos Moctezuma, *Vida y muerte en el Templo Mayor*, Mexico City, 1986

MATOS MOCTEZUMA 1988
Eduardo Matos Moctezuma, *The Great Temple of the Aztecs*, London and New York, 1988

MATOS MOCTEZUMA 1989
Eduardo Matos Moctezuma, *Los aztecas*, Barcelona and Madrid, 1989

MATOS MOCTEZUMA 1990
Eduardo Matos Moctezuma, 'El águila, el jaguar y la serpiente', *Artes de México*, 7, 1990, pp. 54–66

MATOS MOCTEZUMA 1991
Eduardo Matos Moctezuma, 'Las seis Coyolxauhqui: variaciones sobre un mismo tema', *Estudios de Cultura Náhuatl*, 21, 1991, pp. 15–29

MATOS MOCTEZUMA 1993
Eduardo Matos Moctezuma, 'Los mexicas y el rumbo sur del universo', in *El arte de Mezcala*, Mexico City, 1993, pp. 120–39

MATOS MOCTEZUMA 1994
Eduardo Matos Moctezuma, 'Los mexica y llegaron los españoles', in *México en el mundo de las colecciones de arte*, vol. 2, *Mesoamérica*, Mexico City, 1994, pp. 179–243

MATOS MOCTEZUMA 2000
Eduardo Matos Moctezuma, 'Rostros de la muerte', *Arqueología Mexicana*, 6, 2000, pp. 12–17

MATOS MOCTEZUMA, BRODA AND CARRASCO 1987
Eduardo Matos Moctezuma, Johanna Broda and David Carrasco, *The Great Temple of Tenochtitlan*, London and New York, 1987

MATOS MOCTEZUMA AND LÓPEZ LUJÁN 1993
Eduardo Matos Moctezuma and Leonardo López Luján, 'Teotihuacan and Its Mexica Legacy', in San Francisco 1993, pp. 156–65

MATRÍCULA DE TRIBUTOS 1997
Matrícula de Tributos o Códice Moctezuma, Ferdinand Anders, Maarten Jansen and Luis Reyes García (eds), Graz and Mexico City, 1997

MAUDSLAY 1899
Arthur Percival Maudslay and Anne Cary Maudslay, *A Glimpse at Guatemala, and Some Notes on the Ancient Monuments of Central America…with Maps, Plans, Photographs, etc.*, London, 1899

MAYER 1844
Brantz Mayer, *Mexico as It Was and as It Is*, New York, 1844

MAZA 1971
Francisco de la Maza, 'La mitra mexicana de plumas de El Escorial', *Artes de México*, 137, 1971, pp. 71–72

MEDELLÍN ZENIL 1983
Alfonso Medellín Zenil, *Obras maestras del Museo de Xalapa*, Veracruz, 1983

MEMORIAL DE LOS INDIOS DE TEPETLAOZTOC 1992
Memorial de los indios de Tepetlaoztoc o Códice Kingsborough, Perla Valle (ed.), Mexico City, 1992

MENDIETA 1945
Gerónimo de Mendieta, *Historia eclesiástica indiana*, 4 vols, Mexico City, 1945

MERLO 1995
Eduardo Merlo, 'Maquetas prehispánicas de Calipan', *Arqueología Mexicana*, 3, 9, 1995, pp. 60–62

MEXICO CITY 1980
El arte del Templo Mayor, exh. cat., Museo del Palacio de Bellas Artes, Mexico City, 1980

MEXICO CITY 1995
Dioses del México antiguo, Eduardo Matos Moctezuma, Alfredo López Austin, Miguel León-Portilla, Felipe Solís Olguín, Miguel A. Fernández and José Enrique Ortiz Lanz (eds), exh. cat., Antiguo Colegio de San Ildefonso, Mexico City, 1995

MEXICO CITY 1996
European Traveller-artists in Nineteenth-century Mexico, exh. cat., Palacio de Iturbide, Mexico City, 1996

MEXICO CITY 1997
La cerámica de la Ciudad de México (1325–1917), Karina Simpson (ed.), exh. cat., Museo de la Ciudad de México, Mexico City, 1997

MEXICO CITY 2001
Descubridores del pasado en Mesoamérica, exh. cat., Antiguo Colegio de San Ildefonso, Mexico City, 2001

MEYER AND SHERMAN 1979
Michael C. Meyer and William L. Sherman, *The Course of Mexican History*, New York, 1979

MILAN 1990
L'America prima di Colombo: arte precolombino dal 2000 a.C. agli Aztechi, exh. cat., Castello di Lerici, Milan, 1990

MILLER AND TAUBE 1993
Mary Miller and Karl Taube, *The Gods and Symbols of Ancient Mexico and the Maya: An Illustrated Dictionary of Mesoamerican Religion*, London, 1993

MILNE 1984
Michael George Milne, *Diego Durán: Historia de las Indias de Nueva España*, Ann Arbor, 1984

MONGNE 1994
Pascale Mongne, 'La Messe de Saint Grégoire du Musée d'Auch', *Revue du Louvre*, nos 5–6, 1994, pp. 38–47

MONJARÁS-RUIZ 1987
Mitos cosmogónicos del México indígena, Jesús Monjarás-Ruiz (ed.), Mexico City, 1987

MONTERROSA 1967
Mariano Monterrosa, 'Cruces del siglo XVI', *Boletín del INAH*, 30, 1967, pp. 16–19

MOORE 1981
Henry Moore, *Henry Moore at the British Museum*, London, 1981

MORENO DE LOS ARCOS 1967
Roberto Moreno de los Arcos, 'Los cinco soles cosmogónicos', *Estudios de Cultura Náhuatl*, 7, 1967, pp. 183–210

MÜLHLENPFORDT 1844
D. T. Mülhlenpfordt, *Intento de una descripción exacta de la República de México*, Hanover, 1844

MÜLLER 1970
Florencia Müller, 'La cerámica de Cholula', in *Proyecto Cholula*, Ignacio Marquina (ed.), Mexico City, 1970, pp. 129–42

MUNICH 1958
Präkolumbische Kunst aus Mexiko und Mittelamerika, exh. cat., Haus der Kunst, Munich, 1958

MUNICH 1968
Altamerikanische Kunst: Mexico-Peru, Andreas Lommel (ed.), exh. cat., Staatliches Museum für Völkerkunde, Munich, 1968

MUNICH 2001
Gold: Magie, Mythos, Macht – Gold der Alten und Neuen Welt, Ludwig Wamser and Rupert Gebhard (eds), exh. cat., Archäologische Staatssammlung: Museum für Vor– und Frühgeschichte, Munich, 2001

MUÑOZ CAMARGO 1981
Diego Muñoz Camargo, *Descripción de la ciudad y provincia de Tlaxcala de las Indias y del Mar Océano para el buen gobierno y ennoblecimiento dellas*, René Acuña (ed.), Mexico City, 1981

MUÑOZ CAMARGO 1984
Diego Muñoz Camargo, *Descripción de la ciudad y provincia de Tlaxcala, Relaciones geográficas del siglo XVI, Tlaxcala*, vol. 1, Mexico City, 1984

NALDA AND LÓPEZ CAMACHO 1995
Enrique Nalda and Javier López Camacho, 'Investigaciones arqueológicas en el sur de Quintana Roo', *Arqueología Mexicana*, 14, 1995, pp. 12–27

NAVARRETE 1968
Carlos Navarrete, 'Dos deidades de las aguas, modeladas en resina de árbol', *Boletín del INAH*, 33, 1968, pp. 39–42

NAVARRETE 1995
Carlos Navarrete, 'Anotaciones sobre el reuso de piezas durante el Postclásico mesoamericano', *Utz'ib*, 3, 1995, pp. 22–26

NAVARRETE AND CRESPO 1971
Carlos Navarrete and Ana María Crespo, 'Un atlante mexica y algunas consideraciones sobre los relieves del Cerro de la Malinche, Hidalgo', *Estudios de Cultura Náhuatl*, 9, 1971, pp. 11–15

NEBEL 1963
Carlos Nebel, *Viaje pintoresco y arqueológico sobre la parte más interesante de la República Mexicana, en los años transcurridos desde 1829 hasta 1834*, 2nd edition, Mexico City, 1963

NEW YORK 1940
Alfonso Caso, Antonio Castro Leal, Miguel Covarrubias, Roberto Montenegro and Manuel Toussaint, *Twenty Centuries of Mexican Art*, exh. cat., Museum of Modern Art, New York, 1940; published in conjunction with the Instituto Nacional de Antropología e Historia, Mexico City

NEW YORK 1970
Before Cortés: Sculpture of Middle America, Elizabeth Kennedy Easby and John F. Scott (eds), exh. cat., The Metropolitan Museum of Art, New York, 1970

NEW YORK 1976
Aztec Stone Sculpture, Esther Pasztory (ed.), exh. cat., Center for Inter-American Relations, New York, 1976

NEW YORK 1983
The Vatican Collections: The Papacy and Art, exh. cat., The Metropolitan Museum of Art, New York, 1983

NEW YORK 1990
Mexico: Splendors of Thirty Centuries, John P. O'Neill and Kathleen Howard (eds), exh. cat., The Metropolitan Museum of Art, New York, 1990; San Antonio Museum of Art; Los Angeles County Museum of Art

NICHOLSON 1955
Henry B. Nicholson, 'Native Historical Traditions of Nuclear America and the Problem of Their Archaeological Correlation', *American Anthropologist*, 57, 1955, pp. 594–613

NICHOLSON 1971
Henry B. Nicholson, 'Major Sculpture in Pre-Hispanic Central Mexico City', in Ekholm and Bernal 1971, pp. 92–134

NICHOLSON 1971B
Henry B. Nicholson, 'Religion in Pre-Hispanic Central Mexico', in Ekholm and Bernal 1971, pp. 395–446

NICHOLSON 1979
Henry B. Nicholson, 'Correlating Mesoamerican Historical Traditions with Archaeological Sequence: Some Methodological Considerations', in *Actes du XLIIe Congrès International des Américanistes, 1976*, Paris, 1979, pp. 187–98

NICHOLSON 1988
Henry B. Nicholson, 'The Iconography of the Deity Representations in Fray Bernardino de Sahagún's *Primeros Memoriales*: Huitzilopochtli and Chalchiuhtlicue', in *The Work of Bernardino de Sahagún, Pioneer Ethnographer of Sixteenth-century Aztec Mexico*, Jorge Klor de Alva, Henry B. Nicholson and Eloise Quiñones Keber (eds), New York, 1988, pp. 229–53

NICHOLSON 1991
Henry B. Nicholson, 'The *Octli* Cult in Late Pre-Hispanic Central Mexico', in *To Change Place: Aztec Ceremonial Landscape*, David Carrasco (ed.), Niwot, 1991, pp. 158–87

NICHOLSON 2001
Henry B. Nicholson, *Topiltzin Quetzalcoatl. The Once and Future Lord of the Toltecs*, Boulder, 2001

NOGUERA 1954
Eduardo Noguera, *La cerámica arqueológica de Cholula*, Mexico City, 1954

NOWOTNY 1959
Karl Anton Nowotny, *Americana*, Archiv für Völkerkunde, vol. 14, Vienna, 1959

NOWOTNY 1960
Karl Anton Nowotny, *Mexikanische Kostbarkeiten aus Kunstkammern der Renaissance*, Vienna, 1960

NOWOTNY 1961
Karl Anton Nowotny, *Americana*, Archiv für Völkerkunde, vol. 16, Vienna, 1961

NUREMBERG 1992
Focus Behaim Globus, exh. cat., Germanisches Nationalmuseum, Nuremberg, 2 vols, 1992

NUREMBERG 1993
Ludwigs Lust: Die Sammlung Irene und Peter Ludwig, Michael Eissenhauer (ed.), exh. cat., Germanisches Nationalmuseum, Nuremberg, 1993

OLIVIER 1997
Guilhem Olivier, *Moqueries et métamorphose d'un dieu aztèque. Tezcatlipoca, le 'Seigneur au miroir fumant'*, Paris, 1997

OLMEDO VERA 2001
Bertina Olmedo Vera, 'Mezcala', in *The Oxford Encyclopaedia of Mesoamerican Cultures*, David Carrasco (ed.), Oxford and New York, 2001, vol. 2, pp. 303–05

OLMEDO VERA 2002
Bertina Olmedo Vera, *Los templos rojos del recinto sagrado de Tenochtitlan*, Mexico City, 2002

OMAN 1968
Charles Oman, *The Golden Age of Hispanic Silver 1400–1665*, London, 1968

PARIS 1928
Les Arts anciens de l'Amérique: exposition organisée au Musée des Arts Décoratifs, exh. cat., Palais du Louvre, Paris, 1928

PARIS 1981
Mexique d'hier et d'aujourd'hui: découverte du Templo Mayor de Mexico; artistes contemporains, exh. cat., Ministère des Relations Extérieures, Paris, 1981

PARIS 2000
Esther Acevedo, Teresa del Conde, Eloísa Uribe Hernández, Jacques Lafaye, Carlos Monsiváis, Efraín Castro Morales and Salvador Rueda Smithers, *Soleils mexicains*, exh. cat., Petit Palais, Musée des Beaux-Arts de la Ville de Paris, 2000

PARSONS 1980
Lee Parsons, *Pre-Columbian Art*, New York, 1980

PASZTORY 1983
Esther Pasztory, *Aztec Art*, New York, 1983

PAZ 1989
Octavio Paz, *Los privilegios de la vista. Arte de México*, Mexico City, 1989

PEÑAFIEL 1910
Antonio Peñafiel, *Descripción del Templo Mayor de México antiguo*, Mexico City, 1910

PHILADELPHIA 1954
George Kubler, *The Louise and Walter Arensberg Collection of Pre-Columbian Sculpture*, exh. cat., Philadelphia Museum of Art, 1954

PIJOÁN 1946
José Pijoán, *Arte precolombino, mexicano y maya, Summa Artis: historia general del arte*, vol. 10, Madrid, 1946

PIÑA CHAN 1982
Román Piña Chan, *Los olmecas antiguos*, Mexico City, 1982

POHL 2002
John M. D. Pohl, 'Narrative Art, Craft Production, and Gift Economy in Postclassic Oaxaca and Related Areas of Mexico: Workbook for the Advanced Mixtec Class, Mixtec Workshop at the Maya Meetings, University of Texas', Austin, 2002

POLACO AND GUZMÁN 2001
Óscar Polaco and Ana Fabiola Guzmán, *Los peces arqueológicos de la ofrenda 23 del Templo Mayor*, Mexico City, 2001

PORTER 1948
Muriel N. Porter, 'Pipas precortesianas', *Acta Antropológica*, vol. 3/2, Mexico City, 1948

PREM AND DYCKERHOFF 1986
Hanns J. Prem and Ursula Dyckerhoff, *El antiguo México*, Esplugues de Llobregat, 1986

PROSKOURIAKOFF 1974
Tatiana Proskouriakoff, *Jades from the Cenote of Sacrifice, Chichén Itzá, Yucatan*, Cambridge, Mass., 1974

PURCHAS 1624
Samuel Purchas, *Haklvtvs Posthvmvs; or Pvrchas his Pilgrimes. Contayning a History of the World, in Sea Voyages & lande Travells, by Englishmen & others. Wherein Gods Wonders in Nature & Providence, The Actes, Arts, Varieties & Vanities of Men, vⁱᵗʰ a world of the Worlds Rarities are by a world of Eyewitnesse-Authors, Related to the World. Some left written by Mr Hakluyt at his death & perfected. All examined, abreviated, Illvftrated vⁱᵗʰ Notes, Enlarged vⁱᵗʰ Difcourses Adorned vⁱᵗʰ pictures, and Exprefsed in Mapps. In fower Parts Each containing five Bookes*, London, 1624; *Pvrchas his Pilgrimes in Five Bookes…*, London, 1625

QUIÑONES KEBER 1993
Eloise Quiñones Keber, 'Quetzalcoatl as Dynastic Patron: The "Acuecuexatl Stone" Reconsidered', in *The Symbolism in the Plastic and Pictorial Representations of Ancient Mexico: A Symposium of the 46th International Congress of Americanists, Amsterdam, 1988*, Jacqueline de Durand-Forest and Marc Eisinger (eds), Bonn, 1993, pp. 149–55

RAMÍREZ 1844–46
José Fernando Ramírez, 'Descripción de cuatro lápidas monumentales conservadas en el Museo Nacional de México, seguida de un ensayo sobre su interpretación', in *Historia de la conquista de México de William H. Prescott*, Mexico City, 1844–46, pp. 106–24

RAMÍREZ 1864
José Fernando Ramírez, 'Antigüedades mexicanas conservadas en el Museo Nacional de México', in *México y sus Alrededores*, 2nd edition, Mexico, 1864, pp. 48–57

RAMSEY 1975
James Ramsey, 'An Analysis of Mixtec Minor Art, with a Catalogue', 2 vols, PhD thesis, Tulane University, New Orleans, 1975

RATHJE 1973
William L. Rathje, 'El descubrimiento de un jade olmeca en la isla de Cozumel, Quintana Roo, México', *Estudios de Cultura Maya*, 9, 1973, pp. 85–91

REYERO 1978
Manuel Reyero, *Fundación Cultural Televisa: Colección prehispánica*, Mexico City, 1978

RIGOLI 1992
A. Rigoli, *Due 'Mondi' a confronto*, Milan, 1992

ROBERTSON 1959
Donald Robertson, *Mexican Manuscripts of the Early Colonial Period: The Metropolitan Schools*, New Haven, 1959

ROBERTSON 1968
Donald Robertson, 'Paste-over Illustration in the Durán Codex of Madrid', *Tlalocan*, 5, 1968, pp. 340–48

ROMANCES DE LOS SEÑORES 1964
Romances de los Señores de Nueva España, Ángel María Garibay Kintana (trans.), Mexico City, 1964

ROME 1960
Arte Precolombiana del Messico e dell'America Centrale, exh. cat., Centro di Azione Latina, Rome, 1960

ROMERO 1982
Erica Romero, 'Evidencias post-teotihuacanas en el lado este de la Ciudadela', in *Teotihuaca 80–82, primeros resultados*, Rubén Cabrera Castro et al. (eds), Mexico City, 1982, pp. 149–54

ROUSSELL 1957
The National Museum of Denmark, Aage Roussell (ed.), Copenhagen, 1957

SAHAGÚN 1905
Bernardino de Sahagún, *Historia general de las cosas de Nueva España*, Francisco del Paso y Troncoso (ed.), vol. 5, Madrid, 1905

SAHAGÚN 1950–82
Bernardino de Sahagún, *Florentine Codex: A General History of the Things of New Spain, Books 1–12*, Arthur J. O. Anderson and Charles E. Dibble (trans. and eds), Santa Fe, 1950–82

SAHAGÚN 1979
Bernardino de Sahagún, *Códice florentino. Historia general de las cosas de Nueva España*, facsimile, 3 vols, Mexico City, 1979

SAHAGÚN 1988
Bernardino de Sahagún, *Historia General de las cosas de Nueva España*, with introduction, glossary and notes by Alfredo López Austin and Josefina García Quintana, 2 vols, Madrid, 1988

SAHAGÚN 2000
Bernardino de Sahagún, *Historia general de las cosas de Nueva España*, Mexico City, 2000

SANDERS, PARSONS AND SANTLEY 1979
William T. Sanders, Jeffrey R. Parsons and Robert S. Santley, *The Basin of Mexico: Ecological Processes in the Evolution of Civilization*, New York and San Francisco, 1979

SANDOVAL 1945
Fernando B. Sandoval, 'La relación de la conquista de México en la Historia de Fray Diego Durán', in *Estudios de Historiografía de la Nueva España*, Mexico City, 1945, pp. 51–90

SAN FRANCISCO 1993
Teotihuacan: Art from the City of the Gods, Kathleen Berrin and Esther Pasztory (eds), exh. cat., Fine Arts Museums of San Francisco, 1993

SANTA BARBARA 1942
Maurice Ries, *Ancient American Art, 500 BC – AD 1500, The Catalog of an Exhibition of the Art of the Pre-European Americas*, exh. cat., Santa Barbara Museum of Art, 1942

SANTA BARBARA 1992
Cambios: The Spirit of Transformation in Spanish Colonial Art, Gabrielle Palmer and Donna Pierce, exh. cat., Santa Barbara Museum of Art, 1992

SAUNDERS 1998
Icons of Power: Feline Symbolism in the Americas, Nicholas J. Saunders (ed.), London, 1998

SAUNDERS 2001
Nicholas J. Saunders, 'A Dark Light: Reflections on Obsidian in Mesoamerica', *World Archaeology*, 33, 2, 2001, pp. 220–36

SAUNDERS FORTHCOMING
Nicholas J. Saunders, *Mirrors, Aras and Tezcatlipoca: Obsidian Sorcery in a Colonial Landscape*, forthcoming

SAVILLE 1922
Marshall H. Saville, *Turquoise Mosaic Art in Ancient Mexico*, Indian Notes and Monographs, no. 8, Museum of the American Indian, Heye Foundation, New York, 1922

SÉJOURNÉ 1966
Laurette Séjourné, *Arqueología de Teotihuacan, la cerámica*, Mexico City and Buenos Aires, 1966

SELER 1960–61
Eduard Seler, *Gesammelte Abhandlungen zur Amerikanischen Sprach- und Altertumskunde*, 2nd edition, 5 vols, Graz, 1960-61

SELER 1996
Eduard Seler, 'The Animal Pictures of the Mexican and Maya Manuscripts', in Idem, *Collected Works in Mesoamerican Linguistics and Archaeology*, vol. 5, Lancaster, California, pp. 167–340

SERNA ET AL. 1953
Jacinto de la Serna et al., *Tratado de las idolatrías, supersticiones, dioses, ritos, hechicerías y otras costumbres gentílicas de las razas aborígenes*, 1687; 2 vols, Mexico City, 1953

SERRA PUCHE 1994
Mari Carmen Serra Puche, 'Objetos de Obsidiana y otros cristales en el México antiguo', in *Cristales y obsidiana prehispánicos*, Mari Carmen Serra Puche and Felipe Solís Olguín (eds), Mexico City, 1994, pp. 73–216

SEVILLE 1997
Tesoros de México, Paulino Castañeda, Antonio-Miguel Bernal, Felipe Solís Olguín, Martha Carmona, Alma Montero and Pedro Bazán (eds), exh. cat., Real Monasterio de San Clemente, Seville, 1997

SHELTON 1989
Anthony A. Shelton, 'An Aztec Cihuateotl Discovered in Scotland', *Apollo*, vol. 129, no. 326, 1989, pp. 261–62

SHELTON 1992
Anthony A. Shelton, *Anthropology, Art and Aesthetics*, Jeremy Coote (ed.), Oxford, 1992

SHELTON 1994
Anthony A. Shelton, 'Cabinets of Transgression: Renaissance Collections and the Incorporation of the New World', in *The Cultures of Collecting*, John Elsner and Roger Cardinal (eds), London, 1994, pp. 177–203

SMITH 1996
Michael E. Smith, *The Aztecs*, Oxford, 1996

SMITH AND RUPPERT 1953
A. L. Smith and Karl Ruppert, 'Excavations in House Mounds at Mayapán: II', *Current Reports of the Carnegie Institution of Washington*, 1, 1953, pp. 180–206

SOCIETY OF ANTIQUARIES OF LONDON 1844
Archaeologia: or, Miscellaneous Tracts Relating to Antiquity, vol. 30, Society of Antiquaries of London, 1844

SOLÍS OLGUÍN 1981
Felipe Solís Olguín, *Catálogo de escultura del Castillo de Teayo, Veracruz, México*, Mexico City, 1981

SOLÍS OLGUÍN 1982
Felipe Solís Olguín, 'The Formal Pattern of Anthropomorphic Sculpture and the Ideology of the Aztec State', in *The Art and Iconography of Late Post-Classic Central Mexico*, Washington DC, 1982, pp. 73–110

SOLÍS OLGUÍN 1991
Felipe Solís Olguín, *Gloria y fama de México Tenochtitlan*, Mexico City, 1991

SOLÍS OLGUÍN 1991B
Felipe Solís Olguín, *Tesoros artísticos del Museo Nacional de Antropología*, Mexico City, 1991

SOLÍS OLGUÍN 1992
Felipe Solís Olguín, 'El Centro de Veracruz', in *Museo de Antropología de Jalapa*, Mexico City, 1992, pp. 76–161

SOLÍS OLGUÍN 1993
Felipe Solís Olguín, 'Aztekische Steinplastik', in *Die Sammlung vorspanischer Kunst und Kultur aus Mexiko im Museum für Völkerkunde, Berlin*, Veröffentlichung des Museums für Völkerkunde Berlin, n.s., 57; *Abteilung Amerikanische Archäologie*, vol. 7, Berlin, 1993, pp. 66–81

SOLÍS OLGUÍN 1997
Felipe Solís Olguín, 'Un hallazgo olvidado: relato e interpretación de los descubrimientos arqueológicos del predio de la calle de Guatemala núm. 12, en el Centro Histórico de la Ciudad de México, en 1944', in *Homenaje al doctor Ignacio Bernal*, Leonardo Manrique and Noemí Castillo Tejero (eds), Mexico City, 1997, pp. 81–93

SOLÍS OLGUÍN 2000
Felipe Solís Olguín, 'La Piedra del Sol', *Arqueología Mexicana*, 7, 41, January–February 2000, pp. 32–39

SOLÍS OLGUÍN 2001
Felipe Solís Olguín, 'La época mexica revelada por los estudios arqueológicos', in *Mexico City 2001*, pp. 333–67

SOLÍS OLGUÍN FORTHCOMING
Felipe Solís Olguín, 'La imagen de Ténoch en los monumentos conmemorativos de la capital azteca', in *Acercase y mirar. Homenaje a la Dra. Beatriz de la Fuente*, Mexico City, forthcoming

SOLÍS OLGUÍN AND CARMONA 1995
Felipe Solís Olguín and Martha Carmona, *El oro precolombino de México*, Mexico City, 1995

SOLÍS OLGUÍN AND MORALES GÓMEZ 1991
Felipe Solís Olguín and David Morales Gómez, *Rescate de un rescate: colección de objetos arqueológicos de El Volador, Ciudad de México*, Mexico City, 1991

SOTHEBY AND WILKINSON 1859
S. Leigh Sotheby and John Wilkinson, *Catalogue of the Extensive Collection of Assyrian, Babylonian, Egyptian, Greek, Etruscan, Roman, Indian, Peruvian, Mexican, and Chinese Antiquities and Articles of Vertu Formed by B. Hertz, Corresponding Member of the Archaeological Institute at Rome, with the Prices and Purchasers' Names; Preceded by the Descriptive Analysis, Published in the Berlin Archaeologische Zeitung by E. Gerhard*, London, 1859

SOUSTELLE 1940
Jacques Soustelle, *La Pensée cosmologique des anciens mexicains. Représentations du monde et de l'espace*, Paris, 1940

SOUSTELLE 1969
Jacques Soustelle, *El arte del México antiguo*, Barcelona, 1969

SPAGNESI 1993
Enrico Spagnesi, 'Bernardino da Sahagún, la natura in Messico, l'arte a Firenze', *Quaderni di Neotropica*, 1, 1993, pp. 7–24

STEINHAUER 1862
Carl Ludwig Steinhauer, *Catalogue of a Collection of Ancient and Modern Stone Implements, and of Other Weapons, Tools and Utensils of the Aborigines of Various Countries in the Possession of Henry Christy*, London, 1862

STEPHENS AND CATHERWOOD 1844
John Lloyd Stephens and Frederick Catherwood, *Views of Ancient Monuments in Central America, Chiapas and Yucatan*, London, 1844

STEPHENS AND CATHERWOOD 1854
John Lloyd Stephens and Frederick Catherwood, *Incidents of Travel in Central America, Chiapas and Yucatan…Illustrated by Numerous Engravings…Twelfth Edition*, London, 1854

STOCKING 1985
George W. Stocking Jr, 'Essays on Museum and Material Culture', in *Objects and Others: Essays on Museum and Material Culture*, George W. Stocking Jr (ed.), Madison, 1985, pp. 3–14

SWANSEA 1988
Eduardo Paolozzi, *Lost Magic Kingdoms and Six Paper Moons: An Exhibition Created by Eduardo Paolozzi for the Museum of Mankind and Toured by the South Bank Centre*, exh. cat., Glynn Vivian Art

Gallery, Swansea, 1988;
Birmingham City Art Gallery;
Graves Art Gallery, Sheffield;
York City Art Gallery; Bolton
Museum and Art Gallery;
Leeds City Art Gallery

TALADOIRE 1981
Eric Taladoire, *Les Terrains de
Jeu de Balle (Mésoamérique et
Sud-ouest des Etats-Unis)*, in
Etudes Mesoaméricaines, 2, 4,
Mission Archéologique et
Ethnologique Française au
Mexique, Mexico City, 1981

TAUBE 1993
Karl A. Taube, 'The Bilimek
Pulque Vessel: Starlore,
Calendrics and Cosmology
of Late Postclassic Central
Mexico', *Ancient Mesoamerica*,
4, 1, 1993, pp. 1–15

TENA 1987
Rafael Tena, *El calendario
mexica y la cronografía*, Mexico
City, 1987

THOMAS 1993
Hugh Thomas, *The Conquest of
Mexico*, London, 1993

THOMAS 2000
Hugh Thomas, *Who's Who of
the Conquistadors*, London,
2000

**TONALAMATL DE LOS POCHTECAS
1985**
*Tonalamatl de los pochtecas
(Códice Fejérváry-Mayer)*, Miguel
León-Portilla (ed.), Mexico
City, 1985

TOORIANS 1994
Lauran Toorians,
'The Earliest Inventory of
Mexican Objects in Munich,
1572', *Journal of the History of
Collections*, 6, 1, 1994,
pp. 59–67

**TORRES MONTES AND FRANCO
VELÁZQUEZ 1989**
Luis Torres Montes and
Francisca Franco Velázquez,
'La orfebrería prehispánica en
el Golfo de México y el
tesoro del pescador', in
Aguilar et al. 1989,
pp. 219–70

TOSCANO 1940
Salvador Toscano, *Arte y
arqueología en México, hallazgos
en 1940*, 2, 6, *Anales del Instituto
de Investigaciones Estéticas,
Universidad Autónoma de
México*, Mexico City, 1940

TOUSSAINT 1948
Manuel Toussaint,
Arte colonial en México, Mexico
City, 1948

TOUSSAINT 1982
Manuel Toussaint, *Pintura
colonial en México*, Mexico City,
1982

TOUSSAINT 1983
Manuel Toussaint, *Paseos
coloniales*, Mexico City, 1983

**TOUSSAINT, GÓMEZ DE OROZCO AND
FERNÁNDEZ 1938**
Manuel Toussaint, Federico
Gómez de Orozco and
Justino Fernández, *Planos de
la Ciudad de México, Siglos XVI
y XVII*, Instituto de
Investigaciones Estéticas,
Universidad Autónoma de
México, Mexico City, 1938

TOVAR 1951
Juan de Tovar, *The Tovar
Calendar: An Illustrated Mexican
Manuscript, c. 1585*, facsimile,
George Kubler and Charles
Gibson (eds), New Haven,
1951

TOVAR 1972
Juan de Tovar, *Manuscrit
Tovar: origines et croyances des
Indiens du Mexique*, facsimile,
Jacques Lafaye (ed.), Graz,
1972

TOWNSEND 1979
Richard F. Townsend, *State
and Cosmos in the Art of
Tenochtitlan*, Studies in
Pre-Columbian Art and
Archaeology, vol. 20,
Dumbarton Oaks,
Washington DC, 1979

TOWNSEND 1982
Richard F. Townsend,
'Malinalco and the Lords of
Tenochtitlan,' in *The Art and
Iconography of Late Postclassic
Central Mexico*, Elizabeth H.
Boone (ed.), Dumbarton
Oaks, Washington DC, 1982,
pp. 111–40

TOWNSEND 1987
Richard F. Townsend,
'Coronation at Tenochtitlan,'
in *The Aztec Templo Mayor*,
Elizabeth H. Boone (ed.),
Dumbarton Oaks,
Washington DC, 1987,
pp. 371–410

TOWNSEND 1992
Richard F. Townsend,
The Aztecs, London and
New York, 1992

TOWNSEND 2000
Richard F. Townsend,
The Aztecs, London and
New York, revised edition,
2000

TOWNSEND 2000B
Richard F. Townsend, 'The
Renewal of Nature at the
Temple of Tlaloc', in *The
Ancient Americas: Art from
Sacred Landscapes*, exh. cat.,
Richard F. Townsend (ed.),
Art Institute of Chicago,
2000, pp. 171–86

UMBERGER 1981
Emily Good Umberger,
*Aztec Sculptures, Hieroglyphics
and History*, Ann Arbor, 1981

UMBERGER 1987
Emily Good Umberger,
'Antiques, Revivals, and
References to the Past in
Aztec Art', *Res: Anthropology
and Aesthetics*, 13, 1987,
pp. 63–106

URIARTE 1994
Teresa Uriarte, 'Teotihuacan:
el legado de la ciudad de los
dioses', in *México en el Mundo
de las Colecciones de Arte:
Mesoamérica I*, María Luisa
Saban García (ed.), Mexico
City, 1994, pp. 70–129

VAILLANT 1941
George Vaillant, *The Aztecs of
Mexico*, New York, 1941

VARGAS 1989
Ernesto Vargas, *Las máscaras
de la cueva de Santa Ana
Teloxtoc*, Mexico City, 1989

VEGA SOSA 1975
Constanza Vega Sosa, *Forma y
decoración en las vasijas de
tradición azteca*, Mexico City,
1975

VELÁZQUEZ CASTRO 1999
Adrián Velázquez Castro,
*Tipología de los objetos de concha
del Templo Mayor de Tenochtitlan*,
Mexico City, 1999

VELÁZQUEZ CASTRO 2000
Adrián Velázquez Castro,
*Simbolismo de los objetos de concha
encontrados en las ofrendas del
Templo Mayor de Tenochtitlan*,
INAH, Colección Científica,
Serie Arqueología, Mexico
City, 2000

VIENNA 1992
*Das Altertum der Neuen Welt:
Voreuropäische Kulturen
Amerikas*, exh. cat., Museum
für Völkerkunde, Vienna,
1992

VIENNA 1997
*Gold und Silber aus Mexiko:
Präkolumbisches Gold und
koloniales Silber aus dem
anthropologischen
Nationalmuseum und anderen
bedeutenden Sammlungen
Mexikos*, Wilfried Seipel (ed.),
exh. cat., Kunsthistorisches
Museum, Vienna, 1997

VIENNA 2000
*Kaiser Karl V (1500–1558): Macht
und Ohnmacht Europas*,
Wilfried Seipel (ed.), exh. cat.,
Kunsthistorisches Museum,
Vienna, 2000

VIENNA 2001
*Die Entdeckung der Welt,
Die Welt der Entdeckungen:
Österreichischer Forscher, Sammler,
Abenteuer*, Wilfried Seipel
(ed.), exh. cat.,
Kunsthistorisches Museum,
Vienna, 2001

VOLLMER 1981
Günter Vollmer (ed.),
*Geschichte der Azteken: Der
Codex Aubin und verwandte
Dokumente*, Berlin, 1981

WALDECK 1866
Jean Frédéric de Waldeck,
*Monuments anciens du Mexique:
Palenque et autres ruines de
l'ancienne civilisation du Mexique;
Collection de vues, bas-reliefs,
morceaux d'architecture, coupes,
vases, terres cuites, cartes et plan –
Dessinés d'après nature et relevés
par M. de Waldeck*, Paris, 1866

WASHINGTON 1947
Robert Woods Bliss,
*Indigenous Art of the Americas:
Collection of Robert Woods Bliss*,
exh. cat., National Gallery of
Art, Washington DC, 1947

WASHINGTON 1983
*Art of Aztec Mexico: Treasures
of Tenochtitlan*, Henry B.
Nicholson and Eloise
Quiñones Keber (eds), exh.
cat., National Gallery of Art,
Washington DC, 1983

WASHINGTON 1991
*Circa 1492: Art in the Age of
Exploration*, Jay A. Levenson
(ed.), exh. cat., National
Gallery of Art, Washington
DC, 1991

WASSON 1983
Gordon Wasson, *El hongo
maravilloso: Teonanácatl*,
Mexico City, 1983

WEIDITZ 2001
Christoph Weiditz, *El Códice
de los trajes/ Trachtenbuch*,
facsimile, 2 vols, Valencia,
2001

WESTHEIM 1962
Paul Westheim, *La cerámica del
México antiguo, fenómeno artístico*,
Mexico City, 1962

WESTHEIM ET AL. 1969
Paul Westheim, Alberto Ruz,
Pedro Armillas, Ricardo de
Robina and Alfonso Caso,
*Cuarenta siglos de plástica
mexicana, arte prehispánico*,
Mexico City, 1969

WETHERELL 1842
John Wetherell, *Catálogo de
una colección de antigüedades
mejicanas con varios idolos,
adornos, y otros artefactos de los
indios, que ecsiste en poder de Don
Juan Wetherel*, Seville, 1842

WINNING 1987
Hasso von Winning,
*La iconografía de Teotihuacan:
los dioses y los signos*, 2 vols,
Mexico City, 1987

WOLF 1999
Eric R. Wolf, *Envisioning
Power*, Berkeley, 1999

WOODWARD AND LEWIS 1998
David Woodward and
Malcolm G. Lewis,
The History of Cartography,
Chicago, 1998, vol. 2, book 3,
pp. 183–247

YOUNG 1855
Charles Bedford Young,
*Descriptive Catalogue of the
Collection of Mexican Antiquities
now Exhibiting at No. 57,
Pall Mall*, Leamington, 1855

YOUNG-SÁNCHEZ 1993
Margaret Young-Sánchez,
'Figurine of a Warrior',
*Bulletin of the Cleveland Museum
of Art*, 80, 4, 1993, pp. 144–47

YOUNG-SÁNCHEZ 1996
Margaret Young-Sánchez,
'An Aztec gold warrior
figurine (from the Cleveland
Museum)', *Res: Anthropology
and Aesthetics*, 29–30, 1996,
pp. 102–26

ZANTWIJK 1985
Rudolph van Zantwijk,
*The Aztec Arrangement: The
Social History of Pre-Spanish
Mexico*, Norman, 1985

ZANTWIJK 1994
Rudolf van Zantwijk,
*Zegevierend met de Zon: Duizend
jaar Azteekse gedichten en
gedachten*, Amsterdam, 1994

**ZANTWIJK, RIDDER AND BRAAKHUIS
1990**
*Mesoamerican Dualism.
Dualismo mesoamericano*, Rudolf
van Zantwijk, Rob de Ridder
and Edwin Braakhuis (eds),
Utrecht, 1990

LIST OF LENDERS

AUCH
Musée des Jacobins

BASLE
Museum der Kulturen Basel

BELFAST
Ulster Museum

BERLIN
Staatliche Museen zu Berlin:
Preußischer Kulturbesitz,
Ethnologisches Museum

BOLOGNA
Biblioteca Universitaria

BRUSSELS
Musées Royaux d'Art et
d'Histoire

CAMBRIDGE, MASS.
Peabody Museum of
Archaeology and Ethnology,
Harvard University

CHICAGO
The Art Institute of Chicago
The Field Museum of Natural
History

CLEVELAND
Cleveland Museum of Art

COLOGNE
Rautenstrauch-Joest-Museum für
Völkerkunde

COPENHAGEN
The National Museum
of Denmark

EL ESCORIAL
Monasterio de San Lorenzo
de El Escorial

FLORENCE
Biblioteca Medicea Laurenziana
Biblioteca Nazionale Centrale
di Firenze
Museo degli Argenti

GLASGOW
University Library

HAMBURG
Museum für Völkerkunde
Hamburg

HELSINKI
Didrichsen Art Foundation

JALAPA
Museo de Antropología de Jalapa

LIVERPOOL
Liverpool Museum

LONDON
British Museum
Victoria and Albert Museum

LOS ANGELES
Los Angeles County Museum
of Art
Fowler Museum of Cultural
History, UCLA

MADRID
Biblioteca Nacional

MANNHEIM
Völkerkundlichen Sammlungen
der Stadt Mannheim im
Reiss-Museum

MEXICO CITY
Fundación Televisa
Museo Nacional de Antropología
Museo Templo Mayor
Museo Universitario de Ciencias
y Arte, Universidad Nacional
Autónoma de México

MUNICH
Schatzkammer der Residenz
München
Staatliches Museum für
Völkerkunde

NEW HAVEN
Peabody Museum of Natural
History, Yale University

NEW YORK
American Museum of Natural
History
Brooklyn Museum of Art
Metropolitan Museum of Art

NUREMBERG
Germanisches Nationalmuseum
Museen der Stadt Nürnberg

OAXACA
Museo de las Culturas de Oaxaca

OXFORD
Bodleian Library

PARIS
Bibliothèque Nationale
de France
Musée de l'Homme

PHILADELPHIA
Philadelphia Museum of Art

PRINCETON
The Henry and Rose Pearlman
Foundation, Princeton
University Art Museum

PROVIDENCE
The John Carter Brown Library,
Brown University

PUEBLA
Museo Regional de Antropología
de Puebla

ROME
Museo Nazionale Preistorico
ed Etnografico 'Luigi Pigorini'

SAINT LOUIS
The Saint Louis Art Museum

ST PETERSBURG
The State Hermitage Museum

TEOTENANGO
Museo Arqueológico del Estado
de México 'Dr Román Piña
Chan'

TEOTIHUACAN
Museo de la Pintura Mural
Teotihuacana

TEPOTZOTLAN
Museo Nacional del Virreinato

TLAXCALA
Museo Regional de Tlaxcala

TOLUCA
Instituto Mexiquense de Cultura:
Museo de Antropología
e Historia del Estado de
México

TULA
Museo de Sitio de Tula

TURIN
Museo Civico d'Arte Antica,
e Palazzo Madama

VATICAN CITY
Biblioteca Apostolica Vaticana
Museo Missionario Etnografico

VERACRUZ
Museo Baluarte de Santiago

VIENNA
Museum für Völkerkunde

VILLAHERMOSA
Museo Regional de Antropología
Carlos Pellicer

WASHINGTON
Dumbarton Oaks Pre-Columbian
Collection

PHOTO CREDITS

All works of art are reproduced by kind permission of the owners. Special acknowledgements for providing photographs are as follows:

AUCH
Musée des Jacobins, cat. 325

BASEL
© Museum der Kulturen/Peter Horner, cats 45, 92, 149, 205, 230, 248

BELFAST
© Ulster Museum. Photograph reproduced with the kind permission of the Trustees of the Museums & Galleries of Northern Ireland, cat. 350

BERLIN
© Bildarchiv Preussischer Kulturbesitz/Martin Franken, 2002, cats 47, 104, 146, 208, 218, 289; Dietrich Graf, cats 219, 316; W. Schneider-Schütz, cats 109, 112, 168, 199

BOLOGNA
Biblioteca Universitaria, Bologna/Roncaglia, Modena, cat. 340

BRISTOL
Bristol Museums and Art Gallery, fig. 71

BRUSSELS
Musées royaux d'art et d'histoire/Raymond Mommaerts, cats 77, 298

CAMBRIDGE (MA)
© The President and Fellows of Harvard College, cat. 254

CHICAGO
© 2002 The Field Museum/Diane Alexander White, cats 3, 14
© The Art Institute of Chicago. All Rights Reserved, cat. 226
Newberry Library, fig. 8

CLEVELAND
© The Cleveland Museum of Art, cats 107, 186

COLOGNE
Rautenstrauch-Joest-Museum of Anthropology, cats 84, 103

COPENHAGEN
© The National Museum of Denmark, Department of Ethnography/John Lee, cat. 297

FLORENCE
Microfoto s.r.l./Alberto Scardigli, cat. 344
su concessione del Ministero dei Beni e le Attività Culturali. Biblioteca Nazionale Centrale/Microfoto s.r.l., cat. 342; Museo degli Argenti/Studio Fotografico Quattrone, cat. 12

GLASGOW
Glasgow University Library, Department of Special Collections, cat. 356; fig. 62

LIVERPOOL
© The Board of Trustees, National Museums & Galleries on Merseyside, Liverpool Museum, cat. 341; fig. 54

LONDON
The Art Archive/Dagli Orti, figs 2, 10, 42, 44
© British Library, fig. 65
© The British Museum, cats 18, 66, 81, 83, 88, 121, 143, 152, 175, 185, 200, 294, 296, 303, 304, 351, 354, 357, 358; fig. 61; Colin McEwan, fig 46
Guildhall Library, Corporation of London/Geremy Butler, figs 66, 67, 68
Tate, fig. 69
V&A Picture Library/D.P.P. Naish, cat. 324

LOS ANGELES
© 2002 Museum Associates/LACMA. All Rights Reserved, cat. 327
© UCLA Fowler Museum of Cultural History/Don Cole, cat. 165

MADRID
Biblioteca Nacional, cat. 343; figs 1, 63
© Patrimonio Nacional, cat. 323; fig. 64

MANNHEIM
© Reiss-Engelhorn Museen/Jean Christen, cats 106, 120

MEXICO CITY
courtesy CONACULTA – INAH, figs 13, 16, 28, 37, 40, 41/Fernando Carrizosa, fig. 17; Salvador Guilliem, figs 14, 20; Leonardo López Luján, fig. 21; Germán Zúñiga, José Luis Rojas Martínez, fig. 18

MEXICO CITY
Universidad Nacional Autónoma de México, fig. 55

MUNICH
© Bayerische Schlösserverwaltung/Wolf Christian von der Mülbe, Dachau, cat. 177
© Staatliches Museum für Völkerkunde/Alexander Laurenzo, cats 213, 220, 315

NEW HAVEN (CT)
© 2002 Peabody Museum of Natural History, Yale University, cats 35, 224

NEW YORK
© American Museum of Natural History Library, fig. 7; Craig Chesek, cats 46, 49, 158; D. Finnin, cat. 292;
Brooklyn Museum of Art/Central Photo Archive, cats 39, 57, 71
© 2002 The Metropolitan Museum of Arts, cats 25, 180; fig. 38

NUREMBERG
Courtesy Germanisches Nationalmuseum, cat. 359
Museen der Stadt Nürnberg, Gemälde und Skulpturen, cat. 336

OXFORD
© The Bodleian Library, University of Oxford, cat. 349; fig 36

PARIS
© Assemblée Nationale Française, figs 26, 57
Bibliothèque Nationale de France, cats 345, 348, 355; figs 22, 35, 39
© Musée de l'Homme/D. Destable, cats 76, 101, 319; fig. 58; M. Delaplanche, cats 127, 128; P. Ponsard, cat. 100

PHILADELPHIA
© Philadelphia Museum of Art/Graydon Wood, 1991, cat. 7; 1995, cat. 225; 2002, cats 11, 173

PRINCETON
© Trustees of Princeton University/Bruce M. White, cat. 53

ROME
IKONA, figs 24, 53; IKONA/Microfoto, figs 27, 29, 30, 31, 32, 33, 34, 48, 56, 59; Museo Pigorini/Damiano Rosa, cat. 295

ROUEN
© 2002 AREHN/Th. Asencio-Parvy, fig. 19

ST LOUIS
The Saint Louis Art Museum, cats 189, 196, 215, 305

ST PETERSBURG
© 2002 The State Hermitage Museum, cat. 183

TURIN
su concessione dei Musei Civici di Torino. Fototeca dei Musei Civici/Ernani Orcorte, cats 176, 188, 190

VATICAN CITY
© Biblioteca Apostolica Vaticana, cat. 346
Musei Vaticani/A Bracchetti, cat. 114

VIENNA
© Museum für Völkerkunde, cats 21, 22, 23, 74, 142, 150, 187, 193, 299, 312, 313, 321, 334; figs 47, 51

WASHINGTON
Dumbarton Oaks Research Library and Collection, Washington, D.C, cats 178, 192, 195, 314, 320, 335

© Yann Arthus-Bertrand/Corbis, fig. 12

© Gianni/Dagli Orti/Corbis, fig. 11

Richard Hurley, cat. 347

Jürgen Liepe, cats 16, 293

© Alfredo López Austin, fig. 23

Eduardo Matos Moctezuma, figs 43, 45

© Marco Antonio Pacheco/Raíces/INAH, fig. 15

Matti Ruotsalainen, cats 166, 197

© Michel Zabé/BMI, figs 5, 6, 9, 49, 50

Michel Zabé, cats 1, 2, 4, 5, 6, 8, 9, 10, 13, 15, 17, 19, 20, 24, 26, 27, 28, 29, 30, 31, 32, 33, 34, 36, 37, 38, 40, 41, 42, 43, 44, 48, 50, 51, 52, 54, 55, 56, 58, 59, 60, 61, 62, 63, 64, 65, 67, 68, 69, 70, 72, 73, 75, 78, 79, 80, 83, 85, 86, 89, 90, 91, 93, 94, 95, 96, 97, 98, 99, 102, 105, 108, 110, 111, 113, 115, 116, 117, 118, 119, 122, 123, 124, 125, 126, 129, 130, 131, 132, 133, 134, 135, 136, 137, 138, 139, 140, 141, 144, 145, 147, 148, 151, 153, 154, 155, 156, 157, 159, 160, 161, 162, 163, 164, 167, 169, 170, 171, 172, 174, 179, 181, 182, 184, 191, 194, 198, 201, 202, 203, 204, 206, 207, 211, 212, 214, 216, 217, 221, 222, 223, 227, 228, 229, 231, 232, 233, 234, 235, 236, 237, 238, 239, 240, 241, 242, 243, 244, 245, 246, 247, 249, 250, 251, 252, 253, 255, 256, 257, 258, 259, 260, 261, 262, 263, 264, 265, 266, 267, 268, 269, 269, 270, 271, 272, 273, 274, 275, 276, 277, 278, 279, 280, 281, 282, 283, 284, 285, 286, 287, 288, 290, 291, 300, 301, 302, 306, 307, 308, 309, 310, 311, 317, 318, 322, 326, 328, 329, 330, 331, 332, 333, 337, 338, 339, 352

ACKNOWLEDGEMENTS

Dawn Ades
Jean-Jacques Aillagon
César J. Aldama Muciño
Richard Alford
Robert Anderson
Chris Anderton
Carmen Aneiros
Franca Arduini
Emilio Azcárraga Jean
Christine Bailey
George Bankes
Bruce Barker-Benfield
Brent R. Benjamin
María Clara Bernal Bermúdez
Marla C. Berns
Clara Bezanilla
Antonino Biancastella
Warwick Bray
Gordon Brotherston
Alexander Brust
Francesco Buranelli
Richard Burger
Reg Carr
Ximena María Chávez Balderas
Mary Clapinson
Carlos A. Córdova
Carlos Córdova-Plaza
Alan Curry
Lily Díaz
Manuel Díaz Cebrián
Peter Didrichsen
Joanne Doornewaard
Beret Due
Brian Durrans
Gregory Eades
Ángeles Espinoza Yglesias
Raffaele Farina
Fabien Ferrer-Joly
Miguel Fernández Félix
Norman Fiering
David Flemming
Antonia Ida Fontana
Teresa Franco
Simonetta Fraquelli
Maria Antonietta Fugazzola Delpino
Ellen V. Futter
Laura Galbán
Mercedes de la Garza Camino
Juliete Giménez Cacho G.
Daniel Goeritz Rodríguez
Heriberto Gómez Ramírez
Blanca González
Claudio X. González
Ulf Göranson

Rosario Granados
Habil G. Ulrich Grossmann
Anne d'Harnoncourt
Joanne Harwood
Allis Helleland
Ian Hughes
Jean-Noël Jeanneney
Mark Jones
Peter Kann
Lily Kassner
Edward L. Keenan
Viola König
Wulf Köpke
Milena Koprivitza Acuña
Rolf Krebs
Ursula Kubach-Reutter
Amelia Lara Tamburino
Arnold Lehman
Roberto López
John Mack
Mauricio Maillé
Juan Manuel Santin
Anna Maris
María Teresa Márquez Díez-Canedo
Monica Martí
Juan Carlos de la Mata González
Irene Martin
Jesús Martínez Arvizu
John W. McCarter, Jr.
Colin McEwan
Rafael Micha
Diana Mogollón González
Martín Antonio Mondragón
Carolina Monroy del Mazo
Rúben B. Morante López
Marilena Mosco
Philippe de Montebello
Claudius Mueller
Lars Munkhammar
Virginia Murrieta
Thomas D. Nicholson
J. C. Nolan
Francis van Noten
Jaime Nualart
Santiago Oñate Laborde
José Enrique Ortíz Lanz
Joanna Ostapkowicz
Ignacio Padilla
Enrica Pagella
Vanessa Paredes
Néstor Paredes C.
María Esther Paredes Solís
Alejandra de la Paz
Rebeca Perales

Mikhail Piotrovsky
Jeffrey Quilter
Luis Racionero Grau
Yolanda Ramos Galicia
Froilán Ramos Pérez
Miguel Ángel Recio Crespo
Katherine Lee Reid
Andrea L. Rich
Catherine Rickman
Pierre Robbe
Miguel Rodríguez-Acosta Carlström
Juan Alberto Román Berrelleza
Rosa María Romo López
Eduardo Rostán
Nancy Rostoff
Sandra Rozental
Mariana Salgado
Juan Manuel Santín
Klaus Schneider
Cristina Serrano Pérez
Marjorie Shiers
Charles Spencer
Annie Starkey
Kate Storey
Robert Tavenor
Keith Taylor
Michael Taylor
Susan Taylor
Michael Tellenbach
Richard Townsend
Loa Traxler
Miguel Ángel Trinidad Meléndez
Ernst W. Veen
Manuel Velasco
Roberto Velasco Alonso
Emilo Velázquez Gallegos
Roxana Velásquez Martínez del Campo
Robert A. Vornis
John Vrieze
Gabriele Weiss
David Weston
Clara Wilpert
Anne Winton
James N. Wood
Greg Youmans
Michel Zabé
Arturo Zárate Ramírez

INDEX

All references are to page
numbers; those in **bold** type
indicate catalogue entries and
those in *italic* type indicate essay
illustrations.

Mrs Michael Green
Mr and Mrs Thomas Griffin
Mr and Mrs Clifford J Gundle
The Harris Family
Mr Andrew Hawkins
David and Lesley Haynes
Michael and Morven Heller
Robin Heller Moss
Mrs Margarita Hernandez
Mrs Alexander F Hehmeyer
Mr and Mrs J Hodkinson
Anne Holmes-Drewry
Mr and Mrs Ken Howard
Mrs Sue Howes and Mr Greg Dyke
Mr and Mrs Allan Hughes
Mrs Pauline Hyde
Simone Hyman
Mr Oliver Iny
Mr S Isern-Feliu
Mr and Mrs F Lance Isham
Sir Martin and Lady Jacomb
Mr and Mrs Ian Jay
Harold and Valerie Joels
Sir Paul Judge
Mr and Mrs Richard Kaufman
Mr and Mrs Laurence Kelly
Rona and Robert Kiley
Mr D H Killick
Mr and Mrs James Kirkman
Miss Divia Lalvani
Tom Larsen, Holt Value Associates
L A Tanner & Co, Inc
Mr George Lengvari
Colette and Peter Levy
Sir Christopher and Lady Lewinton
Mrs Rosemary Lieberman
Susan Linaker
Mrs Livingstone
Miss R Lomax-Simpson
Mr and Mrs Mark Loveday
Mr Charles G Lubar
Richard and Rose Luce
Mrs Gertie Lurie
Mrs Marilyn Maklouf
Mr and Mrs Eskandar Maleki
Ms Claudine B Malone
Mr and Mrs Michael (RA)
 and Jose Manser
Mr and Mrs M Margulies
The Lord Marks of Broughton
Marsh Christian Trust
R C Martin
Mr and Mrs Stephen Mather
Mrs M C W McCann
Mr and Mrs Andrew McKinna
Mr and Mrs Bruce McLaren
Sir Kit and Lady McMahon
Mr and Mrs Philip Mengel
The Mercers' Company
Lt Col L S Michael OBE
Mr and Mrs Donald Moore
Mr and Mrs Peter Morgan
Mr and Mrs I Morrison
The Mulberry Trust
Mr and Mrs Carl Anton Muller
N Peal Cashmere
Mr and Mrs Elis Nemes
John Nickson and Simon Rew
Mr and Mrs Simon Oliver
Mr Neil Osborn and Ms Holly Smith
Sir Peter Osborne and Lady Osborne
Mr Michael Palin
Mr and Mrs Vincenzo Palladino
Mr and Mrs Gerald Parkes
Mr and Mrs Stephen Partridge-Hicks
John Pattisson
Mr and Mrs D J Peacock
The Pennycress Trust
Miss Karen Phillipps
Mr David Pike
Mr Godfrey Pilkington
George and Carolyn Pincus
Mr and Mrs William A Plapinger
David and Linda Pohs-Supino
Mr and Mrs John Pomian
John Porter Charitable Trust
Miss Victoria Provis
The Quercus Trust
John and Anne Raisman
Sir David and Lady Ramsbotham
Martin Randall Travel Ltd
Mr T H Reitman
Mrs Clare Rich

Sir John and Lady Riddell
The Roland Group of Companies Plc
Mr and Mrs Ian Rosenberg
Alastair and Sarah Ross Goobey
Mr and Mrs Kerry Rubie
Mr and Mrs Derald H Ruttenberg
The Audrey Sacher Charitable Trust
Dr P B St Leger
Mr and Mrs Victor Sandelson
Mr and Mrs Bryan Sanderson
Mr and Mrs Nicholas Sassow
Mrs Sylvia B Scheuer
Mr and Mrs Stuart L Scott
Dr Lewis Sevitt
The Countess of Shaftesbury
Mr and Mrs Paul Shang
Mr and Mrs Colin Sharman
Mrs Lois Sieff OBE
Mr and Mrs William Sieghart
Mr Peter Simon
Mrs Margaret Simpson
Brian D Smith
Mr and Mrs John Sorrell
Don and Susan Starr
Mrs Jack Steinberg
Mr and Mrs David Stileman
John and Sheila Stoller
Mr and Mrs R W Strang
The Swan Trust
Mr and Mrs David Swift
Mr John Tackaberry
Mr and Mrs John D Taylor
Mrs Jonathan Todhunter
The Hon Barbara S Thomas
Mr and Mrs Julian Treger
Miss Joanna Trollope OBE
Carole Turner Record
Mrs Kathryn Uhde
Miss M L Ulfane
Michael and Yvonne Uva
Visa Lloyds Bank Monte Carlo
Mrs Catherine Vlasto
Mr and Mrs Santo Volpe
Mrs Claire Vyner
Mr and Mrs Ludovic de Walden
Mrs Cynthia Walton
John B Watton
Mr and Mrs Jeffrey M Weingarten
Edna and Willard Weiss
Mrs Gerald Westbury
Mr and Mrs Anthony Williams
Mr Jeremy Willoughby
Mr John D Winter
Miss Caroline Wiseman
The Right Hon and Lady Young
 of Graffham
and others who wish to remain anonymous

SCHOOLS PATRONS GROUP
The Lord Aldington
Arts and Humanities Research Board
The Charlotte Bonham-Carter
 Charitable Trust
Mrs Stephen Boyd
Mr Robert Bullock
The Candide Charitable Trust
Mr Raymond Cazalet
Smadar and David Cohen
Mr Simon Copsey
Keith and Pam Dawson
The Delfont Foundation
The D'Oyly Carte Charitable Trust
Mr Alexander Duma
The Marchioness of Dufferin and Ava
The Gilbert & Eileen Edgar
 Foundation
The Eranda Foundation
Mr Hani Farsi
Jack and Greta Goldhill
The Headley Trust
Fiona Johnstone
The Lark Trust
Lora Lehmann
The Leverhulme Trust
The Loughborough Fellowship
 in Fine Art
Mr John Martin
The Henry Moore Foundation
Robin Heller Moss
The Mulberry Trust
Newby Trust Limited
Miranda Page-Wood
N Peal Cashmere

The Worshipful Company
 of Painter-Stainers
The Stanley Picker Trust
Pickett Fine Leather Ltd
Edith and Ferdinand Porjes
 Charitable Trust
Mr David A Robbie
Mr and Mrs Anthony Salz
Paul Smith and Pauline Denyer Smith
The South Square Trust
Mr and Mrs Michele Sportelli
The Starr Foundation
Mr and Mrs Robert Lee Sterling Jr
The Peter Storrs Trust
Mr and Mrs Denis Tinsley
Mr David Tudor
The Celia Walker Art Foundation
The Harold Hyam Wingate
 Foundation
and others who wish to remain anonymous

GENERAL BENEFACTORS
Mr Keith Bromley
Miss Jayne Edwardes
Catherine Lewis Foundation
Lady Sainsbury
and others who wish to remain anonymous

American Associates

BENEFACTORS
Mrs Deborah Loeb Brice
Mr Francis Finlay
Mrs Melville Wakeman Hall
Mrs Jeanne K Lawrence
Sir Christopher and Lady Lewinton
Ms Brenda Neubauer Straus

SPONSORS
Mrs Jan Cowles
Mrs Katherine D W Findlay
Ms Frances S Hayward
Mr James Kemper Jr
The Honorable and Mrs Philip Lader
Mrs Linda Noe Laine
Mrs Edmond J Safra
Mr Peter Schoenfeld
Mr Arthur O Sulzberger
 and Ms Allison S Cowles
Virgin Atlantic

PATRONS
Ms Helen Harting Abell
Mr and Mrs Steven Ausnit
Mr and Mrs Stephen D Bechtel Jr
Mrs William J Benedict
Mr Donald A Best
Mr and Mrs Henry W Breyer III
Mrs Mildred C Brinn
Dr and Mrs Robert Carroll
Mr and Mrs Benjamin Coates
Ms Anne S Davidson
Ms Zita Davisson
Mr and Mrs Charles Diker
Mrs June Dyson
Mrs John W Embry
Mrs A Barlow Ferguson
Mrs Robert Ferst
Mr Richard E Ford
Mrs William Fox Jr
Mr and Mrs Lawrence S Friedland
Goldman, Sachs & Co
Mrs Betty Gordon
Ms Rachel K Grody
Mr and Mrs Martin D Gruss
Mrs Richard L Harris
Mr and Mrs Gurnee F Hart
Mr Edward H Harte
Mr and Mrs Gustave M Hauser
Dr Bruce C Horten
Mr Robert J Irwin
Ms Betty Wold Johnson
 and Mr Douglas Bushnell
The Honorable and Mrs W Eugene
 Johnston III
Mr William W Karatz
Mr and Mrs Stephen M Kellen
Mr and Mrs Gary A Kraut
William M and Sarah T Lese
 Family Fund

Mr Arthur L Loeb
The Nathan Manilow
 Foundation
Mrs John P McGrath
Mrs Mark Millard
Mrs Barbara T Missett
Mr Paul D Myers
Mr and Mrs Wilson Nolen
Mrs Richard D O'Connor
Mr and Mrs Jeffrey Pettit
Mr Robert S Pirie
Mrs Nanette Ross
Mrs Frances G Scaife
Ms Jan Blaustein Scholes
Mr and Mrs Stanley D Scott
Ms Georgia Shreve
Mr James Sollins
Mrs Frederick M Stafford
Mr and Mrs Stephen Stamas
Elizabeth F Stribling
Mrs Royce Deane Tate
Mrs Britt Tidelius
Mrs Richard B Tullis
Ms Sue Erpf Van de Bovenkamp
Mrs Vincent S Villard Jr
Mr and Mrs Stanford S
 Warshawsky
Mrs Sara E White
Dr and Mrs Robert D Wickham
Mr and Mrs Robert G Wilmers
Mr Robert W Wilson
Mr and Mrs Kenneth Woodcock
and others who wish to remain anonymous

Contributing Friends of the Royal Academy

PATRON FRIENDS
Mrs Yvonne Barlow
Mr and Mrs Sidney Corob
Mr David Ker
Mrs Janet Marsh
Mrs Maureen D Metcalfe
Mr R J Mullis
Mr Robin Symes
and others who wish to remain anonymous

SUPPORTING FRIENDS
Mr Keith G Bennett
Mrs C W T Blackwell
Mr C Boddington
 and Ms R Naylor
Mr Paul Brand
Miss E M Cassin
Mr R A Cernis
Mrs M F Coward
Mrs Nadine Crichton
Mrs Belinda Davie
Mr John Denham
Miss N J Dhanani
Mr Kenneth Edwards
Jack and Irene Finkler
Mrs D Goodsell
Mr Gavin Graham
Miss Karen Harper-Gow
Mr R J Hoare
Mr Christopher Hodsoll
Mrs Manya Igel
Ms Shiblee Jamal
Mrs Jane Jason
Mrs G R Jeffries
Mr and Mrs J Kessler
Mrs L Kosta
Mrs Carol Kroch
Mrs Joan Lavender
Mr Owen Luder CBE PRIBA FRSA
Mr Donald A Main
Mrs Gillian McIntosh
Mrs Barbara Minto
Mr George Moore
Angela Nevill
Mrs Elizabeth M Newell
Miss Kim Nicholson
Mr C Mark Nicolaides
Mrs Elaine Nordby
Mr Ralph Picken
Mr Benjamin Pritchett-Brown
Mrs Elizabeth Ridley
Mr D S Rocklin
Mrs A Rodman

Mr and Mrs O Roux
Lady Sainsbury
The Rt Hon Sir Timothy
 Sainsbury
Mrs D Scott
Mrs Josephine Seaton
Mrs E D Sellick
Mr R J Simmons CBE
Mr John H M Sims
Mr Brian Smith
Mrs K M Söderblom
Mrs J A Tapley
Mrs Claire Weldon
Mrs Jacqueline Williams
and others who wish to remain anonymous

Corporate Membership of the Royal Academy of Arts

Launched in 1988, the Royal
Academy's Corporate Membership
Scheme has proved highly successful.
Corporate membership offers
company benefits to staff and clients
and access to the Academy's facilities
and resources. Each member pays an
annual subscription to be a Member
(£7,000) or Patron (£20,000).
Participating companies recognise the
importance of promoting the visual
arts. Their support is vital to the
continuing success of the Academy.

Corporate Membership Scheme

CORPORATE PATRONS
Ashurst Morris Crisp
Bloomberg LP
BNP Paribas
BP Amoco p.l.c.
Debenhams Retail plc
Deloitte & Touche
Deutsche Bank AG
Ernst and Young
GlaxoSmithKline plc
Granada plc
John Lewis Partnership
Merrill Lynch
Radisson Edwardian Hotels
Royal & Sun Alliance

CORPORATE MEMBERS
Anonymous
Accel Partners
Apax Partners Holding Ltd
Barclays plc
Bear, Stearns International Ltd
BMP DDB Limited
The Boston Consulting Group
Bovis Lend Lease Limited
The British Land Company PLC
BT plc
Bunzl plc
Cantor Fitzgerald
Cazenove & Co
CB Hillier Parker
Christie's
Chubb Insurance Company
 of Europe
Citigroup
CJA (Management Recruitment
 Consultants) Limited
Clifford Chance
Colefax and Fowler Group
Credit Agricole Indosuez
De Beers
Diageo plc
Dresdner Kleinwort Wasserstein
The Economist Group
Eversheds
F&C Management plc
Goldman Sachs International
Govett Investment Management
 Limited
Hay Group

Hewitt, Bacon and Woodrow
H J Heinz Company Limited
HSBC plc
ICI
King Sturge
KPMG
Linklaters & Alliance
Macfarlanes
Man Group plc
Mayer, Brown, Rowe & Maw
Mellon Global Investments
Morgan Stanley
MoMart Ltd
Pearson plc
The Peninsular and Oriental Steam
 Navigation Company
Pentland Group plc
Provident Financial plc
Raytheon Systems Limited
Redwood
Reed Elsevier Group plc
The Royal Bank of Scotland
Schroders & Co
Sea Containers Ltd.
SG
Six Continents PLC
Skanska Construction Group
 Limited
Slaughter and May
The Smith & Williamson Group
Sotheby's
Travelex
Trowers & Hamlins
Unilever UK Limited
UBS AG Private Banking
Vivendi Water

HONORARY CORPORATE MEMBERS

All Nippon Airways Co. Ltd
A.T. Kearney Limited
Derwent Valley Holdings plc
London First
Reuters Limited
Yakult UK Limited

Sponsors of Past Exhibitions

The President and Council of the Royal Academy thank sponsors of past exhibitions for their support. Sponsors of major exhibitions during the last ten years have included the following:

Allied Trust Bank
 Africa: The Art of a Continent, 1995*
Anglo American Corporation of South Africa
 Africa: The Art of a Continent, 1995*
A.T. Kearney
 231st Summer Exhibition, 1999
 232nd Summer Exhibition, 2000
 233rd Summer Exhibition, 2001
 234th Summer Exhibition, 2002
The Banque Indosuez Group
 Pissarro: The Impressionist and the City, 1993
Barclays
 Ingres to Matisse: Masterpieces of French Painting, 2001
BBC Radio 3
 Paris: Capital of the Arts 1900–1968. 2001
BMW (GB) Limited
 Georges Rouault: The Early Years, 1903–1920. 1993
 David Hockney: A Drawing Retrospective, 1995*
British Airways Plc
 Africa: The Art of a Continent, 1995
Cantor Fitzgerald
 From Manet to Gauguin: Masterpieces from Swiss Private Collections, 1995
 1900: Art at the Crossroads, 2000
The Capital Group Companies
 Drawings from the J Paul Getty Museum, 1993
Chase Fleming Asset Management
 The Scottish Colourists 1900–1930. 2000
Chilstone Garden Ornaments
 The Palladian Revival: Lord Burlington and His House and Garden at Chiswick, 1995
Christie's
 Frederic Leighton 1830–1896. 1996
 Sensation: Young British Artists from The Saatchi Collection, 1997
Classic FM
 Goya: Truth and Fantasy, The Small Paintings, 1994
 The Glory of Venice: Art in the Eighteenth Century, 1994
Corporation of London
 Living Bridges, 1996
Country Life
 John Soane, Architect: Master of Space and Light, 1999
Credit Suisse First Boston
 The Genius of Rome 1592–1623. 2000
The Daily Telegraph
 American Art in the 20th Century, 1993
 1900: Art at the Crossroads, 2000
De Beers
 Africa: The Art of a Continent, 1995
Debenhams Retail plc
 Premiums and RA Schools Show, 1999
 Premiums and RA Schools Show, 2000
 Premiums and RA Schools Show, 2001
 Premiums and RA Schools Show, 2002
Deutsche Morgan Grenfell
 Africa: The Art of a Continent,

1995
Diageo plc
 230th Summer Exhibition, 1998
The Drue Heinz Trust
 The Palladian Revival: Lord Burlington and His House and Garden at Chiswick, 1995
 Denys Lasdun, 1997
 Tadao Ando: Master of Minimalism, 1998
The Dupont Company
 American Art in the 20th Century, 1993
Elf
 Alfred Sisley, 1992
Ernst & Young
 Monet in the 20th Century, 1999
eyestorm
 Apocalypse: Beauty and Horror in Contemporary Art, 2000
Fidelity Foundation
 The Dawn of the Floating World (1650–1765). Early Ukiyo-e Treasures from the Museum of Fine Arts, Boston, 2001
Fondation Elf
 Alfred Sisley, 1992
Friends of the Royal Academy
 Victorian Fairy Painting, 1997
Game International Limited
 Forty Years in Print: The Curwen Studio and Royal Academicians, 2001
The Jacqueline and Michael Gee Charitable Trust
 LIFE? or THEATRE? The Work of Charlotte Salomon, 1999
Générale des Eaux Group
 Living Bridges, 1996
Glaxo Wellcome plc
 The Unknown Modigliani, 1994
Goldman Sachs International
 Alberto Giacometti, 1901–1966. 1996
 Picasso: Painter and Sculptor in Clay, 1998
The Guardian
 The Unknown Modigliani, 1994
Guinness Peat Aviation
 Alexander Calder, 1992
Guinness PLC (see Diageo plc)
 223rd Summer Exhibition, 1991
 224th Summer Exhibition, 1992
 225th Summer Exhibition, 1993
 226th Summer Exhibition, 1994
 227th Summer Exhibition, 1995
 228th Summer Exhibition, 1996
 229th Summer Exhibition, 1997
Harpers & Queen
 Georges Rouault: The Early Years, 1903–1920. 1993
 Sandra Blow, 1994
 David Hockney: A Drawing Retrospective, 1995*
 Roger de Grey, 1996
The Headley Trust
 Denys Lasdun, 1997
The Henry Moore Foundation
 Alexander Calder, 1992
 Africa: The Art of a Continent, 1995
Ibstock Building Products Ltd
 John Soane, Architect: Master of Space and Light, 1999
The Independent
 Living Bridges, 1996
 Apocalypse: Beauty and Horror in Contemporary Art, 2000
International Asset Management
 Frank Auerbach, Paintings and Drawings 1954–2001. 2001
Donald and Jeanne Kahn
 John Hoyland, 1999
Land Securities PLC
 Denys Lasdun, 1997
The Mail on Sunday
 Royal Academy Summer Season, 1992
 Royal Academy Summer Season,

1993
Marks & Spencer
 Royal Academy Schools Premiums, 1994
 Royal Academy Schools Final Year Show, 1994*
Martini & Rossi Ltd
 The Great Age of British Watercolours, 1750–1880. 1993
Paul Mellon KBE
 The Great Age of British Watercolours, 1750–1880. 1993
Merrill Lynch
 American Art in the 20th Century, 1993*
 Paris: Capital of the Arts 1900–1968. 2002
Midland Bank plc
 RA Outreach Programme, 1992–1996
 Lessons in Life, 1994
Minorco
 Africa: The Art of a Continent, 1995
Natwest Group
 Nicolas Poussin 1594–1665. 1995
The Nippon Foundation
 Hiroshige: Images of Mist, Rain, Moon and Snow, 1997
Olivetti
 Andrea Mantegna, 1992
Peterborough United Football Club
 Art Treasures of England: The Regional Collections, 1997
Premiercare (National Westminster Insurance Services)
 Roger de Grey, 1996*
RA Exhibition Patrons Group
 Chagall: Love and the Stage, 1998
 Kandinsky, 1999
 Chardin 1699–1779. 2000
 Botticelli's Dante: The Drawings for The Divine Comedy, 2001
 Return of the Buddha: The Qingzhou Discoveries, 2002
Redab (UK) Ltd
 Wisdom and Compassion: The Sacred Art of Tibet, 1992
Reed Elsevier plc
 Van Dyck 1599–1641. 1999
 Rembrandt's Women, 2001
Republic National Bank of New York
 Sickert: Paintings, 1992
The Royal Bank of Scotland
 Braque: The Late Works, 1997*
 Premiums, 1997
 Premiums, 1998
 Premiums, 1999
 Royal Academy Schools Final Year Show, 1996
 Royal Academy Schools Final Year Show, 1997
 Royal Academy Schools Final Year Show, 1998
The Sara Lee Foundation
 Odilon Redon: Dreams and Visions, 1995
Sea Containers Ltd
 The Glory of Venice: Art in the Eighteenth Century, 1994
Silhouette Eyewear
 Wisdom and Compassion: The Sacred Art of Tibet, 1992
 Sandra Blow, 1994
 Africa: The Art of a Continent, 1995
Société Générale, UK
 Gustave Caillebotte: The Unknown Impressionist, 1996*
Société Générale de Belgique
 Impressionism to Symbolism: The Belgian Avant-garde 1880–1900. 1994
Spero Communications
 Royal Academy Schools Final Year Show, 1992
Thames Water Plc
 Thames Water Habitable Bridge Competition, 1996

The Times
 Wisdom and Compassion: The Sacred Art of Tibet, 1992
 Drawings from the J Paul Getty Museum, 1993
 Goya: Truth and Fantasy, The Small Paintings, 1994
 Africa: The Art of a Continent, 1995
Time Out
 Sensation: Young British Artists from The Saatchi Collection, 1997
 Apocalypse: Beauty and Horror in Contemporary Art, 2000
Tractabel
 Impressionism to Symbolism: The Belgian Avant-garde 1880–1900, 1994
Union Minière
 Impressionism to Symbolism: The Belgian Avant-garde 1880–1900, 1994
Vistech International Ltd
 Wisdom and Compassion: The Sacred Art of Tibet, 1992
Yakult UK Ltd
 RA Outreach Programme, 1997–2002*
 alive: Life Drawings from the Royal Academy of Arts & Yakult Outreach Programme

* Recipients of a Pairing Scheme Award, managed by Arts + Business. Arts + Business is funded by the Arts Council of England and the Department for Culture, Media and Sport.

Other Sponsors

Sponsors of events, publications and other items in the past five years:

Carlisle Group plc
Country Life
Derwent Valley Holdings plc
Dresdner Kleinwort Wasserstein
Fidelity Foundation
Foster and Partners
Goldman Sachs International
Gome International
Gucci Group
Rob van Helden
IBJ International plc
John Doyle Construction
Marks & Spencer
Michael Hopkins & Partners
Morgan Stanley Dean Witter
Prada
Radisson Edwardian Hotels
Richard and Ruth Rogers
Strutt & Parker

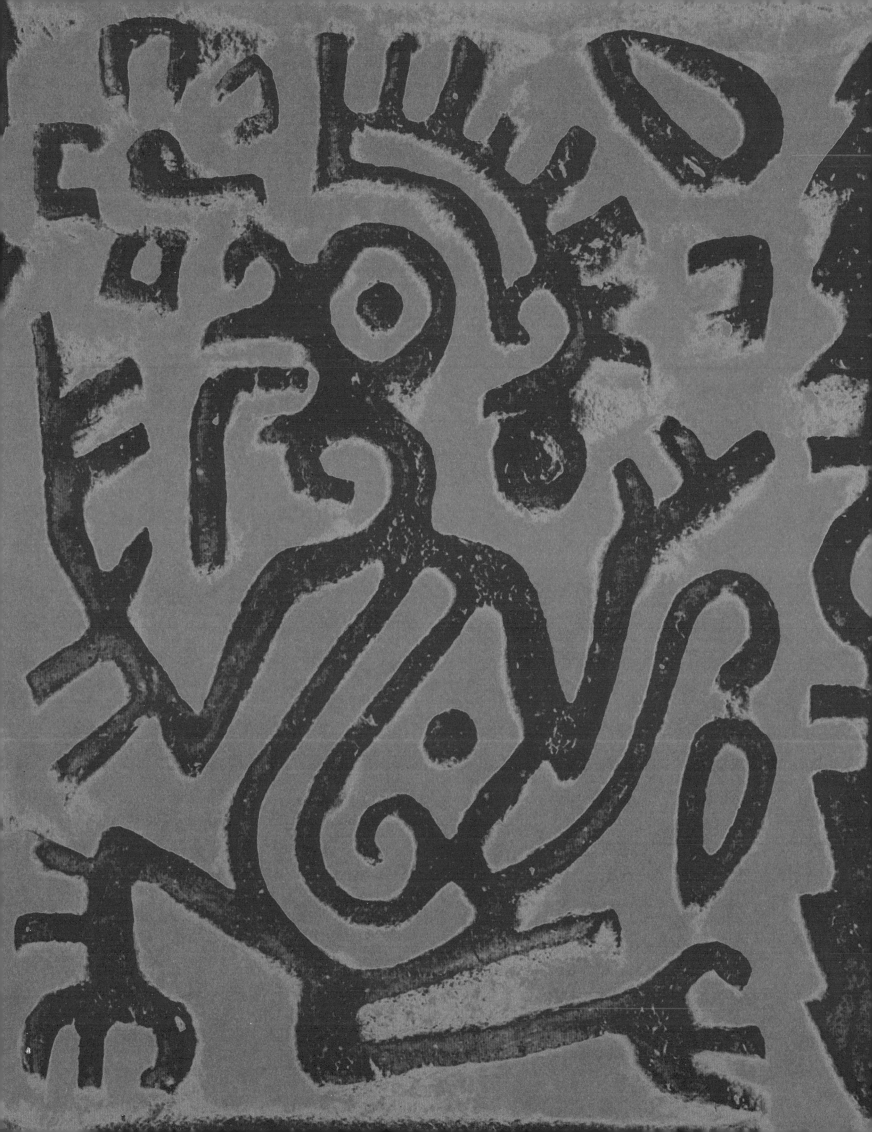